ARCHITECTURE SINCE 1400

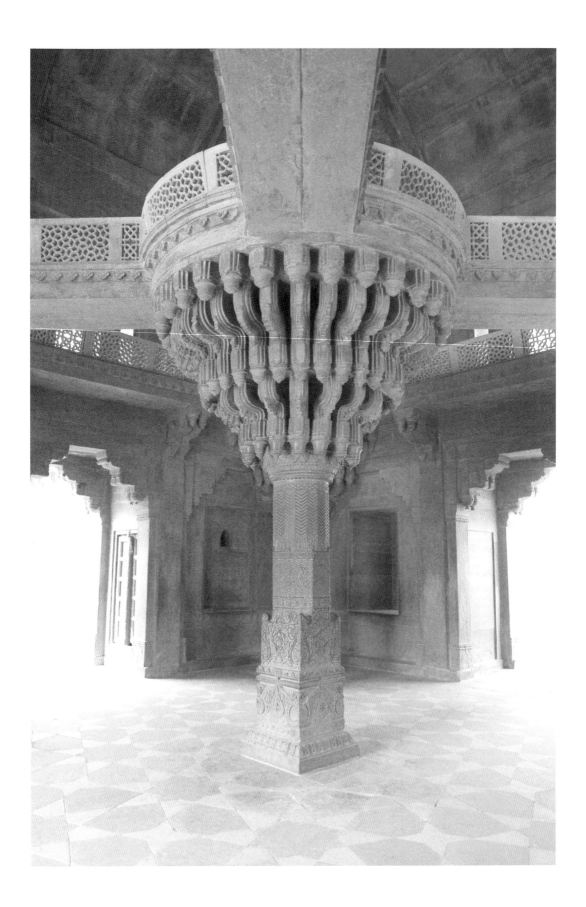

ARCHITECTURE SINCE 1400

Kathleen James-Chakraborty

UNIVERSITY OF MINNESOTA PRESS

MINNEAPOLIS · LONDON

This book is published with assistance from the
Margaret S. Harding Memorial Endowment honoring the
first director of the University of Minnesota Press.

Frontispiece: Interior, Diwan-i-Khas, Fatehpur Sikri, India.

For information on the illustrations in this book, see pages 489–97.
Unless otherwise credited, architectural plans were drawn by Neil Christianson.

Every effort was made to obtain permission to reproduce material in this book.
If any proper acknowledgment has not been included here, we encourage
copyright holders to notify the publisher.

Published by the University of Minnesota Press
111 Third Avenue South, Suite 290
Minneapolis, MN 55401-2520
http://www.upress.umn.edu

Library of Congress Cataloging-in-Publication Data
James-Chakraborty, Kathleen, 1960–
Architecture since 1400 / Kathleen James-Chakraborty. Includes bibliographical
references and index.
ISBN 978-0-8166-7396-4 (hc) — ISBN 978-0-8166-7397-1 (pb)
1. Architecture—History. 2. Architecture and society—History. I. Title.
NA200.J36 2014
720.9—dc23
2013032562

Printed in the United States of America on acid-free paper

The University of Minnesota is an equal-opportunity educator and employer.

27 26 25 24 23 22 10 9 8 7 6 5 4 3

For

SHOMIK

CONTENTS

ACKNOWLEDGMENTS

Like a three-legged stool, this book rests on a triad of experiences.

The first was my education at the University of Pennsylvania between 1985 and 1990. There a stellar team of architectural historians insisted that the architecture of the entire world, not just Europe and the United States, mattered. In particular, Renata Holod challenged us to consider colonial architecture and postcolonial theory as integral to our study of the architecture and ideas of the past two centuries.

The second is my experience teaching architectural history. My former colleagues, teaching assistants, and students will recognize the debt this book owes to Architecture 170B at the University of California, Berkeley, which I team taught with Stephen Tobriner, Dell Upton, and Andrew Shanken. I was fortunate that an exceptionally talented group of graduate student teaching assistants kept me abreast of the issues Holod had raised for me at Penn. More recently, teaching Courts and Court Cultures at University College Dublin helped me to sharpen my arguments about the sixteenth and seventeenth centuries.

Finally, my marriage to Sumit Chakraborty and the birth of our son, Shomik, shifted my personal as well as my professional perspective as I began to spend more time in Europe and Asia.

Along the way I accrued many debts. The most important are to my friend Elizabeth Byrne, the former head of the Environmental Design Library at Berkeley; to my research assistant Yishi Liu (paid by the Committee for Research at the University of California, Berkeley); to my editor at the University of Minnesota Press, Pieter Martin, and to Kristian Tvedten, Mackenzie Cramblit, Etta Berkland, Gwendolyn Hoberg, and, above all, Neil Christianson, who assembled the illustrations (always as challenging a task as writing the text!); and to my first readers, Catherine Asher, Carol Krinsky, Nancy Steinhardt, and a very thoughtful anonymous reviewer. Through a grant to research Louis Kahn, the Graham Foundation funded my travel to Modena, Italy, and to Japan. Finally, I must thank the many friends and friends of friends who contributed illustrations.

INTRODUCTION

The tomb of Timur, known as the Gur-i-Mir, erected in Samarqand in what is now Uzbekistan, and the Glass House in the suburbs of São Paulo, Brazil, would at first appear to have little if anything in common (Figures I.1 and I.2). The tomb was constructed around 1404 out of load-bearing baked bricks. These are techniques and materials that have been used since prehistoric times. The front of the Glass House, designed in 1950 and completed the following year, is a glass-filled reinforced concrete box. The steel pillars upon which it is perched run through the interior of the cantilevered reinforced concrete floor slab, minimizing the scale of the mullions that hold the vast windows in place. Such construction has been possible for little more than a century. Glazed tile ornament encrusts the most important exterior surfaces of the Gur-i-Mir; the interior of the tomb features a stunning net of *muqarnas* (ornament derived from the sections of the sphere that can be used to support a dome) executed in papier-mâché atop onyx wall paneling (Figure I.3). This ornament helps to establish a hierarchy within a composition focused on the *iwans* (vaulted openings framed by pointed arches) of the forecourt and entrance, the flanking minarets, the fluted dome resting on a high drum, and the two layers of domed chambers located under it. By contrast, the Glass House exhibits only the facts of its construction; there is no added decoration. The purposes of the buildings differ, too. The Gur-i-Mir was intended by a great conqueror to be the burial place of a cherished son, although he was laid to rest there as well; the Glass House served as the dwelling of an upper-middle-class couple who were active in the arts (Figure I.4). Finally, there is a distinction in how these buildings were designed. The patron probably played a major role in the case of the tomb; the name of his master builder does not survive. A professionally trained architect, Lina Bo Bardi, designed the house in which she and her husband lived.

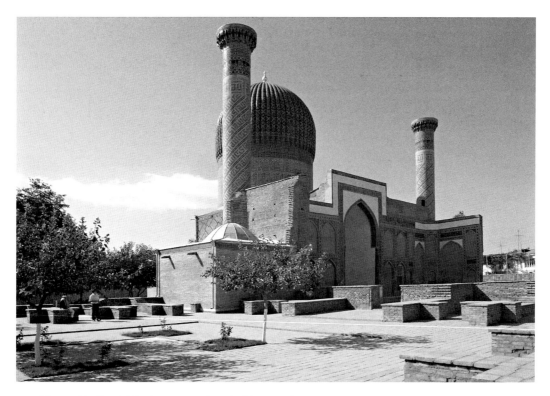

Figure I.1. Gur-i-Mir, Samarqand, Uzbekistan, 1404.

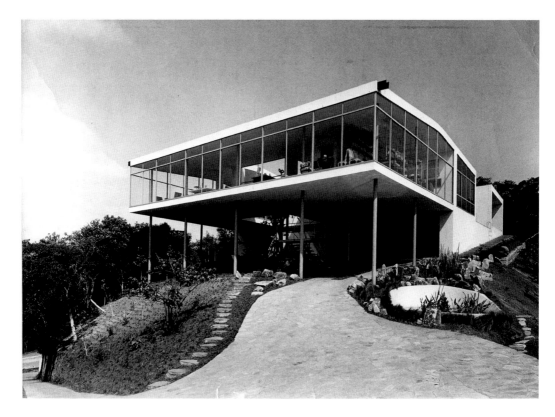

Figure I.2. Lina Bo Bardi, Glass House, São Paulo, Brazil, 1951.

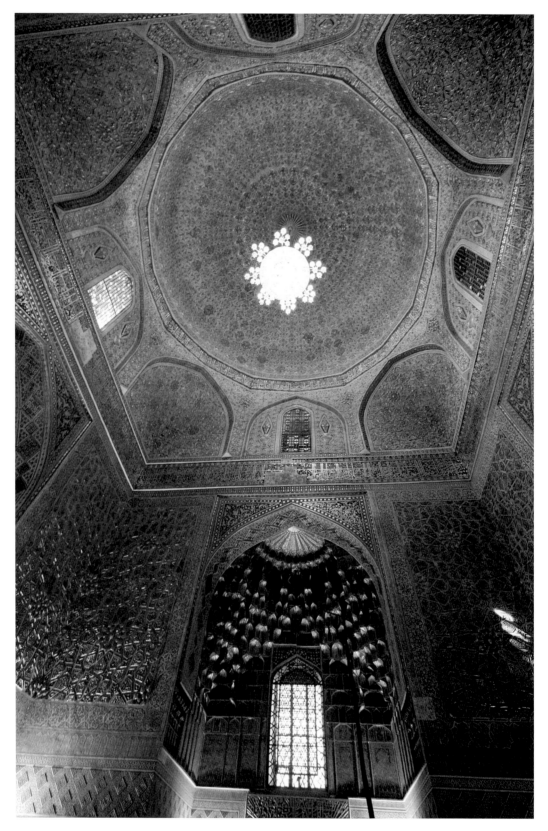

Figure I.3. Interior of dome, Gur-i-Mir.

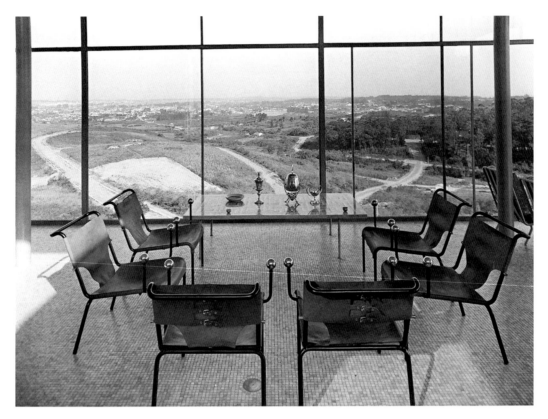

Figure I.4. Living room, Glass House.

For much of the nineteenth and twentieth centuries, many architectural histori-ans focused on the history of style—in other words, on the formal characteristics of a building that enabled it to be identified with a particular time and, very often, a particular place. A history of architecture organized entirely around style empha-sizes these differences. In such an account the details of the forms, materials, and technologies used to convey these messages matter enormously. Baked brick and tile revetment, large *iwans,* and *muqarnas* decoration identify the Gur-i-Mir as an Islamic building; expansive windows, exposed reinforced concrete, and bare sur-faces demonstrate that the Glass House exemplifies the International Style from the middle of the twentieth century.

Style can also help to explain what those who designed and commissioned a building intended to communicate, as well as affect how later audiences understand a building. Timurid (the adjective derived from the name of Timur) architecture in central Asia and modern architecture in Latin America can both be presumed to reflect significant aspects of the cultures that erected them. The Gur-i-Mir, for instance, illustrates the ambitions of individual medieval rulers at a time when polit-ical units were defined more by the extent of territory a ruler could conquer and control than by a strong sense of national identity. Its impressive scale correlates

with the ambitions and achievements of Timur, also known as Tamerlane, the most successful warrior of his day. From Samarqand, he raided cities from Damascus in the east to Delhi in the west; the empire he founded stretched from the shores of the Black Sea to the edge of the Himalayas and from the Persian Gulf north to the shores of the Caspian and Aral Seas. The Timurids ruled Iran from Herat in modern Afghanistan for a century after his death. In such an account the much more modest Glass House serves as an example of the search for individual expression mounted, especially since the beginning of the nineteenth century, by members of the educated upper-middle classes, often in opposition to such autocratic rule. Rather than demonstrating their wealth or power, the Glass House was primarily a testament to the advanced taste of the Bardis. Its publication in the European architectural press enhanced their standing in Brazil, where Bo Bardi designed Latin America's leading art museum, the São Paulo Museum of Art, of which her husband was the founding director.

Many such histories have also implied that style was relatively constant in most parts of the world but in almost constant flux in Europe and in territories settled by people of European descent. In such an account the Gur-i-Mir might stand for buildings erected from the seventh through the eighteenth centuries in territories governed by Muslims, or, at the least, be seen as emblematic of central Asia for this entire period. The modernism of the Glass House, on the other hand, would be seen as a way station between, for instance, art nouveau and postmodernism within a progression of styles stretching from ancient times to the present. It might be compared with similar buildings in France and the United States as an example of a homogenizing globalization or—particularly if the emphasis is shifted from the architecture to the remnants of rain forest that eventually almost enveloped it (as Bo Bardi always intended that they do)—of a specifically Brazilian modernism.

For more than a century, analyses of style have included discussions of how structure shapes space; more recently scholars have focused on the ways in which space structures experience at the multiple levels of buildings, cities, and even landscapes. This newer approach has been particularly useful in shifting architectural history away from a preoccupation with aesthetics—a major purpose of the field has always been to train architecture students by introducing them to exemplary buildings cherished for their beauty—toward a deeper engagement with social history. The differences between the courtyards of the Gur-i-Mir and the Glass House can thus be explained in relation to both style and purpose (Figures I.5 and I.6). The presence of a forecourt at the Gur-i-Mir emphasizes the importance of the tomb chamber and the room above it by creating a space that buffers them from the main road; supplementary complexes also open off this forecourt. The interiors are not private spaces but the focal point of the ensemble, above which the double-shell dome rises as an exclamation mark. In the Glass House, the first courtyard injects the landscape into the house. This heightens the effect of a transparent tree house by minimizing the distance from the surrounding flora and fauna. While the purpose

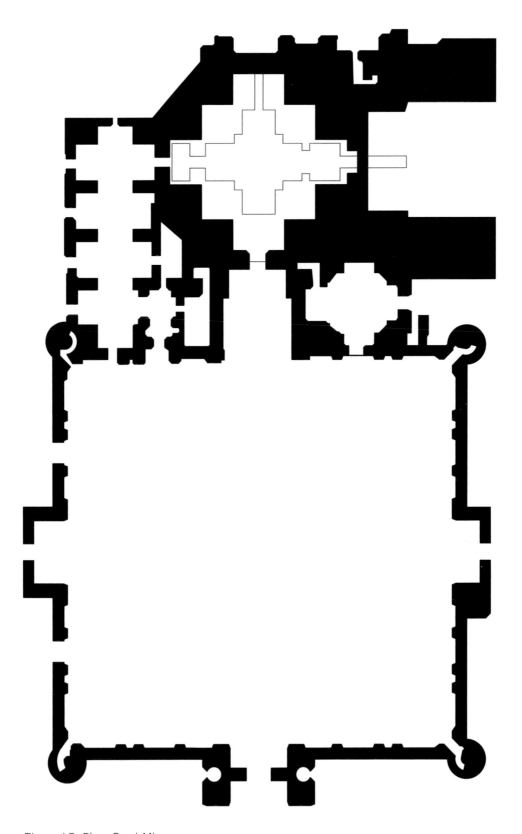

Figure I.5. Plan, Gur-i-Mir.

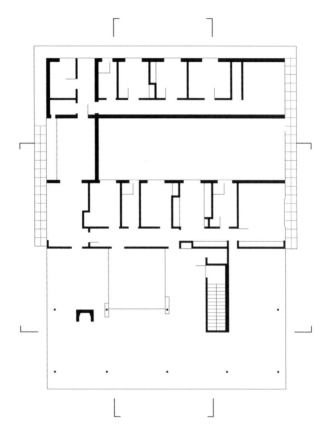

Figure I.6. Plan, Glass House.

of a visit to the Gur-i-Mir is to penetrate to the rear of its site, this is not the case at the more private Glass House. A second, larger courtyard separates the reception and bedroom areas from the service areas to the rear, which were occupied primarily by servants.

As this comparison of a fifteenth-century central Asian and a twentieth-century Latin American building indicates, on close inspection buildings erected more than five centuries and thousands of miles apart can have a great deal in common. Both the Gur-i-Mir and the Glass House enabled the clients, who in the case of the Glass House doubled as the architect, to make statements about their identities and about their relationships to the places in which the buildings were located. Fulfillment of the purpose of this book—to reconstruct the story of how environments are created that shape experience and communicate identity through the ways in which spaces are formed and surfaces are decorated—thus requires much more than just the identification of style or even the analysis of space.

This book detours from this familiar path in three further ways. A basic premise is that since at least 1400, many builders and architects, as well as their clients, have used either the history of local architecture or an awareness of past and present architecture elsewhere, and often both, to create novel structures that shaped the ways in which they and their societies were perceived. The convenient date of 1400

has been chosen because both the clearly antiquarian character of architecture in many different parts of the world and the extent of contact and interaction between geographically disparate cultures quickened at about that time. New, too, was the scale of the distances across which architectural ideas traveled with increasing speed. Long before the Industrial Revolution transformed the technologies out of which buildings were constructed, new trading links had already affected the appearance of the dwellings, workplaces, leisure environments, and houses of worship in cities around the world. Timurid architecture can stand for Islamic architecture as a whole not because Muslims from Morocco to Bangladesh shared a single approach to architecture—monumental tombs, for instance, remained almost unknown out-side central and South Asia—but because Timur compelled skilled artisans from the vast range of territory he either raided or controlled to come to Samarqand, where their combined talents produced new syntheses of previously diverse local forms and motifs. Bo Bardi, who emigrated from Italy to Brazil after World War II, was well aware of contemporary architecture in Europe and North America, as well as enthusiastic about her new home.

There is no reason, moreover, to believe that western Europe, joined later by the United States, has consistently been in the forefront of developing or popularizing new styles or construction technologies. The double-shell dome was used in Iran and central Asia before it was employed in Renaissance Italy. Reinforced concrete housing with little ornamentation was more popular in upscale neighborhoods like Bo Bardi's across the developing world during the 1950s than in most of their Euro-pean and North American counterparts. Thus the chapters that follow balance tar-geted discussions of environments around the world, not privileging one continent over another as the locus of modernity or of modernism, the aesthetic expression of modernity, at any particular time.

The second point reiterated throughout the pages that follow is the importance of recognizing the large number of people who share responsibility for the creation and maintenance of buildings. The history of architecture since 1400 has usually been told in terms of the architects who since the Renaissance have designed many of Europe's most aesthetically ambitious buildings and, since about 1800, an increas-ing share of those in the rest of the world. Patrons have also regularly appeared in the pages of these accounts when they were powerful men. A wider range of clients and construction workers, not to mention generations of users, should properly share credit for building and maintaining the structures that surround us. The activ-ities of Soviet authorities in the case of the Gur-i-Mir, for instance, and the institute devoted to the lives and careers of the Bardis in that of the Glass House have been crucial to the restoration and preservation of these sites.

Even the assumption that the Glass House is modern specifically because of the involvement of a woman in its design falters when one considers the activities of Timur's daughter-in-law, Goharshad. In addition to serving as regent for her grandson, she was an important architectural patron. Her commissions included a

celebrated mosque in Mashhad, in what is now Iran. Nor are there any grounds for believing that although most professional architects have been men, women have not always played an important role as designers, builders, patrons, and users of buildings. This book repeatedly draws attention to women's as well as men's changing relationships to the ways in which buildings have been designed, constructed, and used.

Finally, architecture has always allowed individuals as well as societies, responding in many cases to external forces beyond their control, to project realities that are as often aspirational as actual. Timur was indeed one of the most important figures of his day, but the scale of his tomb is no indicator of this; that of his descendant the Mughal emperor Humayan, who died in Delhi in 1556, was even larger and more splendid, despite Humayan's relative ineffectiveness. The transparency of many modern buildings was often equated with democracy. Although during the 1960s and 1970s Bo Bardi was critical of Brazil's military dictatorship, before the couple immigrated to Brazil her husband had been a prominent supporter of Benito Mussolini; Philip Johnson, another prominent architect who lived in a glass house he designed for himself, also flirted with fascism.

Architecture does not allow one to try on identities with the same ease as clothing, although both can be strongly influenced by fashion. It can, however, give substance to the ambitions of those individuals and groups with enough wealth and clout to build. Rather than merely reflecting culture, architecture contributes to crafting it. Timur's tomb speaks of his political power and personal taste; the visitor transfixed by the elegance of its decoration momentarily loses consciousness of the brutality of many of his military campaigns. In the Glass House Bo Bardi presented her husband with the perfect stage set from which to rehabilitate himself as a major figure in the postwar art world. Unlocking this persuasive, rhetorical power of buildings, which can fade or change over time, is the third point of this book.

No single volume, however, can come close to doing justice to the complexity and variety of architecture around the world over the course of more than six centuries. This one is no exception. It focuses on a relatively small number of examples, chosen to illustrate the range of ways that architects, builders, and their clients have built and occupied structures that in more cases than not were in their day in the forefront of change. A separate—and much longer—volume could be devoted to a more comprehensive survey of the dwellings and sacred structures erected by people with less awareness of the wider world but with similar aesthetic discernment, on farms and in villages and towns around the world. More countries are left out than included; two continents are entirely absent, as are an enormous number of celebrated buildings and their architects. Nor can any book of this relatively modest size illustrate each building that is included in adequate detail. Even on the Internet, it can be difficult to locate the plans, sections, and elevations that give those trained to read them far more information than a single shot of a facade and perhaps a general view of an interior can possibly provide. A bibliography of recent scholarly

literature follows each chapter; the books and articles listed and the ones they in turn cite provide the detail that cannot possibly be included here.

One book can help, however, to encourage an awareness and an appreciation of the desires, meanings, and experiences embedded in buildings and of the multiple ways that they have been communicated. More than simply sheltering the living and the dead from sun and rain, wind and cold, the Gur-i-Mir and the Glass House are examples of the ways in which buildings, humble as well as monumental, convey the force of personality, the wonder of technology, and the daunting power of imagination.

FOR FURTHER READING

On the Gur-i-Mir, see Markus Hattstein and Peter Delius, eds., *Islam: Art and Architecture* (Potsdam: h.f.ullmann, 2007); on the Glass House, Marcelo Carvalho Ferraz, ed., *Lina Bo Bardi* (São Paulo: Instituto Lina Bo Bardi e P. M. Bardi, 1994). For discussion of Timur as a point of departure for early modern history and the history of globalization, see John Darwin, *After Tamerlane: The Global History of Empire since 1405* (New York: Bloomsbury Press, 2008).

1

Ming and
Qing China

In 1368 the Ming dynasty seized control of China from the descendants of the Mongol invader Genghis Khan, who had ruled the Middle Kingdom since 1271. The Hongwu emperor, the founder of the new dynasty, shifted his capital from Dadu, present-day Beijing, to Nanjing. Upon his death, his grandson became emperor. After only four years, however, Hongwu's fourth son seized the throne from his nephew. Already governor of Dadu, the Yongle emperor shifted the capital back to his stronghold there. To confirm his rule, in 1407 he began the construction of the Forbidden City, still the world's largest palace and the center of Chinese government until the declaration of a republic in 1912 (Figure 1.1). The process of building the palace helped consolidate Ming rule. The Forbidden City's delicate balance of order and flexibility, tradition and innovation, and its integration of monumental and vernacular precedent demonstrate architecture's ability to embody aspirations and to support their realization. The form of the vast palace was indivisible from the identity of the Middle Kingdom over the course of half a millennium. Although almost nothing one sees on the site today dates to Yongle's reign, no structure provides a better introduction to the enduring importance of early fifteenth-century architecture and urbanism.

The palace compellingly quoted and expanded two key precedents. The first was a long history of planned Chinese capital cities, the second the courtyard house, whose prevalence from north to south and east to west was a unifying element throughout the empire. Already for more than three thousand years, Chinese imperial capitals had been planned in a roughly similar fashion determined by ideas of celestial order. Capital cities were built within rectangular enclosures, most auspiciously with mountains located to the north. Although each wall was pierced by at least one gate, the main gate was typically located to the south. Major avenues running north–south or east–west connected these gates. Major and even minor avenues

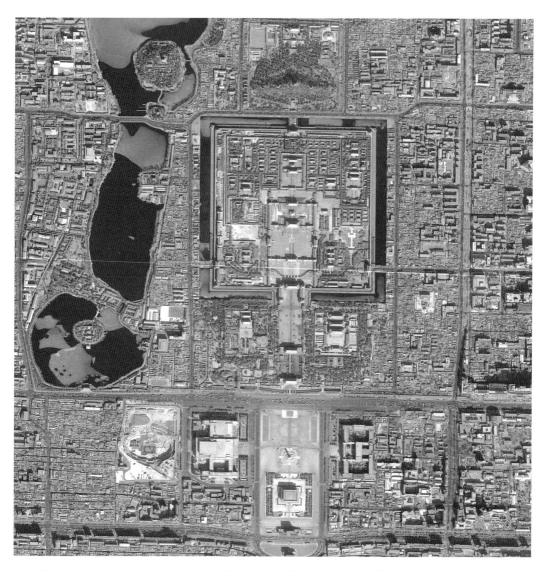

Figure 1.1. Aerial view, Forbidden City, Beijing, China, begun 1407.

bounded a grid of residential wards, which were often themselves walled and entered
through gates. The grandest of these, typically located either in the center or at the
northern end of the city, was the walled palace compound. This was eventually
divided into administrative and residential halves. While access to the palace was
limited, thriving markets were visited regularly both by the inhabitants of the city
and by traders from throughout China and beyond. Also located outside the palace,
but within the city walls, were the altars to which the emperor traveled annually
to make sacrifices and pray. Gardens and the water running through them were
the chief interruption to the geometrical regularity of Chinese imperial city plans.
Imperial tomb complexes, always situated beyond the city walls, were, however,

almost as rigidly planned as the palaces formerly inhabited by the people buried within them. For most of the history of the type, these cities were usually the largest in the world in terms of both area and population. Only in the period covered by this book did they begin to be equaled and even eclipsed by the expansion of urbanism in other parts of Asia and the world.

The plan of fifteenth-century Beijing conformed to these norms but also improved upon them. This was, for instance, one of the first Chinese cities to feature brick rather than only rammed-earth walls. The palace compound was an island within a walled imperial city that was surrounded by what became known as the inner city once further extensions were built to the south. All major buildings were arranged along or just to the side of the north–south axis, but the central location of the Forbidden City disrupted traffic across Beijing in any direction.

For much of recorded human history, China has been the world's best-established and most powerful empire, with some of its highest standards of living. China's emperors have not often controlled all the land within the country's present boundaries, but they have typically ruled both the north and the south. The expanse of territory and its population was far greater than that governed by any European between the collapse of the Roman Empire in the fifth century and the flowering of its Spanish successor a thousand years later.

Since at least the fifth century B.C.E., ancient Iran had served as the origin for both the European and Islamic understanding of royal ritual. China performed the same role in East Asia. The great empires of the ancient eastern Mediterranean and Middle East, including the Roman and the Byzantine, did not survive into modern times. In China the imperial system remained relatively stable until the nineteenth century, despite changes of dynasty, across the ancient, medieval, and early modern eras. Thus there was no need in China for a Renaissance or even for the complex transformations of local traditions found in the Ottoman and Mughal Empires, whose architecture was inflected by their indigenous pre-Islamic heritage. Rather than leaping over a millennium to revive a past culture, as many Italian intellectuals were to do during the Renaissance, Chinese architects and their imperial patrons refined long-standing traditions whose origins were in many cases equally remote. During the Ming dynasty, China was the global power it had always been. Its international exports, above all silk, porcelain, and tea, were in increasing demand throughout the Islamic and European world, as well as closer to home.

The Ming dynasty ruled until 1644, when it was replaced by the Qing, a Manchu dynasty, the members of which, like the Mongols, were descended from inhabitants of the central Asian steppes. The Ming and Qing dynasties spanned the period in Chinese history that saw the greatest centralized rule by the emperor. This centralization was facilitated in part by the form of the imperial palace.

Although many of the elements of Chinese imperial city planning and of Chinese architecture remained relatively constant over centuries, there was room for dynamic change. The original Forbidden City was begun in 1407 and completed in

1421. Alterations continued, however, right up to the abolition of the monarchy. Over time, the palace slowly changed, as the series of halls was rebuilt after frequent fires and as the location of imperial government shifted from the outer fringes to the more private inner sanctum. Moreover, in keeping with more general trends in Chinese architecture, the private parts of the palace became increasingly elaborate.

This splendid palace, home for centuries to one of the most celebrated courts that has ever existed, differed only in scale, color, and the details of its decoration from environments with which most Chinese were familiar, whether or not they lived in them. Much of the architecture of the Forbidden City was but a larger and grander version of the houses of many far more ordinary Ming- and Qing-era Chinese, particularly if they were prosperous city dwellers, wealthy rural landowners, or the servants of either. This continuity across class lines supported a stable social order in which hierarchy was accorded within the primary social unit—the extended family—according to age and gender. The high degree of formal order present throughout much Chinese domestic architecture represented a cosmic diagram of an ideal political and social order adhered to by many across the length and breadth of China.

The Ming palace was composed of a series of five gates leading to the Three Great Halls, in which state ceremonies were conducted, behind which were the Three Back Halls (Palace of Heavenly Purity), where the imperial family lived, and a garden. This basic organization had a long history in China. Quarters for family members, servants, and staff flanked the raised courtyards around the main halls. In the eighteenth century the emperor moved out of the Palace of Heavenly Purity, which became an audience hall, but he still lived along the central axis.

One aspect of the palace that most distinguished it from ordinary dwellings was the approach. Typical Ming courtyard houses were entered from slightly off center, but the avenue to the palace lay on axis with the main boulevard north from the city's principal gate. Visitors gained admission through a sequence of five gateways. The most important of these was the third, or Wu Men, also known as the Meridian Gateway (Figure 1.2). The U-shaped Wu Men was the place where the government presented itself to the public, where edicts were issued to the civil service, where high-ranking officials waited for imperial audiences, and where rebels were executed in full sight of the city. The Wu Men was set apart from the rest of the city by the bright red color of its walls and by the use of yellow roof tiles, both of which were allowed only in this imperial context. Color and scale, rather than form and material, originally distinguished the palace from the other buildings of the city.

On the other side of the Wu Men are the marble bridges spanning the River of Golden Water. The sinuousness of this carefully channeled waterway provided one of the "natural" antidotes to the rigorous rectilinear geometry of the rest of the complex, a feature integral to traditional Chinese architecture and essential in preventing it from becoming monotonous. At one time the waterway may have had a

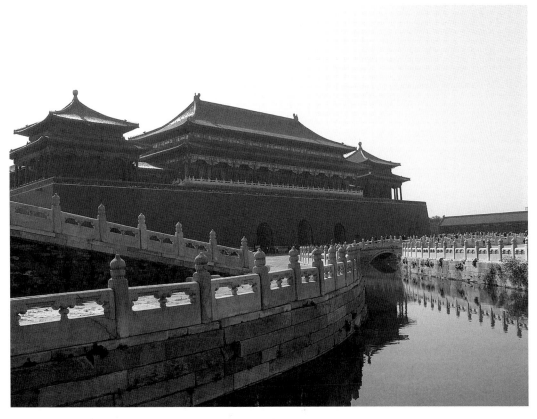

Figure 1.2. Wu Men (Meridian Gateway), Forbidden City, begun 1407, refurbished 1647.

defensive role, much like the moats surrounding medieval European castles, but that was no longer the case by the time the Forbidden City was built.

At the far end of the grandest of the palace courtyards is the Taihe Dian, or Hall of Supreme Harmony (Figure 1.3). Built in 1669 on the site of the Ming throne hall and remodeled in 1765, it was used by the Qing only on the most special occasions, such as the celebration of the New Year or the emperor's birthday. Here one has on an unequaled scale the plan of a typical Chinese courtyard house. The form accorded any male head of a prosperous Chinese extended family was elaborated to make it appropriately grand for the emperor.

The single-story hall was the basic unit of Chinese courtyard houses; columns rather than walls supported its roof. When the inhabitant ranked high enough, as here, these columns terminated in an elaborate system of brackets. Sumptuary laws controlled access to many ornamental and some structural details. The lavishness found here bore testimony to the emperor's ability to pay for the time-consuming skills of the best craftspeople to elaborate the fundamentals of this architectural system. A series of stepped platforms lifts the hall, which is wider and deeper than its vernacular counterparts, far up into the air, as if the building itself were a throne.

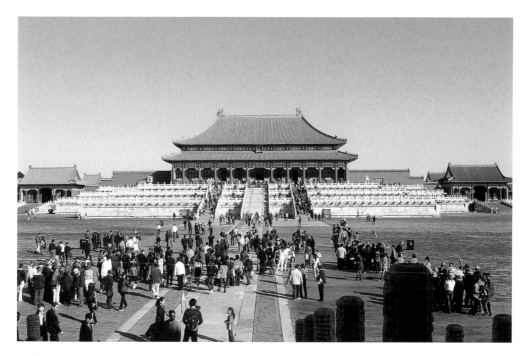

Figure 1.3. Taihe Dian (Hall of Supreme Harmony), Forbidden City, 1669, remodeled 1765.

One of the building's most important features, reserved for the emperor, is a special path up the center of its stairs. Called a spirit way, it is flanked by steps for the emperor's bearers—the emperor never walked up to the Taihe Dian unassisted.

The interior is a columned hall (Figure 1.4). At the center, reached by yet another flight of steps, is the throne. Gold leaf and lacquer decoration ornament a wooden frame; its ceiling is carved into elaborate coffers. At the summit sat the splendidly attired emperor. From here he could look out over the assembled courtiers and over the routes through which his edicts were carried into the distant corners of the realm. He and his highest courtiers could also watch the proceedings taking place in the great plaza beyond; flags, banners, and music contributed to the overall effect.

In terms of its length and spatial discipline, this sequence was the longest and most rigidly organized of any palace in the world. The Forbidden City, like its counterparts elsewhere, however, was not just a place of ritual display; it was also home to a court composed of thousands of family members, officials, and servants. The more intimate spaces provided appropriate settings for the daily rituals of the lives of the majority of the palace's inhabitants. The emperor's many concubines had their own quarters, guarded by eunuchs. The shift of the center of the emperor's residence from the Palace of Heavenly Purity to the less formal Palace of Mental Cultivation provided court women with unprecedented access to the locus of rule. From 1861 until her death in 1908, the Dowager Empress Cixi was China's de facto ruler, holding audience from behind a curtain in a room of this palace.

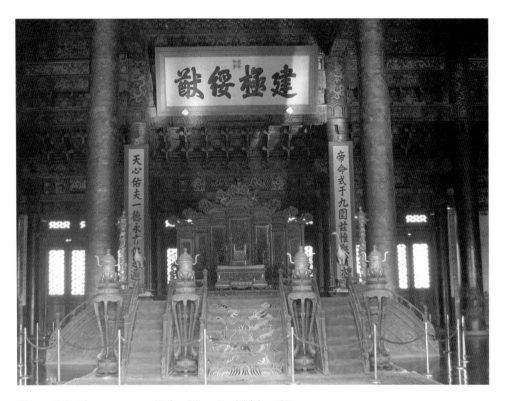

Figure 1.4. Throne room, Taihe Dian, Forbidden City.

During the Ming and Qing dynasties, much of the housing stock of Beijing consisted of miniature versions of the Forbidden City (Figure 1.5). A family's wealth and status were expressed architecturally by the number of times they were able to repeat the hall form; in larger houses a hall often consisted of a single three-, five-, or even seven-bay room. Originally halls were built largely of wood; over time, brick became more popular as greater population densities depleted the available forest resources. If the family could afford it, rooms to the left and right of the main hall provided quarters for married sons or grandsons, or for second wives and their children. A slightly larger house included separate quarters for unmarried daughters and a second court for additional male relatives and their families, or for servants. The largest of these complexes had literally hundreds of courtyards and were inhabited by clans, extended families stretching over three or more generations and including first and second cousins as well as hundreds of servants. Little of this structure, social or architectural, was ever visible from the street, however. The entrance was usually located off center, an asymmetrical twist intended to ward off evil spirits, who were believed to travel in straight lines, and to make the house more easily defensible against attack.

The courtyard house functioned as a social as well as an architectural system. Individual families across much of China inhabited these houses according to almost

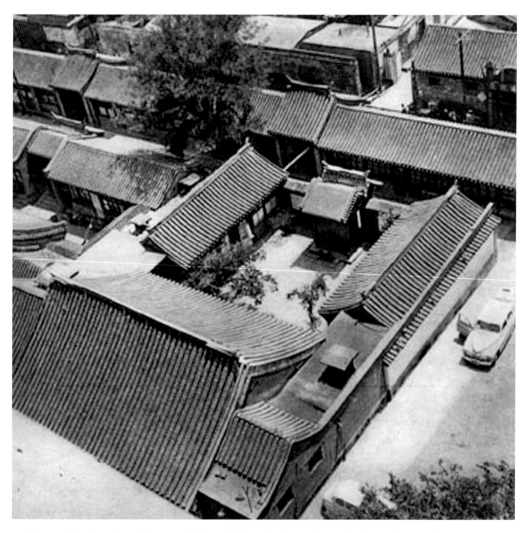

Figure 1.5. Courtyard house, Beijing, China, eighteenth to nineteenth centuries.

identical patterns. In this hierarchy, everyone knew where he or she belonged. Age always took precedence over youth, as did men over women of the same generation. The experience could be reassuring or confining, depending on one's temperament and that of the relatives with whom one lived according to these social conventions.

This spatial system was exceptionally rigid, giving definition to an equally inflexible social structure, whether on the scale of the imperial government or the ordinary extended family. But it was not the only kind of environment the Chinese inhabited. A government like China's depended not only on the emperor and his court but also on a large civil service spread throughout the country. Passing the exams to become part of this bureaucracy, and potentially to make one's fortune through participation in it, required training as a scholar. In the equivalent of liberal arts education today, this necessitated not only learning to read and write and mastering

the body of knowledge required of an administrator—say, the value of the cloth to be taxed—but also gaining knowledge of the culture in a larger sense. This system was one of the most modern aspects of the empire. It unified the elite of the entire society, wherever in the empire they lived. One thing that these elite were trained to appreciate, regardless of where they grew up, was mountain landscapes. This was different from Europe, where those who lived elsewhere regarded mountainous regions as uncivilized until about 1800.

In addition to serving the government, those trained for the civil service exams constituted the intellectual elite from which most of the great calligraphers, poets, and landscape painters, as well as their patrons, were drawn. Many civil servants doubled as talented intellectuals who upon their retirement devoted themselves to cultivating the arts. This group appreciated the classical Chinese relationship between human emotions and natural settings and often collected the poetry and paintings of their predecessors.

During the Ming and Qing dynasties, members of this class accommodated the irregularity of nature in two interrelated ways. One was through the set of beliefs called feng shui, which mandated variations in the otherwise systematic geometry used to order cities and houses, variations inspired by beliefs about the good and evil spirits that dwelled in nature and needed to be either encouraged or controlled. The second was through a tradition of closely intertwined poetry, landscape painting, and garden design.

Although scholars were raised to appreciate mountain landscapes, they lived in cities, especially when they were successful. Their appreciation of such landscapes was integrated in a highly artificial but beautiful way into the setting of the courtyard house. Assisted by feng shui experts and gardeners, scholars laid out highly stylized representations of untamed nature, environments that they could savor in the normal course of daily life as distractions or retreats from their administrative duties and scholarly pursuits. Their appreciation of this artifice coexisted with the disappearance during the Ming and Qing dynasties of much actual wilderness, as formerly economically marginal areas were cultivated, often producing crops imported from the Americas, to feed the empire's expanding population.

Suzhou, a city near Shanghai, is particularly famous for the scale and number of its scholar gardens, including the Zhou Zheng Yuan, or the Garden of the Humble Administrator (Figure 1.6). The garden's origins date to between 1506 and 1521. The scholar class revered their own traditions. Innovation for its own sake was little prized, but change did occur. Therefore what one sees today is not exactly what existed in the sixteenth century, but most of the basic elements remain similar to those of the garden in its original state.

The main elements of any Chinese scholar garden were the hall, the water, and the mountain. The hall was the architectural element from which one looked out over the garden. From one's desk there, one might write a poem or paint a picture inspired by one's contemplation of the surrounding nature. Views were carefully

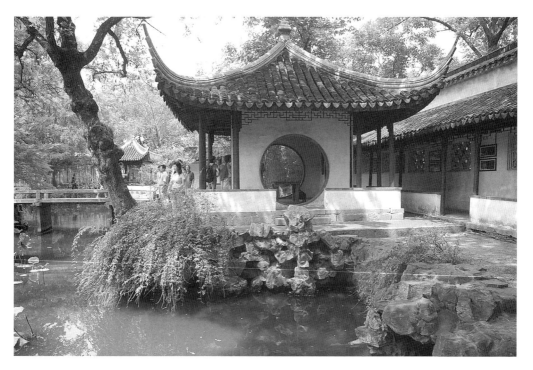

Figure 1.6. Zhou Zheng Yuan (Garden of the Humble Administrator), Suzhou, China, begun 1506–21.

framed through unglazed openings. Although children certainly played in these gardens, they were primarily places to be looked at rather than sites of active physical recreation. In addition to providing sheltered positions from which to gaze out over the garden, the architectural elements doubled as things to be viewed. The second element was water. Great care was taken to make its course irregular; if one could not easily discern the water's edges, the garden would appear larger than it was. The variety of viewing experiences available within the garden's walls, rather than the size of the space, was what was most prized. The third element was the mountain. Few gardens were large enough to have even sizable hills; the mountain was instead represented metaphorically by carefully arranged, artfully carved stones. One studied these as if they were mountains; the art of the miniature could also be found in the dwarf trees that were frequent features of these gardens. Suzhou's gardens were renowned for the quality of their rocks.

Although there were outdoor paths, much of the procession through these gardens took place along covered walkways. These even bridged the water, further obscuring its source. They also framed their surroundings. Flanking them opened not only halls but also windows offering views that were little different from the aesthetic experiences offered by the landscape paintings that also lined their walls, cherished works of art to which owners sometimes added poems inspired by their content.

Throughout the garden, views large and small were carefully considered. Every-where one looked—from the paving and planting of even the smallest spaces between pavilions to the organization of every detail of the central space—each decision had been made in order to delight the eye with the harmony of the composition, a harmony that was all the more complex for its asymmetry.

A Chinese poem from the fourth century gives a taste of the way in which the garden was to be appreciated:

Living in retirement beyond the World,
Silently enjoying isolation,
I pull the rope of my door tighter
And bind firmly this cracked jar.
My spirit is tuned to the Spring-season;
At the fall of the year there is autumn in my heart.
Thus imitating cosmic changes
My courage becomes a universe.

The scholar garden provided a release from the strict discipline governing the lay-out of many Ming and early Qing Chinese environments. The rigidity of domestic architecture, whether for the court or commoners, did not preclude the creation of spaces in which one could escape from formality. Although modern outsiders are apt to emphasize the degree of discipline and control, if not rigid symmetry, that charac-terized the supposedly natural environments of these gardens, they offered those who built them a refreshing antidote to the world outside their walls. In the gardens, these men and women found a place where they could contemplate a mannered view of nature in ways that calmed and soothed, as well as indicated the refinement of their intellect and taste. The members of this class were able to create spaces whose variety ultimately enhanced rather than critiqued a system few chose to challenge.

The contemplative experience of the Chinese garden does little, however, to explain the prosperity of the Chinese market-town city and the bustle of the market streets that lined entire districts of large cities and the centers of smaller market towns (Figure 1.7). Here arcades sheltered vendors and more settled shop owners alike. Many goods were made just behind the spaces in which they were sold, with those who made them dwelling behind or upstairs from the shop. Chinese cities had relatively few public spaces equivalent to the squares of early modern European and West Asian cities. Much of civic life took place instead in the administrative courtyards of what were largely domestic spaces. Nonetheless, an active commercial sphere created lively public alternatives to the more private courtyard house.

The ordinary dwellings of rural Chinese during the Qing dynasty ranged from conventional courtyard houses to distinctive local types. Like its urban counter-parts, rural housing reflected and shaped the daily experience of its inhabitants and the social structure that framed their lives. Accommodation to the natural setting

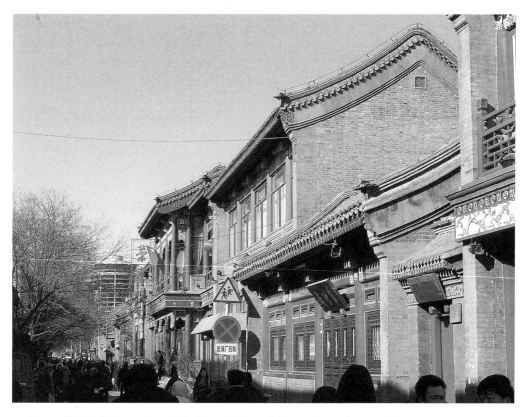

Figure 1.7. Liulichang Street, Beijing, China, eighteenth to nineteenth centuries, reconstructed 1980s.

was far more important, however, in the countryside than in towns and cities. Across a country as large as China, climate—heat and rainfall, cold and snow—and local vegetation and geological conditions vary considerably. Although the basic spatial organization of many vernacular dwellings was surprisingly constant, alternatives also developed.

Rural houses were built from the materials at hand, which varied from region to region. The simplest farmhouses were built of reeds or bamboo, materials that supported only thatched rather than heavier tiled roofs. These lightweight plants could be gathered from the immediate environs; the occupants could build a house, perhaps with the help of their neighbors, but certainly without full-time construction workers, who represented a degree of specialization for which such communities had little need. This type of structure demanded little initial expenditure but frequent maintenance, a situation that characterizes many vernacular dwellings. Rammed earth was also popular. Although constructed out of different materials, these houses still followed as much as possible (or possibly originally inspired) the spatial patterns found in the elite districts of cities such as Beijing and Suzhou. Space rather than structure, in other words, was the essential characteristic of these houses.

At times, however, local conditions produced unique buildings. Near Xi'an in Shaanxi Province, for instance, entire villages were carved out of rather than perched onto the local hills (Figure 1.8). Organized in many cases around court-yards, these dwellings consisted of rooms hollowed out of the earth. These, too, could be excavated by most villagers with little assistance from anyone from outside their communities. These houses attracted considerable attention in the 1980s, when scientific studies confirmed that, despite problems with ventilation, they were much warmer in winter and cooler in summer than conventional dwellings. Thus they can be understood as a particularly sophisticated instance of human adaptation to natural conditions rather than as evidence of poverty; in fact, many were far more spacious than conventional peasant dwellings.

Over the centuries, alternatives to courtyard houses developed in the Chinese countryside. Among the most interesting are the *tolous,* circular dwellings of the Hakka or Kejia peoples in Fujian Province in southern China (Figure 1.9). These were typically built out of rammed earth. Villages could be composed of a single or multiple examples of these structures, each of which housed an entire clan rather than a single extended family. The form obviously facilitated defense. Inside these multistory structures, balconies screened public from private spaces. The centers

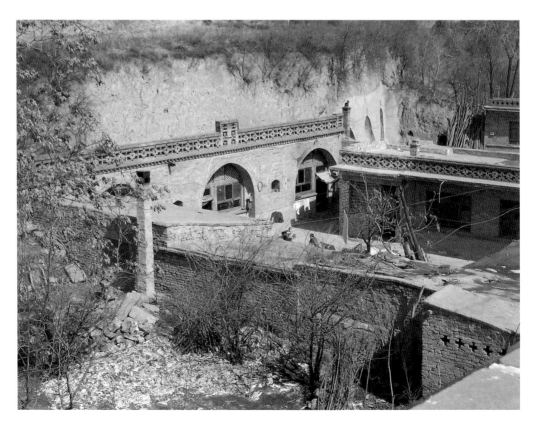

Figure 1.8. Cave dwellings, Shaanxi Province, China, twentieth century.

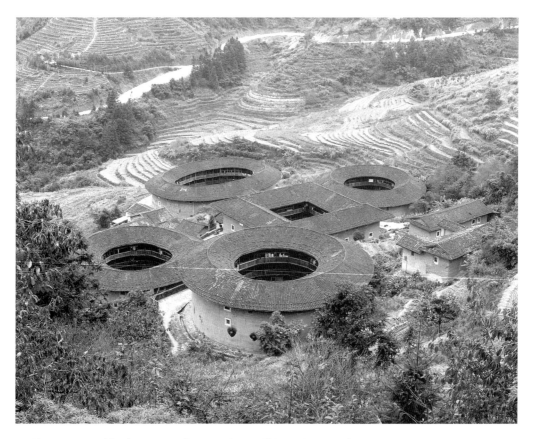

Figure 1.9. Hakka houses, Fujian Province, China, nineteenth century.

were devoted to public activities, with purposes ranging from marketplaces to ances-
tor shrines. Although these dwellings were different in form from courtyard houses,
they provided no more room for individuality.

In China, evolving traditions of construction and social organization produced
building types that were more stable over long periods of time than those of many
other cultures. A basic spatial paradigm gave concrete structure to the upper strata
of Chinese society and tied it to their governments. That did not mean that there
was no change, even though the appearance of buildings was in many cases less
important in this system than the spaces the buildings created and framed. The shift
in materials and increase in the richness and variety of ornamentation that took
place across the Ming and Qing dynasties were subtler, however, than the dramatic
transition from Gothic to Renaissance or baroque that occurred in Europe during
these same centuries. This was true above all of the Forbidden City, where the
world's largest palace for one of its most powerful governments was designed along
far more rigidly disciplined lines than, for instance, the urbanism if not the archi-
tecture of the Italian Renaissance. Although courtyard houses could be built with
the humblest of materials, where climate and social uses called for it, other forms

of domestic architecture did develop, from urban shop-houses to quasi-fortified circular villages. Architecture helped knit Chinese society together, but the forms it took were not so regular as to preclude all alternatives.

FOR FURTHER READING

Basic introductions to the subject are available in Nancy Steinhardt and Fu Xinian, eds., *Chinese Architecture* (New Haven, Conn.: Yale University Press, 2002); and Laurence Liu, *Chinese Architecture* (New York: Rizzoli, 1989). On Beijing, see also Nancy Berliner, *The Emperor's Private Paradise: Treasures from the Forbidden City* (New Haven, Conn.: Yale University Press, 2010); Susan Naquin, *Peking: Temples and City Life, 1400–1900* (Berkeley: University of California Press, 2000); Nancy Steinhardt, *Chinese Imperial City Planning* (Honolulu: University of Hawaii Press, 1999); and Jianfei Zhu, *Chinese Spatial Strategies: Imperial Beijing, 1420–1911* (London: Routledge, 2004). For more on domestic architecture, see Ronald G. Knapp and Kai-Yin Lo, eds., *House, Home, Family: Living and Being Chinese* (Honolulu: University of Hawaii Press, 2005). On the Chinese scholar gardens, see Maggie Keswick, *The Chinese Garden: History, Art, and Architecture,* rev. ed. (Cambridge, Mass.: Harvard University Press, 2003); and Stewart Johnston, *Scholar Gardens of China: A Study and Analysis of the Spatial Design of the Chinese Private Garden* (Cambridge: Cambridge University Press, 1991).

2 Tenochtitlán and Cuzco

It can be difficult for us to remember how limited the knowledge of world geography was in the fifteenth century. Europeans, Asians, and Africans were at least vaguely aware of each other, but not of the inhabitants of the two continents that separated the Atlantic Ocean from the Pacific. Nor did the worldview of the people who lived in what we now call the Americas encompass the great Eurasian–African land masses. There had, of course, been contact between these two halves of the world. Vikings from what are now Iceland and Greenland, for instance, had briefly settled in the eastern region of today's Canada, and Africans, Americans, Asians, and Europeans probably washed ashore on distant continents from time to time. Nonetheless, the cultures of the peoples of the different halves of the earth had developed in isolation from one another.

Contact between the two transformed both. Before European adventurers crossed the Atlantic, potatoes, chocolate, tomatoes, peanuts, and chilies were unknown outside the Americas. They soon became staples of cuisines from Morocco to China. The encounters were not always benign, however. Indigenous Americans had no resistance to the most common European diseases, which proved even more dangerous than European soldiers, decimating entire populations.

Many accounts of indigenous Americans emphasize their adherence to unchanging traditions stretching back to time immemorial. Change is, however, fundamental to all human experience. The evolution of the Chinese courtyard house and of the Forbidden City that was its grandest manifestation was gradual, but real. Similar durability would not occur in the Americas, where the palace cities of what are now Mexico City and Cuzco, roughly contemporary with the Forbidden City, were both more novel and shorter-lived. Americans proved amazingly flexible. Until they tamed animals that had escaped from the Spanish, the tribes of the Great Plains, for instance, did not have horses, the animals they would ride with skill in

the last wars fought within the borders of the United States against encroaching settlers of European, African, and Asian ancestry. Accounts that focus on timeless cultural practices fail to address those historical facts that are known about peoples whose cultures and civilizations were transformed and often erased in the face of conquest.

The Americas have long been the site of repeated and radical change. The architecture and urbanism of the Mexica (or Aztecs) and the Inca offer vivid proof of this dynamism. These two peoples founded the greatest empires yet known in North and South America, respectively. Only in the fifteenth century did they achieve dominance over neighbors who had long created monumental architecture and orderly urban environments. Like those of their local predecessors, the buildings and cities of the Mexica and Inca expressed beliefs about the organization of society, nature, and the universe held by a political and religious elite—beliefs that, in many cases, were probably adopted by the community as a whole. The results were impressive. The first Europeans to visit the great Mexica and Inca cities of Tenochtitlán and Cuzco were astounded by the cities' clearly defined layouts and by their enormous stone buildings. In their scale and quality of construction these equaled anything their conquerors had ever seen. They have also proved more seismically stable, an important consideration in earthquake-prone Mexico and Peru. Indeed, the sight of these great American cities may have helped inspire Europeans to match the planning principles they displayed.

Much of what we know about Ming- and Qing-era architecture in China comes from written sources. We do not need to rely solely on the physical evidence offered by surviving structures and archaeological excavations. The situation is radically different when we turn to preconquest Mesoamerica. The Mexica were literate and the Inca quasi-literate, with complex record-keeping systems that they used to keep track of tribute paid by those they had conquered. Most of this documentation was destroyed, however, following the Spanish conquest, and in other cases the ability to decipher it was lost. Thus the fragmentary remains of Mexica and Inca buildings offer some of our most vivid evidence about the lives of those who once inhabited them. They can be only partially supplemented by the observations of the Spanish and information supplied to them by local informants. In the absence of extensive literary sources, archaeologists rather than architectural historians have studied these complexes most intensely.

The center of the Mexica empire was the city of Tenochtitlán, located on Lake Texcoco on the site of present-day Mexico City. Today Mexico City is one of the world's largest cities. Tenochtitlán probably had only two hundred thousand inhabitants in 1519, but in Europe only perhaps Naples and Istanbul could boast of equally large populations. It was, therefore, by far the grandest city that almost any of its Spanish conquerors had ever glimpsed. It was also a new city. The Mexica had arrived at this place only around 1325. According to their creation myth, they had been born in seven caves. An eagle had then marked the island on the lake as the

place where they should settle. Indeed, the site proved ideal, not only because it was easily defensible but also because it was fertile.

The Mexica developed a system of floating fields, called *chinampas,* separated by canals and anchored by trees (Figure 2.1). Although the eventual growth of the city made it dependent upon food brought in tribute from the mainland, the *chinampas* gave the inhabitants access to fresh vegetables and flowers, as well as a moderate supply of staples such as grains and beans. Some floating gardens survive in Mexico City, although enormous recent urban growth has choked this once-subtle relationship between inhabitant and environment. Indeed, the decline of the water table is one of the city's greatest contemporary problems. Agriculture was only one facet of Mexica culture, however. The other was war. Mexica prosperity depended on tribute paid by neighboring peoples. Illustrations in the few surviving Mexica codices document these conquests and the tribute that they netted.

Built on an island that had gradually been extended by landfill, Tenochtitlán was connected to the mainland by causeways (Figure 2.2). The system made it easily defensible. Early Spanish views of the city may exaggerate its regularity. Nonetheless, its cross-axial arrangement around a great central square certainly rivaled the sequential courtyards of the Forbidden City as one of the most disciplined urban environments of the day.

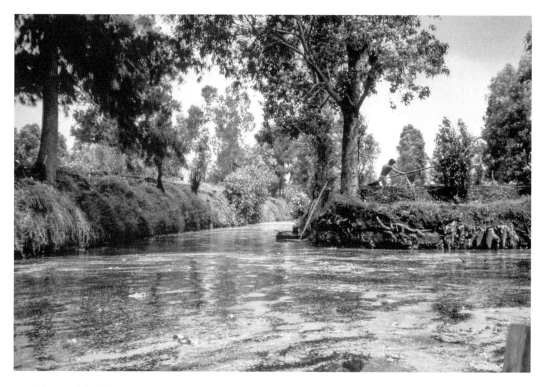

Figure 2.1. *Chinampas,* Mexico City, Mexico, twentieth century.

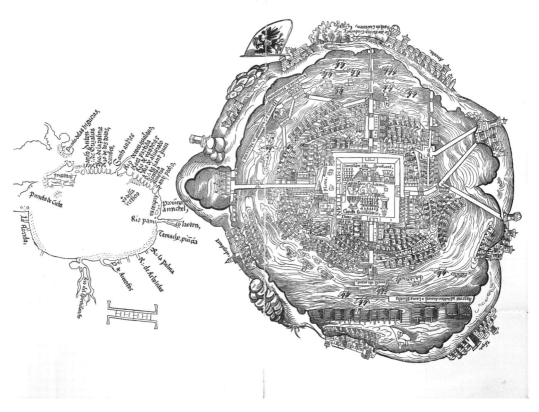

Figure 2.2. Plan of Tenochtitlán, Mexico, attributed to Hernán Cortés, 1524.

The city was centered on the Great Temple complex (Figure 2.3), which stood near present-day Mexico's City Zócalo, the plaza in front of the cathedral. Pyramids like the one now known as the Great Pyramid were a common feature of Mesoamerican religious architecture. Tiered structures, often built of stone, with central stairways ascending to sanctuaries survive from Central America north to Saint Louis. Some of the most impressive are in Teotihuacán, near Tenochtitlán, by Mexica times a largely deserted but easily accessible site.

Within this well-established tradition Tenochtitlán's Great Pyramid was distinctive because of the double sanctuary at its crest, reached by a double staircase. This represented its dual role as a temple to the rain god Tlaloc and the war god Huitzilopochtli. Here the two sides of Mexica life, agriculture and warfare, were both acknowledged and worshipped. This temple was destroyed following the Spanish conquest. Between 1978 and 1982, however, extensive excavations recovered a wealth of new information about it. They revealed a construction process of expansion and renewal that had lasted for nearly two centuries. Seven structures stood in turn upon this site, each grander than the last that served as the core of the next layer (Figure 2.4).

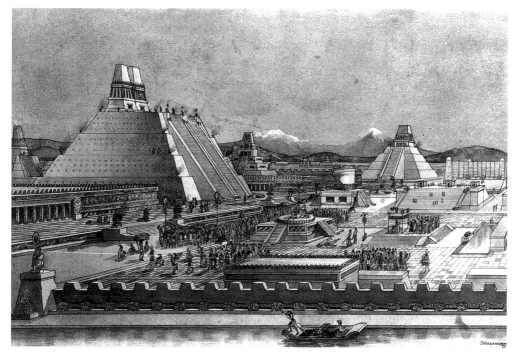

Figure 2.3. Reconstruction drawing, Great Temple, Tenochtitlán, begun 1390.

Why did the Mexica continually rebuild and enlarge this temple rather than begin anew elsewhere? It is difficult to overestimate the power of revered sacred places. A number of churches and mosques stand on sites where Roman temples were once built; the great Gothic cathedrals of medieval Europe were erected on the foundations of their more modest predecessors. Furthermore, for the Mexica as for many other peoples, the principal religious sanctuary was an *axis mundi,* the symbolic center of the world. This was the point where the underworld and the heavens intersected, with the present world stretching out horizontally from this most holy point. Thus it was constantly embellished rather than abandoned.

The Spanish, like the peoples who paid tribute to the Mexica, were both impressed by the vast scale of the Great Temple and appalled by the form of worship that took place here. This most urbane culture was also violent. Its great religious rituals consisted largely of human sacrifices. Racks of skulls decorated the building, undoubtedly inspiring a mixture of awe and horror in foreigners if not necessarily in the Mexica themselves.

The Mexica religion depended upon killings, which ritually reenacted the dismemberment of the goddess Coyolxauhqui, one of the most important Mexica myths. In 1978 an enormous stone relief depicting the goddess was found at the base of the Great Temple stairway. This stunning discovery prompted the excavation of the temple site. Huitzilopochtli, the war god, had decapitated his sister, after

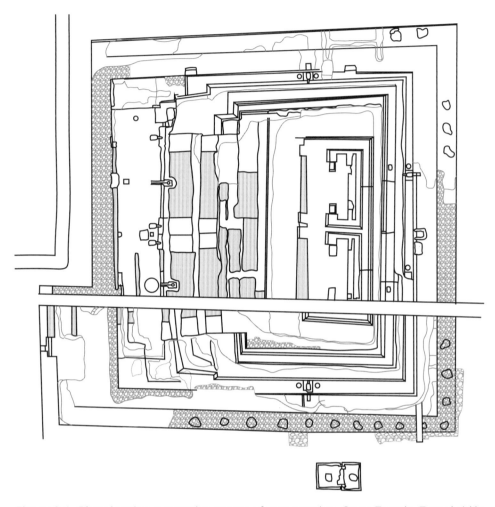

Figure 2.4. Plan showing successive stages of construction, Great Temple, Tenochtitlán.

which her body was thrown to the bottom of a hill. Those the Mexica sacrificed, who for the most part were prisoners of war, were hurled down the steps of the Great Temple. First, however, their hearts were cut out. Still beating, these were placed upon the altars of the gods. The Great Temple, like the bodies of its priests, was usually encrusted in blood and other gore, which the Mexica hoped would ensure the agricultural fertility and successful warfare upon which the society depended.

This gruesome ritual enabled Hernán Cortés, the leader of a Spanish expedition that reached the city in 1519, to conquer Tenochtitlán. Cortés depended on native allies. The early Spanish conquerors, like almost all successful colonizers, exploited divisions between the locals to found their own replacements for the last great native regimes. The peoples that had been conquered by the Mexica embraced the possibility of bringing an end to the paying of tribute and, above all, to the ritual slaughter. Although human sacrifice had long been a feature of life in Mesoamerica,

it had never before reached such horrifying dimensions. Furthermore, while the Spaniards fought to the death on the battlefield, the Mexica goal was to gain live captives for eventual sacrifice. This cultural clash immeasurably aided the Spanish and their local allies. Two years after Cortés landed at what is now Veracruz and was received at the court of the last Mexica emperor, Montezuma, the Great Temple and much of Tenochtitlán were destroyed in a siege. The defeat of Montezuma enabled the Spanish to establish their empire on the American mainland.

Twelve years later, another Spanish conqueror, Francisco Pizarro, reached the capital of the other great American empire of the day. The Inca realm was even younger than that of the Mexica to their north. Only around 1438 did the Incas, under the leadership of Pachacuti (their word for earthquake), achieve dominance over their neighbors, forming the largest state yet seen in the Andes. This empire was tied together with an impressive network of roads—really pathways, since only people on foot and pack animals traveled on them.

Here, too, aspects of technological development far exceeded anything yet accomplished elsewhere. The weaving of cotton thread to make distinctive checkerboard capes had reached a stage of refinement matched again only during the Industrial Revolution of the eighteenth century. And although they were not fully literate, the Incas developed a complicated system of tying knots in strings that allowed them to keep complex statistical records.

Inca pathways ran through rugged mountain terrain. The Incas built suspension bridges out of rope to span the gorges that threaded through this Andean landscape. Bridges of this kind are still being constructed, but because the materials used are impermanent, no Inca examples survive. Along their roads, the Incas posted runners who quickly conveyed news throughout the empire. Also important for uniting the new state was a system of *tambos,* the equivalent in many ways to present-day truck stops and storage depots. Built in the fifteenth century, Tambo Colorado was located where the mountain meets the plain (Figure 2.5). Where the Mexica had demanded tribute goods from the people they captured, the Inca rulers required their subjects' labor for set periods of time each year. This provided the workforce needed to construct and maintain the empire's buildings, roads, and bridges. While much of this infrastructure glorified the rulers, some benefited everyone. In times of famine, for instance, food stored in the *tambos* could be distributed.

The Inca empire centered on Cuzco. Two things stood out about this city. First, it was not a capital or even a city in the way that we understand these terms. Only the royal family, aristocrats, and their servants apparently lived here; artisans and merchants, for instance, dwelled elsewhere. This was not a place in which goods were manufactured and traded, but a purely governmental and religious center, one that subsisted on the tribute that every visitor had to bring. It was a place of display, not of production, one that nonetheless became more impressive with each passing day as more gold, silver, and other valuables were brought into it. This meant as well that the population, consisting mainly of a political and religious elite, was relatively

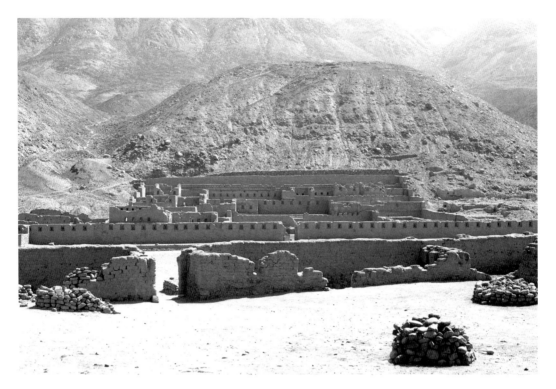

Figure 2.5. Tambo Colorado, Peru, fifteenth century.

small, numbering several tens of thousands, still a substantial number in an era when the largest Spanish city—Seville—had roughly sixty thousand inhabitants. At its height, the Inca empire had a population of perhaps eight million.

Second, the plan of Cuzco, while also ideal, was very different from the geometry that informed Chinese urban schemes or determined the layout of Tenochtitlán (Figure 2.6). The city had a large central plaza and districts laid out along grids. Many of the streets had canals running down their centers. The determining factor of the plan was more unusual, however. The city appears to have been built in the image of a puma, the fiercest example of local wildlife. The major architectural complexes were located at each end of this figure.

The Qorikancha, or main temple, stood at the base of the puma's tail. Also known as the Temple of the Sun or Golden Enclosure, this structure was decorated with magnificent sheets of gold. It was this hoard that sparked Spanish interest in the city. Although it did not stand at Cuzco's geographic heart, the Qorikancha was nonetheless the center of the Inca world. It was here that the richest tribute was collected and in some cases displayed on the gleaming surfaces of the complex itself. One interior court contained the so-called Garden of the Sun. There, thrice annually, including at the times when they planted and harvested their crops, the Incas installed a garden of corncobs made out of gold and silver.

Figure 2.6. Plan, Cuzco, Peru, fifteenth to early sixteenth centuries.

The buildings on the four sides of the Qorikancha's central courtyard repre-
sented the four quadrants of the Inca empire. From here, in a position easily visible
from throughout the city and well beyond, abstract lines radiated like the spokes
of a wheel out into the surrounding landscape. Today only the foundations survive,
integrated into the colonial church of Santo Domingo (Figure 2.7). For the Spanish
conquerors, converting the Inca's most sacred place into a Christian church offered
a familiar means of seizing some of the power of the site for their own religious
and political system. Already in the thirteenth century the Spanish had turned the
Great Mosque of Córdoba into a cathedral. Spanish colonial and modern Peruvian
Cuzco were built literally upon the foundations of the Inca city that continued to
define the street grid and often extended up through the first story of the buildings,
although the canals were all paved over.

At the other end of the city, forming the head of the puma, was the Sacsahua-
man (Figure 2.8). This may have been Pachacuti's royal residence. It was certainly
a fortress, with storerooms overflowing with military goods. The zigzag walls of
this complex on what was once the edge of the city constitute the finest surviving

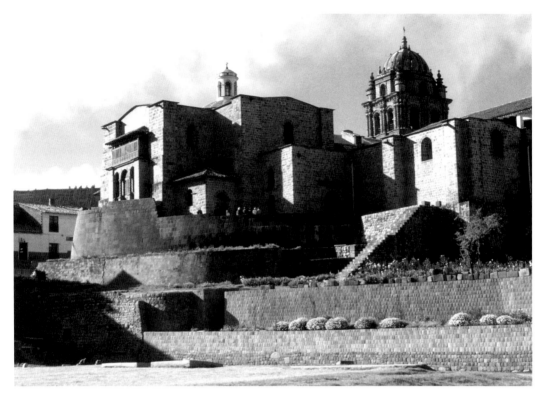

Figure 2.7. Qorikancha/church of Santo Domingo, Cuzco, Peru, fifteenth to sixteenth centuries.

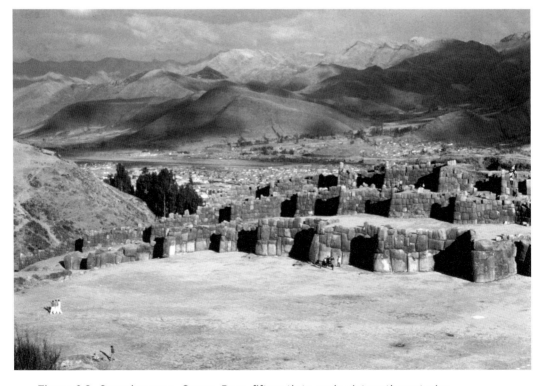

Figure 2.8. Sacsahuaman, Cuzco, Peru, fifteenth to early sixteenth centuries.

example of preconquest masonry in the Americas. Extraordinary stonework had long been a staple of monumental construction in the Andean area. The fine quality of the Sacsahuaman's walls ensured the building's survival centuries after it was abandoned. Indeed, Inca stonework has withstood the region's frequent earthquakes far better than Spanish masonry, which employs arches. These are inherently far less stable than the more firmly interlocked stones fit together by the Incas. Without access to modern machine tools, the Incas used large stones, no mortar, and extremely thin joints. Modern scholars have duplicated the high quality of Inca stonework by rubbing stones together and further polishing them with the aid of wet sand.

The construction of modern Cuzco atop Inca remains makes it difficult to conceptualize the original city. Tenochtitlán has been even more completely obscured. Farther up the Urubamba River valley from Cuzco, however, a more private complex gives a better sense of an entirely Inca environment and its relationship to the surrounding landscape (Figure 2.9).

Machu Picchu's spectacular mountain setting has made it one of the world's great tourist attractions. The complex was arranged in stepped terraces that echo the fields whose agriculture sustained its inhabitants and integrated them symbolically into the landscape. Here historians face a different situation from that of addressing the remains of Tenochtitlán and of Cuzco. The site remained unknown to and thus

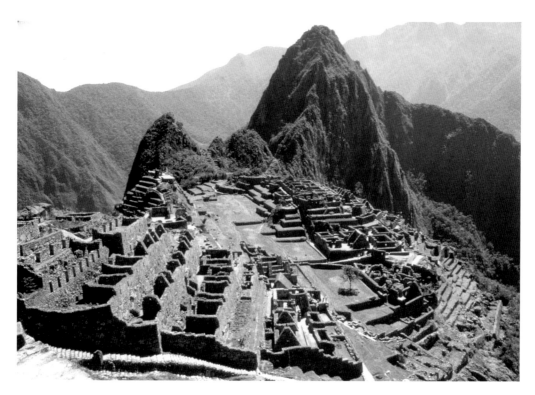

Figure 2.9. Machu Picchu, Peru, fifteenth to early sixteenth centuries.

undocumented by the Spanish. The first outside explorers to chart it, an American team from Yale University, arrived only in 1911. This is thus literally a prehistoric site, about which we must extrapolate from the physical remains, in this case supplemented by relatively scant written documentation regarding related sites.

In the absence of sixteenth-century sources, many myths have sprung up about Machu Picchu. Hiram Bingham, who led the Yale expedition, was not an expert on Inca culture, and although many of his suppositions have been disproved by generations of scholars, they still dominate popular writings, such as guidebooks. Bingham, for instance, believed he had found a very ancient city, whereas scholars now think that Machu Picchu was probably occupied only from the mid-fifteenth to the mid-sixteenth centuries. And instead of being the birthplace of the Inca empire, as Bingham speculated, it is now believed to have been Pachacuti's secluded private country residence.

Machu Picchu, like Cuzco, had a large plaza at its center. In 1438 Pachacuti promulgated a decree demanding that all Inca settlements be organized around such plazas, where both markets and public ceremonies took place. As a royal estate, the site would have been occupied year-round by servants, most of them captives from peoples the Inca had conquered. Throughout Machu Picchu rooms and corridors were organized around unroofed courtyards. Because they were entered from a single door and the quality of the interior stone finishes was particularly high, some complexes have been identified as the residents of courtiers or aristocrats. Another section of the city appears to have been the emperor's private residence, complete with a ritual bath. Springwater flowed here first before being distributed to the rest of the site. Here and on the far side of the plaza were clustered buildings that may have been associated with sacred purposes, given that their forms appear to accord with Inca religious beliefs.

The landscape dominated all of these human-made features. Farmers lived outside Machu Picchu close to the terraces on which they grew their crops. Their agricultural techniques, like the *chinampas* of the Mexica, enabled the Incas to get far greater yields than would otherwise have been possible in this inhospitable setting, whose extremely high altitude was entirely unsuited for conventional farming. At Machu Picchu the Incas integrated city, land, and mountain into something that was part natural and part artificial, with the distinction between the two almost imperceptible. Indeed, it now appears that some of these terraces were more ornamental than functional. In addition to agriculture, the Incas would have hunted for wild game and enjoyed the fifty species of orchids that grow in the immediate surroundings. Royal estates provided material sustenance, especially in terms of a varied diet, for the emperor and his family.

We shall probably never know the exact reason the Incas were drawn to this site, which was remote even for them, but the topography may well have accorded with their religious practices. The Incas claimed descent from the sun, a fact that they used to legitimate their conquests. Pachacuti himself claimed to have been rewarded

for his worship at a spring by a vision in a mirror of a deity who recognized him as his son. Scholars have speculated that the arc of the so-called Temple of the Sun corresponded to that of the rainbows frequently seen at Machu Picchu, although the solar temples in Cuzco have no such astronomical alignment. For the Incas, rainbows were a means of communicating with the sun. Certainly various features here do match annual celestial events, such as the summer solstice. Another feature is known, for obvious reasons, as the Temple of Three Windows. Its form possibly referred to an Inca creation story. Although many cultures have constructed cosmic diagrams, this is the only Inca building in which the possibility of a literal reference has been discerned.

The societies of the Mexica and the Inca were technologically advanced, with complex political structures capable of organizing hundreds of thousands, if not millions, of people, many of whom lived in forbidding terrain. To this day the remains of their architecture provide our richest evidence of their accomplishments and of the worldview that inspired them. The rational organization of Tenochtitlán, Cuzco, and Machu Picchu provided templates for Mexica and Inca concepts of an ideal society.

These cities and their buildings were not enough, however, to sustain the cultures that had created them and that they embodied. In the sixteenth century the Mexica and the Inca fell victim to the Spanish thirst for gold. The process was violent and terrifying, destroying the social and architectural patterns that had once ordered these unusually prosperous societies. A Mexica poem says it all:

> Broken spears lie in the roads;
> we have torn our hair in our grief.
> The houses are roofless now, and their walls
> are red with blood.
> Worms are swarming in the streets and plazas,
> and the walls are splattered with gore.
> The water has turned red, as if it were dyed,
> and when we drink it,
> it has the taste of brine.
> We have pounded our hands in despair
> against the adobe walls,
> for our inheritance, our city, is lost and dead.
> The shields of our warriors were its defense,
> but they could not save it.

FOR FURTHER READING

Hugh Thomas, *Conquest: Montezuma, Cortés, and the Fall of Old Mexico* (New York: Simon & Schuster, 1993), recounts Cortés's invasion of Mexico. On the Mexica and their architecture, see Richard F. Townsend, *The Aztecs,* 3rd ed. (London: Thames & Hudson, 2010);

and Eduardo Matos Moctezuma, *The Great Temple of the Aztecs: Treasures of Tenochtitlan* (London: Thames & Hudson, 1988). On Cuzco, see Brian S. Bauer, *Ancient Cuzco: Heart of the Inca* (Austin: University of Texas Press, 2004); on Inca masonry, Jean-Pierre Protzen, *Inca Architecture and Construction at Ollantaytambo* (New York: Oxford University Press, 1993); and on Machu Picchu, Richard L. Burger and Lucy C. Salazar, eds., *Machu Picchu: Unveiling the Mysteries of the Incas* (New Haven, Conn.: Yale University Press, 2004).

3 Brunelleschi

In 1418 the city of Florence in what is now Italy held an architectural competition. More than one hundred years after work had begun on Santa Maria del Fiore (Our Lady of the Flower), the city's cathedral, construction had reached an impasse. How were the Florentines to build the projected dome, which would be the broadest erected in Europe in almost a thousand years? In particular, how could such a dome be realized without the expensive centering used for the pointed rib vaults of the nave, which were neither as wide nor as tall as the space that now needed to be spanned?

It was completely in character for the Florentines to have commenced such an ambitious enterprise assuming that a solution would appear. At the time, Beijing and Tenochtitlán were planned cities built relatively recently around monumental secular and sacred complexes. Elsewhere cities grew incrementally, with their most impressive structures added slowly over time. Florence had been one of Europe's richest since the thirteenth century. In the process of solving the problem of the dome's construction, a new profession began to emerge as architects began to work beside the master builders who, assisted by priests and courtiers, had long supervised the design and erection of buildings. Although the earliest work generated by this approach appeared unusually systematic by contemporary European standards, it eventually unleashed new possibilities for the expression of the individual tastes and talents of the men, and more rarely women, who operated with new-found independence.

Florence, famous for its banks and its woolen cloth, was a center of both finance and industry at a time when the political and economic balance in Europe had definitively shifted to the cities from a countryside still dominated by monastic and feudal estates. The most dazzling built expression of that shift took the form of splendid new cathedrals (Figure 3.1). Beginning in the eleventh century, cities on

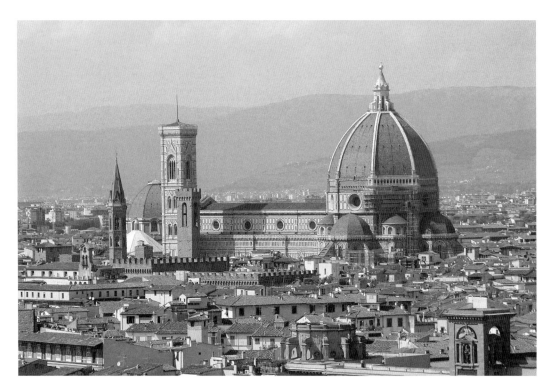

Figure 3.1. Santa Maria del Fiore, Florence, Italy, 1296–1471. Dome designed by Filippo Brunelleschi, begun 1419.

the Italian Peninsula (the territory was united into a single country only in 1861) and then also north of the Alps began erecting large and elaborate urban churches for their bishops. These were often placed, as in Florence, on the sites of earlier, more modest buildings, which in turn often sat atop the remains of ancient Roman temples. Historians continue to debate the degree to which the creation of medieval cathedrals and major monastic churches was motivated by religious piety as opposed to civic pride (in Florence, the city government directed the construction and paid the bills). Indisputable is that these houses of worship were the most impressive structures that had been built within the European territories of the ancient Roman Empire since its collapse and the largest ever erected in the parts of Europe that lay north of that empire's borders. So mammoth and magnificent were these churches in relation to the resources of the societies that sponsored them that they often took several centuries to complete. Many still tower over the cities in which they stand. Very few medieval cathedrals have ever been completely destroyed or replaced. And Florence's was to be the grandest yet.

The Florentines embarked upon the cathedral's construction in 1296. Arnolfo di Cambio launched the nave using Gothic elements, such as pointed arches and rib vaulting, imported from France. More unusual was the large dome, shown already in a fresco by Andrea di Bonaiuto, with which by the late 1360s Florentines

proposed to cap the crossing of the Latin cross plan. Smaller domes were common in Italian and also in English cathedrals, but nothing on this scale had ever been proposed before. Why such a large one?

Although big domes were uncommon in medieval Europe, fifteenth-century Florentines associated them with a distinguished past. They understood the Pantheon in Rome to be a typical ancient temple. And, although we now know it was only several centuries old at the time, Florentines also believed that their centrally planned Baptistery, located just opposite the entrance to the cathedral, had been a Roman temple. In a city increasingly fascinated by antiquity, a domed cathedral offered a means of creating a distinctively Italian alternative, grounded in hallowed tradition, to contemporary northern European (and particularly French) fashion. The grand span of Hagia Sophia in the Byzantine capital of Constantinople, present-day Istanbul, may have influenced the Florentines' decision. By 1418 some in the city may have been aware of the world's most impressive new dome, atop the Gur-i-Mir.

Why were Florentines fascinated by ancient Rome? A thousand years after its demise, the political power and cultural achievements of the Roman Empire still set the standards by which the city-states of the Italian Peninsula measured their ambitions. The Romans had founded Florence on a bend in the fertile valley of the Arno River. The city retains the grid plan characteristic of Roman army camps. Its wealth led prominent Florentines to want to build on a scale and according to the art of ancient Rome in order to rival that city's legendary splendor. Equally important, both ancient Rome and the more recent Romanesque offered a means to declare artistic independence from France, where the Gothic had originated in the mid-twelfth century, and from central Europe, where it was currently being employed with great imagination and originality.

To solve the problem of the dome's construction, Florentines organized a competition. Although the initial results were inconclusive, they were not to be disappointed by this means of collecting fresh ideas. Two years later, they agreed to adopt the proposal made by Filippo Brunelleschi, a goldsmith and sculptor. This result was less surprising in Florence than it would have been in northern Europe, where master builders supervised the construction of great cathedrals. For generations, Florentines had instead turned to painters and sculptors for the design of important buildings, including the earlier phases of the cathedral. Giotto, Florence's greatest fourteenth-century painter, designed Santa Maria del Fiore's bell tower. His expertise was in composition, not construction, but Brunelleschi proved to have a talent for engineering as well as for the aesthetic side of architecture.

Brunelleschi was the first person to be a professional architect in the sense we understand that term today, as someone who focuses on the appearance and structure of buildings without contributing his or her own labor to their construction. He supervised the erection of the cupola, often daily, and designed the lantern that topped it, but he was trained neither as a mason nor as a carpenter. What was

exceptional for Giotto became Brunelleschi's career, as he eventually abandoned sculpture to focus on the design of buildings. In learning about Brunelleschi, we see how architecture has been practiced, first in Florence, then in Italy, and eventually throughout much of the world, and about the presumptions that continue to shape the profession today.

Professional training in architecture dates only to the eighteenth century, when architecture finally became completely distinct from painting, sculpture, and engineering. In addition to learning to be a goldsmith, Brunelleschi had received a classical education, which most master builders of the day had not. He probably read Latin as well as Italian and had some acquaintance with mathematics as well as with ancient Greek and Roman thought. In other words, although he had not attended architecture school, his learning was, like that of architects today, principally theoretical rather than practical. This divide between those who design and those who construct buildings is one that continues to separate the relatively elite practice of architecture from vernacular construction, in which the builder typically takes greater responsibility for the appearance of the results.

Brunelleschi's competition entry was not a set of plan, section, and elevation drawings, as it would be today, but instead, according to the custom of the time, included a wooden model. The original is now lost, but a later one survives. Constructed between 1420 and 1436, the dome itself demonstrates the three interrelated principles that would characterize a new movement in architecture. Writing in *Lives of the Artists,* first published in 1550, Giorgio Vasari coined the term *Renaissance,* which means rebirth, to describe it and related changes that took place across the visual arts and extended into fields such as literature and philosophy. Vasari's emphasis on Florence distracted attention, however, from the degree to which dynamic changes, not necessarily grounded in the recovery of classical precedent, were taking place in other parts of Europe and the world. These are more usefully considered "early modern," a label that encourages us to pay attention to the purpose of the changes rather than the style through which they were expressed. That the new approach Vasari chronicled would first challenge and then largely supplant the older Gothic style across the Italian Peninsula remains beyond dispute, however. The hallmarks of Italian Renaissance architecture were already visible in Brunelleschi's dome. They include the increasing importance of theory over pure craft, the recovery of ancient Roman motifs and construction technology, and the use of these forms and construction techniques to invent new solutions to technological and artistic problems.

How did Brunelleschi actually solve the problem of the dome? The technical demands were daunting. The largest groin vault ever built, it rose three hundred feet above the floor of the crossing. Brunelleschi employed the same medieval Gothic rib vault technology Arnolfo had introduced in the nave (Figure 3.2). He did so, however, on a new scale and in the service of a different, more Roman, form. Most important, he, like the builder of the Gur-i-Mir, used a double shell. A light outer

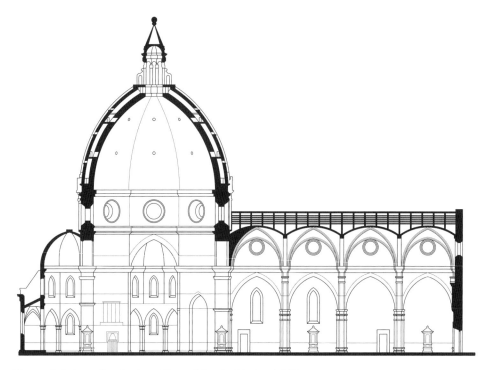

Figure 3.2. Longitudinal section of Santa Maria del Fiore.

shell encased a thick inner shell. The two were affixed in two ways, which buttressed both shells. The first was a skeleton of cross-braced ribs: eight visible on the exterior and sixteen more located between the shells (Figure 3.3).

One can still climb to the top of the dome through the narrow passage between the two shells. There one glimpses the second way in which the two domes were woven together, this time horizontally. Redundant systems offered extra insurance. As many as three stone chains and one wooden one, tied together with iron, girdle the dome, while the brickwork is laid in a herringbone pattern that creates a particularly strong bond. This brickwork may have been one of the lessons of ancient Roman construction, which Brunelleschi could have studied in Rome, only a few hundred miles to the south. In his own time, the technique was practiced primarily far to the east, in Iran and central Asia.

Much of Brunelleschi's contribution to the dome falls within what we would call engineering rather than architecture. Brunelleschi accomplished the difficult task of constructing the dome by erecting working platforms and designing the machines that would carry materials to them. He cantilevered the scaffolding from the inner face of the dome, anchoring it in the fabric and moving upward as necessary. He also developed a number of machines with which to assist the process. One of these was a hoist, constructed in 1420–21, that carried building materials up to the scaffolding (Figure 3.4). This technologically advanced machine, one of at least three

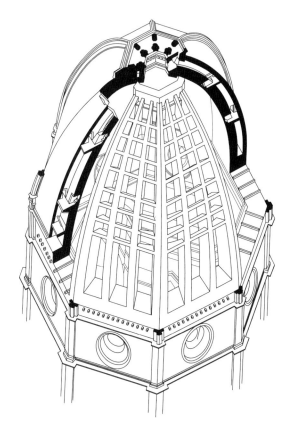

Figure 3.3. Structural analysis of dome, Santa Maria del Fiore.

Figure 3.4. Hoist used in construction of dome, Santa Maria del Fiore. Reconstruction drawing.

Brunelleschi designed in order to erect the dome, attracted the admiring attention of later Renaissance figures, including Leonardo da Vinci.

Although it was designed only after most of the rest of the building, except the nineteenth-century facade, had been constructed, Brunelleschi's dome seems to emerge organically out of its setting. To this day it remains the city's principal landmark. Contemporaries marveled. The architect Leon Battista Alberti declared in his treatise *De Pictura (On Painting),* "Who is so dull or jealous that he would not admire Filippo the architect in the face of this great building, rising above the vaults of heaven wide enough to receive in its shade all the people of Tuscany, and built without the aid of any trusswork or mass of timber."

For centuries, the most ambitious churches throughout Europe, such as Saint Peter's in Rome and Saint Paul's in London, would follow its example and be domed as well. In turn, domes would mark the importance of major civic buildings, once they began to be erected in the eighteenth century. Although built out of different materials and ornamented with different architectural details, the domes of the U.S. Capitol and its many progeny in the individual American states are just some of the many descendants of Brunelleschi's great structure.

If he had realized only the dome, Brunelleschi would be remembered today as an extraordinary figure. Following this success, Brunelleschi inaugurated a new approach to the design of buildings that did not require such stunning engineering. In his later architecture, he instead emphasized the orderly articulation of wall plane, plan, and, eventually, by extension, space.

Brunelleschi's genius and his importance to the founding of the Renaissance are unquestioned. It is easy, however, to overstate his degree of responsibility for the buildings in whose design he participated. Just as today's architects have offices full of assistants who collaborate with technical consultants and contractors, recent scholarship has demonstrated that Brunelleschi should share credit with others or perhaps not be credited at all for three of what have been regarded as his other most important buildings. The point here is not the details of these debates, but the way in which Brunelleschi and his successors joined history and novelty. There was a sea change in Florence around 1420 in the way in which space was conceptualized and elevations were organized.

This change relates to Brunelleschi's greatest artistic achievement, his rediscovery of single-point perspective, which had been ignored in European art for a millennium. The convincing depiction of depth was accompanied by an increasingly sophisticated ability to frame and describe space, one probably informed by the skills of the city's many merchants and artisans, who had learned to judge quantity visually. Not surprisingly, Brunelleschi exploited the same geometrical idealism, which he accentuated through the revival of the Corinthian order, an ancient Greek system of intertwined structure, proportion, and decoration.

Work on the Hospital of the Innocents began in 1419 (Figure 3.5). Brunelleschi quit in 1427, but the hospital was not completed and opened until 1445, calling

Figure 3.5. Filippo Brunelleschi, facade, Hospital of the Innocents, Florence, Italy, begun 1419.

into question the degree to which he was solely responsible for the harmonious result. Loggias, open arcades fronting buildings, were already integral to late medieval Florentine hospitals, and yet there were important differences in the way that this building's loggia was articulated. Most crucially, Brunelleschi introduced a rigorous mathematical order. The height of the columns equals the span of the arches; each of the nine cubes is ten *braccia*, the Florentine unit of measure at the time. This framework of proportions would have been alien to many ancient Roman builders. Perhaps for this reason Brunelleschi did not just supervise the construction of a model of the facade; he also made careful drawings that highlighted these relationships.

Brunelleschi clad this modernity in traditional guise. Although the surfaces were relatively austere—the issue here is the organization of the wall elevation, not its decoration—the details accurately replicated those on classical columns. Indeed, he used the same Corinthian order found on the exterior of the Pantheon. The orders appear nowhere in the dome, although they do feature in the lantern that tops it. In the hospital facade Brunelleschi introduced an archaeological correctness that dominated many later interpretations of the Renaissance, at times to the detriment of the hospital's more innovative qualities.

These include the fusion of architectural and social order. The Hospital of the Innocents, to translate the Italian name of the institution, is also known in English as the Foundling Hospital. It was established by wealthy men in the silk industry to house abandoned children and orphans and the staff who cared for them. Then as now, unwanted pregnancy was a major social issue, especially among servant women, who often could not refuse the advances of members of the households in which they worked lest they lose their jobs. The architectural order of Brunelleschi's facade helped create a sense of rationalism and stability that echoed the mission of the institution it housed, reweaving the elite's sense of communal norms, which had been flouted by the actual behavior of men of all backgrounds acting in concert with mostly lower-class women.

This clarity extends to the original plan. The building was organized around a courtyard, as many secular structures in Florence were (Figure 3.6). Its facades were articulated along the same lines as the loggia facing the public plaza. This increased formality of the courtyard design, including its classical details, quickly reappeared in the design of private palaces. Such regular and impressive courtyards would have a long European history.

Surviving documents from the time attest to the fact that Brunelleschi designed nine bays of the facade of the Hospital of the Innocents; his role in the design of the parish church of San Lorenzo is murkier. In 1418, the Medici, a wealthy Florentine family of bankers, commissioned him to build what is now known as the Old Sacristy. This served as a funeral chapel for the parish's most prominent family and was an example of the increasing importance of the expression of nonaristocratic family pride in the religious as well as the secular sphere. In 1421, the rebuilding of the interior of the church began at the choir end (Figure 3.7). This is the only phase

Figure 3.6. Plan, Hospital of the Innocents.

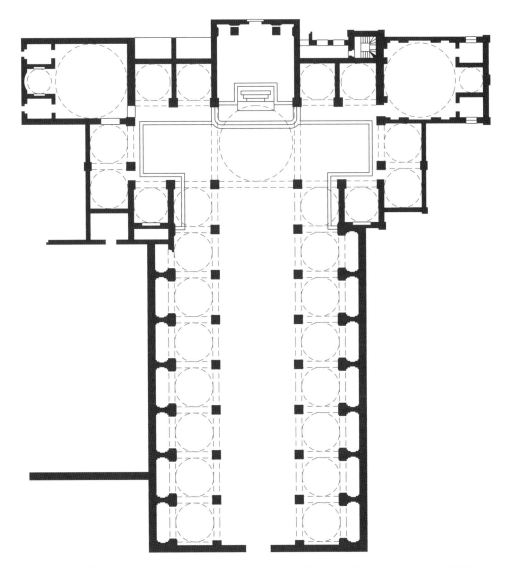

Figure 3.7. Filippo Brunelleschi, plan, San Lorenzo, Florence, Italy, begun circa 1419.

certainly designed by Brunelleschi. Most of the rest of the building was completed over the course of the century, long after Brunelleschi's death in 1446.

Despite these questions of attribution, San Lorenzo is important for two reasons. The first is the use here of ideal mathematical order as a reflection of divine order (Figure 3.8). This important idea, which reappears in many different religions around the world, Christianizes the pagan legacy of the Romans, whose state religion included a multiplicity of gods. The particular form it took here was far more explicit than its Gothic predecessors had been and, as at the hospital, it was dressed in the garb of classical details. The Latin cross is expressed very clearly: the crossing, transepts, and the sanctuary are each composed of a square module, and a row

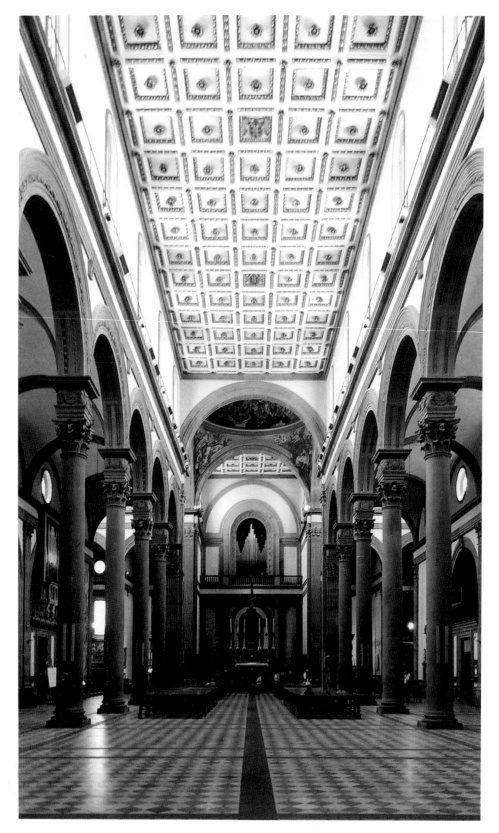

Figure 3.8. General view of nave, San Lorenzo.

of four more of these squares serves as the nave. With only slight irregularities, the cross is encased in smaller modules, each a quarter the size of the one that defines the central figure.

The second reason San Lorenzo remains a landmark in the history of architecture is the revival here of the basilican tradition. The basilica was an ancient Roman building type that fourth-century Christians adapted when churches were allowed to become architecturally ambitious buildings. Basilicas typically have naves divided from lower side aisles by colonnades. Recent Florentine churches, including the cathedral, had been designed in the modern Gothic style. In these buildings ribbed vaulting spanned the nave and aisles. San Lorenzo is instead similar in plan and construction to early Christian and Romanesque churches throughout Italy, although here a flat roof has been substituted for the usual open-timber truss. This return to the basilica type, like Brunelleschi's use of classical details, was an architectural badge of early modern Italy's increasingly independent cultural identity.

The canons of San Lorenzo, one of Florence's oldest parish churches, rather than the building's architect, made the choice to revive the basilican type. No doubt they did so because of the pride they took in the antiquity of their parish, even as they rebuilt its church. Nevertheless, they were not averse to changes that sustained the church's role in the neighborhood. Doubling the number of side aisles, from two to four, for instance, provided spaces that could serve as burial chapels for the parish's other prominent families, many of whom resented the Medici control of most of the church construction.

The culmination of the equation of mathematical and divine order introduced in the Old Sacristy came in the design of the Pazzi Chapel, commissioned in 1429 but completed, once again, only long after the death of its purported architect. The building is located in the cloister of the Gothic church of Santa Croce, whose Franciscan monks it served as a chapter house. The Pazzi Chapel doubled as a tribute to the magnificence of an old aristocratic family who numbered among Florence's leading bankers. After the old chapter house burned in 1423, they agreed to rebuild it. They advanced the money only very slowly, however, which is why construction took so long.

The form of the chapel is more interesting than its ostensible function. Here we find the second (San Lorenzo's Old Sacristy being the first) of a long line of Renaissance experiments with centralized sacred spaces (Figure 3.9). Roman Catholic liturgy demands an axiality that these places do not easily accommodate, which is why they remained rare despite the interest Italian architects had in designing them throughout the fifteenth and sixteenth centuries. As this chapel was intended to serve mostly as a meeting place and as housing for family tombs, rather than as a place to say Mass, liturgical concerns mattered less than they would have in the neighboring church.

Barrel-vaulted bays flank the central domed space that also opened onto a small recess holding the altar. Gray Corinthian pilasters carved of *pietra serena* stone

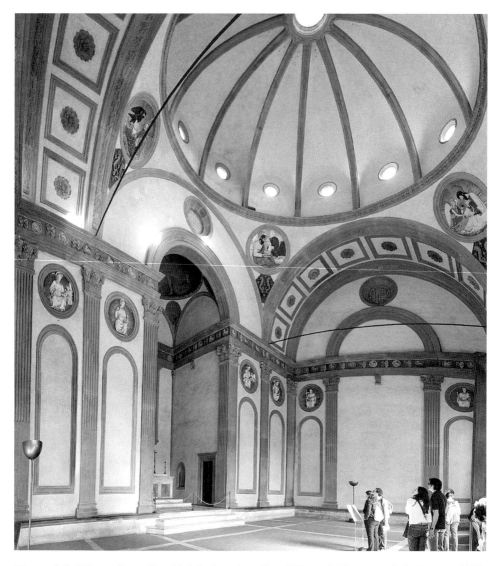

Figure 3.9. Filippo Brunelleschi, interior view, Pazzi Chapel, Florence, Italy, begun 1429.

accentuate the proportional relationships Brunelleschi established between these spaces. More moldings highlight the division between the walls and the superstructure and define the semicircles, spherical sections, and ribbed dome into which it was in turn divided. In the Pazzi Chapel, Brunelleschi replaced Gothic architecture's emphasis on a mystic vision of heaven with a lucid rationalism, anchored in history as well as in geometry. Like much Renaissance erudition, the result was slightly chilly, but it was also supremely logical and even inspiring in its aspiration toward perfection.

Brunelleschi can be considered the first early modern architect, although this title is often bestowed on Alberti, for reasons that will be addressed in the following

chapter. Brunelleschi was divorced from the actual construction of his buildings, which, admittedly like many medieval master builders (most of whom had trained, however, as masons), he engineered but did not labor on with his own hands. Either the strength of his personality or later hero-worship led him to receive credit for more than he actually designed, whereas most of his predecessors remain largely anonymous, even when their names can be located in archives. His focus on ideal form threatened at times, as in the ideal plan of the Pazzi Chapel, to overwhelm the function of his buildings. All of these traits continue to haunt the profession Brunelleschi did so much to define. Also new was Brunelleschi's ability to ride the wave of a new respect for individuality and to find in architecture a means for personal as well as communal expression, although his ability to distill complex social realities into geometrically pure forms would certainly have felt familiar to the inhabitant of a Chinese courtyard house.

Brunelleschi used history to derive from the past an approach to both form and its articulation and ornamentation that was entirely modern in its logic. He learned from the ancient Romans and the less ancient Florentines, but he was never satisfied with merely copying them. Indeed, he often misunderstood them. We know, for instance, as he did not, that the Baptistery was not a Roman temple. The relationship he charted, however, between past and present, in which the recovery of the past inspires an entirely new future, would be repeated in many early modern and modern buildings, many of them designed, built, and occupied by women and men who had no idea Brunelleschi had even existed.

FOR FURTHER READING

For discussion of Brunelleschi's dome, see Giovanni Fanelli and Michele Fanelli, *Brunelleschi's Cupola: Past and Present of an Architectural Masterpiece* (Florence: Mandragora, 2004); Howard Saalman, *Filippo Brunelleschi: The Cupola of Santa Maria del Fiore* (London: Zwemmer, 1980); and Marvin Trachtenberg, *Building-in-Time: From Giotto to Alberti and Modern Oblivion* (New Haven, Conn.: Yale University Press, 2010). I am indebted to Gülru Necipoğlu, *The Age of Sinan: Architectural Culture in the Ottoman Empire, 1539–1588* (London: Reaktion, 2005), for the possible connections among the great Italian Renaissance domes, Hagia Sophia, and Timur's tomb. On the development of perspective, see Hubert Damisch, *The Origin of Perspective* (Cambridge: MIT Press, 1994). Model building is among the aspects of Renaissance architecture addressed in Henry Millon and Vittorio Magnago Lampugnani, eds., *The Renaissance in Architecture from Brunelleschi to Michelangelo: Representation in Architecture* (New York: Rizzoli, 1994). Howard Saalman, *Filippo Brunelleschi: The Buildings* (University Park: Pennsylvania State University Press, 1993), surveys Brunelleschi's later work and the degree to which he can be credited with its design. See also Matthew A. Cohen, "How Much Brunelleschi? A Late Medieval Proportional System in the Basilica of San Lorenzo in Florence," *Journal of the Society of Architectural Historians* 67, no. 1 (2008): 18–57; and Marvin Trachtenberg, *Brunelleschi, Michelozzo, and the Problem of the Pazzi Chapel* (New Haven, Conn.: Yale University Press, 2008).

4 Medici Florence

The ancient forms and construction techniques revived by Filippo Brunelleschi served the modern uses of fifteenth-century Florence, one of the most dynamic cities of the time. For the next century and a half, the organization of elevation, plan, and section according to an ideal mathematics and accented in the revived classical orders continued to be developed by Florentines and others on the Italian Peninsula. This new order was, however, almost never applied to Renaissance cities as a whole. Instead, these schemes remained confined largely to painting. The example in Figure 4.1, attribution of which remains the subject of considerable scholarly debate, depicts ancient Roman structures as well as a building much like Florence's Baptistery using single-point perspective. No fifteenth- or sixteenth-century city in Italy ever featured the organized open spaces featured in paintings like this one or that characterized cities such as Beijing and Tenochtitlán. Why not, and what did they look like instead?

The changes in the appearance of Florence during this period were profound, but they were always isolated and incremental. The principal impetus was never the creation of an ideal urbanism; it was the expression of the power and wealth of the city's leading families. This was a dynamic process, one that established a tension between neighborhoods and the center rather than encouraging a unified urban image. It takes us beyond form for its own sake to the economic, functional, political, and social forces that affect that form.

Although in the late Middle Ages nominally a part of the Holy Roman Empire centered in what is now Germany, Florence was in fact, like many European cities, a republic. In other words, it was independent from imperial, royal, or aristocratic government. In Florence the male heads of a number of leading families governed the city. They were people whose income came from artisanal and business activities, especially the wool trade and banking, rather than the control of agricultural

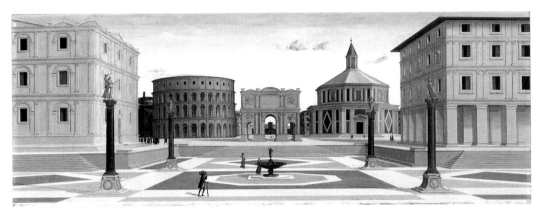

Figure 4.1. Ideal city with a fountain and statues depicting the virtues, late fifteenth century.

land. City governments of this kind stressed the frequent rotation of offices and council membership in order to ensure relative equality among the competing families. Sometimes offices were even assigned through the drawing of lots. Brunelleschi was among the Florentines to hold such positions.

The story of Florence during the fifteenth and sixteenth centuries is one not of expansion, with new districts laid out, but of the reorganization of existing urban places as a single family, the Medici, slowly wrested political power away from the civic collective. The Black Death of 1348 halved the population, eliminating the need for growth. Florence's late medieval boundaries, like those of cities across Europe, are marked through the locations of the churches the mendicant orders established in the thirteenth century. Santa Maria Novella, erected by the Dominicans, lies to the northwest and the Franciscan church of Santa Croce to the southeast of the center. Also just to the north of the original Roman grid are the parish of San Lorenzo and, slightly to the east, the Hospital of the Innocents.

In 1445 construction began, only a block from the church of San Lorenzo, on the building now known as the Medici–Riccardi Palace (Figure 4.2). Although the building had an architect, Michelozzo di Bartolomeo, the real force behind this extraordinary structure was Cosimo de' Medici, a wealthy banker who, working largely behind the scenes, also controlled the city government. The development of the urban palace in Italy was inextricable from Cosimo's challenge to the city's republican government. The basic block-like form, organized around a courtyard, already had deep European and Florentine roots. It was utterly unlike the pavilion arrangement that remained characteristic of most Asian palaces until the nineteenth century.

Cosimo did not design his palace, but he knew exactly what he was doing. He was well equipped to understand architecture's effectiveness as political propaganda. Three years earlier, he had jump-started the long-dormant process of constructing San Lorenzo. Nor was he unique; most of his political rivals had also served on

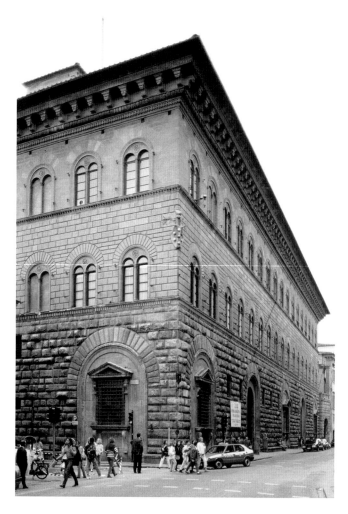

Figure 4.2. Michelozzo di Bartolomeo, Medici–Riccardi Palace, Florence, Italy, begun 1445.

building committees for civic and religious commissions and vied with architects for authority in making judgments about the appearance of buildings.

The Medici–Riccardi Palace was startlingly innovative. It established a paradigm that lasted for more than two centuries. Previously, religious or secular rulers, bishops and princes, built most palaces; those erected by members of the bourgeoisie were relatively rare exceptions. The towers of competing families had instead dominated medieval cities throughout Tuscany and as far beyond as Bologna. From now on, those families who could afford it would build splendid urban residences, sinking one-half to one-third of their net worth into the construction of these badges of family identity. The shocking new scale of Cosimo's new palace is demonstrated by the fact that twenty existing houses were demolished for its construction. Fourteenth-century houses were usually anonymous, but the Medici coat of arms was prominently displayed on the corner of the family's palace.

In medieval European cities, the most aesthetically ambitious and largest buildings usually belonged to the church or to the rulers. The Palazzo Vecchio, for instance,

was Florence's medieval city hall and a building whose tower rivaled the newer cathedral dome as the city's most prominent landmark. Cosimo not only tacitly controlled the government it housed but also openly erected a building that immediately became another of the city's principal secular landmarks. He and Michelozzo accomplished this by referring to the older building, even while they refined it. Both are almost fortified blocks, with rusticated surfaces that make them seem more formidable. Both have arched windows (the Medici Palace's ground-floor windows seen today are later additions designed by Michelangelo). Both were lined with benches. These provided seating for petitioners and also accommodated casual conversation; on festival occasions dignitaries occupied them. And yet the Medici Palace is a much more regular, less apparently arbitrary volume than the Palazzo Vecchio. The Medici Palace also excluded commercial functions; the main Medici banking facilities were elsewhere. Originally only Cosimo and his wife, their children, their servants, and their slaves occupied the palace. Over time, however, the number of family retainers increased to evoke a princely court; Michelangelo, for instance, lived and worked in the palace for a time.

Nothing about the exterior of the Medici–Riccardi specifically revives ancient Roman models, but the prominence of an interior courtyard defined by a Corinthian colonnade follows the example established by Brunelleschi in the Hospital of the Innocents (Figure 4.3). In some cultures the courtyard is the private core of the house, but in Renaissance Florence these spaces were easily glimpsed from the street and more easily entered than the major rooms, which were located one story above. In this case the entrance sequence led up the stairs, along the edge of the courtyard, and into the main room for entertaining and the only slightly less grand bedroom behind it. From here, as from the corridor, one could go into either the chapel or a more private study.

Fifteenth-century Florence and Venice were Europe's richest cities. New standards of interior luxury and comfort were established in both. A contemporary painting of the birth of the Virgin by Domenico Ghirlandaio from the church of Santa Maria Novella depicts a palatial Florentine bedroom (Figure 4.4). Even splendid rooms had far fewer pieces of furniture than are customary today. Lavish bedsteads and fabrics served as major indicators of a family's wealth. The master bedroom was often one of the most public rooms in the house, above all after the birth of a child, when the mother's friends came to wish her well, as is depicted in this painting.

Painted by Benozzo Gozzoli, the original decorations of the Medici Palace chapel survive. Although more appreciated today, these paintings were substantially less expensive than the tapestries that decorated the walls of princely residences. Gozzoli incorporated portraits of many Medici family members into his depiction of an expansion of the biblical story of the three Magi. The chapel, like the Old Sacristy of San Lorenzo, demonstrates the way in which Medici patronage, as well as that of families like the Pazzi, privatized sacred experience.

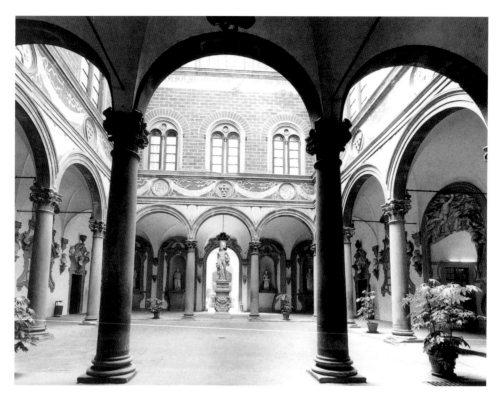

Figure 4.3. Courtyard, Medici–Riccardi Palace.

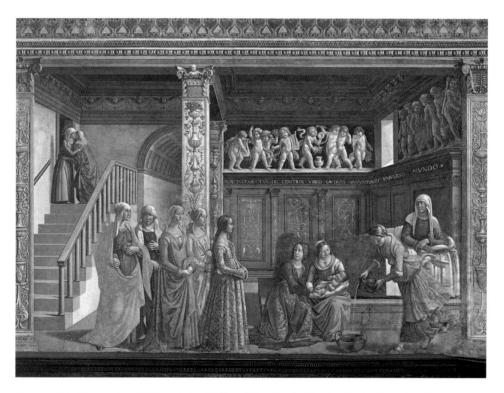

Figure 4.4. Domenico Ghirlandaio, *Birth of the Virgin,* Santa Maria Novella, Florence, Italy, 1485–90.

As a public relations strategy, the palace succeeded. It was considered such an ornament to the city that it was never sacked, even when the Medici were thrown out of the city, as happened twice. Not surprisingly, other Florentine families soon clamored to build their own equivalents. Leon Battista Alberti designed one of the first of these.

Alberti was a very different kind of architect from Brunelleschi, but the model he established was as important. A gentleman rather than an artisan, he had a higher social status than Brunelleschi, determined in part by birth, in part by education. Gentleman architects would play an important role in the architecture of Europe and its colonies for centuries to come. As recently as the early nineteenth century, amateur architects, including Thomas Jefferson in the United States, were among the most important designers of their day. Alberti was an intellectual. He lacked Brunelleschi's engineering abilities but had a greater knowledge of ancient Latin texts. His *Ten Books on Architecture,* after the ancient Roman writer Vitruvius's only the second European theoretical text on architecture to survive, was originally written in Latin rather than in the Italian that people actually spoke. It was the first in a long line of works in which architects assembled ancient and modern knowledge about the design and construction of buildings. Such texts also served to display the erudition of the writers and to enhance the prestige of the new profession.

Two of Alberti's earliest architectural commissions were a pair of facades designed for the Rucellai family. Work began on the street front of the family's palace around 1453 (Figure 4.5). While the Medici Palace was an entirely new building, the Rucellai remodeled existing houses and pasted a fashionable new face on the resulting ensemble. Alberti's patron, Giovanni Rucellai, was Florence's third-richest citizen, and thus someone particularly likely to want to hold his own against the display of wealth and power articulated by Cosimo.

The principal difference between this facade and that of its Medici predecessor was Alberti's introduction of pilasters as an ordering device and an ornamental motif. A pilaster is a strip applied to a wall surface whose ornamentation resembles that of a freestanding classical column. Drawing upon the ancient Colosseum in Rome, Alberti articulated the divisions between window bays with Doric below, Ionic, and finally, Corinthian pilasters, thus adhering to the ancient hierarchy of the orders.

Rucellai was enormously pleased with the result. He later wrote: "I think I have done myself more honor by having spent money well than by having earned it. Spending gave me deeper satisfaction, especially the money I spent on my house in Florence."

Sacred architecture also served the Rucellai, like the Medici, as a site of display. Alberti revised and completed the facade for Santa Maria Novella, the city's Dominican church and the one where the Rucellai worshiped (Figure 4.6). The facade is inscribed "Giovanni Rucellai son of Paolo 1470," although work had begun around 1458. This public declaration of the family's contribution to the

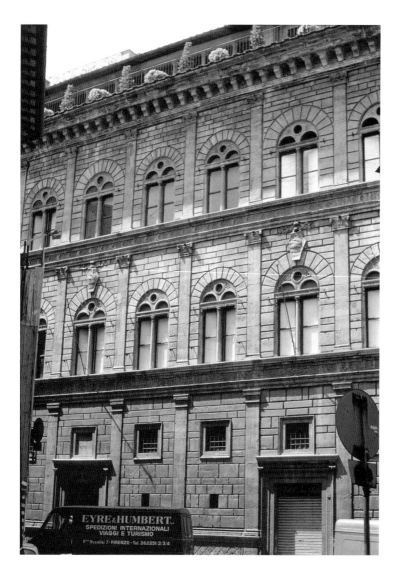

Figure 4.5.
Leon Battista
Alberti, facade,
Rucellai Palace,
Florence, Italy,
begun 1453.

building, which is just a decorative front for one of Florence's major Gothic churches, demonstrated the Rucellai family's control of the neighborhood and of its most important institution.

Once again a conflation of Roman and Romanesque sources created an image of local identity. Here for the first time an ancient Roman temple front, although interrupted by an oculus, was directly quoted in the upper story of the facade of a church. Santa Maria Novella was thus the ancestor of countless Renaissance and baroque church facades throughout Italy and far beyond. Many later church designers also adopted the volutes that bridge the difference in height between the central nave and the lower aisles flanking it. An important Romanesque source was the thirteenth-century facade of the church of San Miniato al Monte, which overlooks

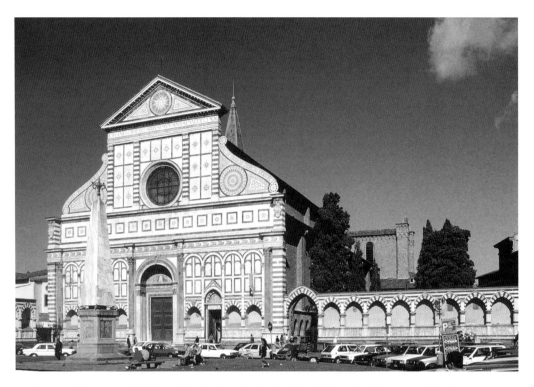

Figure 4.6. Leon Battista Alberti, facade, Santa Maria Novella, Florence, Italy, begun 1458.

Florence. This church, begun in 1013, almost certainly provided a precedent for Alberti's decorative vocabulary, as well as for the plan of San Lorenzo. Although Brunelleschi knew the building equally well—indeed he must have glimpsed its facade almost every day—his more austere architecture did not mimic its marble veneer surfaces.

The Medici government flourished under Cosimo's son, Lorenzo the Magnificent. After his death in 1492, however, the family was forced into exile. Many Florentines greatly resented Medici control of what had once been a more representative system of government. The family returned in triumph only after a Medici pope, Leo X, was elected in 1513. Like Cosimo before them, Leo and his nephew, who later became Pope Clement VII, used architecture to demonstrate their family's status. Since they were religious rather than secular rulers and lived in Rome rather than Florence, they focused their architectural activity on the parish church of San Lorenzo rather than on a palace. First Leo commissioned a facade for the building in 1516 from the painter and sculptor Michelangelo, who was at the age of forty already one of Italy's most famous artists. It would have been his first architectural commission had it been realized. Two further Medici commissions completed by Michelangelo grace the complex. These are the New Sacristy and the Laurentian Library.

Designed in 1519 and 1520, the New Sacristy housed the tombs of two of Leo's nephews. Located just across the choir from Brunelleschi's Old Sacristy, the New Sacristy in plan, elevation, and materials related closely to its predecessor (Figure 4.7). Both were crowned with circular domes, and both featured gray *pietra serena* stone classical details that emphasized the geometrical division of the surfaces they framed. Both also displayed the Medici's ability to marshal the city's finest

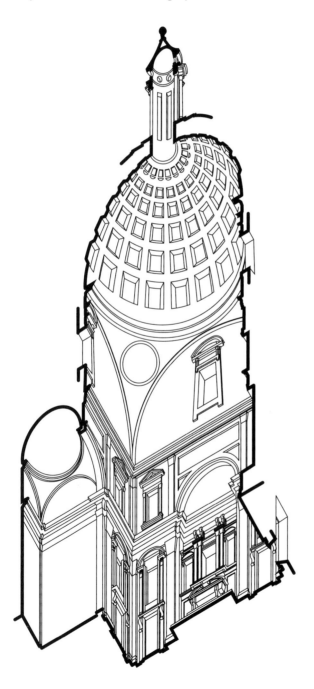

Figure 4.7. Michelangelo, axonometric, New Sacristy, San Lorenzo, Italy, begun 1519.

artists to celebrate the family. This necessarily entailed innovation as well as imitation. The first significant difference between the two sacristies is the upper story Michelangelo added to achieve heightened grandeur.

As befits the work of the leading European sculptor of the day, the tombs of Lorenzo and Giuliano de' Medici are far more prominent than those of their ancestors in the Old Sacristy (Figure 4.8). Furthermore, the marble walls behind them contribute a richness entirely antithetical to Brunelleschi's understated wall surfaces. The tombs' themes of death, resurrection, and glorification connect the temporal experience of the Medici family's return to Florence with the iconography of the Christian faith. Finally, the framing sculptures, which seem about to slide off their perches, add an unstable note foreign to Brunelleschi's search for geometrical certainty.

The differences between the two sacristies of San Lorenzo embody the major distinction between fifteenth- and sixteenth-century Renaissance architecture in Italy. In the sixteenth century the classical past was recaptured in more detail and then manipulated for far richer sculptural and emotional effect than fifteenth-century architects and artists had imagined. Michelangelo thought of wall surfaces and the space they shape as plastic, rather than as the static planes that were Brunelleschi's forte. The wall surface in the New Sacristy is no longer a clearly defined flat surface, but a sculptured block to which the *pietra serena* details add substance and depth.

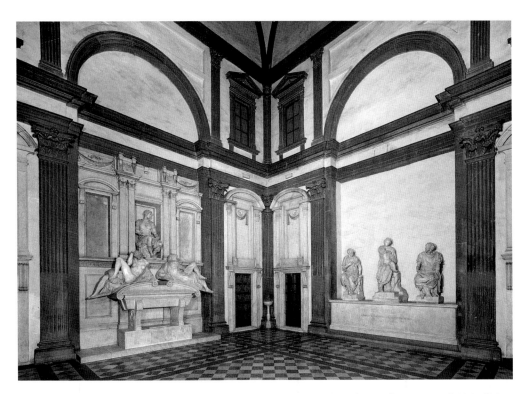

Figure 4.8. Interior view, New Sacristy, with the tomb of Giuliano di Lorenzo de' Medici.

This approach reached its Florentine climax next door in the vestibule of the Laurentian Library. Begun in 1524, the library housed Lorenzo de' Medici's collection of manuscripts, which Pope Leo donated to the monastery of San Lorenzo, monasteries still being the principal repositories of learning. The site was predetermined: a third floor added to an existing building. This raised location protected the books from damp and provided the most natural light. Michelangelo welcomed working with difficult circumstances; he viewed it as a challenge. The main room of the library adhered to the existing typology for such spaces. It was a long rectangular space with an aisle separating two rows of desks to which the books and manuscripts were chained.

It is the vestibule that is magnificent, if—because it is tall and narrow—almost impossible to depict adequately with photographs (Figure 4.9). In this confined space there is enormous tension between the rectangular organization of the tall walls and the way in which the staircase comes cascading out to meet those who enter, almost pushing them back out of the building. This is an early and influential example of the monumental stairs that soon became a staple of palaces and eventually also civic buildings.

Brunelleschi had striven for an architectural logic and order that could in turn enhance social and echo divine order. Michelangelo, in contrast, delighted in what the architect Robert Venturi would later term complexity and contradiction. Nowhere are these qualities more richly expressed than in the way he embedded the columns in the side walls of the vestibule. The ancient Romans attached pilasters and engaged columns to walls; Michelangelo's innovation was to inset them into the wall, where they doubled as buttresses.

Michelangelo's working method made an equally sharp break with the past. In Gothic cathedrals engaged shafts led up to the rib vaults that spanned the nave, but here the structure is carried within rather than upon the wall surface. In northern Europe, architectural drawings had first achieved importance in the late Middle Ages; in the sixteenth century they finally began to rival models for importance in Italy. Michelangelo made many sketches for this project, using them to work out design ideas as well as to communicate them to others.

Michelangelo's additions to Florence enhanced the prestige of the Medici family. Although less visible than the Duomo or the Medici Palace, they remain among the city's most popular tourist attractions. It is unlikely that, at the time they were built, there was any Florentine who was unaware of them, even though their nuances elude those not trained to see them. One man who especially appreciated their details was the painter and architect Giorgio Vasari, who supervised the construction of the vestibule. He wrote of first the New Sacristy and then the library:

> [Michelangelo] wanted to execute the work in imitation of the old sacristy made by Filippo Brunelleschi but with different decorative features; and so he did the ornamentation in a composite order, in a style more varied and more original than any

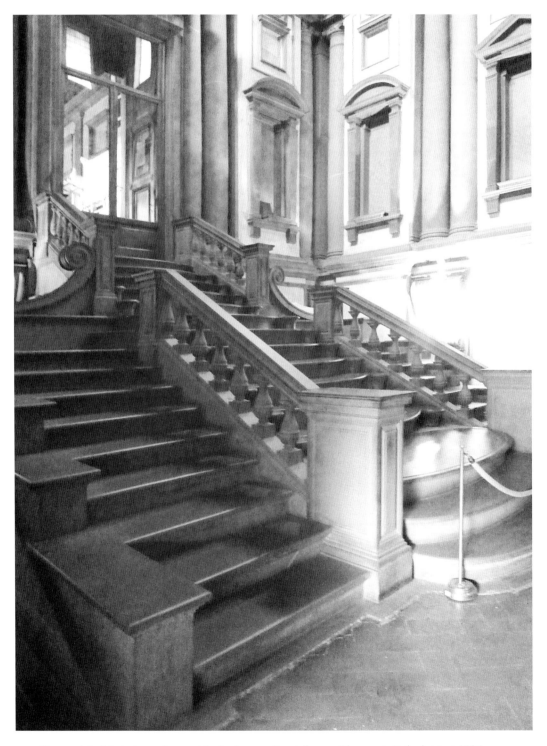

Figure 4.9. Michelangelo, vestibule, Laurentian Library, Florence, Italy, begun 1524.

other master, ancient or modern, has ever been able to achieve. For beautiful cornices, capitals, bases, doors, tabernacles, and tombs were extremely novel, and in them he departed a great deal from the kind of architecture regulated by proportion, order, and rule which other artists did according to common usage and following Vitruvius and the works of antiquity but from which Michelangelo wanted to break away.

The license he allowed himself has served as great encouragement to others to follow his example. . . . All artists are under great and permanent obligation to Michelangelo, seeing that he broke the bonds and chains that had previously confined them to the creation of traditional forms. Later Michelangelo sought to make known and to demonstrate his new ideas to even better effect in the library of San Lorenzo, namely in the beautiful distribution of the windows, the pattern of the ceiling, and the marvelous entrance of the vestibule. Nor was there ever such a resolute grace, both in detail and overall effect, as in the consoles, tabernacles, and cornices, nor any stairway more commodious. And in the stairway, he made such strange breaks in the design of the steps, and he departed in so many details and so widely from normal practice, that everyone was astonished.

A generation after Michelangelo's work at San Lorenzo, a member of a new generation of Medici invented a new civic architecture with Vasari's able assistance for what was no longer a republican city. Cosimo I declared himself Grand Duke of Tuscany only in 1569, after these urban transformations were complete, but they cannot be separated from his political ambitions. Now the family would rule as hereditary princes, leaving their merchant past behind. This transformation was symptomatic of the extinction of communal rule in much of Europe across the course of the sixteenth century. It would take the French Revolution at the end of the eighteenth century to restore Europe's urban bourgeoisie, on the cusp of being transformed by the Industrial Revolution, to their late medieval position of power.

Almost as important as Cosimo to this process was his wife, Eleanor of Toledo, the first in a line of powerful Medici women. Eleanor ruled the city several times in her husband's absence. As political power shifted away from feudalism and toward urban courts, a handful of wellborn European women acquired a degree of political power that had been rare in the Middle Ages and was not matched again until Margaret Thatcher became the British prime minister in 1980. Eleanor's husband's distant cousin Catherine de' Medici, whose father was buried in the New Sacristy, and her own granddaughter Marie de' Medici would both become queens of France and would be regents during the minority of their sons. The Medici queens introduced their family's methods of representing political authority into northern Europe.

Architecture remained central to the Medici expression of power. Cosimo used old buildings in new ways and erected entirely new ones to serve the purposes of his absolutist state. In 1540 he and Eleanor moved from the old Medici Palace next to San Lorenzo into the Palazzo Vecchio. They lived there for nine years, in rooms

designed for their use by Vasari, before moving across the Arno to the Pitti Palace. In 1560, Cosimo commissioned Vasari to erect the Uffizi, which housed offices for an expanded civil service. Finally, in 1565 Cosimo had Vasari build a corridor (*corridoio* in Italian) to link these three buildings, allowing him privacy and security as he traveled from one to another.

Construction of the core of the Pitti Palace began in 1458 when yet another bourgeois family attempted to rival the Medici Palace. Eleanor bought it in 1549 to serve as the headquarters for the new court. Why did Cosimo not remain in the palace his ancestor had built? That was the quarters of a merchant prince, located in the crowded center of this city. Placed on the city's edge, the Pitti Palace could be and was expanded into something different. Beginning in 1558, Bartolommeo Ammannati transformed it into the definition of a modern royal palace. Ammannati designed the Boboli Gardens, which rise up the hillside behind the house, and added the wings that created a three-sided courtyard on axis with the main elements of the garden (Figure 4.10). Framed with boldly rusticated walls, the courtyard hosted the spectacles, in many cases performed by the entire court, that continued to bolster political authority, as in the late Middle Ages. This splendid setting provided an important precedent for two lavish palaces in Paris commissioned by Medici queens, the Tuileries and the Luxembourg. At the same time, by continuing to dwell in what had once been a merchant's palace, Cosimo did not entirely break with the old order.

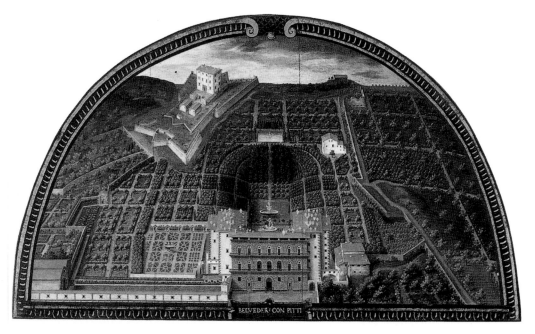

Figure 4.10. Pitti Palace, Florence, Italy, 1458. Cortile by Bartolommeo Ammannati, 1558–70, at rear.

The new political order required more, however, than splendid dwelling quarters for the grand duke, his family, and his court. The Uffizi was begun in 1560 in order to bring together in one place the various arms of the city administrations that had been scattered throughout the city (Figure 4.11). Today it houses one of the world's most famous collections of European paintings, but it was originally an office building, one of the first monumental examples of the type. As the scale and authority of the state grew, the number of people required to govern it also expanded. Until the nineteenth century, these were usually accommodated within the palace, but in Florence, where the institutions of republican rule remained prominent, they were instead placed close to the Palazzo Vecchio, the old town hall. Cleverly, Cosimo did not pay for the building. Instead he commanded that its users erect it according to the design he specified.

Because it was entirely new, the Uffizi was the most obvious statement of grand ducal rule. It was nonetheless replete with references to the republican past and to the Medici tradition that had supplanted it. The Palazzo Vecchio can be clearly seen from its courtyard, which was trimmed in *pietra serena* stone, and the Duomo glimpsed from the upper floors. By now a badge of Medici architecture, *pietra serena* could be used only with government permission. Furthermore, the facades echo those of the interior of the Laurentian Library, for which Vasari expressed great respect.

Cosimo exerted his authority, ordering the houses and other buildings on the site cleared and moving separate republican institutions into a place from which he could more easily control them. This anticipated the official imposition of absolutist grand ducal control over the Florentine government. Indeed, in its own day the Uffizi was understood and even criticized as an emblem of Medici authority. Opponents of the regime exaggerated the amount of demolition required to build it but not the disruption it caused in the lives of the former inhabitants of the buildings it replaced.

As the courtyard of the Uffizi demonstrates, there was some room in Renaissance Florence for idealizing urban stage sets. Yet the Uffizi is best viewed in the context of the city's irregularly formed past. The tower of the Palazzo Vecchio looms over the former office block, now a museum; the Duomo lies only a few blocks to the north. Walking through the new Uffizi toward them, one would have experienced these monuments of republican Florence as reframed by Medici authority. This helps explain why the Medici, while reshaping Florence, never reconfigured it entirely. Erasing the republican past by building a new city hall, for instance, would have diminished the city. Instead, the subtle reinterpretation of that past, not least through the construction of the Palazzo Medici and the Uffizi, further ornamented the city even as the Medici undercut the political principles the Palazzo Vecchio had once embodied. Fifteenth-century Florence saw the initial stages of the rise of professional architects, but from the beginning powerful clients checked the architects' ability to implement new aesthetic visions. The emergence of architects, and

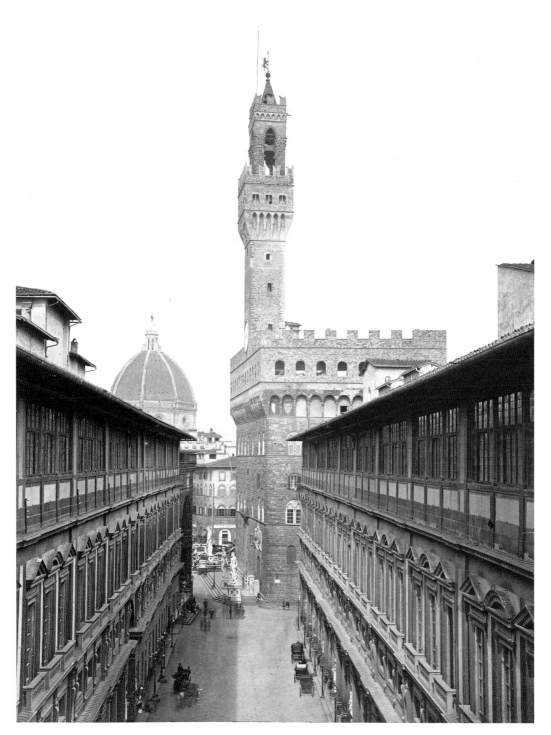

Figure 4.11. Giorgio Vasari, Uffizi, Florence, Italy, begun 1561.

the revival of arcane classical references and subtle details not easily appreciated by the general public, did not diminish the importance of patrons or the designer's responsibility to society as a whole.

FOR FURTHER READING

In addition to the sources cited in chapter 3, useful literature on fifteenth-century Florence includes Richard Goldthwaite, *The Building of Renaissance Florence: An Economic and Social History* (Baltimore: Johns Hopkins University Press, 1980); and Richard Goy, *Florence: The City and Its Architecture* (London: Phaidon, 2002). Yvonne Elet, "Seats of Power: The Outdoor Benches of Early Modern Florence," *Journal of the Society of Architectural Historians* 61, no. 4 (2002): 444–69, describes the prominence of this feature of both the Palazzo Vecchio and the Palazzo Medici. For more on housing, see Marta Ajmar-Wollheim and Flora Dennis, eds., *At Home in Renaissance Italy* (London: Victoria and Albert Museum, 2006). Lisa Jardine, *Worldly Goods: A New History of the Renaissance* (New York: Nan A. Talese, 1996), describes the prestige of tapestries in relation to painting. For discussion of Renaissance treatises, see Alina Payne, *The Architectural Treatise in the Italian Renaissance: Architectural Invention, Ornament, and Literary Culture* (Cambridge: Cambridge University Press, 1999); and Christine Smith, *Architecture in the Culture of Early Humanism: Ethics, Aesthetics, and Elegance, 1400–1470* (New York: Oxford University Press, 1992). On Alberti, see Robert Tavernor, *On Alberti and the Art of Building* (New Haven, Conn.: Yale University Press, 1999). On Medici architectural patronage in sixteenth-century Florence, see William E. Wallace, *Michelangelo at San Lorenzo: The Architect as Entrepreneur* (Cambridge: Cambridge University Press, 1994); and Leon Satkowski, *Giorgio Vasari: Architect and Courtier* (Princeton, N.J.: Princeton University Press, 1993). Cammy Brothers, *Michelangelo: Drawing and the Invention of Architecture* (New Haven, Conn.: Yale University Press, 2008), provides an analysis of Michelangelo's use of this medium. The importance of Eleanor of Toledo and the two French Medici queens is addressed in Annette Dixon, ed., *Women Who Ruled: Queens, Goddesses, Amazons in Renaissance and Baroque Art, 1500–1650* (London: Merrell, 2002).

5 The Renaissance in Rome and the Veneto

I f Brunelleschi's original goal was to solve technological problems, much of his genius lay in his invention of a new architectural vocabulary capable of expressing social and divine order. He and his talented Florentine successors sought to create a modern architecture tied as well to ancient Roman and medieval Italian precedents. Because there was nothing intrinsically Florentine about its sources, other Italians quickly adopted Renaissance architecture. As it spread, it was transformed to buttress existing institutions, especially the Catholic Church, as well as to express change, such as the new importance to Venetian merchant families of their agricultural hinterland. Indeed, this process was already well under way by the time many of the buildings discussed in the preceding chapter were built. After the Medici were temporarily expelled from Florence in the 1490s, the center of architectural experimentation on the peninsula shifted south to Rome and then, after the Spanish sack of Rome in 1527, north and east to Venice.

Historians of architecture have often considered the adoption of particular styles, such as Gothic or Renaissance, as a sign of progressive good taste. They have labeled those slow to adopt new paradigms as provincial. This is history as told by victors interested in particular kinds of formal unity. New styles met principled resistance whenever they did not fulfill the needs of individual patrons or societies. The Renaissance succeeded in displacing alternatives only slowly and only when it offered those who adopted it something they craved.

Nowhere was the new style's mixture of modernism and antiquarianism more welcomed than in Rome. After all, it was here, in a city that in 1400 had a population of only seventeen thousand people, that the challenge of equaling the imposing achievements of the past was most immediate. There were two reasons for this. First, prominent ancient buildings such as the Pantheon and Colosseum, erected on a scale unknown in the city for the last thousand years, remained clearly visible. Second,

the city was then, as now, the center of the Catholic Church. On the eve of the Reformation, just before the emergence of Protestantism, all Christians in central and western Europe owed religious allegiance and paid taxes to the pope, whose palace and church were located here. Especially after the nasty papal politics of the late Middle Ages, when as many as three popes ruled at once, one of them from Avignon in southern France, it was important to demonstrate that the popes were the heirs to the ancient Roman Empire and that, as Christians, they could at least equal and possibly even surpass the greatest achievements of their pagan predecessors.

The introductory salvo in the campaign of architectural magnificence that transformed the city over the course of the sixteenth and seventeenth centuries was, however, extremely small. The first entirely classical structure erected in Rome during the Renaissance was San Pietro in Montorio, begun shortly after 1502 (Figure 5.1). It fills a small courtyard, which its architect, Donato Bramante, had also originally intended to remodel. The church is also known as the Tempietto, which is Italian for "little temple." Who was Bramante and why was this little round building important?

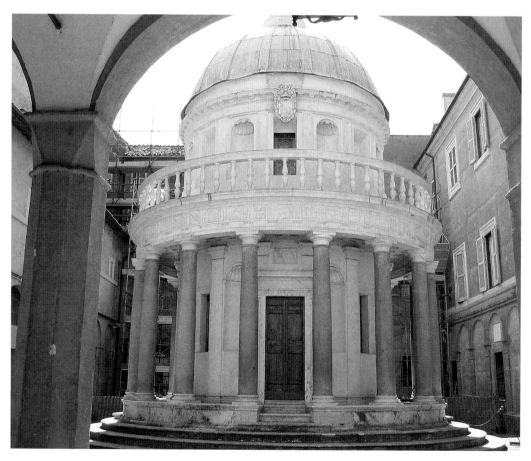

Figure 5.1. Donato Bramante, San Pietro in Montorio (Tempietto), Rome, Italy, begun after 1502.

Bramante arrived in Rome in 1499, when he was already over fifty years old. He had trained in Urbino and practiced in Milan, where he had been close to Leonardo da Vinci. Almost immediately upon his arrival in the papal city, Bramante demonstrated in his design for San Pietro the forceful emphasis on three-dimensionality that is the principal formal difference between fifteenth- and sixteenth-century Italian Renaissance architecture. San Pietro calls attention to form rather than facade. Bramante emphasized massing rather than the organization of planar surfaces upon which Brunelleschi and Alberti had focused. For instance, he ringed the Tempietto with freestanding columns rather than the pilasters that the two Florentines had used to define their compositions. Although the Tempietto is small, Bramante's muscular detailing imbued it with real grandeur.

This grandeur ties the Tempietto back to ancient Roman architecture, which Bramante studied closely. Here for the first time a Renaissance architect used Doric triglyphs to establish a rhythm of niched openings and applied the orders, in this case as pilasters, to a dome. Bramante fused his respect for antiquity to Christian purposes. The site was revered as the place where Saint Peter was crucified. Like basilican churches, centralized pilgrimage sites dedicated to Christian martyrs had been built in Rome since the fourth century. Bramante articulated his ideal plan with particular forcefulness. Only an altar at one end of the interior disturbed the perfect circle. Although deftly designed, the building is too small to be used by more than a few people at a time. The Tempietto is largely a place for private devotion.

Cardinal Bernardino de Carvajal commissioned the Tempietto on behalf of King Ferdinand and Queen Isabella of Spain. Building a small but noteworthy church in the Holy City was for these patrons a declaration of their Christian faith (the notoriously intolerant pair had recently completed the reconquest of Spain from the Muslims and expelled the country's Jews). Many countries and communities had churches in Rome, much as many countries today have embassies and consulates in the world's chief cities. Ferdinand and Isabella's patronage links the Tempietto to the expansion of the Renaissance in Spain and its Latin American colonies, a story to which we shall return.

Popes, however, instigated the most important architectural and urban interventions in sixteenth-century Rome. The process began with Julius II. The papacy did not focus exclusively on architecture as a means of artistic expression. Painting and sculpture were also important. Julius, for instance, commissioned Michelangelo to fresco the Sistine Chapel ceiling.

Today's popes have modest backgrounds and are primarily religious leaders. Julius, like all Renaissance popes, was also a secular ruler and governed much of central Italy. Furthermore, like his two Medici successors, Leo X and Clement VII, he came from a powerful family, the Della Rovere. He was the nephew of Pope Sixtus IV. Most Renaissance popes used their position to enrich their families and to promote the careers of their nephews and, in some cases, such as that of Julius's immediate predecessor, the notoriously corrupt Alexander VI, their sons.

Almost immediately after he was elected pope in 1503, Julius II launched two vast building projects. Both were conceived to demonstrate the papacy's secular and religious authority. Because they took decades to construct, they were realized by a succession of popes and their architects. Both began, however, as commissions that Julius gave Bramante. His renovation and expansion of a villa, the Belvedere, at one end of the papal palace set the tone for sixteenth-century palace and garden architecture throughout Europe. Its great courtyard, the Cortile del Belvedere, has, however, been transformed by later construction.

Even more important was the rebuilding of Saint Peter's, Western Christianity's major church. The original church had been begun by Constantine, the first Roman emperor to support Christianity. It had been built on the site associated with the burial of the same Saint Peter whose place of crucifixion the Tempietto marked. Already more than a thousand years old by Julius's day, the Constantinian building no longer seemed adequate. In particular it was not as tall as the immense cathedrals that were now the pride of cities across Europe or the imperial mosques being constructed in Istanbul. It took more than a century to build the new church. Although the beginnings may seem tentative, eventually they contributed to the formation of one of the greatest architectural ensembles in the world. This sequence of spaces continues to awe cultural as well as religious pilgrims.

The first stone was laid in 1506 according to a design begun the previous year. Both Bramante and Michelangelo, who took charge of construction in 1546, envisioned a centralized church (Figure 5.2). Note the spatial clarity of Michelangelo's plan in comparison to the geometrical complexity of Bramante's overly diagrammatic scheme. In the end, both architects' ideal visions were sacrificed by popes interested in focusing on the altar end of the building and in accommodating pilgrims and processions, for which a nave was essential. Once again the practical demands of function trumped artistic expression for its own sake.

To be fair to the architects, however, the dual function of Saint Peter's as the seat of the pope and the site of the holiest shrine in Western Christendom pulled everyone in two directions. Reliquary churches, like baptisteries, had been centrally planned since early Christian times. The location of Saint Peter's atop a holy tomb was the very reason for the existence of this church, viewed in Europe as the world's most important after the Church of the Holy Sepulchre in Jerusalem, erected to mark the spot from which Christ was resurrected. Saint Peter's needed an impressive crossing. Inspired by Brunelleschi's great dome in Florence and the new domed mosques being built in Istanbul, Bramante, too, envisioned a dome. He began the four great arches, wrapped in a giant order of Corinthian pilasters, upon which it would be set. All later architects had to work around this core.

Construction proceeded slowly after Bramante's death in 1514. Responsibility for the design fell first to the painter Raphael and then to the architect Antonio da Sangallo the Younger before devolving upon Michelangelo, who first built the walls of the eastern end of the church before turning his attention in 1554 to the

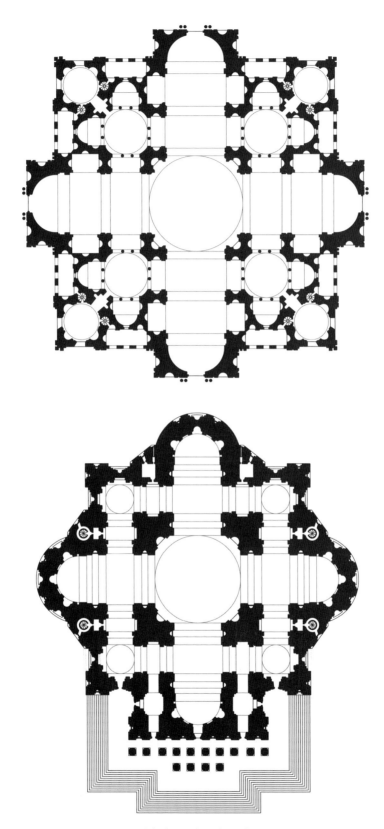

Figure 5.2. Donato Bramante and Michelangelo, plans for Saint Peter's, Rome, Italy, begun 1506 and 1546, respectively.

drum of the dome (Figure 5.3). Michelangelo's work at Saint Peter's constitutes the greatest demonstration of the compositional clarity at which he excelled. He unified both the interior space and the exterior expression of that space. On the exterior his giant order of pilasters established a dominant vertical that he then echoed in the freestanding columns of the dome.

The dome itself was equally impressive. Like its Florentine predecessor, it was a double shell with an octagonal lantern, although Michelangelo increased that dome's eight exterior ribs to sixteen. Like Bramante's dome at the Tempietto, it incorporated the ancient Roman orders into what was now, as in Florence, a superb achievement of modern engineering. Here the paired projecting columns of the drum doubled as buttresses. If Brunelleschi established the importance of a dome for churches and civic buildings to come, Michelangelo developed many more of the details to which these successors adhered.

In the dome of Saint Peter's, we see one of the ways in which sixteenth-century Romans expanded the precedents established in fifteenth-century Florence. At the Vatican, teams of architects labored for decades on enormous projects whose cultural importance, almost regardless of their quality, was bound to be consequential. Another notable aspect of the sixteenth-century Roman Renaissance was the degree to which both the new mathematical organization of space and recovery of ancient Roman forms were applied to the shaping of the landscape. Here, far more than

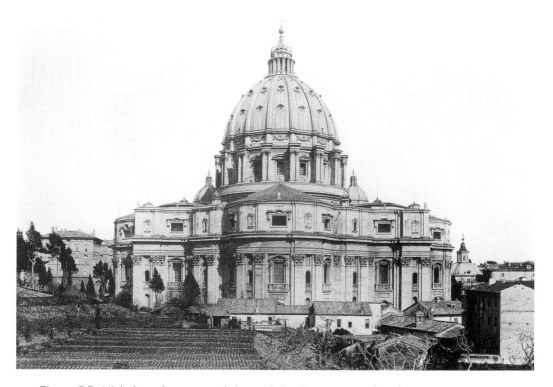

Figure 5.3. Michelangelo, apse and dome, Saint Peter's, completed 1591.

within the city, it was possible for a single patron working with his—rarely her—designers to implement an ideal order.

Sixteenth-century Italians witnessed the weakening of republican rule over most of the peninsula's cities. This development was accompanied by the blurring of boundaries between bourgeois and aristocratic families and between rural and urban life. Aristocrats came to the cities to participate at court, and bourgeois families, following the ancient Roman model, traveled out of the city to enjoy themselves on their country estates. Here they could escape the worst of the summer heat as well as increasingly formal princely etiquette. The ancient Roman Sanctuary of Fortuna Primigenia at Praeneste (modern Palestrina) provided an antique source for the use of steeply sloping sites. It was in this context that ornamental gardens began to be built on a new scale. Landholdings provided income as well as a variety of food, much of it, such as fresh game and fruit grown in hothouses, unavailable on the open market. Another influence on the creation of sixteenth-century Italian gardens may have been the Alhambra, built by Muslims in Granada, in a part of Spain that had recently been captured by Ferdinand and Isabella.

One of the most impressive of these gardens surrounds the Villa d'Este in Tivoli, a town about twenty miles from Rome (Figure 5.4). Tivoli was the site of the ancient Roman villa erected by the emperor Hadrian, a building whose ruins were well-known to Renaissance Romans and remain to this day the town's other principal tourist attraction. In the Renaissance, Tivoli became once again the locus of suburban retreats.

The man who built this garden, however, lived there much of the year. Cardinal Ippolito d'Este was the town's papal governor from 1550 until his death in 1572. His principal achievement in that position was to give the town a new water supply. The hydraulic engineering of the ancient Romans numbered among their most impressive achievements. Although much of the original system of supplying water to Rome and the communities surrounding it had long ago fallen into disrepair, its remnants formed prominent landmarks. Reestablishing a sophisticated water system ranked alongside constructing monumental domes as a badge of Renaissance equality with the ancient past. The cardinal celebrated his achievement by diverting one-third of the new water supply to feed the fountains of his garden, much of which was designed by Pirro Ligorio. Work began in 1550.

Visitors entered the garden at the bottom of a steep slope. Ippolito's villa, their ultimate destination, crowned the hill above them. Little about the garden was natural in the sense that we understand the term. In a demonstration of absolutist political power, Ippolito demolished an entire neighborhood before excavating and filling the site. The verticality of the garden was determined in part by the existing topography, but it was also strongly influenced by the terraced garden Bramante had built for Julius II at the Belvedere. Organized around the central axis, the ascent was interrupted by strong cross axes leading off to each side. Although the basic architectural features of the garden largely survive, today's plantings are quite different

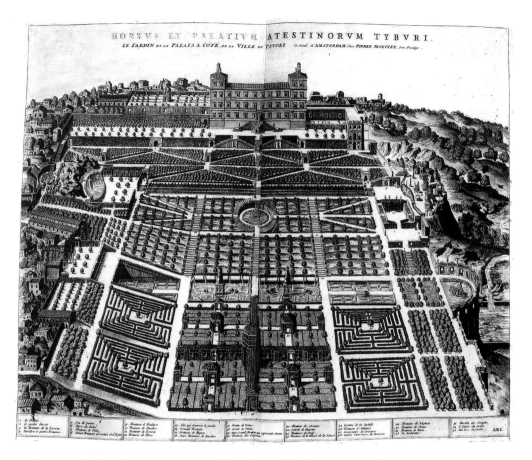

Figure 5.4. Pirro Ligorio, gardens, Villa d'Este, Tivoli, Italy, 1560–72, as engraved in 1573 by Etienne Dupérac.

from the originals. There are many more tall trees now and fewer bushes organized into neat geometrical beds. Finally, like the Belvedere in Rome, this garden was also one of the major sculpture gardens of the day, featuring many ancient statues recently recovered from the environs. Some were excavated from Hadrian's nearby villa. In both cases, the sculptures have since been moved indoors into museums.

Roman Renaissance gardens were designed to impress the courtiers and peers of those who built them. They surprised and startled visitors. The axes in the Villa d'Este culminate in dramatic set pieces invisible from the entrance and from one another. The Water Organ, for instance, is located on the main axis leading to the villa; the cross axis established by the alley of a hundred fountains connects the Tivoli and Roman fountains. In addition to being great fun, the Water Organ was one of the garden's great technological achievements. Water was stored behind this fountain. When released, it ran through passages sized to result in the sound of musical notes before cascading down the hillside. Along the alley of a hundred fountains, water spurts forth from the side of the hill in delicate little jets (Figure 5.5). These

are enormously cool and refreshing on a hot summer day. Their tinkling still drowns out the noise of the increasingly busy town below and of the many tourists who now fill the garden. Cuzio Maccarone, an expert in the construction of fountains, designed the Tivoli fountain. Its cascade refers to the town of Tivoli's own famous waterfall. Art imitated nature here in a way that local visitors would easily have recognized. A semicircular loggia runs behind the pool of this fountain. It provides a refreshingly cool place from which to look back upon the garden; Renaissance visitors to these gardens were often teased, however, when secret geysers suddenly drenched them.

The garden of the Villa d'Este provided contemporaries with an opportunity to muse upon the relationship of nature and artifice. Daniele Barbaro wrote to Cardinal d'Este:

> Nature agrees to confess to having being conquered by the art and splendor of your mind, so that in an instant the gardens are born and the groves shoot up, and trees full of the most delicious fruit are discovered in one night, also hills issue from the valleys and in the hills of the hardest rock are laid the beds of rivers and stones opened up to give place to waters and flood the dry earth, irrigated by fountains and running streams and the choicest fish pools of which men more intelligent than I have given honored judgment.

Figure 5.5. Pirro Ligorio, alley of a hundred fountains, Villa d'Este.

This highly intellectual approach to nature, which provided the backdrop for courtly entertainment, was not the only one, however, that influenced the architecture of the Italian Renaissance. In the Veneto, the mainland area around Venice, Barbaro was among those who set out a new relationship to the working—that is, the agricultural—landscape.

The monumental forms of the Roman Renaissance arrived late in Venice. Two conditions spurred its adoption there. The first was the invasion of Rome in 1527. The resulting disruptions in patronage encouraged the architect Jacopo Sansovino to move north to the Veneto, where he built the first examples of modern Roman architecture in Venice and neighboring Verona. The second and more profound condition was the shift in Venice's relationship to its hinterland.

Pushing steadily westward in the sixteenth century, the Ottoman Empire seized most of the former Venetian colonies that had supplied the city with grain. Between 1504 and 1564 Venice's population increased from 115,000 to 170,000. The potential for a food shortage encouraged the Veneto's established nobility and Venice's merchant elite to expand agricultural production. Reclamation of swamps, improved irrigation, and the seizure of former communally held lands by private producers generated higher yields and profits, but almost all the new wealth went to rich landowners who could afford to make expensive improvements. Peasants, whose social and economic position was eroded through these changes, often attempted to sabotage them.

The reality of increased social tensions was effectively masked in the new rural infrastructure designed throughout the Veneto by Andrea Palladio. Palladio was trained as a stonemason. A native of the Venetian-controlled city of Vicenza, he eventually attracted the attention of the city's intellectuals, who groomed him to become an architect. They took him, for instance, to Rome to visit the ancient and modern buildings there. Although Palladio was among those who erected Renaissance churches, palaces, and public buildings in Venice and the cities of the Veneto, it was his rural villas that bestowed ideal form and order upon a socially unstable and rapidly changing landscape and proved paradigmatic for later agricultural reformers in Europe and its colonies.

Palladio's significance is twofold. First, there are the actual buildings. Equally important, however, is the way in which most of Palladio's contemporaries, and his successors, learned of those buildings—through his published writings. The fame of Brunelleschi's dome depended on its prominent position in the skyline of one of Europe's most important cities, which ensured that large numbers of people saw it for themselves. Palladio's villas, however, were scattered through fairly remote countryside; even today it is impossible to glimpse many of them from public roads. They quickly became among the very most influential buildings in the history of architecture because in 1570 Palladio published a book. Only in the sixteenth century did the first printed, illustrated books about architecture appear, of which this was the most important. In *The Four Books of Architecture* Palladio illustrated not only his own work but also the ancient buildings he had studied in Rome. This

work is still in print and has been translated into many languages (the first complete English edition was published between 1716 and 1720).

The Four Books of Architecture integrated the tradition of architectural theory represented by the ancient Roman architect Vitruvius and the fifteenth-century intellectual Alberti with the new fashion for picture books through which architects, builders, and their patrons could learn about architecture. Palladio's clarity and logic were not necessarily as compelling as the expressiveness of Michelangelo's more mannered buildings, but the set of rules he established appealed to those seeking a consistent method to apply to their own architectural tasks. This was something that Michelangelo could not provide because it did not interest him.

Palladio designed and built palaces, civic buildings, and churches, but his villas are especially original. They are part of the increasing conquest of built space by the architectural profession, which was now extending its tentacles to working farms. Palladio's ability to focus on aesthetic harmony in an era in which rural dwellings on this scale were no longer routinely fortified imbued what remained an uncertain political situation with an air of stability. One of the buildings illustrated in *The Four Books* is the Villa Maser, built for Daniele Barbaro and his brother during the 1550s (Figure 5.6). The graphic attention Palladio places on the plan almost overwhelms the details of the elevation. Both are strictly symmetrical. Furthermore, the shapes of the individual rooms were designed according to the same rigorous proportional logic that underpinned Brunelleschi's elevation of the Hospital of the Innocents and the plan and interior elevations of the Pazzi Chapel.

Like Brunelleschi, Palladio grafted the ideal mathematics of Renaissance architecture onto the revival of ancient Roman forms. More specifically, he was the first architect to apply an ancient temple front—here expressed through pilasters rather than a freestanding portico of columns—to the facade of a secular building. The connection to the ancient Roman past was particularly strong at Maser, where Palladio's patron, Daniele Barbaro, had translated the one surviving ancient Roman architectural text, Vitruvius's *Ten Books on Architecture,* from Latin into Italian. Published with illustrations by Palladio, it was dedicated to Cardinal Ippolito d'Este.

The appeal of Palladio's villas, both to his contemporaries and to those who imitated them in eighteenth-century Britain and its colonies around the world, was the way in which he married ancient Roman precedents to modern gentleman farming. Palladio fused the intellectual and the social to the functional in ways that were poetic as well as practical. Both the villa and the nymphaeum behind it were built of brick covered with stucco, for instance, rather than more expensive cut stone. Moreover, once one subtracts the agricultural functions—dovecotes, barns, and the like in the outer wings and the passages leading to them—the villa, whose principal rooms are on the ground story, is modest in scale, especially in comparison to the merchant palaces of Renaissance Florence and Venice.

To be sure, one could not possibly mistake those rooms for their counterparts in a more ordinary house. Paolo Veronese, one of the most important Venetian painters of the day, painted their illusionistic frescoes (Figure 5.7). As well as populating the

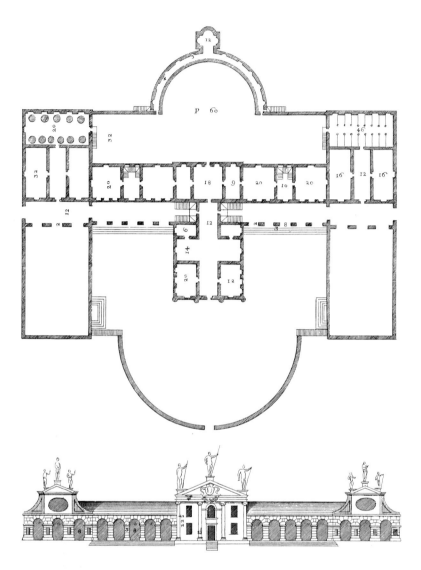

Figure 5.6. Andrea Palladio, elevation and plan, Villa Maser, Maser, Italy, 1549–58.

house with figures who seem about to engage viewers in conversation, these paintings create an even richer relationship with the surrounding landscape than does the house itself. This painted garden never turns brown in winter or requires maintenance.

Palladio's most perfect villa, the Villa Rotonda, was little more than a suburban banqueting pavilion (Figure 5.8). His only villa originally to lack agricultural out-buildings, it was erected in the 1560s a short walk from the center of his native Vicenza. Its perch atop a small hill offers sweeping views out over the surrounding countryside. The shallow dome and porticoed front of the ancient Roman Pantheon are liberated here from their original urban context and converted into a perfect object in the round. This is, like the Tempietto, an architecture in three dimensions,

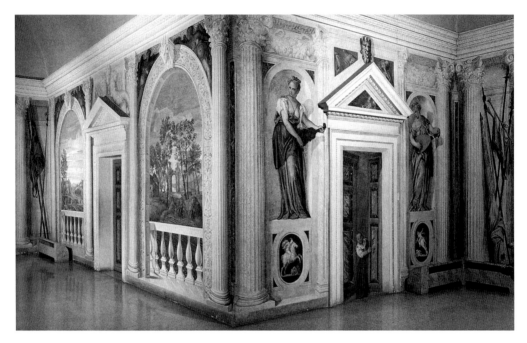

Figure 5.7. Interior, Villa Maser, as decorated by Paolo Veronese, 1560–62.

rather than merely one of facades. The villa is a paradigm of Renaissance logic. Its four identical facades are capped with the first dome to cap a villa. In the Villa Rotonda, the ideal centralized plan that failed to work for large Roman Catholic churches, which must be oriented toward an altar placed at one end of the building, was successfully transferred to a house for a retired Vatican official.

The Villa Rotonda represents the apex of Palladio's efforts to create an ideal architecture, in which harmonious proportions and antique sources fused to produce a sense of perfection equally comprehensible to those who visited it for themselves or were only familiar with the plates in *The Four Books.* The clarity of its design, in which plan and elevation so completely supported one another, made it among the most influential of all Renaissance designs.

Across the sixteenth century the Renaissance expanded to include the particular needs of two different sets of elite patrons in two different regions of Italy. In Rome, the Renaissance served the papal court, whose grandeur Grand Duke Cosimo de' Medici could only hope to equal; in the Veneto it was embraced by precisely the local equivalent of the elite families whom, in Florence during the same years, Cosimo was squeezing out of the political process. In both cases, it remained the province of an intellectual, political, and economic elite, proving adaptable to existing and emerging circumstances. And this was just the beginning. At the same time that revived classicism was transforming the appearance of Italy's leading cities and their hinterlands, it was also being disseminated across Europe and its colonies, changing in the process to suit far more alien climates and situations.

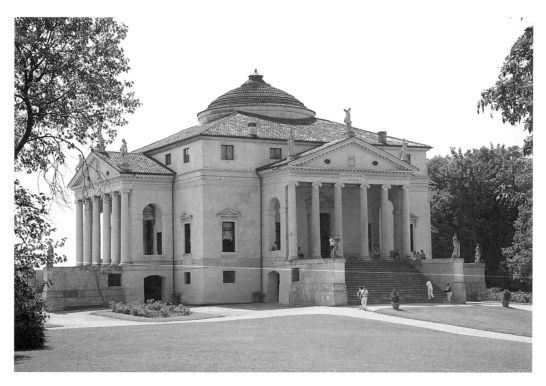

Figure 5.8. Andrea Palladio, Villa Rotonda, Vicenza, Italy, 1566–71.

FOR FURTHER READING

In addition to the literature cited previously, see Wolfgang Lotz, *Architecture in Italy, 1500–1600* (New Haven, Conn.: Yale University Press, 1995), which provides a useful survey of this material. For more on Michelangelo's Roman architecture, see James Ackerman, *The Architecture of Michelangelo* (Chicago: University of Chicago Press, 1986). On gardens and villas, see James Ackerman, *Palladio* (Harmondsworth: Penguin, 1966); David Coffin, *Gardens and Gardening in Papal Rome* (Princeton, N.J.: Princeton University Press, 1991); Denis Cosgrove, *The Palladian Landscape: Geographical Change and Its Cultural Representation in Sixteenth-Century Italy* (University Park: Pennsylvania State University Press, 1993); and Claudia Lazzaro, *The Italian Renaissance Garden: From the Conventions of Planting, Design, and Ornament to the Grand Gardens of Sixteenth-Century Italy* (New Haven, Conn.: Yale University Press, 1990). My understanding of this topic is also informed by two studies that bracket the periods and places under consideration here: Dianne Harris, *The Nature of Authority: Villa Culture, Landscape, and Representation in Eighteenth-Century Lombardy* (University Park: Pennsylvania State University Press, 2003); and Amanda Lillie, *Florentine Villas in the Fifteenth Century: An Architectural and Social History* (Cambridge: Cambridge University Press, 2005).

6 Resisting the Renaissance

By the middle of the sixteenth century, Renaissance churches were being erected in Latin America and in Portuguese outposts in Asia. Colonial architecture continued to be a showcase for advanced European design ideas until well after World War II. North of the Alps, however, the Renaissance met considerable resistance. As late as the end of the seventeenth century, the Grand Place in Brussels, Belgium, was rebuilt complete with towering gables that were unlike anything in Italy, but that had—admittedly with considerable variation—been in fashion there for five hundred years. Similar gables also capped the seventeenth-century houses that lined the canals of Amsterdam, in many ways the most modern environment in the world at the time. Ming China was scarcely the only technologically advanced place where architectural precedent was prized. Why did Gothic verticality linger so long? Were the French and Germans and especially the English, Dutch, and Flemish really so provincial that they were unable to understand, appreciate, and thus accept the new style? If we do not automatically assume that the Renaissance was aesthetically superior or intellectually more advanced than the Gothic, we can recognize why northern Europeans adopted only what they found useful from Italian architectural fashions.

Northern Europeans were conscious of themselves as different from Italians, and they used architecture to express that difference. Many Protestants, for instance, saw little reason to want to imitate what they saw as the architecture of the Catholicism whose doctrines and political control they rejected during the Reformation, launched by Martin Luther in 1517. Luther and his followers condemned the papacy as corrupt, including the way in which it raised money for the construction of Saint Peter's through the sale of indulgences. Protestant worship stressed the relationship of the individual to God, a relationship unmediated by the intervention of the religious hierarchy and its saints. One demonstration of the immediacy of this

connection was the emphasis Luther placed on the local language. His followers said Mass in German rather than in Latin, and Luther personally translated the Bible into German. Another was the refusal of Protestants to recognize the primacy of the pope and his bishops and to pay them taxes.

Wherever the northern European urban middle class successfully resisted the encroachment of absolutist monarchies or papal authority, Gothic forms and types endured. Although northern Europeans often employed Renaissance and baroque details in their dwellings, places of worship, and civic buildings, these seldom masked this latent medievalism. Moreover, rulers, noblemen, and burghers alike located their claims to political power in medieval precedents that were an important component of national and local pride.

Innovation was nonetheless prominent. From Britain to Russia, medieval prototypes were modernized in ways that had little or nothing to do with the Italian influences that were only occasionally reflected on their surfaces. Kings created ever more splendid showcases in which to display royal authority. The increasing power wielded by female monarchs and aristocrats generated changes in the interior plans of stately houses. Where urban economies boomed, plumped up with the profits from increasingly far-flung trading networks, the middle class enjoyed unprecedented comforts.

Francis I, who ruled from 1515 to 1547 and was the most powerful French king of the sixteenth century, greatly admired Italian art. He brought numerous Italian painters to decorate his palaces, including most famously Leonardo da Vinci. Francis was certainly aware of contemporary Italian architecture and in a position to employ its greatest talents, but there is no confusing the principal buildings of his reign with their Italian counterparts.

Take, for instance, the magnificent palace of Chambord, erected between 1519 and 1550 (Figure 6.1). Why does it look so different from the Palazzo Medici? First, it is located in the countryside rather than the city. In sixteenth-century Europe, royal control could be exerted only with difficulty over the urban middle class. The countryside was an entirely different matter. Here lingering feudal hierarchies gave kings and their courtiers far greater opportunities to express their rule because they exercised far greater political control over the land and the peasants who worked it. Chambord was a hunting lodge. Hunting was a prized royal and aristocratic ritual that demonstrated the elite's dominion over the landscape. Peasants were allowed to farm the land, a privilege for which they paid either with a share of the crops they raised or through taxes, but they were not allowed to hunt wild game and were often forbidden access to the forests in which game animals lived. In many parts of Europe, peasants were little more than slaves, as they were also often forbidden to move away from their ancestral lands, although they could not be sold. Not surprisingly, most sixteenth-century monarchs spent relatively little time in their ostensible capitals. The Louvre in Paris was just one of the palaces that Francis and his court could expect to visit over the course of several years as they proceeded

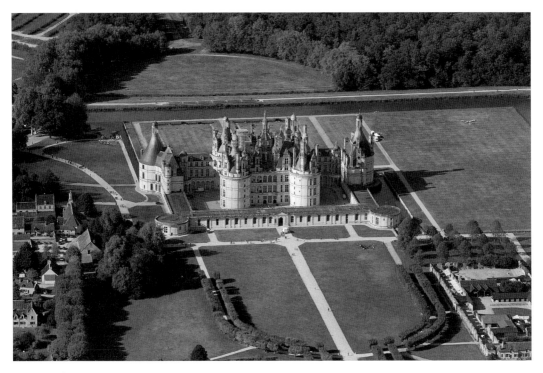

Figure 6.1. Aerial view, château, Chambord, France, 1519–50.

from one country seat to another. This travel cemented a monarch's rule over large areas of territory.

The form of Chambord deliberately suggested the precedents of medieval castles. The central block, which in earlier times would have been the most fortified part of the complex, and the towers suggested earlier models within their stout perimeter walls. A closer look reveals Chambord's many windows, which would have made the building difficult to defend in the event of a siege. The new degree of political stability in France and the country's emergence as a centralized national state allowed for an architecture of display, which no longer privileged military considerations.

Chambord was not an actual medieval castle, but a building that alluded to a precedent central to French royal and aristocratic identity. Spurred by nostalgia rather than by the necessity for powerful fortifications, Francis brought the castle type up to date by re-creating it as a fairy tale. Florentines and other Italians had revived a combination of ancient Roman and more recent Romanesque sources, transforming them in the process into Renaissance architecture. The French, too, were reluctant to part with the precedents provided by their own rich cultural heritage.

The Renaissance is present here, but its impact is limited to the symmetry of the plan of the complex and to some of the decorative details, such as pilasters overlaid on its clearly subdivided facades. Here, for instance, we find inscribed on an open rural site the kind of ideal planning that was still almost impossible to execute

within the walls of an Italian city. The details of the facades and of the lively roof-line reveal the French awareness of contemporary Italian architectural forms as well as the French refusal to integrate that awareness into the basic organization of elevations. Roofs are almost invisible in Renaissance and baroque palaces in Italy. French sixteenth-century architects and builders, on the other hand, exaggerated the steepness of roofs far beyond what their snow-shedding function necessitated. Gabled windows also remained prominent, even as their surrounds, like the buttresses supporting the roof over the stair, were dressed in classical details. These were purposeful choices made by patrons and artisans who were simultaneously proud of local traditions and also of their acquaintance with the latest architecture elsewhere in Europe.

Nor did this approach produce a mere pastiche. The exterior of Chambord has long been one of the most romantic images of France, one that has graced tourist literature for well over a century. Moreover, the grand spiral stair at the core of its interior is one of the great tours de force of sixteenth-century court architecture in Europe (Figure 6.2). The sense of spatial procession that had long informed court pageantry and civic—not to mention religious—rituals was now brought indoors in a secular environment. Medieval stairs had mostly been narrow passageways, in

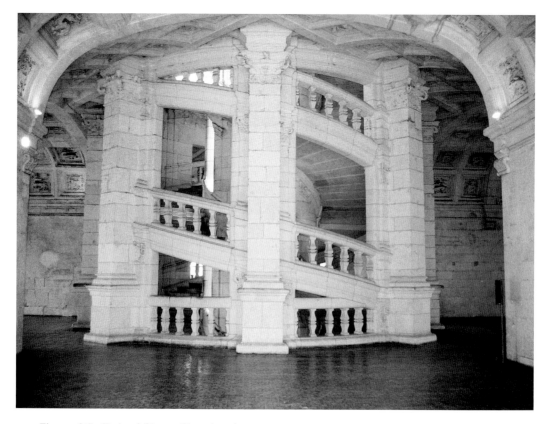

Figure 6.2. Stair, château, Chambord.

part because those were easier and cheaper to build, in part because they were easier to defend. Scholars continue to debate the extent of Italian influence in the design of this intricate structure. In particular, they wonder whether Leonardo contributed to its ingenious design.

Whoever designed it, this was by far the grandest stair yet built in a European palace on either side of the Alps. This is not surprising, given that Francis's was the most splendid court in Europe. Its pageantry could easily fill this imposing space. Here we encounter the first example of the spatial innovation that is the real hallmark of northern European architecture in the sixteenth and seventeenth centuries.

Pride in a local past was not unique to France. The Tudor kings and queens of England, most notably Henry VIII (ruled 1509–47) and his daughter Queen Elizabeth I (ruled 1558–1603), used medieval imagery to cement their rule at a time of tremendous change. Henry broke with the pope in order to divorce the first of his six wives, a move that also allowed him to consolidate his authority by seizing the church's considerable landholdings and redistributing them to loyal members of the middle class, who became country-based aristocrats in the process. He and his children transformed the English economic, political, and social landscape.

The English court, like that of France, moved around the country, which inspired a number of leading courtiers to build vast palaces to house, or potentially house, the monarch and his or her retinue. Henry's children, Edward VI, Mary I, and Elizabeth I, built almost nothing, guarding the national purse at the same time that Elizabeth, in particular, encouraged her courtiers to almost bankrupt themselves through conspicuous display. This was a calculated strategy to keep the nobility, old and new alike, out of political trouble; the English would repeat it in colonial India, where they allowed the local rulers all of the trappings of absolutist rule while stripping them of control over foreign affairs and defense. The English peerage and landed gentry, like their counterparts throughout Europe, divided their time between the court, wherever it might be, and their land, over which they retained considerable authority and which generated enormous wealth until at least the end of the nineteenth century.

The wealthiest female English courtier of the day, Elizabeth or Bess of Hardwick, finally gained considerable say in her own political and economic affairs after the death of her fourth and final husband. She apparently built Hardwick Hall as a badge of her new authority and perhaps also of her hope that her granddaughter Arbella Stuart might become queen of England (Figure 6.3). Like Eleanor of Toledo, the Medici queens of France, and her own sovereign, Elizabeth I, Bess is an example of the increasing importance of women as rulers, regents, and landowners in early modern Europe. Class now trumped gender in noble as well as royal families, at a time when authority was reconfigured around the courtier rather than the warrior.

Hardwick Hall, erected in Derbyshire between 1590 and 1596, was the most extraordinary of all Elizabethan country houses, although, as with Chambord, its modernity was not expressed in terms of Italian architectural style. One reason for

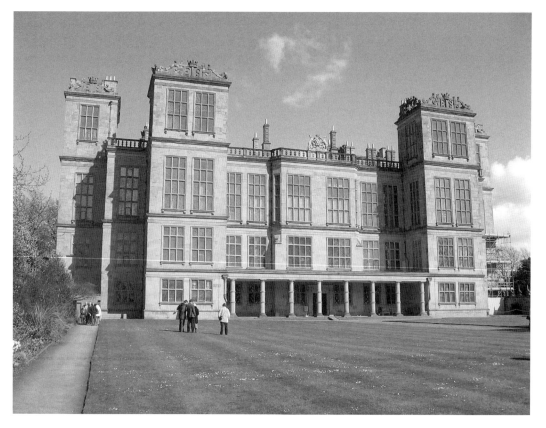

Figure 6.3. Robert Smythson, Hardwick Hall, Derbyshire, England, 1590–96.

its exceptional height and symmetry was Bess's relatively unusual status as a woman in control of her own land. Another was that Bess, unlike most English patrons of the day, employed an architect, Robert Smythson. Originally trained as a stone-mason, he assumed increasing responsibility for the design of the country houses on which he worked.

As in Chambord, an orderly plan did not correlate here, as it typically did in Italy, with the application of the Doric, Ionic, or Corinthian orders. Smythson applied very little ornament, whether classical or medieval, to the facades of Hard-wick Hall. The building thus lies almost completely outside the two conventional poles of contemporary European architectural style, classical and Gothic. There are classical details, as well as the prominent medieval survivals of the towers, crested with Bess's initials, but the most prominent external features of Hardwick Hall are its enormous windows. The extraordinary proportion of glazing to wall surface earned the admiration of twentieth-century observers, who recognized an affinity with the skeletal frames of their own time.

In an era when glass was made entirely by hand and heavily taxed, Hardwick Hall's windows constituted an imposing display of conspicuous consumption, even

more so than the cost of the hand-carved ornament Bess and Smythson eschewed. As at Chambord, these huge windows also advertised the political stability of the period, in which centralized political authority ensured that Bess would not be militarily attacked. Finally, they allowed Bess to survey her estates from the properly (for a woman) private vantage point of domestic interiors. The major public rooms at Hardwick Hall were on the third rather than the second floor as at the Palazzo Medici and most other great houses of the day.

The limited appeal of Italian precedent in England is often associated with distaste for Catholicism, so the question at Hardwick Hall is why we find such a limited medievalism. The most modern aspect of Hardwick Hall was its symmetrical plan. Throughout the medieval period in Britain and into the sixteenth century, the location of the great hall to one side of the entrance had made symmetry impossible in the rural seats of peers and the landed gentry. The great hall was initially the location of the dwelling's single hearth. It was the place where the entire medieval household, mostly male servants and military retainers as well as the lord and his family, gathered for their daily meals as well as the site of banquets welcoming important guests. For centuries, this seat of male political authority had increasingly given way to the more private spaces in which the lord's family lived out of public view, but Bess and Smythson were the first to acknowledge this shift so dramatically. Although they awarded the great hall a central position in the house, it was not the most important space (Figure 6.4). Bess, her ladies-in-waiting, and her guests dined upstairs. Except for servants, the men who would have entered this room would have been limited to a social elite, unlike those who occupied the hall.

Although none of the details of Hardwick Hall are specifically Italian, Bess, more than most occupants of British manor houses, lived like the inhabitants of an Italian palazzo in richly decorated staterooms to which access depended on social status. British interior spaces remained distinctive, however. Hardwick Hall boasted an early example of the long gallery, which ran along one end of its upper floor. In the seventeenth century this space, never found elsewhere in Europe, largely replaced the great hall in aristocratic country houses. This distinguished them from the houses of prosperous farmers, where the great hall survived until around 1800. From the long gallery Bess could look out over her land from a position of authority, which was underlined by the portraits of monarchs and family members that hung on the walls.

Another important reason northern Europeans resisted Renaissance architecture was its association with the assertion of royal and aristocratic rather than bourgeois authority. Cities, especially in the Netherlands, were the locus of many of the early modern changes in social and economic organization that would eventually fuel the Industrial Revolution of the eighteenth century. The descendants of the late medieval urban elite challenged the authority of monarchs and aristocrats in buildings in which Italian influence was mediated by local traditions and concerns.

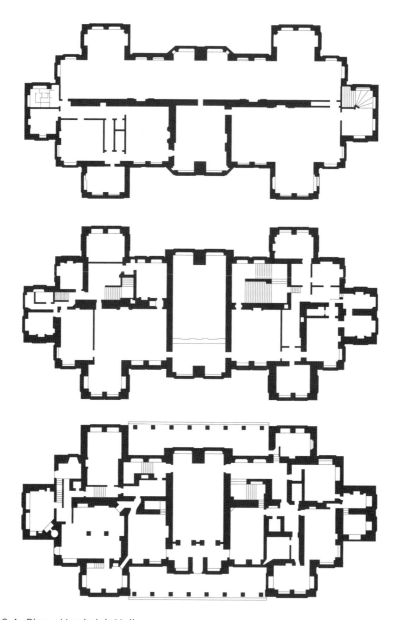

Figure 6.4. Plans, Hardwick Hall.

Although many cities north as well as south of the Alps owed their prosperity in the fifteenth and sixteenth centuries to their independence from feudal authority, the importance of others was growing due to the increasingly permanent presence of local courts. In particular, the market for luxury goods that such courts created could support a thriving middle class of merchants and artisans. The tension between the two groups is clearly visible in the plan of Kraków, at that time the capital of Poland (Figure 6.5). The royal palace lay within the Wawel, the fortified compound located on a hill above the city. The Wawel sits high overlooking a

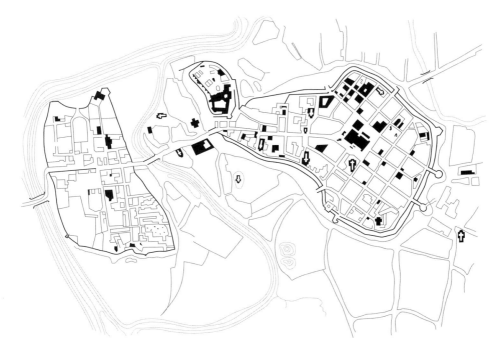

Figure 6.5. Plan, Kraków, Poland, sixteenth century.

bend in the river atop the ideal strategic position that led to the city's founding; from here one can survey the surrounding landscape, to here one can retreat as a final defense in times of war. The medieval cathedral stands beside the royal palace, an arrangement found also in Prague. A short walk from the base of the Wawel is an unusually vast market square, anchored by the imposing parish church of Saint Mary. The city's substantial Jewish population lived separately across the river in territory granted them by the king. Sixteenth-century Polish noblemen sometimes offered settlement to Jews, who helped to promote commerce, but here as elsewhere Jews had to live in specific areas or ghettos (the word comes from the Italian *ghèto*).

In the early sixteenth century, the Kingdom of Poland and Lithuania reached its greatest extent under the leadership of the Jagiellonian dynasty. In 1506, Sigismund, who ruled until 1548, became king. He had been educated by an Italian humanist and married an Italian, Bona Sforza, whose father had been Duke of Milan. During Sigismund's reign Kraków became the center of Renaissance architecture outside Italy. And yet the popularity of the Renaissance, however pure its expression here, remained constrained by the association of the new style with royal aggrandizement at the expense of the burghers.

In 1499, the royal palace burned in a fire. The exteriors of the rebuilt palace followed the topography in ways that prevented the implementation of the kind of ideal plan found at Chambord and Hardwick Hall. Nonetheless, fortification was obviously not important here either, as the generous scale of the windows reveals.

The most impressive feature of the new palace was its U-shaped courtyard (Figure 6.6). The Italians Franciscus Italus and Bartolomeo Berrecci built it between 1507 and 1536. This was the first Renaissance courtyard in Poland, and it established a precedent for sixteenth- and seventeenth-century palace construction throughout central Europe. It was much larger and more open than anything found in contemporary Italian palaces, which all stood on tighter urban sites. Instead, the scale here was adapted from castle precedents. Like the interiors of those castles, this courtyard was the locus for court pageantry.

In Kraków, as elsewhere in northern Europe, there was no reason to build a new cathedral; the existing medieval one remained a cherished part of the city's heritage. Instead, the architects and craftsmen Sigismund brought from Italy built royal tombs, appended to the existing building (Figure 6.7). Since the end of the fifteenth century, Italian architects, engineers, sculptors, and other craftsmen had begun to seek their fortunes north of the Alps. For the most part, the initial role of these craftsmen was limited to importing new construction technology. In Moscow, for instance, in the late fifteenth century they erected churches built within established Byzantine conventions, but using ashlar masonry, a technique unprecedented in the region. There, as elsewhere, their ability to modernize fortifications was especially valued.

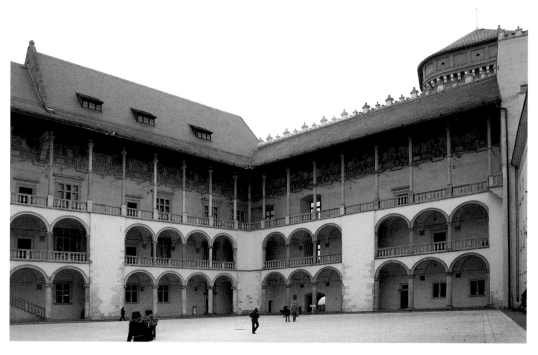

Figure 6.6. Franciscus Italus and Bartolomeo Berrecci, courtyard, Wawel Castle, Kraków, Poland, 1507–36.

Figure 6.7.
Bartolomeo
Berrecci,
Sigismund
Chapel, Kraków,
Poland, 1517–33.

In the Sigismund Chapel in Kraków, however, one finds pure Italian Renaissance forms rarely known anywhere else outside Italy. Why did Sigismund turn to Italy for his burial chapel, created between 1517 and 1533 by the Florentine Berrecci? As with the Medici, who commissioned the New Sacristy of San Lorenzo during the same years, the new style gave expression to political ambitions. In this case complicated iconography, both Christian and antique, celebrated the triumphs of the king, who invoked the authority of geometrical order and modern learning as well as antique precedent. The only local touch was the red Hungarian stone, used for the tombs of many previous Polish monarchs, from which the Sigismund's tomb and other details of the interior were carved.

This strong association of the Italian Renaissance style in Poland with the assertion of royal authority may account for its limited appeal to the burghers living in the lower city. In 1555, the Sukiennice, or Cloth Hall, in the middle of the city's great market square burned. The market square, rimmed by the houses and shops of the city's most prominent merchants and craftsmen, was the center of bourgeois rather than royal government. Here medieval survivals represented cherished rights. The citizenry hired an Italian named Giovanni Maria Padovano to rebuild the city's most prominent commercial building (Figure 6.8), but Padovano's building was apparently only a thin skin applied to the mass of an older structure. The fanciful

Figure 6.8. Giovanni Maria Padovano, Sukiennice (Cloth Hall), Kraków, Poland, after 1555.

roofline, for instance, remains. Renaissance classicism appears only in the gables. Gables like these were called Italian gables, probably because of the way Italian fashions were overlaid on characteristically northern European vernacular forms.

The arcades and meeting rooms of the Cloth Hall served as the locus of the cloth trade in the city. Most shops were located in the ground stories of the houses of merchants and craftsmen. Everyone else—from farmers bringing produce from the surrounding countryside to merchants from foreign lands selling expensive imported cloth—had a chance to set up his or her wares under the protection of this building's arcades. The market hall was a well-established medieval building type with little need for alteration. The new building was probably organized along the lines of its predecessor. Most surviving European market halls date from the fifteenth and sixteenth centuries, because the scope of trade boomed during these years, but the form usually continued to follow late medieval precedent.

Such precedent was cherished as well in the greatest burgher-controlled city of seventeenth-century northern Europe: the busy port of Amsterdam. By the seventeenth century, the largely—but not exclusively—Protestant United Provinces, today's Netherlands, had achieved independence from Spain. The seventeenth century was Amsterdam's golden age. Because the United Provinces was then a republic, the country did not yet have a king to impose new ideas of urban order on the cities. As a consequence, late medieval patterns of urban development remained in place, even as Amsterdam and other Dutch cities grew rapidly. At the same time, Dutch maritime supremacy, Dutch colonization of what is now Indonesia, and the Dutch invention of many of the features of capitalist finance made Amsterdam a uniquely modern city. Almost literally the Venice of the north, the low-lying, waterlogged city depended on trade. As well as being a hub of local manufacturing, it replaced Venice as the leading European distribution point for luxurious goods from Asia that were now transported by sea around the Cape of Good Hope instead of by caravan across central Asia. Although its waterways rivaled streets in importance, the streets were unusually pleasant. "The beauty and cleanliness of the streets are so extraordinary," noted one visitor, "that Persons of all rank do not scruple, but even seem to take pleasure in walking them."

Today the Royal Palace dominates Amsterdam's main square; it was erected, however, in the middle of the seventeenth century as the town hall. This was one of the few buildings in the city that could be termed classical, although there is no specific Renaissance or baroque precedent for it. Far more typical were the town houses that lined the three new canals circling the city's medieval center (Figure 6.9). In Venice the ground stories of the merchant family palaces had served as the seats of individual family-owned businesses; there was no separation between commercial and residential districts. In Amsterdam, however, in an important shift toward the corporate-dominated economy we have today, companies rather than families controlled the economy. Warehouses were mostly located close to the waterfront, away from the new tree-lined residential districts. In these, housefronts

Figure 6.9. Town houses, Leidsegracht, Amsterdam, the Netherlands, seventeenth to eighteenth centuries.

adhered to medieval typology, with classical ornament limited to the decoration of the occasional window surround or door. No one would ever confuse these thin, gable-capped buildings for descendants of the Palazzo Medici.

Inside, however, they were far more comfortable than their late medieval or even sixteenth-century predecessors (Figure 6.10). Amply glazed windows let in plenty of light. Furnishings, although relatively spare by modern standards, included maps of the seas navigated by Dutch sea captains and sailors, carpets imported from western Asia (most of which were placed atop tables rather than on the floor), and woods from the African and Asian tropics. Although these luxuries remained affordable only to a relatively small elite, their numbers nonetheless exceeded anything in European history since at least the fall of the Roman Empire. Contemporaries were impressed. One wrote:

> In pictures and marble the[se houses] are profuse; in their buildings and gardens they are extravagant to folly. In other countries you may meet with stately courts and palaces which nobody can expect in a commonwealth where so much equality is observed as there is in Holland but in all Europe you shall find no private buildings so sumptuously magnificent as a great many of the merchants' and other gentlemen's

Figure 6.10. Emanuel de Witte, *Interior with a Woman Playing a Virginal*, circa 1660.

> houses are in Amsterdam, and in some of the great cities of that small province, and
> in the generality of those that are built there, lay out a greater proportion of their
> estates on the houses they dwell in than any people upon the earth.

Dutch burgher houses, in other words, were resolutely modern, even if neither the
Renaissance nor the later baroque made much impression upon their appearance.
What was new was the new standard of comfort made possible by a newly global-
ized network of trade and supported as well by impressive local artisan production.

That Dutch wealth was held by a relatively broad urban elite composed of sea
captains, merchants, and particularly skilled craftspeople encouraged tolerance. After
the Jews were expelled from Spain and Portugal, some migrated to Amsterdam,
where they, along with their counterparts from eastern Europe, enjoyed greater
freedom of religion than anywhere else in the contemporary Christian (as opposed

to the Islamic) world. The second Esnoga, or Sephardic (Iberian ritual) synagogue, built between 1671 and 1675, was the city's most impressive (Figure 6.11). The architectural models for this included, not surprisingly, Polish synagogues and Dutch Protestant churches. The nine-square plan with distinctive buttresses was inspired as well by the Spanish architect Juan Bautista Villalpando's re-creation of the Temple of Solomon.

The interior was roughly square, more centralized than any contemporary Dutch church. In churches a central nave concluded in an altar, but here the bimah, from which the Torah scrolls were read, was located in the middle of the space. The holiest place in a synagogue is the ark, in which the Torah scrolls are kept. Today the bimah and the ark are often close together, but that was not the case in the seventeenth century. The synagogue's details, such as the shrine housing the ark, are entirely classical, but the building does not resemble its Italian or Latin American counterparts. Classical elements are combined here in new ways that served as the point of departure for eighteenth-century developments throughout the English-speaking world after a British queen, Mary II, shared the throne with her Dutch husband, William of Orange.

Figure 6.11. Interior, Esnoga, or Portuguese synagogue, Amsterdam, the Netherlands, 1671–75.

The slowness of northern Europeans to adopt Renaissance forms should not be credited to ignorance or provincialism. However ideal those forms have seemed to generations of architects and architectural historians, they did not appear that way to everyone north of the Alps. From France to Poland, the mathematical order and classical details of the Italian Renaissance were firmly associated with local royal and foreign papal political ambitions, which it behooved many in the urban elite to resist, just as fifteenth-century Florentines had challenged the Medici. Thus Francis I, Bess of Hardwick, and the burghers of Kraków and Amsterdam continued to value medieval traditions as they worked to created a new architecture that was not necessarily Italian, Catholic, or imperial. If the buildings that resulted do not fit easily into Italian-dominated accounts of architecture in early modern Europe, they nonetheless both reflected and shaped the values of their own distinctive societies in equally innovative ways.

FOR FURTHER READING

This chapter is inspired by Svetlana Alpers, *The Art of Describing: Dutch Art in the Seventeenth Century* (Chicago: University of Chicago Press, 1983). On Chambord, see Anthony Blunt, *Art and Architecture in France: 1500–1700* (New Haven, Conn.: Yale University Press, 1999). On Hardwick Hall and Elizabethan architecture, see Alice Friedman, "Architecture, Authority, and the Female Gaze," *Assemblage* 18 (1992): 41–61; Mark Girouard, *Elizabethan Architecture: Its Rise and Fall, 1540–1640* (New Haven, Conn.: Yale University Press, 2009); and Maurice Howard, *The Building of Elizabethan and Jacobean England* (New Haven, Conn.: Yale University Press, 2007). For discussion of Kraków, see Thomas DaCosta Kaufmann, *Court, Cloister, and City: The Art and Culture of Central Europe, 1450–1800* (Chicago: University of Chicago Press, 1995). On Amsterdam, see Simon Schama, *An Embarrassment of Riches: An Interpretation of Dutch Culture in the Golden Age* (New York: Knopf, 1987); and Jan de Vries, *Industrious Revolution: Consumer Behavior and the Household Economy, 1650 to the Present* (Cambridge: Cambridge University Press, 2008). On the synagogue, see Carol Krinsky, *Synagogues of Europe: Architecture, History, Meaning* (New York: Architectural History Foundation, 1985); and Sergey R. Kravtsov, "Juan Bautista Villalpando and Sacred Architecture in the Seventeenth Century," *Journal of the Society of Architectural Historians* 64, no. 3 (2005): 312–39.

7 The Ottomans and the Safavids

The Netherlands and at times Great Britain aside, across Europe and Asia the fifteenth and especially the sixteenth and seventeenth centuries were marked by increasingly centralized governments ruling from ever more splendid courts. The person of the ruler, buttressed by increasingly professional armies and civil servants, assumed progressively more importance, as absolutism pushed both aristocrats and the urban middle class to the side. The courts surrounding these rulers were not only filled with goods purchased on an increasingly international market but also housed in more regularized environments, which symbolized secular as well as sacred control over space. Classicism offered one, but by no means the only, rational system of organizing space at a time when consolidating control of distant territories assumed ever greater importance. The scope of carefully planned environments expanded to include the integration of green spaces into new urban and suburban environments as well as a developing interest in palace gardens as the stage sets for court spectacles.

Many of these courts were located in or on the edge of Asia. Although Ming China boasted the world's largest palace supported by the most centralized bureaucracy, other dynasties were almost equally renowned. The Ottomans, Safavids, and Mughals, who ruled over North Africa and much of western, central, and southern Asia, constructed dazzling environments of unprecedented splendor. In Istanbul, Isfahan, Agra, Delhi, and Lahore, cities located in what are now Turkey, Iran, India, and Pakistan, palace life featured carefully scripted rituals intended to buttress royal authority. All were inspired in part by the Timurids, as well as inflected by local conditions, especially climate, social norms, and construction technology. Indigenous architectural traditions played an even greater part in the construction of the major mosques that served as badges of state and personal power as well as testimonies of faith and philanthropy.

The Ottomans controlled eastern Europe, the Middle East, and North Africa; the Safavids were based in what is now Iran. The Ottomans and Safavids were rival Muslim dynasties, one Sunni and one Shiite, but they nonetheless had a good deal in common. Both ruled over heterogeneous populations that included substantial Christian and Jewish minorities. Both sponsored extensive urban improvements. The rulers of both dynasties erected monumental mosques that referred respectfully to local architectural traditions at the same time that they inhabited modern palaces consisting in part of pavilions set within courtyards and gardens.

In 1453, the Ottoman sultan Mehmet II captured Constantinople, which he called Istanbul. Founded by Hellenistic Greeks, who named it Byzantium, the city grew under ancient Roman rule. Constantine, the first Roman emperor to legitimate Christianity, relocated the imperial capital here in the fourth century. For more than a thousand years the Byzantine Empire, despite a decline in the amount of territory it controlled, set a standard of imperial magnificence that inspired ambitious rulers in Europe, North Africa, and Asia. Now that empire, the seat of Greek learning and the last territories this far to the south and east to be ruled over by Christians, was to be ruled by the Muslims who had dominated its eastern hinterland since shortly after the time of Muhammad himself. The first task, as in fifteenth-century Rome, was to reestablish a capital whose population, urban amenities, and new monuments rivaled those of earlier occupants of the same spaces.

Under the Ottomans, Istanbul remained one of the world's great cities. Its population of half a million, including Greeks, Armenians, and Jews, made it the largest as well as the most religiously diverse city in Europe in the sixteenth century. It also benefited from a superb site. Poised between Europe and Asia, it controlled the straits that led from the Black Sea, into which the Danube flows east from what is now Germany to the Mediterranean. Indeed, protected by water, the city has been captured only twice. Throughout its long history, it has been a place where ideas and goods from Asia, Europe, and even Africa have been exchanged. The Ottomans, like the Byzantines before them, maintained close contacts with the entire Mediterranean world, much of which they would come to control, and with central Asia.

Two Ottoman complexes in Istanbul, the Topkapı Saray, or imperial palace, and the Süleymaniye imperial mosque complex, illustrate the way in which architecture helped sustain this mighty empire. Both were built on sites whose importance was already long established, the first on top of the city's original acropolis, the second on the site of the Byzantine royal palace. Begun in 1459 by Mehmet II and sporadically rebuilt and expanded over the following four centuries, the Topkapı Saray served as the center of Ottoman government until it was abandoned in 1856 in favor of the new Dolmabahçe Palace (Figure 7.1). The Topkapı Saray was, with the Forbidden City, one of the world's grandest palaces. Moreover, following the construction of the Harem, or women's quarters, at the end of the sixteenth century, it paired relatively public structures from which the empire was officially governed with more private quarters typically supervised by the powerful figure of the ruler's mother.

Figure 7.1. Plan, second, third, and fourth courtyards, Topkapı Saray, Istanbul, Turkey, begun 1459.

In contrast to the Medici and Pitti Palaces, massive blocks embedded in the fabric of their respective cities, the Topkapı Saray had its origins in elevated fortified castles of the Middle Ages, in which a succession of courtyards contained increasingly private and secure spaces from which the ruler could survey the surrounding territory. Inside the palace walls, pavilions were arranged, if not occupied, in a relatively informal manner. Much of daily life took place outdoors. Although parts of the Topkapı Saray were obviously splendid, a number of its individual components differed little from the vernacular architecture of the rest of the city. This was particularly true of the administrative buildings in the first two courtyards, many of which were constructed of wood and have not survived the periodic fires that damaged the complex over the years.

Entrance into the first two courtyards is through massive and well-fortified gates. The Gate of Salutation, with its stout flanking towers, is another of the oldest parts of the entire complex. Beyond it is the second courtyard, where imperial ceremonies were staged in front of courtiers and ambassadors. Here lie the appropriately grand imperial council hall, the locus of the state administration, as well as the more mundane kitchens that supplied food to the imperial family, their bureaucrats, and their servants. Mehmet II erected the original council hall, where the grand vizier met with other ministers and humble male and female suppliants alike; its sixteenth-century successor was repeatedly renovated. Built of stone to diminish the risk of fire, the fifteenth- and sixteenth-century kitchens are among the most imposing surviving utilitarian buildings. Their open verandas and porticos are typical of the

openness of the buildings that surround Ottoman courtyards. Thick curtains could be let down when necessary to keep rain out. Throughout Europe at this time, kitchens were placed as far as possible from the main parts of the palace, to keep the smells of food being cooked at a distance and to reduce the danger of fire consuming the central palace.

The fifteenth-century Gate of Felicity, redecorated in 1774, leads from the second into the third courtyard (Figure 7.2). The emperor held his public audiences in front of this gate. It is a prominent example of an entirely characteristic Ottoman architectural form: a domed pavilion whose columned porch projects far forward at a low angle. It may not seem particularly imposing, but that is because architecture was never the whole story here, as an illustration of Sultan Selim III receiving the court in the late eighteenth century demonstrates. Such Ottoman displays, which were rare in the seventeenth and early eighteenth centuries, were usually staged in the open air. Furthermore, the architectural setting was enhanced here, as in the Safavid and Mughal courts to the east, with lavish textiles, including rich hangings and carpets in addition to the multicolored dress of the participants.

Only at the specific invitation of the sultan were visitors to the Topkapı Saray able to penetrate the Gate of Felicity and be received in the audience chamber. In

Figure 7.2. Sultan Selim receives the court in front of the Gate of Felicity, Topkapı Saray, late eighteenth century.

addition to this space and the imperial storehouses, the third courtyard contained quarters for the *devsirme* (slaves who served in the government and the army) and for the women and children of the court. While early modern European monarchs had to worry about keeping their powerful landholding aristocrats in line, the Ottomans joined the Chinese in pioneering the development of a modern state bureaucracy. Young male and female slaves from Christian families—it was illegal to take fellow Muslims into slavery—were brought to the palace to be educated and trained in gender-appropriate activities. The boys became soldiers and civil servants; the girls, wives of the sultan and his family members or, more often, of other slaves. These converts to Islam constituted a loyal elite; their Muslim children were born free but could not inherit their parents' position, which was instead filled by the next generation of converted slaves. This system solidified the sultan's control of his empire by skimming off the most talented potential opponents, leaving few leaders for potential revolts in the Christian provinces, and isolating the imperial bureaucracy from potential Islamic opposition as well as nepotism.

In the late sixteenth century, breaking with earlier precedent, Sultan Murad III moved his bedchamber into the Harem (Figure 7.3). Isolating the sultan in the third court was intended to enhance his magnificence. In the end, however, he increasingly became its prisoner, as, although some sultans traveled widely, others became detached from life beyond the walls of this palace sanctum. Murad III's bedroom is one of the palace's most lavishly decorated rooms. It dates from 1578–79 and is the work of the architect Sinan. The walls are covered with Iznik tiles. Two of the most important kinds of Islamic architectural decorative motifs are found here: calligraphic inscriptions, largely from the Koran, and stylized patterns, typically derived from botanical sources.

The shift in balance away from public magnificence and toward private splendor occurred in part because the bedrooms in the Topkapı Saray were off-limits to male functionaries and diplomats—in contrast to Europe, where bedrooms were often the most public spaces of any dwellings, including palaces. The sultan's mother, his wives, his small children of both sexes, his unmarried daughters of whatever age, and the court's female slaves all lived in the Harem. Ironically, although the women were kept in strict seclusion from all men other than the sultan and the eunuchs who guarded them, their proximity to the chambers in which the affairs of state were conducted within their hearing eventually gave the sultan's mother in particular, but also his wives and daughters, enormous power. Murad III's mother and widow were two of the first in a chain of powerful queen mothers, many of whom were de facto rulers. Imperial women, who controlled their own property and corresponded with foreign rulers, were also important architectural patrons, often erecting impressive Friday mosques, and in the case of Hadice Turhan Sultan, regent from 1648 to 1656, even fortifications.

Few of the sultan's subjects ever entered the third or fourth private garden court of the palace; all of Istanbul's many citizens had access to the other major locus

Figure 7.3. Sinan, Sultan Murad III's bedroom, Topkapı Saray, 1578–79.

of the regime's architectural expression, the imperial mosques built by successive emperors. This was a new type of mosque architecture, inspired as much by the great sixth-century Byzantine church of Hagia Sophia as by mosques built elsewhere. The Ottomans converted Hagia Sophia into the first of the city's great Friday mosques, mosques whose ability to house large numbers of worshippers makes them roughly equivalent to Christian cathedrals. In the process, the former church gained four minarets, the towers from which the faithful are called five times a day to prayer. Previously one minaret had been sufficient, but under the Ottomans a hierarchy developed, with four being reserved for mosques commissioned by the sultan himself.

Two of Hagia Sophia's new minarets were designed by Mimar Sinan, who was for half a century, beginning in the late 1550s, the Ottoman state architect. In the sixteenth century, Sinan became one of the first men outside Italy to have a career as an architect. He was one of the century's most original members of this still-fledgling profession. His career offers an example of the heights to which former Christian conscripts could rise. In the second half of his extremely long life (he was almost one hundred years old at his death) he controlled the highly centralized bureaucracy that maintained the city of Istanbul and erected public works throughout the empire. Thus, in addition to monumental works of architecture and infrastructure in Istanbul, his office designed buildings in other major cities. Sinan's range of skills, which included those needed to create a new water system for Istanbul, was enormous; the bureaucracy at his command dwarfed anything found elsewhere until the nineteenth century.

One of Sinan's most important works was the imperial mosque complex he built between 1551 and 1558 for the emperor Suleyman on a hill overlooking Istanbul (Figure 7.4). The early Ottoman sultans each built at least one such complex in Istanbul itself, as well as many in other major cities. Their function as emblems of imperial rule was thus in many ways comparable to that of the royal squares erected throughout France in the seventeenth and eighteenth centuries. As an institution these complexes cemented Ottoman control over the city, bringing the imperial presence into individual neighborhoods.

Suleyman, who ruled from 1520 to 1566, was a brilliant administrator and warrior; his conquests stretched from the Balkans to Yemen to Algiers. The Süleymaniye represents the final stage of a century-long dialogue between Ottoman and Italian Renaissance architecture. The original centralized designs of Saint Peter's in Rome were almost certainly influenced by earlier Ottoman imperial mosques, and in the Süleymaniye Sinan crafted his response to the largest church in Christendom. Moreover, the plan of the complex, like that of earlier imperial mosques, was possibly prompted by ideal schemes for Renaissance cities, just as the scale of the Duomo and Saint Peter's were inspired by an awareness of the enormity of Hagia Sophia and possibly the Gur-i-Mir, as well as, in the case of Saint Peter's, the mosques erected by Suleyman's predecessors, Mehmet and Bayazid.

Figure 7.4. Sinan, Süleymaniye, Istanbul, Turkey, 1548–59.

Ottoman imperial mosques included a number of income-producing and chari-
table activities in addition to the mosques themselves. The provision of public
amenities through private endowments was common on the part of pious Muslims.
Rents supported the religious institution as well, and, in many cases, the family that
had donated it. The original Süleymaniye complex, not all of which survives,
included in addition to the mosque itself a hospital, a soup kitchen for students
and the poor (note the pairing of these two groups), coffeehouses, a religious school
for young boys, a college for the advanced study of religious law, a bath complex,
a building regulating the district's water supply, public latrines, and tombs, includ-
ing those of Suleyman, his wife Roxelana, and Sinan. The income from shops
and coffeehouses inserted into the platform upon which many of these were erected
supported many of these charitable activities in perpetuity. There were also five
madrassas, or religious schools. Thus, as an institution, the imperial mosque com-
plex brought the Muslim men of the community together for commerce, conversa-
tion, hygiene, and, above all, religion and education, which could hardly be separated
in a faith that stressed being able to read the holy book. At a time when in Europe
the civic realm was increasingly being detached from the sacred, here they remained
tightly linked.

The centerpiece of this type of complex was, of course, the mosque itself, which
was fronted by a courtyard composed of domed modules. Sinan favored this archi-
tectural system in part because of the way it eased the process of designing build-
ings throughout a far-flung empire. Unable to supervise simultaneous constructions
across its length and breadth personally, he used ground plans to establish a con-
sistent vocabulary of forms. Furthermore, Istanbul's steep topography meant that
few of these complexes had entirely regular plans; reliance on the basic module of
the domed square arranged around open courtyards imparted a high degree of
architectural order.

The design of the Süleymaniye Mosque responded directly to Byzantine tradi-
tions. Its assertion that Muslims could build an equal to Hagia Sophia, one of the
engineering marvels of the world, paralleled Italian Renaissance efforts to match
the achievements of ancient Rome. Sinan buttressed the mosque's central dome, as
his predecessors had at Hagia Sophia, with half domes. That famous dome has col-
lapsed once and been threatened on other occasions by earthquakes, a fate Sinan
was anxious to avoid. He declared to his patron, "My Emperor, I have built you a
mosque that will remain on the face of the earth until the Day of Judgment, and
when Hallaj Mansur [a pious Persian mystic] comes to shake Damavand from its
foundations, he will be able to shatter the mountain but not this dome."

Pendentives, triangular sections of a sphere, support the dome rather than the
squinches characteristic of monumental architecture in many other parts of the
Islamic world. The Süleymaniye's dome was built using modern variations on indige-
nous Byzantine techniques. As at Hagia Sophia, the windows slotted into the dome
and half domes form necklaces of light (Figure 7.5). From a formal and structural

Figure 7.5. Interior, Süleymaniye Mosque.

point of view, much of the drama of this space comes from the relationship among the central dome, the half domes buttressing it, and the smaller domes that descend from them. Beneath them, the spacious interior contains the characteristic features of any mosque. These include the mihrab niche set into the *qibla* wall, oriented toward Mecca, and the *minbar,* a wooden pulpit from which the Friday sermon is preached. Rich carpets cover the floors. Their color and deep pile imbue the space with distinctive warmth.

In the seventeenth century, new rivals emerged to challenge Istanbul's splendor. In addition to Amsterdam and Paris, Delhi and Agra, these included Isfahan. Shah Abbas I, who ruled from 1587 to 1629, moved his capital here in 1598. Isfahan had a distinguished past; its Jami Masjid, or Friday mosque, had long been one of the world's most imposing. No city in the world was more comprehensively modernized at the end of the sixteenth century and the beginning of the seventeenth. Isfahan acquired a garden-oriented extension that contained the largest urban plaza and one of the broadest boulevards to be found anywhere in the world. Studded with new mosques and palaces, it provided the stage set for a far more public court than that of the Ottomans and turned inside out almost every stereotype about the Islamic city as a relatively unplanned sequence of inward-facing buildings. Like the transformation of sixteenth- and seventeenth-century Rome and Paris, which it often appeared to anticipate rather than to follow, the expansion of Isfahan featured the delivery of water; the provision of broad, straight streets; the creation of vast urban plazas; the erection of domed sacred spaces; and finally the construction of splendid palaces set in gardens.

The key to Safavid Isfahan was the control of water and the greening at the city's new suburban edge of the arid local landscape. Shah Abbas I's extension of the city consisted largely of gardens, and the Safavids also built a series of bridges spanning the Zayande River (Figure 7.6). At its outermost edge, the mile-long avenue of the Chahar Bagh runs from the river north to the great public plaza of the Maidan. A canal lined with rows of shade trees, this public promenade doubled as a garden. Off the Chahar Bagh opened private palaces and madrassas with their own gardens. From the Maidan, ringed with identical shops and coffeehouses, one can enter the royal palace and its garden, one of two new mosques, both sporting prominent domes, or the bazaar leading to the old mosque in the medieval core of the city. Isfahan's gardens were public amenities that doubled as displays of imperial ability to control what was, given the climate, the state's most precious resource. They possibly also served as a pious act in that they may have been understood as re-creating paradise.

The Safavids delighted in public rituals and festivities. The Maidan-i-Shah, created by Shah Abbas I, was exceeded in scale only in the 1950s when Tiananmen Square was cleared in Beijing. Laid out around 1600, the Maidan's twenty acres dwarfed the great market squares of Venice and Kraków. It made a dramatic break as well with the quasi-private lanes that led to most Isfahani houses. Polo matches

Figure 7.6. Plan, Shah Abbas's additions to Isfahan and the street to the Friday mosque, Iran, 1588–1629.

and other forms of public entertainment and court ceremonies were staged in the Maidan in full view of the city's population as well as visiting foreign dignitaries (Figure 7.7). As with the other new features of the city, Abbas I created the Maidan by building a new suburban district, rather than by demolishing existing structures. Nothing marked the shah's magnificence more than his ability to create an urban space of this scale and uniformity and to control what happened in it.

Opening off the Maidan was a new bazaar, or covered marketplace. Isfahan, like many other Asian and North African cities, already featured a higher degree of functional separation than would be common in Europe until the nineteenth century. In part in order to ensure domestic privacy and in part to accommodate their scale, major, as opposed to neighborhood, marketplaces were placed at a distance from individual homes. Trade was key to Isfahan's prosperity. This was one of the world's richest markets, full of goods from Europe and China as well as the carpets and silks that were the city's chief exports. Overland trading routes still crossed the city, even as ships sailing around the Cape of Good Hope challenged the supremacy of caravans and cut Safavid and other western and central Asian middlemen out of a share of the profits.

The inhabitants of Safavid Isfahan included a few Zoroastrians and Jewish and Christian communities as well as Muslims. Each group had its own sacred buildings,

Figure 7.7. Maidan, Isfahan, Iran, 1590–95, with Ali Qapu, circa 1597–1660, on far right and Masjid-i-Shah (shah's mosque), 1611–38, on right.

but the most impressive new religious structures were a pair of domed mosques built by Shah Abbas. Both are entered from the Maidan. The larger and more public of the two, the Masjid-i-Shah, or shah's mosque, was erected between 1611 and 1638 (Figure 7.8). Sacred architecture in Isfahan was clearly distinct from its secular counterpart. Oriented like all mosques toward Mecca, the interior courtyard of the Masjid-i-Shah is slightly off axis from the Maidan itself. Although a pair of madrassas flank it, fewer functions were attached to this mosque than one finds in Ottoman imperial complexes. All of these institutions existed in Isfahan, but not grouped together.

If the signature form of Ottoman architecture was the domed square, in Safavid Iran it was the *iwan*. Large central Asian and Iranian mosques, including since the early twelfth century Isfahan's own Jami Masjid, were often already organized around courtyards with an *iwan* at the center of each facade. At the Masjid-i-Shah, the *iwans* span the full height of the building (Figure 7.8). They provide a useful transition from the center of the court, which is often too hot to be occupied, and the dark, cool rooms of the building's interior. In other contexts, *iwans* create an interstitial space between entirely public and entirely private areas; in madrassas it was there that students gathered to attend lectures and chat with friends. Long reflecting pools within the courtyards help lower the ambient temperature, and rich tile decoration covers every surface of the courtyard.

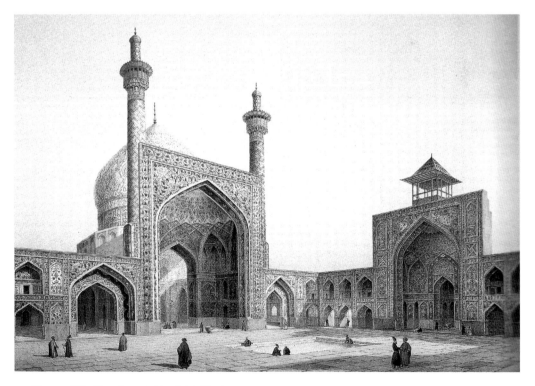

Figure 7.8. Courtyard, Masjid-i-Shah.

There was little local stone in Isfahan, so the city was built largely of baked brick. The tiles decorating the courtyard of the Masjid-i-Shah and the dome rising over the prayer hall are some of the richest in the entire city. The Isfahanis imported both the dome form and the tile work that encrusted it from the Timurids. Note the characteristically Islamic emphasis on calligraphic and floral motifs; the Safavid court employed the rich Iranian tradition of representational art only in secular settings.

The Safavids neatly reversed the preferences of their Ottoman rivals for centralized mosques, instead favoring courtyard-focused mosques. Large areas of their palaces were also composed of courtyards and gardens. Constructed and steadily expanded across the first third of the seventeenth century, the Ali Qapu offered a gateway to the pavilion-studded garden running between the Maidan and the Chahar Bagh. It also served as an audience hall and provided a platform from which the shah could review events staged in the Maidan from an appropriately elevated position. Although access to the palace itself was limited to nobles, royal guests, servants, and guards, this was a larger group than penetrated the third and fourth courtyards of the Topkapı Saray. The Safavid court was far more oriented toward the public. Its palaces were less defensible, but this was not because there was no political unrest; Shah Abbas executed two of his sons, leaving the throne to his grandson. Only in the second half of the seventeenth century would the Safavid rulers retreat deep into the garden. As in Istanbul, this shift was marked by a substantial increase in the authority of the rulers' wives and mothers; between 1642 and about 1647, Shah Abbas II's mother ruled as regent until he reached his majority. While this could be taken to be evidence of greater privacy, in fact the opposite seems to have been the case, as more and more people were now allowed entrance into what had been a sanctum.

The largest and most famous Safavid palace pavilion sits in the garden behind the Ali Qapu. Shah Abbas II inaugurated construction of the Chihil Sutun, or the pavilion of many columns, in 1647; it was rebuilt in 1706 after a fire (Figure 7.9). In front of it sits a large reflective pool featuring jets of water. The relatively insignificant scale of the building in relation to its setting helped create a comfortable microclimate in this hot, dry city. So did the deep pillared porch, a larger version of the elevated one at the Ali Qapu. In a nod to local architectural traditions, both this architectural form and the carvings upon which the wooden columns are set were inspired by the oldest palace in the region, Persepolis, already two thousand years old when Shah Abbas settled in Isfahan. Opening onto the center of the porch is a throne room. From his elevated perch at the rear of this space the shah had a privileged view out over the festivities being staged in front of him. Pieces of glass, some of them mirrors, are set into the *iwan* behind where he sat and shimmer in the light.

Running across the rear of the structure is an enormous banqueting hall decorated with large mural paintings depicting the highlights of Safavid history. This was the site of the feasts that were by this time the main state rituals. Proximity to

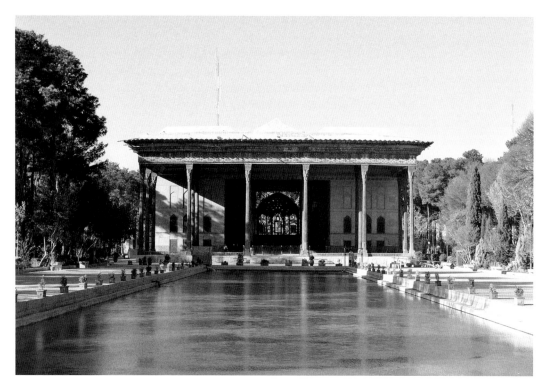

Figure 7.9. Chihil Sutun, Isfahan, Iran, begun 1647.

the jewel-draped ruler was a badge of social standing within the court, whose major figures included ambassadors from European as well as from the Ottoman and Mughal courts. It was also possible for the court women to watch from a secluded position.

The magnificence of the architecture of the Ottomans and Safavids did more than display the wealth and power of these great empires. The Ottomans and the Safavids ruled over ethnically diverse empires, with large religious minorities. Here the sense of internal logic and mathematical order favored as well by Renaissance architects did more than reinforce royal rule. The highly structured articulation of architectural and at times urban space encouraged an image of unity within this considerable social variety, one, however, that was flexible enough to draw strength from the varied indigenous traditions it assimilated. The results included cities as splendid and filled with public amenities as any in the world at the time.

FOR FURTHER READING

The standard sources on the Ottoman monuments discussed here are both by Gülru Necipoğlu: *Architecture, Ceremonial, and Power: The Topkapı Palace in the Fifteenth and Sixteenth Centuries* (New York: Architectural History Foundation, 1991) and *The Age of Sinan: Architectural Culture in the Ottoman Empire, 1539–1588* (London: Reaktion, 2005). See also Çiğdem Kafescioğlu, *Constantinopolis/Istanbul: Cultural Encounter, Imperial Vision, and the*

Construction of the Ottoman Capital (University Park: Pennsylvania State University Press, 2009). On the building activities of the Ottoman court women, see Lucienne Thys-Şenocak, *Ottoman Women Builders: The Architectural Patronage of Hadice Turhan Sultan* (Burlington, Vt.: Ashgate, 2006). For discussion of Isfahan, see Jonathan Bloom and Sheila Blair, *The Art and Architecture of Islam, 1250–1800* (New Haven, Conn.: Yale University Press, 1994); Henri Stierlin, *Islamic Art and Architecture: From Isfahan to the Taj Mahal* (London: Thames & Hudson, 2002); and especially Sussan Babaie, *Isfahan and Its Palaces: Statecraft, Shi'ism and the Architecture of Conviviality in Early Modern Iran* (Edinburgh: Edinburgh University Press, 2008). On the gardens discussed in this and the following chapter, see D. Fairchild Ruggles, *Islamic Gardens and Landscapes* (Philadelphia: University of Pennsylvania Press, 2007).

8 Early Modern South Asia

New dynasties also transformed the cities of early modern South Asia, whose imperial courts from the middle of the sixteenth to the end of the seventeenth century numbered among the world's most impressive. Medieval ideas of spatial order grounded in Hindu religious beliefs were, like other indigenous architectural practices, at times supplanted by ideas imported from central and western Asia. The leaders in these developments were two Muslim emperors, Akbar and his grandson Shah Jahan, but a number of Hindu rulers also played an important part in the process.

Akbar and Shah Jahan were Mughals, members of the third great Islamic dynasty of their day. They ruled over the lands that today make up Afghanistan, Pakistan, northern India, and Bangladesh. The empire was established when Babur, a descendant of both Genghis Khan and Timur, entered Delhi from Kabul in 1526, seizing control of the region from the Delhi Sultanate, whose Muslim rulers had controlled it since the late twelfth century. The Mughal Empire reached its architectural apogee under Babur's grandson Akbar (ruled 1556–1605) and Shah Jahan (ruled 1628–58). Akbar was a particularly remarkable ruler, while Shah Jahan was an extraordinary patron of architecture.

Two stories intersect on the subcontinent. The first tells how an initially foreign dynasty loyal to what remained a minority religion assimilated architecturally to its new homeland. Drawing with great aesthetic sophistication upon disparate architectural traditions, it created what remain some of the world's most admired buildings. The second recounts how Hindu kings, ruling over smaller, localized states, harnessed planning ideals rooted in Hindu scripture to new architectural forms, many but not all of which display the influence of the Mughal court.

Outside South Asia, Islamic conquest had typically been accompanied by forced conversion, with only some Christian and Jews and almost no one else allowed to

practice other religions. From the beginning, India was different. Here Muslim rulers always had to choose between cementing political and military control and converting the largely Hindu populace. Dynasty after dynasty chose the former course, although some rulers imposed extra taxes on the vast majority of their subjects who refused to convert to Islam.

During the second half of the sixteenth century and throughout the seventeenth, only the Chinese emperor ruled over more Asians than his Mughal counterpart, and only he governed more contiguous territory. The Mughal government was financed with taxes imposed on agricultural production, which boomed throughout much of the empire during this period as cultivation was systematically expanded into the hinterlands. In particular, cash crops and the products made from them were sold at increasing distances from where they were grown. This was the case, for instance, in eastern Bengal, where rice and cotton fields replaced forests and wetlands. Locally woven gauzes and other cotton fabrics enjoyed an international market.

Control of the entire subcontinent eluded the Mughals, however. In the south, independent kingdoms survived throughout the seventeenth century; to the north, the Rajputs gained increasing autonomy in the eighteenth century from the empire that many of their ancestors had once loyally served. Hindu religious architecture reached nearly unprecedented heights during these years in South India under the patronage of the Nayaka dynasty, which ruled from 1559 to 1736. Although a temple had existed in the center of the Nayaka capital of Madurai already for centuries, the present Minakshi Sundareshvara Temple dates largely to the seventeenth century (Figure 8.1). Minakshi is a goddess with the eyes of a carp. She is a symbol of fertility, maternal nurturing, and fighting. The temple sits atop the site where the goddess married the god Shiva. This story represents the incorporation of local deities such as Minakshi into the orthodox Hindu pantheon embodied by Shiva. The heart of the temple complex consists of temples devoted to each of these two deities. In the seventeenth century a succession of Nayaka rulers refurbished these sanctuaries and expanded the ritual spaces ringing them, which now include a tank for ritual ablutions and *mandapas,* or covered prayer halls. The rulers intended these renovations to support their claims to semidivine status.

The temple's boundary walls rigidly define the sanctified space, although the sacred geometry extends as well into the surrounding city. Square "rings" of streets were named after the months of the major festivals in which the images of the deities are taken out of their shrines within the temple and paraded through the city. The temple itself functioned as an *axis mundi,* understood to be the center of the city as well as of the universe, and as a storehouse for grain, which promoted local economic and political stability by guarding against famine.

Clearly visible along the straight streets leading to it, *gopurams,* or monumental gateways, demarcate the entrances to the temple. In medieval northern Indian temples, *shikhara* towers rose over the sacred spaces in which the images of the deities were stored. By this time, however, southerners instead emphasized the entrance

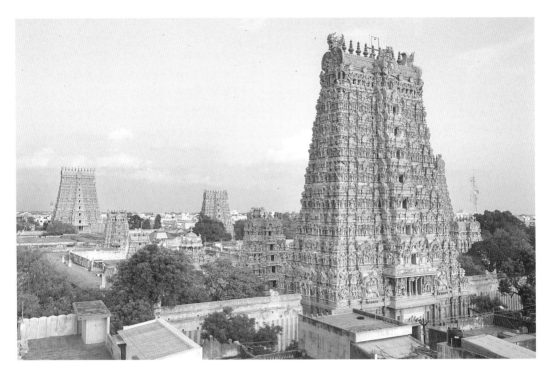

Figure 8.1. Minakshi Temple, Madurai, India, mostly seventeenth century.

towers. At Madurai, the largest of these, begun by Raja Tirumalia Nayak, who was responsible for a great deal of the seventeenth-century embellishment of the temple, was never finished. The *gopurams* rise high over the roofline and courtyards of the rest of the complex. They are covered with rich figural decoration, some of which is sculpted in stucco rather than stone, and all of which was originally brightly painted. Figural sculpture is very important to Hindus, who believe the divine can dwell in natural forms, such as trees and rocks, or, through certain rituals, come to reside within sculptures that depict particular divinities.

The most prominent open space within the temple walls is the great tank, a place for ritual bathing. The tank is rimmed by steps leading down to the water. This is a particularly flexible architectural form that takes into consideration the rise and fall in water level across the course of the year, as the edge is graded.

The holiest spaces within the complex are far less monumental but no less important. Although in Madurai the temple has been open to Dalits (members of the so-called untouchable caste) since the time of Mahatma Gandhi, the place where the image is kept is so sacred that in some temples those who are not members of the priestly caste, whether or not they are Hindus, have very little access to it, with the result that these parts of the temple are very seldom photographed. The more public pillared *mandapas* are the destination of most pilgrims. Several of these were donated by Nayaka queens, one of whom, Rani Mangammal, ruled Madurai

in her own right for fifteen years at the end of the seventeenth and the beginning of the eighteenth century, during which she was responsible for an impressive number of public works.

Even as the Minakshi Temple was achieving its present form, a very different kind of architecture was being perfected to the north. Two Mughal building types are particular distinctive: the fortified royal palace and the tomb. A pair of each is illustrative. Between 1571 and 1585 Akbar lived in a new palace at Fatehpur Sikri, near Agra. Akbar built Fatehpur Sikri to honor the presence there of Salim Chishti, the Sufi holy man who had predicted the long-awaited birth of the emperor's first son. Chishti's tomb is located within the courtyard of its Jami Masjid, or Friday mosque, also built by Akbar (Figure 8.2). Although we know the names of some of the men who designed and built major Mughal buildings, none of them played as central a role in setting the artistic tone as Michelangelo and Sinan had. Women and men, Hindus and Muslims, worked together on Mughal building sites.

Sufi holy men were revered during their lives and worshipped as saints after death, which accounts for the construction of this elaborate tomb. The Sufis led the way in integrating Islam into the Indian context and were responsible for most Indian conversions to the imported faith. Their architecture, too, drew upon both indigenous and imported precedents. The basic form of this building is quite similar to the Ottoman Gate of Felicity, for instance, since the two had central Asian sources in common. And yet there are significant differences. These include

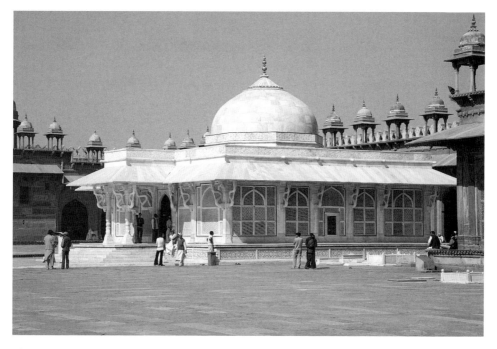

Figure 8.2. Tomb of Salim Chisti, Jami Masjid (Friday mosque), Fatehpur Sikri, India, after 1572.

the white marble of which the unusually lavish, if not particularly large, building was constructed. Until the reign of Shah Jahan, it was used only for tombs. Mughal builders otherwise used the local red sandstone for royal commissions. The quality of the stonework on buildings sponsored by the Mughal rulers was always superb. Unlike central Asia and Iran, the Indian subcontinent had a long and splendid tradition of craftsmanship in stone. Local workers did not hesitate to introduce indigenous motifs into their new buildings. The attenuated brackets that support the projecting roof represent the translation into stone of motifs that originated in carved wood. These were introduced into Islamic architecture in what is now the western Indian state of Gujarat, which Akbar added to the Mughal Empire. In the wake of that conquest, he brought a number of Gujarati stone carvers to Fatehpur Sikri. Finally, the particularly hot climate at Fatehpur Sikri encouraged the builders to follow the example of Hindu and Muslim alike and add pierced screens or *jalis* to filter the light. The increasingly complex patterns into which these screens were carved and the intricate shadows they created on the marble surfaces of the interior represent one of the aesthetic triumphs of Mughal architecture.

The Jami Masjid and Akbar's palace, just to the northeast, were set at the city's highest points. The palace consisted of a series of courtyards; the most important contained the major audience halls (Figure 8.3) and the women's quarters. The climate, local building materials, and pre-Mughal local precedents all ensured that the palace bore only a slight family resemblance to its counterparts in Istanbul and Isfahan. In Fatehpur Sikri, where temperatures never fall below freezing, the rainy

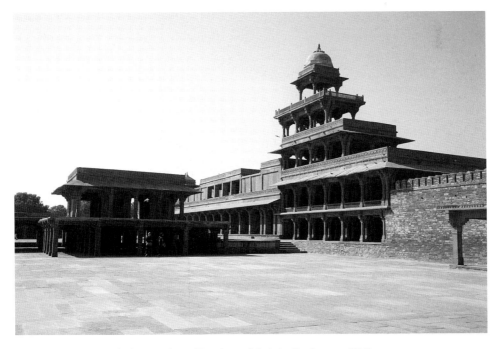

Figure 8.3. General view, palace, Fatehpur Sikri, India, begun 1571.

season is during the summer; in Isfahan it is during the relatively cold winter. Istanbul is even colder and wetter. The greater openness of many of the structures at Fatehpur Sikir suited a nomadic military elite comfortable in tents and a climate in which complete enclosure is seldom necessary. The Panch Mahal (five pavilions) stretches even taller than the entrance pavilion to the Ali Qapu palace, for instance, in order to catch cool evening breezes. The finest details on the Ottoman and Safavid palaces were typically either carved of wood or painted on plaster or tile. In Fatehpur Sikri, where they were carved out of malleable sandstone, only a handful of interiors remain (at least in the complete absence of the original furnishings) as memorable as the exteriors. There is also more paving and less planting in Fatehpur Sikri. Distinctively Indian as well are the *chhatris,* umbrella-like towers, that crown many buildings throughout the palace and have roots in Buddhist architecture. Finally, although its location was far from a metropolitan center, this was a far more public court than at least its Ottoman counterpart.

Splendid displays, whether of wildlife, jewels, or textiles, were a staple of Mughal court ritual. Ceremonies cemented Akbar's alliances within and beyond his empire; the state bureaucracy, composed of appointed nobles who supplied set numbers of soldiers in return for the tax revenue from specified places, was a less important factor here than in Istanbul. We know a great deal about the Mughal Empire from written and illustrated records, but the purpose of some of the buildings at Fatehpur Sikri remains unclear.

The Diwan-i-Khas, or private audience hall, in particular is quite unusual. Here we find four corner *chhatris* in place of a central dome and a less obvious distinction between the front and other sides of the building. The specific reason for this centralized building is unknown. Inside, four bridges led from the corners of the second level to a central circle, supported on a single massive column (Figure 8.4). The antecedents for its impressive brackets were once again Gujarati. Stone versions can be found in Hindu temples built before the introduction of Islam into the region; wooden ones still support the richly carved balconies and windows of many old houses in Ahmedabad.

More private areas such as Jodha Bai's Palace have similar details. This was part of the *zenana,* or women's quarters, which was occupied by the emperor's wives, both Hindu and Muslim, as well as other female family members and their maidservants. As in Istanbul, court women lived in relative seclusion, although here they were able to look out on the public activities of the court from screened balconies. Active as architectural patrons, many Mughal women, especially Nur Jahan, Akbar's daughter-in-law and Shah Jahan's stepmother, were at least as influential politically as their Ottoman counterparts.

The palace at Fatehpur Sikri was abandoned in 1584 in the middle of Akbar's reign. The emperor moved the capital to Lahore in order to deal more effectively with political unrest in the northwest. Chishti's tomb, however, continued to be a major pilgrimage site, not only for Muslims but also for people of other faiths.

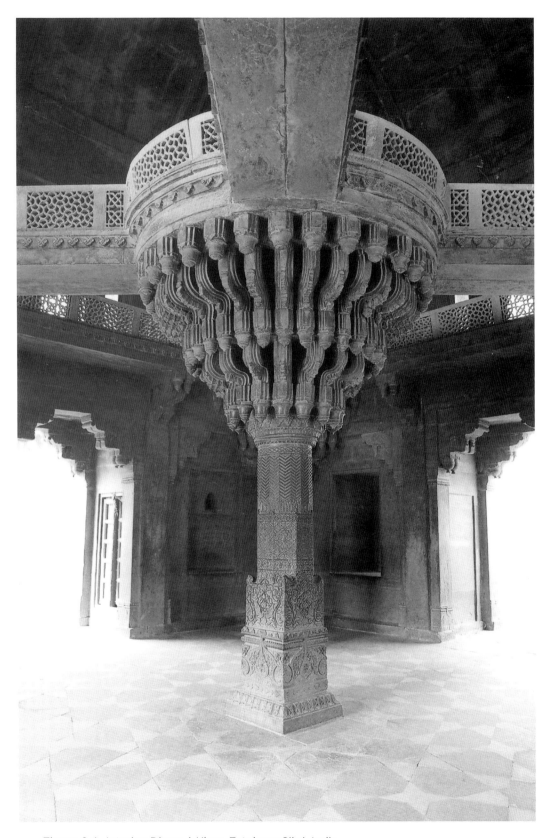

Figure 8.4. Interior, Diwan-i-Khas, Fatehpur Sikri, India.

Akbar was the most enlightened intellectual and effective ruler of all the Mughals. His grandson Shah Jahan was the dynasty's greatest patron of the arts. Shah Jahan built palaces, called Red Forts, in Lahore, Agra, and Delhi. Delhi's was particularly important. Although the Mughals traveled from place to place, and other cities often had more inhabitants, it was in Delhi that the first mosque in northern India had been built, and successive Islamic dynasties left their mark there. Shahjahanabad, the city Shah Jahan founded there and named for himself, remains the core of the present old city of Delhi. Although now a bustling and crowded commercial artery, its central avenue, Chandni Chauk, was once a broad boulevard lined with spacious courtyard-oriented town houses called *havelis*.

Built between 1639 and 1648, the Red Fort in Delhi overlooks the banks of the Yamuna River. Shah Jahan's son Aurangzeb added the fortifications that now surround it. Fortifications remained important components of Mughal palace architecture. Always a religious minority and vulnerable to potential attack by ambitious Muslims from the northwest, the Mughals liked to surround their palaces with stout walls and defensible gates. Narrow passageways through the Lahore Gate, entered off axis, now provide the main entrance into the Red Fort.

On this flatter site, Shah Jahan laid out the pavilions of the palace along far more regular lines than his grandfather had been able to have at Fatehpur Sikri. The most important pavilion, the Diwan-i 'Amm, or public audience hall, is on axis with the Lahore Gate (Figure 8.5). This new form of pavilion, rectangular in plan

Figure 8.5. Diwan-i 'Amm, Red Fort, Delhi, India, 1639–48.

and open on three sides, its roof slabs supported by rows of columns, can be found in all three Red Forts. Here the arches are cusped.

Along the closed back wall stood the royal throne on which Shah Jahan sat to receive his nobles (Figure 8.6). Formally displaying themselves to their subjects, following the Hindu concept of *darshan,* was more important to the Mughals than to most early modern rulers. The canopy of Shah Jahan's throne was far more conventional than his grandfather's more private reception hall. The bench in front was for his vizier, or chief minister. The throne's high curved roof was borrowed from the vernacular architecture of yet another region of the subcontinent, this time Bengal. Shah Jahan's integration of motifs from throughout his far-flung empire was balanced by the importation of art and artistic techniques from as far away as Europe. Most notable among these was the *pietre dure* technique, an Italian type of inlay work featuring semiprecious stones. A *pietre dure* panel from Italy is set into the throne. The even more splendid legendary gem-encrusted Peacock Throne

Figure 8.6. Throne, Diwan-i 'Amm.

was originally installed nearby in Shah Jahan's private audience hall. A century later Iranian invaders seized it. From both pavilions, the emperor could look out upon splendid gardens.

The most memorable of all Shah Jahan's buildings is not one in which he lived in splendor but the one in which he is buried. He built the *Taj Mahal* in Agra between 1632 and 1643 in memory of his wife Mumtaz Mahal (Figure 8.7). For a thousand years, Asian Muslims had built imposing domed tombs. Even before the Mughals arrived in South Asia, Islamic tombs there had reached monumental proportions, matched elsewhere only rarely. The Gur-i-Mir is an important exception that helped encourage Mughal splendor. The Taj is the celebrated culmination of this tradition.

Today the Taj is India's most famous building. Indians and foreigners alike often view it as intrinsically Indian. It is better understood as one of the richest architectural examples of cultural synthesis, a single structure in which Iranian, central Asian, and local architectural techniques and materials are so closely intertwined as to be inseparable. This is a building that could have been designed and constructed only in the Mughal Empire, but it also offers sophisticated evidence of the international awareness and ambition of that court.

The Taj embodies the diversity of peoples, religions, artistic ideas, and raw materials from within and beyond the empire's political borders that shaped life at the Mughal court. Many of the emperors took Hindu wives. This meant that eventually all members of the imperial family, including Shah Jahan himself, whose mother and paternal grandmother were both Rajput princesses, were of mixed ethnic and religious heritage. The empire's enormous wealth and relatively centralized political structure created at court an international community of enormous talent. Poets, painters, musicians, soldiers, and administrators, not to mention builders, with Turks and Persians, as well as South Asians of all religions, made prominent contributions. In return the empire's chief exports—spices, paper, cotton, and silk— were sold around the world. During the seventeenth century, for instance, Mughal carpets were cherished from England to Japan.

The tomb stands embedded in a meticulously organized suburban complex along the banks of the Yamuna. Flanked by four minarets and two outbuildings, one of which is a mosque, it terminates a walled quadripartite garden called a *char-bagh*, which was here entered through an imposing gateway. Originally a second garden lay across the river. By the seventeenth century the *char-bagh* garden was common throughout Iran and India. The basic form of the garden remains intact here, with water channels dividing it into quarters. Originally, however, the plantings were different. The yield from an orchard full of exotic fruit trees provided the funds with which the building was maintained. Garden imagery incorporated into the decoration of the building enhanced its paradisiacal character.

The Taj Mahal is much larger than it appears in most photographs, in which the platform that marks the garden's midpoint seems to be located directly in front of

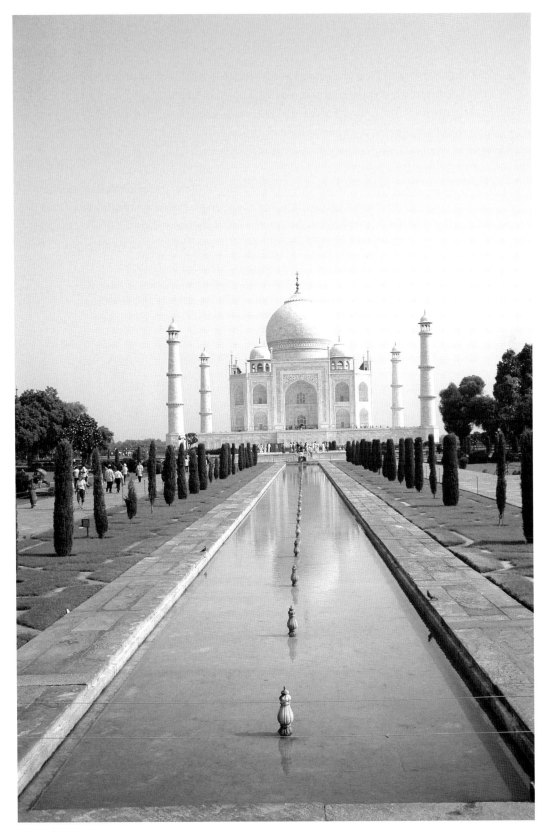

Figure 8.7. Taj Mahal, Agra, India, 1631–47.

it. It is thus far more imposing than most visitors expect. Another reason for the building's renown is the quality of the marble, which is opaque or nearly translucent depending on the light and the weather. The exquisiteness with which it is carved is also remarkable. Calligraphic inscriptions from the Koran in jasper, multicolored flowers in lapis lazuli and other semiprecious stones, and bas-relief carving of tulips and other flowers ornament its surfaces inside and out.

The rigorous plan, complemented by a hierarchy of similar elements repeated at different scales, provides a disciplined frame for the rich ornament (Figure 8.8). Far more complex spatially, the plan of the Taj is as lucidly rational as that of another ideal suburban building, the Villa Rotonda. While both can be entered from the center of each facade, the Taj can also be accessed from three openings in each corner. Both buildings feature four symmetrical quarters, but the number and variety of these spaces are fewer at the Villa Rotonda. Palladio set a circle within a square divided into eight chambers of two different sizes; four smaller curved spaces square

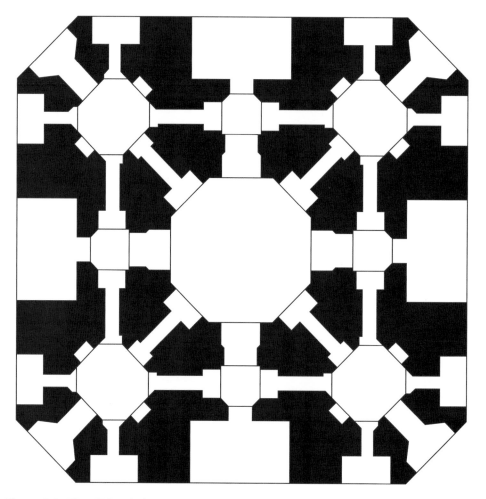

Figure 8.8. Plan, Taj Mahal.

the circle. The Taj features a larger number of spaces of more varied shapes. Even as the Ottomans, Safavids, and Mughals experimented with representation, especially of flowers, they continued to elaborate upon the geometrical patterns from which much medieval Islamic ornament had been derived. Four deep *iwans,* or *pishtaqs,* as they are more often called in India, lead to a ring of intermediary spaces from which one can return to the chamfered corners or enter the central space, where a marble screen allows one to glimpse the cenotaphs through lacework inset with malachite, jasper, and lapis. A contemporary poet wrote of this vision of heaven on earth, "They have inlaid stone flowers in marble which surpass reality in color if not in fragrance."

Certainly a romantic emblem of one man's love for his wife, the Taj is also a catalog of the political and creative power of the empire over which that man ruled. The thousands of highly skilled craftspeople whose labor it could afford to buy, the materials and techniques it could import from throughout the known world, the subtlety of its geometry—all were crucial here. Ultimately Shah Jahan was able, in architectural terms, to achieve his most literal purpose, the re-creation of paradise on earth, even though he could not prevent his son from overthrowing him and confining him, in his final years, to a prison cell just across the river.

Following the death of Aurangzeb in 1707, the Mughal Empire all but collapsed. Local princes, some of whom had ruled over their territory since before the Mughals entered India, regained their autonomy. The example of the Mughal courts inspired all of them, including the Hindu princes of western India, the Rajputs, as they founded their own successors to those courts.

In 1727 one of these maharajas, a king named Jai Singh, felt safe enough to shift his court down from the citadel of Amber to the plain below, where he founded the new multiethnic city of Jaipur. A Hindu, many of whose subjects were Muslims and Jains, Jai Singh turned to ancient sacred texts called the *shastras* for inspiration. These texts called for a city of nine squares, a dictate he modified slightly to accommodate the local topography (Figure 8.9). The result was an unusually orderly city. Jaipur's broad, straight streets, lined in the principal cases with almost identical shops, continue to impress visitors. Uniformity was also achieved through the application of a pink wash to all of the city's stuccoed facades. This originally imitated the color of the local sandstone, the favorite of all Mughal building materials, for which the Red Forts were named. In addition to the palace and its gardens, the city boasted many fine *havelis.*

The city's most famous palace is the Hawa Mahal, added in 1799 by Maharaja Sawai Pratap Singh (Figure 8.10). From behind its screen wall, women of the court could view activities and pageantry taking place in the city beyond without compromising their privacy. Like the seven-story Chandra Mahal, the main block of the palace, it also caught cooling breezes, making it one of the city's most pleasant destinations on hot summer days. It was dedicated to the Hindu deity Krishna and his wife Radha. Its main architectural motifs are miniaturizations of the same Bengali

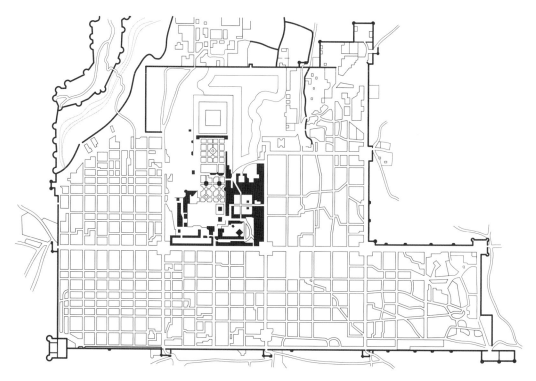

Figure 8.9. Plan, Jaipur, India, 1727.

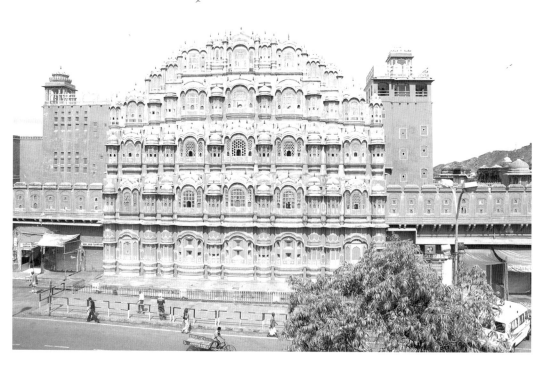

Figure 8.10. Hawa Mahal, Jaipur, India, 1799.

roof form employed by Shah Jahan for his throne, testimony to the lingering power of the Mughal synthetic approach to architecture.

Jai Singh also built a series of five observatories across the subcontinent, including the Jantar Mantar in Jaipur, erected around 1734 (Figure 8.11). The lunar calendar is important to Hindu religious observation; many Hindus also take astrology very seriously. The Jantar Mantar aided in calculations of the exact time of day and year, the information necessary to determine when to perform particular rituals. The abstract forms of these observatories have had a powerful influence upon modern architecture in India.

The tolerance of the Ottomans, the Safavids, the Mughals, and the Rajputs—above all of Akbar—accounts for the richness of their architecture. There were no national traditions in architecture before the invention of nation-states. These dynasties ruled over empires and kingdoms united by the political and military reach of individual monarchs, not over ethnically homogeneous populations. They took inspiration from the range of cultures and techniques of which they were aware. There are many circumstances that localize architectural ideas—materials, climate, and social patterns among them. At its best, however, architecture has always drawn upon the entire world at its command. Its coherence depends on the artistry with which disparate sources are fused into a harmonious whole, one that enriches the aesthetic experience of the society that creates it and of those who come afterward. These amalgamations do not have to result in banal sameness;

Figure 8.11. Jantar Mantar, Jaipur, India, circa 1734, with Chandra Mahal at far right.

at their best they inspire a rich synthesis of diverse motifs and techniques. The Taj Mahal sets a particularly impressive standard for the accommodation of difference within unity.

FOR FURTHER READING

For general background, see Catherine Asher and Catherine Talbot, *India before Europe* (Cambridge: Cambridge University Press, 2006). On the expansion of Mughal agriculture, see John F. Richards, *The Unending Frontier: An Environmental History of the Early Modern World* (Berkeley: University of California Press, 2003); this work is the source for the discussion of early modern environmental history throughout this volume. George Michell, *The Hindu Temple: An Introduction to Its Meaning and Forms* (Chicago: University of Chicago Press, 1988), offers a general study of this building type. On the importance of dynastic patronage, see Sonit Bafna, "On the Idea of the Mandala as the Governing Device in Indian Architectural Tradition," *Journal of the Society of Architectural Historians* 59, no. 1 (2000): 26–49. For discussion of the Minakshi Temple, see Susan Lewandowski, "The Hindu Temple in South India," in *Buildings and Society: Essays on the Social Development of the Built Environment,* ed. Anthony D. King (London: Routledge & Kegan Paul, 1980), 123–50. The standard sources on Mughal architecture are Catherine Asher, *Architecture of Mughal India* (Cambridge: Cambridge University Press, 1992); and Ebba Koch, *Mughal Architecture: An Outline of Its History and Development, 1526–1858* (Delhi: Oxford University Press, 2002). On Mughal carpets and their dissemination, see Daniel Walker, *Flowers Underfoot: Indian Carpets of the Mughal Era* (New York: Metropolitan Museum of Art, 1997). On the Taj, see Ebba Koch, *The Complete Taj Mahal* (London: Thames & Hudson, 2006). On Jaipur, see Vibhuti Sachdev and Giles Tillotson, *Building Jaipur: The Making of an Indian City* (New Delhi: Oxford University Press, 2002).

9　Baroque Rome

From Beijing to Istanbul and from Florence to Tenochtitlán, most new and many existing forms of early modern architectural and urban order were inherently rectilinear. Even in northern Europe, where the classical orders were infrequently deployed as part of a comprehensive system for organizing built space, in the configuration of ambitious works of architecture such as Chambord and Hardwick Hall, axial symmetry increased in importance. At the end of the sixteenth century, however, Renaissance ideas of order began to give way to something new, particularly in Rome. A more dynamic approach to the shaping of architectural and, equally important, urban space characterized the ongoing transformation of the papal city in the late sixteenth century and throughout the seventeenth century. Applied on a comprehensive scale, the more sculpturally expressive forms pioneered by Michelangelo developed into a theatrical approach to architecture now usually called the baroque.

The term *baroque,* referring to an irregularly shaped pearl, was originally an eighteenth-century French pejorative for an architecture that was seen as misshapen and willful, insufficiently attentive to the authority of ancient classical precedent. Enlightenment critics associated such architecture with religious superstition and political absolutism. At the end of the nineteenth century, however, the Swiss art historian Heinrich Wölfflin spearheaded a new, more appreciative understanding of the baroque, one that celebrated its expressive techniques. The effectiveness of its emotionalism proved to resonate as well with twentieth-century explorations of human psychology.

The baroque was an architecture of persuasion that sought to convey the completeness of secular political power as well as transcendent religious experience. Its air of unreality was particularly suited to propaganda. Baroque art and architecture were dynamic; baroque plaster and stone often seem in motion, even about to take

flight. The baroque originally celebrated Catholicism, its princes, and the pope. It was quickly adopted, however, to reinforce increasingly absolutist European states of the kind already being developed in sixteenth-century Florence by the Medici. The baroque proved equally important in the far-flung colonial empires being founded by some of those states. It literally set the often clearly illusory stage upon which religious and political rituals were enacted; the stories it told were persuasive even when partly fantastical. Wherever the baroque was deployed, it utterly transformed the static and rational classicism it inherited from Brunelleschi and his Renaissance successors. As a result, it had a far greater appeal than their cerebral approach to ideal geometry. The baroque was an architecture understood and appreciated by princes and peasants in equal measure, rather than only by intellectuals with special training in its fine points.

The baroque was an expansion upon rather than a rejection of Renaissance precedent. The ancient orders, the system of architectural detailing associated with the Doric, Ionic, and Corinthian columns, continued to link the present to the ancient Roman past. Moreover, the new focus on urban ensembles revived an aspect of ancient Roman architecture that had proven beyond the willingness of Renaissance architects and their patrons to emulate. Why was this now possible, and what was the impetus for the shift from Renaissance to baroque classicism?

The threat to Catholicism posed in the first half of the sixteenth century by the Protestant Reformation helped provoke the creation of baroque Rome, its plazas, fountains, streets, palaces, and churches. The Catholic Church was slow to reform itself, acting only once Protestantism had spread from Germany north to Scandinavia; west to France, the Low Countries, England, and Scotland; south into Switzerland; and east to what are now the Czech Republic and Hungary. In 1563, the Council of Trent completed its precepts for the revitalization of faith. Although these included no specific artistic formulas, they led from an initial austerity to the drama that characterized seventeenth-century Italian architecture and urbanism. In late sixteenth- and seventeenth-century Rome we finally find the reorganization of the city that is missing in Renaissance Florence.

In 1585, Sixtus V was elected pope. He ruled for just over five years. Where Julius II and his successors had focused their energies on the rebuilding of the Vatican Palace and the basilica of Saint Peter's, Sixtus, like his contemporary Shah Abbas, fixed his sights on the city as a whole. Instead of developing a new district, however, he now applied to the city the network of axes that organize one's experience of the garden of the Villa d'Este (Figure 9.1). These impressive urban interventions served not only to facilitate travel but also to demonstrate their patron's physical control over his domain. Sixtus planned new streets through existing fabric and extended others beyond the areas of dense habitation. All connected the early Christian pilgrimage churches located on what had been the fringes of the city a thousand years earlier and was now open land. The new streets allowed the wealthy to negotiate the city in their fashionable new carriages, conveyances that required

Figure 9.1. Plan of Sixtus V's interventions, Rome, Italy, 1585–90.

broader streets than had the simple handcarts and single horses of an earlier era. The Strada Felice, the width of five carriages, was one of the broadest streets in Europe. It was also one of the straightest new European streets to be established in such irregular terrain since the days of ancient Rome itself.

Domenico Fontana, the architect who worked most closely with Sixtus V, described this motivation:

> Our lord, now wishing to ease the way for those who, prompted by devotion or by vows, are accustomed to visit frequently the most holy places of the City of Rome, and in particular the seven churches so celebrated for their great indulgences and relics, opened many most commodious and straight streets in many places. Thus one can by foot, by horse, or in a carriage, start from whatever place in Rome one may wish, and continue virtually in a straight line to the most famous devotions.

Important differences distinguished Sixtus V's new streets from the gardens laid out only a quarter century earlier in Tivoli. At the Villa d'Este, although there was no underlying grid, axes were located at right angles to one another. Rome's

new streets were more dynamic, running in straight lines that often intersected at oblique and acute angles. In Tivoli the entire landscape was integrated in a new order, but behind the new streets, the old Roman urban fabric or its rural counterpart remained untouched. Where fountains had provided the exclamation marks organizing and ornamenting the experience of visitors to Tivoli, obelisks performed that role in Rome. Fontana erected these at strategic locations throughout the city. Originally brought to Rome from Egypt during ancient times, these shafts accented the new spatial system.

The decades that followed represented a second golden age in the history of Roman architecture. The popes, cardinals, and their families, joined by the city's many monastic orders, turned to architects to imbue the environments in which they lived and worshipped with a new magnificence. It was a somewhat bombastic effort, as the city's importance in European politics declined steadily throughout the period, but what better way to deny that decline than by erecting buildings that so effectively masked it?

A triplet of buildings in the same neighborhood by three of the city's principal architects documents the way in which the city was embellished during these years. Two of these, the Barberini Palace and the church of San Carlo alle Quattro Fontane, are located almost opposite each other across the new Strada Felice. The third, a chapel in the church of Santa Maria della Vittoria, is just two blocks away from San Carlo.

The palace is the oldest of the three (Figure 9.2). Begun by Carlo Maderno in 1628, it includes contributions by Gianlorenzo Bernini and Francesco Borromini, who became the city's most important seventeenth-century architects. The line of descent was familial as well as artistic. Maderno was Fontana's nephew and Borromini's uncle. Bernini designed the Cornaro Chapel and, like Maderno, contributed to the completion of Saint Peter's, while Borromini, who assisted Bernini at Saint Peter's, was entirely in his own right the architect of San Carlo alle Quattro Fontane.

The Barberini Palace had an unusual H-shaped form, but its internal organization proved almost paradigmatic for seventeenth-century Europe (Figure 9.3). Roman palaces had long been built on the courtyard model established in Florence by the Palazzo Medici. Here, however, two separate sections of a single family needed to be housed. Although palaces often housed extended families, in this case the need prompted a novel spatial solution in which each leading member of the family received his or her own suite of rooms. Taddeo Barberini, his mother, Constanza Magalotti, and his wife, Anna Colonna, lived in the northern block of the palace; the opposite block was for his brother, Cardinal Francesco Barberini. Each brother paid for his own half of the building, with Taddeo constructing his side first. The two brothers were nephews of Pope Urban VIII and thus at the very center of Roman secular and sacred society.

Taddeo Barberini's suite of rooms was on the ground floor, a location typically devoted to more utilitarian or even commercial purposes. His wife's and his brother's

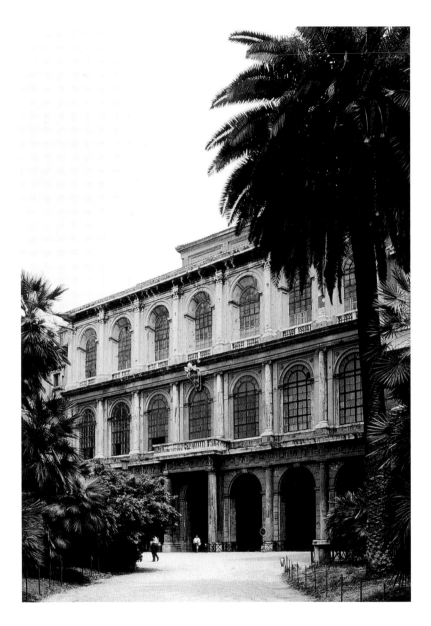

Figure 9.2.
Carlo Maderno,
Gianlorenzo
Bernini, and
Francesco
Borromini,
Palazzo
Barberini,
Rome, Italy,
begun 1628.

suites were one level higher. This created a complex series of entrances and stairs lead-
ing to shared public rooms as well as to private apartments. A seventeenth-century
apartment within a palace was organized quite differently from the sequence of spaces
within Renaissance palaces, such as the Palazzo Medici. It consisted of a straight line
of rooms, or an enfilade; in this arrangement the doors are typically all aligned,
allowing one to look straight through a suite of rooms. As in a Chinese palace, this
was a hierarchically arranged layout. Visitors gained access to these rooms based
on their social status. The higher a person's status, the farther down the sequence
he or she was allowed to proceed, and the farther forward the host would travel to

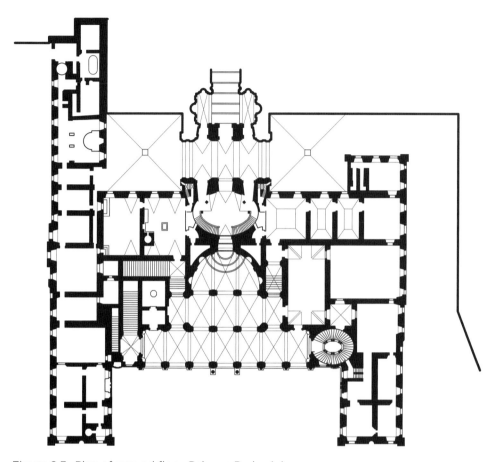

Figure 9.3. Plan of ground floor, Palazzo Barberini.

greet the visitor. The bedroom now lay at the end rather than the beginning of the sequence, well beyond the reach of most guests. Anna Colonna's female attendants lived above her apartment, but male retainers lived in modest houses in the neighborhood.

The link between the two buildings was the most original and interesting aspect of the palace's many prominent facades. Little more than a covered loggia, it was far more open than earlier palace architecture. Here one gets a glimpse of the play of light and shadow that characterize the baroque. Borromini designed the third-floor windows, which are framed to exaggerate perspectival depth. Beyond the screen-like facade, complex spaces led to three sets of stairs, which in turn led to individual apartments and the central public spaces they shared. In an echo of Michelangelo's vestibule of the Laurentian Library, paired columns spiral around Borromini's oval stair.

The architectural and iconographic climax of the palace is located in the center link on the first floor between Anna Colonna's and Cardinal Francesco Barberini's apartments. From here it was originally possible to see all the way to the seat of the

family's prestige, the Vatican itself. Between 1633 and 1639, Pietro da Cortona decorated the ceiling of this linking space with one of the tours de force of baroque painting. Titled *The Triumph of Divine Providence and the Accomplishment of Its Ends through the Pontificate of Urban VIII Barberini,* it is a typical baroque synthesis of mythological allegory and spatial illusionism. Cortona created a vision of heaven as the abode of the Barberini family. At few times in the history of Western art would painted architecture be so important as in the baroque, which prized illusionism.

Baroque drama and emotional immediacy are even more apparent in the Cornaro Chapel, which Bernini, acting as both sculptor and architect, inserted into the existing church of Santa Maria della Vittoria between 1647 and 1651 (Figure 9.4). Bernini's contemporaries saw him as the heir to Michelangelo. Like his Florentine predecessor, he began as a virtuoso sculptor before becoming an equally effective architect. In the Cornaro Chapel, Bernini was responsible for a total environment: the design of the architecture and the execution of the sculpture that this architecture frames so effectively. Bernini manipulated color and light with a sophisticated sense of drama at odds with the clarity of Renaissance art and architecture. He created a heavenly light whose source is not immediately visible. It falls on richly colored marbles and carved moldings, including a broken pediment that curves convexly.

The sculpture of the ecstasy of Santa Teresa gives physical reality to that saint's descriptions of her mystic visions. Teresa of Avila, a Spanish saint who embodied the emotionalism of Counter-Reformation piety, was canonized in 1622, only forty years after her death. In her autobiography, she described four states of prayer, with the fourth culminating in a trancelike experience of union with God, which she experienced as both intensely painful and pleasurable. In this state, she wrote, one lost consciousness of one's body and might possibly levitate. There is in Bernini's sculpture, as in his subject's writings, an obvious correlation between spiritual and sensual experience. We see the saint elevated from the earth in a state of spiritual ecstasy. An angel comes to pierce her heart, as she had described experiencing in a vision.

Bernini developed a wide range of effects to make the personal and mystical believable and public. The literalness of metal rays of light, for instance, and the dynamism of Teresa's drapery, which billows to rest upon the cloud on which she floats, are key. The expressiveness of both faces makes an even more powerful contribution to the effectiveness of the entire ensemble. This depends as well on the setting in which this transcendent experience takes place. It is impossible to photograph this tall, narrow space or, even in person, to comprehend it from one point of view in its entirety. Indeed, that two different points of view are necessary makes it more convincing.

Figures seated in flanking balconies mediate between visitors and the almost miraculous central grouping. The audience is composed of members of the Cornaro family who donated the chapel. Some look, but others seem oblivious to the vision unfolding before them and us. The chapel is a carefully controlled environment designed to produce a sense of literal and emotional identification with the saint's vision and thus encourage us in our own faith.

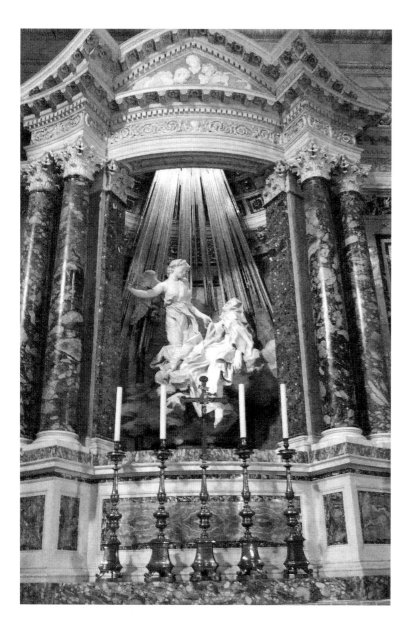

Figure 9.4.
Gianlorenzo
Bernini, Cornaro
Chapel, Santa
Maria della
Vittoria, Rome,
Italy, 1647–51.

The other junior architect involved in the Palazzo Barberini presented a very different side of the baroque in San Carlo alle Quattro Fontane. Borromini, like Maderno and Fontana before him, was a native of the Ticino, an Italian-speaking canton of Switzerland still famous for the quality of its architects and building craftsmen. Bernini was a supreme insider, comfortable with Roman tradition and establishment positions such as chief architect for the Vatican. Borromini had a more introverted personality.

The name of his church translates as Saint Charles of the Four Fountains. It was named for preexisting fountains at each corner of the intersection. Work on the

monastery began in 1634, and that on the church interior spanned 1638–41. The facade was built last, between 1665 and 1667 (Figure 9.5). Baroque facades remained, like their Renaissance counterparts, urban projects detachable from buildings' interiors. Often different architects designed the two; there was not necessarily an organic relationship between them. As alive and plastic as this facade is, it is obviously pasted onto the building behind it. The facade of San Carlo introduces the complex spatial games that Borromini substituted for the ideal geometry of the Renaissance. The play of convex and concave curves stretches and tugs at the otherwise rectangular space of the street.

The interior is a small, domed space, difficult to photograph but stimulating to experience (Figure 9.6). The lower story features little of the overtly mystical and emotional drama of Bernini's Cornaro Chapel, or even its rich polychromy and gilt ornamentation. San Carlo is equally complex, but its intricacy is revealed in the

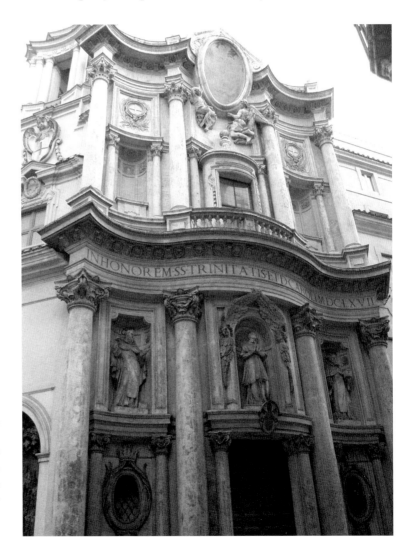

Figure 9.5. Francesco Borromini, facade, San Carlo alle Quattro Fontane, Rome, Italy, 1665–67.

shaping of space rather than in the decoration of surface. Notice, for instance, how the columns alternately screen and shape the central oval space. Although the interior is inhabited by sculptures of saints, they are not the focus of the drama unfolding here. This is nonetheless a drama, one in which the roles are played by architectural forms that act upon our emotions almost as effectively as if they were human beings. Layers of space reveal themselves only slowly and never in a completely rational manner. Here space becomes something to be molded as if it had substance. The resulting ambiguity, unstable but unified, and the sculptural vigor mark the result as baroque. Borromini forces space to contract and expand, almost ebb and flow. Seemingly arbitrary shapes in fact result from careful manipulation of pure forms: the circle and the equilateral triangle. Although he clearly worked in terms of plan, Borromini expressed his true talents in section (Figure 9.7).

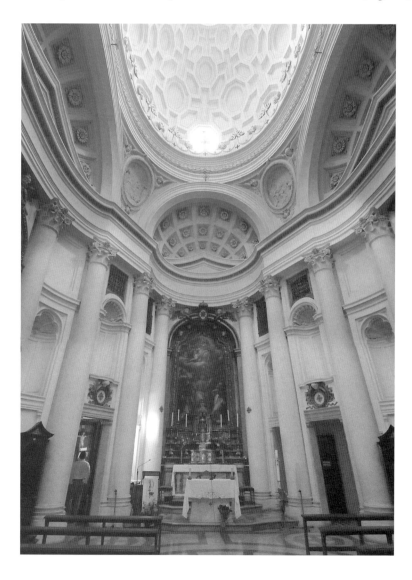

Figure 9.6.
Interior, San
Carlo alle Quattro
Fontane, 1638–41.

Borromini layered the shells of the dome to produce an ethereal effect that cannot be understood rationally from the ground. Four shallow niches support an oval dome. The coffering of these niches and that of the dome itself work in counterpoint to one another. An opening in the center of the dome is, like the face of Santa Teresa at the Cornaro Chapel, illuminated by a hidden source, creating yet another heavenly vision. In contrast to the calm, clear divine order invoked in the Pazzi Chapel, the earth on which we live appears here to be inherently unstable, held together only by forces that are larger than any of us.

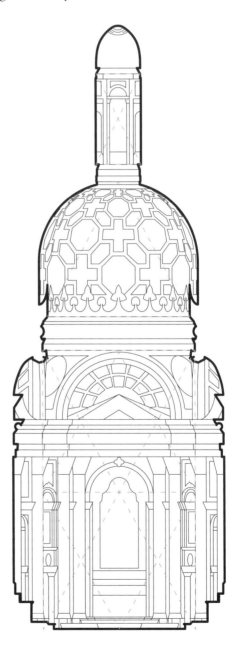

Figure 9.7. Section, San Carlo alle Quattro Fontane.

The climax of baroque Rome was not achieved in the city's neighborhoods, how-ever, but back at Saint Peter's. Not surprisingly, Sixtus V marked the plaza in front of Saint Peter's with an obelisk. In 1586 Domenico Fontana, at the pope's instiga-tion, moved one that had been standing near the side of the building so that it would be on axis with the crossing of the new church (Figure 9.8). This feat required two thousand laborers and was a major engineering accomplishment.

Fontana's nephew, Carlo Maderno, led the next phase of construction. By 1612, his great barrel-vaulted nave and the facade that capped its far end were complete. Some contemporaries, however, were dissatisfied. The enormous size of the nave was its most impressive feature. Its decoration with an almost overwhelming variety of polychrome marbles, figural sculpture, and giant order of Corinthian pilasters, capped with a gilded coffering vault, continued for years after. For critics, none of these additions gave it enough architectural definition. The facade masked the magnificence of Michelangelo's dome. Finally, the space in front of the grand new church lacked focus. The obelisk alone was insufficient.

In the end all perceived flaws were convincingly masked by the final additions to the complex. Designed largely by Bernini, they were fully in keeping with the earlier accomplishments of Michelangelo. In 1656 Bernini began the piazza, one of the world's greatest urban spaces. Form and utilitarian function are balanced here in a way that is grand without being grandiose. Note the characteristically baroque combination of trapezoid and oval forms. Bernini himself described the arms of the piazza as embracing "Catholics to reinforce their belief, heretics to re-unite them

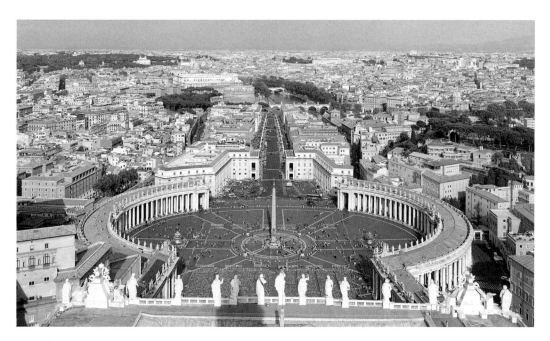

Figure 9.8. Gianlorenzo Bernini, piazza of Saint Peter's, Rome, Italy, begun 1656. Obelisk erected by Domenico Fontana, 1586.

with the Church, and agnostics to enlighten them with the true faith." The sense of surprise with which one initially entered on axis was diminished during the 1930s when Mussolini cut an imposing boulevard through the neighborhood, terminating at the oval.

The piazza remains one of the most important public spaces in the world. It is packed on Easter and Christmas, when the pope blesses the crowds assembled there. It also prepares one for the experience of entering the great church and holds the excess crowds that even that vast building cannot accommodate. This was the largest plaza in the city or, for that matter, in any other European city of the day except for the courtyards of the French royal palaces in Paris and Versailles. Unlike them, it was a grand public gesture not reserved for intimates of the court, but open from the beginning to all: Romans, pilgrims, and tourists alike. Here as much as in Bernini's far smaller Cornaro Chapel, we find the theatricality characteristic of the baroque.

The imposing order defines the space without blocking it off. The piazza is porous, open in all directions. This is important because of the variety of buildings behind it, including the Vatican palaces, whose disparate facades it so effectively screens. At the same time it offers welcome protection from the rain and sun.

In its flexibility Bernini's great portico shows his understanding of the advantages of its possible sources. Porticoes were a notable feature of ancient Roman cities in East Asia, above all of Constantinople as it was expanded by Constantine. Alexander VII, the pope who commissioned the portico, seems to have been particularly interested in what was by then Istanbul, already in his day governed for two centuries by the Ottoman sultans. At a time when the papacy was losing its influence over even Catholic countries like France, the pope apparently dreamed not just of ancient Rome but also of uniting the Greek Orthodox and Roman Catholic Churches.

Under Alexander's predecessors, Bernini had already bestowed a similarly convincing order on the interior of the vast church. His Baldacchino, or altar canopy, of 1624 to 1633 sits in the crossing designed by Bramante and under Michelangelo's great dome (Figure 9.9). Urban VIII, whose family built the Palazzo Barberini, commissioned the Baldacchino. This was the first of Bernini's important contributions to the building and its setting. Its towering structure marks the site of the tomb of Saint Peter. The Baldacchino also marks the injection of baroque dynamism into this basilican church. Once again, the details cite important precedents. The spiral columns that animate the composition refer to King Solomon's temple in Jerusalem, which was believed to have had these forms. The canopy has its origins in the iconography of kingship. The whole composition was cast out of bronze rather than carved from stone. Again this was an impressive technical achievement, one that was executed with the invaluable assistance of Borromini. The bronze came from the porch beams of the Pantheon, which were melted down to provide it.

Finally, Bernini contributed the Cathedra Petri in the apse (Figure 9.10). The process of designing and constructing it lasted a decade, from 1656 to 1666. It

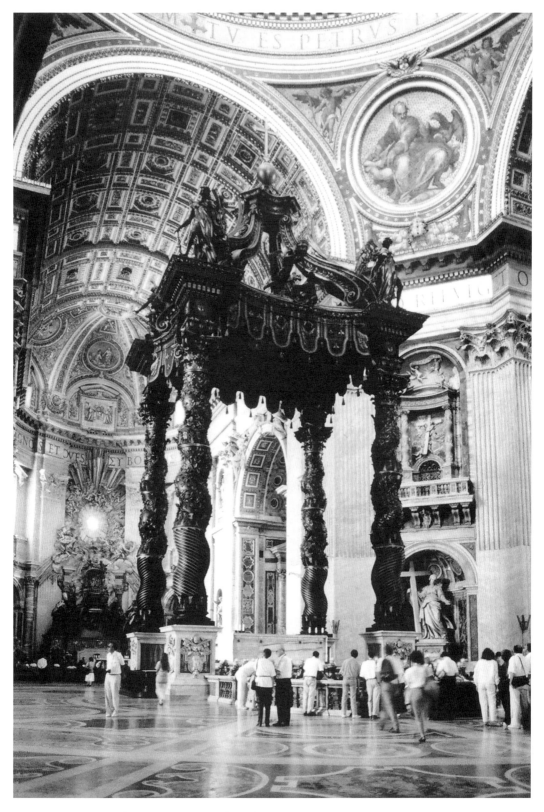

Figure 9.9. Gianlorenzo Bernini, Baldacchino, Saint Peter's, 1624–33.

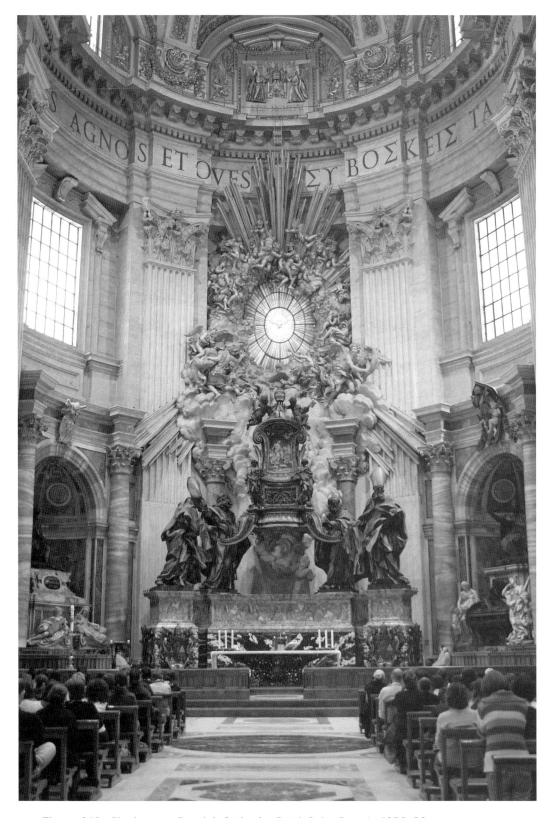

Figure 9.10. Gianlorenzo Bernini, Cathedra Petri, Saint Peter's, 1656–66.

was built out of bronze, marble, and stucco. This is the symbolic seat or throne of the pope and the spatial culmination of the entire building, and it refers to Saint Peter as the first bishop of Rome and thus the first pope. Bernini designed it to be seen through the Baldacchino. Its location makes clear, however, that it is not to be used. Light, which both shines upon and enters through the structure's gilded surfaces, is once again crucial, representing the divine as it often does in the world's many religions.

How effective was this expressive new scenography of grandeur? Many associate the spatial techniques pioneered in baroque Rome with absolutism. In their original Roman context, however, the popes and their architects carefully accented rather than entirely reshaped the city. Their distance from architectural if not political authoritarianism can be seen in the pragmatism of Bernini's shaping of the piazza in front of Saint Peter's as well as in the way that Sixtus's interventions only intermittently interrupt the older fabric of the city. Later monumental planning would control the appearance of entire buildings, even whole cities.

The difference between magnificence in architecture and urbanism and its relative ineffectiveness as propaganda is also significant. The seventeenth century saw the spread of Protestantism curtailed. This happened, however, because of warfare in central Europe, not because of the policies of the papacy. Indeed, the pope's political authority as well as his wealth waned throughout this period and remained in decline afterward. The ultimate power of baroque Rome was aesthetic rather than political, or perhaps even religious, judging from the large number of non-Catholic tourists that filled it from the beginning. And this aesthetic power was considerable. Its influence was immediate throughout the Catholic world, and it remains today a favorite of almost all city planners: a middle ground in which advocates of both the organic and ordered traditions can meet.

FOR FURTHER READING

A useful introduction to the baroque is provided in Henry Millon, ed., *The Triumph of the Baroque: Architecture in Europe, 1600–1750* (New York: Rizzoli, 1999). The classic study of baroque Rome remains Rudolf Wittkower, revised by Joseph Connors and Jennifer Montagu, *Architecture in Italy, 1600–1750* (New Haven, Conn.: Yale University Press, 1999). See also Andrew Hopkins, *Italian Architecture from Michelangelo to Borromini* (London: Thames & Hudson, 2002). On the Barberini Palace, see Patricia Waddy, *Seventeenth-Century Roman Palaces: Use and Art of the Plan* (New York: Architectural History Foundation, 1990); and on Bernini, T. A. Marder, *Bernini and the Art of Architecture* (New York: Abbeville Press, 1998). On Alexander VII, see Dorothy Metzger Habel, *The Urban Development of Rome in the Age of Alexander VII* (Cambridge: Cambridge University Press, 2002); and Richard Krautheimer, *The Rome of Alexander VII, 1655–1667* (Princeton, N.J.: Princeton University Press, 1985).

10 Spain and Portugal in the Americas

Bernini's piazza fronting Saint Peter's is the most imposing of the European public spaces whose design may have been unconsciously inflected by an awareness of the great plazas of the Americas. By the middle of the sixteenth century the two most important of these, the Zócalo in Mexico City and its counterpart in Cuzco, were dominated by Christian churches. The European conquerors of the Americas were most successful when they learned enough about the local societies to sense what aspects of their own culture could best be paired with indigenous ones in order to convince the native inhabitants to become loyal subjects and good Christians. Although an ocean separated the new colonies from the motherland, new design ideas traveled quickly across it. The American-scaled Plaza Mayor in Madrid was first projected in 1560, although it was not completed until much later.

In 1494, Pope Alexander VI divided the non-Christian world, finally understood to be part of a spherical Earth, between the Spanish and the Portuguese. The Portuguese had initiated the voyages of discovery by finding a sea route to Asia around the coast of Africa, which they dotted with outposts along both African coasts and across to Goa in India and Macao in southern China. The pope also gave them the right to Brazil. The Spanish got everything from the Philippines to the rest of the Americas. Of course, the two Iberian countries were not in a position to control these vast and largely uncharted territories completely. But both, relative upstarts to the community of European powers, gave it a very good try, especially before the British, Dutch, and French began to mount their own convincing challenges in the seventeenth century.

Sixteenth-century Spain and Portugal sponsored the first empires ever to control significant amounts of noncontiguous territory (various Italian cities, most notably Genoa, had in the Middle Ages colonized the lands bordered by the Adriatic and

Aegean Seas, as well as the coast of the Black Sea). They were also the first European empires to rival and at times even surpass the size of their ancient Roman predecessor. Architecture was a crucial component of this new imperialism. The conquerors felt that they had to match the scale and splendor of the buildings their new American and Asian subjects had already erected. This was not always easy.

The immediate task of many colonizers was resource extraction. Mining and the production of cash crops provided ways of enriching themselves, often at the expense of the native or imported labor assigned to do the real work. Nonetheless, religious architecture was crucial to these colonizers. The conquerors justified their invasions to themselves and to other Europeans in the name of spreading what they regarded as the one true faith, Christianity. This was often only a transparent cover for greed, especially on the part of military figures, but it was heartfelt in the case of many of the friars who settled far from home in the hope of saving American souls. Just before dispatching Columbus across the Atlantic, the Spanish monarchs King Ferdinand and Queen Isabella had completed their conquest of formerly Muslim-controlled territories in Spain. Granada had for centuries been an island of cultural tolerance where a majority-Christian population under Muslim rule coexisted with a Jewish culture renowned for its philosophy and medicine. The Spaniards forced their Muslim and Jewish subjects to convert or emigrate. Many conversions were only superficial, and some Jews were among the earliest immigrants to the Americas, settling in what was then extremely remote territory in present-day New Mexico in order to preserve remnants of their faith, far from the feared Inquisition. Religion offered the colonial state a culturally sanctioned means for controlling the population, whether immigrant or indigenous. Although colonial architecture featured many building types—houses, palaces, government buildings, warehouses, and so forth—churches were the buildings that represented the empire's understanding of itself.

From the beginning Mexico City was the centerpiece of Spain's American empire. Because of the capital's enormous growth over the course of the twentieth century, the monastery of San Agustín in Acolman offers better evidence of early colonial architecture (Figure 10.1). In this rural location, the buildings erected between the 1520s and the 1560s survive intact. The monastery in Acolman was one of an impressive number of monasteries that Spanish missionaries established quickly across the original Mexica empire and beyond.

The cultural dislocation endured by the Mexica and their subjects was traumatic. Millions of natives died of disease, often without ever having encountered Europeans, or gave way to what seems to have been depression. Others were slaughtered outright or forced to work in conditions that all but ensured their early death. Across the course of the sixteenth century the native population of the Americas fell by as much as nine-tenths, down to five or six million. From the beginning, local colonial authorities found their ability to harness the natives as slave labor hindered, if seldom entirely prevented, by the voices of fellow European advocates of better treatment. The friars, who came from throughout Catholic Europe, were charged

Figure 10.1. Monastery of San Agustín, Acolman, Mexico, 1520s–60s.

with converting Amerindians. In many cases they were genuinely interested in the material as well as the spiritual welfare of the natives. That they offered the indigenous peoples access to a religion understood by all involved to be extremely powerful (after all, the Mexica gods had not been able to protect those who believed in them) helped enormously. Locals quickly and reverently accepted the new faith, while often retaining elements of the old one.

Two extraordinary stories come together at Acolman. The first has to do with native labor. The monastery complex was built and decorated entirely by Mexica workers. From a technological standpoint, this should be no surprise, as it arose practically in the shadow of the monumental structures at Teotihuacán, not to mention Tenochtitlán. Nor, considering that the Spanish colonists were relatively scarce and given to certain social pretensions, is it startling that they were not willing to engage in the necessary manual labor. The second story concerns the way that the friars and the natives integrated indigenous elements into the Christian faith in order to enhance its familiarity and encourage its acceptance. The vast walled patio in front of the church replicates, for instance, the plazas that fronted Mesoamerican temples at the same time that it provided a space vast enough to accommodate the peasants who attended open-air masses here. Familiar iconographic and stylistic elements also smoothed the transition to Christianity. A Virgin Mary resembling a Mexica goddess sits at the base of a crucifix situated in this forecourt, which also

followed indigenous iconography by showing Christ as a tree integral with the cross rather than as a crucified figure affixed to it.

If assimilation is one feature of cross-cultural interchange, aesthetic excellence is often another. Architectural historians have often assumed that the farther one is from an intellectual center of architectural discourse, the more provincial the result will be. At Acolman, however, distance seems to have encouraged unusual sophistication. Renaissance architecture in Spain is usually described as Plateresque. Unique to the Iberian Peninsula, Plateresque architecture often featured lingering Gothic and Islamic elements. Acolman's builders applied a recollection of a Roman triumphal arch to the facade, which also features two motifs never found in a Spanish church. They are the Mexica glyph naming the place and the image of the pierced heart, here the Sacred Heart of Jesus. The popularity of this imagery in Counter-Reformation devotion in Europe may have been encouraged by its meaningfulness to the Mexica.

Inside, one finds the introduction of two different aspects of contemporary Flemish more than Spanish architecture (many of the friars came from the Low Countries, which were ruled by Spain) (Figure 10.2). The first are Gothic vaults. At first glance these may seem provincial, although they were still being constructed in much of Europe. What is astonishing about their presence here, however, is that Mexica craftsmen, to whom these forms had been entirely unknown just a few years earlier, were able to realize them with skill. Equally impressive is their assimilation of European representational traditions, undoubtedly taught to them by Spanish or Flemish friars. Imported prints served as the sources for the grisaille (black-and-gray) paintings that decorate the apse interior.

Nor was the interface between Spanish and Mexica architecture the only one addressed in colonial Mexico. One of the most remarkable characteristics of several sixteenth-century Mexican colonial churches was their resemblance to the mosques that the Spaniards had converted into churches in cities such as Córdoba. Such buildings were much broader than basilican churches and featured not only multiple naves but also large entry courtyards. This form may have been inspired by the assumption that the mosque of Al-Aqsa on the Temple Mount in Jerusalem was the Temple of Solomon, the oldest recorded religious structure erected by the Jews, and thus venerated as well by Christians and Muslims.

The tight geometry of Acolman, almost certainly in part a response to local traditions, fused in Spain itself with the Italian Renaissance to create a new image of Hispanic kingship. This happened during the rule of Philip II. Philip was the son of Charles V, who as the grandson of Ferdinand and Isabella on his mother's side and of the Holy Roman Emperor Maximilian on his father's ruled over central Europe and the Low Countries (modern Belgium and the Netherlands) as well as the Spanish Empire. Philip inherited Spain, its empire, and the Low Countries, to which he temporarily added England, during his childless marriage to Mary I, the daughter of England's Henry VIII and elder sister of Queen Elizabeth I. His

Figure 10.2. Interior, monastery church of San Agustín.

unpopularity in England, where he and his wife sought to reimpose Catholicism, contributed to Elizabeth's determination not to marry, as there were no other rulers she could have married who practiced the Anglican faith.

Philip, a devout Catholic with relatively unostentatious personal tastes, considering the scale of the empire over which he ruled, presided over the creation of the Royal Monastery of San Lorenzo de el Escorial (Figure 10.3). Built between 1563 and 1584 by Juan Bautista de Toledo, who had worked under Michelangelo on Saint Peter's, and Juan de Herrera, the complex brought together an unusual array of building types: monastery, royal palace, library, college, and royal burial church. Its plan was intended in part to be a re-creation of the Temple of Solomon in Jerusalem, which Toledo and Herrera presumed had been a classical building. The fusion of sacred and secular purpose featured at the Escorial was characteristic of the sixteenth-century Spanish state, which derived much of its authority at home and abroad from expressions of piety.

According to the Italian Renaissance precepts by which it was strongly influenced, this was an austere architecture, in which the orders, for instance, are almost entirely absent. And yet the ashlar masonry of these long facades was extremely expensive. Not surprisingly, the one part of the building that features what contemporaries at the time would have recognized as "architecture"—that is, the conscious attempt to

Figure 10.3. Juan Bautista de Toledo and Juan de Herrera, Royal Monastery, San Lorenzo de el Escorial, Spain, 1563–84.

elevate building into art—was the facade of the church, decorated with figural sculpture as well as applied Doric columns. The most novel aspect of this facade was the integration of medieval bell towers into a Renaissance church. Monumental *retablo* altarpieces, distinctive features of Renaissance and baroque art in Spain, dominate the interior (Figure 10.4). During the seventeenth century, *retablos* would be transformed into central elements of Spanish and Spanish colonial sacred architecture.

Some idea of Philip's relative modesty comes through in the location of his bedchamber (Figure 10.5). Early medieval emperors had often viewed the Mass from an elevated position at the opposite end of their palace churches from the altar. At the Escorial Philip could glimpse the sacrament from the relatively private position of his bed. From here he also enjoyed a privileged view out over the landscape. This demonstrates the distinctly private approach to worship characteristic of sixteenth-century piety on both sides of the Alps.

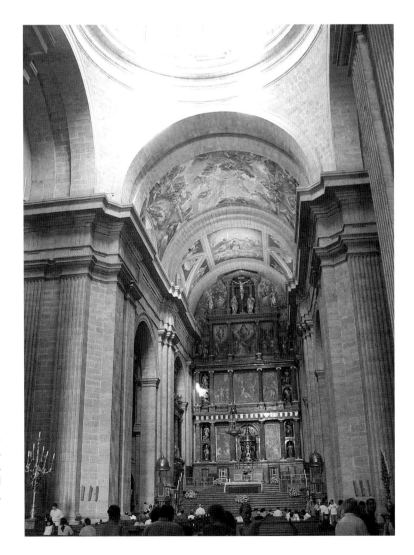

Figure 10.4.
Interior, chapel,
Royal Monastery,
San Lorenzo de el
Escorial, Spain.

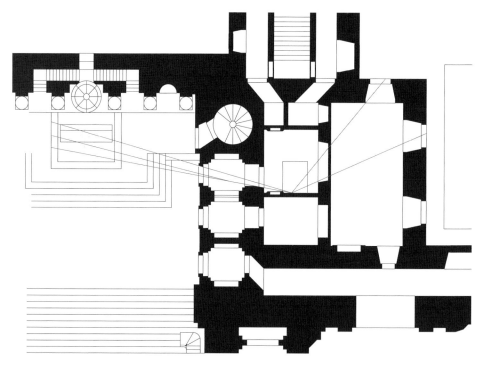

Figure 10.5. Plan, chapel and Philip II's bedchamber, Royal Monastery, San Lorenzo de el Escorial, Spain.

Philip's interest in ideal space manifested itself as well in the Law of the Indies. Proclaimed in 1573, it codified the way in which towns had been sited and organized throughout the Spanish empire for nearly half a century. It prescribed a grid plan and a central square, called in Spanish the *plaza mayor,* which was to be scaled to the number of inhabitants and was to provide a training and parade ground for local troops. The most prominent site on the square was reserved for government buildings; a secondary one was allotted to the church.

The standardization of Spanish colonial planning had no peer in any European culture since the ancient Romans. The text of the Law of the Indies emphasized that these towns were new foundations, designed to impress the region's indigenous population:

> While the new settlement is being completed, the settlers should as far as possible try to avoid communication and trade with the Indians, and should not go to their villages, nor should they amuse themselves nor disperse themselves about the country, nor should they let the Indians into the confines of the settlement until it is completed and fortified, and the houses built, so that when the Indians do see it they are amazed, and they understand that the Spaniards are settling there permanently and not temporarily, and they will fear them and will not dare offend them, and they will respect them and wish to have their friendship.

There was a huge gap, however, between theory and practice. Most towns were on the sites of previous settlements and were constructed exclusively with indigenous labor. The order prescribed by the law, which may have been inspired in part by the form of the original indigenous settlements or by idealistic schemes for a New Jerusalem, lacked any clear Spanish precedent, although it may have been influenced by late medieval *bastides,* or fortified towns, in the South of France. Certainly the rigorous design ideals embodied in the Law of the Indies were more rarely implemented in Spain than in its colonies. Possible indigenous precedent did not imply respect for local populations. Completion of the conversion of existing American settlements into Spanish colonial ones was typically accompanied by the expulsion of the native labor force into the countryside. Until relatively recently, in many former Spanish colonies a characteristic ethnic division placed peasants of mostly indigenous stock on the land, while town dwellers were the descendants of European settlers.

The confluence of indigenous Mesoamerican urbanism and its ideal Renaissance counterpart was exported far to the north. One of the last places developed along these lines was Sonoma, California (Figure 10.6). Sonoma was founded in 1823, not by the Spanish, who by this time had lost most of their American empire, but by Mexicans, from whom the United States was soon to seize present-day Texas, New Mexico, Arizona, Nevada, and California. Sonoma features a central plaza that is much larger than the courtyard squares one finds in county seats in the American Midwest. The church is in one corner of the plaza, and government buildings line one side.

Figure 10.6. Plaza, Sonoma, California, 1823.

Although Sonoma was provincial, throughout the seventeenth and eighteenth centuries Spanish and Portuguese colonial cities were the richest and most urbane settlements in the Americas. Mexico City was by far the biggest city in the Western Hemisphere. In comparison, Quebec, Montreal, Boston, New York, and even Philadelphia were little more than overgrown towns. Today oil is the most valuable natural resource—in the eighteenth century, the most valuable resources were precious metals. Much of the wealth of Mexico City came from the silver fields that lay to the north. The Mexican baroque reached its peak in buildings like the church of Santa Prisca in the silver-mining center of Taxco (Figure 10.7). Located in the state of Guerrero, it was built between 1751 and 1758 and probably designed by Diego Durán Berruecos.

Acolman illustrates the fusion of indigenous and imported practice. Two centuries later, however, Santa Prisca is little different from what one would have found in contemporary Spain. Mesoamerican references are entirely absent in what was before the mining boom a lightly settled area without its own history of monumental architecture. Instead one finds a full-fledged example of the Spanish baroque, or Churrigueresque, the most prominent feature of which is the way it fractures and elaborates the classical orders, perhaps influenced by lingering medieval and Islamic

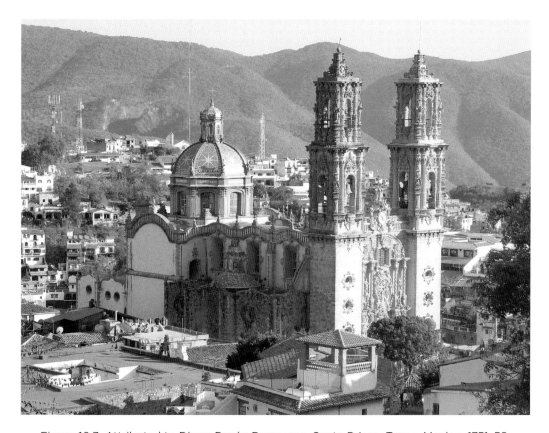

Figure 10.7. Attributed to Diego Durán Berruecos, Santa Prisca, Taxco, Mexico, 1751–58.

sensibilities or by contemporary central European architecture. The prime location for this rich decoration is the *retablo,* whose form is repeated on the facade of the church. The framing bell towers are equally ornate. Tiles ornament the dome over the crossing. This kind of tile work, which had Mediterranean origins, became in the eighteenth-century deeply ingrained in Mexican culture.

Two hallmarks of Churrigueresque are visible on the interior (Figure 10.8). One is the elaborate and monumental high altarpiece. Only slightly smaller counterparts were located as well in adjacent chapels. As was true of eighteenth-century Spanish architecture around the world, there is none of the ebb and flow of architectural space present here that was so important to the Roman baroque. In plan, this is a simple hall church whose basic volume is no more complicated than that of Acolman.

The greatest eighteenth-century boomtown of all in the Americas belonged not to the Spanish but to the Portuguese, who found gold in the Brazilian state of Minas Gerais. Mining activity was centered on the city of Ouro Preto. Half of Portugal's adult male population left their homes for the gold fields. They were assisted there by the victims of one of the most horrific aspects of European colonization of the Americas, slaves imported from Africa. The Portuguese, with extensive African colonial holdings of their own, quickly followed the lead established by the Spanish in importing slaves to the New World in order to raise cash crops for sale on the European market. Slavery was hardly new, but the conditions of slavery in the Americas

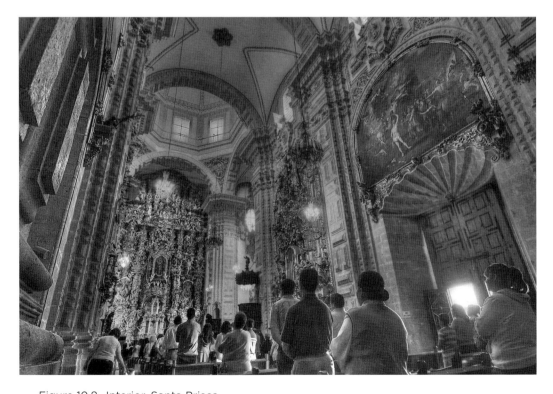

Figure 10.8. Interior, Santa Prisca.

were unprecedentedly ugly. The ancient Romans had kept slaves, and the tradition continued among both Christians and Muslims in the Mediterranean, as well as in many other parts of the world, but seldom were multiple generations born into slavery in these regions, as was to be the case for nearly four centuries in the Americas. Islam, for instance, mandated that slaves not be fellow Muslims and that any Muslim children of slaves be free.

Of Ouro Preto's population of one hundred thousand at its mid-eighteenth-century peak (more than twice that of the largest English-speaking city in the hemisphere, Philadelphia), half were Africans or their descendants. These new arrivals, like the Mexica at Acolman, almost immediately assimilated European religious architectural conventions. Ouro Preto boasts many sophisticated examples of baroque architecture.

The most celebrated of all the city's churches is São Francisco de Assis, which was apparently designed in 1764 by Antônio Francisco Lisboa, known as Aleijadinho, or the cripple (Figure 10.9). This architect and sculptor, the son of the Portuguese-born architect with whom he trained and an African slave mother, was himself a slave. This did not prevent him from becoming the local equivalent of Bernini, a talented wood-carver who is believed to have designed as well as ornamented the churches on which he worked.

The exterior of this church is radically different from that of Santa Prisca. Instead of a *retablo* facade, Lisboa crafted a composition far more in keeping with mainstream European fashion. He built São Francisco out of wood and stucco, popular materials in parts of Europe at the time as well, rather than stone, which was far more expensive. And its plan, like that of many Brazilian colonial churches, features the concave curves characteristic of Roman baroque, but not of its Mexican counterparts. In São Francisco, following a European fashion first established in early eighteenth-century France, ornament breaks free of classicism, instead imitating plant forms. The rococo carving here is of exceptionally high quality. *Rococo,* an eighteenth-century term derived from the French word for ornament made of shells, describes the nonclassical, curvilinear details, often derived from shells and plants, favored by many late baroque artists.

At São Francisco a half-African artist who had never left Brazil produced an entirely modern work of art, completely in keeping in style and quality with churches in Portugal and in central Europe. This involved assimilating his own artistic taste to something radically different from what either of his parents had grown up with. Leaps into the unknown are especially likely to take place in environments under the pressure of tremendous social and economic change.

Two missions located within the borders of what is now the United States offer less radical evidence of the way in which design ideas traveled and were transformed in the seventeenth and eighteenth centuries. Throughout the period, missions continued to be the typical way in which the Spanish colonial empire, in the absence of discoveries of silver, gradually expanded out into the hinterland. Located in what

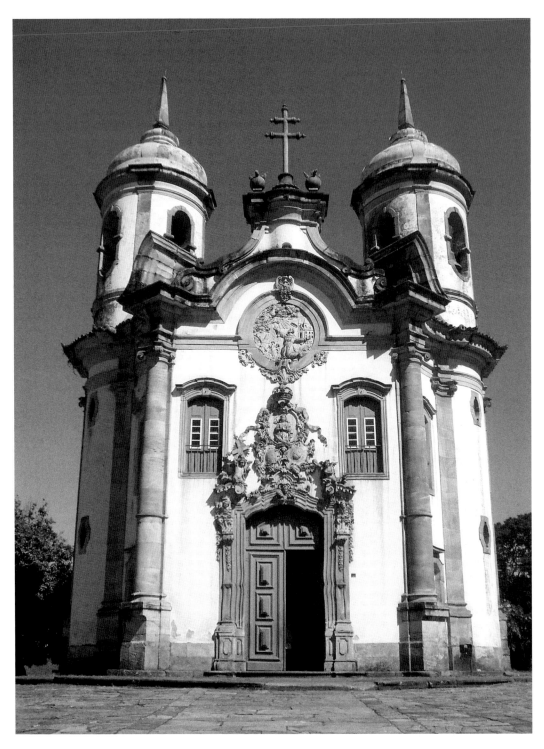

Figure 10.9. Antônio Francisco Lisboa, São Francisco de Assis, Ouro Preto, Brazil, begun 1766.

are now New Mexico and Arizona, respectively, one of the first and one of the last missions to be built north of the Rio Grande are representative as well of the churches erected in larger numbers in Texas and California.

Acoma is one of the longest continually inhabited places in the United States. The indigenous people who established it had already endured a great deal before they built San Estevan between 1629 and 1664 (Figure 10.10). In 1598 Acoma was the site of one of the most notorious episodes in the history of the Spanish colonization of what is now the United States, a massacre in which the adult male natives were maimed or slaughtered and the entire population enslaved. Nonetheless the locals, like the Mexica before them, eventually embraced the religion of their conquerors.

San Estevan is very different from Acolman. In Acoma the local priests foreswore any attempt to echo European tradition. Only the two bell towers remain as markers of a church as they would have understood the type from their own youth in Mexico or Europe. Instead they challenged the largely female local labor force to produce a more monumental architecture than had previously been realized using the adobe mud brick that had long been the chief local building material. The ceilings, as in the local domestic buildings, were constructed of timber, which had to be brought a considerable distance to this hilltop site. The result, thus, was neither entirely indigenous nor imported; it was a hybrid, in this case leaning so heavily toward the

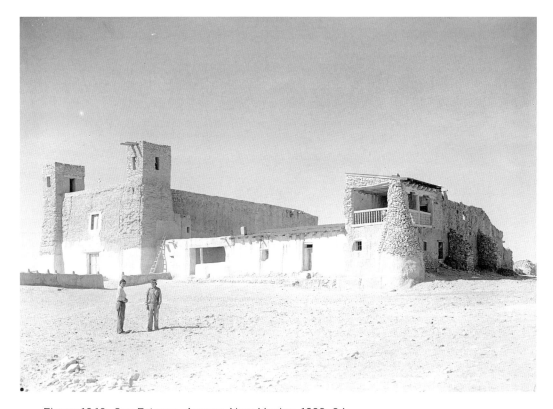

Figure 10.10. San Estevan, Acoma, New Mexico, 1629–64.

indigenous that many local commentators have sensed that the building almost grew organically out of the surrounding village. Because adobe is impermanent, the church has in fact changed over time and must be restored at regular intervals.

The interior of San Estevan, like that of many churches on Native American reservations, remains off-limits to outsiders. Not so that of San Xavier del Bac, outside of Tucson (Figure 10.11). Built between 1783 and 1797, it is located on the edge of the Sonoran Desert. This was one of the places, like the Californian missions farther west, where the friars tried to induce settled living among largely nomadic populations, something that was extremely difficult to enforce and not always suited to the terrain. A new spatial as well as political and religious order resulted from this interweaving of imported agricultural practice, religion, and political authority. This was far more disruptive than the conversion of settled populations, whose house forms, for instance, often changed only gradually during the period of Spanish colonization.

San Xavier is a provincial version of Santa Prisca. Two bell towers frame a *retablo* facade. There is even a small dome over the crossing. Instead of a simple nave ending in an altar, there is a full Latin cross plan with transepts branching off to the side. There is also a choir loft and a series of domes, again a technical innovation for the local labor force. Indigenous craftsmen were once more responsible for the decoration, into which apparently they incorporated aspects of their pre-Christian beliefs. This was an extremely ambitious undertaking at the very end of the supply lines of the empire.

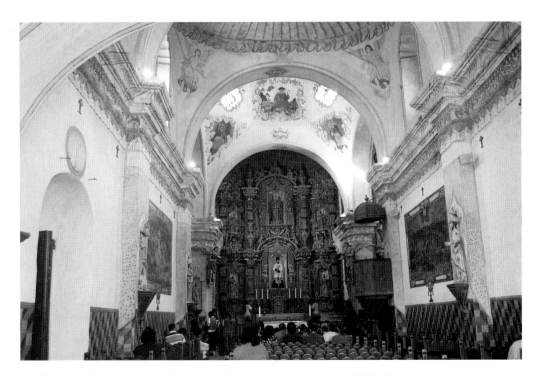

Figure 10.11. Interior, San Xavier del Bac, Tucson, Arizona, 1783–97.

Throughout the Americas, the colonized and the colonizers collaborated in producing environments to which both groups could relate. These buildings bridged the enormous gaps between two very different spatial, technological, and architectural cultures. The colonizers had all the political and most of the economic power but depended on the labor of natives to transform that power into built form. Many of the results were new to both cultures, highly modern within the European as well as the American context. The encounter generated changes that were often traumatic for the original Americans but also transformative for the colonizers. The results may be mourned as evidence of the erasure of the original cultures of the indigenous peoples and the forcibly imported African slaves, but they can also be appreciated as outsized aesthetic achievements, which is why they often continue to be embraced with such great pride by the descendants of their colonized makers.

FOR FURTHER READING

For examples of medieval European colonial architecture, see Maria Georgopoulou, *Venice's Mediterranean Colonies: Architecture and Urbanism* (Cambridge: Cambridge University Press, 2001). The basis of my discussion of Mexican colonial architecture is provided by Samuel Edgerton, *Theaters of Conversion: Religious Architecture and Indian Artisans in Colonial Mexico* (Albuquerque: University of New Mexico Press, 2001), reinforced by Jaime Lara, *City, Temple, Stage: Eschatological Architecture and Liturgical Theatrics in New Spain* (Notre Dame, Ind.: University of Notre Dame Press, 2004). On the Escorial, see Catherine Wilkinson Zerner, *Juan de Herrera: Architect to Philip II of Spain* (New Haven, Conn.: Yale University Press, 1993). For discussion of the possible impact of New World precedents on Old World architecture and planning, see Jesús Escobar, *The Plaza Mayor and the Shaping of Baroque Madrid* (Cambridge: Cambridge University Press, 2003). On the Law of the Indies, see Valerie Fraser, *The Architecture of Conquest: Architecture in the Viceroyalty of Peru, 1535–1635* (Cambridge: Cambridge University Press, 1990); on Ouro Preto, see Damian Bayon and Murillo Marx, *History of South American Colonial Art and Architecture: Spanish South America and Brazil* (New York: Rizzoli, 1992). William Pierson discusses San Xavier del Bac in *The Colonial and Neoclassical Styles,* volume 1 of *American Buildings and Their Architects* (Garden City, N.Y.: Doubleday, 1970).

11 Northern Baroque

lthough the Renaissance had a limited impact on architecture in northern Europe, in the right circumstances the more flexible and theatrical baroque triumphed north of the Alps. Several court-sponsored designs from the seventeenth and eighteenth centuries demonstrate that even as it was still being developed in Rome, the baroque was being thoroughly transformed to serve absolutist rulers elsewhere. Kings who sought unprecedented political and spatial authority appreciated the way in which the baroque could be used to create compelling propaganda. The new spatial order, which included suburban estates as well as urban squares, supported and symbolized a top-down political system at a time when European monarchs, like their counterparts in Istanbul, Isfahan, and Delhi, were attempting, often successfully, to force landed aristocracies and urban burghers into relinquishing power to increasingly centralized states.

The first of these kings was Henri IV of France, whose second wife was Marie de' Medici. Henri entered Paris at the end of a long civil war that had pitted Protestants against Catholics. Declaring that the city was worth a Mass, he converted to Roman Catholicism in 1593 shortly before this triumphal moment. His assassination in 1610 cut short the reign of the most important French king between Francis I and Henri's grandson Louis XIV.

During the sixteenth century, European royal authority seldom extended to the reorganization of urban space. Nor were burghers in cities like Kraków interested in collective expression in domestic architecture. Those who could afford it instead sought to distinguish themselves in the design of house facades that retained a high degree of individuality. All of this changed early in the seventeenth century in Paris, however, as Henri imposed his will upon the city in a series of urban interventions that became the badges of his right to rule. He created the first squares in Paris, public spaces rimmed—as in the much larger Maidan in Isfahan—by identical buildings,

in this case houses. Only fragments of the earliest of these, the Place Dauphine, sur-
vive, but the Place Henri IV, or Place des Vosges, as it is now known, built between
1605 and 1612, remains one of the glories of European urbanism (Figure 11.1).

Originally Henri had intended the Place to house silk workers. Silk was one of
France's principal imports, and he wanted to encourage local production of this pre-
cious commodity. In the end, however, those who lived around the square were
mostly aristocrats. As important as the regular form of the square itself was the
uniformity of the facades. In fact, only these were identical; behind these public
faces, individual builders were free to do as they wished. An arcade around the
ground story testified to the Place's original commercial purpose. The orders and
detailing associated with them play a relatively minor role in these largely brick
houses, trimmed in more expensive stone. In general, classical details were far less
important in seventeenth- and eighteenth-century northern Europe than in Italy.
Crucial instead, as already at Chambord and Hardwick Hall, was a firmly articu-
lated sense of hierarchy, established here in the height of the higher central pavilions
that face each other across two of the four ends of the square.

Although there is little specifically Italian about these facades, the organization
of urban space along orderly lines did have a degree of Italian precedent, in Michel-
angelo's far more dynamic design for the Campidoglio in Rome, construction of
which was finally completed at about the same time. Both spaces are centered on
equestrian statues of rulers, the ancient Roman emperor Marcus Aurelius in the
Roman instance and Henri IV himself in Paris. Until the French Revolution, suc-
cessive French kings established royal squares in cities throughout the realm. From

Figure 11.1. Place Henri IV (Place des Vosges), Paris, France, 1605–12.

France the fashion spread throughout Europe. The centers of these squares often served, as here, as among the earliest public parks. The introduction of open space was particularly welcome as it became increasingly difficult to walk from the middle of the largest European cities directly into the countryside.

Although most of the Place's inhabitants were aristocrats or their servants, the burghers for whom it was originally intended did gain substantial economic ground during the seventeenth century, which they attempted, with mixed success, to convert into increasing political power. Trade and artisan production were replacing agriculture as the primary sources of private wealth as France—along with the rest of western Europe, its chief trading partners in Asia, and its new colonial empires in Africa, Asia, and the Americas—moved toward a mercantile economy. During the reign of Henri's son Louis XIII and the regency of Marie de' Medici that followed his early death, this class, many of them Protestant, increasingly rivaled the traditional aristocracy in importance. Indeed, many joined the aristocracy by buying noble titles, the sale of which was a major source of income for the Crown, as well as estates in the countryside surrounding Paris. Buying an estate entailed tax exemption in return for abstaining from trade. That made this class of newly rich landowners particularly interested in both showing off their new social status and reconfiguring their land to make money.

The results included the most splendid gardens that had yet been laid out in Christian Europe. The paradigmatic example is Vaux-le-Vicomte, built for Louis XIV's minister Nicolas Fouquet, between 1657 and 1661 (Figure 11.2). The architects Louis Le Vau and Jules Hardouin-Mansart designed the château (French for country palace). Charles Le Brun assisted in its decoration, and the landscape architect André Le Nôtre laid out the grounds. Like Chambord, Vaux retains the essence of a stylized medieval castle with moat. What is different here, aside from the more emphatically classical details of the château, is the scope of the reorganization of the surrounding landscape. The Renaissance view of the relationship between nature and divine order was carried here to new extremes that had more than a love of hunting and of fountains in common with the gardens of Safavid Iran and Mughal India. The discipline present here was also emblematic of the rationality of much seventeenth-century French philosophy, which encouraged intellectual inquiry into natural law. Note the chilly distance from the Italian and Hispanic emphasis on emotion during the same years, as well as the shift in emphasis from the sacred and spiritual to the secular and political.

The techniques on display were derived from technologies that were crucial to the consolidation and economic development of the French state. The design of fortifications, for instance, had a great influence on the newly disciplined organization of space and the technology used to reshape it. Old fortifications were demolished within France in the seventeenth century, as a standing army loyal only to the king replaced aristocratic fiefs. New fortifications were constantly being erected, however, on the borders. The connection of this landscape to these new forts would

Figure 11.2. Louis Le Vau and Jules Hardouin-Mansart, château, and André Le Nôtre, garden, Vaux-le-Vicomte, France, 1657–61.

have been clear to contemporaries, not least the actual laborers, many of whom worked on both forts and gardens. An important influence on the design of the relatively small beds of tightly clipped plants, called parterres, was fabric design. Jean Baptiste Colbert, another important minister of the period, successfully campaigned to establish France as the source of luxuries for its own aristocrats and for foreign markets. Previously both had subscribed to Dutch, Spanish, and Italian fashions. The production in France of expensive goods for the export market was crucial to the growth of the national economy. Raw materials remained too expensive to transport over large distances, but the market for French brocades, for instance, would soon stretch all the way to the Americas.

Vaux was the birthplace of the French garden tradition in which a rational view of nature as geometrical abstraction is overlaid onto the more general expression of power through the control of nature, particularly of water. This seems artificial today, but the seventeenth-century French understood it as reflecting underlying natural—and thus also divine—order. The synthesis of military engineering, consumer-oriented pattern making, and control of water found in the vast gardens of Vaux was developed by a commoner, but the association of such synthesis with Europe's most powerful monarch hastened its adoption by monarchs and aristocrats across the continent. In 1661, Louis XIV assumed power in his own right; his mother, Anne of Austria, had earlier served as regent. When Fouquet gave a fete at Vaux for

the entire court in his honor, Louis glimpsed the usefulness of an appropriate stage for his enormous ambitions. Shortly afterward, Fouquet was arrested for embezzlement. Louis seized for himself the team of artists and architects his minister had assembled there and brought them to Versailles.

During Louis XIV's long reign, France surpassed Italy and Spain as the center of wealth and fashion, with the continent's most splendid court. Louis XIV called himself the Sun King and declared, with considerable justification, "I am the state." During Louis's reign France's central civil service was finally able to reach into even the smallest villages. Originally Louis ruled, as had his predecessors, from Paris. He felt threatened there, however, both by the aristocrats, who had rebelled against his mother's regency in his youth, and by the urban middle class, whose loyalties were also difficult to command. He consolidated his power by transforming his father's hunting lodge in the suburb of Versailles into the largest and most splendid palace in European history (Figure 11.3).

Versailles was even bigger than Vaux. Three avenues converged on the courtyard in front of the palace, which developed slowly as a series of accretions added to the original lodge (the trident motif would be widely imitated in the design of both cities and gardens). Louis's bedroom was located at the absolute center of this facade. Behind it, at the center of the garden facade, stands the most splendid European

Figure 11.3. Louis Le Vau and Jules Hardouin-Mansart, palace, and André Le Nôtre, garden, Versailles, France, renovations begun 1661.

interior of its day, the Hall of Mirrors, from which one looks out onto magnificent gardens, stretching, as at Vaux, to the horizon. In addition to the palace itself, Louis erected stables, dining halls, and buildings for the growing governmental staff. The focus on the exhibition of the ruler raises interesting parallels with Iran and India, where Shah Jahan also equated himself with the sun, but the form of Versailles—an entirely enclosed series of contiguous blocks—makes a more obviously monumental impression, especially in the bird's-eye views that were at the time a popular European means of depicting such estates.

In the Hall of Mirrors, Le Brun paired a wall of mirrors with a long row of windows (Figure 11.4). The technical difficulty and expense of this undertaking was enormous. The mirrors were made in a new French factory established to compete with Venetian glassworks. High light levels showed off Le Brun's ceiling paintings, which depicted France's recent success in a war against the Netherlands. The scale of the space and the richness of the materials are the story here rather than the spatial drama that was key to the work of Bernini and Borromini, but the mirrors certainly contribute an effect of insubstantiality that would be much imitated in European palaces for more than a century to come. The room was designed specifically to impress diplomats, emissaries from the courts of Louis's chief rivals, whom he received amid its splendor.

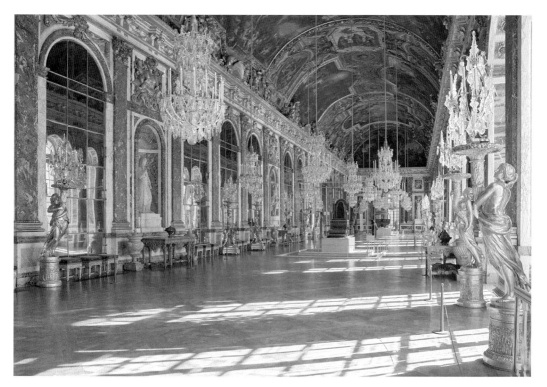

Figure 11.4. Jules Hardouin-Mansart and Charles Le Brun, Hall of Mirrors, Versailles, 1678–84.

Versailles's distance from Paris enhanced Louis's ability to control both the place and the people who inhabited it. This included almost the entire French aristocracy. He held them virtually hostage at court, forcing them to live within the palace itself rather than on their individual estates. Here they, like his many foreign visitors, were constant witnesses to splendid rituals that enhanced Louis's prestige and with it that of the French state. Ceremony was far more important than privacy in the carefully scripted ritual of French court pageantry. From the time the king awoke in the morning until he retired at night, he was always in the public eye. The aristocrats upon whom he kept a watchful eye as they waited upon him had no time or space to plot revolt. Molière, the French playwright, described the responsibilities of courtiers:

Kings love nothing so much as ready obedience, and hate to meet with obstacles. Things are never good but just when they desire them, and to defer their diversion, is to deprive them of all the agreeableness with respect to them. They'd have pleasures which may not make 'em wait, and what is least prepared, is always most pleasing to them. We ought never to regard our own convenience in what they desire of us; all our business is to please, and when they lay commands on us, 'tis our duty to improve with speed what they desire. We had better acquit ourselves soon enough; and if we have the shame of not succeeding, we have however the glory of a quick obedience.

The entrance facade at Versailles, which contained the kernel of the earlier palace, never achieved absolute coherence. The same cannot be said for its counterpart facing the garden, however. Here Le Vau created, with the assistance of Jules Hardouin-Mansart and Le Brun, a compelling design that maintains its power over the seventeen bays of the Hall of Mirrors and well beyond. The enormous palace also contained apartments for all the important members of the royal family, including the queen, the king's son, his grandson, and his legitimated children by his mistresses, as well as more modest accommodations for the courtiers.

The gardens at Versailles were even more extensive than those at Vaux. If Bess's gaze out from the long gallery of Hardwick Hall gave her command of the surrounding territory, and Shah Abbas viewed the proceedings on the Maidan from the Ali Qapu, on how much greater a scale could Louis XIV look out over his dominion, which here demonstrated a command, as it did not at Hardwick Hall, of both ideal geometry and modern engineering. The baroque garden displays the power of those who built and maintained it with an immediacy masked in its Renaissance counterpart. The garden's basic features are immediately visible. Close to the palace itself were parterres. Broad paths separated these from one another and provided a place for strolling. Although small, shallow ponds, also called *bassins,* accented by fountains were set into the parterres, the larger water elements were located at a greater distance from the palace and were flanked by woodlands, within which were tucked a variety of grottoes and pavilions and yet more fountains. The largest water feature of all, the Grand Canal, stretched to the horizon.

The scale and technology of this garden easily impressed its viewers, who ranged from diplomats and courtiers to the workers charged with its creation and upkeep. Like the palace itself, the garden provided ample backdrops for courtly ritual, including complex spectacles staged in honor of visiting ambassadors. Sculpture was key to the meaning of the garden, which appeared to be inhabited by classical gods and goddesses as well as courtiers. The allegorical equivalence between Louis and Apollo, the sun god, was particularly important, and the Apollo Fountain was one of the garden's central features. Nor were the fountains and sheets of water purely ornamental. They demonstrated the king's ability to control nature as well as France. The Grand Canal, for instance, represented France's expanding maritime power, which encompassed a new international commercial as well as military presence. The discipline that the king and Le Nôtre, his garden designer, exercised over the land extended even to the surrounding forests. These were carefully planted and maintained for hunting, with straight paths threaded through them as well, and dotted with secluded destinations for strolling courtiers.

Versailles was the largest and most splendid palace ever erected in Europe. It was both the instrument and the representation of Louis's authority as the absolute monarch of Europe's wealthiest and most powerful state. By building it, Louis reined in the independence of the aristocracy, appropriated the new emblems of the bourgeoisie, and exhibited his authority to both French and foreign audiences in a way that cemented his power. Not surprisingly, this display of raw power dressed up in high art appealed to other monarchs. In 1703, the Russian czar, Peter the Great, founded the city of Saint Petersburg. Peter had several reasons for building a new capital, one that would replace Moscow. Above all, he sought to modernize both the appearance and the reality of the Russian state.

As early as the fifteenth century, Italian architects and engineers had traveled to Moscow, where they introduced new architectural and military technologies. During the Renaissance, technology transfer facilitated ever more complex elaborations upon prized local architectural traditions. This is a precolonial model of architectural influence in which cultural authority was retained by the importers. Czar Ivan the Terrible erected the cathedral of Saint Basil the Blessed in Moscow between 1555 and 1561 to celebrate his recent victory over the Tatars (Figure 11.5). The design, by Postnik Yakovlev, symbolized Ivan's ambition that Moscow, following the fall of Jerusalem and Istanbul to Muslims, should be the new Jerusalem. Because the Russian Orthodox Church recognized the primacy of the Orthodox patriarch in Istanbul rather than the pope in Rome, the Russians had no reason to attempt to adopt ancient or modern classical forms. Thus, although Italian technology was essential to its construction, Saint Basil's intricate and colorful nine domes are rich elaborations of Byzantine imagery. Today simpler onion domes continue to denote Russian Orthodoxy in churches around the world.

Peter's new city had a far more direct relationship with European precedent for the good reason that the czar was now trying to join Europe rather than rival the

Figure 11.5. Postnik Yakovlev, cathedral of Saint Basil the Blessed, Moscow, Russia, 1555–61.

splendid past of the Byzantine Empire or the Middle East. By 1700 he had much more to gain in terms of technology and trade from looking at France, Germany, the Netherlands, and Britain than had been the case for his predecessors more than a century earlier. In particular he adopted an architectural vocabulary that stressed his personal authority at the expense of the aristocrats he left behind in Moscow. Equally important was the physical distance Peter put between himself and his other rivals for authority, the leaders of the Russian Orthodox Church. In Moscow, for instance, as in Kraków, major churches were sheltered within the walls of the imperial palace, known as the Kremlin. This would not be the case in Saint Petersburg.

Peter placed the new city directly on the Baltic, on land he had recently conquered from Sweden. Saint Petersburg thus enjoyed closer contact with the rest of Europe than did Moscow, which was hundreds of miles to the southeast. By beginning anew Peter created a modern European city, one that posed a compelling challenge to the general view of Russia as one of the continent's most remote and economically underdeveloped nations. Inhabiting a modern environment, Peter hoped, in a dream shared by ambitious founders of new cities ever since, would help mold his subjects into modern men and women.

Both seventeenth-century Rome and Versailles provided precedents for the trident motif of Saint Petersburg's major streets (Figure 11.6). Peter's initial grid plan was quickly distorted by more rapid development to the south, especially along Nevsky Prospect, which became the city's most important street. More than a century after

Figure 11.6. Plan of Saint Petersburg, Russia, begun 1703, map 1776.

Henri IV's death, urban and political order coincided here in the creation of repetitive facades.

The original kernel of the city was the Peter and Paul Fortress, begun in 1706, built to defend against possible Swedish attackers. Its star form is an excellent example of contemporary state-of-the-art fortifications. By the sixteenth century, cannons had rendered the walls of medieval cities obsolete. Renaissance and baroque cities featured low, sloping walls ringed by vast open spaces edged with ditches. Like much of early Saint Petersburg, the fortress was built by huge numbers of conscript laborers (in other words, by slaves). This was a simultaneous demonstration of Peter's authority and of Russian remoteness from the market economics fueling economic growth in other parts of Europe and the world. Many died during the fortress's construction as a result of the atrocious working conditions.

Within the fortress stands the slightly later church of Saints Peter and Paul, erected between 1712 and 1732 (Figure 11.7). Domenico Trezzini designed the church, the first structure in the city to be built of stone. Peter imported technical experts, craftsmen as well as professionals like Trezzini. Just as the resemblance of the city's plan to that of Le Nôtre's gardens marked Saint Petersburg as modern, so the architecture of this church indicated Peter's rejection of Russian traditions. Since the importation of Christianity into the country in the Middle Ages, Russian Orthodox churches had been centrally planned and capped by at least five domes. Saints Peter and Paul instead has a classical facade and an enormous spire, which continues to be one of the city's most prominent landmarks, as well as a basilican plan. Even by the standards of the Netherlands and England, where church spires continued to punctuate city skylines, this was an unusually tall urban marker.

The first palaces in Saint Petersburg were enormous but built of wood. All later burned, often in spectacular fires. The main imperial palace was the Winter Palace (in summer the court moved to the countryside), erected between 1754 and 1764 by Peter's daughter the Empress Elizabeth, who ruled in her own right and completed the city her father had started (Figure 11.8). Her architect, Bartolomeo Rastrelli, although of Italian descent, was raised at Versailles, where his father worked as a sculptor, and in Russia. The Winter Palace was the largest urban palace in Europe, but it was built far more cheaply than Versailles, of brick covered in stucco, which was originally painted a sand color that made it resemble stone. Funds from taxes on alcohol and salt paid the bills.

Although the interior of the Winter Palace has been extensively rebuilt, the facade facing the Neva River appears much as it did in Elizabeth's time. A rhythmic process of engaged columns, some supporting pediments, runs the length of the three-story facade. The central three bays, capped by a pediment, are no more ornate than the nine-bay-long pavilions that terminate each end of this elongated composition. Indeed, much of the architectural interest is provided not by the classical orders but by the ornate window treatments, whose decorative twirls and twists often broke with ancient Roman precedent.

Figure 11.7. Domenico Trezzini, cathedral of Saints Peter and Paul, Peter and Paul Fortress, Saint Petersburg, Russia, 1712–32.

Throughout the first half of the eighteenth century, Versailles continued to serve as the model for European palaces. From Stockholm in the north to Naples in the south and Saint Petersburg in the east, emperors, kings, and more minor princes erected enormous baroque palaces. In particular, large numbers of such palaces were built in central Europe. The collapse of the authority of the Holy Roman Empire at the end of the Thirty Years' War in 1648 left much of what is now Germany fragmented into very small but prosperous states. One way in which this stability was expressed was in the erection of fashionable new palaces.

Some of these were for bishops who, together with the occasional abbess, ruled as princes as well as religious leaders over a handful of dioceses and archdioceses and an even smaller number of convent towns in the Catholic parts of the empire. Their titles often passed from uncle to nephew or aunt to niece. Successive prince-bishops of Würzburg erected the most splendid of all the new central European palaces. Very modern art and architecture buttressed, perhaps not very effectively, what was by the middle of the eighteenth century an increasingly anachronistic political system.

Previously the prince-bishops of this small southern German principality had their easily defensible seat high above the city, like the kings of Poland in Kraków or the maharajas of Jaipur in Amber. Now they came down to a site just within the city walls where Johann Balthasar Neumann built their palace between 1720 and 1744. The Residence provided an appropriately grand dwelling for the prince-bishop. It also served as a combination of a modern office building and living quarters for members of the court, from servants to administrators.

Nothing on the stone facades facing the U-shaped entrance court or even the more informal garden facades, from which the oval character of the principal reception room can be easily discerned, prepares visitors for the drama within. One reaches the great stair through an almost gloomy forest of columns. Neumann traveled to Paris and Vienna, the two most important European architectural centers of the time, to consult with his leading colleagues about the stairs' design. He built a wooden truss that covered what was for the period an enormous clear span. But almost no one, then or now, noticed. The clear articulation of structure that characterizes so much medieval and modern architecture in Europe was not a concern for baroque architects. Instead the entirely invisible truss is but a means to an end, its entire apparatus hidden, indeed displaced from our consciousness by the work of the painter Giambattista Tiepolo, imported from Venice to paint the splendid ceiling (Figure 11.9).

As one ascends, one's attention is also drawn upward by the light that pours in from the courtyard windows and illuminates the ceiling. Its purpose, ridiculous if it were not so beautiful, was to glorify the prince-bishop as the ruler of the four corners of the known world. Europeans had by this point colonized much of Africa, the Americas, and Asia, but Würzburg, located hundreds of miles inland and without a navy, played absolutely no role in these far-flung enterprises. Indeed, the prince-bishop had only several tens of thousands of subjects inhabiting several

Figure 11.8. Bartolomeo Rastrelli, Winter Palace, Saint Petersburg, Russia, 1754–64.

Figure 11.9. Johann Balthasar Neumann, stair hall, Residence, Würzburg, Germany, 1720–44. Fresco decoration by Giambattista Tiepolo, begun 1750.

hundred square miles of land. We find here not a representation of reality but the expression of the client's clearly impossible aspirations. The scale of the Residence and the ambition of its decoration had little relationship to the severely limited authority of the prince-bishop. They constituted, however, an effective demonstration of his extraordinary taste, which brought together one of Europe's most talented architects and one of its most talented painters to celebrate this fictive power, whose illusionary character is highlighted by the way in which figures step out beyond the ceiling's boundaries.

This integration of painting and architecture equal Bernini's fusing of painting and sculpture in the Cornaro Chapel. The lightness and airiness of the result are new, however. Neumann's white walls and Tiepolo's pastel colors replaced the richly colored marble of the Cornaro Chapel and gold leaf of Versailles. These are, however, to be found, albeit in a lighter key, in the white-and-gold *Kaisersaal,* or imperial room, and in the chapel. They are as characteristically rococo as the stylized natural forms Neumann often substituted for correct classical detailing. This highly ornamental style, used mostly for interior decoration, had its origins in French circles challenging the absolute authority of the French monarchy in the early eighteenth century after the death of Louis XIV. Originally related more explicitly to pleasure than to politics, it was employed in Paris in settings whose scale was far more intimate than that of Versailles. At Würzburg, however, the decorative excesses of the rococo were applied on a scale that remained truly baroque.

The identification of baroque art and architecture with absolutist politics enhanced the appeal of the baroque for ambitious seventeenth- and eighteenth-century European rulers. They found in the baroque a compelling imagery of a control that was seldom as complete as it appeared from the decoration of their palaces and the organization of their gardens. Far more rigid in northern and central Europe than in Italy, it often implied an attempt to subjugate as well as to impress. The association of these forms with royal and Catholic authority limited their appeal, however, to those who prized their relative independence from that control. Whether Renaissance, baroque, or rococo, secular or sacred, this architecture was one of the innovative effects created to enhance political and religious institutions and experiences that by the middle of the eighteenth century often seemed outmoded. Yet these effects endure, popular with the public, for whom they still serve as shorthand for real luxury, despite the fact that many architects and tastemakers have for more than two centuries condemned them as irrational. For many, the craftsmanship and the splendor of the baroque are entirely detachable from their original purposes. Their continued appeal is illustrated by the Soviet Union's loving restoration of the Winter Palace after it was badly damaged during World War II and by press images of diplomats perched on rococo chairs in foreign ministries and presidential palaces around the world.

FOR FURTHER READING

On Henri IV's changes to Paris, see Hillary Ballon, *The Paris of Henri IV: Architecture and Urbanism* (Cambridge: MIT Press, 1991). My discussion of the gardens at Vaux and Versailles is based on Chandra Mukerji, *Territorial Ambitions and the Gardens of Versailles* (Cambridge: Cambridge University Press, 1997). On Versailles, see also Robert W. Berger, *Versailles: The Château of Louis XIV* (University Park: Pennsylvania State University Press, 1985); Guy Walton, *Louis XIV's Versailles* (Chicago: University of Chicago Press, 1986); and Michel Baridon, *A History of the Gardens of Versailles* (Philadelphia: University of Pennsylvania Press, 2008). On Saint Petersburg, see William Craft Brumfield, *A History of Russian Architecture* (Cambridge: Cambridge University Press, 1993); and James Cracraft, *The Petrine Revolution in Russian Architecture* (Chicago: University of Chicago Press, 1988). Neumann's contribution to the Würzburg Residence is addressed in Christian Otto, *Space into Light: The Church Architecture of Balthasar Neumann* (New York: Architectural History Foundation, 1979); Tiepolo's is discussed in Michael Levey, *Giambattista Tiepolo: His Life and Art* (New Haven, Conn.: Yale University Press, 1986).

12 City and Country in Britain and Ireland

By the middle of the seventeenth century, mercantile capitalism had unleashed major changes in the appearance of cities and buildings. From Amsterdam to Edo (present-day Tokyo) and along the seacoasts of Africa and the Americas, cities and their rural hinterlands were increasingly organized to participate in international trading networks. Although the seventeenth century is remembered across Europe and Asia as an age of absolutism, in which powerful emperors such as Louis XIV and Shah Jahan wielded unprecedented authority, the new emphasis on the production and consumption of commodities provided many nobles, merchants, and artisans with exciting new opportunities, even as others, including many peasants, slaves, and indigenous Americans, were subjected to newly rationalized forms of oppression. Nowhere were these processes more advanced by the eighteenth century than in Britain and Ireland, where the Stuart dynasty's claims to royalist absolutism had been effectively checked by the execution of Charles I in 1649 and the overthrow of his son James II thirty-nine years later. Here urban architecture, as in seventeenth-century Amsterdam, was less often the expression of state or dynastic authority and more closely related than ever before to market forces. Although these political and economic changes spawned an unprecedented diversity of urban environments, the immediate result was not always the chaos now widely associated with capitalist real estate speculation; rather, it was often a series of relatively orderly spaces and buildings and an equally disciplined and productive countryside.

The Glorious Revolution of 1688, in which James II was toppled in favor of his daughter and Dutch son-in-law, Mary II and William III, clearly established the political power of British landowners and cemented their control over Ireland. Throughout the eighteenth century, the British had a weak monarchy but a strong oligarchy, in which power was shared among the members of a relatively broad elite

composed of peers and gentry in the countryside and successful professionals and businessmen in the cities. This power came at the expense of both the monarch and the rest of his or her subjects. The welfare of many of the latter actually declined over the course of this period. Throughout the eighteenth century, the architectural taste of the British elite was interlocked with the political philosophy with which they expressed their right to rule over both the countryside and the capital.

Since the Middle Ages, London, like Kraków, has had two major centers: Westminster, where the Parliament and the royal palace remain today, and the City, originally the stronghold of the upper-middle class. Each had its own monumental medieval church. Westminster Abbey in the west is the royal counterpart to Saint Paul's Cathedral in the City. In 1666, in one of the greatest urban conflagrations of world history, the City of London—but not Westminster—burned. Most of its medieval fabric was destroyed. The fire sparked intense debate over the City's future. This debate took place in the context of the various attempts the four Stuart kings had made to impose Italian Renaissance architecture, French-style rule, and Roman Catholicism on a population whose members steadily resisted what they saw as the erosion of their cherished rights. Sixteenth- and seventeenth-century European cities were often shaped by political absolutism or the appearance of absolutism. Amsterdam, the capital of a republic, was one important exception to this phenomenon; London in the wake of the fire asserted itself as another.

Christopher Wren, the royal astronomer, proposed changing the City completely (Figure 12.1). In a plan clearly influenced by Rome and Versailles, he envisioned replacing its medieval warren of streets with broad baroque boulevards. London was not, however, rebuilt along these grandiose lines. Eventually, King Charles II, Parliament, and City officials chose to preserve the City's street network. Parliament,

Figure 12.1. Christopher Wren, city plan, London, England, 1666.

although an elected body, was composed exclusively of representatives of the nobility and the church (the House of Lords) and the gentry and upper-middle class (the House of Commons). Why was Wren's design rejected? First, the government was extremely hesitant about infringing on the rights of the City's individual property owners. Most of these people wanted to rebuild as quickly as possible, and that would be easier if existing property lines were retained. Second, because Charles did not possess the right to tax his subjects, no money was available for grand new designs, no matter how skillfully conceived. Finally, the English, like the Dutch, continued to have doubts about continental fashions. For them the baroque was too firmly associated with both Catholicism and absolute monarchy. Parliament did implement a building code requiring that new construction be of brick, with wood reserved for door and window frames, but respect for private ownership ensured that landowners rebuilt their individual buildings on the plots they already owned.

In the aftermath of the Great Fire, Wren's emerging architectural talent nonetheless received ample opportunities. Among the victims of the fire were the City's cathedral and more than two dozen of its parish churches. Wren supervised the rebuilding of them all. The number of churches in this district of the City and the prominence of their spires in defining the skyline tell much about the London that had burned. In the seventeenth century individual churches still defined the dense neighborhoods within the City, while the cathedral was its most important landmark. In steeples like that of Saint Bride's, first erected between 1670 and 1674 in what later became London's vibrant newspaper district, Wren established a successful new paradigm that conflated medieval urban typology—the spire as urban marker—with modern classical detail (Figure 12.2). Two and a half centuries after Brunelleschi, imported Italian forms remained rare in England. The neighborhood around the church was composed of relatively homogeneous brick row houses mandated by new building codes. Woven into this fabric were taverns and shops.

The cathedral was Wren's most important commission. The new Saint Paul's, like many of its medieval predecessors, took decades to construct (Figure 12.3). Begun in 1675, it was not completed until 1710. The English had not built a new cathedral since the Reformation; these constructions remained rare throughout Europe, where the towering structures erected during the Middle Ages continued to serve their purpose. In the context of a cathedral, Wren was able to insist on the grandeur of a great dome. This one's triple shell married the complexity of the section of Borromini's San Carlo alle Quattro Fontane to the scale of Saint Peter's. The relatively shallow dome, visible from the crossing, with an oculus that glows with light that enters through the lantern, is wrapped in not one but two superstructures. The first, a brick cone wrapped in iron chains, helps support the weight of that lantern. The second, erected out of wood covered with lead, establishes the bold profile that has long dominated the London skyline.

Even at Saint Paul's, the British embrace of the baroque had its limits. The sweeping curves of Wren's original model proved too redolent of Bernini for local tastes.

Figure 12.2.
Christopher Wren,
Saint Bride's, London,
England, 1672–1703.

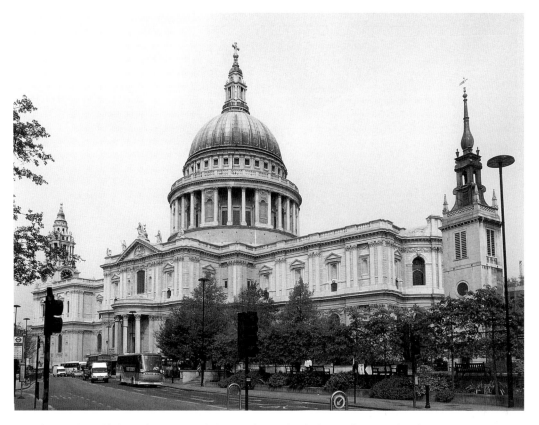

Figure 12.3. Christopher Wren, Saint Paul's Cathedral, London, England, 1675–1710.

A Latin cross was retained in its stead, and Wren adhered to medieval precedent as well in engineering the structure of the buttresses tucked into the walls, while modernizing cherished prototypes through the application of classical ornament.

Saint Paul's was an extraordinary situation, one that demanded a singular solution. Although it quickly became one of the city's most cherished landmarks, it was seldom imitated, as no other churches of its size were needed. Instead, it was the new parish churches that established the paradigm for the Church of England and for some of its dissident offshoots, as the adherents of these churches colonized the North American seacoast and established trading centers in India. The great wave of London church building entrusted to Wren following the fire remained exceptional, however. Until the middle of the nineteenth century, relatively few new Anglican churches were built in England. An important exception, prominently located in London's fashionable West End, was Saint Martin-in-the-Fields, designed by James Gibbs and erected between 1721 and 1727 (Figure 12.4). Gibbs added a temple front to the Wren model. This juxtaposition of a pedimented portico with a prominent steeple broke all the classical rules, but the appeal of the conjoined symbols was enormous. Gibbs wrote a famous pattern book, and copies of this church

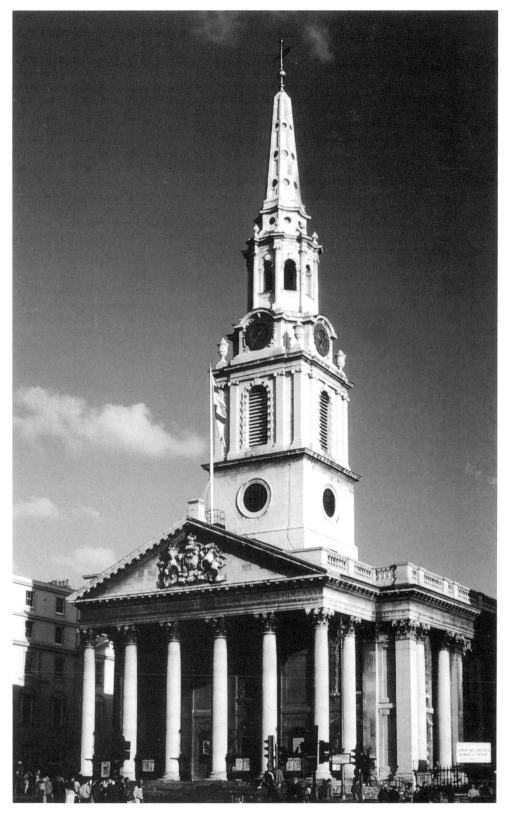

Figure 12.4. James Gibbs, Saint Martin-in-the-Fields, London, England, 1726.

sprung up relatively quickly, especially in North America, where imitations have been built almost without interruption ever since.

The demands of the Anglican liturgy, which in the seventeenth and eighteenth centuries emphasized the word of God rather than the sacrament of Holy Communion, were crucial to the design of the interiors of the new London churches (Figure 12.5). The lectern from which the clergyman read the lesson and the pulpit from he preached the sermon were the focal points of these spaces, not the altar. The addition of galleries to the medieval nave-and-aisle plan facilitated church-goers' seeing and hearing his performance.

The destruction wrought by the fire was one factor that encouraged those eighteenth-century Londoners who could afford it to move to new districts in the West End. Here in Westminster, proximity to the court and to Parliament provided higher social status as well. London's new neighborhoods, as well as their counterparts in Edinburgh and Dublin, married the royal squares of Paris to the more egalitarian urbanism characteristic of seventeenth-century Amsterdam. Private real estate development rather than royal decrees governed the construction of these

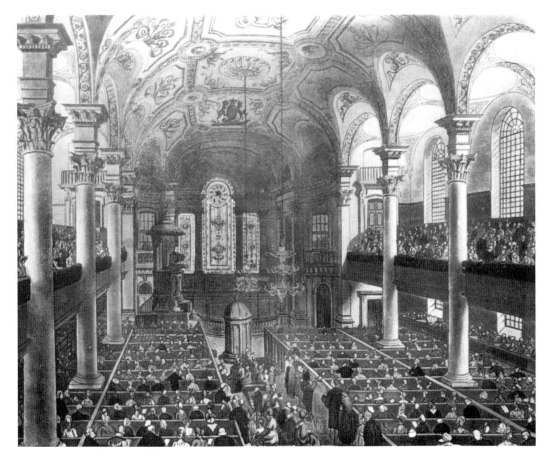

Figure 12.5. Interior, Saint Martin-in-the-Fields.

environments. In the fifteenth through the seventeenth centuries, secular and sacred authority consistently surpassed capital's ability to shape buildings. By the eighteenth century that situation had clearly changed, at least in British and Irish cities. Rather than being laid out by the king or the Parliament, eighteenth-century London, Edinburgh, and Dublin were all constructed by individual landowners. Market forces and the existence of a vibrant urban middle class combined to create surprising homogeneity—almost all Londoners lived in the same basic house type—as well as a diversity expressed in the development of new building types such as coffeehouses and banks. The relative standardization of house construction lowered construction costs and facilitated the consideration of dwellings as commodities. Houses could be more easily sold or rented if they conformed to tastes that spanned increasingly fluid social boundaries in which wealth, more than birth, determined the scale and quality of the conditions in which people dwelled.

Across the course of the eighteenth century, Bloomsbury, the area north of Westminster, was laid out around a series of squares. The land belonged for the most part to a single family that became Dukes of Westminster in recognition of their enormous new wealth. They retained ownership of the property, which they rented out on ninety-nine-year leases. The squares were fronted by row houses owned or rented by urban professionals and merchants or by members of the rural aristocracy and gentry. The latter were most likely to spend part of the year in London if they were active at court or in Parliament or had daughters to marry off. Although largely built on spec a few at a time by carpenters, these residences usually shared a fairly uniform appearance. Three bays wide and two to three rooms deep, they rose from two to four stories, depending on the value of the land.

The squares themselves gave light and prominence to the houses of the well-to-do. Merchants and artisans lived and worked in the streets between them. Their houses, although almost identical in appearance and plan, were smaller and housed more people, some of them in rented rooms. The sizes of individual rooms offered the best measure of the economic status of the inhabitants. In less genteel circumstances, shops rather than parlors occupied the ground story front rooms.

Although architects were seldom involved in the design of these squares, by the end of the eighteenth century, as Bedford Square, which dates to 1776, demonstrates, they were increasingly being developed as if the individual houses were part of a larger palace (Figure 12.6). This allowed the tenants of these buildings to share in the sense of grandeur that a central pedimented pavilion bestowed on the entire row. The production of such a uniform environment relied not only on the relatively homogeneous taste of those who would occupy it but also on the literate builders and carpenters, working from pattern books and construction documents, who financed and erected it. Also involved in the construction of this environment was one of the most extraordinary businesswomen in eighteenth-century Britain. Many of the standardized trimmings on these houses were prefabricated of Coadestone, a cement-like substance invented, manufactured, and marketed by Eleanor Coade.

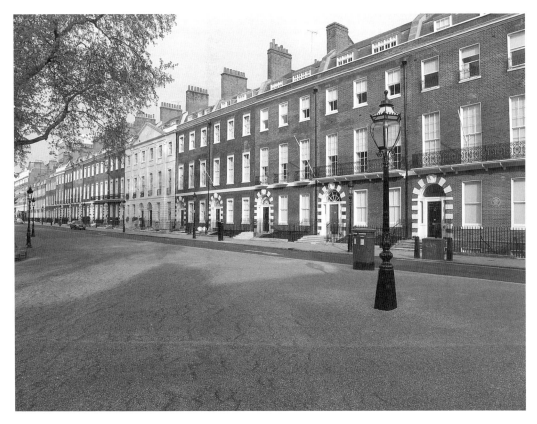

Figure 12.6. Bedford Square, London, England, 1775–86.

Although at first glance there appears to be little room for individuality in the domestic streetscapes of Amsterdam, Edo, and London, in fact a rich assortment of building types were developing, largely at the behest of the urban middle class. Although in London most looked like houses, new political and economic institutions hinted at the explosive variety that would characterize the nineteenth-century city. In London, many of these new building types could be found in the City, the rebuilt commercial core, which was being redeveloped as the financial center for the increasingly far-flung British Empire and provided capital for the nascent Industrial Revolution. Residents of all classes were forced out—the upper class moved west, the middle class north, and the working class east—by the increase in property values, as for the first time an almost exclusively commercial district developed within a European city. The linchpin of the City was the Bank of England. From 1788 to 1833, the bank's building was transformed by the architect John Soane. Only the external corner of his building survived a comprehensive reconstruction in the 1920s. Soane's bank was shaped as much by programmatic concerns as by the architect's eccentric spatial genius and his fashionable interest in Roman and Greek antiquity.

For security reasons the complex had no exterior windows; its fireproof construction was instead topped with skylights. The main interior halls, such as the colonial office, designed in 1818, featured shallow domes supported on terra-cotta vaults (Figure 12.7). Customers filled the center; staff remained at the sides. Grandeur was particularly important because the monetary system supported by the bank rested on trust, as the bills issued by the bank were no longer backed by bullion. The new kind of space invoked classical precedents, such as Roman baths, without directly quoting them in what instead became a boldly innovative architecture for a modern empire. Height and light both mattered here, and Soane invented a new architecture to provide them. He coupled the lightness of Gothic engineering (realized, however, through different materials) with just enough classical details to impart the necessary decorum at minimum expense. The result was modern in its efficiency and simplicity while not entirely devoid of ornament. Although the base of the dome was ringed with conventional Corinthian columns, for instance, the pendentives upon which it sat were edged with moldings for which there were no classical precedents.

Throughout the eighteenth century, London boomed. Much of the money that was made there and throughout the empire was reinvested in land. Neo-Palladian

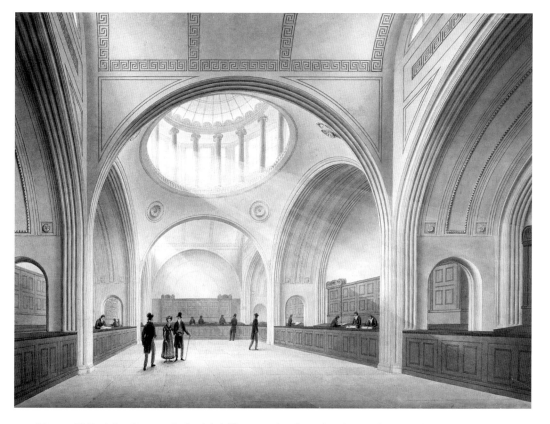

Figure 12.7. John Soane, Colonial Office, Bank of England, London, England, 1818.

architecture and picturesque landscape architecture developed as expressions of a particular political ideal: liberty. In the 1720s, Richard Boyle, Lord Burlington, one of England's wealthiest peers, began to formulate an architectural expression of his class's political rights. Its first fruit was the villa that he built himself at Chiswick, just outside London, beginning in 1725 (Figure 12.8).

Lord Burlington, not the king, was the major British patron of the arts of his day. In addition to architecture, his interests encompassed painting, poetry, and music. His circle included the painter, architect, and landscape gardener William Kent, the poet Alexander Pope, and the German-born composer George Frideric Handel. He was a member of the Whigs, the British political party that most strongly advocated constitutional restraints on the power of the monarchy. Much of the appeal of the architecture Burlington sponsored lay in its creation of imagery appropriate to this more diffuse power structure, centered on wealthy landowners rather than on the royal family.

Burlington was a gentleman architect. Instead of inventing new architectural forms, he turned to the example of Palladio in particular and the Renaissance villas of the Veneto in general for inspiration. Not content with working from Palladio's own *Four Books,* he amassed an impressive collection of his predecessor's original drawings. He did this when he traveled to Italy in his twenties, as many Englishmen of his class did in the final step of their education. Burlington's architecture relied

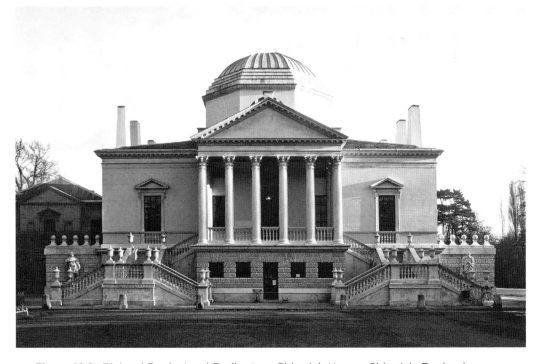

Figure 12.8. Richard Boyle, Lord Burlington, Chiswick House, Chiswick, England, 1725–29.

heavily on treatises and precedent. Following what were understood to be the rules of the classical orders was for eighteenth-century British gentlemen a demonstration of their adherence to the laws that they also believed both justified and governed their political rights. Many equated their political system with that of republican Rome, also an oligarchy. They appreciated that Palladio had published reconstructions of ancient Roman buildings, whose temple fronts his own villas reproduced, and recognized that many of his patrons had been members of another landowning oligarchy, Venice's merchant elite.

Chiswick House was not an exact copy of any particular villa but a synthesis of several, not all of them designed by Palladio. Above all, it was Burlington's critique of the baroque. Like its predecessors in the Veneto, it was modest in scale, especially in comparison to the country houses of Britain's leading noblemen. The plan was a compact block, without the enfilade of rooms arranged into apartments that characterized more palatial settings. In fact, it was just an appendage to a much larger older house that has since been demolished. Burlington used the villa, located a short distance outside London, mostly for entertaining.

Why did a man as wealthy as Burlington build on a modest scale? For Burlington, the monumental country house in the midst of the rural domain of a great nobleman was insufficiently distinct from the type of house built by royalty. A noble's right to political power resided, he believed, in part in the moral character supposedly imparted by his distance from the court and what he believed to be the pure rural origin of his wealth and political power. The contrast was consequently not only with the Crown but also with the increasingly prosperous urban middle class, who soon appropriated the villa type. For the latter, a villa served as a family's only residence, allowing the members to live in quasi-rural, suburban surroundings within easy reach of their countinghouses and law courts.

The interiors of Chiswick House departed radically from baroque and rococo precedent (Figure 12.9). In place of these styles' characteristic blurring of the border between wall and ceiling ornamented with gilt decorations whose tendrils increasingly broke free of classical conventions, Burlington favored a strict adherence to rectilinear geometry; those curves that survive are segments of circles rather than ovals. The square plan features seven rooms, four of them rectangular, ringing a domed octagonal hall. Only at the garden end, where a library and a boudoir open off a hall with apsed ends, do things become more complex. Burlington based the house's columned screens and niches on ancient Roman precedent as understood by Palladio and other early modern sources. He did not embrace the innovation present, for instance, in Soane's later bank interiors, but he gave persuasive architectural form, however unoriginal, to the most important political beliefs of his class and opened up the architectural profession to the members of that class, for whom it would continue to be an important activity for nearly a century.

Throughout the eighteenth century English, Scottish, and Irish nobles, as well as those who aspired to their status, built impressive country palaces on their rural

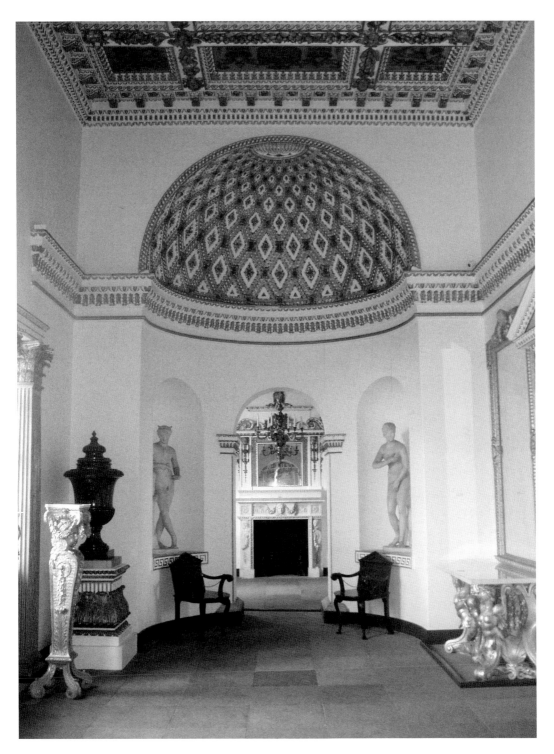

Figure 12.9. Gallery, Chiswick House.

estates that doubled as architectural fashion plates. For decades most were in the Palladian style popularized by Burlington.

The first and largest modern classical house in Ireland was built not by a member of the nobility, however, but by William Conolly, who rose from very modest circumstances to be Speaker of the Irish House of Commons. His wealth came from dealing in land confiscated from Catholics, a source as well of Burlington's fortune (in addition to being second Earl of Burlington, he was third Earl of Cork). Work began on Conolly's country seat, Castletown House, in 1722 and finished about seven years later (Figure 12.10). Far more than the English, the Irish employed Italian architects and craftsmen. Alessandro Galilei designed the facade during a brief visit to Ireland; the rococo plasterwork in the double-story central hall is by Paolo and Filippo Lafranchini. An Irish architect, Edward Lovett Pearce, added the colonnades and the service wings and may have laid out the original interior. The house's principal inhabitants during its first century were Conolly's widow, Katherine, and his great-niece by marriage, Louisa. Many of the most splendid surviving rooms date to the redecoration supervised in the 1760s by Louisa; both women were also active in designing the parkland surrounding the house.

Burlington's interests were not confined to architecture. Equally important was the way in which, in concert with William Kent, Burlington helped pioneer a new

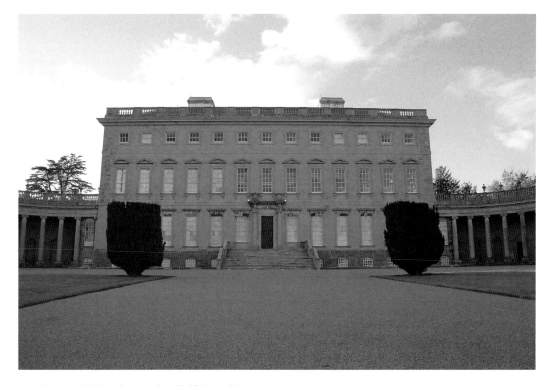

Figure 12.10. Alessandro Galilei and Edward Lovett Pearce, Castletown House, County Kildare, Ireland, begun 1722.

approach to landscape gardening. This, too, was intended to express the political independence of the British landowning aristocracy and gentry. At Chiswick and in other gardens designed and erected by members of Burlington's circle, a new and enduring alternative to French gardens such as Vaux and Versailles emerged.

Seeing Castletown in its landscape setting, one has the sense of a palace set into open land. Indeed, it is precisely in eighteenth-century Britain and Ireland that landscape began to be appreciated as a site of leisure, including strolling and hunting, rather than of productive agriculture. Actual farming was usually invisible in the immediate environs of these houses. The picturesque gardens that surrounded them, beginning at Chiswick, were above all the products of the ongoing transformation of the British and Irish countryside by acts of enclosure. During the medieval period, an individual tenant farmer might till lands in several long strips in different parts of a single landowner's estate, while other lands would be held in common, particularly for grazing. These practices supported a great number of people on the land, but they did not generate great revenues for the landowner. From the late sixteenth through the eighteenth centuries, the British agricultural landscape was completely transformed as landowners consolidated land use, shifting in many cases away from extensive cultivation of grains toward grazing and in others draining formerly marginal lands. The new ways were far more economically efficient, yielding increased incomes for those who owned the land and greatly expanding the food supply. In Ireland a more radical displacement occurred as most Irish and Anglo-Irish landlords, especially the majority who continued to adhere to Catholicism, lost their lands across the course of the late sixteenth and seventeenth centuries to successive waves of Protestant colonists from England and Scotland or to descendants of recent converts like Conolly. The newly efficient means of using the countryside depended on its rational organization. This was facilitated and documented through the use of increasingly sophisticated methods of surveying and mapping. These provided new means of documenting who owned what land and assisted the many military campaigns that facilitated changes in ownership. In Ireland, the creation of maps proved tantamount to the conquest of the territory they described.

Modernization disproportionately benefited those who already had political and economic power. For many who tilled the land, enclosure meant losing the right to farm enough to support themselves. They were often forced off the land. Irish peasants and the Highland Scottish supporters of the deposed Stuart dynasty fared particularly badly; together with their English counterparts they eventually provided much of the labor force crucial for the twin engines of Britain's increasing wealth: colonization and industrialization.

Across the eighteenth century, the style of landscaping employed by Kent at Chiswick was elaborated upon. This was accomplished in part through the use of ditches, called ha-has, that kept livestock from trespassing onto those parts of the park that were lawns, while the outlying meadows became integral parts of the

garden composition. Even more notable than the garden created at Castletown was that at Stourhead, where work began in 1743 (Figure 12.11). Henry Hoare, who supervised their transformation, was a banker. Like many British men who made their fortunes in eighteenth-century trade or nineteenth-century industry, he adhered to the conventions of the landed nobility. His heir, Richard Colt Hoare, became an important theorist of the picturesque.

Stourhead was one of the most complete realizations of this new aesthetic. Here the ideas of liberty, informality, patriotism, and nostalgia came together in a powerful way. One important source for the studied informality of this garden was the Chinese scholar garden, which offered artfully varied visual forms—rocks, trees, water, and pavilions. Another was seventeenth-century landscape painting, especially the work of the French artist Claude Lorrain. Burlington and his circle admired such paintings as visual representations of Roman pastoral poetry; they showed artificial sequences of hills and trees and romanticized the lives of shepherds and shepherdesses, ignoring those who actually tilled the land (*picturesque* originally meant being like a picture).

The garden at Stourhead was at first intended to re-create these pictures, but its design also had political content. Asymmetry was widely understood at the time to pose a challenge to the French garden tradition epitomized by Vaux and Versailles and to the absolutism with which the latter was associated. It was also understood

Figure 12.11. Garden, Stourhead, Wiltshire, England, begun 1743.

to be more "natural" during a period when the discussion of natural law dominated political philosophy.

Stourhead was meant to be experienced as a series of views of and from individual pavilions in the landscape. Originally one's course through the garden, between and around the two irregularly shaped lakes on whose edges the pavilions sit, was intended to re-create the journey described in Virgil's *Aeneid*, a republican Roman epic poem that, like so much else about ancient Rome, served in eighteenth-century Britain to buttress aristocratic claims to political power. The garden pavilions, which are meant to be viewed from afar as much as they are meant to be visited, double as representations of new architectural knowledge. The Temple of Apollo reproduced a recently published ancient Roman temple in Baalbek, in what is now Lebanon. Over time, however, Stourhead came to include references to Britain's medieval past and vernacular present, as Hoare integrated a medieval market cross, the parish church, and a rustic cottage into the composition. This presaged the direction of the picturesque, away from painted precedents and toward an incorporation of a specifically British past and present. Lines from Alexander Pope's "Epistle to Lord Burlington" make clear the spirit of this new approach:

> To build, to plant, whatever you intend,
> To rear the Column, or the Arch to bend,
> To swell the Terras, or to sink the Grot;
> In all, let Nature never be forgot.
> But treat the Goddess like a modest fair,
> Nor over-dress, nor leave her wholly bare;
> Let not each beauty ev'ry where be spy'd,
> Where half the skill is decently to hide.
> He gains all points, who pleasingly confounds,
> Surprizes, varies, and conceals the Bounds.

Two different engines of modernization transformed seventeenth- and eighteenth-century London and its rural hinterland. The first was the capitalist real estate market. Held in check by strong government regulation and elite taste, market forces produced some of the finest and most equitably distributed housing ever built, as well as dramatic new environments such as those Soane designed for the Bank of England. The second was a political philosophy that, although developed to benefit those who were already greatly privileged, would eventually assist many others. Although this expression of liberty originated in an oligarchy, neither the political ideas nor the physical forms it spawned proved to be containable within that milieu. What began as aristocrats upholding their privileges against possible incursions by the monarchy became a call for the political empowerment of the middle and eventually the working classes across Europe and around the world.

FOR FURTHER READING

John Summerson, *Georgian London* (1946; repr., New Haven, Conn.: Yale University Press, 2003), remains the classic work on the subject. See also Kathryn McKellar, *The Birth of Modern London: The Design and Development of the City, 1660–1720* (Manchester: Manchester University Press, 1999); and Damie Stillman, *English Neo-classical Architecture* (London: A. Zwemmer, 1988). On Wren, see Kerry Downes, *The Architecture of Wren* (London: Granada, 1982); and James W. P. Campbell, *Building St. Paul's* (London: Thames & Hudson, 2007); on vernacular architecture, Peter Guillery, *The Small House in Eighteenth-Century London: A Social and Architectural History* (New Haven, Conn.: Yale University Press, 2004); and on the Bank of England, Daniel Abrahamson, *Building the Bank of England: Money, Architecture, and Society, 1694–1942* (New Haven, Conn.: Yale University Press, 2005). For discussion of Chiswick, see John Harris, *The Palladian Revival: Lord Burlington and His Villa and Garden at Chiswick* (New Haven, Conn.: Yale University Press, 1994). On the Irish country house and its English cousins, see Amanda Cochrane, ed., *Great Irish Houses* (Dun Laoghaire, Ireland: Image Publications, 2008); Finola O'Kane, *Landscape Design in Eighteenth-Century Ireland: Mixing Foreign Trees with the Native* (Cork: Cork University Press, 2004); and Mark Girouard, *Life in the English Country House: A Social and Architectural History* (New Haven, Conn.: Yale University Press, 1978). On enclosure and the English garden, see Ann Bermingham, *Landscape and Ideology: The English Rustic Tradition, 1740–1860* (Berkeley: University of California Press, 1986); Tom Williamson, *The Transformation of Rural England, 1700–1870* (Exeter: University of Exeter Press, 2002); and Tom Williamson, *Polite Landscapes: Gardens and Society in Eighteenth-Century England* (Baltimore: Johns Hopkins University Press, 1995). The Irish story is told in William J. Smyth, *Map-Making, Landscapes and Memory: A Geography of Colonial and Early Modern Ireland c. 1530–1750* (Cork: Cork University Press, 2006).

13 Living on the North American Land

The British sixteenth- and seventeenth-century recolonization of Ireland, parts of which the English had originally seized in the twelfth century, provided a template for the British settlement of lands across the Atlantic, where new cash crops could be raised at great profits to those who supervised the process—profits that seldom benefited the labor they exploited or enslaved. A comparison of the settlements of Native Americans in what is now the United States and Canada with those of the European and African settlers in the British colonies founded along the Mid-Atlantic coast in the seventeenth century reveals that cultural differences helped account for the clashes that occurred between the two groups, particularly differences in the ways in which the indigenous peoples and the settlers conceived of property rights. The English, unwilling or unable to understand how the Irish or the indigenous Americans inhabited the land, felt justified in appropriating it. At the same time, American colonial environments, which included as well the immensely profitable sugar plantations of the Caribbean, differed in important ways from those of contemporary Britain.

Four examples of Native American architecture give a sense of the variety of building traditions it encompassed. The tipi still dominates the popular concept of the subject (Figure 13.1). Well into the nineteenth century, tipis were common throughout the Great Plains. The inhabitants of the plains held out the longest of all indigenous peoples in the lower forty-eight states against armies and settlers of European and, at times, African descent, something they were able to accomplish in part because of their mobility.

A tipi is a conical structure consisting of tanned buffalo hides or, after about 1800, canvas sheeting wrapped around wooden poles or stakes. The whole structure is easily demountable. Before the arrival of Europeans in North America, native peoples dragged fairly small tipis from place to place. After their builders learned in

191

Figure 13.1. Kiowa people, tipis, Minnesota, nineteenth century.

the seventeenth century to tame the wild descendants of horses imported by the Spanish, tipis grew in size. There were two reasons for this: it became easier for the natives to hunt the buffalo out of whose skins the tipis were made, and, with horse-power, it became easier to transport the tipis themselves.

For much of the year, the Kiowa, one of the peoples who built tipis, lived in small settlements, their tipis arranged so that the entrance holes faced south. The hearth of each tipi was located in the center so that smoke could more easily escape. In the winter, a liner of insulating grasses was added to protect against the cold. In the summer and at times of political crises, different bands of Kiowa would gather for religious festivals and strategizing. At such a gathering they would arrange their tipis into an enormous circle, which defined the space of an enlarged community, with each band within the tribe defining an arc of that circle. Women owned, stitched, put up, and took down the tipis, but men painted those that were decorated. Two subjects were common in tipi decoration: sacred symbols and scenes of warfare. The latter generally glorified the senior male inhabitant of the individual tipi.

Tipis were the portable dwellings of nomadic peoples. Other Amerindians lived more settled lives. On the Queen Charlotte Islands off the Pacific coast of British Columbia in Canada, for instance, the Haida spent the winter in permanent water-front villages (Figure 13.2). They moved inland to temporary quarters for the milder

Figure 13.2. Masset, British Columbia, Canada. Photograph from 1878.

summer months. Towering over their houses were totem poles that both recounted sacred stories and served as markers identifying their communities from the sea, the direction from which they were commonly approached.

The Haida built their houses out of cedar planks set atop posts and beams. While these structures were permanent, they often removed the planks in the spring and carried them to their summer camping grounds inland, where they formed parts of temporary buildings. In the winter, situated between sea and forest, these dwellings became sacred structures, around whose sunken hearths various religious rituals were performed. At these times, the hearth became an *axis mundi,* tying the Haida to the spirit worlds under and above the plane on which they lived. The Haida did not have separate religious structures comparable to churches, synagogues, mosques, or temples (all of which in fact had domestic origins). Instead, the dwelling itself doubled as a place of worship.

Not surprisingly, considering the forests that surrounded them, the Haida were skilled woodworkers, although there is debate about the degree to which these skills were enhanced by their access during the nineteenth century to new wood-carving

tools. Like totem poles, housefronts served as exhibition pieces for their talents. Examples of Haida woodworking fill museums throughout the Pacific Northwest. The sacred symbols the Haida carved into wood recurred in their ceremonial regalia and body paint.

The architecture of indigenous peoples did not remain static. Over the course of the second half of the nineteenth century, European housing forms began to replace the cedar-plank houses characteristic of earlier Haida dwellings, but the totem poles remained as prominent as ever. The distinctive interior form, of a gabled roof over an interior with a central hearth pit, also remained. The introduction of milled lumber altered the construction of Haida houses without necessarily affecting the spatial practices that were bound together with social structure and religious beliefs. The largest of all Haida dwellings known to Europeans was a plank house built around 1850 in the village of Masset by Chief Wiah. It featured a three-tier earthen floor stepping down to the fire pit (Figure 13.3). It was furnished in part with chairs, which the Haida acquired by trading with the European and American sailors whom they supplied with food.

The characteristic dwellings of Native American peoples are often envisioned as relatively impermanent and thus inconsequential. Thinking of these peoples as less than civilized made it easier for the settlers of European descent who coveted the natives' lands to take these lands from them. The Haida certainly occupied the land in a way that was very different from that of most Europeans, who, with the exception of those living high in the mountains, did not often migrate with the seasons, but Haida dwellings were substantial. They were not, however, the most imposing

Figure 13.3. Interior, Chief Wiah's house, Masset, British Columbia. Photograph from nineteenth century.

dwellings created by indigenous peoples within the borders of what is now the United States and Canada. Those are found in the pueblos of what is now New Mexico.

Acoma's inhabitants worked with the local topography in order to build a defensible community atop a desert mesa (Figure 13.4). The Spanish finally destroyed the pueblo in 1598, almost sixty years after they had first noted its existence. Despite the harsh conquest, native culture endured, and the pueblo was rebuilt. Acoma's houses, constructed largely of adobe, typically face south (Figure 13.5). Many are three stories in height; inhabitants and visitors use exterior ladders to gain access to the upper stories. Until relatively recently an additional protective measure was the small size of ground-floor doors. The main dwelling areas are the second- and third-floor terraces and the rooms immediately behind them. Most of the rest of the structure is devoted to storage, something for which the Haida, with their easy access to fish and bountiful plant life, did not need so much space. Acoma's inhabitants formerly stored many of their foodstuffs in handmade pots; the manufacture and sale of such pots is now one of the community's principal sources of income.

Adobe, the primary building material used at Acoma, requires constant maintenance. Every year the women refinish the surfaces of these buildings. Historically,

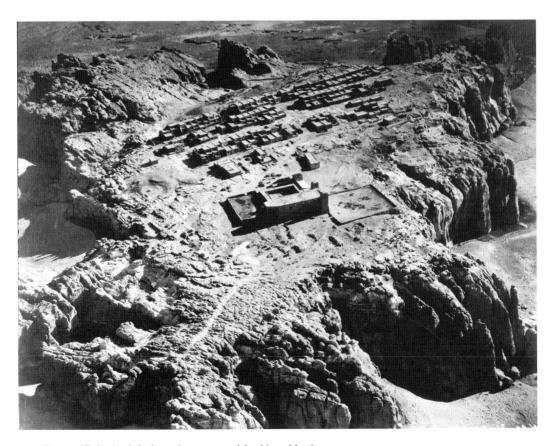

Figure 13.4. Aerial view, Acoma pueblo, New Mexico.

Figure 13.5. Acoma pueblo, New Mexico. Photograph from 1899.

there was a strict gender division of labor, with men responsible for other construction and maintenance tasks. Adobe is not the only building material here. Traditionally the ceiling/floor beams of the upper stories were wood, a material in short supply in this dry climate. On these beams sat mats of branches covered with grasses and a mud plaster. Today many who live in Acoma use concrete, which allows for larger windows. Although the first church in Acoma dates to the seventeenth century, the town's inhabitants continue to practice their indigenous religion as well. Their circular sacred spaces, or kivas, remain invisible to outsiders, now modern tourists but once colonial-era priests ready to persecute what they saw as heresy.

The many pueblos of New Mexico provide an unusually monumental example of native architecture in what is now the United States, but the first English to visit the Atlantic seacoast also encountered settled villagers. John White spent the winter of 1585 in North Carolina, where he made watercolors of villages inhabited by Algonquin. In one of his paintings, a timber palisade defines and helps protect the village of Pomeioc (Figure 13.6). The buildings within the palisade were longhouses. These were among the most common dwelling types along the coast and inland throughout what is known as the Eastern Woodlands. Each longhouse consisted of a bent-timber frame covered by reed matting that could be adjusted according to

Figure 13.6. Theodor de Bry (after John White), Pomeioc, North Carolina, after 1585.

the time of day and the season to let in more or less light and air. It was the inhabitants of villages like these, whose dwellings were scarcely less substantial than the wattle houses inhabited by many European peasants, who were the first to be displaced by the arrival of English, Dutch, and Swedish settlers into what are now the states of Georgia through Maine.

Around the world, the sixteenth through the eighteenth centuries saw a steep increase in the amount of land under cultivation and in the degree to which agricultural commodities were traded on the world market. In the Netherlands and Britain, imported foodstuffs and other products supplemented increasingly efficient uses of existing land. Similar innovations in farming were being developed simultaneously in India and Japan. The creation of new frontiers extended as well to the Americas. In some cases, European colonists established plantations where they employed African slaves as well as indigenous peoples to raise crops, especially tobacco and sugar, for international sale; in others they cleared former woodlands to support themselves on new farmsteads larger than anything they could have obtained at home. They were able to accomplish this in part because their weapons enabled European concepts of private property to overwhelm the native concept of communal ownership. Furthermore, even before the arrival of permanent European settlers, the introduction of European diseases through contact with sailors and fishermen in the sixteenth century decimated native populations, substantially thinning the indigenous inhabitation of these fertile lands.

The first permanent British settlement in North America was established in Jamestown, Virginia, in 1608. Almost no trace survives today, however, of seventeenth-century European architecture along the eastern coast of what is now the United States except in New England. Early European dwellings in the southern colonies were usually scarcely more substantial than those of the dwindling number of natives to whom their occupants continued to live in proximity. By the eighteenth century, however, tobacco farming began to finance increasingly impressive houses in Virginia and Maryland.

One such house was built on Tuckahoe Plantation in Virginia in 1712 (Figure 13.7). Tuckahoe was the birthplace of Thomas Jefferson. The house was emblematic of the new center-hall dwellings that began to be erected in British colonies in the early eighteenth century. These were originally one-room deep, although eventually many two-room-deep examples were built. At Tuckahoe additional grandeur was achieved through the unusual combination of two center-hall houses into an H-plan. Tuckahoe was constructed of wood, with expensive brick employed only for the chimneys on each end. More imposing examples were often erected entirely of brick. As the grandest type of eighteenth-century American colonial architecture, the center-hall plan has dominated colonial revivals.

The richly paneled parlor at Tuckahoe was probably originally painted (Figure 13.8). Its mantel and perhaps the paneling are later additions to what was once a simpler house. Ornament was often derived from pattern books. In some cases

Figure 13.7. Big house, Tuckahoe Plantation, Goochland County, Virginia, begun 1733.

indentured servants (men and women who paid their passage to the New World by agreeing to serve limited terms of slavery) executed this work.

In Britain and Ireland, center-hall houses were built by members of the rural gentry and their social counterparts among the professionals living in towns. These dwellings remained modest in comparison to the country houses being erected by the nobility, but most southern planters in North America exerted far more authority over their labor force. British tenant farmers' experience of enclosure paled in comparison to the sufferings of the enslaved labor crucial to the establishment of the plantation system. Indentured servants, many forced by enclosure to emigrate, worked in British colonies alongside slaves imported under horrific conditions from the West African coast. Spanish and Portuguese plantations also relied on the labor of Africans, who proved more resistant than Europeans to tropical diseases.

Although a relatively small proportion of the white inhabitants of Britain's southern colonies along the Atlantic Seaboard and in the Caribbean islands owned any slaves, the wealthiest, overwhelmingly white but including a handful of blacks, owned hundreds. Until the early nineteenth century, many prosperous northerners

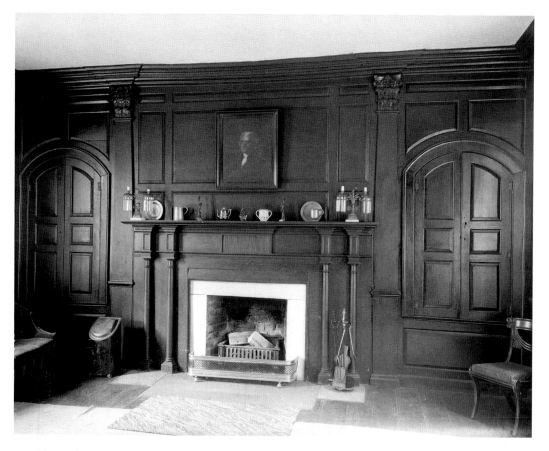

Figure 13.8. Parlor, big house, Tuckahoe Plantation.

also owned slaves, almost all of whom worked as domestic servants. In the American South, in addition to working as field hands and house servants, many slaves labored as blacksmiths and carpenters. Most plantation buildings were constructed largely with slave labor. Working under varying degrees of white supervision, slaves seldom had the opportunity, however, to erect dwellings that replicated the spaces they had been forced to leave behind in Africa. Spatial dislocation was one of the most important psychological dimensions of captivity for the first generation of black immigrants.

Plantation owners, surrounded by dependents they regarded as their social inferiors, spun off service spaces from the main house (Figure 13.9). Putting the kitchen in a separate structure, as had been done in medieval European monasteries and the Topkapı Saray, had the advantage of keeping the main house cooler in the region's sweltering summers. It also ensured that if the kitchen caught fire, a frequent occurrence, the main house would survive. The kitchen at Tuckahoe was built of brick. So was the smokehouse, in which the plantation's supply of pork, the region's most common meat, was salted, smoked, and stored.

Figure 13.9. Outbuildings, including slave cabins, Tuckahoe Plantation, second half of eighteenth century.

At Tuckahoe a double row of outbuildings was set at one side of the approach to the house. Here, like the villages erected close to English and Irish country houses, they could impress those riding or walking up to the main house while still being clearly set apart from it. The area between these outbuildings, called the yard, doubled as an important work space. Together with the kitchen and smokehouse, an office or dairy and a schoolhouse created a middle ground between the big house and the slave cabins. The office and schoolhouse were spaces in which the planter's family members encountered people they might not have been willing to entertain in the house itself. Schooling in the South was private rather than communal until the late nineteenth century. Low literacy rates characterized the antebellum white population; the law often forbade slaves from learning to read. The slave cabins at Tuckahoe, each of which housed up to two dozen people in a single room, are exceptional. Their unusually high standard is indicated by the enduring quality of their construction, which even includes a central chimney.

The preponderance of outbuildings on Virginia plantations established social distance between the servants and slaves who labored in the fields and the planters'

own families. Tuckahoe is one of the relatively rare instances with surviving cabins in the quarters, as slave dwellings were known. Upon Emancipation, newly freed slaves determined to escape the direct physical supervision of their former masters and mistresses quickly erected new dwellings in more remote locations.

Tobacco farming in the American South, like grazing in Britain, represented the replacement of subsistence farming with an emphasis on a more profitable cash crop. Towns were marginal to this enterprise, and the South had few of them compared to New England and the Mid-Atlantic colonies. Many planters shipped their crops to Britain directly from their own wharves and traveled by boat rather than road to attend church and visit friends. In the North, however, those who settled New England in the seventeenth century and had emigrated largely for religious reasons often replicated aspects of the preenclosure British countryside and the village architecture found adjacent to it.

New England villages were typically organized around a green or common, originally the place where the community's cows and sheep grazed. Onto this open space fronted the meetinghouse or church and the town's most substantial houses. In the nineteenth century, the town hall, school, post office, and library often clustered around the common, where the general store might also be located. From the beginning, some larger towns—New Haven in Connecticut is the earliest example—were laid out on grids, with the rectilinear common at the center of a nine-square plan, but most were irregular spaces, oriented to details of an often hilly topography.

Seventeenth-century New England farmers generally lived in villages and walked or rode to their farmsteads. This followed the pattern in much of England. It also provided the farmers with protection against attacks as well as the supervision of neighbors, which was valued by the pious settlers. Most villages were just one building deep on each side of the road. Over time, many barns became extensions of the houses, a system that worked well in cold New England winters.

A number of well-built seventeenth-century timber-frame houses survive in Connecticut, Rhode Island, and Massachusetts. These structures were extraordinary in their own time; many families continued to live in much less well constructed single-room dwellings known today largely from written descriptions and archaeological excavations. The Whipple House in Ipswich, Massachusetts, built in stages beginning in 1677, is one of the exceptional survivals (Figure 13.10). Two stories tall, with an attic under the steep roof, this kind of house is often called a saltbox. Prerestoration photographs prove its picturesque gables to be reproductions; the attic windows were enlarged in the eighteenth or nineteenth century and reduced again in the twentieth.

Houses often grew over time. The Whipple House originally consisted of only the two front rooms. At their core sat the chimney, placed so as to warm as much of the house as possible during winters that were much harsher than those to which the English were accustomed. On one side of it was a tight stair. On the other side of the hearth was the hall, the same room that played only a minor role at Hardwick

Figure 13.10. Whipple House, Ipswich, Massachusetts, begun 1677.

Hall. In seventeenth-century America, however, the hall continued to be the main—and often the only—room, the place in which meals were cooked and eaten and in which most family activities took place. A house as large as this one also typically had a parlor downstairs, a showpiece room used mostly for social display. Upstairs were bedrooms. When, as here, rear additions were added, they were generally single-story spaces, often containing the kitchen, the first function to spin off the hall, or pantries for food storage. No seventeenth-century American interiors survive intact; what one sees today are largely restorations undertaken in the late nineteenth and twentieth centuries. Even those early eighteenth-century examples that do survive are generally exhibited today with more and better furniture than all but the very most splendid houses actually had. Ceilings were low; walls were plastered or had simple wood paneling. Hearths were enormous and windows small.

William Harrison, an Englishman writing in 1577, gives a sense of the transformations that had recently occurred in the standards of village life that came only slowly to the New World:

There are still old men yet dwelling in the village where I remain, which have noted three things to be marvelously altered in England within their sound remembrance; and other three things too much increased. One is the multitude of chimneys lately

erected, whereas in their young days there were not above two or three, if so many, in most uplandish towns of the realm. . . . The second is the great (although not general) amendment in lodging, for (said they) our fathers (yea and we ourselves) have lain oft on straw pallets, on rough mats covered only with a sheet under coverlets made of dayswain or hopharlots [types of reeds], and a good round log under their heads, instead of a bolster or pillow. If it were so that our fathers or the good man of the house, had within seven years after his marriage purchased a mattress or flockbed, and thereto a sack of chaff to rest his head upon, he thought himself to be as well lodged as the lord of the town. The third thing they tell of is the exchange of vessel, as of wooden platters into pewter and wooden spoons into silver or tin.

Higher standards were more common in cities than in the countryside. The oldest city in North America founded by the British is Boston in New England, but the first to be organized along resolutely urban lines was Philadelphia, in Pennsylvania. Throughout the eighteenth century, this was the largest English-speaking city in North America. New York, founded by the Dutch as New Amsterdam, supplanted it only in the early nineteenth century after the opening of the Erie Canal.

Philadelphia was laid out in 1682 (Figure 13.11). Comprehensive planning was relatively easy upon the relatively flat land that William Penn had been granted by

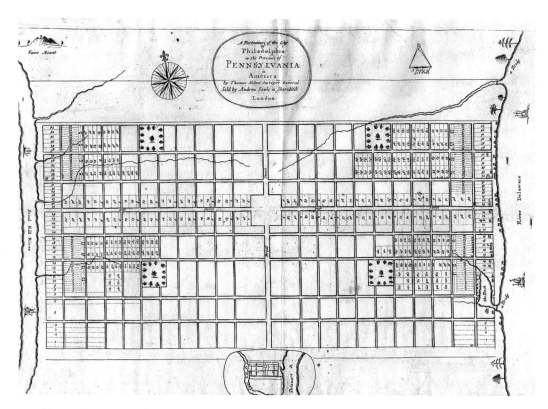

Figure 13.11. Map, Philadelphia, Pennsylvania, 1689.

the English Crown. Penn, as a Quaker dissenter from mainstream Protestantism, used his authority to plot a city that had more in common with the way in which London was actually growing than with the way in which Wren dreamed of re-organizing it. He imposed a grid on the land between the Delaware and Schuylkill Rivers. It was interrupted by five squares, of which the largest, in the center, was reserved for the town hall. Noteworthy was the generous breadth of the streets: fifty feet for most and one hundred feet for the two main ones. Penn's grid filled in slowly across the course of the eighteenth century. The city hall was not erected on Center Square until after the Civil War. Instead, growth initially focused on the busy water-front. Eighteenth-century Philadelphia was a thriving port city, serving a substantial agricultural hinterland. One reason for the success of Penn's Pennsylvania colony was the freedom of religion the Quaker founder granted those who settled there. The colony became a favorite destination of various dissenting Protestants from Germany as well as from throughout the British Isles, including many veterans of the Scottish plantations in northern Ireland. Another reason for Pennsylvania's success lay in the relatively good relations Penn maintained with the indigenous peoples.

As in London, steeples dominated Philadelphia's skyline. On the ground, how-ever, much of the life of the city came from its commercial streets. The city attracted many of the seaboard's most talented men and women, most notably Benjamin Franklin. Working as a publisher, this native of Boston helped to found many of Philadelphia's most important institutions, ranging from the Library Company to the University of Pennsylvania.

The individual pieces of the Philadelphia cityscape resembled their British and Irish counterparts. The row house remained the most important building type, sup-plemented by churches and an increasing array of public buildings. As in eighteenth-century London, master carpenters built most of colonial Philadelphia. They used brick masonry to fireproof exterior walls. Although there were no imposing urban ensembles to rival the great squares of Bloomsbury, Philadelphia would otherwise have impressed Europeans. It remained exceptional, however. The row house model dominated few other American colonial cities, with Baltimore, Boston, and New York being the most notable exceptions.

The city was also exceptional in the number and variety of its public buildings. The most prominent civic building in eighteenth-century Philadelphia was the Pennsylvania statehouse, from which the colony was governed (Figure 13.12). It is now known as Independence Hall because it is here that the Second Continental Congress met in 1776 and here that the delegates ratified the Declaration of Inde-pendence. The authorship of the building's design remains a subject of dispute. Was it the gentleman architect Andrew Hamilton or Edmund Woolley, a builder and carpenter? Whatever the answer, at that time master carpenters were responsible for far more design decisions than are contractors who work with architects today. Car-penters were so prominent in the life of Philadelphia that their meeting place, Carpenters' Hall, housed the First Continental Congress.

Figure 13.12. Pennsylvania statehouse (Independence Hall), Philadelphia, begun 1731.

Like all the other major institutional buildings along the Atlantic Seaboard, the Pennsylvania statehouse strongly resembled the grandest mansions in the region. Here the same center-hall plan as at Tuckahoe was expanded from five to an extraordinary nine bays and built of brick, with some stone as well as wood trimmings. By 1731, when construction began, dependencies like the ones that flank the main structure were also beginning to be added to neo-Palladian houses in the colonies, many of which were erected in towns, rather than just in the countryside as was customary in Britain. This domestic model was dressed up by the addition of a tower. The original was added in 1750–53; the present one is a nineteenth-century replacement. Both exhibit the influence of Wren's churches. In fact, churches in the colonies often resembled houses more than they did their religious precedents from England. Here, however, the influence clearly went the other way. Like the steeple, the galleried interior had precedents in Wren's and Gibbs's parish churches.

Native Americans, European colonists, and the colonists' African slaves had different architectural traditions and different ways of organizing the land that supported them. All these groups adapted, often imaginatively, to the circumstances of

their encounters with new conditions, but the overwhelming advantage belonged to the Europeans. Superior military technology in concert with concepts of private ownership of the land enabled the colonists to supplant the native inhabitants and retain authority over their imported slaves. In the beginning, the indigenous peoples had no framework for understanding the process in which they were taking part, and the physical subjugation of the slaves was expressed in the spatial arrangement of southern plantations. The most durable results of European colonization include the endurance of the single-family house as the predominant North American dwelling type, rather than communally oriented indigenous alternatives.

FOR FURTHER READING

Unfortunately, few comprehensive surveys are available of Native American architecture in what is now the United States and Canada. This account relies on Peter Nabokov, *Native American Architecture* (New York: Oxford University Press, 1989). William Cronon, *Changes in the Land: Indians, Colonists, and the Ecology of New England* (New York: Hill & Wang, 1983), provides a seminal discussion of the way in which differing cultural attitudes and use of the land facilitated European colonization. For discussion of American architecture in general, see Dell Upton, *Architecture in the United States* (Oxford: Oxford University Press, 1998); on the colonial, see his *Holy Things and Profane: Anglican Parish Churches in Virginia* (1986; repr., New Haven, Conn.: Yale University Press, 1997), and "White and Black Landscapes in Eighteenth-Century Virginia," *Places: A Quarterly Journal of Environmental Design* 2, no. 2 (1984): 59–72. For more on structures inhabited and used by slaves and former slaves, see Clifton Ellis and Rebecca Ginsburg, *Cabin, Quarter, Plantation: Architecture and Landscapes of North American Slavery* (New Haven, Conn.: Yale University Press, 2010); and Charles S. Aiken, *The Cotton Plantation South since the Civil War* (Baltimore: Johns Hopkins University Press, 1998). On the relationship of different forms of American colonial housing to their British sources, see David Hackett Fischer, *Albion's Seed: Four British Folkways in America* (Oxford: Oxford University Press, 1989). For more on the disputed authorship of the Pennsylvania statehouse, see James F. O'Gorman, Jeffrey A. Cohen, George E. Thomas, and G. Holmes Perkins, *Drawing toward Building: Philadelphia Architectural Graphics, 1732–1986* (Philadelphia: University of Pennsylvania Press, 1986).

14 Court and Dwelling in East and Southeast Asia

Colonization entails the imposition of a foreign power upon a landscape, a process that, although necessarily involving compromises, by definition places outsiders in control of spatial and architectural decisions previously controlled by locals. Influence, or the power of example, operates more subtly. For centuries, China was the world's most powerful country. Not surprisingly, the Chinese architectural system had an enormous impact on the architecture of neighboring countries. Ringing China were cultures that balanced developing their own architectural solutions with modulating Chinese and other outside paradigms to suit their own purposes. The palaces, temples, and houses of Korea, Tibet, Thailand, and Sumatra (the largest island in what is now Indonesia) give a taste of the way in which Chinese and other outside influences fused with local building cultures to create architectures that were neither imposed nor provincial.

Korea directly borders China, and its architecture was strongly influenced by that of its powerful neighbor. Nonetheless, the two were seldom identical. Korea was ruled from 1394 to 1910 by the Chosun (or Joseon) dynasty, which governed from the capital in Seoul, where the rulers built five royal palaces. The most famous of these is Changdeokgung (Figure 14.1). The first phase of this palace was completed between 1405 and 1412, while the Forbidden City was still under construction in Beijing. Built as the secondary royal palace, it served throughout the seventeenth and eighteenth centuries as the site of dynastic rule following the destruction of the main palace by the Japanese in 1592. Changdeokgung was also burned in 1592, but it was rebuilt in 1609; two more fires, in 1621 and 1830, did considerable damage but did not substantially alter the basic organization of the complex.

In comparison to the Forbidden City, Changdeokgung was small, and its courts appear to be disposed rather informally, with the roofs of its major pavilions following the ridgeline of the hills behind them. One reason for this asymmetrical layout

Figure 14.1. Plan, Changdeokgung Palace, Seoul, South Korea, begun 1405.

was that this was originally the subordinate of the two royal palaces. The outer palace contained a throne hall for receiving ambassadors, especially from China, and two halls in which the king met nearly daily with officials. The more private inner palace contained quarters for the king, the queen, concubines and children, the queen mother, officials, ladies-in-waiting, soldiers, and slaves. Here, as in other cultures, queen mothers were especially important figures who often ruled as regents. One of the principal changes made at Changdeokgung in the period when it was the chief royal palace was the addition of quarters for three generations of queen mothers; in the eighteenth century the crown prince also received a larger residence. *Ondol,* or under-floor heating, provided warmth in the winter months.

Behind the main palace lies an enormous garden that ascends a steep, wooded hillside and is studded with pavilions. This was not the most private part of the palace, however, as in Beijing and Istanbul. From the Juhamnu Pavilion, erected here in 1776, the king could observe the civil service exams being held (Figure 14.2). Those who passed these prestigious examinations would study at the extensive royal library located on the upper floor of the pavilion and in a neighboring building before receiving their assignments in the government bureaucracy. Civil servants were not, in other words, confined to the front parts of the palace;

Figure 14.2. Juhamnu Pavilion, Changdeokgung Palace, 1776.

they penetrated deeply, as did even candidates for these prestigious posts. Thus at Changdeokgung we find Chinese architectural forms, such as halls and gates, being arranged in ways that diverge considerably from the overwhelming hierarchy communicated so effectively by the architecture of the Forbidden City.

Moreover, there was plenty of room within the Korean as well as the Chinese architectural system for new forms when they corresponded to new uses. That is the case with the Hwaseong Fortress in Suwon, built between 1794 and 1796 (Figure 14.3). This was the most modern fortification in East Asia (castles had become less important in Japan following the end of civil strife there), built with a mixture of Eastern and Western military technology. Located not far south of Seoul, it was also the burial place of King Chongjo's father, who while crown prince had been murdered by his own father. Jeong Yak-Yong, a crucial figure in contemporary reform movements that advocated a pragmatic adoption of new technology, built Hwaseong.

One of the key political innovations of the time was integral to the construction of the fortress: the workers who built this immense and powerful structure were paid wages; they were not forced slave laborers. The building campaign, which introduced the use of brick on a new scale to Korea, was also meticulously documented.

Figure 14.3. Hwaseong Fortress, Suwon, South Korea, 1794–96.

This was part of a series of political changes in Korea proposed and in some cases realized at the end of the eighteenth century and the beginning of the nineteenth. The hope, as with the contemporary European Enlightenment and the revolutions it spawned, was that political and economic power, concentrated in the elite of each class—aristocracy, merchant, and peasant—would be shared more equitably throughout the society. The erection of the fortress and the calls for change that influenced its construction demonstrate the continued possibility of indigenous modernization outside of European colonization.

The Korean Peninsula borders China to the east. The Tibetan Plateau separates China from the Himalayas, the mountain range created when the Indian subcontinent crashed into the Asian mainland. Here the topography and the climate—the combination of high altitude with relatively little rainfall—contributed to the creation of architectural forms that were also informed by the two urban cultures of China and India, which border the region.

In the seventeenth century, Lhasa, already for a thousand years the site of the Jokhang Monastery, the center of the local Buddhist faith, became the region's capital. The city then acquired a second architectural focal point, the Potala Palace (Figure 14.4), while the monastery was refurbished and expanded. Winding to accommodate the difficult terrain, the pathway between the religious and political

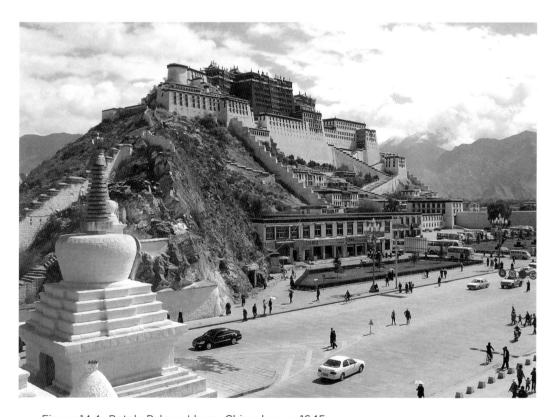

Figure 14.4. Potala Palace, Lhasa, China, begun 1645.

centers of the small city became the route of many processions. Here Chinese pillar-and-beam architectural details were married to Indian planning concepts in ways that were strongly inflected as well by local construction practices. In particular, the Hindu and Buddhist concept of the *axis mundi* replaced the Chinese emphasis on axially symmetrical ground plans. Built on a far steeper site than the hill behind Changdeokgung, the Potala Palace comprises a series of cliff-like compressed blocks that tower over the surrounding city.

From the time construction began in 1645 until the middle of the twentieth century, the Potala Palace was the seat of the local religious leader, the Dalai Lama. Like the prince-bishops of Würzburg, he was also a secular ruler. Most of the palace was erected during the second half of the seventeenth century. The building is dramatically affixed to a promontory, giving it a spectacular position from which to survey the neighboring territory. It is also impressive defensively, as visitors ascending along a complicated series of switchbacks are at the mercy of those atop walls that appear almost to grow out of the landscape.

From below, the structure appears to be a solid block, but there are actually substantial courtyards within it, edged by the main multistory buildings (Figure 14.5). The Potala Palace consists of a series of structures, the most famous being the red palace. This was completed between 1690 and 1694 (except for the top two

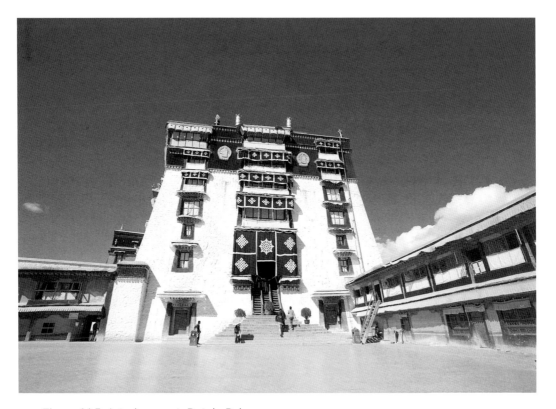

Figure 14.5. Interior court, Potala Palace.

stories, which date to 1922) and houses the sacred functions. One enters the red palace through the smaller residential white palace. The complex housed the Dalai Lama and his court, reception halls in which state ceremonies could be held, and schools in which monks were trained, as well as the tombs of previous Dalai Lamas and other sacred pilgrimage sites.

A great deal of skill was required to construct even ordinary Tibetan houses, which were built by specialized craftsmen rather than by everyday inhabitants. The palace represents the apex of this careful response to local materials and seismic conditions. The stone walls are covered with stucco that masks the complexity of the masonry, which is designed to withstand earthquakes. The timber ceilings are supported internally on timber posts. Large windows facing both the street and the court, shadowed by decorative friezes, bring light into the interior. The golden roofs at the crest of the complex mark the tombs of deceased Dalai Lamas rather than halls as in China or Korea. Within these spaces are stupas, the mounds that cover Buddhist relics, including the tomb of the Buddha. Stupas, each of which represents Mount Meru, the center of the world in Hindu and Buddhist cosmology, were originally built over the body and objects used by the Buddha. They take various forms in different architectural cultures; in China and Japan they become multi-storied pagodas.

Another Buddhist culture that balanced Chinese and Indian influences with local influences was that of Thailand. In the eighteenth century, Thais governed much of Indochina; these dominions were gradually whittled away by the French and British colonial empires. In 1767 Burmese invaders burned the capital city of Ayuthaya. Within fifteen years King Rama I, the founder of the Chakri dynasty, had begun construction in Bangkok of a new capital, which included a major royal palace. Here the Chinese walled palace compound type was fused with Buddhist temple planning precepts, themselves informed by Hindu precedents. Individual components, however, included elaborations of local house types different from those found in Tibet.

Like other Asian palace compounds, the Grand Palace contains spaces for administration, for royal ritual, and for women and children. The prominence within its walls of the holiest Thai shrine, the Wat Phra Kaew, or Temple of the Emerald Buddha, firmly distinguishes it, however, from its Chinese and Korean counterparts (Figure 14.6). The Wat Phra Kaew's prominence is closely related to the role the Emerald Buddha played in legitimating the new emperor and his dynasty. Throughout history, monarchs have seen themselves as the intermediaries between their subjects and the divine. Rama I seized this statue of the Buddha, which is made of jade, as war booty four years before he became king. The legitimacy of the Thai monarchy rests in part on the care it takes of this relic, which is housed in a shrine whose architecture recollects that of Ayuthaya. Although the monarchy moved out of the Grand Palace in 1925, the king still returns three times a year to dress the image himself.

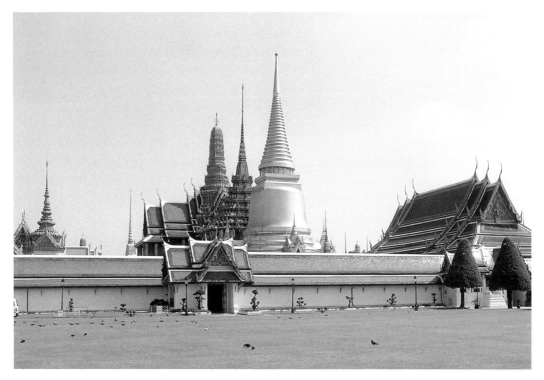

Figure 14.6. Wat Phra Kaew (Temple of the Emerald Buddha), Bangkok, Thailand, begun 1782.

The Wat Phra Kaew is located in one corner of the Grand Palace within its own walled enclosure. Its importance is marked architecturally through a number of enhancements to the central shrine that echo, without exactly repeating, those of such Hindu precedents as the Minakshi Temple. The first is a cloister, or open arcade, that wraps around the entire precinct and is decorated with bas-reliefs illustrating the Ramakien, a Thai transposition of the Indian Ramayana. One version of this epic was written under the supervision of Rama I himself. Also present within the precinct are several *chedis,* or stupas. Stupas take varied architectural forms throughout Asia; the bell-shaped *chedi* was imported into Southeast Asia from Sri Lanka. These *chedis,* like more monumental examples elsewhere in the region, are covered in gold leaf. Other accessory structures include a library housing sacred texts. Standing in front of the central shrine are eight boundary markers.

The central shrine, called an *ubosot,* holding the Emerald Buddha is not particularly large, nor is its architecture radically different from that of Thai houses of the period. These were typically set on stilts, built out of wood or bamboo, and featured high gabled roofs. Temple and palace pavilions alike were grander, more elaborately constructed versions of this basic type, which is found throughout Southeast Asia. The colorful decoration of the exterior surfaces of the central shrine, the rich permanent materials, such as ceramic roof and walls tiles, with which it is decorated,

and the multitiered gables of both the main roof and the projecting porches all define this as an entirely exceptional building. Although the cores of both this pavilion in particular and the temple complex as a whole date to the late eighteenth century, the process of enriching them by elaborating their decoration has continued across time, just as the complex as a whole has grown steadily more ornate as generations of kings have donated additional buildings. Only the king may enter the shrine through the central door, and only the king may touch the image. The interior is splendidly decorated with paintings describing Buddhist cosmology (Figure 14.7). The statue sits on a tall golden throne that features the same repetition of architectural elements as the rest of the building. Above the Buddha's golden crown are suspended a series of the umbrellas that symbolize royalty in Thailand, as they also do in India, where they inspired the decorative roofed pavilion known as a *chhatri.*

The form of the domestic prototype for the pavilions found throughout the Grand Palace is not uniquely Thai. Variations on the form are found throughout Southeast Asia. On the island of Sumatra, for instance, where timber is plentiful and tropical rainfalls occur, these houses were the chief form of domestic architecture until the middle of the twentieth century and continue to play a major role in supplying the symbolism used to define regional identity. As in Tibet, construction methods reflect the region's history of massive earthquakes. Thus carpenters avoided using nails, preferring to joint or lash wooden members together. Originally domestic animals were tethered or penned under the house, where they could eat the refuse that fell through the floorboards. Fires set under the house helped smoke out mosquitoes. Lifting the house above the land also offered insurance against flooding in monsoon downpours as well as protection from predatory animals, which could not easily climb the retractable ladders through which people entered the house. The saddle-back roofs were originally thatched, although as early as one hundred years ago corrugated metal began to replace this labor-intensive and relatively impermanent material. In either case, the steep pitch was designed to shed rain as quickly as possible, while the ample overhangs created the intermediate spaces in which much of family life took place. Several related nuclear families might share sleeping quarters on the rear and sides of the interior, which had at least one elevated platform at the far end, and store their most important belongings in the safety of the high, cross-ventilated attic above it. The amount of space occupied by each family was originally quite modest, as the inhabitants spent much of their time outdoors.

Anthropologists believe that this basic house type flourished for centuries if not millennia across Southeast Asia. Such houses were built to last only about seventy years, however, so most surviving examples are relatively recent, although the photographic record goes back to the late nineteenth century, when Dutch colonial officials documented many examples. The scale, the quality of the detailing, and the number of people occupying these houses remind us that impressive architecture

Figure 14.7. Interior, *ubosot*, Wat Phra Kaew.

was built at the village scale in many different parts of the world. It was mirrored in the smaller rice barns that originally stood in front of the houses. Although some ethnic groups in Sumatra, such as the Toba Batak, who live in the north of the island, no longer construct these houses, others, such as the Minangkabau, who live in western Sumatra, continue to do so. While the houses of the Toba Batak are celebrated for their elaborately carved woodwork and enormous gables, those of the Minangkabau are distinguished by the multiple spires of their elaborate roofscapes (Figure 14.8).

The Minangkabau began to convert to Islam in the sixteenth century. Although the construction of mosques as separate sacred structures began at this time, the ways in which houses are constructed and inhabited continue to be infused with a strong sense of ritual. These are presumed to predate the arrival of Islam, as before this time the house doubled as the chief site of worship. Ritual sacrifices and particular foods accompany specific stages in the construction. The erection of the frame is supervised by a professional carpenter and carried out by his staff, but the completion of the house is entrusted to its owners.

Figure 14.8. *Rumah gadang* (Minangkabau house) with rice barns, Pandai Sikek, Sumatra, Indonesia, twentieth century.

The matrilineal character of the society has also influenced the way in which the house is conceptualized and inhabited. Individual rooms belong to the married women, and each husband dwells with his wife's family. Only particularly distinguished guests sit on the platform, where the bedrooms of the most recently married women are typically also located. Kitchens are at the opposite end, close to the door. The house is viewed as largely the domain of women; most adult men spend very little of their waking lives inside it.

Although relatively few Minangkabau live in traditional houses today, such houses continue to be built, not least to serve as the settings for family rituals such as weddings and funerals and to mark the economic and social status of individual lineages or extended families. The elaborate roof spires originally found on these houses now cap a variety of modern building types, including banks and government buildings; they have come to symbolize the Minangkabau at the national as well as the local level.

From the sixteenth through the early nineteenth centuries, regional cultures in Asia held their own and in many cases profited from newly globalized trading networks for the commodities they produced with increasing efficiency. From the Ottomans to the Qing, and from Korea to Sumatra, powerful empires, ambitious kingdoms, and prosperous communities built dwellings that balanced indigenous precedents and conditions with an awareness of the world beyond. Even colonialism, when it arrived, did not always significantly erode distinctive vernacular architectures, which, although challenged by recent changes in construction technology and social patterns, continue to supply a strong sense of identity even to those members of the community who no longer dwell in them.

Regional traditions of construction, modified by climate and geology, informed vernacular architecture, but the most ambitious buildings—most of which were palaces or at least sponsored by those charged with ruling as well as conducting the most important religious ceremonies—were infused with an awareness of, if never subordinated to, imported paradigms. The two most influential of these in East and Southeast Asia were the axial layout and the post-and-beam halls of the Forbidden City, in combination with the form and conceptualization of space of the *axis mundi* represented by the stupa. These influenced the way in which secular rule and sacred ceremony were conceived without displacing the local. The juxtaposition of two structures, the Potala Palace and the Temple of the Emerald Buddha, which share the same sources and functions, clearly demonstrates the way in which local circumstances could inflect their use.

FOR FURTHER READING

For more on Korean architecture, see Kim Dong-uk, *Palaces of Korea* (Elizabeth, N.J.: Holym, 2006); and Myong-ho Sin, *Joseon Royal Court Culture: Ceremonial and Daily Life* (Paju-si, South Korea: Dolbegae, 2004). Knud Larsen, *The Lhasa Atlas: Traditional Tibetan Architecture and Townscape* (Boston: Shambhala, 2001), offers an overview of Lhasa and its

architecture. On Thai architecture, see Nithi Sathapitanon and Brian Mertens, *Architecture of Thailand: A Guide to Traditional and Contemporary Forms* (New York: Thames & Hudson, 2006). For a general account of Southeast Asian houses, see Roxana Waterson, *The Living House: An Anthropology of Architecture in South-East Asia* (London: Thames & Hudson, 1997); and for the Minangkabau in particular, Marcel Vellinga, *Constituting Unity and Difference: Vernacular Architecture in a Minangkabau Village* (Leiden: KITLV Press, 2004).

15 Edo Japan

Of all of China's neighbors, Japan strayed furthest from the Chinese example. This had not been the case when in the eighth century imported Chinese architectural elements dominated the monumental temple and palace complexes of Nara, once one of East Asia's most important cities. By the seventeenth century, the situation was different. The relative stability of the Chinese imperial architectural system and its oneness with the organization of space for Chinese extended families and religious institutions contrasted with the substantial architectural changes that took place across the course of the seventeenth and eighteenth centuries in Korea, Tibet, and Thailand. In Japan the emperor had wielded only nominal power since the twelfth century; during what is known as the Edo period (1603–1867), in its capital city (also named Edo and today's Tokyo) an increasingly distinctive architecture was spawned. Japanese vernacular architecture had never been strongly influenced by Chinese prototypes, but instead was closer to that of Southeast Asia. Renewed political stability following a long civil war gave birth to urban and suburban forms with strong ties to this vernacular.

During the Edo period, Japan was already one of the world's most technologically advanced and urban societies. The government's decision to control trade with other countries limited contemporary awareness of Japan's rapid urbanization at the same time that it protected the Japanese from the ravages of colonialism; by 1700 this formerly almost entirely rural society boasted in Edo one of the world's largest cities, with a population estimated at one million. This rapid transformation was not accompanied, however, by the creation of much monumental architecture. Most Japanese continued to favor modestly scaled buildings erected almost entirely out of wood. Overt grandeur was seen only in rare and special circumstances. Instead, well-defined rural building types that owed nothing to Chinese precedent were repeated with considerable local variation. Sophisticated variants on ordinary rural

construction constituted an innovative architecture increasingly divorced from Chinese precedent, not least because throughout this period the countryside retained both its actual importance—little food was imported—and its centrality to the culture's view of itself.

The *minka,* or characteristic vernacular Japanese farmhouse, consists of a single block (Figure 15.1). *Minka* have thatched roofs; often several stories are set into their high gables. The roofs spread well beyond the house walls, protecting them from rain and snow. The length of the ridgepole traditionally served as a marker of social and economic status. These structures, unlike their Sumatran counterparts, housed single families, and their woodwork was far less elaborately carved. The steep roofs of *minka* also provided protected space for the cultivation of silkworms. Local carpenters built individual *minka* almost entirely of timber. Primary posts supported the roof; a variety of framing systems determined the rest of the structure. These varied by region and by carpenter. The walls were not structural. This encouraged a flexible definition of the boundary between exterior and interior space, with walls composed in part of sliding screens (Figure 15.2). Originally, the wooden posts of the *minka* roof structure were set directly on the ground, where they eventually rotted in the relatively damp climate. By the seventeenth century, however, they were increasingly often being placed on stones, as in Southeast Asia. In the cooler Japanese climate, there was no need to raise the main living quarters

Figure 15.1. Murakami House, Gokayama, Japan, possibly late sixteenth century.

Figure 15.2. Interior, Murakami House.

high above the ground. The floors of early *minka* were simple earth, but greater prosperity brought substantial improvements. Eventually only the working areas of these houses retained earthen floors; those who could afford it built raised platforms for the living and sleeping areas, which they covered with tatami mats woven from reeds. Aside from the storage chests that held the bedding, there was little furniture in the interior. The family sat on the floor. The hearth was a sunken pit within this part of the house; smoke dissipated up into the eaves and through the thatched roof; most European farmhouses once had a similar arrangement.

Minka have been built since at least the fifteenth century, but early seventeenth-century political and social changes led to considerable architectural innovation. Then as now, Japan had an imperial family. Many of the emperor's subjects believed him to be semidivine. However, he and his court enjoyed little direct political power. Instead the shogun, a member of the island nation's powerful daimyo or warrior class, actually governed the country. While the title of emperor has remained in the same family since prehistoric times, the shogunate passed from one family to another, seldom without civil war. One of these periods of instability began during the early sixteenth century and lasted into the seventeenth century, ending only after Tokugawa Ieyasu established a new dynasty of shoguns in 1603. Before and just after he accomplished this, the fractured political organization of Japan was expressed physically in the rival castles of the country's daimyo, rather than in the architecture of the central government. Following Tokugawa's success, new architectural forms embodied the delicate relationship between the shogun and the emperor, as well as the relative ineffectualness of the imperial family.

Before 1500, the only tall buildings in Japan were pagodas, the East Asian version of stupas, and the only real city was Kyoto, the successor to Nara as the Japanese capital. During the sixteenth century, however, the daimyo began to build impressive castles. New towns, many of which grew into cities, arose around the relative safety of these fortifications. Medieval Nara and Kyoto had originally been as rigidly planned as the Chinese capitals on which they were based, but the cities that grew up around these castles were not, in part because hilly topography often interfered. Grid plans remained common, however. Straight streets might conclude in T-intersections designed to reduce the threat of invasion by rival warlords or revolt on the part of commoners from within the city itself.

The most imposing of the surviving castles is Himeji, built between 1601 and 1613 as the fortress of Ikeda Terumasa, the shogun Tokugawa Ieyasu's son-in-law (Figure 15.3). The position of the castle in relation to the town around it was as important as the architecture itself. Not surprisingly, in Japan as in Europe, castles were typically sited on the highest part of a city, taking advantage of topography to tower over the surrounding landscape. Long after they ceased to be important militarily, castles continued to be built as emblems of the political power of individual families. The Himeji castle, on the scale of a whole urban neighborhood, was walled and surrounded by a moat (Figure 15.4). At its core, the degree of fortification increased with layer upon layer of walls protecting the compound from attack. The more lightly fortified compounds at the bottom of the plan constituted the major residential areas for the daimyo's court and soldiers.

The plan of Himeji reflected considerable social stratification. The most privileged members of the warrior class lived for the most part within the inner walls, others clustered close to the perimeter of the second set of walls, and the other townspeople, segregated by occupation, were grouped in a band just outside the first set of walls. Within the inner city, most temples and shrines were grouped close together within easy reach of all; in the outer city they often sat between the residences of the townspeople and those of the warriors. In neither location did they challenge the supremacy of the castle, the irregular shape of which was determined in part by military considerations and in part by topography.

Monumental stone walls, extremely unusual in Japanese architecture, made the fortifications as effective as they were imposing. The stone remained undressed—that is, it was not cut into uniformly rectangular blocks. The area above the walls was made of wooden frames several feet thick, which was filled in with bamboo lath and clay before being covered with plaster and whitewashed. The frequent turns one had to make to ascend through the palace gave the advantage to its defenders. Indeed, the potential invader's best chance of success was not outright attack but a long siege, cutting off the daimyo from food, water, and military assistance.

The castle tower is composed of a series of vertically stacked pavilions. Pavilions had been built in Japan for several centuries, primarily as part of temple and palace architecture. These originally Chinese-influenced structures had, however, relatively

Figure 15.3. City plan, Himeji, Japan, seventeenth century.

little impact on vernacular *minka* architecture, which adhered to older traditions, or on the gabled modules of the new castles. The daimyo created this building type in order to enhance their physical security. Today the interlocking gable roofs and their deeply projecting gables can be admired as elegant details of construction, but in the early seventeenth century they must have appeared as very forbidding signs of the country's political instability and of the suffering that resulted from civil war among the daimyo.

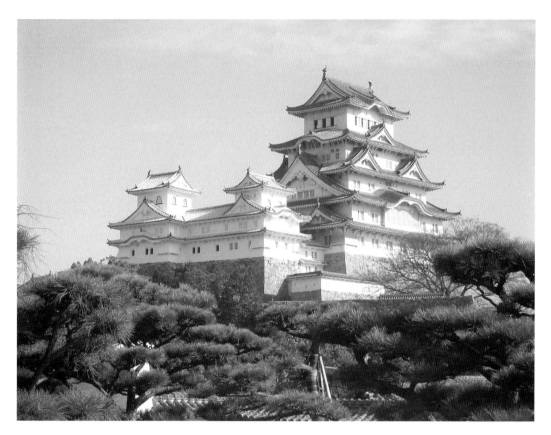

Figure 15.4. Castle, Himeji, Japan, 1601–13.

Few East Asian building types are known for their extraordinary height. The builders of Himeji learned from the country's pagoda tradition, erecting the building around two heart pillars (a pagoda has one). One of these was a single trunk of a silver fir tree; the other consisted of two tree trunks tenoned together. Secular architecture now achieved a monumentality previously attained only by religious buildings, one that sustained the political ambitions of individual daimyo families, who used architecture as a means of asserting their political and military strength. The tall towers were the most heavily fortified spaces. In theory they could be defended even after the attackers had broken through the strong walls below. In fact, social custom demanded that the daimyo retreat at that time to the top of the tallest tower, where he would commit ritual suicide rather than face capture by his enemies. These towers also served, of course, as excellent observation points.

Himeji is the most impressive surviving castle in Japan, but it paled beside the one eventually erected in the center of the new city of Edo, founded in 1580. Although it stood for only about two decades before it burned in the middle of the seventeenth century, Edo's castle was the largest ever constructed in Japan. When peace finally came in the seventeenth century, Edo prospered. The entire city was

built of wood. Every one of the houses, shops, theaters, and other buildings erected there in the eighteenth and early nineteenth centuries has vanished as a result of re-development, earthquake, fire, or war. Edo was thus as ephemeral as it was impressive. Because almost no foreigners visited the city during the centuries in which Japan was almost entirely closed to them, it made almost no impression on the outside world. It was nonetheless, along with London, the largest and most modern city on the planet in the late eighteenth and early nineteenth centuries.

The Tokugawa shoguns required that the daimyo spend alternate years in their new capital, and that the families of the daimyo remain behind in the city even when they traveled to their country estates. The houses of the daimyo were located on the high ground beyond the castle. These individual dwellings consisted of audience halls, called *shoin,* surrounded by gardens and hidden from public view by boundary walls. (*Shoin* were derived from the studies found in Zen monasteries, from which they borrowed a distinctive alcove with shelves for the display of hanging scrolls or other works of art.) This pattern of land use continues to influence the development of these urban districts, where the legacy of detached structures is often still visible. Closer to the water were the houses of the merchants. Those dwellings were, like the *minka,* framed in wood (Figure 15.5). Under their heavy tile roofs, however, these houses had plans that were entirely different from those of *minka.* Typically, customers and guests were entertained in the front rooms. These more public areas were also where any goods sold in the house might be produced. Behind these spaces, which could easily be opened to the street, lay the private quarters of the family, and at the back of the lot, a small courtyard or garden.

The consolidation of the daimyo class spawned an enormous market for luxuries, which in turn created a prosperous middle class of merchants and artisans. Along the waterfront and near temples, in two locations that were less firmly governed by the shogunate, huge entertainment districts sprang up centered on theaters and courtesans, although they also featured places to eat and shop. Because of its proximity to the city's canals, this phenomenon was known as the Floating World. Today we know it from written sources and from prints that give the flavor of the city's shopping streets, which were lined as well with restaurants and surmounted in many cases by the dwellings of their owners (Figure 15.6). The scale and materials of these buildings were not particularly imposing, but the social flexibility of these areas presaged the mix of entertainment and shopping found in modern industrial cities.

The fundamental elements of Japanese architecture were modest, but they could be and were elaborated in the luxurious dwellings built for the island's most powerful people. Two very different palaces, both erected in the seventeenth century in Kyoto, illustrate the emerging role of taste within societies in which luxury alone no longer sufficed. The first, Nijo Palace, was built by the shogun Tokugawa Hidetada, the son of Tokugawa Ieyasu, from 1624 to 1626 as a proper place to receive a visit from Emperor Go-Mizunoo in 1626 and, more generally, to receive the obeisance of the daimyo. On his visit, the emperor stayed within the moated Honmaru

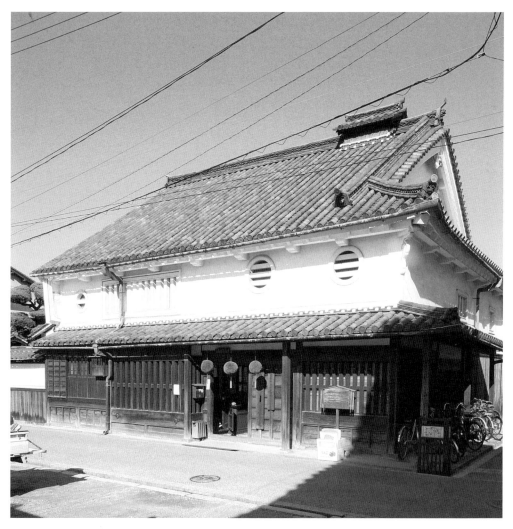

Figure 15.5. Kawai House, Imai-cho, Japan, middle of the eighteenth century.

compound, whose present buildings, however, are more recent in date. The shogun occupied the more relaxed Ninomaru Palace, also known as the second compound (Figure 15.7). The walls of the Nijo Palace are quite imposing, but they convey the idea more than the fact of real fortification. The main gate could be easily breached; furthermore, it gave almost direct access to the rest of the palace. The monumental definition of spatial boundaries was more important here than any strictly military purpose.

One enters through the Ninomaru Palace through the Karamon gateway. Instead of being arranged in succession or around a court in the Chinese fashion, the three semiattached *shoin* of the main wing of the palace are set slightly back from one another along what is known as a "flying geese" formation. *Shoin* was originally a term that meant reception hall. Over time it came to mean any building that had

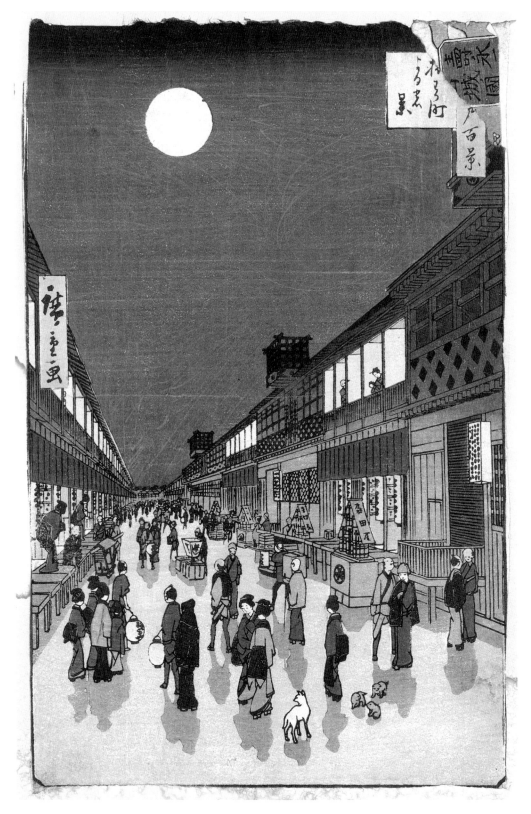

Figure 15.6. Ando Hiroshige, *Surawaka-cho in Moonlight,* in *One Hundred Famous Views of Edo,* 1856, woodcut.

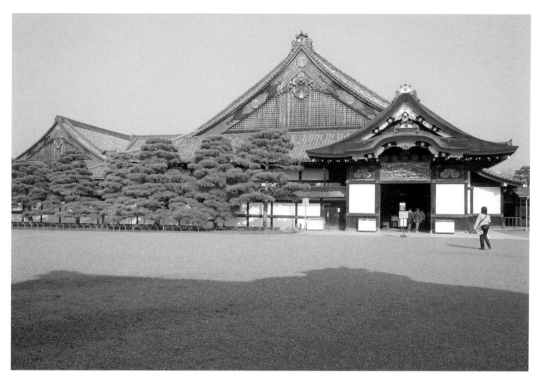

Figure 15.7. Ninomaru Palace, Nijo Castle, Kyoto, Japan, 1624–26.

a formal hall that was also distinguished by a writing alcove. The other essential fea-
tures of a *shoin* included exposed square posts supporting suspended coffered ceil-
ings, as well as tatami mat flooring woven out of grass and shoji, the sliding paper
screens that served as wall dividers. At Nijo two *shoin* contain anterooms through
which visitors proceeded before entering one of the two audience halls. Behind these
formal rooms were the more private quarters in which the shogun actually slept and
detached service buildings. Note the elaboration of the gables with gold ornaments.
Note as well how much more enclosed these buildings are than their Chinese coun-
terparts (Japan, after all, has a colder climate than much of China) and the play
between white stucco and painted wooden framing established here.

 The third *shoin* was the Kurshoin, where the shogun received daimyo whose fam-
ilies had been loyal to the Tokugawa for far longer than those who paid obeisance
in the second hall (Figure 15.8). The floor of this hall, and of all *shoin* chambers,
was covered in tatami mats whose standard size served as a module for interior
organization. The distinction in height between the seat of the shogun and that of
his courtiers was subtle but noticeable. Behind the shogun was a painting of a pine
tree, a traditional Japanese emblem of eternity. Indeed, all the surfaces of this cham-
ber were elaborately painted with landscapes set against a gold ground; the roof was
also splendidly coffered and decorated with lacquerwork. Apart from these paintings
and the shelves, there were very few furnishings; everyone sat on the floor. The scale

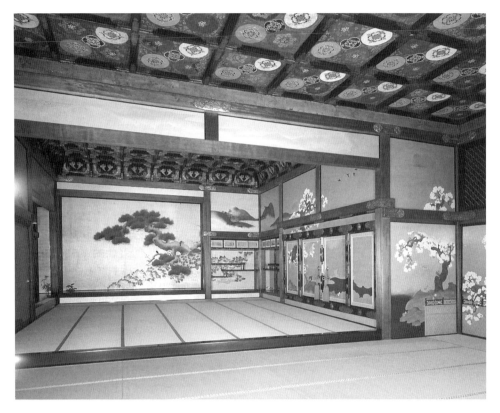

Figure 15.8. Kurshoin, Ninomaru Palace.

of this room was not as great as that of the Hall of Mirrors at Versailles, or the materials as rich as those used in the Red Fort in Delhi, for instance, but the subtlety of the chamber's ornamentation made it an equally imposing setting for expressions of hierarchical political authority.

Because the shogun was the effective political power in seventeenth-century Japan, imperial architecture developed along distinctive lines. The most widely admired imperial Japanese villa of this or any other period was not the site of imposing political rituals such as those staged at Nijo or, for that matter, the Topkapı Saray or the Red Fort. Instead it was a place of retreat from ceremony. In this it is more like the Chinese scholar garden, and it is set in the Japanese equivalent of that garden. Here, even more than in the Forbidden City, the architecture of everyday Japanese life was stylized and refined until it became an index of a particular kind of power, the power of art rather than that of politics. This is the same power, which one could also define as taste, that specifically animates some rococo architecture in Europe, especially the prince-bishop's Residence in Würzburg. The Katsura Rikyu, or Katsura Imperial Villa, was built between 1605 and 1663 by three members of the imperial family: Prince Toshihito, younger brother of Emperor Go-Mizunoo (who made two formal visits to the palace after he had renounced the throne in

favor of his daughter Empress Miesho, who was also the granddaughter of Tokugawa Ieyasu); Toshihito's son Prince Noritada; and Go-Mizunoo's son Prince Sachi. They intended it as a retreat for private life and above all, contemplation. Because the imperial family played only a marginal role in Japanese politics, there was little else left for these princes to do.

The villa is set not in the center of the city, as most buildings that embodied political power still were, but on what were then the outskirts of Kyoto. Although suburban summer palaces were becoming the fashion in both Europe and Asia, the location of Katsura testified to the political impotence of its builders. The entire irregularly shaped compound was marked off by bamboo fencing. The stone border that defines the platform onto which the gate is set, the rough bark facing the timbers that frame the gate, the bamboo slats hung from the door frame (different from the bamboo lattice of the fence itself), and the two scales of thatching provide glimpses of the refinement that characterizes the entire environment. The materials are unassuming, indeed rustic, but this rusticity is supremely self-conscious. Throughout Katsura simple materials that would have been familiar to peasants were used with extreme sophistication in a conspicuous display of exquisite refinement rather than extraordinary wealth.

On the other side of the gate is a garden of studied informality and stunning complexity (Figure 15.9). Within it, always off axis, are the three interlocked pavilions of the main palace and a number of detached structures. The latter are mostly destinations within the garden, which was planted with an eye toward its appearance across changing seasons. Bridges link the entire ensemble together and structure one's passage through it. One approaches the palace from the side, gaining a view of the whole ensemble only after passing through the *shoin* into the garden. The villa is made up of the old, middle, and new *shoin* (Figure 15.10). This is roughly the same organization as at Nijo, but here the buildings are distinguished by the simplicity of their materials.

In place of lavish ornament is a subtle attention to space, visible, for instance, in a detail that marks the transition from the garden to interior space. First there is the platform on which the building was placed. Their height distinguishes these *shoin* from vernacular construction. Next is the veranda situated atop the open arcade of the ground story. Sliding screens modulate its connection to the garden. Behind it are the individual *shoin,* whose relationship to both the veranda and the garden remains flexible. The lightness of their construction reflects the widespread deforestation that drove the Japanese in the seventeenth century to make more economical use of their natural resources.

The Katsura *shoin* are far less richly decorated than their counterparts at Nijo. They retain a subtlety much admired by twentieth-century architects more interested in proportion and construction than in ornament. The flexibility of the sliding screens in particular had an enormous impact on the spatial concepts of Western architects moving from masonry to frame construction in steel and reinforced

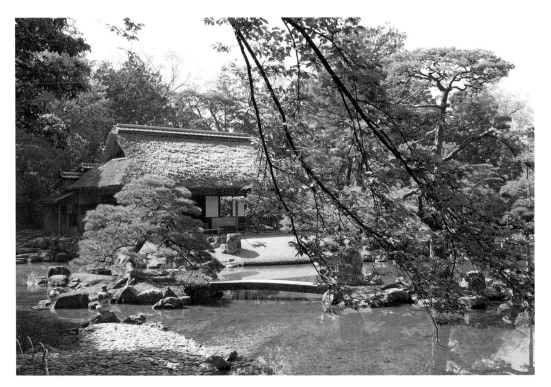

Figure 15.9. Garden with Shokintei teahouse, Katsura Imperial Villa, Kyoto, Japan, 1615–63.

Figure 15.10. Katsura Imperial Villa with old *shoin* in foreground on right.

concrete. Several of Japan's own modern architects wrote books on Katsura. Many people today take sliding floor-to-ceiling porch doors for granted; they have been a feature of vernacular houses in many parts of the world for half a century. They are not intrinsically modern, however; rather, they have their origins in the specific time and place of the Katsura Imperial Villa.

In spite of their apparent modernity, such spaces were used very differently by their original inhabitants in comparison to their modern descendants. Wealthy Europeans were almost unique in the seventeenth century in their fondness for chairs; the Japanese still sat or knelt on the floor, or on the edges of platforms. Instead of spending money on furnishings, the Japanese devoted attention to their clothes, their major locus of social display. Furthermore, the many layers of the kimono protected the wearer against the cold breezes that quickly penetrated the shoji screens of Japan's underheated dwellings. Instead of trying to warm entire rooms, the Japanese carried with them small charcoal braziers, which they used to warm the space directly around them.

In addition to housing living space, the *shoin* served as platforms from which to view the garden and to depart for strolls through it. Perhaps the most distinguished feature of the old *shoin* is the moon-viewing platform, which projects out into the surrounding garden. Its pillars sit atop irregular stone bases that protect them from rot. Note the only apparently random distribution of the large boulders and the precise placement of the carefully selected stones, some of which serve as a modern gutter for rainwater cascading from the roof. A couplet from *The Tale of Genji,* an eleventh-century literary work attributed to the Japanese noblewoman Murasaki Shikibu, helps set the tone:

A village far down the river where the moon is clear
Katsura [here a kind of wood] tree's shadow is serene.

The garden at Katsura is larger and less obviously formal than its Chinese counterparts, as architecture is here firmly subordinate to a more casually, if no less carefully, arranged assemblage of plant and rock material. There is a far less obvious sense of artifice here than in the Chinese scholar garden, but nothing was left to chance here either. The varied plantings were carefully chosen so that texture and color play off against each other and are mirrored once again in the water. The garden is not meant merely to be seen from the palace, but to be strolled through. Six teahouses provide destinations. The tea ceremony is characterized by the same self-conscious rusticity that distinguishes Katsura. Both were inspired by Zen Buddhism, which, although it originated in China, took distinctive cultural shape in Japan. The unplaned tree-trunk columns, bamboo screens, and outdoor pantry of the Shokintei teahouse imitate rural architecture, but just as the apparent roughness of the ceramic cups of the tea ceremony represents a self-conscious refusal of beautifully painted porcelain, this architecture is deliberate in its rusticity (Figure 15.11).

Together house and garden at Katsura were intended, like the Chinese scholar garden, to provoke specific emotional responses, to act much like poetry, to which they were closely related.

The tendency when looking at preindustrial architecture is to think that the spirit of a culture resides in its rural buildings, which typically change far more slowly than their urban counterparts. Many modern observers yearn for traditions that can inoculate us against the uncertainties of our own lives. Certainly the princes, father and son, who built Katsura had this aspiration. They renounced the Chinese-influenced profiles of Nijo Palace's tile roofs and the gilded ornament that decorates them in favor of something that conveyed the flavor of the *minka* in which so many ordinary Japanese dwelled. Although built at almost the same time, Nijo and Katsura are very different places because, even within the Japanese elite, individuals had access to and sought out different kinds of experiences. Nor does a single aesthetic tie elite to vernacular Japanese architecture. We find in Edo Japan yet another incipient indigenous modernism. Its locus is not the aesthetic that has so influenced the architecture of the West for more than a century but the variety of urban and aesthetic experiences on offer here to audiences of diverse classes. There was a vigor in the streets of Edo and the apparent delicacy of Katsura that survived the transformations wrought by imported industrialism, transformations that cracked and finally erased the magnificence of other court cultures from Versailles to Beijing.

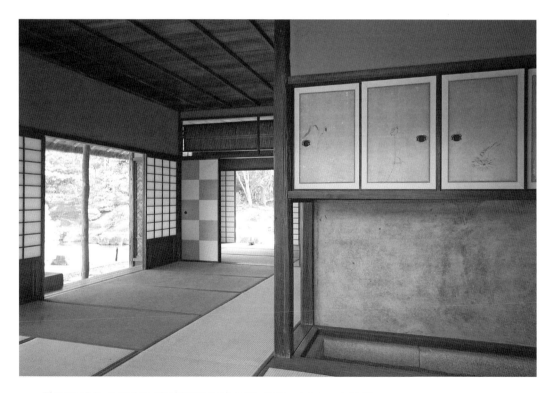

Figure 15.11. Interior, Shokintei teahouse, Katsura Imperial Villa.

FOR FURTHER READING

On the *minka,* see Chuji Kawashima, *Minka: Traditional Houses of Rural Japan* (Tokyo: Kodansha International, 1986). For discussion of Edo, see Nicolas Fiévé and Paul Waley, eds., *Japanese Capitals in Historical Perspective: Place, Power and Memory in Kyoto, Edo and Tokyo* (London: Routledge, 2003); and James McClain, John Merriman, and Ugawa Kairu, *Edo and Paris: Urban Life and the State in the Early Modern Era* (Ithaca, N.Y.: Cornell University Press, 1994). My comparison of Nijo and Katsura follows William Coaldrake, *Architecture and Authority in Japan* (London: Routledge, 1996), as does my discussion of Himeji. On Katsura, see Virginia Ponciroli, ed., *Katsura: Imperial Villa* (Milan: Electa Architecture, 2004).

16 Neoclassicism, the Gothic Revival, and the Civic Realm

The creation of new building types in the eighteenth century was not limited to the appearance of new structures for entertainment and commerce in Edo and London. One aspect of the enormous shifts in European and North American social and political organization that took place from the mid-eighteenth through the mid-nineteenth century was the emergence of civic buildings as the major preoccupation of a rapidly growing architectural profession. In 1776 the Americans declared their independence from Britain. Thirteen years later, the French stormed the Bastille. These were only the two most important of the revolts that resulted in the independence of most of the Americas and the transformation of Europe.

The new civic architecture was both prompted by and created through increasingly public debates over the appropriate appearance of architecture and the ideal organization of government. How could the rule of law substitute for the divine right of kings, and how could it foster both individual liberty and economic prosperity? This Enlightenment discussion fostered the creation of a civic realm composed of institutions, sponsored largely by governments, in which citizens gather for administration or edification. These include legislative assemblies, government offices, monuments, universities, museums, and even theaters. The establishment of these new buildings types and the spaces they housed transformed the appearance and experience of even those cities, such as London and Berlin, that were spared actual revolution, as well as of centers of action and ideas, such as Paris and Charlottesville, Virginia. The expanded civic sphere had three important characteristics. First, it housed functions that were either new or assuming new importance. Second, it was built for the middle class by the state, rather than for the court by the monarch. There was a recognition that bourgeois challenges to royal authority needed to be addressed if not satisfied. Third, it created a new zone for public

activity, including political discussion, which was frequently more accessible to men than to women.

Equally important, these new buildings were never baroque. Instead, although their architects sometimes revived medieval styles, including Romanesque as well as Gothic, they were usually neoclassical. Already the English aristocracy had turned to the Renaissance as an alternative to the baroque. Now architects harnessed new archaeological examinations of ancient Roman and Greek ruins to identify sources for new buildings. This approach flourished in particular in Rome, to which young European architects and the youthful aristocrats they hoped would employ them traveled in increasing numbers across the course of the eighteenth century. Often anchored in scholarship, neoclassicism nonetheless was associated with innovations in the organization and purpose of buildings; it could also feature radical simplification entirely unadorned by the orders.

Neoclassical architecture was seen as more correct because it was more literally historical; it followed what were understood to be the rules of ancient classicism. The new emphasis placed on the origins of architecture also encouraged two innovative phenomena: the increased importance of abstract, ideal geometry to the making of form and the increased importance of the expression of structure to the construction of that form. The Abbot Marc-Antoine Laugier developed these ideas in more detail in Paris. In his *Essay on Architecture,* published in 1753, Laugier described the primitive hut as the origin of the Greek temple (Figure 16.1). He preferred Greek architecture to Roman because of its greater antiquity, although he and his western European contemporaries as yet knew little about its actual appearance. Through the primitive hut Laugier attempted to reduce architecture to its hypothetical origins in columns, entablature, and pediment. Buildings, he believed, should be stripped of the overlay of nonstructural ornament that had decorated classical architecture since Roman times. Echoing the language of Enlightenment philosophers such as Jean-Jacques Rousseau, he defended this reductionism as natural.

Both Laugier's writings and the intellectual climate of the French Academy in Rome, to which the government in Paris sent promising young artists to study antiquity, had an enormous impact on Jacques-Germain Soufflot's design for a new cathedral-scale church in Paris (Figure 16.2). Originally named Sainte-Geneviève, for the city's patron saint, it became the Panthéon when it was converted to serve as the shrine of the French Revolution and of the revolutionary republican French state. Already in the 1720s British aristocrats such as Lord Burlington were turning to republican Rome and its architecture for a model of a more participatory political system. By 1757, when Soufflot received his commission, that association had acquired an even wider audience in France, where many members of both the aristocracy and the bourgeoisie challenged the concept of an absolutist monarchy by appealing to the republican Roman rhetoric of virtue.

The French state responded by attempting to co-opt the architecture rather than the substance of political reform. The single most important building in this effort

Figure 16.1. Marc-Antoine Laugier, *Essay on Architecture,* second edition, 1755, frontispiece.

Figure 16.2. Jacques-Germain Soufflot, Sainte-Geneviève (Panthéon), Paris, France, 1757–90.

was Sainte-Geneviève, completed only in 1790 after the storming of the Bastille had rendered its original purpose irrelevant. Here three distinct architectural styles—the Gothic, the baroque, and the neoclassical—are fused. The church was built on the scale of a Gothic cathedral and with the same attention to engineering. It featured, however, the dome expected of all large urban churches in the centuries since Brunelleschi's first rose over Florence. And yet its design was also informed by the sense of rules, derived largely but not exclusively from ancient architecture, characteristic of neoclassicism.

The complicated construction history of this building reveals the difficulties inherent in the French attempt to recast classicism as a rational system in which the orders served entirely structural roles. For the church to serve as the built representation of royal virtue, it would have to be constructed along the lines described by Laugier, who had advocated an arrangement in which classical forms were retained even as they were converted from decoration to structure, which now served as an allegory of the morality and integrity of the building's royal patron and its architect. Laugier was not an architect, however, and his belief that one could construct

Gothic structures using classical forms tested the engineering of the day. The result was an engineering tour de force on the level of Brunelleschi's dome.

Soufflot's main challenge was to support his dome on columns rather than on piers. Although the entire entablature of his nave is supported on columns and piers, far thinner walls and lighter vaulting distinguish it from its Renaissance or baroque predecessors and recall the membrane-like architecture of the great Gothic cathedrals. Engineering had recently become a distinct profession when the National School of Bridges and Roads was founded in Paris in 1747, but Soufflot remained responsible for the structure of his building. He relied on stereotomy—the science of stonecutting—and iron reinforcement. Elaborate technical drawings were needed, which detailed as well the rich ornament required of a royal commission. These drawings were unusual in an era when most carpenters knew how to build anything an architect drew for them in elevation and plan.

Contemporaries criticized Soufflot's design as structurally unsound, sometimes because such criticism could double as commentary on the royal regime that was his patron. But the criticism had architectural merit as well. Soufflot's arches were filled in during construction after cracks began to appear. He had to redesign the dome to lighten its weight and substitute a triple shell for the original double one. Supplemental buttresses were added in 1806. Nevertheless, the interior retains a remarkable lightness (Figure 16.3).

The church of Sainte-Geneviève was intended to be the built embodiment of civic virtue cast by the monarch in religious terms. With the shift in the building's function after the French Revolution to that of a shrine to French patriotism, it became the midpoint between Europe's greatest Renaissance and baroque churches on one hand and nineteenth-century domed legislative buildings such as the U.S. Capitol on the other. When Antoine-Chrysostome Quatremère de Quincy, later the secretary to the Academy des Beaux-Arts, secularized it in 1791, only a year after it was finished, he also filled in most of the windows, giving the building its present almost fortresslike appearance. In its secular role, the Panthéon houses the tombs of France's most important citizens. It is accessible to all, a place where tourists and schoolchildren pay homage to the French state, a space whose purpose is to inspire patriotic loyalty.

The conversion of Sainte-Geneviève into the Panthéon also highlighted the abstraction of much of the building's detailing, which here began to be liberated from the archaeological correctness of classical precedent. For instance, the capitals of the pilasters on the side and rear facades did not duplicate any of the classical orders but were instead a highly simplified new invention that accentuated rather than terminated the vertical character of the form. Such abstraction characterized the boldest neoclassicism, but radical architectural solutions did not always serve increasingly radical political developments. The French state's willingness to adopt neoclassical architecture in lieu of real reform, or in association with only the most repressive reforms, greatly compromised the ability of such architecture to serve as an emblem of political reform.

Figure 16.3. Interior, Sainte-Geneviève.

By the time the French Revolution actually broke out in 1789, Claude-Nicolas Ledoux, the country's most talented architect, was widely detested. He was extraordinarily lucky not to lose his life in the terror that followed. Ledoux was unpopular above all because the brilliantly imaginative architect had exercised his talents in 1783 by designing a series of gateways to the city of Paris, located at every roadway and waterway leading in and out of the city, at which all those entering the city had to pay taxes on the goods they were bringing in with them (Figure 16.4). The efficiency of the new system was particularly unpopular because there was little public accounting of how the monarchy was spending the funds raised; anger over taxation to support a regime widely perceived as a drain on the French economy was a principal cause of the French Revolution. Built from 1784 to 1787, the Barrières, as they were called, were completed on the eve of the storming of the Bastille.

The most imposing of the surviving gates is the Barrière de la Villette. It marked a major entrance to the city and housed a customs house in addition to the usual guard post. In comparison with even Sainte-Geneviève, this was a reductive design, the aesthetic power of which came from its apparently extreme simplicity. A pediment surmounts baseless Doric piers, which neoclassical artists and architects of the time associated with civic virtue. There is no frieze or other ornament here, nor a full dome. A cylinder alone suffices in this severe reduction of the classical architectural system to its compositional essentials. The extraordinary austerity of this

Figure 16.4. Claude-Nicolas Ledoux, Barrière de la Villette, Paris, France, 1784–87.

building did not adhere, however, to Laugier's or anyone else's rules. Laugier called for pure pier-and-lintel construction, without arches, whereas Ledoux, inspired by British neo-Palladianism, wrapped around the domeless drum a motif of paired columns between arches, derived from the so-called Serliano or Palladian windows found in many neo-Palladian British and North American buildings, including Chiswick House in England and Independence Hall in Philadelphia. This emphasis on pictorial effect over Laugier's rationalism was characteristic of Ledoux's work on the Barrières, in which he developed or took from less accessible earlier examples of his own work new architectural motifs, such as a niche opening screened by columns, thus expanding the neoclassical repertory.

Ledoux's revolution in thinking about architecture matched in its boldness the political revolution to come, even if the two worked at cross-purposes. The mob stormed the Barrières on their way to the Bastille. Nonetheless, it was the architecture of Ledoux, the enlightened Royalist, that would all across Europe become the cliché of the age, uniting the architectures of countries divided by war and different political systems. Although neoclassicism was the dominant style for the expanding public sphere, history alone was not a sufficient model for the new tasks buildings were called upon to fulfill or envisaged fulfilling. One of the most important of these tasks was educating members of the public so that they would be able to assume the new civic duties to which they aspired. This encouraged architects to experiment with how buildings communicated their new purposes. One of the leaders in this experimentation was another French architect, Étienne-Louis Boullée. Although he built relatively little, he was an important architectural educator and dreamer who inspired generations of later architects.

Boullée's design for a cenotaph for the physicist Isaac Newton, which dates to 1784, could never have been constructed (Figure 16.5). A cenotaph is a gravestone or monument for someone whose body does not lie underneath, often because he or she has been lost at sea. In the eighteenth century most European public monuments were either images of monarchs, like the equestrian statues that served as the centerpieces of French royal squares, or marked actual graves. Commemorative architecture would soon become an important instrument for edifying a bourgeois public, imbuing it with the goals of the real or an imagined state (monuments to George Washington and then the Civil War, for instance, became ubiquitous in the United States in the nineteenth century). Newton was buried in his native England, but Boullée dreamed of memorializing him in France, whose Enlightenment philosophers admired the pioneering physicist's reliance on reason to explain natural laws. This accorded with their desire to follow the examples set in Britain after 1688 and replace royal whim as much as possible with the rule of law.

Boullée projected the construction of an enormous sphere, ringed at the top of its substantial anchorage with rows of cypress trees, associated in ancient Greek mythology with mourning. Small holes in the roof of the structure would give daytime visitors a chance to study the constellations of the night sky; from within

Figure 16.5. Étienne-Louis Boullée, cenotaph for Isaac Newton, 1784.

in these conditions the building would function as an armillary sphere. At night it would be illuminated from within. The building's vast scale, its reversal of day and night, and the bold contrast of light and shadow in Boullée's representations of his scheme are all examples of the sublime. As defined by the Irish philosopher and politician Edmund Burke, writing in 1757, the sublime was the emotion generated by nature's grandeur, which he carefully distinguished from the appreciation of more conventional and harmonious beauty. Burke declared, in words that later helped to launch romanticism, "The passion caused by the great and the sublime in nature, when those causes operate most powerfully, is astonishment; and astonishment is that state of the soul in which all its motions are suspended, with some degree of horror."

The balance Boullée established between sublime effects and rational geometry, now almost completely liberated from its classical origins, captured the two sides of nature that fascinated his contemporaries. An understanding of natural law as the basis for logical social and political as well as scientific systems was increasingly accompanied by an appreciation of both natural grandeur and irregularity, whether jagged Alpine peaks or the changeable atmospheric conditions that governed the way in which they were perceived. The resulting emphasis on the emotive aspects of architecture was not always immediately apparent in the expanding civic sphere, however.

Neoclassical architecture had an ambivalent relationship with real political reform, but whether sponsored by democrats or kings, European civic buildings had by 1800 acquired a monumental architectural presence that had been the exception rather than the rule since the late Middle Ages. Housing the institutions that nurtured the bourgeoisie by educating them to positions of leadership was especially important in the new United States. The University of Virginia in Charlottesville was founded and designed by the same man (Figure 16.6). Thomas Jefferson was also the author of the Declaration of Independence, third president of the United States, and the most important gentleman architect in the history of the country he did much to establish. Most Americans of Jefferson's generation who cared about architecture followed British fashions, but after serving as American ambassador to France, Jefferson preferred French neoclassicism.

Jefferson established the university in order to educate the white male electorate (the university began to accept African Americans in 1950 and women as undergraduates only in 1970). This education was to consist above all in schooling in the Greek and Latin texts that had provided Jefferson's own generation with the political concepts of a democratic republic, but it was also to include architecture. The original buildings were erected between 1817 and 1826. They created an architectural as well as an educational showpiece, embodying Jefferson's vision of community. The campus doubled as a diagram of social hierarchy. At one end of the Great Lawn stands the Rotunda. It originally housed the library, which Jefferson

Figure 16.6. Thomas Jefferson, University of Virginia, Charlottesville, Virginia, 1817–28.

regarded as the university's most important structure, as well as the central admin-
istration. Next came the houses of the ten professors. At a time when both shops
and professional offices were still typically located within residences in Europe and
its former American colonies, the front rooms of the professors' houses served as
classrooms. An arcade, lined with student rooms, connected the faculty houses.
A second layer of student rooms was separated from the first by gardens. The prox-
imity between faculty and students was intended to ensure appropriate adult super-
vision of the students. Although the university catered strictly to white males, women
and slaves lived in the faculty houses along with the white male professors.

Jefferson carefully balanced unity and diversity in the university's design. The
arcade that ties the entire composition together, as well as offering protection from
rain and sun, is stepped to harmonize with the gradual slope of the land, and the
individual pavilions have different elevations. These provide examples of the correct
use of the three orders—Doric, Ionic, and Corinthian. Jefferson consulted with all
of the nation's few professional architects in order to make the university a place in
which potential patrons as well as future gentleman architects could learn about the
discipline.

Jefferson's design became a prototype for American college and university archi-
tecture. The idea of learning in a garden remains one of the most distinctive aspects
of American higher education. Elsewhere, especially in German-speaking central
Europe, new civic buildings served an expanding bourgeoisie who were gaining
partial control of their governments only subtly and slowly, often by working as
civil servants rather than through voting. In the lands of the former Holy Roman
Empire, abolished in 1806, nation-states—many raised only by Napoleon to the
status of kingdoms—competed to become the core of a unified Germany. Mon-
archs reached out beyond their own borders to impress this educated middle class.
The members of this group, which consisted of professionals, civil servants, and
Protestant clergy, defined themselves in part through their ability to appreciate new
state-sponsored cultural facilities.

Between 1815 and 1848, Berlin, Munich, Dresden, Karlsruhe, and Stuttgart, the
respective capitals of Prussia, Bavaria, Saxony, Baden, and Württemberg, all gained
imposing arrays of civic buildings. The institutions they housed—art museums,
opera houses, concert halls, government office buildings, and educational facilities—
were emblematic of the shift in location of culture and, to a much lesser degree,
politics from the monarch and the court to the state and the upper-middle class.
Architects such as Karl Friedrich Schinkel were civil servants whose government-
sponsored offices specialized in the design of public infrastructure. While Munich
and Dresden grouped their new cultural facilities into urban ensembles, Schinkel
and his royal Prussian patrons instead placed such facilities in relation to existing
urban landmarks.

Schinkel addressed the question of the civic most explicitly in the Altes Museum,
or Old Museum, constructed from 1824 to 1828 on a site across a small park from

the Prussian royal palace (Figure 16.7). Until the French Revolution, when the people of France nationalized the royal art collection and put it on display in the Louvre, a former palace, art belonged to individuals, most of them—except in the Netherlands—members of the nobility. In the 1820s, German kings began to display their personal collections publicly, turning over what had been personal property to the state. In Berlin some of the first art historians were hired to develop a comprehensive collection that would educate the citizenry in the new discipline of art history. Access to culture created a sense of empowerment that nonetheless fell far short of representative government.

The form Schinkel chose was as important as the site selected by the king. In place of a temple front, he took the ancient Greek stoa as his model. Seeking a secular rather than sacred precedent, he selected the building type in which Athenian male citizens had gathered for public discussions. Schinkel strove to create a place for civic assembly and discussion, as well as one in which visitors could look at art. Two distinct entrance paths led through monumental spaces into the galleries (Figure 16.8). Through the front door one entered an ample rotunda, ringed with sculpture. One could also ascend directly from the exterior up a monumental staircase, an example of the way in which a palatial scale and sense of procession were being appropriated for the bourgeoisie. This led to a sheltered second-story space looking out over the open space that separated the museum from the palace. Monumental staircases like this one were places where one could stroll in conversation with friends as well as study works of art. (Although the museum was open to men

Figure 16.7. Karl Friedrich Schinkel, Altes Museum, Berlin, Germany, 1824–28.

Figure 16.8. Plan, Altes Museum.

and women of all backgrounds, Schinkel's own drawings show them inhabited exclusively by well-dressed men and boys.)

Behind this facade, however, was an essay in architectural logic of the kind that was being advocated throughout continental Europe by those interested in the interlocking of civic building types and neoclassical form. Schinkel borrowed the plan, a circle and two courtyards inscribed within a rectangle, from a French architectural educator named Jean-Nicolas-Louis Durand, whose publications provided useful models for civic architecture throughout Europe at this time. The galleries for paintings were arranged in the two floors along the building's perimeter. Side lighting interrupted the wall area without providing regular enough lighting, but later museums would usually feature illumination from above.

By the 1830s the primacy of neoclassicism was being challenged by the increasing popularity of alternative styles. Schinkel employed the Gothic for certain commissions, including churches, but even classicists, inspired by the discovery that ancient Greek temples had originally been brightly painted, began to turn away from designing splendid white temples. Many began to experiment with constructional polychromy, the use of different colored building materials. In Britain, the revival of the Gothic style for civic buildings was predicated on the way the Gothic had already

been deployed in the eighteenth century in domestic architecture in buildings such as Strawberry Hill, a villa not far outside London inhabited and extended by Horace Walpole over the course of the last half of the eighteenth century. What had been almost a folly in the eighteenth century, however, acquired in the nineteenth century the seriousness of moral purpose that neoclassicism had lost through repeated use.

The pairing of the neo-Palladian country house with the picturesque garden was supplemented in gardens such as that at Stourhead by the insertion of Gothic elements into the park. It took only one small step more to apply the picturesque to the house itself. This happened most famously at Strawberry Hill (Figure 16.9). Walpole, a scion of a famous British political family, created a building that reflected his interests as an antiquarian and a historian (he was also a novelist) in British medieval rather than ancient Greek or Roman material. Walpole was one of the first to construct his own sense of self through the design of his domestic environment, a strategy that would appeal especially in years to come to those, including his fellow homosexuals, interested in alternatives to social convention. He opened the result to relative strangers, even publishing a guide to the collections Strawberry Hill housed.

For its owner, Strawberry Hill was not only a place to live, write, and entertain. Like so many homes today, Strawberry Hill functioned as a stage set that reinforced the individual sensibility of its chief inhabitant. The supposedly natural asymmetry of Stourhead's garden now infused the composition and style of an entire building, as Walpole rephrased Burlington's original messages of liberty and patriotism in more personal terms and in a different architectural style. Walpole did not re-create

Figure 16.9. Strawberry Hill, Twickenham, England, 1747–90.

a real medieval castle; instead, he added a veneer of Gothic decoration to the creature comforts of his eighteenth-century life. Because he was interested in evoking a medieval style rather than function, he had no compunction about basing most details on religious rather than secular buildings, nor did he follow contemporary French theory's interest in structural integrity. Image was what mattered when he derived the elaborate papier-mâché fan vaulting of the long gallery, for instance, from Henry VII's Chapel at Westminster Abbey, built nearly a century before Hardwick Hall. This provided a far more ornate precedent than the more modestly decorated ceilings of the original Elizabethan and Jacobean long galleries.

Decades later, the British turned to a more serious Gothic at a time of crisis. On October 14, 1834, a fire destroyed the Houses of Parliament in London, the center of the country's unusually strong tradition of representative government. The competition brief for their replacement specified that the building be erected in the Gothic or the Elizabethan style. The intention was to ease the sense of loss by building something that would appear connected to a deeply venerated past. The architects were also charged with bringing order to what had been an ensemble of accretions. The winner was Charles Barry, best known for his Renaissance revival rather than his Gothic buildings. Barry's building, begun in 1836, was finally completed in 1867 (Figure 16.10). It coupled picturesque asymmetrical massing, anchored by the iconic Big Ben clock tower, to a pragmatic plan very different from the more ideal geometries favored by neoclassical architects on the continent. Westminster Hall,

Figure 16.10. Charles Barry, Houses of Parliament, London, England, 1836–67.

built in the eleventh century, which had survived the fire, threw Barry's cross-axial plan slightly off-kilter.

Augustus Welby Northmore Pugin, the son of a French émigré architect, was, like his father, an authority on the Gothic. He worked as a draftsman on the drawings for Barry's competition entry and was responsible for much of the interior decoration. The synthesis of modern function and historical form found here characterized much nineteenth-century architecture, easing the transition from old to new. At first glance the House of Lords, the complex's most splendid interior, appears entirely medieval (Figure 16.11). A closer examination of the room from which the monarch delivers the annual address to Parliament reveals, however, an entirely modern scale and degree of organization. The floor area, uninterrupted by supports, is extremely large, and the flat ceiling enormously high. Comfortable tiered benches, grouped on three sides of the speaker's desk, provide seating for lords; leaving the fourth side open prevents them from having their backs to the ornate throne, which dwarfs its occupant. Here neoclassicism's original austerity gave way entirely to a Gothic splendor different in style but not degree from that found at Versailles. By this date the Industrial Revolution's infusion of wealth was making the middle class as comfortable as their aristocratic superiors with this degree of display.

Today we are prone to romanticize the public sphere, which appears to be yielding to the pressures of an increasingly commercialized and decentralized cityscape. In its own time, however, it also had limitations, most notably the restricted access that women of all classes and men from the lower-middle and working class had to it. The public for these buildings remained narrowly defined, and the architecture addressed itself only to those well enough educated to understand the meanings embedded in it. Nonetheless, the emergence of these new building types was crucial to the development of real political change, as the size of the governing class and the opportunity for social mobility both increased.

FOR FURTHER READING

For a survey of European architecture during this period, see Barry Bergdoll, *European Architecture: 1750–1890* (New York: Oxford University Press, 2000). The emergence of civic architecture was accompanied by public debates over its appearance. See Joseph Rykwert, *The First Moderns: The Architects of the Eighteenth Century* (Cambridge: MIT Press, 1983); and Richard Wittman, *Architecture, Print Culture, and the Public Sphere in Eighteenth-Century France* (New York: Routledge, 2007). Marc-Antoine Laugier, *Essay on Architecture,* trans. Wolfgang Hermann and Anni Hermann (1753; New York: Hennessey and Ingalls, 1971), gives the flavor of the architectural rhetoric of the period. For an analysis of the relationship between social change and architectural change during the French Enlightenment, see Anthony Vidler, *Claude-Nicolas Ledoux: Architecture and Social Reform at the End of the Ancien Régime* (Cambridge: MIT Press, 1990), which builds upon Michel Foucault, *Discipline and Punish: The Birth of the Prison* (New York: Vintage, 1979). Antoine Picon, *French Architects and Engineers in the Age of Enlightenment* (Cambridge: Cambridge University Press, 1991), chronicles the split between architecture and engineering. For discussion of

Figure 16.11. House of Lords, Houses of Parliament. Decoration by Augustus Welby Northmore Pugin.

Schinkel's Berlin buildings in relation to the politics and culture of the period, see Barry Bergdoll, *Karl Friedrich Schinkel: An Architect for Prussia* (New York: Rizzoli, 1994); and James Sheehan, *Museums in the German Art World: From the End of the Old Regime to the Rise of Modernism* (New York: Oxford University Press, 2000). Michael Lewis, *The Gothic Revival* (New York: Thames & Hudson, 2002), offers a useful introduction to the subject; and see Michael Snodin, *Horace Walpole's Strawberry Hill* (New Haven, Conn.: Yale University Press, 2009), on this pioneering example.

17 The Industrial Revolution

At the end of the eighteenth century, new political ideas began to transform architecture and society in Europe and the Americas. The emergence of civic architecture, however, was not the only force prompting architectural and urban transformation. Another was the Industrial Revolution. Since the seventeenth century, Amsterdam and London had been focal points for European economic modernization. These were mercantile cities, in which international trade and colonization generated a rapidly expanding middle class. Architectural historians have focused on the domestic and religious architecture of these cities' new districts, but both also featured new environments in which to spend money, such as London's Vauxhall Gardens, which opened in the middle of the seventeenth century. People paid to enter this precursor of the amusement park in order to eat, drink, listen to music, hear the latest gossip, and show off the newest fashions. In Paris the Palais-Royal filled a similar role before, during, and after the Revolution, while in Japan the city of Edo offered a comparable array of opportunities for consumer-oriented distraction. The new shopping districts, coffeehouses, and theaters that sprouted in cities around the world during this period were more entertaining than edifying.

The emergence of the mercantile city foreshadowed the development of the industrial city, which was a very different kind of environment, one that typically lacked the amenities that made Amsterdam, London, and Edo exciting places to live. The products created in these unappealing industrial settings, however, had an enormous impact on metropolitan life. Capitalist real estate speculation already surpassed civic virtue as a factor in the development of eighteenth- and early nineteenth-century London. During the nineteenth century, capitalism increasingly challenged the primacy of the state, whether controlled by absolutist monarchs or bourgeois citizens, in determining urban form. This chapter charts two aspects of these interrelated phenomena. First are the new industrial landscapes in which iron and textiles, two

of the characteristic products of this revolution, were produced. Second are the new building types in which mass-produced materials—glass as well as iron—were used as construction materials. In many cases, these uses were inseparable from the economic and technological changes that resulted from other aspects of industrialization.

Eighteenth-century Britain was the site of stunning technological changes fueled by cheap labor resulting from enclosure as well as capital from the country's global trading network. Highly literate artisans from the same class that produced the carpenters and builders who erected much of eighteenth-century London on spec began to experiment with the technological processes that produced iron, textiles, and energy. The results were an enormous expansion in the production of all three and the dawn of the Industrial Revolution.

These changes occurred not in metropolitan London, but in smaller towns located closer to natural resources, such as Coalbrookdale, which was transformed by the construction of numerous blast furnaces. Early industrial production was typically located far from established cities. Access to raw materials, in this case iron and coal, determined the efficient placement of what was originally small-scale production. By the last quarter of the eighteenth century an unprecedented amount of iron was being forged in Coalbrookdale. The town's blast furnaces were fueled by coal, which across the course of the century replaced wood as the country's most important source of energy. New uses were quickly found for the iron produced here. The first bridge constructed of iron was built between 1777 and 1779 to span the Severn River (Figure 17.1). Thomas Pritchard designed it in collaboration with Abraham Darby, a local ironmaster whose foundry, then England's largest, cast the parts. Darby was interested in expanding the market for his product. The bridge's construction was so lightweight that the arch rose higher above the approaches than expected, producing a peaked roadbed.

Iron was not the only material being manufactured in greater quantities than ever before. In the second half of the eighteenth century, British inventors transformed the processes of textile manufacture. A French engraving made in 1766 of a carpet workshop showed artisans spinning, winding, and weaving. The workers were well dressed, and tasks executed by women within the home were shown being performed by men. These enterprises grew in number and size from the fifteenth through the eighteenth centuries, especially in Britain and France, India, China, and Japan. The emphasis remained on the skills of individual craftsmen. The final products were often expensive; consequently, the artisans who made them enjoyed a relatively high economic and social status.

This changed when the processes of first spinning and then weaving were mechanized in Britain. The Enlightenment spurred pragmatic thinking about ways to rationalize craft and industrial processes. Woolen cloth had been Europe's chief manufactured product since the late Middle Ages, sold wherever Europeans traded. Now the process of its creation was mechanized. The change began in 1767, when John Hargreaves invented the spinning jenny, which spun wool into thread mechanically.

Figure 17.1. Thomas Pritchard and Abraham Darby, Iron Bridge, Coalbrookdale, England, 1777–79.

Although the machine was hand powered, it was far more efficient than a single spinning wheel, as it had not one but eight spindles. The result was that by the second quarter of the nineteenth century Britain was exporting textiles to places such as India, from which it had previously imported them. This was not an entirely positive development. Much of the impoverishment of the so-called Third World resulted from the devaluation of its finished goods on the international markets. At home, the social changes were equally intense as inexpensive female and child laborers increasingly replaced skilled male artisans in workplaces that were also unhealthier. It took more than a century for the European and American labor movement to restore to factory workers the standard of living enjoyed by their artisan predecessors; in many parts of the world today such workers continue to fall far short of that standard.

Once thread could be spun with the aid of a machine, the mechanization of the rest of the production process proceeded rapidly. The development of the steam engine meant that by 1780 mills could in theory be located almost anywhere. Nonetheless, water continued to be the principal source of power throughout much of the nineteenth century, not least because it was inexpensive. The first result of the

dependence on hydropower was the location of mills on the fall line, which was located outside existing major towns and cities, where navigable water had been a priority. This produced new communities, or complete transformations of preexisting rural ones, organized along entirely new principles of production. The second result of the dependence on hydropower was seen in the form of individual factory buildings. The vertical organization of manufacturing to make most efficient use of power produced tall factory buildings, in contrast to the low-slung ones that had predominated earlier and that would return in the twentieth century with cheap electricity.

The first American mill town on this new scale was Lowell, Massachusetts, at the confluence of the Merrimack and Concord Rivers (Figure 17.2). Lowell was named in 1826 for a Bostonian who had toured British textile mills and, one generation after the first textile mills had opened in the United States, proposed a unified production process for spinning raw wool and then weaving it into cloth. The first factory there was established in 1822. Tall mills quickly lined the town's waterfront, giving it an urban scale. The town's development was backed by capital from Boston's established merchant class. Much of the wealth produced in Lowell would be spent in Boston, in most cases by people who were almost entirely unfamiliar with the mill town. The new civic environments were largely absent from working-class Lowell.

Lowell's mills lined the rivers as well as the canals built to facilitate industrial development. It was this engineering, now harnessed to manufacturing rather than

Figure 17.2. Merrimack Company Mills, Lowell, Massachusetts, founded 1823, view from 1850.

to the leisure and agricultural activities of court gardens like those at Tivoli, Versailles, Isfahan, and Agra, that determined the shape of the city. Worker housing was mostly infill. Except for Pritchard's contribution to the Iron Bridge, almost everything at Coalbrookdale and Lowell was built without the involvement of architects. Builders and carpenters, advised at times by engineers, erected foundries and mills. In Lowell, as elsewhere, the mills were at first giant versions of Independence Hall. In Lowell there were simply more stories, more bays, and less ornamentation. The stair tower and cupola containing the bell that regulated the working day stood either at one end or in the center of the building. Brick exterior walls enclosed timber-frame internal construction. Eventually, the substitution of arched window openings allowed the greater perforation of brick wall planes and thus higher levels of interior light (Figure 17.3). Classic American factory architecture followed this pattern for the rest of the century. Many of these buildings were simple rectangular blocks, without even a tower detracting from their purely industrial function.

The shift in the location of carding, spinning, and weaving from the home to the factory entailed having to house as well as pay the labor force. In some mill towns this was done in a haphazard fashion, but not in Lowell, where the discipline of the workplace extended systematically to domestic environments as well. Here, too, an established architectural vernacular was married to a new degree of rational planning. The boardinghouses and dormitories for the originally largely female workforce were larger than typical single-family dwellings of the period, but no fancier. The housing was built, owned, and maintained by the individual companies, which hired matrons to supervise and chaperone their workers, who usually lived four to a room.

Mill jobs constituted some of the first paid labor outside domestic servitude available to New England women. The sister of two mill workers wrote:

> The girls began to go work in the cotton factories of Nashua and Lowell. It was an all-day ride, but that was nothing to be dreaded. It gave them a chance to behold other towns and places, and see more of the world than most of their generation had ever been able to see. They went in their plain, country-made clothes, and after working several months, would come home for a visit, or perhaps to be married, in their tasteful city dresses, and with more money in their pockets than they had ever owned before.

The use of young farm women was viewed at the time as a social improvement on previous reliance on child labor. After going on strike twice in the 1830s to demand a ten-hour workday, these mill workers established the first labor union for women in the United States in 1844. By the 1850s, more desperate (and thus docile) immigrants from famine-stricken Ireland had replaced them.

Aside from rational organization and decent construction, aesthetics played a small role in the construction of Lowell in comparison, for instance, to contemporary

civic architecture in London, Paris, or Berlin. Lowell was designed for production rather than for leisure or edification, and it continued to be occupied by the working class rather than the upper classes. By the 1840s, however, the architecture of established cities was beginning to be transformed as new functions were accommodated in buildings that took advantage of the availability of unprecedented quantities of iron, glass, and eventually steel.

One such building was the Palm Stove, which Decimus Burton designed and built from 1845 to 1848 in the Royal Botanic Gardens at Kew, a suburb of London, which was gradually being transformed from a private royal botanical garden into a public one (Figure 17.4). As a cross between the Altes Museum and a public park, Kew was a popular site of Sunday expeditions by middle-class Londoners. They came to look at exotic species of flora. Colonialism, exploration, and the developing science of natural history brought a new awareness as well as examples of more plants to Britain, many of them tropical. There was a great vogue for azaleas, peonies, orchids, palms, and other species that needed protection from England's much colder climate in order to survive.

Figure 17.3. Countinghouse, 1835–38, center, and Mill Number 6, 1871, right, Boott Mill, Lowell, Massachusetts.

Figure 17.4. Decimus Burton, Palm Stove, Royal Botanic Gardens, Kew, London, England, 1844–48.

The first great strides in the design of enormous greenhouses came from Joseph Paxton, the gardener at Chatsworth, the country seat of Bess of Hardwick's descendant the Duke of Devonshire. That building no longer survives, but in the Palm Stove, the first significant structure to be built entirely of iron and glass, we can get a good sense of the new aesthetic. The new greenhouses were great glass bubbles in which the heat and moisture necessary to sustain exotic species could be contained in an environment tall enough to allow the trees to reach their full height. These buildings were inconceivable only a few decades earlier, when glass remained a luxury item. The use of glass expanded exponentially after the excise tax on it was repealed in 1845, producing a rapid increase in production of cylinder and plate glass. Burton's design was not entirely rational, however. Much of the Palm Stove's wrought-iron features the same Greek revival detailing that was common in the monumental civic buildings of the day.

Visiting the Palm Stove gives one a sense of what an even larger glass building must have been like. Paxton's Crystal Palace, erected in London in 1851, was the largest building of its day (Figure 17.5). Here, too, new construction techniques were employed to fulfill new architectural functions. The Crystal Palace housed the first in a series of trade fairs now known as world's fairs. This building was thus also the ancestor of the modern convention center. The fair's organizers, who included Queen Victoria's husband, Prince Albert, needed an inexpensive temporary structure

Figure 17.5. Joseph Paxton, Crystal Palace, London, England, 1851.

that could be erected quickly. They preferred a partition-free interior that could span over trees in Hyde Park, which was London's major public park. Most mid-nineteenth-century civic buildings in Britain were designed through competitions like the one held for the Houses of Parliament, but the competition held on this occasion yielded no satisfactory results. Paxton came to the rescue, suggesting a glass-and-timber structure similar to the greenhouses he had been building at Chatsworth.

Many artisans were impoverished by industrialization, but a few found extraordinary opportunities for advancement, as mechanical ability replaced classical learning in importance. Paxton, a gardener with no training in architecture or engineering, is now better known than the fabulously wealthy duke for whom he worked. His obituary in the London *Times* said of him, "He rose from the ranks to be the greatest gardener of his time, the founder of a new style of architecture, and a man of genius, who devoted it to objects in the highest and noblest sense popular." Paxton did not work alone, however, but in concert with several of the leading engineers and construction firms of the day.

The Crystal Palace can only be described in superlatives. It occupied a site 1,848 feet long and 408 feet wide and covered nineteen acres. In comparison, the Palm Stove was a mere 100 feet wide and 138 feet long. The arched central transept that cut across the Crystal Palace was 72 feet wide and 108 feet long. Far larger than any Gothic cathedral, it was also unprecedented in both the transparency of its surfaces and the clear spans of its interior. Not only was the Crystal Palace larger than any previous single structure, but it was also built with extraordinary speed, in a mere seventeen weeks. This was attainable because its iron, wood, and glass components

were all prefabricated and, as far as possible, standardized. Paxton and his collaborators employed post-and-lintel construction except for the vaulted transept and the diagonal stiffening of the truss members that they substituted for beams. This substitution enabled them to use less material in shorter pieces, which were easier to fabricate in a hurry. Furthermore, no scaffolding was necessary. The Crystal Palace represented the culmination of Paxton's experimentation with ridge-and-furrow construction (Figure 17.6). The structure was covered with a pleated surface of glass panes set in wood, with cast-iron columns and girders providing the supporting

Figure 17.6. Detail of ridge-and-furrow construction, Crystal Palace.

frame. The ridge-and-furrow system, which gives glass the same strength that corrugating paper gives cardboard, had been suggested by John Loudon, another gardener, but Paxton was the first to execute it. Now he applied it on an unprecedented scale. The finished building required four hundred tons of glass.

The exhibition held in the Crystal Palace was intended to showcase British machinery and the goods it produced. The original hope had been that this would enable the British to celebrate their technological superiority and find new markets for their goods. All that happened, but the exhibition also generated an important cultural critique of the way in which products were being designed. Many commentators preferred, for instance, exotic handcrafted goods from India. What had been intended as a celebration of industrialization instead provoked strong criticism of its excesses. This disagreement was not limited to a debate over the quality of industrial products but also encompassed the Crystal Palace itself. Since the 1930s, historians of the modern movement have wondered why more pragmatic variants of this style did not immediately triumph over designs such as that for the Houses of Parliament. At the time, however, many were not sure if the Crystal Palace was even architecture. The general public for the most part believed that it was, but those who were closer to the architectural profession often demurred. Pugin labeled it a "Great Monster." John Ruskin, Britain's leading architectural critic, dismissed it as a "cucumber frame." This harsh criticism provided an early sign of British distrust that art and industry were compatible.

Another failing should also be noted. Originally, those who built with iron believed that they were using a fireproof material, because iron does not burn. It does, however, deform at high temperatures. Paxton's palace proved so popular that it was disassembled and erected again after the fair in an outlying London park, where it eventually fell victim to a spectacular conflagration. By the time that happened in 1936, multistory construction using exposed metal structure such as was employed in the Crystal Palace had long been banned.

The difference between the pragmatic expression of the new and disguising technology to conform with what mid-nineteenth-century Londoners recognized as art confronts those who stand in front of two London railroad stations built next door to each other less than twenty years apart. The mechanization of the textile industry was matched in importance by new developments in transportation. The most famous of these, the railroad and the steamship, depended on the growth of the iron industry and the invention of the steam engine, but major improvements predate even these new forms of transportation. The period spanning the eighteenth and early nineteenth centuries was an era of road and canal building, especially in Britain, France, and the eastern United States. These revolutions in transportation transformed the way that people experienced the landscape and the way in which it was organized.

Industry was typically located far from existing cities, but railroad tracks brought the new technology and inexpensive manufactured goods into established urban

centers. The occasional greenhouse or exhibition aside, it was through railway travel that most members of the urban middle class directly confronted the technology that was dramatically improving their standard of living. Train tracks were inherently disruptive, and most government officials sought to keep them out of the hearts of their cities. Indeed, the mid-nineteenth-century edges of many European cities can be discerned through the locations of train stations or, in the case of larger cities, the rings of stations built by competing private companies, as in London.

London's earliest surviving station is King's Cross, completed in 1852 (Figure 17.7). Lewis Cubitt, its architect, was also the brother of Thomas Cubitt, London's leading real estate developer of the period. His cousin William Cubitt was a prominent railroad engineer. King's Cross, the London terminus of the Great Northern Railway, was the largest railway station that had yet been built. The extreme simplicity of the almost unornamented facade and the transparent correspondence between the interior and exterior distinguished the station from civic architecture. The two arches of the facade conformed to the two spans of the double-shed interior. Originally one arch of the station gave access to arriving trains, the other to departures. Even after arrivals and departures began to take place from the same tracks, the double-arched arrangement established here remained standard for train stations throughout Europe. Railroad stations required enormous spans, because great height was required to diffuse the smoke of the steam engines. They also needed to provide shelter for passengers. The shed at King's Cross is 280 feet long with two 105-foot

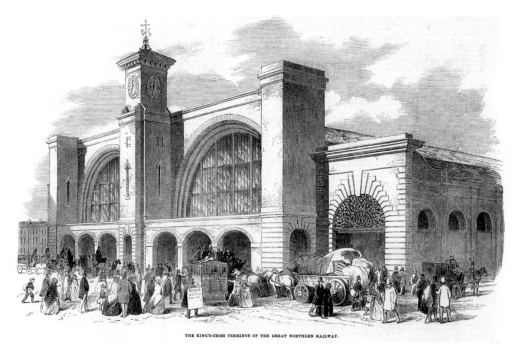

THE KING'S-CROSS TERMINUS OF THE GREAT NORTHERN RAILWAY.

Figure 17.7. Lewis Cubitt and William Cubitt, King's Cross Station, London, England, 1852.

spans 71 feet high separated by an arched brick wall. Originally a laminated timber truss set in cast-iron shoes supported this structure; it was replaced with iron in 1869, after the horizontal thrust of the first arrangement proved excessive.

Many contemporaries were uncomfortable with the stark simplicity of King's Cross. Architects were also often distressed that engineers were making substantial inroads on their profession and dissatisfied with the challenge that engineers' pragmatic designs posed to historic revivals. Bourgeois patrons often preferred more obviously artistic solutions to simple diagrams of technology and capital. This was the case with the Midland Grand Hotel and St. Pancras Station, a collaboration between the architect George Gilbert Scott and two engineers, William Henry Barlow and Roland Mason Ordish (Figure 17.8). It was built from 1865 to 1876 by the Midland Railway. Here the hotel's Gothic revival facade gives a decorous public face to the terminal behind. The combination of hotel and train station proved both convenient and profitable, but it required a very different architecture from that of King's Cross—one that promised both cultivation and comfort. The Gothic motifs here, as in the Houses of Parliament, were placed atop an entirely modern plan and function. In this case, they had Flemish and Italian rather than local sources; the railroad facilitated the study tours English architects were making to the continent. Hotels were a new building type that supported this rise in travel and in tourism.

The train station that lay behind the hotel and provided most of its customers was equally impressive from an engineering standpoint (Figure 17.9). For a generation, its clear span of 240 feet was the largest in the world. It was 100 feet high and 689 feet long. The grade required an elevated station. The great real estate value of the site inspired the use of space beneath the station as storage for a brewery. Beer barrels served as the module for the vaults, supported on iron columns, that covered this space. The wrought-iron lattice ribs of the vault form a pointed arch, which conformed to the Gothic aesthetic and proved at the same time to be the best for resisting lateral wind pressures. The glass infill used the ridge-and-furrow system, following the precedent established at the Crystal Palace. By the time St. Pancras was built, the British upper-middle class was no longer sure about the engineering aesthetic that had been left mostly bare at the Palm Stove, Crystal Palace, and King's Cross. The Midland Grand Hotel remains the archetypal example of the way in which the art of architecture was used to tame the industrial character of new urban environments. Nonetheless, the industrial aesthetic eventually helped inspire the modern movement.

The Eiffel Tower, erected in Paris as the centerpiece of the world's fair held in 1889, had no function except to serve as a landmark and a viewing platform (Figure 17.10). The fair to which it was attached celebrated the centennial of the storming of the Bastille and thus the outbreak of the French Revolution, as well as, less overtly, French industry and products. The tower was a monumental version of the pylons out of which Gustave Eiffel, the engineer who designed it, had constructed railway viaducts throughout Europe and the Americas. Eiffel, who also created the armature

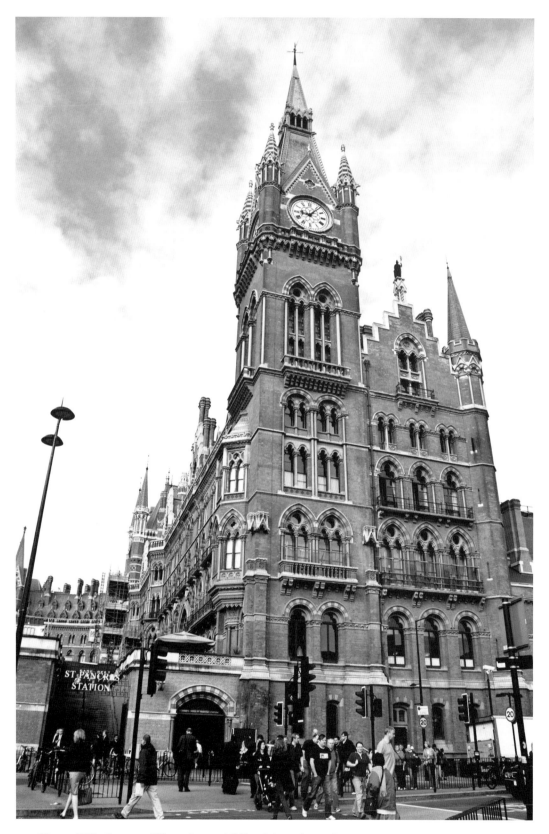

Figure 17.8. George Gilbert Scott, Midland Grand Hotel, London, England, 1865–76.

Figure 17.9. William Henry Barlow and Roland Mason Ordish, St. Pancras Station, London, England, 1865–76.

for the Statue of Liberty and designed locks for a projected Panama Canal, here brought back to Paris a scale of ambition derived from working on colossal and often highly profitable infrastructure projects abroad. A thousand feet high, the Eiffel Tower was for four decades the world's tallest structure, surpassing the twin towers of Germany's recently completed Cologne Cathedral. Built entirely of iron, it demonstrated the potential of a completely metal architecture, and, like the Crystal Palace, it was erected out of prefabricated pieces. That it took two years instead of seventeen weeks to build it is one index, however, of the far greater complexity of its lacy structure. Efficiency did not control all aspects of the design; some details are partially ornamental. Initially, Paris's many artists were almost unanimous in condemning the tower as grotesquely ugly, but it became an icon by the twentieth century, when an industrial aesthetic took hold, and eventually surpassed even Notre Dame as the symbol of Paris and of France.

The balance between aesthetics and engineering that conformed to the taste of the time was best struck in the last of the century's great bridges, the Brooklyn Bridge, spanning the East River between Manhattan and Brooklyn in New York City

Figure 17.10. Gustave Eiffel, Eiffel Tower, Paris, France, 1889.

(Figure 17.11). It was the work of two engineers, John and Washington Roebling. While most architects and many of their well-educated patrons viewed the inroads that engineers had made on the built environment with distrust, the Roeblings knew that an industrial aesthetic alone would not suffice for an urban landmark. John Roebling, a German-born and -trained engineer, originally conceived the bridge. Begun in 1867, it was completed only in 1883, long after Roebling's death as the result of an accident on the site. His son Washington suffered from a combination of the bends, also acquired on the site, and a nervous breakdown. Washington's wife, Emily, who later earned a law degree, assumed all public functions associated with the construction, passing his calculations on as needed.

The Brooklyn Bridge was not the first suspension bridge erected using metal instead of rope, but it was by far the largest that had yet been built. Furthermore, it was constructed using steel cables developed and manufactured by the Roeblings, rather than much weaker cast-iron or wrought-iron members. The new Bessemer process made steel widely available by the late 1860s.

The engineering challenge was enormous. From low banks on each side, the bridge had to leap high enough in a single span to accommodate river traffic that still included high-masted sailing vessels. The roadbed rises 120 feet above the water to span a river 1,595 feet wide. The length of the bridge, including the long approaches, is 5,862 feet. The anchorages alone are seven stories high, taller than most buildings in the city at the time the bridge was built. At a height of 268 feet each, the towers were taller than any structure in New York except the spire of Trinity Church.

From the beginning, John Roebling was conscious of the aesthetic component of his design. Immodestly, he wrote in 1867:

> The completed work, when constructed in accordance with my designs, will not only be the greatest bridge in existence, but it will be the greatest engineering work of the continent, and of the age. Its most conspicuous features, the great towers, will serve as landmarks to the adjoining cities, and they will be entitled to rank as national monuments.

Indeed, the bridge became an icon, not only to contemporaries but also to succeeding generations increasingly enamored of the industrial aesthetic Roebling had rejected in favor of Gothic-inspired arches and stone cladding of the towers. The architecture critic Lewis Mumford wrote of the bridge in 1931: "The stone plays against the steel, the heavy granite in compression, the spidery steel in tension. In this structure the architecture of the past, massive and protective, meets the architecture of the future, light, aerial, open to sunlight, an architecture of voids rather than of solids."

The Industrial Revolution transformed the organization and construction of the built environment. New sites of production were organized around newly efficient

Figure 17.11. John Roebling and Washington Roebling, Brooklyn Bridge, New York, 1867–83.

manufacturing processes, and the building materials they generated were used to construct new building types on an unprecedented scale. The very relationship between space and time was permanently altered by railroads and by bridges, both of which sped people from place to place at an unprecedented pace.

FOR FURTHER READING

Recently historians have demonstrated that patterns of urban sociability and consumerism previously thought to have developed only in the eighteenth century and only in the West have earlier roots in diverse cultures and were a cause rather than a product of industrialization. See in particular Linda Levy Peck, *Consuming Splendor: Society and Culture in Seventeenth-Century England* (New Haven, Conn.: Yale University Press, 2005). For discussion of the Iron Bridge in Coalbrookdale and the use of iron more generally, see Christine Vialls, *Iron and the Industrial Revolution* (Cambridge: Cambridge University Press, 1989). On Lowell and its workforce, see Thomas Dublin, *Transforming Women's Work: New England Lives in the Industrial Revolution* (Ithaca, N.Y.: Cornell University Press, 1994). On

the Crystal Palace and its predecessors, see Patrick Beaver, *The Crystal Palace, 1851–1936: A Portrait of Victorian Enterprise* (London: Hugh Evelyn, 1970). The classic comparison of London's two train stations appears in John Summerson, *Victorian Architecture: Four Studies in Evaluation* (New York: Columbia University Press, 1970). On the Eiffel Tower, see Darcy Grimaldo Grigsby, "Geometry/Labor = Volume/Mass," *October* 106 (2003): 3–34. On the Brooklyn Bridge, see Richard Haw, *Brooklyn Bridge: A Cultural History* (New Brunswick, N.J.: Rutgers University Press, 2005); and Alan Trachtenberg, *Brooklyn Bridge: Fact and Symbol* (New York: Oxford University Press, 1979).

18 Paris in the Nineteenth Century

The most famous Napoleon was emperor of France for ten years, from 1804 until 1814, and then again briefly in 1815 until his final defeat at the Battle of Waterloo. He ruled at his peak over territory stretching from Spain and Portugal to the gates of Moscow, but the goal of exporting the principles of the French Revolution—liberty, equality, and fraternity—gave way to personal conquest. In the end, many of the Revolution's accomplishments were erased. The brother of the guillotined Louis XVI returned to the throne in 1815. By then France, the richest and most technologically advanced country in Europe for all of the seventeenth and most of the eighteenth century, lagged behind its neighbors. The growth of Paris had come to a virtual halt, and Napoleon's plans to glorify the city had come to very little.

But there was another Napoleon, the nephew of the first. He came to power following another revolution, this one in 1848. He became emperor in 1852 and ruled until 1870 as Napoleon III (Napoleon II, the son of the first Napoleon, died as a child). His few attempts to equal his uncle on the battlefield ended in unqualified disasters; he lost his throne in 1870. Nonetheless, he is the Napoleon who cannot be ignored by any student of the history of architecture or urbanism. Under his leadership, the Parisian population doubled in twenty years, the country's industrial output finally began to come close to competing with that of Britain, and the capital was transformed from a dowdy metropolis to the most splendid city in the world. Even after Napoleon III was forced into exile in England, his urban policies survived, as did the glamour they created.

In order to understand the story of mid-nineteenth-century Paris and the diffusion of the architectural models established there to cities as far away as Buenos Aires and San Francisco, one must look at the way in which French architects were trained and how they practiced. Until the middle of the eighteenth century, builders and

carpenters rather than architects designed most buildings in Europe and its current and former colonies. Architects remained rare. In the mid-eighteenth century, however, a new way to learn architecture appeared in France: the architecture school. Following the French Revolution, the school sponsored by the Royal Academy was transformed into the École des Beaux-Arts, or School of Fine Arts. Here architecture, painting, and sculpture were taught according to a curriculum that quickly became a model for other institutions throughout Europe and, by the end of the nineteenth century, the world. Although the school was funded by the French state, many students were foreigners who took the system they had mastered in Paris back to their home countries.

The École was the most important architecture school in the world, not only because it was the oldest but also because the education it offered was so systematic. The École's educators conceived of architecture as a rational system. Plans and section drawings were as important as facades, and all three were expected to relate integrally to one another. Classicism was the preferred style, but it could take different forms. More important than style, or for that matter construction, was the rational organization of space, above all on cross-axial circulation systems. Charles Percier's prizewinning design for a building for the French Academies dates to 1786 (Figure 18.1). Each of the three academies was to be given identical space, with the fourth side occupied by an appropriately monumental entrance. Percier established a clear hierarchical relationship between the vaulted corridors, major spaces for the individual academies, and the shared domed central space.

The nature of the commissions Percier addressed in this competition underlines the French government's purpose in sponsoring it: to provide a body of professionals capable of designing buildings that would both serve and represent the state. Over time, both the buildings designed for such competitions and the drawings for them became increasingly richly ornamented. A drawing by Julia Morgan, the first woman to attend and graduate from the school, illustrates the attention to surfaces for which the students eventually became known (Figure 18.2). Morgan, like all École students, divided her time between lectures held at the school and time in the studios, or ateliers, of leading architects, who came by about once a week to give "crits." She and her classmates stayed up to all hours preparing their final drawings, wheeling the final drawings through the streets from ateliers to the École in small carts known as *charettes*. A jury then judged these drawings in private, awarding prizes without issuing any other public comments on the results.

After graduation, Morgan returned home to Oakland, California. The most successful of the École's French graduates, those who had won the Prix de Rome, spent most of their careers directing their own students and working on a very small number of prominent new government-sponsored buildings in Paris. This characterizes the career of Henri Labrouste, perhaps the most imaginative of all the school's French graduates. For much of the twentieth century, the work of the École was criticized for imitating the architecture of ancient Greece and Rome and of the

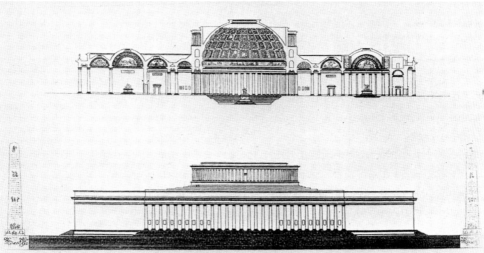

Figure 18.1. Charles Percier, project for Assembling Academies, 1786.

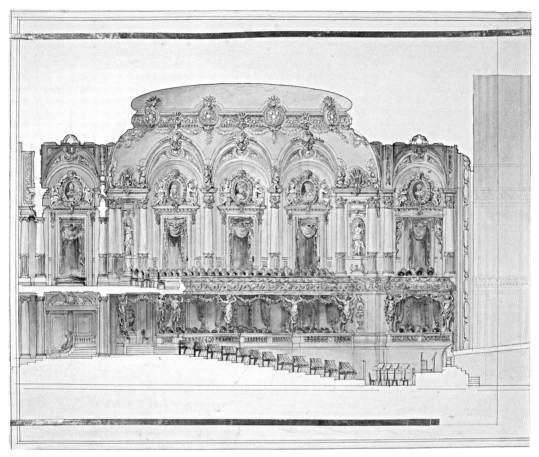

Figure 18.2. Julia Morgan, drawing for a theater, 1902.

Italian Renaissance and baroque in ways that were widely condemned as unoriginal. More recent research has demonstrated the degree to which new materials and new functions prompted dynamic revisions of classical forms as well as plans. One of the buildings that most dramatically illustrates the possibility for change inherent in this system is Labrouste's Bibliothèque Sainte-Geneviève in Paris, designed and built between 1838 and 1850 (Figure 18.3).

At first glance this library, located in the shadow of Soufflot's monumental church, is relatively unassuming: a long row of arched openings above a more closed lower story also marked by a procession of round-headed windows. The substitution of these arches for the neoclassical pier-and-lintel system of the ground story of the neighboring Panthéon provides the first hint of the new. Labrouste believed in clearly articulating the function of his building. Instead of housing every civic structure behind the re-created facade of an ancient Greek or Roman temple, as was then the fashion, he wanted to make it clear that this was a library. He did this in two ways. First, he placed the reading room along the front of the upper story of

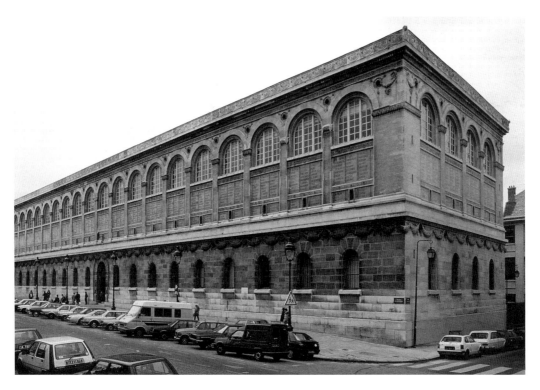

Figure 18.3. Henri Labrouste, Bibliothèque Sainte-Geneviève, Paris, France, 1838–50.

the building, where it would get the most natural light. No pedimented portico or other motif appended to the facade mars the representation of the volume of this space. Second, he ornamented the building in ways that described its purpose. Labrouste believed that architecture should communicate as directly as possible. Ornament that fulfilled that aim was more important to him than classical detailing. More than half of each upper-story arch is filled with plaques that name some of the most prominent authors of the books shelved just behind them, telling the general public that this is a building concerned with knowledge and literature. In the same spirit, Labrouste placed low-relief sculptures of torches on each side of the entrance doors to celebrate the fact that this was the first major library to be open in the evenings, when it was illuminated with lamps using new gas technology.

Once inside those doors, visitors walk through the library's ground floor to the stairway at the back of the building that leads to the second-floor reading room. Labrouste intended this pathway to substitute for the garden he could not tuck into the urban site in front of the library and that he believed was necessary as a transition between the urban bustle outside and the scholarly atmosphere he sought to create upstairs. It is lined with paintings of trees above busts of famous authors. The stairway leading to the reading room features a reproduction of Raphael's *School of Athens*, a fresco in the Vatican showing ancient Greek philosophers and scholars,

whose presence further establishes the character of this place. The reading room was the first public space in Paris to benefit from the lightness and openness made possible by iron construction (Figure 18.4). This was the first time that exposed iron was displayed in a major civic building, although a leading architect rather than an engineer designed this cultural institution. In consequence, the room radiates with light. The arched windows on four sides bring clerestory light into the space that is then reflected off the double-barrel vault more efficiently than it would be if the ceiling were flat. Using iron allowed Labrouste to minimize the columns supporting this structure, furthering his goal of diffusing light throughout the building.

Erudite buildings fusing advanced structure and function would continue to be built in Paris by Labrouste and his former École classmates. They were not, however, what made Paris the model modern city for almost all observers from around 1860 until the outbreak of World War I in 1914. While the buildings of the civic realm were targeted at the bourgeoisie interested in the workings of the state, the interest of the French government in the 1850s and 1860s became one of distracting precisely that public from participating in politics. In lieu of political power, Napoleon offered them a magnificent playground. France would never surpass Britain as an industrial power, but Paris would trump London as the place to buy and display the luxuries made possible by industrialization in environments that were as suited to their purposes as the layout of any factory floor.

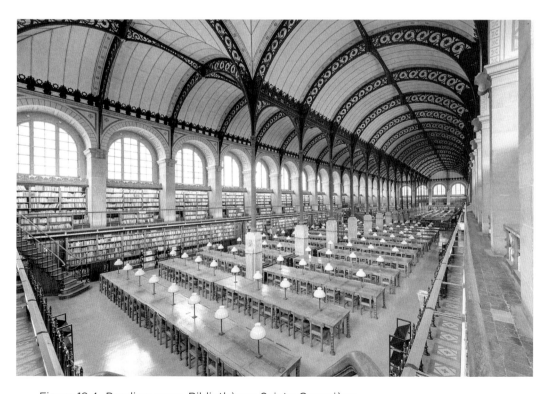

Figure 18.4. Reading room, Bibliothèque Sainte-Geneviève.

This effort was led by the man appointed prefect of Paris in 1853, Baron Georges-Eugène Haussmann, who began the process of cutting new boulevards through the city's existing fabric (Figure 18.5). Although the largest number can be found in the fashionable northwestern quadrant, they were widely distributed through the city. The new boulevards facilitated the efficient movement of traffic through the city, opening new north–south and east–west routes (Figure 18.6). This was particularly important, as the railroads did not bring travelers into the center of town; people and goods arriving from one part of the country often had to make their own way to their point of departure for another French region. From the beginning, critics charged that the new street system was also designed to maintain urban order. Soldiers would, they argued, be able to march (or even shoot) down these avenues, easily clearing the barricades that characterized Parisian street fighting. However, Paris's bloodiest street fighting broke out in 1871 during the Commune and its violent suppression, after rather than before the creation of the boulevards. As recently as 1968, street protests brought down an elected French government.

Haussmann's modernization campaign, of which the boulevards were only the most prominent component, transformed the character of the city and life in it. In 1850, Paris still contained many dirty, narrow lanes. Following paths established in some cases in the Middle Ages, these streets were lined with two- to five-story buildings, most of them erected during the seventeenth and eighteenth centuries as replacements for smaller predecessors. With no sidewalks, little lighting, and indifferent

Figure 18.5. Plan, boulevards added to Paris, France, 1854–89.

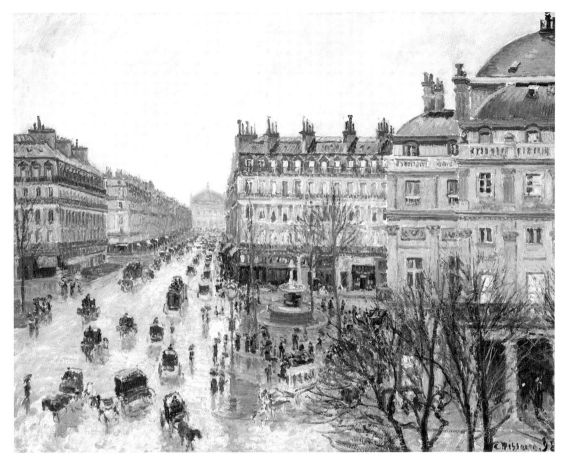

Figure 18.6. Camille Pissarro, *Place du Théâtre Français: Rain Effect (Avenue de l'Opéra)*, 1898.

water and sewer systems, these were often unpleasant places. In contrast, the new boulevards featured central traffic strips lined on both sides with shade trees and broad sidewalks, which opened onto shops and apartments.

Most well-off Parisians and the city's many tourists praised what they saw as urban improvements. Others, particularly those who on political grounds opposed their sponsor, Napoleon III, were not so sure. For the first time in French history, a significant group of intellectuals began to wonder whether some of the history and the charm of the city were being destroyed as its medieval back streets were swept away. This understanding of the value of the past was a new factor in urban planning, unknown, for instance, to the popes who had rebuilt parts of Rome, and one that Haussmann neither comprehended nor sympathized with. He appreciated historic architecture only when it consisted of major monuments, such as the cathedral of Notre Dame. To the horror of conservationists, Haussmann cleared the medieval buildings in front of the cathedral to create the plaza that exists today.

Haussmann's boulevards were new, but wide streets were not. To the baroque forms of Sixtus V's Rome, imported already into Paris by Louis XIV, Haussmann added such up-to-date amenities as sewers, garbage collection, street lighting, and public transportation. This integration of municipal services with a street life based on the public commercialization of leisure activities resulted in a new way of inhabiting the city, one that tied together the public sphere with the fruits of the Industrial Revolution. Haussmann's myriad reforms incontrovertibly made the central city more attractive than it had been previously, especially for the upper-middle class and the rich, both of whose ranks were growing even more rapidly than the city itself. In the 1840s, many of the Parisian elite moved to the suburbs in order to escape the city's grimy, unhealthy conditions. During the Second Empire they moved back to enjoy the city's new urban amenities. Where did that leave the poor, many of whom flocked to the city to take the construction jobs created by France's greatest public works project? As Paris's population grew and much of its oldest, least expensive housing was demolished, the working class crowded into the city's remaining and increasingly expensive slums. Others moved to shanty suburbs on the city's edge, from which they often walked for two hours back into the city to reach their jobs. The continued existence of such deplorable housing conditions was certainly the biggest blot on the renewal of Paris.

Historically, the city of Paris had richer and poorer neighborhoods, but generally speaking different classes lived close to one another, even in the same building; poorer tenants lived on upper floors. Already in the eighteenth century demand for housing in the capital city was so high that purpose-built apartment buildings began to appear. The invention of the elevator ensured that, beginning in the 1860s, many new apartment buildings were inhabited for the most part by the city's expanding bourgeoisie, with only the concierge below and the garret tenants at the very top representing the lower end of the economic scale. Increasingly, entire districts were inhabited almost exclusively by the well-off.

The increasing class segregation of Parisian neighborhoods left the most elegant new boulevards as the playgrounds of those who could afford to stay. Before 1850 there were few places in Paris, or in other European cities, where one would want to stroll. For half a century, elegant shoppers had preferred covered arcades, which were sheltered from the often filthy and narrow lanes along which respectable women in particular walked as little as possible. Now public life spilled onto the streets. Broad, frequently cleaned sidewalks sheltered by shade trees transformed the daily routines of the leisure class as well as those of servants and tradespeople. While their British and American counterparts increasingly took refuge in single-family houses in suburban districts, Parisians willingly moved much of their life into public spaces. They met their friends in cafés rather than in their living rooms.

Napoleon III and Haussmann also provided public access to nature. In the nineteenth century, picturesque parks ceased to be the preserve of the British aristocracy. They were now created within cities to serve the health and recreational needs of

the same middle class that used and appreciated museums and theaters. Originally the working class had relatively little access to these spaces because the new parks were distant from where they lived and because they had only Sundays off from work. As public transportation improved and the workweek gradually shortened, however, the parks came to be enjoyed by all.

The landscape architect Adolphe Alphand created the Parc des Buttes-Chaumont between 1863 and 1867 on what were then the outskirts of the city in a middle-class neighborhood (Figure 18.7). Before it was turned into a park, the site had been a rock quarry. Its dramatic topographical variation assisted in its transformation from an eyesore into a place for children to play and adults to relax. It became one of many neighborhood green lungs in a city in which almost no one could afford a substantial garden. The park was built at a time when reformers were paying increased attention to the health of city dwellers of all classes, arguing for the necessity

Figure 18.7.
Adolphe Alphand,
Parc des Buttes-
Chaumont, Paris,
France, 1863–67.

of better sanitation, supplemented by more sunlight and fresh air. In the English-speaking world, this understanding promoted the development of low-density residential districts. On the continent, however, the rusticity of city parks remained only a foil to cherished urbanity.

The city remained central in Europe not least because it was a place of collective consumption and display. Parisians excelled at creating appropriate arenas for these activities. Their importance was long dismissed because women frequented them in large numbers and because they were emphatically commercial rather than civic. Today, however, the market for luxury commodities is taken seriously as an engine that has fueled economic modernization since at least the sixteenth century.

The Bon Marché, founded in 1852, was one of the world's earliest department stores (Figure 18.8). Bon Marché translates as "good buy"—meaning relatively inexpensive. It was in department stores that the plethora of consumer goods made available by France's rapidly increasing number of factories and by enhanced networks of global trade were displayed and sold. New sales practices spread from there to smaller businesses. Anyone could enter these stores, not just those who intended to make purchases, and survey the staggering array of goods for sale within, learning in the process about what could be bought in the modern city. All customers paid the same prices, which were clearly displayed; no longer did one need to bargain.

Changes in shopping practices affected women most directly. They allowed middle-class and wealthy women, who seldom worked for money and were not allowed to vote, to exercise real economic power as consumers. Department stores also created public places where these women could socialize with friends. Shopping become a middle-class rather than only an aristocratic leisure activity. One might buy something one was unlikely to need, simply for the pleasures of ownership and of wearing fashionable things. Department stores fostered the presence of women downtown by offering restaurants, reading rooms, and clean toilets. Furthermore, the task of selling goods became a common occupation for lower-middle-class women, offering them a welcome degree of financial independence. More rarely, women participated in the management of the stores, which usually began as family businesses; Marguerite Boucicaut, the Bon Marché's cofounder, ran the store after the death in 1877 of her husband, Aristide. Female factory workers and sweatshop seamstresses made most of the textiles, trimmings, and finished garments for sale in shops and department stores. The Industrial Revolution made these things, especially textiles, available in enormous quantities; new transportation networks and illustrated fashion magazines assured the dissemination of Paris fashions internationally.

The Bon Marché began as a small shop before expanding to cover a full block of the city. The store's exterior eventually echoed that of the newly expanded Louvre palace, whose architects had maintained the florid style of the sixteenth- and early seventeenth-century parts of the complex. Consequently, in the 1860s and 1870s this style became a badge of international luxury, before the example of the Paris Opera produced an even more ornate and less historicist alternative. But the real

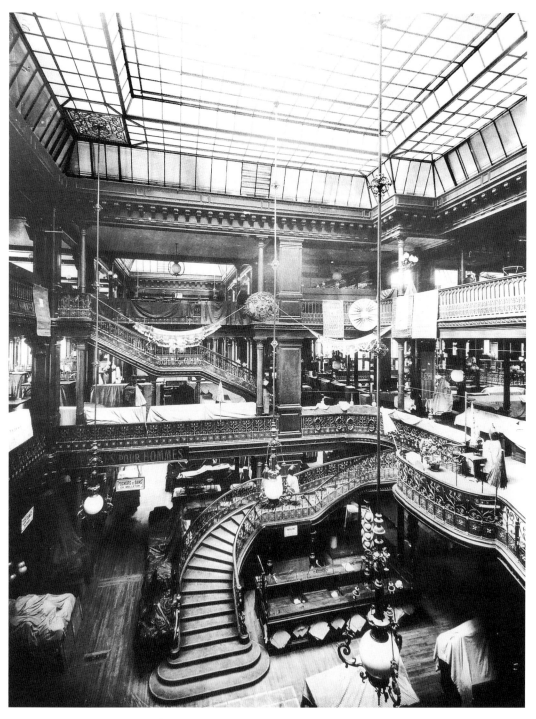

Figure 18.8. L. A. Boileau and Gustave Eiffel, atrium, Bon Marché department store, Paris, France, 1876.

drama lay inside. The new department stores were organized around vast atria that illuminated their deep sites and advertised the presence of their multiple floors, still a novelty. The palatial scale of these glass-and-iron cages coexisted with frank displays of new engineering. The architect L. A. Boileau collaborated with the engineer Gustave Eiffel in the design of this part of the Bon Marché, which dates to 1876. One could ascend by elevator to the top of the store and descend by way of one of the city's most monumental stairs in full view of the other shoppers. The experience matched in grandeur any offered by the city's civic buildings. Although the latter had ostensibly edifying purposes, the Bon Marché was more fun. Behind the scenes, however, one found more functionalism and less luxury. There was a vast mail-order division, from which goods were shipped around the world. A kitchen and dining hall for employees demonstrated the benevolence of the Boucicauts while enabling them to maintain the firm's respectability through the close supervision of their largely female workforce.

Many department stores were clustered in the most glamorous neighborhood created by Haussmann and Napoleon, along the Avenue Napoleon, now known as the Avenue de l'Opéra. This new boulevard, the most prominent north–south axis in the entire city, linked the rue de Rivoli, which ran along the side of the Louvre, to the Opera, itself the single most important architectural commission of the Second Empire. It was lined with fashionable apartments and shops. Furthermore, the city's most elegant hotels, restaurants, and department stores soon clustered in this district. The boulevard's uniform cornice heights and wrought-iron balconies replaced a dense network of smaller properties. The new street cut through but did not fundamentally alter the urban fabric. One's experience passing through this area of the city was changed, but residents lived in relation to both old and new environments.

The avenue reached its climax at the Opera itself (Figure 18.9). Designed by Charles Garnier, it was begun in 1861 but not completed until 1874. Here, as in many cases throughout the city, a prominent building served to terminate an important axis. Haussmann had additional reasons for building the Opera as an island detached from the surrounding streets. The first of these was security, especially as there had been an assassination attempt on Napoleon III at the previous opera house. Second, in an era when dancers often died as the result of their costumes igniting from the gas flames of the footlights, theater fires were among the most frequent and deadly of urban calamities. Now at least it would be easy to isolate a blaze before it engulfed the entire district. Finally, few operagoers arrived on foot and entered through the building's main doors. Instead most came in carriages, which were accommodated at the sides of the building.

The lavish architectural vocabulary invented here expressed the society's new wealth and the pleasure the public took in it. The Opera captured much of the spirit that made Paris the center for European culture, drawing everyone from people who just enjoyed a good party to those who appreciated the exchange of ideas that

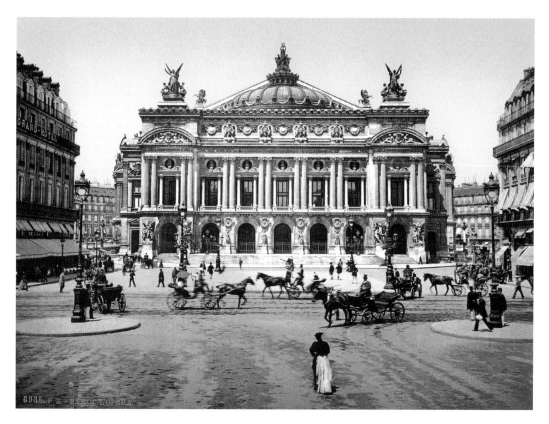

Figure 18.9. Charles Garnier, Opera, Paris, France, 1861–74.

followed from the provision for public meeting places, from casual encounters at boulevard cafés and department store aisles to the carefully staged ritual of attending the opera.

Underneath all the confectionery, the bones of a good neoclassical building remain clearly discernible in plan as well as in elevation (Figure 18.10). Garnier's organization of the Opera's interior was as efficient as that of any factory. Based on the circulation of audiences through the space, it placed as much importance on the processional path through the building as on the auditorium while at the same time creating a generous amount of backstage space. Seeing and being seen were essential components of the performance; the ceremonial space in front and support space behind exceed the volume of stage and auditorium. The monumental staircase, up which all theatergoers ascended to their seats, replaced the imperial court as the center of socially ambitious Paris (Figure 18.11). There was even a room between the carriage entrance and the stairs where one could straighten out one's dress. The stair itself was the ultimate place in all of Paris, indeed perhaps the world, to show off one's finest gowns and jewels or, if one was male, the intimacy of one's acquaintance with those who mattered. Here as throughout Second Empire Paris, participation was defined by the ability to pay, in this case for tickets, rather than by the

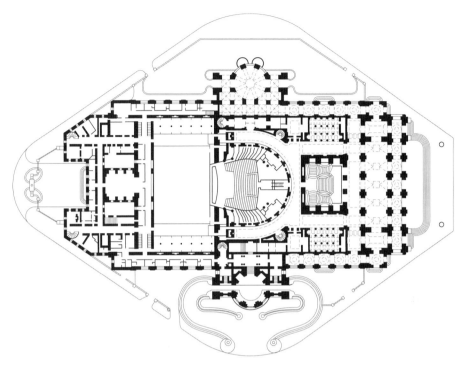

Figure 18.10. Plan, Opera, Paris.

class into which one was born or other social connections, as had been the case a century earlier when most entertainments took place at court.

A major function of the Opera was to display young women. Unlike royal courts or aristocrats' parties, to which only those with the proper social connections were admitted, wealthy courtesans as well as aristocrats, industrialists' wives, and tourists from abroad rubbed shoulders here as they also did in department stores. At the Opera, marriageable young women were introduced to a public of their peers, including potential husbands. Ballet dancers supported themselves not with their meager salaries, but with the money supplied to them by their patrons, whom they attracted through their performances on the Opera stage, dressed in what was then viewed as scanty clothing. Wealthier women, as well as courtesans, were displayed as they ascended the staircase to their box seats or as they strolled during intermission through the foyer, richer than the most splendid ballroom, and when they took their places in the box seats that lined the walls of the auditorium. They were as much a part of the spectacle as anything that took place on the stage.

The Paris created by Napoleon III was, however, much more than a place where women were put on display. Napoleon III sponsored the reemergence of Paris as the most comfortable and pleasurable urban environment in the world. This new Paris reinstated France's claim to global leadership in the arts and in culture. Napoleon III conquered no countries. Instead, he conquered many of the problems of the nineteenth-century city. It was no mean achievement.

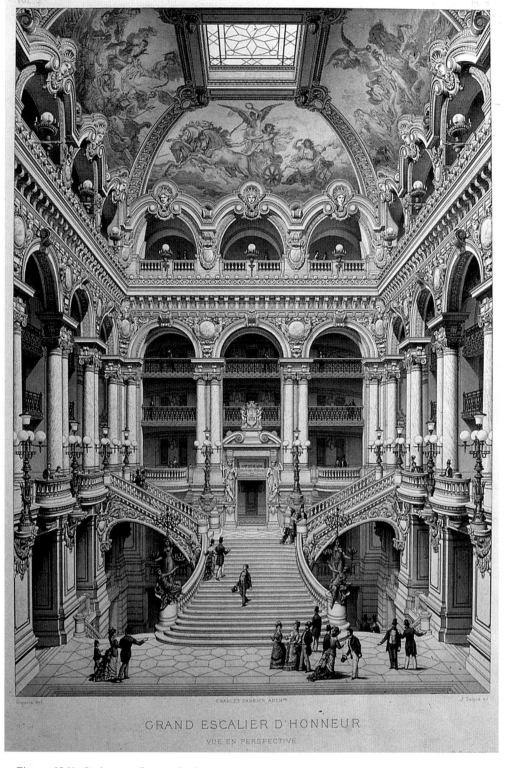

GRAND ESCALIER D'HONNEUR
VUE EN PERSPECTIVE.

Figure 18.11. Staircase, Opera, Paris.

FOR FURTHER READING

Most scholars of Second Empire Paris are much more critical of Napoleon III and Haussmann. See, for example, T. J. Clark, *The Painting of Modern Life: Paris in the Art of Manet and His Followers* (Princeton, N.J.: Princeton University Press, 1984); and David Harvey, *Paris: Capital of Modernity* (New York: Routledge, 2003). My account draws on Robert Herbert, *Impressionism: Art, Leisure, and Parisian Society* (New Haven, Conn.: Yale University Press, 1988); and David Jordan, *Transforming Paris: The Life and Labors of Baron Haussmann* (Chicago: University of Chicago Press, 1995); as well as David Van Zanten's *Designing Paris: The Architecture of Duban, Duc, Labrouste, and Vaudoyer* (Cambridge: MIT Press, 1987) and *Building Paris: Architectural Institutions and the Transformation of the French Capital, 1830–1870* (Cambridge: Cambridge University Press, 1994). On apartment life in Paris, see Sharon Marcus, *Apartment Stories: City and Home in Nineteenth-Century Paris and London* (Berkeley: University of California Press, 1999). On the Bon Marché, see Michael B. Miller, *The Bon Marché: Bourgeois Culture and the Department Store, 1869–1920* (Princeton, N.J.: Princeton University Press, 1981). For the most thorough account of the Opera, see Christopher Mead, *Charles Garnier's Paris Opera: Architectural Empathy and the Renaissance of French Classicism* (Cambridge: MIT Press, 1991).

19 The Domestic Ideal

The same political and technological shifts that spurred the erection of new civic and commercial buildings in cities such as Paris also triggered upheavals in an environment often understood as unchanging: the home. In Paris fashionable apartments were integrated into the same boulevards as the shops that served their residents. Cities in Britain and the United States developed along very different lines from those on the continent of Europe. Throughout the nineteenth century and up to the present, people in English-speaking countries developed a preference for detached or semidetached housing, often surrounded with front as well as rear gardens, on the fringes of cities. Dwelling was thus separated from working, shopping, and governing. This separation occurred when the Industrial Revolution was relocating more and more income-producing jobs away from the home to the factory or the office and also, in the railroad and the steamship, providing new ways of traveling between the two. The result was the suburb, as well as new ways of thinking about the importance of how buildings are made, organized, decorated, and inhabited. Paradoxically, these changes often obscured the newness of suburbia by wrapping its radical new spaces in nostalgia for preindustrial village and country life.

Throughout the English-speaking world, women and men saw the nuclear family households in which more and more people lived as upholding the moral values they believed were threatened by industrialization. Many women championed this ideal, which they used to extend the accepted arena and authority of middle-class women as housewives and reformers. This sentimental view of the middle-class home, as well as early alternatives to it, in turn inspired reforms in decorative arts, domestic architecture, landscape architecture, and suburban planning.

Many assume that nineteenth-century American and European views about the proper role for women have deeper roots than proves to be the case. Only in the

eighteenth century did the French Enlightenment philosopher Jean-Jacques Rousseau's writings on education encourage thinking of children as something other than miniature adults. Similarly, our assumption that until recently men worked outside the home and women within it is incorrect; that arrangement has been standard for middle-class European and American families for less than two centuries and for most others for an even shorter period. Before that, most men worked at home, with most stores, professional offices, and workshops under the same roofs as kitchens and bedrooms. When the place of production moved outside the home, many women and children went with it, to become factory workers. For middle-class women this shift, largely complete by the middle of the nineteenth century in well-off nonagricultural households in New England, created a crisis of purpose. Although as the rich grew richer more could afford servants to help, most of the women left at home when their husbands went to work still had meals to cook (on wood stoves, with almost every dish made from raw ingredients), laundry to wash and iron (again without the help of modern appliances; indeed, much water was pumped by hand), houses to clean (without vacuum cleaners), children to educate, relatives to nurse, and gardens to maintain. Unlike their earlier participation in minding shops or making the goods that were sold in them, these activities were not part of the cash economy, so they were left at an increasingly greater economic disadvantage relative to the male members of their households who doled out money to them. Before the American and French Revolutions most men as well as women had lacked political rights. Now middle-class men were acquiring them, but their wives and daughters were not.

A number of radical solutions to this situation emerged. One was the Oneida Community, founded in 1847 by John Humphrey Noyes in Upstate New York (Figure 19.1). Noyes and his followers lived in what looked much like a hotel or dormitory, a structure that expanded as the community itself did until it dissolved in the 1880s. Each member of the community had his or her own room. This allowed for changing sexual partnerships in place of conventional marriages. It also meant that housekeeping and socializing, like the production of goods for market, were done communally, often by women wearing bloomers, a type of loose long pants that allowed for greater freedom of movement than the women's skirts of the day. Children were reared by the community as a whole, rather than just their parents, who might or might not remain together as couples. Although most of the community's child-care workers were women, no woman was isolated at home alone with only her children, and those women who did care for children had fewer additional duties.

The Oneida Community's challenges to middle-class norms, especially sexual norms, were too radical for most nineteenth-century Americans. Intellectuals, such as Catharine Beecher and her sister the novelist Harriet Beecher Stowe, were more successful in recasting the economic impotence of middle-class women as the seat of their real moral, especially religious, authority. These women, as well as the men

THE KITCHEN. ONEIDA COMMUNITY.

Figure 19.1. Community kitchen, Oneida Community Mansion House, Oneida, New York, circa 1870.

who agreed with them, were uncomfortable with many aspects of the increasing importance of money. They also decried the cruelty and immorality of the new industrialized economy and an increasingly urbanized society. For them the home was the female-dominated refuge from uncomfortable but inevitable change. Here women could soothe their husbands, fathers, and brothers and raise and educate their children in an environment spatially separate from the city.

Beecher was a leader in founding high-quality schools for girls and in establishing teaching as a respectable occupation for women who had been shortchanged by the new division of labor, single women like herself who could not rely on fathers, brothers, or husbands and needed to earn their own income (Beecher's fiancé had drowned in a shipwreck). She also supported herself by writing housekeeping treatises for the many women who lived apart from their mothers and sisters, or whose families were ascending the social ladder and thus living in very different circumstances from those in which they had grown up.

Beecher viewed with nostalgia the farmhouses in which most of the parents and grandparents of her readers had lived. Like many of those Americans who in the second quarter of the nineteenth century wrote handbooks on domestic architecture

and related topics, she favored Gothic revival cottages that made the picturesque qualities of Strawberry Hill available to the middle class. A firm believer in the single-family home with its own garden, she also thought that the dwelling should be well organized. Beecher's emphasis on efficiency in the home—as a place of work as well as repose—distinguished her from the men who also wrote about the architecture of suburban cottages and villas. The design for "the American Woman's Home" that she and her sister published in 1869 featured a central service core around which she disposed more decorative elements, such as bay windows and verandas (Figure 19.2). Beecher paid particularly close attention to the organization of the kitchen and of the heating system. Featuring a single flue for heating and cooking, the latter was practical. She also proposed a movable room divider in which clothes could be conveniently stored. Here one finds the same combination of image and efficiency that has characterized most American suburban houses ever since.

Industrialization did not just transform the roles of middle-class men, women, and children, who now attended school longer instead of being apprenticed to trades or serving stints as maids. It also affected the ways in which the increasing numbers of material goods in their houses were designed and produced. Some were now made in factories and others still in workshops, but almost all were now designed for the mass market rather than individual customers, and many were of types or had decoration that had previously been available only to royalty, aristocracy, and others of great wealth. By the middle of the century, as became clear following the exhibition held in the Crystal Palace, critics were mourning the demise of craft production and the lower standards of quality that often resulted.

For many thoughtful observers in Britain the remedy lay in a revival of medieval forms. They believed this would also result in a return to what they saw nostalgically as a better society. In his book *Contrasts,* published in 1836, Pugin, the architect of the Gothic details of the Houses of Parliament, juxtaposed views of medieval and modern cities and social institutions. Important but contradictory ideas were displayed in his interpretation of the values of the two societies, one of which he understood as pious and charitable, the other as callous and capitalist. First among these ideas was the belief that architecture reflects the values of the society that built it. This argument was a tribute to the nineteenth century's fascination with history. This is the period in which art history was founded as a discipline and in which architectural history moved beyond the mere documentation of the appearance of earlier structures. History had a moral meaning for Pugin, who believed that imitating the architecture of the past was the means of restoring the social values on which it had been based. This hope, which drove the alliance between social reformers and Gothic revival architects, proved misplaced, as style alone proved insufficient as an avenue to social change.

One of the people who eventually became frustrated by this situation was William Morris, the son of a prosperous businessman. Originally a painter and poet, he was inspired by his experience of building and furnishing his own house to devote his

Figure 19.2. Catharine Beecher and Harriet Beecher Stowe, plan, the American Woman's Home, 1869.

life to the design, manufacture, and marketing of interior furnishings. He intended these activities to reinforce his political position as one of Britain's most influential socialists. Although he had limited success in achieving social reform through design, he did effect major shifts in taste and—albeit through a separate set of forthrightly political activities—advance the cause of the working class.

Philip Webb built the Red House on Bexley Heath, outside London, for Morris in 1859 (Figure 19.3). Ironically, Morris could live in the countryside because of the good train connection to London, where his intellectual, economic, and political activities were based. The Red House's recollection of the English rural vernacular, of the farmsteads of prosperous farmers and lower gentry, came shorn of the Gothic ornament favored by figures as diverse as Pugin and Beecher. Morris accepted his middle-class status with pride, rather than trying to emulate the architecture of his social superiors or to adapt sacred prototypes for secular uses. Instead, openings of different sizes and shapes responsive to interior function provided variety. Webb substituted ordinary red brick for the stone or the stucco that could imitate it. For Morris and Webb, like Laugier before them, architectural austerity was a sign of moral character.

The Red House maintained middle-class norms of domestic comfort in a building that resembled many of the new parsonages being built by Gothic revival architects

Figure 19.3. Philip Webb, Red House, Bexley Heath, England, 1859.

in or near the English countryside. It featured two parlors and a dining room supported by ample service spaces into which the Morrises probably seldom ventured. What was distinctive was the way Morris furnished it. Neomedieval pieces made by Morris and his painter friends coexisted with chairs that recalled not-so-distant patterns of rural life. The parlors displayed a very different medieval revival from that found at the Houses of Parliament (Figure 19.4). Instead of taking cues from monumental religious architecture, Morris cherished preindustrial craftsmanship, whether that of contemporary Asia, where his rugs were woven, or village life of a century before, in which such rush-seated rocking chairs would have been common. For Morris domestic architecture and furnishings became emblems of opposition, through taste and lifestyle, to industrialization and the social changes it generated.

Morris's own designs for these chairs and the chintz upholstery fabric that covered them were rooted in more than nostalgia. He greatly admired the critic John Ruskin, who preferred Gothic to classical styles because he believed that medieval workers had been able to express themselves in ways that those working on classical buildings, following more rigid rules that presaged industrial processes, had not been able to do. Ruskin and Morris advocated an aesthetic for what it said about the treatment of the people who had participated in creating it. Ruskin also believed that art should be based on nature, as well as on history. In response, Morris created floral designs from which his customers derived the same escapist and spiritually oriented pleasure they might gain from a garden or park.

Figure 19.4. Parlor, Red House.

These goals had such appeal that the Arts and Crafts movement was not limited to individual houses and their decoration, but also incorporated suburb and garden design. Americans today tend to associate suburbs with the years after World War II, when suburban housing became affordable for vastly greater numbers of families reaching more deeply into the middle class. Even by 1850, and certainly by 1875, however, many of those who worked in British and American cities chose to live on the outskirts of towns, where they could dwell in detached or semidetached houses. The move to the city outskirts was led more by intellectuals and reform-minded members of the upper-middle classes, especially professionals, than by the rich. Then as now, such housing was believed to provide an especially healthy environment for children. Middle-class parents believed their progeny should be exposed to the pleasures of an earlier agricultural era (freed, of course, from its hard labor) rather than what they saw as the dirt and immorality of the contemporary city.

One of these communities was Bedford Park, an area of London developed beginning in 1875. Its design by the architect Richard Norman Shaw consciously recollected preindustrial British villages (Figure 19.5). Two elements were particularly important in this regard. One was the creation of ample public and semipublic green space. The other was the choice of Shaw as the architect. Shaw, with his onetime partner, William Eden Nesfield, was the inventor of an architectural style known as Queen Anne. Queen Anne offered a less austere and more picturesque version of the

Figure 19.5. Richard Norman Shaw, Bedford Park, London, England, begun 1875.

Red House. It was based on Anglo-Dutch architecture of the seventeenth century, when late medieval massing coexisted with some classically inspired decoration. Shaw's vocabulary, complete with such fashionable fanciful details as terra-cotta sunflowers, spoke to most residents of the craftsmanship and individuality characteristic of London before the Great Fire and of the British countryside for a century more. Shaw's houses feature a profusion of gables, as well as bay windows. Their small panes are a conscious rejection of the great sheets of plate glass that had been available for a quarter of a century and had proven popular for London housing.

Looking both backward toward premodern standards of craftsmanship and forward toward greater social justice, Arts and Crafts designers, producers, and consumers hoped they could redeem their age and their souls by making and living with beautiful things. The problem with which Morris struggled was that his high-quality products remained affordable only to the same bourgeoisie he hoped to reform, even after some degree of manufacturing was introduced to bring costs down. Within that middle class, however, the Arts and Crafts movement provided new artistic and economic opportunities for many women. They found in it a respectable way to earn a living without compromising the idealistic roles assigned to them. The virtue of these women was supposedly located not just in their conformity with strict behavioral codes, particularly regarding sex, but also in their distance from the morally contaminated workplaces of their male family members. Craft production, along with teaching, nursing, and librarianship, became an acceptable activity for them, in part because it could be viewed as a natural extension of women's traditional needlework and their more recent assumption of control over the decoration of their houses. Morris himself embroidered, and he encouraged all the female members of his household to do the same. His daughter May became a prominent member of the Arts and Crafts movement.

Even earlier, in 1876, the Royal Society of Needlewomen, a British group, had sent a sampling of members' products to the world's fair held in Philadelphia in honor of the centennial of the Declaration of Independence. Also on display there was furniture designed by Mary Louise McLaughlin, from Cincinnati, who later became one of the leading art potters of the day, turning ceramics into a means of personal expression. One of the visitors to the fair was Candace Wheeler. Wheeler was inspired by the women's work she saw at the fair to undertake a career in the decorative arts, and she became in many respects the American counterpart to Morris, although hers was an entirely artistic career, without his engagement in socialist politics. With Louis Comfort Tiffany, Wheeler was a founding member of one of the first American firms of professional decorators, called Associated Artists. One of the firm's commissions was for the interiors of the Mark Twain House, in Hartford, Connecticut. An illustration of the conditions in which goods used by Associated Artists were made underscores why the Arts and Crafts movement attracted so many middle-class women (Figure 19.6). It shows a homelike atmosphere, far different

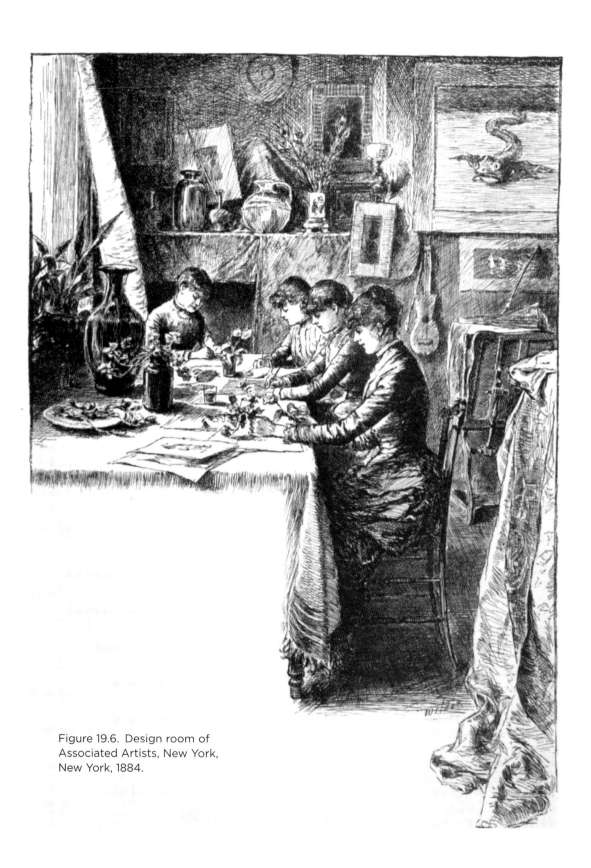

Figure 19.6. Design room of
Associated Artists, New York,
New York, 1884.

from the factory interiors that were the exclusive province of the working class. The Arts and Crafts movement provided opportunities for creative self-expression as well as economic empowerment. Wheeler, however, like Morris, turned to manufacturers to produce designs that won praise as works of art. Many displayed the interest in contemporary Japanese craft that was common in Arts and Crafts circles. High standards of craftsmanship earned respect for Islamic as well as Japanese wares that encouraged Western artists to flatten the picture plane in an important first step toward the twentieth-century fascination with abstraction.

The engagement of English-speaking women with the Arts and Crafts movement was not limited to the design of objects within harmonious interiors. Gertrude Jekyll, for instance, began her artistic activities as a skilled Arts and Crafts needlewoman, but as she aged, she lost the keen eyesight necessary for detailed work. She made a second and more notable career as a landscape architect. She was the leader in reexporting Morris's ideas about nature and design to the shaping of nature itself, and in making landscape architecture a profession in which women played a leading role in both Britain and the United States during the early decades of the twentieth century. At Folly Farm in Sulhamstead, England, she collaborated from 1906 to 1912 with a young architect named Edwin Landseer Lutyens (Figure 19.7). Lutyens got his first commissions renovating, adding to, and even designing houses for Jekyll's patrons.

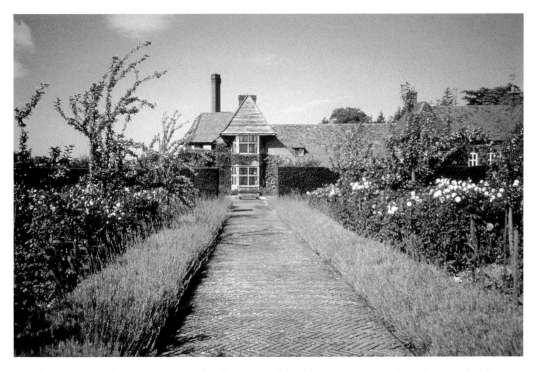

Figure 19.7. Folly Farm. Garden by Gertrude Jekyll; house renovated and expanded by Edwin Landseer Lutyens, Sulhamstead, England, 1906–12.

Jekyll led the way in rejecting the exotics housed in the Palm Stove in favor of native species. She championed informal plantings, arranged, however, in the more spacious and formal settings that mark the waning years of the Arts and Crafts movement in Britain. Jekyll's emphasis on flowers and detail was very different from the structuring of larger earlier picturesque gardens such as the one at Stourhead. None of her eighteenth-century predecessors had paid the same careful attention to plant material. Jekyll conceived gardens on the more intimate scale of flowers and rooms rather than that of trees and fields.

During this period women were also active as writers about architecture and as patrons. In the United States, the first person to make a career as a writer about architecture was Mariana Griswold Van Rensselaer. The novelist Edith Wharton began her writing career as the coauthor of a book on the decoration of houses. Her niece Beatrix Farrand was an important landscape architect. Women were expected to participate in the design of their homes, and many used their roles as clients and collectors as a means of self-expression. One such woman was Theodate Pope Riddle. Hill-Stead, her house just outside Farmington, Connecticut, was designed between 1898 and 1902, ostensibly by the fashionable New York firm of McKim, Mead, and White (Figure 19.8). In fact, it was largely the work of Riddle, who had gone to boarding school in Farmington and persuaded her parents to build a house there. Later she became a licensed architect, designing boarding schools in the region, including Avon Old Farms in Avon, Connecticut, which she established in memory of her parents. Her example helped inspire her nephew Philip Johnson's interest in architecture.

Hill-Stead is typical of the houses that well-to-do Americans of British descent were building around the turn of the century to distinguish themselves both from robber barons imitating the European aristocracy and from impoverished eastern and southern European immigrants. An evocation of what they saw as their own past and the roots of American democratic values, which they believed to be threatened by both capitalism and socialism, buffered them from the increasing chaos of the country's cities. This model acquired such resonance that it continues to dominate the real estate market in many parts of the United States. Buyers of all income groups and ethnic backgrounds have come to see these houses as badges of assimilation and acceptance.

Hill-Stead was designed to look as if it had been extended over time, with a Mount Vernon–like garden front giving way to a later Greek revival side porch. It was, of course, much grander than the rambling farmhouses it intentionally resembled. At Tuckahoe, the service spaces, such as the kitchen, were located for the most part in separate outlying buildings. Here they were integrated into the main house, filling, as at the Red House, fully half the ground floor. Central heating also allowed Riddle and her architects to use a more open plan than that favored by their colonial-era predecessors. The main spaces for entertaining—the parlor and dining rooms—housed the outstanding collection of impressionist art amassed by Alfred Pope, Riddle's

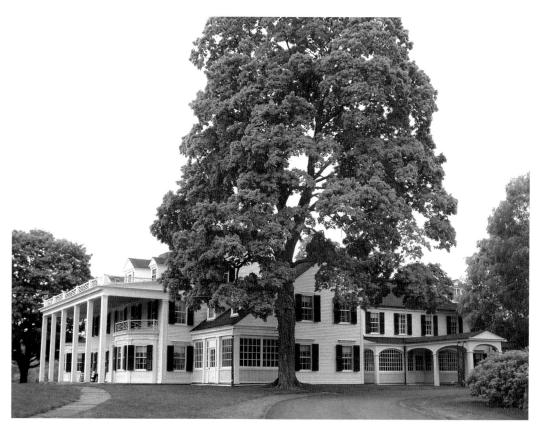

Figure 19.8. Theodate Pope Riddle and McKim, Mead, and White, Hill-Stead, Farmington, Connecticut, 1898–1902.

father. During a trip to Paris, Pope began in 1889 to purchase the work of Claude Monet and his friends. One of the people he consulted was the American impressionist painter Mary Cassatt, who also encouraged Louisine Havemeyer, a prominent suffragette, and Bertha Honoré Palmer, a Chicago socialite and civic organizer, to collect modern French painting. The presence at Hill-Stead of what was at the time radical artistic taste underscores the extent to which the house itself was not entirely conventional.

A generation earlier, McKim, Mead, and White had revived aspects of an earlier rural colonial architecture in the first phase of the American Arts and Crafts movement. This architecture flourished in the 1880s in the summer "cottages" built along the New England seacoast. In many cases, these informal settings stood close to the seventeenth-century models their architects transformed in order to achieve modern standards of comfort. Arts and Crafts theory demanded a total integration of interior architecture and decoration, which increasingly became the role of the architect or of the cultivated female patron. The dining room the firm added in 1881 onto Kingscote in Newport, Rhode Island, the most fashionable summer

resort area of the day, exhibits the range of influences grouped under the Arts and Crafts umbrella (Figure 19.9). The low, broad proportions of the cork-paneled walls and ceiling owe more than a little to the Arts and Crafts movement's fascination with Japan, while the furnishings marry exotic Oriental carpets and seventeenth-century English antiques with new designs whose scale is modern but whose details directly quote Newport's celebrated colonial cabinetmakers. Like the thin wooden framework for the cork, Louis Comfort Tiffany's opalescent tiles make an abstract foil for this carefully controlled range of patterns.

McKim, Mead, and White located their resistance to urban chaos in New England's seventeenth- and eighteenth-century farmhouses. Their own mentor, Henry Hobson Richardson, proposed a more primitive and primeval solution by making a mythic connection with nature. Not for him, however, the pretty flowers that decorated Morris's chairs. Instead, he turned to the region's very bedrock in his Ames Gate Lodge of 1880–81 in North Easton, Massachusetts (Figure 19.10). This extraordinary building had a modest function: to control access to or at least establish visual privacy for the larger house down the road, which belonged to the town's most prominent family, and to provide an extra bedroom for an overflow of male houseguests.

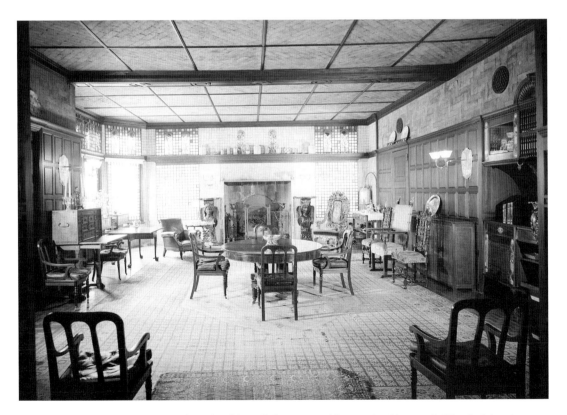

Figure 19.9. McKim, Mead, and White, dining room, Kingscote, Newport, Rhode Island, 1881.

Figure 19.10. Henry Hobson Richardson, Ames Gate Lodge, North Easton, Massachusetts, 1880–81.

Richardson was the major American architect of his day. Trained at the École des Beaux-Arts in Paris, upon his return to the United States he practiced first in New York and Boston. He died in 1886 at the age of forty-eight. Richardson wrote no theory. Most of his extensive library was composed of well-illustrated books, which he used as sources of elements to combine in novel ways. Whether or not he read Ralph Waldo Emerson or Henry Thoreau, however, he certainly had plenty of exposure to the transcendental ideas that had inspired the way in which his friend Frederick Law Olmsted, codesigner of New York City's Central Park, looked at the American landscape. He was certainly familiar as well with Ruskin. In the Gate Lodge, however, his use of nature extends far beyond the inspiration for ornament that Ruskin recommended.

The final ice age left boulders of various sizes strewn across the New England countryside. Colonial farmers cleared their fields of as many as they could, using them to build the walls that marked the boundaries of fields and property lines. During the 1880s many local architects, including Richardson, built tough-looking foundations out of them. Richardson erected the entire exterior of the Gate Lodge in two colors of these rough stones, many of them boulders, making the building appear to have almost grown out of the site. The excellence of the construction came from his collaboration with the Norcross Brothers, contractors who contributed an

extraordinary level of detailing to the realization of Richardson's ideas. In this re-markable building geological metaphors completely replaced historical ones. At the period of America's most dynamic industrialization and urban expansion, the Gate Lodge appeared to be beyond time, rooted in the land with an unshakable perma-nence. Richardson's emphasis on the elemental inspired many architects of the next generation on both sides of the Atlantic.

The popular view of what women's role has historically been in Europe and America has specific origins in the mid-nineteenth-century response to industrial-ization and urbanization. Recent, too, is our sense of the impact that design can have in our own lives and upon society. Design reform alone, however, proved an insufficient means for realizing social change. It was too easily diluted into a more comfortable life for well-to-do patrons. A sense of lost idealism permeates lines from the poem "Adam's Curse," written by William Butler Yeats, who grew up in Bedford Park. Yeats's father and brother were painters; his sisters, one of whom worked for May Morris, were active in the Arts and Crafts movement.

> We sat together at one summer's end,
> That beautiful mild woman, your close friend,
> And you and I, and talked of poetry.
> I said: 'A line will take us hours maybe;
> Yet if it does not seem a single minute's thought,
> Our stitching and unstitching has been naught. . . .'
>
> And thereupon
> That beautiful mild woman for whose sake
> There's many a one shall find out all heartache
> On finding that her voice is sweet and low
> Replied: 'To be born woman is to know—
> Although they do not talk of it at school—
> That we must labour to be beautiful.' . . .
>
> I had a thought for no one's but your ears:
> That you were beautiful, and that I strove
> To love you in the old high way of love;
> That it had all seemed happy, and yet we'd grown
> As weary-hearted as that hollow moon.

FOR FURTHER READING

For discussion of the Oneida Community and Catharine Beecher in the context of a larger examination of American suburbia, see Dolores Hayden, *Building Suburbia: Green Fields and Urban Growth, 1820–2000* (New York: Vintage Books, 2003). Very different views of

suburbia appear in Robert Fishman, *Bourgeois Utopias: The Rise and Fall of Suburbia* (New York: Basic Books, 1987); and Robert Bruegmann, *Sprawl: A Compact History* (Chicago: University of Chicago Press, 2005). John Archer, *Architecture and Suburbia: From English Villa to American Dream House, 1690–2000* (Minneapolis: University of Minnesota Press, 2005), maps the history of the suburban house. On the Red House, see Sheila Kirk, *Philip Webb: Pioneer of Arts and Crafts Architecture* (Chichester: Wiley-Academy, 2005); and Fiona MacCarthy, *William Morris: A Life for Our Time* (New York: Knopf, 1995). John Ruskin's *The Seven Lamps of Architecture,* first published in London in 1849, is a seminal Arts and Crafts text. On Queen Anne, see Mark Girouard, *Sweetness and Light: The Queen Anne Movement, 1860–1900* (New Haven, Conn.: Yale University Press, 1977). On the Arts and Crafts movement, see Peter Davey, *Arts and Crafts Architecture* (London: Phaidon, 1995); and the series of pertinent exhibit catalogs edited by Wendy Kaplan, of which the most recent is *The Arts and Crafts Movement in Europe and America: Design for the Modern World* (New York: Thames & Hudson, 2004). Doreen Bolger Burke, *In Pursuit of Beauty: Americans and the Aesthetic Movement* (New York: Metropolitan Museum of Art, 1986), is also useful. On Candace Wheeler, see Amelia Peck, *Candace Wheeler: The Art and Enterprise of American Design, 1870–1900* (New York: Metropolitan Museum of Art, 2001). For discussion of American design reform, see also J. M. Mancini, *Pre-Modernism: Art-World Change and American Culture from the Civil War to the Armory Show* (Princeton, N.J.: Princeton University Press, 2005). On Jekyll in particular and Arts and Crafts gardens more generally, see Jane Brown, *Gardens of a Golden Afternoon: The Story of a Partnership, Edwin Lutyens and Gertrude Jekyll* (New York: Van Reinhold Nostrand, 1982); and Judith Tankard, *The Gardens of the Arts and Crafts Movement: Reality and Imagination* (New York: Harry N. Abrams, 2004). On Hill-Stead, see Mark Hewitt, *The Architect and the American Country House, 1890–1940* (New Haven, Conn.: Yale University Press, 1990). Vincent Scully, *The Shingle Style and the Stick Style: Architectural Theory and Design from Richardson to the Origins of Wright* (New Haven, Conn.: Yale University Press, 1971), remains the classic study of the subject. For discussion of Richardson, see also Margaret Henderson Floyd, *Henry Hobson Richardson: A Genius for Architecture* (New York: Monacelli Press, 1997); and James O'Gorman, *H. H. Richardson: Architectural Forms for an American Society* (Chicago: University of Chicago Press, 1987).

20 Empire Building

At the end of the eighteenth century the colonial empires founded in the wake of Columbus's voyages to the New World were collapsing. The forces unleashed by the American and French Revolutions appeared to herald the demise of European rule over distant territories. New political ideas about liberty were reinforced by domestic political challenges to the authority of the colonial powers. The economy of revolutionary France was nearly destroyed by the slave revolts that led to the independence of Haiti, the first black-ruled country in the Americas. Napoleon's subsequent effort to seize Egypt from the Ottomans was an equally humiliating failure. Spanish colonies from Mexico to Chile, assisted by Napoleon's invasion of their motherland, broke free as well. The Portuguese king sought refuge in Brazil, and—when one branch of the royal family refused to return to Europe—that country became independent as well.

Colonialism was, however, far from extinguished. A new kind of empire quickly emerged. Between 1800 and 1940 every country in Africa and most countries in Asia, excepting only Turkey, Iran, Afghanistan, Thailand, China, and Japan, came under European or—more rarely—American or Japanese control. Gone were the days of indigenous modernisms like those that had produced the seventeenth-century splendors of Isfahan and Agra. Throughout North Africa and Asia new pressures transformed city and countryside alike, as previously profitable global trading networks were distorted by industrialization to the benefit of Europeans and eventually also Americans. Increasingly the colonized, whose artisan-produced goods had until the nineteenth century been competitive on world markets, were now reduced to being sources of raw materials and markets for the products manufactured elsewhere from those materials.

The story of the confrontation between European and North African and Asian architecture and urbanism in these cities is often told in terms of style. The ways in

which new spatial experiences and social practices were created and old ones main-
tained in the production of hybrid environments is equally important. Although
power rested with the colonizer, the architecture of both colonizers and colonized
was transformed by their contact with one another. Cultural encounters took vari-
ous forms. Europeans introduced new architectural and urban planning ideas in
order to propagate their own authority as well as to create familiar environments
for themselves. The results, however, inevitably differed from their models. Mean-
while, new indigenous elites deployed imported architectural forms in order to
modernize in a process that eventually encompassed resistance to foreign rule, while
existing elites deployed precolonial architectural precedents in new ways to buttress
their own claims to authority.

The single richest prize in this new wave of colonialism lay in South Asia. As the
Mughal Empire gradually declined after the death of Aurangzeb in 1707, the result-
ing power vacuum was filled not only by a number of local princes but also by the
British East India Company, founded in 1600, which conducted trade and eventu-
ally amassed huge territories. By the time Queen Victoria was declared empress
of India in 1877, the British controlled most of what are now India, Pakistan,
Bangladesh, and Sri Lanka. Those local princes who retained nominal authority
over their own territories knew that they did so only as long as they cooperated with
the British, who could march in at any time to replace them. The British acted to
protect those rulers who collaborated with them. Although the princes often focused
on the preservation of the indigenous cultures from which they derived their
authority, such as it was, they gradually ceded power to the urban middle classes.
Living in the metropolitan centers of Calcutta (now Kolkata), Bombay (now Mum-
bai), and Madras (now Chennai), the members of the middle classes sought to
increase their political and social clout by learning from the colonizers, whose
domination they increasingly resented when their mastery of Western knowledge
did not result in shared governance. As the products of entirely new processes,
Indian colonial cities were without precedent, even as they were, like their European
and American counterparts, often cloaked in historicist ornament that masked that
modernity.

Cities were hardly new to South Asia when the trader Job Charnock founded
Calcutta in 1656. Calcutta was one of a new kind of city, however, which began
to develop in Asia only after Portuguese sailors first reached the continent's shores.
In the sixteenth and seventeenth centuries, Macao in China, Batavia (now Jakarta)
in Indonesia, and Calcutta, Madras, and Bombay in India were among the most
important trading posts developed by Europeans far from home. Small foreign
communities, initially mostly male, lived alongside large local populations. The
latter supplied goods for which there was European demand. More recent impor-
tant examples of the type are Singapore and Hong Kong. At first these cities served
as island-like outposts, but in many cases, including Calcutta, they also proved
to be beachheads for European control of the surrounding hinterland. Expansion

depended not only on superior Western military technology but also on the exploitation of divisions between locals. As Mughal rule weakened, strong local rulers emerged, but in Bengal the British triumphed, despite competition from other Europeans.

Asian colonial cities were different from their counterparts in the Americas. Unlike many of the most important Spanish settlements, they typically replaced minor villages rather than being planted on the sites of established urban centers. Most of their inhabitants came from the surrounding countryside rather than from abroad. Moreover, most European colonists hoped to return home once they had made their fortunes; it was not their intent to settle their families permanently on what remained foreign soil. Two late eighteenth-century views of Calcutta hint at the urban and architectural innovations spawned by this situation. The first shows the center of town, dominated by large freestanding buildings with classical details (Figure 20.1). The degree to which these details correspond to those of British buildings of the time does not make them European imports. There was no British precedent for this accumulation of freestanding palaces set perpendicular to Chowringhee Road within walled compounds. This was, for almost all the colonial officials who dwelled within them, a city to be traversed by carriage rather than on foot. The

Figure 20.1. Thomas Daniell, view of Chowringhee Road, Calcutta (Kolkata), India, 1798.

grandeur of these dwellings was made possible by the affordability of large numbers of native servants.

Few if any Europeans lived on Chitpore Road, which was lined by a nearly continuous row of buildings of various heights and levels of permanence (Figure 20.2). Spaces opening directly to the street were common, as were roofs and awnings that sheltered wall surfaces and openings from direct sun. In the background can be glimpsed a structure, possibly a temple, with the steeply sloping roof characteristic of the region's vernacular architecture, which the British appropriated in their turn, as had Mughal and Rajput rulers. The forms here are indigenous, but their presence was occasioned by global flows of goods and capital unmediated by the local religious and political control that had originally influenced the development of Madurai and Delhi.

Certainly there were instances when the British frankly attempted to reproduce familiar buildings. Government House in Calcutta, for instance, was built between 1799 and 1803 in imitation of Kedleston, an eighteenth-century English country house. The means of construction as well as the plan were quite different, however. Throughout Calcutta stucco-covered brick substituted for the expensive permanence of cut stone, which needed to be imported from other parts of India. Moreover, the

VIEW ON THE CHITPORE ROAD, CALCUTTA.

Figure 20.2. Thomas Daniell, view of Chitpore Road, Calcutta, India, 1797.

central interior space, although roofed, owed more to the indigenous practice of courtyard-oriented houses than to either Palladio or his British admirers. Approximating the great durbar halls in which local rulers and landowners held court, it indicated the British ability and willingness to master local forms of authority.

This pattern of European colonization in Asia depended far more than had the seizure of the New World on the collaboration of the local elite, who in many cases found their access to modernity paradoxically enhanced by the degree to which they appeared to preserve tradition. From the beginning many members of the Bengali elite profited from British rule, which provided welcome political stability as well as access to new markets. Generally speaking, their fortunes were anchored in land, over which they now had more secure control as long as they recovered enough taxes to satisfy the British (a situation often disastrous for the peasantry). Many of these landowners, called zamindars, settled permanently in the city, where in tandem with local merchants (from the start the two groups overlapped) they quickly formed an intellectual as well as professional class educated in both British and Bengali ways.

Unlike individual British administrators and soldiers who intended to retire to England and thus lived largely in rented quarters, the Bengali elite lived in mansions that were often continuously occupied by the same extended families over many generations. The Marble Palace, built by the young British-educated Raja Majendra Mullick between 1835 and 1840, is one such structure (Figure 20.3). A large, stucco-clad classical palace set in an urban garden, it had more in common with the houses that the British built themselves in Calcutta than with anything to be found in precolonial Bengal. The rooms are filled with imported treasures that testify to the occupant's position in a global culture, as well as to the degree that he and his family had adopted many Western practices, such as sitting on chairs rather than on rugs and cushions on the floor. Yet the house is arranged around an open courtyard. This is still a place where, in accordance with Hindu religious practice, hundreds of the poor are fed regularly. These buildings were constructed without any contribution by British labor, which even in the case of structures erected for the British was limited to the advice of gentleman architects and engineers.

Just as the Bengali elite learned from the British, the British learned from the people among whom they lived. The architectural terms of this interchange are best represented in the bungalow (Figure 20.4). The term, which has its etymological origin in Bengali, represents an appropriation of a vernacular roof form that provided protection from monsoon rains as well as ample shade from the strong tropical sun. Early bungalows for British colonial officials differed little from those that the locals built for themselves. Over time, the single-story dwellings, often raised high off the ground and always encased in a layer of verandas, featured increasingly classical detailing. They were often built by Indians who rented them to British tenants. They retained their orientation around a large central space. From India, the type was exported throughout the warmer reaches of the empire, while the

Figure 20.3. Courtyard, Marble Palace, Calcutta, 1835–40.

Figure 20.4. Officer's bungalow, Guindy, Madras, India, circa 1851.

name became associated with informal dwellings in the often much cooler climates of Britain and North America. These were usually completely different in both style and plan from the colonial originals.

In the new colonies, British administrators lived in far more splendor than they did in London. Calcutta's palaces, and even rural bungalows, offered more space and service than they could afford at home. The cost of this splendor, however, was a lack of privacy and the knowledge that intimacy gave locals. The servants who lived within the compounds of the British were not, however, offered access to British standards of living. Instead they were often forced to live and work in squalid conditions. The colonizers insisted on believing that these conditions followed local custom; they could not recognize them as the result of poverty triggered by colonial exploitation.

Beyond British India lay territory not directly controlled by the East India Company. The nawabs of Avadh, also known as Oudh, were among the most powerful princes to take advantage of the slackening of Mughal central control. Until 1856, when the British seized control of the state, the court at Lucknow was one of the subcontinent's most splendid, attracting adventurers from Europe and merchants from other parts of India. The process of introducing European architectural ideas into Lucknow and adapting them to local cultural conditions was inaugurated in the construction of Constantia, now known as La Martinière, designed and built by the French adventurer Claude Martin between about 1795 and 1800 to serve as a house and tomb (Figure 20.5). The classical orders are obviously European, but the building was executed entirely by local workmen, who completed it after Martin's death. Like Martin, they worked in part from his collection of architectural treatises. What were for them exotic motifs were for Martin familiar echoes of home.

Many aspects of the building reflect the impact of Indian conditions on the design; this is no conventional French palace. The very program of a monumental tomb is obviously Indian; Martin's belief that any such splendid building should double as a palace is an example of the innovation possible when architecture operates between cultures. Other responses to the Indian setting include the building's semifortified character, which would have been remarkable in Europe at the time despite that continent's frequent wars, and the ventilation stacks, which draw cool air from four wells up through the house.

As the British gained more influence at the Avadhi court, they encouraged spending sprees on a series of large palaces. They preferred that the nawabs splurge not on guns but on what were now fairly empty versions of the displays through which local monarchs had long demonstrated their power. The nawabs, forced to rent British soldiers for his own supposed protection, purchased foreign luxuries, usually at great markups, through European and Bengali merchants. The court's assimilation of European architecture was not accompanied by any great affection for the British. When the Indian Rebellion broke out in 1857, Lucknow, although one of the most Europeanized cities in Asia, offered some of the fiercest resistance to British rule.

Figure 20.5. Constantia (La Martinière), Lucknow, India, 1795–1800.

The plans of early palaces in Lucknow followed indigenous rather than European precedent, with pavilions set into an enclosed landscape. The individual buildings, however, were ornamented with motifs borrowed from European furnishings and textiles. The results conformed to neither previous Indian nor current European usage. Europeans tended to make fun of what they viewed as a misunderstanding, but in the Indian context the mix functioned well as a modernization of well-established typological elements. The final palace, the Qaiserbagh, built by Nawab Wajid Ali Shah around 1850, was modeled directly on Constantia, whose appeal probably resided in the degree to which it obviously differed from other buildings in the city erected for the large European community (Figure 20.6). Access to the main block of the palace, which rose six stories and was crowned with both a pedimented pavilion and a small dome, was through a monumental gateway. Although the building was decorated throughout with the classical orders, its composition remained strongly influenced by the monumental Islamic tombs that had also inspired the massing of Constantia.

Figure 20.6. Qaiserbagh, Lucknow, India, 1850.

Following the Rebellion, the center of the empire moved westward to Bombay. That city's rising importance was enhanced by the cotton boom sparked by the American Civil War, which reduced the supply of American cotton to Britain. It was sustained by the opening of the Suez Canal, which made the trip from London to Bombay substantially shorter than that to Calcutta. Bombay became the premier industrial and port city in British India. It therefore acquired an imposing array of civic buildings designed in the Gothic revival and Indo-Saracenic styles and built by both colonizers and colonized. Their presence in the end undermined rather than cemented British rule. Indians used their access to these spaces to familiarize themselves with the institutions on which European power depended, institutions they would eventually claim for themselves.

Crucial to the development of the city was the extension, through landfill, of the fort area where European settlers had originally clustered. A large public park, fronted by many of the most prominent new public buildings, occupied this space (Figure 20.7). The arrangement was even more modern than the architecture was foreign, just as out of place in early eighteenth-century London or Paris as in Delhi or Beijing.

Figure 20.7. Oval Maidan, Bombay (Mumbai), India, with Henry St. Clair Wilkins, Secretariat, 1874, on right.

It represents both a new kind of urbanism and a new network of civil society, dependent on government officials rather than on the will of individual rulers.

By the 1860s, when Bombay's boom began, the neoclassicism characteristic of late eighteenth and early nineteenth-century Calcutta was being replaced in India as well as London by Gothic revival. The use of Gothic revival in a city in which Christians were always a small minority would seem to be an obvious symbol of the imposition of British rule. Colonialism was often defended with racist remarks such as, "We hold India by virtue of our superiority, and that superiority would soon disappear if we assimilated ourselves to Indian habits and manners." This institutional architecture reminded the British of home and provided them with the spaces from which to govern, but it also provided Indians with the knowledge on which Western mastery was based.

Founded in 1857, the University of Bombay was established by the colonial government to train Indians to enter the lower levels of the colonial administration. Many of its graduates eventually became prominent nationalists. The university library and the adjacent clock tower were financed between 1869 and 1878 by Premchand Roychand, an Indian banker committed to providing Indians with the Western education essential to their economic and political empowerment (Figure

20.8). In Britain, unlike on the European continent, institutional architecture was more often the result of private philanthropy than of government intervention. That was the case in India as well, and hardly unique in the case of Bombay's growing civic infrastructure, but here the high quality of the architecture was remarkable. Unlike the earlier British civic buildings, designed by engineers from the Public Works Department, the university buildings were the first on the subcontinent to be designed by one of England's most famous and highly regarded architects. Roychand turned to George Gilbert Scott, the architect of the Midland Grand Hotel. Scott never traveled to Bombay, but he gladly adapted the Venetian Gothic style to this setting by, for instance, leaving the arcades unglazed.

Not only did Bombay sport a new public sphere composed of institutional buildings similar to those found in European cities, but it also had much of the same sort of infrastructure. Although debates over who was responsible for paying for civic improvements (no taxation without representation!) stalled the construction of adequate sewers, improved transportation was key to British command of the

Figure 20.8. George Gilbert Scott, Convocation Hall and Rajabai Clock Tower, University of Bombay, Bombay, India, 1869–78.

subcontinent's interior. Throughout Asia and Africa, the construction of railroads was essential to the maintenance of colonial authority. In Bombay the terminus of the train lines into the city received the same architectural elaboration it had in London. Frederick Williams Stevens designed the Victoria (now Chhatrapati Shivaji) Terminus, built between 1877 and 1888 (Figure 20.9). The composition of the head house was clearly inspired by Scott's Midland Grand Hotel but lacked that building's commercial function. Instead, the colonial government's ability to override the market forces that shaped nineteenth-century London enabled this to be an emphatically civic structure. Stevens was careful, however, to adjust his imported Gothic revival style to local circumstances. Sympathetic to the Arts and Crafts movement, he hired students from the Jeejeebhoy School of Art in Bombay to execute many of the details.

To be sure, the entire city of Bombay did not consist of landmarks. The characteristic late nineteenth-century streets were broad but lined with buildings whose ground stories housed shops and workshops, while the upper floors contained apartments (Figure 20.10). The result was much different from the contemporary British cityscape, in which shops were more likely to be separated from row houses, each of

Figure 20.9. Frederick Williams Stevens, Victoria Terminus (Chhatrapati Shivaji Terminus), Bombay, India, 1877–88.

Figure 20.10. Street view, Bombay, India. Photograph from 1922.

which ideally was inhabited by a single family. In Bombay, balconies, often screened, provided buffers between the street and interior rooms. Alleys opened off these streets, leading in many cases to dense networks of slum housing. The British often professed to be appalled by these environments, where lack of clean water often precipitated alarming outbreaks of contagious diseases. They seldom acknowledged their own complicity in creating the circumstances that encouraged poor tenant farmers to seek work in the city, where they lived in conditions that responded more to modern market pressures than to precolonial forms of either rural or urban habitation. The British were also uncomfortable with the degree to which middle-class inhabitants of these neighborhoods were mastering not just the imported architectural details that often adorned their buildings but also the rhetoric of democratic self-rule.

In response, late nineteenth- and twentieth-century colonial architecture increasingly incorporated overt references to precolonial architecture of the subcontinent, particularly monumental buildings erected by the Mughals and the Rajputs. Termed Indo-Saracenic, this now substituted for the Gothic detailing that had earlier cloaked innovative plans and functions. The strategy did nothing to lessen the emerging independence movement, not least because—unlike the colonial officials, who often greatly appreciated what they saw as India's picturesque heritage—many

nationalists were unwilling to be locked into a feudal past. They often felt estranged from architecture that to them represented backwardness rather than national identity. That most Indo-Saracenic motifs were drawn from mosques and Muslim tombs did not communicate secular South Asian identity, especially to Hindus at a time of increasing tension between the two communities, sparked by British strategies of divide and rule.

Jaipur retained its status as a protectorate throughout the colonial period. The patronage its maharajas, Ram Singh and Sawai Mahdo Singh II, bestowed on local artisans conformed to the British desire that the princes preserve precolonial traditions. By borrowing from the British new means to do so, they successfully resisted some, but scarcely all, of the most crippling effects of industrialization. In Jaipur, as elsewhere in India, increasingly global markets threatened local craft production. Artisan techniques and cultural values associated with them survived through the establishment of institutions based on the British Arts and Crafts model.

Following the Great Exhibition held in the Crystal Palace, Henry Cole established a school of industrial design in South Kensington to ensure that industrial products would be well designed and to promote the preservation of the techniques they were rapidly replacing. The attached collections of preindustrial artifacts from around the world, intended as exemplary for the general public as well as the school's students, became the Victoria and Albert Museum. This process was repeated a generation later in Jaipur. In 1883 the Jaipur Exhibition displayed crafts from all over India. Three years later, this collection was transferred to the new Albert Hall, a permanent crafts museum intended to offer models for artisans as well as to educate potential patrons to appreciate handcrafts that were now luxury goods (Figure 20.11). Named for Prince Albert, later King Edward VII, who in 1876 had been the first member of the British royal family to visit India, the Albert Hall was designed by Samuel Swinton Jacob, an English engineer in the service of the maharajas. In plan it could have been any European or American civic building inspired by the principles of the École des Beaux-Arts. However, local craftsmen trained at schools rather than through apprenticeships executed the decorative details. Today Jaipur is one of India's major tourist destinations, not least because of the vitality of the craft traditions consciously revived and protected during the last decades of the nineteenth century.

The preservation of craft production came, however, at an enormous cost. While many Arts and Crafts workers in the West could command enough of a premium for their work to preserve their middle-class status, their colonial counterparts remained trapped in a system that kept prices competitive with mass-produced goods and thus condemned them to penury. In Jaipur the self-conscious rejection of industrialization on the part of colonial administrators and tradition-minded princes who viewed modernity as inappropriate for most Indians (the maharajas themselves proved avid consumers of up-to-date automobiles) precluded economic development and the advantages it could bestow.

Figure 20.11. Samuel Swinton Jacob, Albert Hall, Jaipur, India, 1876–87.

Despite the deliberate attempts made by many colonizers and colonists to pre-serve premodern techniques and precolonial styles, aspects of British architecture were inevitably imported into South Asia. Aristocrats used Western luxuries to val-idate an illusion of the authority they had already lost. Europeans grappled with what an appropriate colonial architecture was and with whether and how to adapt their own architectural heritage to foreign situations. They tried to understand local architectural traditions enough to make effective political use of them. Meanwhile, the urban middle class mastered modern European culture in order to begin to wrest economic and political control from the colonizers. They were in many cases more opposed to precolonial cultural and political forms, which they resented as back-ward and oppressive, than to foreign imports.

Modernization's dislocations were universal, but the ability to shape an effective architectural response to them was not. Europeans sloughed off their own architec-tural, urban, and social traditions as the gap between impoverished peasants and workers and their prosperous social superiors widened. Colonialism opened up another gap, this time between races as well as classes. It deprived locals of the oppor-tunity to participate in modernization as equals. European and American military and industrial technological superiority reduced the authority of existing indigenous elites and checked that of new ones, while having an even more brutal impact on peasants and artisans. Even though many British colonial officials genuinely admired

much about precolonial architecture and worked to preserve it, their efforts often trapped their subjects in the past. Precolonial architectural forms were often meaningless when detached from the social structures from which they had arisen. Colonizers seldom integrated the indigenous into their own representations of modernity. They were even more uncomfortable with efforts at indigenous modernization, which they condemned as a betrayal of Indian tradition and an often comic misreading of European models. Abroad as at home, official British architecture attempted to tame change by representing continuities that were often more imagined than actual. Architecture, however, is not as effective in constructing political reality as it is in shaping physical space. The empire did not endure, although much of the damage it wrought continues.

FOR FURTHER READING

The older, more European-oriented literature on colonial cities in the Indian subcontinent is rapidly being replaced by new studies that stress the experience and agency of the cities' indigenous inhabitants. Examples of the former include Norma Evenson, *The Indian Metropolis: A View toward the West* (New Haven, Conn.: Yale University Press, 1989); Anthony King, *The Bungalow: The Production of a Global Culture* (London: Routledge, 1984); Thomas Metcalf, *An Imperial Vision: Indian Architecture and Britain's Raj* (Berkeley: University of California Press, 1989); and G. H. R. Tillotson, *The Tradition of Indian Architecture: Continuity, Controversy, and Change since 1850* (New Haven, Conn.: Yale University Press, 1989). For the latter, see Swati Chattopadhyay, *Representing Calcutta: Modernity, Nationalism, and the Colonial Uncanny* (London: Routledge, 2005); Preeti Chopra, *A Joint Enterprise: Indian Elites and the Making of British Bombay* (Minneapolis: University of Minnesota Press, 2011); Arindam Dutta, *The Bureaucracy of Beauty: Design in the Age of Its Global Reproduction* (London: Routledge, 2006); William J. Glover, *Making Lahore Modern: Constructing and Imagining a Colonial City* (Minneapolis: University of Minnesota Press, 2007); Jyoti Hosagrahar, *Indigenous Modernities: Negotiating Architecture and Urbanism* (London: Routledge, 2005); Rosie Llewellyn-Jones, *A Fatal Friendship: The Nawabs, the British, and the City of Lucknow* (Delhi: Oxford University Press, 1992); and Peter Scriver and Vikramaditya Prakash, eds., *Colonial Modernities: British Building, Architecture, and Dwelling in Colonial India and Ceylon* (London: Routledge, 2007).

21 Chicago from the Great Fire to the Great War

Nineteenth-century Berlin, Paris, Calcutta, and Bombay were unlike any earlier cities. All boasted extensive civic infrastructure, which in Paris, in particular, was supplemented by unprecedented opportunities for shopping and entertainment. Although these cities were shaped by global capitalism, they were not simple diagrams of real estate values. Politics clearly mattered, particularly the need to acknowledge without granting the claims of middle-class men to participate in national and local government. From the brute political force occasionally displayed within the colonial city to the more idealistic new civic building types, such as museums, the architectural response to these demands softened the edges of profit seeking in ways that ultimately strengthened the money-driven economy. Contemporaries were not sure, however, that culture tempered the real estate market in the new American city of Chicago. Precisely because of the explicit relationship displayed there between capital and urban form, Chicago appeared in the 1880s and 1890s to thoughtful observers from throughout Europe and the United States to be the urban face of modernity. It was where visitors went to see the present and to get a glimpse of what the future might hold for them at home. They were often frightened by what they found. The city's explosive growth fed the association of capitalism with chaos. Exactly what role its extraordinarily talented architects could play in taming these forces was not always clear.

The pace of European urbanization during the nineteenth century was unprecedented, and Asian colonial cities also expanded rapidly, but North American cities grew even faster and taller during the second half of the century and had an even greater ethnic mix of citizens. Dozens of languages were spoken in single neighborhoods such as New York's Lower East Side. The greatest success story of all was Chicago. Founded by an African American fur trader named Jean Baptist Point du Sable, the city was little more than a village in 1850, but by 1900 it was one of the

world's major metropolises, with a population of well over 1.5 million. Its spectacular growth was only temporarily interrupted by the Great Fire of 1871, which erased much of the downtown and led to the rebuilding of the city in less combustible materials. Chicago's success was based on the city's importance as a hub of railroad transportation connecting the grain, meat, and lumber of the midwestern hinterland to the major cities of the East Coast, especially to New York and, from there, the rest of the world. These spaces of production were organized around the Loop, as the downtown enclosed within the elevated railroad quickly came to be known. Chicago was also a regional center for the distribution of manufactured goods.

London and New York pioneered the development of districts devoted exclusively to banking and other financial services. In the United States, even more than in London, downtowns were filled with new building types that served the new industrial economy. The combination of the elevator and increasing quantities of iron made possible new kinds of environments in which companies were managed in close proximity to banks and lawyers, competitors and customers, rather than the places in which goods were manufactured. Furthermore, the stores in which these manufactured goods were then sold, whether wholesale or retail, were only blocks away from the offices where the companies that made them were run.

The earliest skyscrapers were built not in Chicago but in New York, where, until the completion of the Sears Tower in 1974, the tallest office towers in the world were for a century consistently located. From the beginning the Chicago office building was different in appearance from its early New York counterpart, which often featured repetitive tiers of floors grouped together under a mansard roof out of which rose a tall clock tower. Erected for the most part on speculation, the Chicago counterparts were not always conceived as individual urban landmarks. Because they were built on sandy soil rather than Manhattan's bedrock, the importance of substituting relatively lightweight iron and steel for heavy masonry construction was greater. Tough fire codes soon ensured, however, that none of that metal was obviously displayed. The city's first experiment with prefabricated construction, its cast-iron storefronts, had buckled in the heat of the Great Fire.

The Chicago office building was largely the product of four firms. William Le Baron Jenney had trained in Paris as an engineer. Young architects who met while working for him founded three more important offices: Dankmar Adler and Louis Sullivan formed Adler and Sullivan, Daniel Burnham and John Wellborn Root established Burnham and Root, and William Holabird and Martin Roche founded Holabird & Roche. These architects focused on the efficient production of office, sales, and loft environments within the Chicago Loop and districts like it throughout the Midwest and, in Burnham and Root's case, eventually across the country. In each of these innovative partnerships, one member typically specialized in the business end, which encompassed everything from dealing with the client to organizing the interior, while the other concentrated on design details. Neither, however, could personally supervise the vast quantity of work that entered practices organized on

the scale of the businesses they specialized in serving. These firms hired armies of draftsmen, who often later worked for rival offices in turn, as well as more experienced architects to lead them. No one working in these vast new enterprises was explicitly interested in expressing the new foundations or skeletal framing they used with increasing confidence. Instead, as an examination of Burnham and Root's Rookery Building demonstrates, real estate considerations drove many of their formal decisions (Figure 21.1).

Upon its completion in 1888, the Rookery Building became the most prestigious office block in the city. Its architects maximized their clients' profits by creating the greatest possible number of high-rent stores and well-lit office spaces. The firm of Burnham and Root itself was among the most prominent tenants occupying the building's six hundred separate offices. The Rookery was an early example of skeletal frame construction. The brick exterior walls no longer carried the entire weight of the building. This enabled the architects to open the facades, now only screen walls, to provide enough daylight to penetrate into deep offices. The design of these buildings was not without its artistic side, however; efficient construction did not preclude ornament. As the building's beautifully carved stone ornament demonstrates, the Rookery's architects struck a balance between monumentality and the permanence it implied on one hand and clarity and efficiency on the other.

The presence of the skeletal iron frame made the most noticeable impact at street level, where the projecting bays of two-story shop fronts became little but glass screens separating pedestrians from the goods displayed within at the same time that they maximized the illumination of the interior. From the street, the Rookery appeared to be a solid brick block, but in fact it was organized around a central light court that ensured that no part of any office was far from a window (gas lighting was also provided). White tile on the walls facing this court reflected the greatest possible amount of light into the interior. If efficiency alone had conditioned the design of street facades, they would have looked more like these tiled courtyard walls. Only the first two floors of the site were entirely covered. Shops lined the interior atrium as well as the street fronts. After twenty years Frank Lloyd Wright gave Burnham and Root's original interior a cosmetic renovation, characterized mostly by new decorative ironwork.

Department stores, hotels, warehouses, light manufacturing, exclusive clubs, arts organizations, and government buildings were all also located in the Loop. At times they were almost indistinguishable from the office buildings designed by the same firms. Construction began on the Schlesinger and Mayer department store, later Carson Pirie Scott, in 1898 (Figure 21.2). Louis Sullivan, its architect, was the only Chicago architect of his generation to produce a significant body of theory. He had trained at the École des Beaux-Arts in Paris but also had been inspired by the writings of Ruskin and of the transcendentalist philosopher Ralph Waldo Emerson. To the rational articulation of the steel frame, Sullivan added—with the collaboration of the office draftsman George Grant Elmslie—elaborate bronze-plated cast-iron

Figure 21.1. Burnham and Root, Rookery Building, Chicago, Illinois, 1885–88.

Figure 21.2. Louis Sullivan, Schlesinger and Mayer department store (later Carson Pirie Scott), Chicago, Illinois, 1898–1906.

ornament of the kind eschewed by most Chicago architects and the developers for whom they worked, but particularly appropriate for the lower stories of a store selling luxuries small and large. Sullivan's ornament, moreover, was inexpensive because it was mass-produced. The pressed terra-cotta bands on the upper stories cost little more than ordinary bricks. The introduction of terra-cotta cladding in the 1880s may have been prompted in part by the fact that it made contractors less dependent on unionized masons; the use on street facades of gleaming tiles originally limited

to light courts optimistically announced a cleanable alternative to the soot-encrusted surfaces of most of the rest of downtown.

Sullivan employed two distinct vocabularies on this facade. For the upper floors he chose "Chicago windows," as this tripartite arrangement was known. Common throughout the city's downtown, each consisted of a large sheet of plate glass separating two panels of operable glazing, essential in the city's hot summers in the days before air-conditioning. Sullivan wrapped ornament around even the interior of the window surrounds. Decorum continued to operate as a check on an architecture of pure efficiency. The crescendo of this ornament is reached, however, at the building's corner entrance (Figure 21.3). Department stores throughout Europe and the United States vied for corner sites, which they almost always accentuated with cylindrical elements. Here the full richness of Sullivan and Elmslie's architecture is displayed in a riot of ornament introduced into an environment very different from the domestic and reform-minded institutional settings in which it usually flourished.

Figure 21.3. Entrance detail, Schlesinger and Mayer department store.

Stylized nature of the kind that was fashionable at the turn of the century on both sides of the Atlantic added a note of chic to a department store built without the usual interior atrium.

Few turn-of-the-century Chicagoans with the leisure to think about architecture were content with the atmosphere projected by the Loop's commercial architecture, despite the decorum of the Rookery or the fancy dress of Carson Pirie Scott's ground story. Chicago was in the forefront of sponsoring the creation of a new civic architecture, one that looked very different even as it was indisputably tied to progressive social goals, as the more aesthetically radical office buildings were not. The desire of Chicago's leading citizens to build for culture as well as commerce culminated in the World's Columbian Exposition, held on the city's South Side in 1893, 401 years after Columbus first crossed the Atlantic (Figure 21.4). The most distinctive aspects of this fair included its scale, the coherent organization of that scale, and the uniformly classical vocabulary that tied together its major buildings. But there was also room for entertainment, such as the first Ferris wheel and exotic dancing in the Persian theater. The fair's balance of edification and entertainment was part of what made it successful. This amusement area provided guidance for later

BIRD'S-EYE VIEW OF THE WORLD'S COLUMBIAN EXPOSITION, CHICAGO, 1893.

Figure 21.4. General view, World's Columbian Exposition, Chicago, Illinois, 1893.

American entertainment districts from Coney Island to Disneyland. A popular culture flourished here that in the future would outstrip the stateliness of the fair's Court of Honor as a model for American commercial architecture.

In the 1920s, well after the fact, Sullivan and Wright's prominent condemnation of the fair's classicism prepared the way for the hostility felt toward it by the historians of the modern movement. At the time, however, and for long afterward, both ordinary Americans as well as most architects were enormously enthusiastic. Contemporaries saw this as the moment American architecture came of age. What was its appeal? First, the exposition presented the possibility of comprehensive professional planning in place of speculative real estate development. Frederick Law Olmsted, the most prominent American landscape architect of the day, collaborated with Daniel Burnham on the plan. The integration of monumental civic, park, and amusement areas with good transportation and up-to-date electric lighting had enormous appeal. It stunned Chicago citizens of all classes, and also Europeans, well-to-do easterners, and small-town shopkeepers from throughout the Midwest. This laid the ground for the City Beautiful movement, which promoted classical civic architecture, and for the birth in the United States of urban planning as an independent profession. Indeed, Burnham's 1909 plan for Chicago, which spurred the development of the city's lakeshore parks, and his subsequent role in schemes for Manila and San Francisco were among the most notable consequences of the fair.

Second, the uniform architectural vocabulary of the Court of Honor presented an image of urban order in contrast to the cacophony of architectural styles found in the late nineteenth-century city. This part of the fair was designed by a consortium of the Midwest's and East Coast's most celebrated architects, supplemented by teams of sculptors. The buildings were temporary structures built largely of plaster on steel frames, but the gleaming white surfaces, uniform classical vocabulary, large scale, and rich decoration, complete with an unprecedented amount of public art, dazzled most visitors, who prized the extent to which the classical correctness created a sense of playing by the rules. The appearance of civic correctness masked the reality that most of the buildings surrounding the Court of Honor were vast shells for exhibits of American industry.

The reform-minded character of the fair included exhibits addressed specifically to women. These were housed in the Women's Building designed by Sophia Hayden, a recent graduate of the Massachusetts Institute of Technology. The competition that Hayden won to design the building was open only to women. The building was the idea of Bertha Honoré Palmer, the wife of one of Chicago's wealthiest men. Despite the involvement of such extremely rich Chicagoans, one reason for the success of the fair was the degree to which it represented upper-middle-class rather than elite tastes and goals. Many of the organizations whose annual conventions met at the fair, such as the American Library Association and the National Household Economics Association, which was founded there, were critical of the unrestrained capitalism represented by the city's and the country's robber barons, preferring

instead a middle-class morality rooted in domestic culture. They applauded the creation of civic environments whose grandeur was public rather than private and whose scale might challenge the primacy of the new commercial architecture. Their taste could be conventional, but they were often also willing to consider new art and radical social reforms.

This is almost visible in the interior of the Women's Building, which was decorated by Candace Wheeler (Figure 21.5). The exhibits there largely dwelled on the accomplishments of American women as craftswomen, social reformers, and professionals. (The limits of contemporary tolerance were exposed by the segregation of African American exhibitions from the rest.) Women's activities were stressed as extensions rather than rejections of women's domestic roles, yet there was nothing domestic about the architecture of the building, which instead harmonized with that of other major exhibit structures. The interior decoration included large murals, now lost, by Palmer's friend Mary Cassatt, which were the most innovative works of art on display at the fair.

Two increasingly divergent views of the way that technology could be used to transform domestic life were presented at the World's Columbian Exposition. One was the Rumford Kitchen, organized by Ellen Swallow Richards and Mary Hinman Abel (Figure 21.6). It prepared up to ten thousand inexpensive and nourishing meals a day for fairgoers. The building comfortingly resembled a homey cottage with

Figure 21.5. Sophia Hayden, architect, and Candace Wheeler, interior decorator, interior, Women's Building, World's Columbian Exposition.

Figure 21.6. Rumford Kitchen, World's Columbian Exposition.

an ample front porch rather than a factory. The exterior architecture of the building belied the industrial organization within. The Electric Kitchen, also on display at the fair, hinted for the first time that the technology used by Richards and Abel, and in other big hotel and restaurant kitchens, could be made affordable for individual households (Figure 21.7).

This contrast was emblematic of the two different directions in which domestic reformers moved in the years that followed. Richards and Abel's experiment was inspired by the writings and lectures of Charlotte Perkins Gilman. Gilman, the great-niece of Catharine Beecher and Harriet Beecher Stowe, advocated the establishment of public kitchens and communal dining to save women work and enable them to pursue charitable and professional careers. She described her ideal as

> a commodious and well-served apartment house for professional women with families. . . . The apartments would be without kitchens; but there would be a kitchen belonging to the house from which meals could be served to the families in their rooms or in a common dining-room, as preferred. It would be a home where the cleaning was done by efficient workers, not hired separately by the families, but engaged by the manager of the establishment; and a roof-garden, day nursery, and kindergarten, under well trained professional nurses and teachers, would ensure proper care of the children. . . . This must be offered on a business basis to prove a substantial business success; and so it will prove, for it is a growing social need.

Figure 21.7. Electric Kitchen, World's Columbian Exposition.

Gilman's call for further transforming the role of women by focusing on public reform rather than private housekeeping and nurture appealed less to many, however, than the Electric Kitchen. Here appliance manufacturers presented housewives with the increased assistance of new appliances. Needless to say, the market for electric stoves, joined in the next half century by refrigerators, vacuum cleaners, and washing machines, would be far larger if each household that could afford one bought its own rather than pooled resources with neighbors to purchase communal appliances. Gilman and her allies did not fully understand the degree to which the domestic ideal they attempted to manipulate in new ways ultimately operated as enabler rather than critic of the status quo. By the 1920s, well-organized kitchens planned by Christine Frederick, an industrial efficiency expert who pioneered the application of time and motion studies to the home, replaced their utopian dreams.

These debates remained academic for many Chicagoans, as middle-class domes-
ticity remained beyond their reach. The city's slums were notorious. Inhabited largely
by recent immigrants from eastern and southern Europe, they were characterized
by poorly maintained and dimly lit dwellings into which families were packed often
into single rooms. The diseases that festered in these conditions threatened the health
of the middle-class neighbors as well. These were the blighted neighborhoods that
after World War II, throughout the United States, were either turned over to black
migrants from the rural South or demolished in favor of freeways and public hous-
ing. Where they survived the 1960s, as in New York's Little Italy or Boston's North
End, they often improved dramatically as population densities decreased and the
descendants of their late nineteenth- and early twentieth-century immigrant inhab-
itants acquired the means necessary to maintain and repair them.

Many members of the middle class responded to the presence of city slums by
fleeing to the suburbs. Others, however, particularly the first generations of col-
lege-educated women, attempted to inculcate middle-class American values in slum
inhabitants, in order to ease their assimilation and reduce the danger to American
values that the trade unionism and socialist politics that flourished in impoverished
areas were assumed to represent. Jane Addams and Ellen Gates Starr founded Hull
House, the country's most renowned settlement house, in Chicago in 1889. They
moved into what had once been a genteel home in a decaying area in order to im-
prove the lives of their new neighbors by befriending them and offering them use-
ful assistance. Under Addams's leadership, the complex eventually grew to occupy
almost four square city blocks (Figure 21.8). It included places to eat inexpensive
and healthy if bland meals (Addams purchased the equipment from the Rumford
Kitchen), classrooms and meeting rooms for adults, and spaces for children, includ-
ing a gymnasium and a nursery. An early example of American day care, its presence
allowed neighborhood women to seek paid employment knowing that their chil-
dren would be well cared for while they worked. All of these facilities were created
through private charity at a time when local, state, and national governments did
not view ameliorating poverty as their responsibility. This callousness encouraged
many middle-class women like Addams to campaign for women's right to vote.

Many of Hull House's buildings appeared domestic rather than institutional.
The homelike setting was important to the largely female inhabitants, as it justified
their entrance into the new field of social work. The simply furnished spaces of the
original house were intended in part as object lessons in good taste for both wealthy
benefactors and impoverished neighbors. Today, many emphasize the degree to
which participants in the settlement house movement attempted to coerce their slum
neighbors into adopting their middle-class American values rather than encourag-
ing revolutionary political solutions to the district's social problems. Addams was an
enormously courageous woman, however, who was not afraid to take radical posi-
tions. The first American woman to win the Nobel Peace Prize, she campaigned to
end child labor, sided with striking workers, and was a founding member of the

Figure 21.8. Hull House, Chicago, Illinois, completed 1907.

National Association for the Advancement of Colored People (NAACP), as well as an outspoken pacifist who opposed U.S. participation in World War I.

Middle-class Chicagoans lived mostly in suburban neighborhoods, isolated from the problems Addams confronted daily. Here, many who could afford it built houses that demonstrated their confidence in experimentation within the parameters of a reassuring domesticity. Wright lived and practiced in suburban Oak Park and lectured at Hull House, which was also a center for artistic reform, about his practice. He led the way in developing the prairie style, a local offshoot of the Arts and Crafts movement that was, however, decidedly international in its sources and ambitions. Although several of his houses were built for more varied topography, Wright argued that their characteristic horizontality harmonized with the flatness of the surrounding landscapes.

Inspired by the buildings the Japanese government erected at the World's Columbian Exposition, Wright quickly moved far beyond the reverence for the preindustrial vernacular that had inspired earlier Arts and Crafts architecture. The Ward Willits House in Highland Park, built 1902–3, is infused with his fascination with Japan (Figure 21.9). (Many of Wright's firm's renderings display the influence of Japanese prints, including those by Marion Mahony Griffin, the first woman

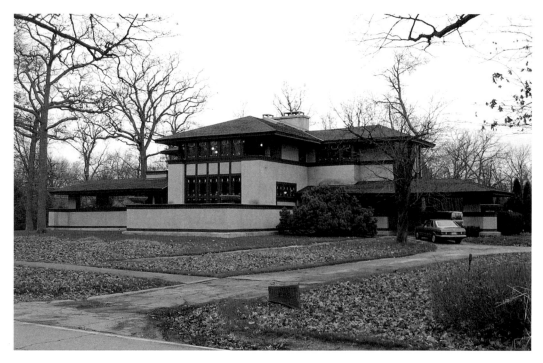

Figure 21.9. Frank Lloyd Wright, Ward Willits House, Highland Park, Illinois, 1902–3.

licensed to practice architecture in Illinois, who worked for Wright between 1895 and 1909.) In 1905 the Willitses and the Wrights traveled together to Japan. More radical than Wright's admiration for Japan, which he had in common with many Westerners engaged in the visual arts, was his willingness to employ steel and reinforced concrete, the new materials being used downtown, to create new kinds of suburban architecture. The crisp black-and-white geometries of the Willits House's facades may have been inspired by Japan, but the thins walls and the broad cantilevers of the low hip roofs were both stiffened with steel beams.

Wright was enormously talented at fusing innovative form with reassuringly familiar social ideas. In the house's pinwheel plan, he rejected the Beaux-Arts organization of the fair buildings in favor of spatial openness (Figure 21.10). The scale of the service areas delineated the limits of social reform. Only in the 1930s, when building for families that could no longer afford servants, would he relate the kitchen to the living room. Wright's upper-middle-class clients implicitly criticized the aristocratic decor favored by very wealthy Chicagoans. Wright purged most ornament, but a great deal of comfort remained, expressed above all through the prominence of the hearths, the warmth of the finishes, the scale of the spaces, and the generous extent of the lots on which these houses sat.

Like McKim, Mead, and White at Kingscote, Wright attempted to retain complete control over the design of the interiors of his houses. Only his own artistry, he believed, could ensure that the proper nearly spiritual effect was achieved. In

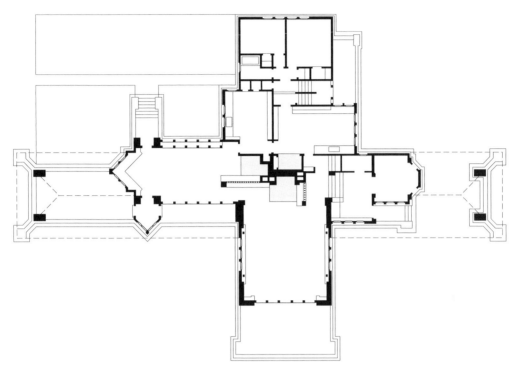

Figure 21.10. Plan, Ward Willits House.

contrast to the open plans made possible by new materials, Wright's minimally up-holstered furnishings, although much prized today, were not unique for an Arts and Crafts architect of the period. The living and dining rooms of the Ward Willits House were quasi-independent pavilions, projecting from the core of the house with three exposed exterior walls. Wright's sensitivity to light and ventilation in the design of these rooms complemented his spatial innovations. Exterior overhangs modulate light during summer and allow windows to be kept open during cooling summer evenings and thunderstorms. The windows of his prairie houses allow in light but screen rather than reveal the surrounding landscape, creating a high degree of visual privacy. For each house Wright designed a stained-glass pattern, typically derived from a particular flower.

Across the course of a sixty-year career in which he designed hundreds of buildings and became America's most celebrated architect, Wright received few opportunities to build downtown. Instead he domesticated and suburbanized the engineering of industrial and commercial architecture not just in houses but in even more radical buildings such as his own church, Unity Temple in Oak Park, built between from 1906 to 1909 (Figure 21.11). Churches followed their members in moving to new residential districts. Here a joint congregation of Unitarians and Universalists renounced conventional church architecture in favor of something more primeval and, most important to them, less expensive.

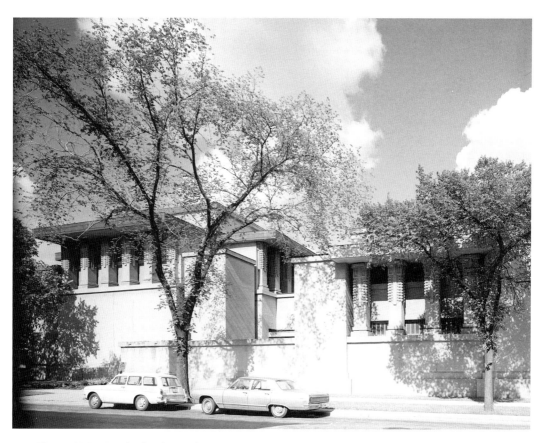

Figure 21.11. Frank Lloyd Wright, Unity Temple, Oak Park, Illinois, 1906–9.

The church complex consists of two volumes: a temple and an auditorium or Sunday school block. Wright characteristically placed the entrance off axis between the two, a decision that forces the visitor to focus on the entire composition of the street facade in order to locate the door. The stark simplicity of the reinforced concrete construction accounts for Unity Temple's fame as one of the early examples of the revolt against nineteenth-century eclecticism. Reinforced concrete, a new material, combined cheapness with monumentality. Also notable, however, are the possible echoes of Mayan architecture that certainly inflected several of Wright's later attempts to create a uniquely American architecture by referring to the monumental architecture of the continent's original inhabitants. This is not so different from the use being made throughout the Southwest at this time of Native American Pueblos and Spanish colonial missions, although it is far more abstract.

In the space for worship, Wright emphasized direct visual and aural access to the spoken word emanating from the speaker's platform (Figure 21.12). This form of Protestantism emphasized the spoken word over the sacrament of the Mass and employed no altar. Good acoustics were essential at a time when electrically amplified sound systems did not yet exist. Wright also emphasized daylight, which in

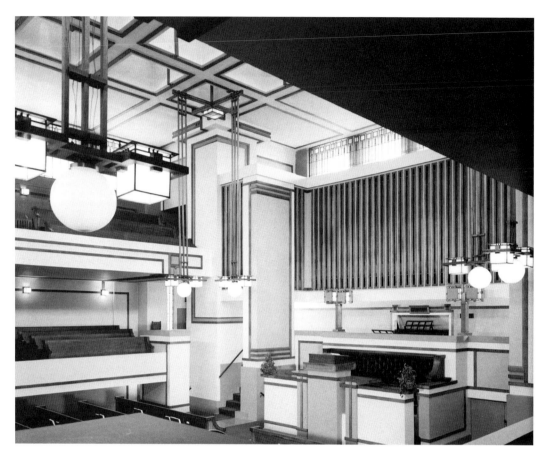

Figure 21.12. Interior, Unity Temple.

many faiths is a metaphor for spirituality, without creating a distracting view outside. He relied on geometry instead of historical ornament to produce a space that is literally as unified as the congregation itself. In producing a sense of warmth rather than austerity, he was attentive to color and scale. He successfully subordinated all details to the manipulation of the clear spans enabled by steel reinforcing. Wright's work was greatly admired in the first decade of the new century, and he built widely across the upper Midwest. He became an outcast, however, in 1909, when he abandoned his family and left for Europe with a client's wife, who was murdered five years later, along with two of her children and four other members of Wright's household. It took a generation for his career to recover.

Later generations have taken for granted the new kind of urban organization that emerged in the English-speaking world in the middle of the nineteenth century. The high cost of real estate pushed most residential uses out from districts devoted to finance and commerce, but the emphasis these societies placed on domesticity as a haven from urban and commercial life also encouraged separation. Commerce itself was never enough, however. From the beginning, those inhabitants of Chicago

who enjoyed sufficient means to think about other things longed as well for culture. This led to the birth by the 1880s of civic institutions to complement the new commercial ones. The buildings that housed these institutions—public libraries, museums, theaters and orchestra halls, and government buildings—were intended in Chicago and elsewhere in the United States not so much to provide places for display, as in Paris, as to edify a broader public. In this, the City Beautiful movement united Beaux-Arts architecture and Arts and Crafts ideas. The latter appealed particularly to reform-minded women interested in extending their idealizing mission from the domestic into the civic sphere. Many members of the middle class yearned as well for the connections to nature, to family, and to God that they believed to have been enshrined in preindustrial life. These yearnings inspired the development of suburban neighborhoods (not always at this period separate towns, although they could be) and the churches that served them. In each of these arenas—commercial, civic, domestic, and religious—new construction materials generated new designs for the expanded and enriched middle class.

FOR FURTHER READING

On Chicago's relationship to its hinterland, see William Cronon, *Nature's Metropolis: Chicago and the Great West* (New York: W. W. Norton, 1991); on the impression it made on others, see Arnold Lewis, *An Early Encounter with Tomorrow: Europeans, Chicago's Loop, and the World's Columbian Exposition* (Urbana: University of Illinois Press, 1997). On New York's skyscrapers, see Sarah Bradford Landau and Carl Condit, *The Rise of the New York Skyscraper, 1865–1913* (New Haven, Conn.: Yale University Press, 1996). For discussion of the Rookery Building, see Daniel Bluestone, *Constructing Chicago* (New Haven, Conn.: Yale University Press, 1991); and Meredith L. Clausen, "Frank Lloyd Wright, Vertical Space, and the Chicago School's Quest for Light," *Journal of the Society of Architectural Historians* 44, no. 1 (1985): 66–74. On the context of architectural production in Chicago at the time, see Robert Bruegmann, *The Architects and the City: Holabird & Roche of Chicago, 1880–1918* (Chicago: University of Chicago Press, 1997); and Joanna Merwood-Salisbury, *Chicago 1890: The Skyscraper and the Modern City* (Chicago: University of Chicago Press, 2009). Joseph Siry, *Carson Pirie Scott: Louis Sullivan and the Chicago Department Store* (Chicago: University of Chicago Press, 1988), is the standard work on the subject. On the Women's Building, see Sally Webster, *Eve's Daughter/Modern Woman: A Mural by Mary Cassatt* (Urbana: University of Illinois Press, 2004); and Wanda Corn, *Women Building History: Public Art at the 1893 Columbian Exposition* (Berkeley: University of California Press, 2010). The Rumford and Electric Kitchens are described in Dolores Hayden, *The Grand Domestic Revolution: A History of Feminist Designs for American Homes* (Cambridge: MIT Press, 1982). On Christine Frederick, see Janice Williams Rutherford, *Selling Mrs. Consumer: Christine Frederick and the Rise of Household Efficiency* (Athens: University of Georgia Press, 2003). The tensions between the commercial and the civic in reform efforts, including Burnham's plan and settlement houses, are recounted in Robin F. Bachin, *Building the South Side: Urban Space and Civic Culture in Chicago, 1890–1919* (Chicago: University of Chicago Press, 2004). Jane Jacobs, *The Death and Life of Great American Cities* (New York:

Random House, 1961), describes the revival of ethnic neighborhoods like the one that once surrounded Hull House. On Hull House itself, see Louise W. Knight, *Citizen: Jane Addams and the Struggle for Democracy* (Chicago: University of Chicago Press, 2005). On Frank Lloyd Wright, see Neil Levine, *The Architecture of Frank Lloyd Wright* (Princeton, N.J.: Princeton University Press, 1996); Reyner Banham, *The Architecture of the Well-Tempered Environment* (Chicago: University of Chicago Press, 1986); and Joseph Siry, *Unity Temple: Frank Lloyd Wright and Architecture for Liberal Religion* (Cambridge: Cambridge University Press, 1996).

22 Inventing the Avant-Garde

Arriving at the architecture of the twentieth century, we confront the origins of the modern movement in the invention of avant-garde architecture. The term *avant-garde,* a French expression originally used by the military to describe advance troops, came to be applied to all forms of culture that consciously rejected the status quo in favor of new propositions about the path others were expected to follow soon. The avant-garde emerged in mid-nineteenth-century Europe, particularly France, as artists, architects, and writers, as well as their supporters, rebelled against the institutionalized taste that had produced buildings that were uninspired versions of Schinkel's Altes Museum or Garnier's Paris Opera. Looking forward rather than back, a select number of continental figures now wanted to express their opposition to that established order in far more radical ways than their Arts and Crafts counterparts. They opposed, or at the very least worked outside, the institutionalized patronage of the state and challenged bourgeois respectability. Many of the avant-garde's products, such as the cubist paintings of Pablo Picasso and Georges Braque, were difficult and antagonistic rather than traditionally beautiful.

Experiments begun as early as the 1890s created cherished precedents for this outburst of formal experimentation. This first generation of avant-garde architects, few of whom actively supported later innovators, offered a greater variety of solutions to the question of how to be new. Champions of the avant-garde have assumed that innovative forms supported revolutionary political goals. That was true at times, but new architectural forms cannot consistently be associated with economic, social, or political change.

Art nouveau, French for "new art," was born in the Belgian capital of Brussels in the 1890s. In buildings such as the Van Eetvelde House of 1895–98, Victor Horta, an architect who during the last decade of the nineteenth century and the early years of the twentieth strayed far from his Beaux-Arts training, pioneered a new

synthesis of iron construction, stylized botanical ornament, and open, light-filled spaces (Figure 22.1). At the end of the nineteenth century well-off Belgians preferred single-family town houses to the urban apartments characteristic of Paris and most other large European cities of the day, or to the semidetached and fully detached suburban houses increasingly popular throughout the English-speaking world. In part because Belgium's heavily industrialized economy was a major producer of iron and steel, by 1890 the architects of many houses were already using iron lintels to enlarge their windows. Horta went further, systematically embracing ferrous construction in order to provide the interiors of homes built on deep, narrow lots with far more light. Horta blew open the middle of the Van Eetvelde House, inserting a double-height skylighted room with a stained-glass ceiling. This splendid atrium did far more than lead visitors from the modest entrance up to the principal reception rooms; it also provided a stage set for lavish entertaining. The facade of the Van Eetvelde House is a suspended iron curtain, hung in front of the plane of the entry.

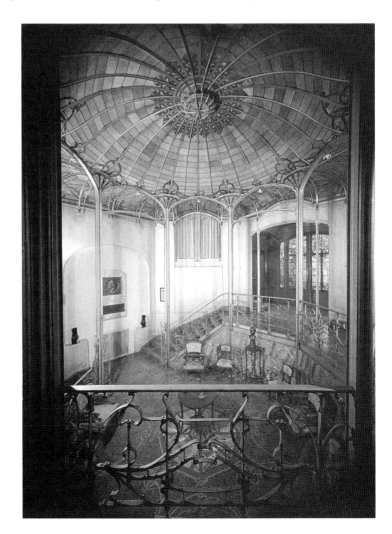

Figure 22.1.
Victor Horta, interior,
Van Eetvelde House,
Brussels, Belgium,
1895–1901.

Horta believed that architecture should express modernity rather than offer a soothing escape from it, but he was not averse to luxury. He rejected history rather than ornament. Horta, like other art nouveau architects and designers, favored whiplash curves that were often inspired by botanical forms. At times, such ornament broke free entirely of representation and became simply a web of abstract lines that simultaneously blurred the boundary between structure and decoration. In the Van Eetvelde House's atrium there is little specificity about the vaguely stalk-like iron piers supporting the sinuous membrane of the glass roof or the stems that carry the flower-like electric light fixtures. Art nouveau's new decorative vocabulary was typically independent as well of the particular materials in which it was executed. Horta repeated in the inlaid mosaic of the floor and painted stencil decoration on the walls motifs similar to those found in the semistructural iron railings that ring the upper story and the staircase. Horta was one of a generation of design reformers who, following the precedent established by Richard Wagner, a German composer who wrote the lyrics and was deeply engaged in the staging of his operas, replaced the panoply of styles and artifacts displayed in upper-middle-class dwellings with unified effects intended to induce a psychological effect as well as visual harmony.

Although Horta, like many members of the Belgian avant-garde, had socialist sympathies, going so far as to design the Maison du Peuple (House of the People) for the Belgian Labor Party, most of his principal patrons were wealthy industrialists. Baron Edmond van Eetvelde was a top administrator of Belgian king Leopold II's notoriously exploitative personal proprietorship over the Congo in Africa. Millions of that region's inhabitants died during the initial period of colonization. The wealth that built this house, and the tropical woods with which many of its rooms were decorated, were products of this brutal rule, which shocked even those contemporaries unwilling to challenge the era's other colonial empires.

By 1900 the fashion for art nouveau had spread throughout much of Europe. It quickly collapsed, however, as the new style proved to be just a fashion rather than an effective comprehensive challenge to established modes of architectural practice. Art nouveau ornament was easily applied to the facades of buildings whose construction and plans remained otherwise unchanged; art nouveau advertisements and cheap consumer goods quickly trivialized the style's usefulness for defining a discerning elite. The center for the fashion, while it lasted, was Paris. Avant-garde architecture is by definition for the few, and most buildings in Paris remained unaffected by the temporary popularity of the new style. It flourished, however, in department stores and cafés, arenas in which the buzz that surrounds the new was important. It was also the architecture that identified the entrances to the city's new subway system, the Metro, one of the new rail networks that were increasingly tying European city centers to new outlying districts. Hector Guimard, art nouveau's principal Parisian adherent, designed the entrances between 1899 and 1905 (Figure 22.2).

Art nouveau's curvilinear decoration at times recalled the rococo. This buttressed the market for exquisitely crafted French luxury goods at a time when the French

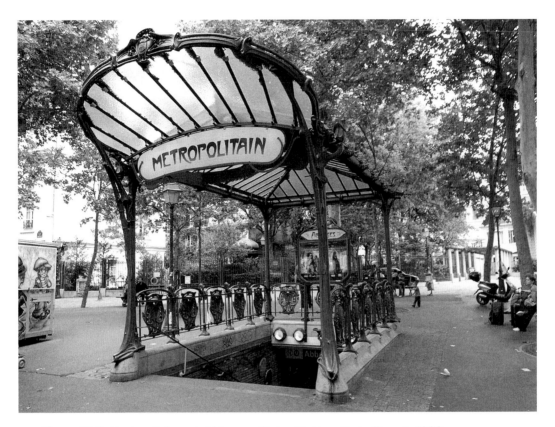

Figure 22.2. Hector Guimard, Abbesses Metro Station, Paris, France, 1900.

monopoly on their production was increasingly being challenged by understated designs from other European countries, particularly Britain and Germany. In his Metro entrances, however, Guimard embraced industrial production even more emphatically than had Horta. He directly addressed one of the principal facts of modernity: mass production. Cast-iron building fronts had been manufactured as early as the middle of the nineteenth century, and prefabricated buildings were also not new. The engagement of the avant-garde with mass production, however, was new and prophetic. Guimard's Metro entrances repeated several standard mass-produced designs across the length and breadth of the city. Their uniformity made a powerful contribution to the legibility of this new means of traversing Paris and saved money as well as labor.

In German-speaking central Europe, art nouveau was known as *Jugendstil,* or the youthful style. Influenced by the region's baroque heritage, it took a slightly different form in the Austro-Hungarian Empire than it had in France and Belgium. Joseph Maria Olbrich's Secession Building was completed in Vienna in 1898 (Figure 22.3). It was commissioned by a group of artists led by the painter Gustav Klimt, who had recently seceded from the state-run Academy of Fine Arts. Since the end of the seventeenth century, the academy had sponsored the education of artists and the

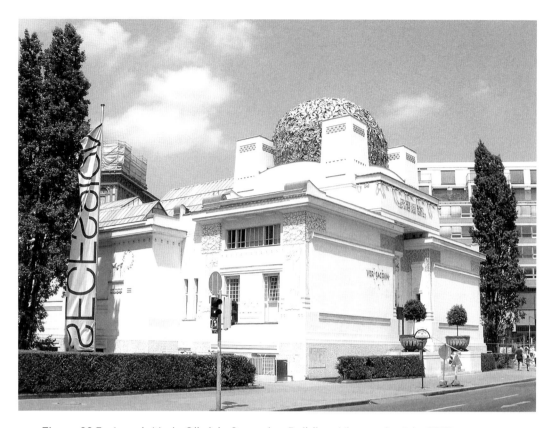

Figure 22.3. Joseph Maria Olbrich, Secession Building, Vienna, Austria, 1898.

exhibition of their work. By the nineteenth century, it also made purchases for the collections of the state's museums. Klimt and others organized the Secession to provide alternative venues for exhibitions.

Charged with representing major institutional change, Olbrich, like Wright, turned to primeval form. Wright greatly admired Olbrich's work when he saw it at the Louisiana Purchase Exposition held in Saint Louis in 1904. Indeed, his knowledge of the block-like Secession Building undoubtedly helped give Wright the courage to design Unity Temple as he did. One of the most important features of twentieth-century architectural culture was the way in which publications in magazines as well as the increasingly international travel and practice of many architects enabled innovative designs to have almost immediate impacts far from where they actually stood. Olbrich participated in this print culture in part by designing the poster depicting the Secession Building that announced its inaugural exhibit.

The Secession Building is emblazoned with lettering that reads (in German) "To the time its art, to the art its freedom." Olbrich's training was classically academic, and the impact of its emphasis on symmetry and monumentality remains visible. From the stylized rose bushes "growing" up the building's sides, which reappear as the structure of the open metal dome, he framed the conventional composition in

bold new terms. As in the pylons flanking that dome, this ornament coexists as well with efforts to reach deep into the history of architecture—here ancient Egypt— to establish a stability that seemed, as in Unity Temple, to lie outside time. The interior was equally novel. An open plan allowed the space to be reconfigured for changing exhibitions. One of the first of these introduced Vienna to the work of the Scottish architect Charles Rennie Mackintosh and his artist wife, Margaret MacDonald Mackintosh.

The Viennese appreciated the way in which the Mackintoshes contrasted art nouveau's characteristic stylization of nature and the female form with an increasingly austere rectilinearity. As the Salon de Luxe in the Willow Tea Rooms, which opened in Glasgow, Scotland, in 1903 makes clear, the Mackintoshes hardly rejected ornament (Figure 22.4). Here, as in an Arts and Crafts house, furnishings and architecture form a unified ensemble, and yet the forms no longer display any nostalgia for a preindustrial past. Clean and crisp white furniture sets off the elaborately abstract stained-glass doors and the only slightly more representational ornamental painted panels. Except for the jewellike insets in the doors, it was the care taken with the decor rather than the lavishness of the material finishes that

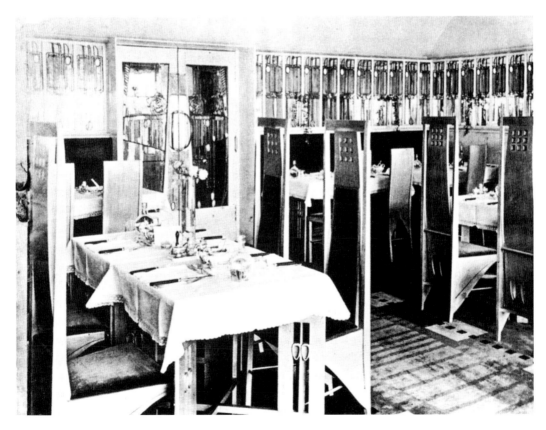

Figure 22.4. Charles Mackintosh, Salon de Luxe, Willow Tea Rooms, Glasgow, Scotland, 1903.

defined this as a luxurious environment, one in which patrons had to pay a penny more for tea than in the other rooms of the establishment, also designed by the Mackintoshes.

Although Margaret Mackintosh's interlinked use of the female form and floral imagery could be sexually suggestive, like so much art nouveau decoration, the Willow Tea Rooms preserved the Arts and Crafts association between aesthetic experimentation and progressive social reform. By moving a domestic aesthetic into the public realm, Catherine Cranston, the owner of a chain of Glasgow tearooms, supported the presence of women downtown while championing a distinct look that distinguished her business from those of her competitors. Tearooms, although open to both sexes, specialized in providing places where women could be comfortable lunching and taking afternoon tea in the city center, singly or in groups. Some rooms in them were open only to women. Women working in shops came for lunch and sometimes supper; wealthier women lingered over tea taken before or after they made their purchases. Many of her customers were, like Cranston, members of the temperance movement; the tearooms did not serve alcoholic beverages. Women who patronized tearooms avoided being harassed by the drunken men often found in the city's restaurants and bars.

For many years, the Mackintoshes deftly balanced abstraction and ornament, but other progenitors of the modern movement were more willing to consider abolishing ornament altogether. In an originally obscure essay widely republished in translation beginning in the 1920s, the Viennese architect Adolf Loos suggestively associated ornament with crime. The cubic starkness of the facade of the Scheu House of 1912 can, like the subtly detailed facade of the Willow Tea Rooms, be seen as a precursor of the modern movement's obsession with the white box. Loos wrote most of his essays to shock. He was as fond of luxurious materials and subtle details as any of his avant-garde rivals, whose work he scorned, but he deplored their holistic approach to design. Loos attempted instead to design environments that would endure shifts in fashion. The entrance hall of the Scheu House, built for a lawyer active in the garden city movement and his wife, an editor of children's books, is soberly detailed (Figure 22.5). The beams carrying the upper floors provide a sense of structure. Plain wooden paneling clads some walls. The upper halves of the windowpanes are neatly subdivided to establish scale. The room can accommodate a wide variety of furnishings selected by the client rather than the architect and change over time in response to shifts in taste.

Loos's renunciation of applied ornament occurred before the emergence of abstract painting inspired a new generation of architects to think of walls as spatial dividers rather than structural elements. The examples set by cubist, expressionist, futurist, constructivist, and de Stijl art, especially during the 1910s, prompted them to use reinforced concrete and skeletal steel framing to create asymmetrical, open plans. This fusion of nonrepresentational art and new construction technologies also encouraged many of these architects, who established their reputations for radical

Figure 22.5. Adolf Loos, stair hall, Scheu House, Vienna, Austria, 1912.

reductionism between 1918 and 1932, to embrace an aesthetic influenced by the appearance of no-nonsense factory architecture, which appealed to them both because it was by definition modern and because it offered an appealing alternative to historicism. Their work dominates most definitions of modern architecture to this day. Although this architecture has been widely seen, both by its advocates and by detractors at the time and since, as emblematic of communism, or at the very least socialist democracy, relatively expensive single-family houses and, in one key instance, a government-built pavilion provided key showcases for this new approach.

The art that triggered their experiments is often seen as presaging the cataclysm of World War I, which began in August 1914 and ended in November 1918. Most of the inhabitants of the original combatant nations—Germany, Austria, Serbia, Russia, Belgium, France, and Britain—greeted the war's outbreak with joy. They assumed it would be a short conflict and that their side would defeat the national enemy. Instead, advances in military technology ensured that millions on both sides were slaughtered, often in battles that resulted in little gain for the winning side. The economies of all the countries involved were devastated; in many the quality of life did not improve until the 1950s. The political effect was equally apocalyptic, as three great empires fell, to be replaced by Soviet communism, feeble German democracy, and the newly independent nation-states of Poland, Finland, Estonia, Lithuania, Latvia, Austria, Hungary, Czechoslovakia, and a newly reconfigured Yugoslavia.

The war sent the winners back to cherished national traditions, in most cases with a clear relationship to classicism. It liberated the losers, however, and even many inhabitants in those countries that had managed to remain neutral, from conventions strongly associated with discredited regimes. The Netherlands, neutral throughout the war, became already in the 1910s a laboratory for an unusual variety of architectural experiments that were widely admired abroad. One of the new Dutch directions was de Stijl, Dutch for "the style," inspired—like so many examples of interwar avant-garde abstraction—by new directions in art, in this case the strict rectilinear abstraction of Piet Mondrian and Theo van Doesburg. In the Schroeder House on the outskirts of Utrecht, designed by Gerrit Rietveld in collaboration with his client Truus Schroeder in 1922 and completed the following year, an emphasis on planes of primary colors floating in space overlapped with the spatial freedom made possible by the shift from the load-bearing masonry wall to skeletal frame construction (Figure 22.6).

From the street, the Schroeder House appeared to be a self-absorbed example of avant-garde architectural production. Concrete slabs accented with steel beams picked out in bright primary colors define the balconies and screen the interior. Innovative aesthetics and construction were not enough, however, for Schroeder, a widowed mother of three children determined to break free of what she experienced as the smothering conventions of middle-class domesticity. The plan of the upper floor reveals a revolutionary alternative fusing formal and social experiments (Figure 22.7). Sliding partitions provided the flexibility Schroeder equated with the capacity for self-expression. On the main floor, one level above the street, she and her children could arrange them to provide private sleeping spaces, to open all but the toilet and bathtub into one great space, or to be in any number of intermediate positions. The Schroeder House met the client's needs in part because Schroeder and her children controlled the way it was used, although Rietveld designed all the furnishings. Nowhere was the equation of personal freedom and the new architectural forms realized with more joy and fewer pretensions. Schroeder lived here for

Figure 22.6. Gerrit Rietveld and Truus Schroeder, Schroeder House, Utrecht, the Netherlands, 1922–23.

Figure 22.7. Plan, Schroeder House.

the rest of her long life. It was a particular environment for a particular individual, rather than a prototype for mass production. Although widely admired, it remained unique.

At the Villa Savoye, a weekend house in the Paris suburb of Poissy constructed by Le Corbusier from 1928 to 1931, a concern with formal issues produced an image radically at odds with bourgeois domesticity (Figure 22.8). The open plan of Europe's most celebrated avant-garde house exploited the spatial possibilities of skeletal construction entirely independently, however, of the sense of individual liberation that infused the Schroeder House. Le Corbusier, whose pithy and often repetitive language demonstrated his appreciation for advertising slogans, famously declared, "Architecture instead of revolution," suggesting that changes in the planning, construction, and appearance of the buildings the European middle class inhabited could substitute for a more fundamental reorganization of society.

Although he never attended a conventional architecture school, the twentieth century's most influential architect had a firm grounding in the architecture of the past and of the present. As a young man, Charles-Édouard Jeanneret (he began to call himself Le Corbusier in 1920) experimented with a wide variety of contemporary approaches to architecture, ranging from the relatively conventional to the avant-garde. Between 1905, when he built his first house at the age of eighteen, and the early 1920s, he progressed from an engagement with the Arts and Crafts movement to becoming an inventive neoclassicist before embracing a conservative form of cubism he labeled purism. As a native of Switzerland, he was well positioned to keep abreast of contemporary architecture in German- as well as French-speaking

Figure 22.8. Le Corbusier, Villa Savoye, Poissy, France, 1928–31.

countries. Before World War I, he visited Vienna and worked briefly in both Berlin and Paris. He also traveled through Greece to Turkey, where he admired both the Parthenon and whitewashed vernacular housing. In 1917 he settled permanently in Paris, where he became one of the first postwar architects to embrace mass production as a model for modern architecture. At a time when many young architects were traumatized by their wartime experiences and industry had been discredited in the eyes of many because of its association with modern weaponry, Le Corbusier realized that technological progress could provide the template for an optimistic view of a utopian future.

Le Corbusier described the house as "a machine for living." He implied that dwellings, although larger and less portable, could be as rationally planned and efficiently delivered as the most exciting new machines of the day, the automobile and the airplane. By the early 1920s, admiration in particular for the assembly-line production of Ford motorcars had inspired many avant-garde architects in Europe to hope that houses would soon be deliverable as standardized packages. Ideally, this would help lower production costs and assist in solving the housing crisis that was particularly acute in overcrowded cities and on the sites of former battlefields. The name of Le Corbusier's Citrohan, a project of 1922 for an industrially produced prototypical house, echoed that of Citroën, a French car manufacturer. Architects employed industrial motifs to present an image as well of apparently cool objectivity that nonetheless retained an air of technological romance; Le Corbusier was not alone in admiring the compact packaging of luxury ocean liners.

Le Corbusier probably did not intend the Villa Savoye to be replicated. The house is instead a study of the way in which concrete frame construction allows for extraordinary spatial manipulation. Exposed concrete columns he labeled *pilotis* support concrete floor slabs; the walls are infill brick covered with stucco. The architect did not place the columns on a strict grid (Figure 22.9). For those attuned to architectural nuances, this provided the tension that animated the (only apparently) rational design. The architect was careful to illustrate his departure from standard load-bearing construction. He juxtaposed the well-defined box of the upper story with its erosion through cutouts that would have been impossible if the exterior walls had been load-bearing. Ribbon windows, some of which he left unglazed, enclose two levels of unroofed terraces as well as the main living areas of the house. Their location on the second floor followed the example of European palaces, town houses, and luxury apartment buildings since the Renaissance, but Le Corbusier lifted the inhabitants above a meadow rather than a commercial street.

Hygiene was an important selling point in convincing a bourgeois audience to renounce the display of wealth in favor of abstract references to industrial modernity. Le Corbusier painted the upper story and the *pilotis* that supported it white; green walls pushed the recessed ground story further out of view. Inside, a prominently located sink allowed a visitor to wash his or her face and hands following the dusty car trip from Paris before ascending to the main living quarters. The sink served

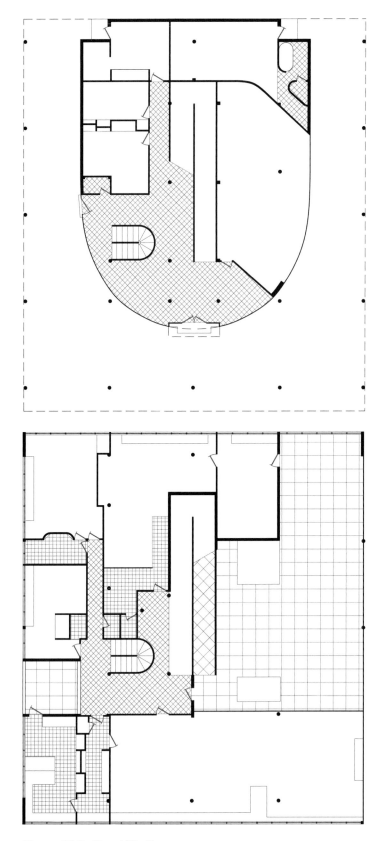

Figure 22.9. Plan, Villa Savoye.

as an icon of cleanliness achieved through technology. Although in other settings an industrial aesthetic would stand for the empowerment of the working class, Le Corbusier provided many of the bourgeois comforts typical of less radically designed vacation houses. Behind the garage he placed rooms for live-in servants. Upstairs, the kitchen was entirely separate from the living spaces for the house's owner, who the architect assumed would neither cook nor clean. The servants were relegated to a spiral stair that doubled as abstract art; as was customary, they did not have access to the ceremonial path to the second floor, here a ramp rather than a staircase. Throughout the rest of his career Le Corbusier favored ramps, in part for the spatial experience they provided but also for the degree to which they demarcated his buildings from more ordinary environments.

Le Corbusier focused on the progression through the building rather than on beautifully crafted details. The spatial relationships he established within the building were novel. On the upper story, conventionally furnished enclosed rooms faced the terrace through floor-to-ceiling glazing that provided carefully framed views of the surrounding landscape (Figure 22.10). A ramp led from the roof terrace out to a third-story viewing platform from which one could look out or indeed down at the interior of the house. Le Corbusier famously declared that "architecture is the masterly, correct and magnificent play of masses brought together in light." Here he

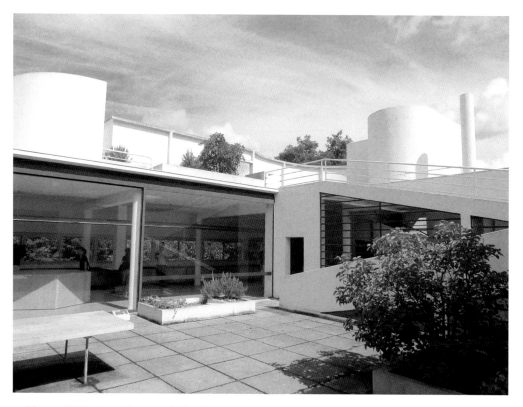

Figure 22.10. Roof terrace, Villa Savoye.

provided a perch from which to watch the changing way in which light and shadow played on the house's pristine surfaces as well as the countryside beyond.

While Rietveld worked quite closely with Schroeder to tailor her house to the way in which she wanted to live, Le Corbusier designed the Villa Savoye above all to impress other architects, for whom it has become a place of pilgrimage. Originally, the house was available to this audience largely through carefully staged photographs published in professional journals and in books on its architect and on modern architecture. The successive volumes of Le Corbusier's complete works, with adjacent texts in French, German, and English, were only the most widely read examples of a new genre, the volume devoted to illustrating the work of an individual architect or firm, and usually prepared in consultation with him (no monographs were published on female practitioners at this early date).

The story of the German Pavilion, originally erected in Barcelona, Spain, for the 1929 International Exposition, proves that firsthand experience of a building was no longer necessary for it to be widely admired. The pavilion, designed by Ludwig Mies van der Rohe, was demolished after the fair. It was rebuilt on its original site between 1981 and 1986, in part to satisfy tourists, some of whom continued to seek it out, not realizing that it was no longer there. Mies had unusual freedom in his design, as the building's function was limited to providing a space in which the Spanish king and queen could come and sign a guestbook. Just over a decade after the end of World War I, this form of recognition remained important to the German government. Like Le Corbusier, Mies was interested in the intersection of skeletal construction and abstract painting. The pavilion's plan, in which the walls appeared to be entirely independent of the columns supporting the roof slab, could have been a de Stijl painting (Figure 22.11). No space within the pavilion was defined by four solid walls. Instead, planes of solid stone and transparent and opaque glass slid past each other.

Like Rietveld, Schroeder, and Le Corbusier, Mies employed an open plan, but unlike them he created an environment luxurious enough to befit the expected royal visitors. Rietveld favored bright primary colors painted onto wood, steel, and concrete; Le Corbusier applied a consistent white stucco finish throughout most of the Villa Savoye. Influenced by his professional and personal partnership with Lilly Reich, who had first on her own and then in collaboration with him designed abstract trade-fair displays for various German industries, Mies selected surfaces that drew attention to their own sensuousness (Figure 22.12). Reich, along with Charlotte Perriand (who collaborated with Le Corbusier) and Eileen Gray, pioneered an elegant modernism that expressed her liberation from nineteenth-century conventions of femininity. Beautifully veined marble reflected in shiny chrome-covered columns created a splendid response to historicist ornament, mirroring its material richness while preserving modernism's abstraction and its fascination with machine-age sleekness. The international economic crisis triggered by the crash of the American stock market the following October curtailed the immediate interest in this

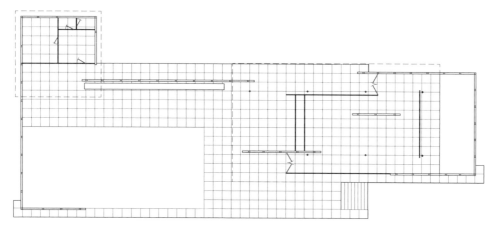

Figure 22.11. Ludwig Mies van der Rohe, plan, German Pavilion, Barcelona, Spain, 1929.

Figure 22.12. Interior, German Pavilion, 1929, rebuilt 1981–86.

restrained expression of modernist luxury. The German Pavilion offered convincing proof once again, however, that avant-garde architecture did not have to challenge but instead could effectively support the interests of established institutions such as the nation-state.

Whatever the politics of the architect and no matter how it affected the design, the avant-garde's necessary distance from conventional taste in most cases alienated

working-class as well as middle-class audiences. Despite modernism's rhetoric of inclusion, many architects found this distance necessary in order to establish the distinctiveness of their individual genius, which remained important to many, although by no means all, of them even at the height of interest in the 1920s in an anonymous machine aesthetic. Avant-garde architecture was always in danger of being merely fashionable rather than fulfilling its own promise of contributing to a better future by harnessing technology to improve housing conditions in particular.

At the same time, avant-garde architects were remarkably successful in creating an architecture that was widely accepted to have captured the spirit of their time. For roughly a century this fusion of abstract art and industrial imagery has effectively communicated newness. From modest beginnings in often beautifully crafted buildings created for aficionados, it eventually came to dominate much construction around the world, not least because less carefully built iterations were relatively inexpensive to build. Symbol may have often trumped reality when the style was embraced by real estate developers or dictators, but architects' hope that they could achieve liberation from history by harnessing the newest technology proved enduring.

FOR FURTHER READING

On Horta in general and on the ties between Belgian art nouveau and the Congo colony in particular, see Pierre Loze, *Belgium Art Nouveau: From Victor Horta to Antoine Pompe* (Ghent, Belgium: Snoeck-Ducaju & Zoon, 1991); Wagner's influence on architecture is chronicled in Juliet Koss, *Modernism after Wagner* (Minneapolis: University of Minnesota Press, 2010). On art nouveau in France, see Debora Silverman, *Art Nouveau in Fin-de-Siècle France: Politics, Psychology, and Style* (Berkeley: University of California Press, 1994). Its Viennese counterpoint is chronicled in Leslie Topp, *Architecture and Truth in Fin-de-Siècle Vienna* (Cambridge: Cambridge University Press, 2004). On Mackintosh, see Alan Crawford, *Charles Rennie Mackintosh* (London: Thames & Hudson, 1994). The complex history of Loos's essay is the subject of Christopher Long, "The Origins and Context of Adolf Loos's 'Ornament and Crime,'" *Journal of the Society of Architectural Historians* 68, no. 2 (2009): 200–223. On the Scheu House, see Eve Blau, *The Architecture of Red Vienna, 1919–1934* (Cambridge: MIT Press, 1999); and on the Schroeder House, Alice Friedman, *Women and the Making of the Modern House: A Social and Architectural History* (New York: Harry N. Abrams, 1998). For an examination of the conservative character of Le Corbusier's purism, see Kenneth Silver, *Esprit de Corps: The Art of the Parisian Avant-Garde and the First World War, 1914–1925* (Princeton, N.J.: Princeton University Press, 1989). The discussion of the Villa Savoye is also informed by Beatriz Colomina, *Privacy and Publicity: Modern Architecture as Mass Media* (Cambridge: MIT Press, 1994); William Jordy, *Symbolic Essence and Other Writings on Modern Architecture and American Culture* (New Haven, Conn.: Yale University Press, 2005); and Mark Wigley, *White Walls, Designer Dresses: The Fashioning of Modern Architecture* (Cambridge: MIT Press, 1995). On the German Pavilion, see Robin Evans, *Translation from Drawing into Buildings* (Cambridge: MIT Press, 1997); Christiane Lange, *Ludwig Mies van der Rohe and Lilly Reich: Furniture and Interiors* (Ostfildern, Germany: Hatje Cantz, 2007); and Terence Riley and Barry Bergdoll, eds., *Mies in Berlin* (New York: Museum of Modern Art, 2001).

23 Architecture for a Mass Audience

The avant-garde was but a single facet of the modern movement and its prehistory. As Mies's German Pavilion demonstrates, architectural reform made particularly strong inroads in the second and third decades of the twentieth century in Germany. Avant-garde buildings were by definition unusual and atypical. In Germany, however, the ornate historicism of the final decades of the nineteenth century was swept aside far more quickly than elsewhere. In many cases, the architecture that replaced it responded directly to conditions of mass culture as well as industrial production; in almost all, it acknowledged a fundamental shift in the audience for architecture. In Germany, as also occurred wherever the new architecture and social reform were paired, for the first time professional architects, rather than carpenters and master builders, addressed not just their social peers and superiors in their designs but also the whole of society, very much including the working and lower-middle classes. These architects appropriated techniques from entertainment, particularly theater and cinema, and from advertising to reach a mass public in buildings often designed overtly to sell goods as well as utopian social ideals.

Germany was a new nation, founded only in 1871. The rise of German nationalism is popularly associated with the construction of enormous monuments, such as those to Otto von Bismarck, the country's first chancellor. These were intended to indoctrinate Germans in a conservative patriotism. The nation's first constitution called for universal manhood suffrage; in 1919 the vote was extended to women. Bismarck had hoped that the peasantry would side with the aristocrats against the middle class, but that did not occur. By 1912, the socialists had become the largest party in the Reichstag, the German parliament. Throughout the first third of the twentieth century, German politics revolved around social divisions between the aristocracy and much of the middle class on one hand and the rest of the middle class plus the working classes on the other. Few German architects were explicitly

active in party politics, but many believed that their designs could help bridge these divides.

Reformers were deeply critical of the social dislocations wrought by industrialization. They championed the transformation of industry into high culture, unlike most adherents of the Arts and Crafts movement, who excluded modern technology from art. In 1907 the Allgemeine Elektrizitäts Gesellschaft (General Electricity Company, usually known as the AEG), hired Peter Behrens as its in-house designer. Behrens's role in packaging the public face of the company encompassed the design of the factories in which the company's products were made, the shops in which they were sold, and even publicity posters, in which the typeface employed and the products advertised were also his work.

Built in Berlin in 1909, the AEG Turbine Factory was emblazoned with the corporate logo Behrens had designed (Figure 23.1). Behrens ably converted the modern factory into a temple to industry by organizing an industrial aesthetic along classical lines. The end wall has emphatic corners supporting a pediment. Running along the long side facade, the supports of a pin truss repeat the rhythm of ancient Greek temple columns within a display of the latest technology. Behrens focused on image rather than the expression of structure. Out of view, he supported the rear

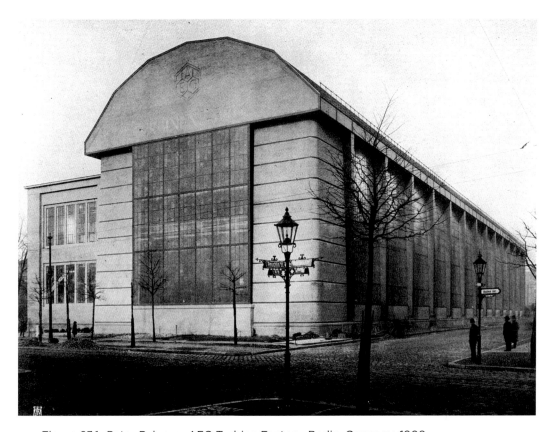

Figure 23.1. Peter Behrens, AEG Turbine Factory, Berlin, Germany, 1909.

long wall conventionally. He also established a tension between the concrete corner that appears to support the gable above it and the steel frame of the central window that actually does so.

The factory reassured many German cultural commentators that understated design anchored in tradition could ward off dislocations unleashed by the country's recent and rapid industrialization. They believed that architecture, as well as industrial and graphic design, could enhance social stability. The degradation of rural landscapes, the chaos of urban districts, and the shrillness of modern advertising could all be ameliorated if the planning of everything, from cities to coffee spoons, was entrusted to artists. Opposition to modernity would be curtailed if machine-made middle-class furniture did not ape handcrafted luxury goods, and if industrialists provided workers with model villages in which to live.

This faith in a unified aesthetic explains why Behrens was made responsible for the appearance of the Berlin shops in which the products he had designed, such as electric fans and teakettles, were sold (Figure 23.2). Shopwindow displays were

Figure 23.2. Peter Behrens, AEG store, Berlin, Germany, 1910.

also carefully arranged. At a time when paintings were still often hung from floor to ceiling in most museums and other art exhibitions, the uncluttered character of these shops was remarkable. Consistently simple, unornamented design became a hallmark of the AEG and helped to distinguish it from competitors, many of which still clad their products in historicist ornament. Even more than the architecture of the World's Columbian Exhibition, this simplicity offered a compelling alternative to the visual chaos associated with modern urban life. Behrens's acknowledgment of technology paved the way for the modern movement, not least because three of its major proponents—Le Corbusier, Walter Gropius, and Ludwig Mies van der Rohe—had all worked for him.

Elsewhere in Germany, other architects soon created a modern monumentality less dependent on classical precedent. The most notable example was the Centennial Hall built by Max Berg in what was then Breslau and is now the Polish city of Wrocław (Figure 23.3). It was dedicated in 1913 to celebrate the centennial of the Prussian king's call to his people to oppose Napoleon. Berg's renunciation of historical styles was regarded at the time as particularly appropriate for a building intended for a mass rather than an upper-middle-class public. The historic allusions that had decorated civic buildings such as those designed nearly a century earlier by

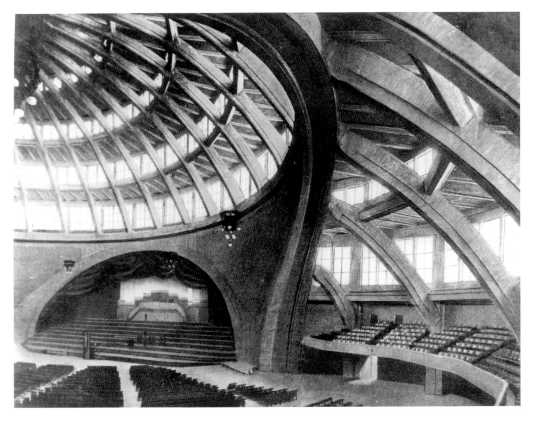

Figure 23.3. Max Berg, Centennial Hall, Wrocław, Poland, 1913.

Schinkel were now understood as inappropriate for a public whose members had not all been educated to appreciate them. Even before the turn away from representational painting gained many adherents, leading German architects were moving toward abstraction in order to communicate with the newly enlarged public.

Built entirely of reinforced concrete, the Centennial Hall was one of the engineering marvels of the day. Berg and others appreciated concrete's monolithic plasticity, which, unlike exposed iron and steel, coupled an explicitly modern monumentality with enhanced fire safety. Equally important was the enormous interior clear span this provided for a hall that seated thousands. The purpose of the hall was to bring together audiences composed of people from all social classes. Undivided by columns or experience, they were to be nurtured in a sense of community that transcended class differences. New theories of empathy posited universal reactions to environmental stimuli, encouraging architects to believe that they could literally build as well as stage community.

These aspirations were inspired by experiments in modern theater, to which the building was closely tied. Abstract set designs preceded abstract architecture. Their communicative power was a major inspiration for architects. Max Reinhardt was one of the leading figures in contemporary theater reforms. He emphasized the importance of abstract set designs and unified theater spaces as backdrops for highly emotional performances intended to elicit charged responses from enormous audiences. The meaning of the Centennial Hall was inscribed not in an iconographic program displayed on its walls but in the opening pageant with a cast of hundreds, written by Gerhart Hauptmann, who had just won the Nobel Prize in Literature, and staged by Reinhardt. Its pacifist message caused a sensation when the crown prince refused to attend the opening ceremony and his father, Kaiser Wilhelm II, boycotted the building.

The importance of spectacle for making abstract architecture appealing was highlighted the following year in the design of the Glashaus (Glass House) in Cologne (Figure 23.4). The work of Bruno Taut, it was part of an exhibit organized by the German Werkbund, a group that brought industrialists, designers, and critics together in an effort to ennoble mass production and the consumer culture it engendered. Emboldened by his contact with the avant-garde poet and novelist Paul Scheerbart, Taut believed in the utopian properties of colored glass. He inscribed Scheerbart's slogan "Colored glass destroys hate" onto the lintel of the Glashaus. Taut and Scheerbart were not alone. More than a decade earlier, Behrens had idealized crystalline forms as innately spiritual. Bold young German expressionist painters were using bright colors; Taut commissioned several of them to make stained-glass windows for the Glashaus's interior.

At the same time, the Glashaus was an advertisement. The Pittsburgh Plate Glass Company underwrote the construction of the pavilion, which showcased a variety of products made out of glass; Taut's own engagement with light stemmed in part from the illuminated displays within a pavilion he had built in the previous year for

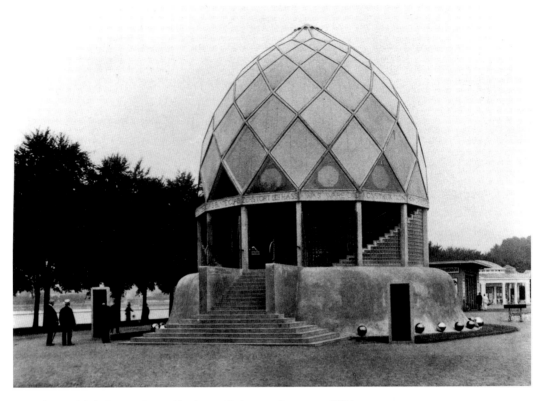

Figure 23.4. Bruno Taut, Glashaus, Cologne, Germany, 1914.

the steel industry. Taut's coupling of advertising techniques with a quasi-medieval vision of social harmony inspired a series of unrealized proposals for grandiose city centers. In these high-tech, socialist revisions of medieval Gothic cathedrals, people of all classes would once again gather in the pursuit of spiritual rather than individual goals.

The Glashaus was a temporary structure, and the exhibition of which it was a part was cut short by the outbreak of World War I. Only black-and-white views survive of its vibrantly colored interior, which pulsated with light cast by a giant kaleidoscope. Taut used electricity and colored glass to produce modern popular alternatives to traditional ornament, in the process creating a nearly immaterial architecture. The result overlapped with the environment in the new amusement parks, although Taut's spectacle, rather than distracting its audience from the realities of capitalist production, was intended to transform and thus eventually transcend those realities.

At the end of 1918, the November Revolution replaced the defeated German monarchy with a weak democracy known as the Weimar Republic. The new regime lacked the support of the country's elite and, because of its early suppression of more radical alternatives, of much of the working class as well. Its first years were

marked by economic chaos, during which little new was built. After the stabilization of the currency at the end of 1923 and particularly before the stock market crash of 1929, the lessons of Behrens, Berg, and Taut were recombined in a variety of new circumstances.

The department store remained the linchpin of urban shopping districts, but during the 1920s in Germany it often took a new form that exposed rather than masked its relationship to the factories where most of the goods on sale had been manufactured. The Schocken department store erected in downtown Stuttgart by Erich Mendelsohn from 1926 to 1928 led the way (Figure 23.5). The Schocken chain, modeled in part on American stores such as Woolworth's, sold a limited number of goods for unusually low prices. The store promised efficiency rather than luxury to a clientele that included the working class. Mendelsohn, who had recently traveled to Chicago, built a relentlessly industrial revision of Sullivan's Carson Pirie Scott store. He modeled the store in part on another American building he had visited, the concrete-framed factory in which Henry Ford's Model T automobiles were being made on assembly lines. He paid careful attention to his site, wrapping four different facade treatments around the structure, each calibrated to the width of the streets it faced and the height of the neighboring buildings. He

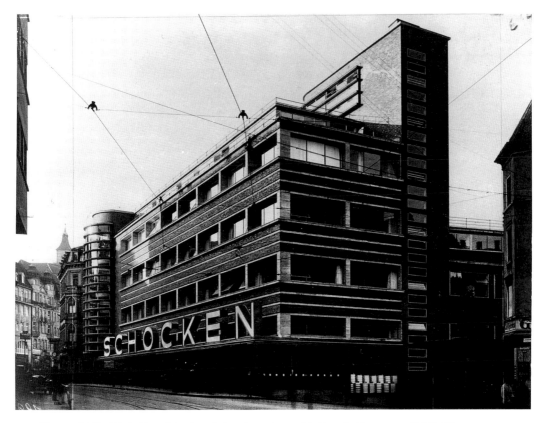

Figure 23.5. Erich Mendelsohn, Schocken store, Stuttgart, Germany, 1926–28.

then dressed this stark alternative to palatial fantasies in spectacle as abstract and technological as that of the Glashaus.

Like Behrens and the AEG before them, Mendelsohn and his client paid careful attention to advertising. Skeletal steel construction allowed the architect to leave the ground story entirely glazed; at night the building sat on a glowing band of display windows capped by illuminated letters spelling out the Schocken name. Most effectively, he displaced the drama of the atrium to the stair tower, an urban marker that he described as "a mountain of glass-rings, an advertisement which requires to be paid for only once and works for always." Signage, display windows, and night lighting set the stage for a radically simplified interior, in which lettering—here used to spell out business slogans on the wall—once again replaced ornament.

The department store was a badge of contemporary modernity, one of the biggest and often newest buildings in any downtown and accessible to all. Another was the cinema, available at least as an occasional treat to almost all city dwellers, including those who could seldom afford to venture into a regular theater. The movies, along with radio and the phonograph, transformed entertainment, which could now be mass-produced rather than only performed live. Large first-run movie houses, which seated thousands, clustered downtown, while smaller ones brought feature films into neighborhoods. In the United States the cinemas built during the 1920s and 1930s offered exotic fantasies to everyone, including a working- and lower-middle-class clientele. In Germany, where there was less money for expensive special effects, theater architects experimented instead with colored light.

Mendelsohn's Universum Cinema, one of the first movie houses built specifically for the "talkies," opened in Berlin in 1928 (Figure 23.6). It was embedded in a development that also included a prominent nightclub, shops, and apartments. Mendelsohn adhered strictly to the existing street line and neighborhood facade heights but split the block open to provide more space for commercial tenants, light and air for the inhabitants of the apartments, and ample egress from the cinema in case of fire. As in Stuttgart, he preferred brick, which did not age quickly, to the white stucco surfaces associated with the avant-garde. One contemporary critic compared the Universum to an island floating in the water of the boulevard on which it stood. One of the first buildings designed to be seen at the speed of automobile traffic, it had a ventilation stack that was an extraordinarily effective and widely imitated urban marker. The ribbon window along the side facades resembled a strip of film. In another nod toward cinema technology, Mendelsohn floodlit the exterior at night and used a stunning variety of often indirect lighting effects in the interior. Referring to several of the most popular films of the day, he proudly declared: "Thus no rococo palaces for Buster Keaton. No stucco pastries for Potemkin. . . . Fantasy—but no lunatic asylum—dominated by space, color, and light." This populist technological fantasy, which made Germans feel up-to-date even as their economy and political system crumbled, quickly spread during the 1930s, when in the wake of a global economic crisis even stucco pastries became too expensive for many.

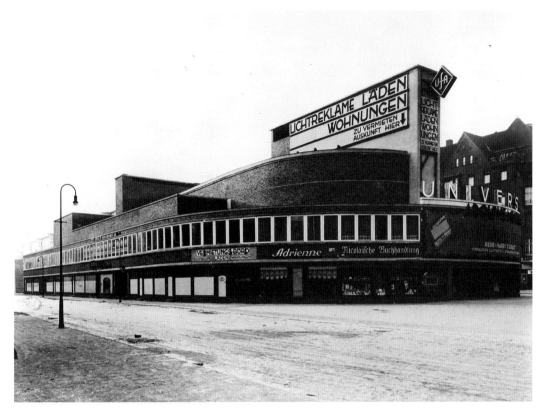

Figure 23.6. Erich Mendelsohn, Universum Cinema, Berlin, Germany, 1926–28.

Even as leftists criticized it for distracting shopgirls from actively opposing the rise of fascism, Mendelsohn's work for private developers and other clients, most of them fellow Jews, became the badge of urban modernity throughout most of interwar Europe. His architecture was also well-known and widely imitated in the Americas and Asia. Although department stores and cinemas dominated public awareness of modern urbanity, the Weimar Republic generated even more comprehensive changes on the outskirts of the country's major cities, where new federal laws helped finance huge housing estates. Built by trade unions and city governments, these estates were tied to older districts by new streetcar lines. They enabled the upper tier of factory workers as well as white-collar office staff to move out of crowded urban neighborhoods into the suburbs. One of the largest of these was the Britz, or Horseshoe, Estate begun in 1927 under the supervision of Martin Wagner, Berlin's city architect, and Bruno Taut (Figure 23.7). Although much of the new housing was built in relatively conventional styles and organized to be reminiscent of preindustrial villages, in Berlin and Frankfurt the impact of abstract art was clearly visible in the brightly painted but otherwise unornamented exteriors. At the Britz, regularly spaced stairs let to paired apartments, each with its own small balcony. The new settlements housed tens of thousands in small, mostly two-bedroom apartments.

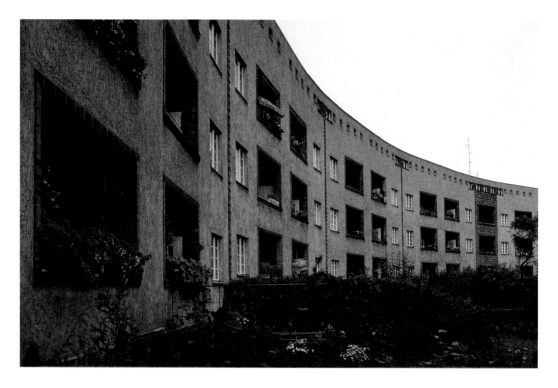

Figure 23.7. Bruno Taut and Martin Wagner, Britz Estate, Berlin, Germany, 1925–30.

In Frankfurt the explicit goal was to build the minimum amount of space that could comfortably house the most people. Although some units and most kitchens, the latter designed by Margarete Schütte-Lihotsky, were smaller than their predecessors, all were better equipped, with hot and cold running water, flush toilets, and electric or gas stoves now standard. Throughout Germany, architects experimented with new construction techniques and planning principles. In Frankfurt many new settlements were laid out with the emphasis on maximum sunlight. In Berlin, however, the street remained important. Taut painted the solid street wall bright red, a color that doubled as an expression of the neighborhood's political sentiments. He broke it open to create a horseshoe-shaped park on land that did not drain well.

The new neighborhoods included basic shops such as bakeries, butcher shops, and small grocers. Churches were also built, often with the explicit goal of countering secular solutions to the country's social problems. The sacred architecture was never as radical as that seen in secular gathering spaces, but those Germans who believed in the eternal were willing to go surprisingly far to identify their institutions as being modern and up-to-date. Dominikus Böhm led the reform of Roman Catholic architecture that culminated in the changes mandated by the Second Vatican Council between 1962 and 1965. His Saint Engelbert church, erected in the Cologne suburb of Riehl in 1930–32, exemplifies the impact of theological shifts on architectural form (Figure 23.8). The Liturgical Movement, to which Böhm belonged, advocated

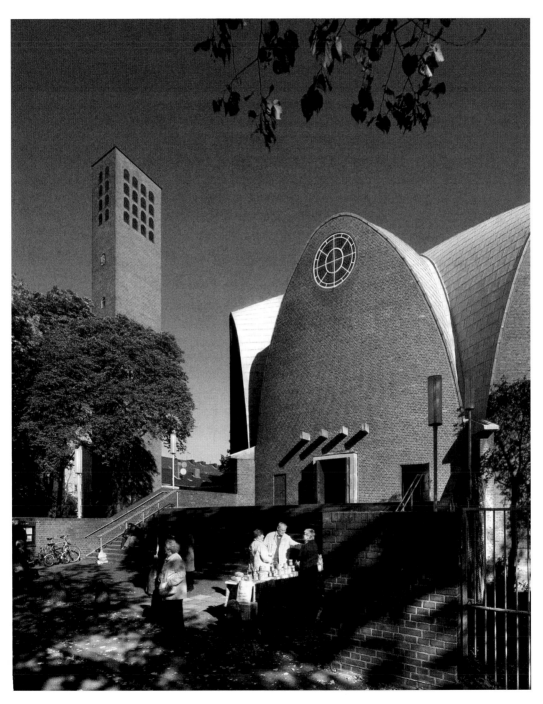
Figure 23.8. Dominikus Böhm, Saint Engelbert, Cologne–Riehl, Germany, 1930–32.

a communal focus on the Mass in place of private devotion to the saints. Böhm responded at Saint Engelbert by providing an uninterrupted circular area for the congregation in which evocative natural lighting substituted for decoration. He eliminated the choir separating clergy from laity, but slightly elevated the chancel containing the altar, now reduced to a simple table, to emphasize the hierarchical relationship between God and humankind. Like the architects of the great Gothic cathedrals, Böhm proudly employed state-of-the-art construction methods, in his case inexpensive parabolic vaults built of reinforced concrete. He tempered his innovations by covering them in a conventional skin—brick for the walls and copper for the roof—and evoking such historic examples as a centrally planned medieval church in the city center and the bell towers of early medieval Italian churches. Böhm's architecture had an enormous, often unacknowledged appeal in the decades that followed as the work of the interwar avant-garde was recast to serve middle-class publics around the world. Neither socially radical nor politically conservative, he established a middle ground between obvious modernity and reassuring eternity.

The multiple modernisms that coexisted in Weimar Germany have often been overshadowed by the century's most important experiment in the education of artists, designers, and architects, the Bauhaus (Figure 23.9). Here the industrial aesthetic pioneered in Behrens's work for the AEG was institutionalized and codified. Walter Gropius founded the Bauhaus in 1919 in the immediate aftermath of the November Revolution. Sympathetic to the Weimar Republic he, Taut, and the critic Adolf Behne had already declared: "Art and people must form a unity. Art should no longer be the pleasure of a few but should bring joy and sustenance to the masses. The goal is the union of the arts under the wings of a great architecture."

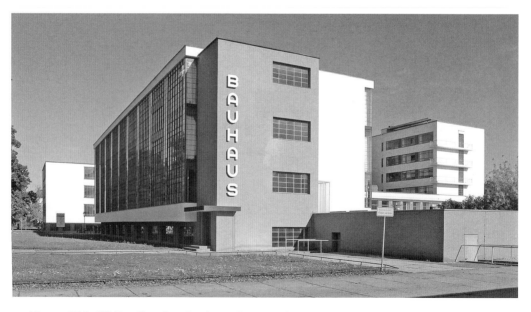

Figure 23.9. Walter Gropius, Bauhaus, Dessau, Germany, 1926.

The initial goal of the Bauhaus was to restore the relationship between art and craft, which Gropius believed had been severed during the Renaissance with the emergence of professional architects. This innately conservative purpose was from the beginning realized through avant-garde form. Instead of emphasizing drawing of the nude human body or of plaster casts from works of classical antiquity, students were educated in the properties and use of materials and in abstract principles of composition. Their instruction in abstraction was paired with the demand that they also master a craft. The school's workshops were intended to help sustain the school financially and help it establish its independence from public money, which was withheld whenever conservative politicians came to power. Worried about the influx of women into the school, Gropius tried to confine them to the weaving workshop. His patent discrimination generated a revolution in textile design. Other workshops focused on furniture making, woodworking, metalworking, ceramics, and advertising. This last eventually concentrated on graphic design.

Much of the impact of the Bauhaus must be credited to its distinguished faculty. Gropius's successors, Hannes Meyer and Mies van der Rohe, were also architects. Two of Europe's leading painters, Wassily Kandinsky and Paul Klee, taught at the Bauhaus. László Moholy-Nagy and Lilly Reich were among the many exponents of a machine aesthetic. Like many of their colleagues, Josef Albers and Marcel Breuer, the first students to be promoted to the faculty, continued to teach after immigrating to the United States. The avant-garde art produced at the Bauhaus and the socialist political sympathies of most of its early faculty and students led to its being hounded out of Weimar when right-wing nationalists joined the local government.

It reopened in 1926 in Dessau, in quarters designed for it by Gropius. The pinwheel plan posed a clear challenge to Beaux-Arts axiality, while the explicitly industrial aesthetic of the studio block created a bold alternative to the continued use of historical, particularly classical, styles. Not exactly practical from the standpoint of lighting, which was too high on sunny days, or ventilation, as it was too drafty to heat in winter and impossible to cool in summer, this was nonetheless an effective display of the school's engagement since 1923 with industrial design. Like the Schocken store, the studio block explicitly recalled American factories. Moreover, Gropius's goal was much the same as that of both Schocken and Mendelsohn: to produce goods that brought the benefits of a modern consumer society to the masses without cloaking them in illusions of class status.

The Bauhaus was also a place to live and play. Although it housed only a small group of students, the dormitory contributed to the lively spirit that characterized the place almost around the clock. Its rooms contained furniture designed by Marcel Breuer and bedcovers designed by Gunta Stölzl and made in the weaving workshop (Figure 23.10). Their austere character belied the antics that took place here. Much of the legendary appeal of this institution was the result of the fun that students and faculty alike had as they broke through the conventions of middle-class life to experiment with sex, jazz, and fashion, as well as art.

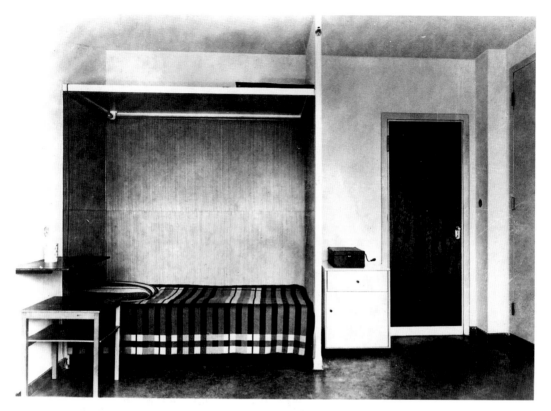

Figure 23.10. Dormitory, Bauhaus. Furniture by Marcel Breuer; bedcovering by Gunta Stölzl.

The immediate success of the Bauhaus in creating compelling alternatives to conventional middle-class taste raised questions from the beginning about the extent to which it was fostering a style rather than a more permanent solution to the relationship between art and either craft or industry. The approach it pioneered has gone in and out of fashion ever since without ever losing its capacity to represent the new. Because the Bauhaus was shut down in 1933 by the Nazis, only months after it was forced to move yet again, this time to Berlin, it has also been enduringly associated with the socialist ideals with which it began. Many of its faculty and students who were not Jewish, however, were able to sustain their careers during the Third Reich, often without changing the style in which they worked.

The circumstances surrounding the closure of the Bauhaus and the emigration of many of its most prominent faculty to the United States encouraged the reduction of the complexity of modern German architecture to an institution that was unusual for the degree to which it remained relatively aloof from the working class, although it aimed to transform daily life. German workers were grateful for improved housing provided by politically sympathetic architects but never became enthusiastic patrons of the avant-garde. When the Nazis usurped the spectacle integral to the architecture

of Berg, Taut, and Mendelsohn, the modern movement turned inward toward aesthetics, establishing in many cases a significant distance from popular taste. It thus quickly lost the broad constituency it continued to claim to represent. Only when and where its abstract evocations of mass production fulfilled dreams and desires would it thrive.

FOR FURTHER READING

Much of this chapter reprises the discussion in my *German Architecture for a Mass Audience* (London: Routledge, 2000). On Behrens and the AEG, see Stanford Anderson, *Peter Behrens and a New Architecture for the Twentieth Century* (Cambridge: MIT Press, 2000); and Frederic J. Schwartz, *The Werkbund: Design Theory and Mass Culture before the First World War* (New Haven, Conn.: Yale University Press, 1996). On the Centennial Hall and the Glashaus, see Jerzy Ilkosz, *Max Berg's Centennial Hall and Exhibition Grounds in Wrocław* (Wrocław, Poland: Muzeum Architektury, 2006); and Iain Boyd Whyte, *Bruno Taut and the Architecture of Activism* (Cambridge: Cambridge University Press, 1982). For more on Mendelsohn, see Kathleen James, *Erich Mendelsohn and the Architecture of German Modernism* (Cambridge: Cambridge University Press, 1997); and Regina Stephan, ed., *Erich Mendelsohn: Architect, 1887–1953* (New York: Monacelli, 1999). Barbara Miller Lane, *Architecture and Politics in Germany, 1918–1945* (Cambridge, Mass.: Harvard University Press, 1968), remains the standard source on German housing projects and the political debate about them. On the Bauhaus, see Barry Bergdoll and Leah Dickerman, eds., *Bauhaus 1919–1933: Workshops for Modernity* (New York: Museum of Modern Art, 2009); Magdalene Droste, *The Bauhaus* (Cologne: Taschen, 1990); Ulrike Müller, *Bauhaus Women: Art, Handicraft, Design* (Paris: Flammirion, 2009); and my edited volume *Bauhaus Culture: From Weimar to the Cold War* (Minneapolis: University of Minnesota Press, 2006).

24 Imposing Urban Order

The modern movement failed to capture the full impact of modernity on architecture and urbanism in the first half of the twentieth century. Industrial and abstract, functional and rational building was an insufficient response to the pressures on the city and the way in which they were tempered by forces of order. Nowhere in the world did modernism dominate architectural production in the 1920s. Even in the 1930s its full impact was largely limited to cities on the edge of Europe that wanted to prove their modernity through the use of radical architectural forms. Abstract industrial architecture had almost no impact on the real modernity of the American skyscraper, for instance, which retained careful and often lively ornamental details.

The story of city planning during the first four decades of the twentieth century illustrates some of the reasons for modernism's limited appeal. American downtowns, where zoning reined in real estate speculation only slightly, continued to be viewed with apprehension by most thoughtful contemporaries. Meanwhile, the problem of urban housing continued to be acute, as for-profit housing failed to accommodate adequately the numbers coming to cities in search of work, let alone the poor. Foremost among the factors inspiring substantial change was the automobile, which transformed transportation, unhitching travelers from nineteenth-century rails. City planning was a new profession in the twentieth century. To be successful, planners required far more political authority than had ever been accorded to architects. The acquisition of that power depended in large part on the planners' ability to adapt forms that would be viewed sympathetically by political elites. Planners, not surprisingly, were hesitant to embrace avant-garde solutions.

Today many architects and urban planners regard the European city of around 1900 with nostalgia. A hundred years ago, however, it was viewed with disdain by

many of its inhabitants. In 1898, Ebenezer Howard introduced the first comprehensive alternative to increasing density and the problems it spawned. In his book *Garden Cities of To-Morrow,* he proposed alleviating urban growth by creating satellite cities, each with a population of about thirty thousand, separated from each other and from the central city by bands of park or agricultural land. He also inserted institutions into these greenbelts (Figure 24.1). Howard's focus was on planning, not architecture, but the stress he placed on access to green space reinforced the nostalgia that British Arts and Crafts architects had always had for reviving preindustrial village life. This fondness was made explicit when the first

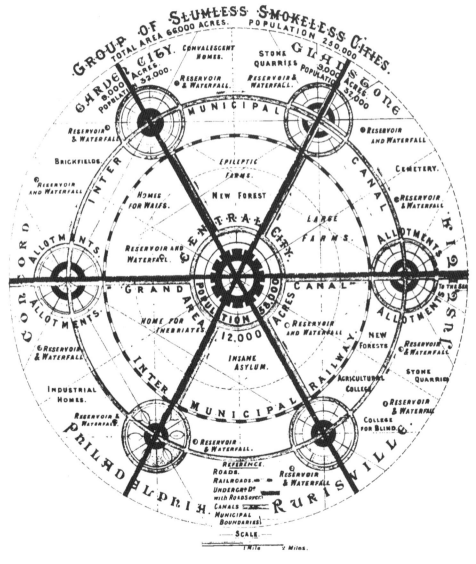

Figure 24.1. Ebenezer Howard, plate from *To-Morrow: A Peaceful Path to Real Reform,* 1898; republished as *Garden Cities of To-Morrow,* 1902.

garden city was actually built. The emphasis in Letchworth, England, begun in 1904 according to the design of Barry Parker and Raymond Unwin, was on improved housing for what was intended to be a working-class population (Figure 24.2).

Before World War I, most housing reform was largely a product of private initiative—a mix of charity and investment. Enlightened private developers, philanthropists by the standards of the day, funded Letchworth, hoping in the process to realize only a modest profit. The center of town was laid out following the Beaux-Arts ideals that informed Haussmann's planning for Paris, without being circumscribed by an existing city. This formality promised urban order and adequate representation for civic buildings, which would not be crowded out by commercial uses. The real innovation came in the neighborhoods. In Letchworth, the middle-class domestic ideal that inspired Bedford Park now moved down the social ladder. Although many tenants were middle-class reformers who moved to the new community in order to live in an ideal environment, the houses were built specifically for industrial workers. This was one reason they were much smaller and simpler than their predecessors in Bedford Park, as well as even more uniform in appearance. The other reason was that, even before the birth of the modern movement in the 1920s, architects were already moving toward greater simplicity, reducing ornament in favor of what was seen as greater formal clarity as well as, in this case, affordability. Coupled with forms that explicitly recalled village life was a new comprehensive emphasis

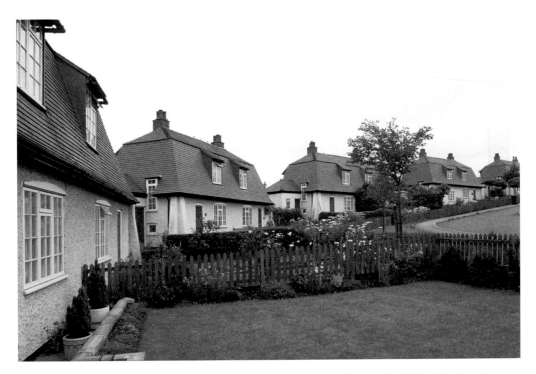

Figure 24.2. Barry Parker and Raymond Unwin, Letchworth, Hertfordshire, England, begun 1904.

on the provision of enormous amounts of green space on the neighborhood as well as the urban level. Living in village-like conditions would, Letchworth's builders believed, be healthier for both minds and bodies, especially those of children. Parker and Unwin were particularly concerned about creating picturesque, pedestrian-oriented alternatives to urban streets. They set their houses far back from the street and provided them with ample gardens.

During the next decades, few independent garden cities were realized, but hundreds of garden city developments were built on almost every continent. Taut was a major German disciple of the garden city movement. He eventually coupled its planning principles with abstract architectural forms as in the Britz housing estate. Implementing visions of urban planning proved enormously difficult, however, between 1910 and 1940 in democratic countries, except in those Western European countries, such as Germany, the Netherlands, and Sweden, where social democracy was beginning to be established. Private ownership and public political representation both operated as powerful checks. Those Europeans with ideas about how reformed cities should appear typically found that in order to realize their ideas they had to operate where governments had more authority. Colonial cities provided laboratories for new European planning ideals, which encompassed formal civic ensembles as well as a garden city–inspired focus on open space.

Both of these characterized the most comprehensive colonial city built by the British. New Delhi, the new capital of India, Britain's most important colony, was specifically designed to counter increasingly organized locals agitating for representative government (Figure 24.3). Calcutta was no longer a city the British could control politically or spatially. Its streets and newspapers were easily flooded with opposition to colonial rule, and Indians owned a great deal of its real estate. The British turned instead in 1912 to a site in Delhi adjacent to Shahjahanabad. Here, on land that bore the traces of earlier empires, they constructed a monumental stage set for the performance of empire. They hoped that the fusion of precolonial Indian architectural forms to state-of-the-art Western urban planning would attract the support of traditional elites (the maharaja of Jaipur owned much of the land) and of the peasantry. For the planning they selected Edwin Landseer Lutyens, Gertrude Jekyll's collaborator and the son-in-law of a previous viceroy, as the British termed their colonial governors. Lutyens, who had no previous experience working at an urban scale, was becoming known as the architect of increasingly grand country houses as well as the gardens he was designing with Jekyll.

The creation of New Delhi allowed the British to present a diagram of political control and colonial civic order that they could no longer inscribe on Calcutta. This was the last stage in the transition between the search for profit that caused the empire to be founded and the emphasis on control that the British hoped would sustain it. Disproportionately, upper-level British government staff in India were drawn from the landowning elite who remained critical of the way in which capital was transforming cities at home as well as in India. They also disdained the way in

Figure 24.3. Herbert Baker, Central Secretariat, New Delhi, India, begun 1912.

which the Indian middle class was becoming modernized, a process that increased the pressure for independence. In New Delhi, they resolved to hold in check both forces for change. In Calcutta and Bombay, the spatial segregation of the races had long since collapsed. Indian industrialist families such as the Tatas and the Sarabhais lived more splendidly than most British colonial administrators; the Sassoons, a family of Jewish financiers from Iraq, eventually left Bombay to join the British gentry. In New Delhi, however, the British could mandate a clear hierarchy. Planners could impose, for instance, a degree of aesthetic control over Connaught Circus, the elite shopping district, that would have been unthinkable in the market-dictated conditions of either Bombay or London. Social control was most obviously expressed in the provision of housing, most of which was controlled by the government. This was carefully organized by grade, as in army cantonments, with comfortable bungalows bestowed on top British administrators, whose Indian clerks were denied the benefit of indoor running water because it was not perceived to be part of the indigenous culture.

In New Delhi, garden city planning took on an imperial formality. The focal point of the city was the Rajpath, or imperial way, which led from the All India War Memorial, commemorating the Indians killed in World War I, past the paired Secretariats housing administrative offices to the viceroy's palace. The processional path was a grander version of the National Mall in Washington, D.C., which was then

being refurbished. The long open vistas, inspired, as in Washington, by seventeenth-century French gardens, discouraged ordinary pedestrian traffic. In tandem with the grassy surroundings of even the humblest new housing, this expansiveness ensured that New Delhi was one of the greenest cities of its day. Lutyens and his team turned to classicism as a badge of imperial order and Western civilization. The All India Memorial was the latest in a long line of monumental arches descended from the ones emperors such as Titus and Constantine had erected in and around the ancient Roman Forum. In Herbert Baker's Secretariats, built between 1912 and 1927, the modernity of paired office blocks based on Michelangelo's Italian Renaissance Campidoglio in Rome is dressed with materials and details taken from Indian precedents. The resulting exoticism makes both the Secretariats and Lutyens's palace for the viceroy more original than their contemporary counterparts in London and Washington. At the time, however, the integration of Indian architectural details into classical compositions was meant to convey British mastery of indigenous architectural traditions and of the peoples to whom they belonged.

Built between 1912 and 1931, the palace was the city's crown jewel. The British hoped to impress Indians by creating a palace far larger than the one in which King George V lived in London. Sophisticated references to Indian precedent, ranging from the great stupa at Sanchi, the model for the dome, to the Mughal gardens that inspired the landscaping, coexisted with quotations from Sir Christopher Wren. This hybrid architecture projected an imperial authority that was already largely illusory. Indians proved more impressed by Mahatma Gandhi, dressed in little more than a hand-woven loincloth, than by this magnificence. Jawaharlal Nehru, later the first prime minister of an independent India, dismissed New Delhi as the "visible symbol of British power, with all its pomp and circumstance and vulgar ostentation and wasteful extravagance." A photograph taken on the eve of independence portraying the last viceroy and his family surrounded by uniformed Indian staff numbering in the hundreds poses the question of whose palace it had ever been. For decades the Rajpath has been the setting of India's annual Republic Day parade. New Delhi has now been the capital of an independent nation for far longer than it was the capital of a colony.

Like the British, French colonial authorities used cities as urban laboratories. In the nineteenth century, the French imported the latest in architecture and urbanism into their colonies, paying little or no attention to indigenous precedent. They eventually shifted course, in part to present themselves as the only ones capable of preserving local culture, even as they inevitably destroyed much of it. This nod toward the indigenous coincided with the importation of idealist planning models difficult to impose in France itself, where property rights in tandem with representative government hindered urban reform. The French general Hubert Lyautey served first as military governor and then as resident general in Morocco, part of which became a French protectorate in 1912. He entrusted the modernization of the protectorate's three largest cities, Casablanca, Fez, and Rabat, to the urban planner Henri Prost

(Figure 24.4). The results were widely lauded. Prost carefully preserved the medina (as the French, using an Arab word, called the precolonial city), but as colonial rule displaced large numbers of people from the agricultural hinterland, densities rose in the old city centers. There the French had forbidden substantial architectural changes, so the quality of life fell substantially, with whole families crowding into single rooms of courtyard houses, overwhelming the original provisions for privacy and sanitation. Slightly apart from the existing city, Prost laid out new neighborhoods. These featured the clear spatial separation of functions—residential, commercial, and industrial—that became the hallmark of modernist city planning, even

Figure 24.4. Henri Prost, city plan, Rabat, Morocco, circa 1917.

though Prost never renounced his interest in precedent, whether Beaux-Arts classicism or the Arab vernacular. Broad boulevards were lined with concrete buildings in simplified classical styles, while those few structures that the government erected in the medina harmonized as much as possible with their older surroundings. By the 1930s, however, Casablanca in particular marched ahead of Paris as the French-speaking city where the modern movement proved most popular.

Many of Prost's ideas reappear in avant-garde guise in the most influential urban plan of the twentieth century, Le Corbusier's proposed City for Three Million, produced in 1922, only five years later than Prost's plan for Fez (Figure 24.5). Le Corbusier accommodated the automobile within a reworking of garden city planning inspired by both the scale and the organization of downtowns such as Chicago and the abstract aesthetics of the modern movement. The street plan differed less than might be expected from that of New Delhi, with radial avenues, a monumental arch, and even obelisks, as in Sixtus V's Rome, but at the center of the city broad boulevards designed for speeding automobiles coexisted with an airstrip. On both sides rose unornamented high-rise office buildings with cross-axial plans that placed most interior space close to windows. Towers inserted into parklike settings, they were also elevated, like the Villa Savoye, on *pilotis,* with most pedestrian circulation taking place one story up from the ground level. The same was true of the low-rise slab housing Le Corbusier wrapped around this downtown.

The City for Three Million imposed the same separation of functions found in the plans for New Delhi and Rabat. Le Corbusier replaced the mixture of uses that

Figure 24.5. Le Corbusier, Contemporary City (City for Three Million), 1922.

characterized Haussmann's Paris, as well as most European cities, in which apart-
ments characteristically sat atop shops and restaurants, with the clear division be-
tween residential and commercial areas typical of English-speaking cities such as
London and Chicago. Forgoing the sentimentality associated especially with the
Anglo-American suburb, he posited new densities coexisting with unprecedented
access to light, air, and greenery. Increasing the height of apartment blocks enabled
him to leave more of the ground surrounding them open for parks. In the 1920s,
modernist planning did not gain more than a toehold in European downtowns.
Architects nonetheless dreamed of the day when they could shape what were obvi-
ously among the most emphatically modern environments, in terms of scale, con-
struction, and prominent siting. Furthermore, downtowns were the parts of the
cities that were most affected by the new affordability of cars, for which their dense,
often medieval, networks of streets had obviously not been designed.

Although many of Le Corbusier's ideas had ample precedent in the work of main-
stream planners like Prost, in 1922 he almost certainly designed the City for Three
Million to shock. Nothing of this kind was implemented anywhere for nearly twenty
years. In the wake of World War II, however, tower-in-the-park planning took on
enormous appeal. European and American cities had recently reached the densest
points in their histories, and the political will finally existed to give the working
classes access to the green spaces that had long remained out of their reach. During
the 1930s Le Corbusier understood that he was less likely to be able to implement
his ideas in France than in its colonies. He provided multiple schemes for Algiers
in which he proposed monumental elevated highways connecting the French neigh-
borhoods to downtown, with housing slotted underneath the roadbed (Figure 24.6).
Downtown he envisioned a large, rugged office building taller than anything that
yet existed in a European city.

Most of the major urban planning projects actually realized in Europe during
the 1920s were garden city–infused housing schemes. A decade later, the emphasis
shifted to environments that glorified the nation-state. In Germany and the Soviet
Union, widely accepted ideas about modern planning reinforced political propa-
ganda that glorified the Nazis and the Communists, respectively. Adolf Hitler and
Joseph Stalin portrayed themselves as decisive where capitalist democracies were
weak, and as having at heart the interests of the people as a whole rather than only
a wealthy few. Architectural set pieces were crucial in buttressing these claims.

As a young man in Vienna, Hitler had aspired to be an architect. In his autobiog-
raphy, *Mein Kampf* (My struggle), he complained of the way in which modern com-
mercial buildings, in particular Jewish-owned department stores, had replaced civic
buildings in importance in cities throughout Germany. He vowed that if he came
to power this would change. In fact, although Nazi architecture has come to be syn-
onymous with monumental neoclassical buildings, a variety of design approaches
flourished in Germany during the 1930s. Vernacular housing and modern factories,
utilitarian rather than civic, and both often built by the same architects as during

Figure 24.6. Le Corbusier, Obus Plan for Algiers, Algeria, 1933.

the Weimar Republic, balanced an appreciation of the past with a progressive vision of the future. Hitler himself, however, focused on grandiose schemes such as the grounds of the annual Nazi Party rallies held on the outskirts of Nuremberg and a new north–south axis for Berlin (Figure 24.7).

As in colonial India, in Nazi state architecture inflated forms were used to mask uncomfortable truths. The impression of participation and consent was crucial to the rhetoric of what was actually a dictatorship with no respect for individual rights. Bricks and mortar were intended to prove the stability of a regime that failed before its ascent to power to attract the support of more than a third of the electorate. They were also meant to show the might of a nation that had recently suffered a humiliating defeat. In Nuremberg, Albert Speer ringed the Zeppelinfeld with searchlights. At night, the lighting of the Lichtdom, or Cathedral of Light, masked the paunches of the middle-aged Brownshirts as they marched in strict formation, as well as the neoclassical details of the vast architectural setting, a spectacle captured in Leni Riefenstahl's 1935 documentary film *Triumph of the Will*. Indeed, the way in which architecture, whether avant-garde or neoclassical, appeared in newsreels and the popular press, as well as professional journals, was now almost as important as how it looked to those who saw it in person.

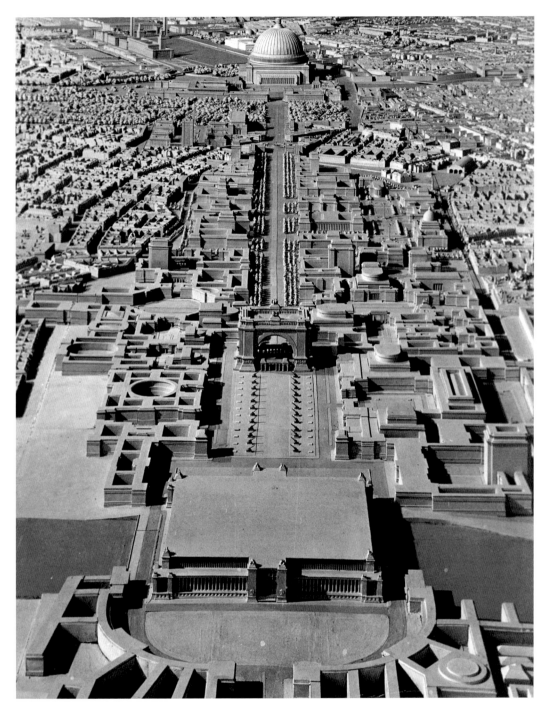

Figure 24.7. Albert Speer and Adolf Hitler, Germania Plan, Berlin, Germany, model 1939.

The north–south axis, proposed in 1937, was more conventional. A Haussmann-like boulevard, it adhered to the suggestions of several generations of planners for a new artery through the center of the city. Government ministries, private office buildings, and movie palaces were to line the route connecting two enormous structures, both designed with Hitler's own advice. Here classicism entirely lost its relationship to human scale. The Great Hall was intended to accommodate crowds of up to 180,000, many more than fit into the largest modern stadia even today.

The identification of this architecture as specifically Nazi is complicated by the fact that during the same years liberal democracies in France and the United States erected similar complexes, which Speer later professed to have admired. Specifically Nazi, however, were the ways in which labor and expropriation of land were handled. State intervention in the market entailed the seizure of land rather than just the provision of subsidized mortgages such as those that had enabled the erection of workers' housing during the Weimar Republic. Hitler's SS, or secret police, ran concentration camps in which political prisoners quarried stone for his monumental buildings; slave labor was often employed in building them. When Speer began to clear the site, he moved displaced families into apartments that had been seized from the city's Jewish residents in the first step toward the eventual annihilation of half of the continent's Jewish population during the Holocaust.

To the east, the Soviet Union sponsored similar planning policies. In the immediate aftermath of the October Revolution of 1917, avant-garde art and architecture had briefly flourished in the new Soviet Union. The constructivists, many of them artists who had returned to Russia from Paris in 1914, championed an unprecedented degree of abstraction, which they harnessed to political propaganda. Moscow's architecture school, Vkhutemas, rivaled the Bauhaus as the world's most radical. Ivan Leonidov's 1927 thesis project for a Lenin Institute proposed to house the revolutionary's writings and papers in a building whose geometrically pure forms and utopian engineering communicated the technological progress the Soviet state would achieve under communism (Figure 24.8). A precariously balanced glass sphere housed an auditorium, and one wall could slide open to double as a speaker's platform for mass gatherings.

Constructivism's appeal to the government waned, however, during the 1930s, when Stalin instead adopted socialist realism. The new direction stressed classical architecture and planning as a way to communicate the empowerment of the masses, although, for the most part, its showcase projects served relatively few people. The significant exception was the palatial new subway system, which opened in 1935, and which almost everyone could afford to ride. Aboveground, the rebuilding of Moscow's Gorky Street, begun in 1937 under the leadership of Arkady Mordvinov, provided the new image for the modern socialist city (Figure 24.9). Gorky Street promised a future in which workers would live in palace-like apartment blocks, which at present the regime could afford to bestow only on a loyal new elite of state bureaucrats. The apartments were small by European standards, but not by

Figure 24.8. Ivan Leonidov, Lenin Institute, thesis project, 1927.

Figure 24.9. Arkady Mordvinov, Gorky Street (Tverskaya Street), Moscow, Russia, begun 1937.

Soviet ones, and unlike earlier constructivist experiments, they did not include communal facilities for child care and dining. Shops and restaurants lined the ground floor of a street leading directly to the Kremlin. Street widening here, as in Berlin, continued to be based on the model of Haussmann's boulevards, rather than that of the highways that featured prominently in the schemes proposed by Le Corbusier. Soviet adherence to widely accepted conventions of urban planning provided a reassuring impression of stability at exactly the time when Stalin's campaign of terror against potential opponents, many of them within the Communist Party, was reaching its zenith.

Although the image Gorky Street presented was not one of industrial modernity, much here was emphatically new. The apartment houses reached heights that required elevators. Many architectural elements, including the decoration, were mass-produced. Also emphatically new here, as in Berlin, was state-sponsored redevelopment to produce residential and commercial buildings. Although private capital had constantly replaced individual structures in downtowns during the late nineteenth and early twentieth centuries, governments had focused exclusively on the creation of civic architecture and infrastructure. Gorky Street made particularly compelling propaganda because it conformed to the taste of almost everyone the Soviet regime hoped to address at home or abroad. In the wake of the Great Depression,

the modern movement all but collapsed in the countries that had originally nurtured it. It flourished only on the margins of Europe in cities such as Budapest, Bucharest, Helsinki, Tel Aviv, and Ankara, where a variety of clients sought to demonstrate their modernity by belatedly adopting what was then a slightly dated formula. In the place of secondhand fashion, Gorky Street, like the north–south axis proposed for Berlin, appeared to offer a vision of the way in which undemocratic regimes could effectively conquer otherwise intractable problems of the modern city: chaos, congestion, and poverty. In comparison, anything the major Western democracies managed to accomplish at home, rather than in their colonial showpieces, appeared ineffectual.

How, then, did the modern movement eventually return triumphant? Why would Americans and Western Europeans alike quickly come to shun what had as recently as the 1930s been their own prized if often incomplete visions of urban and civic order? An important clue is provided by the Stalinallee, now the Karl Marx Allee, built in East Berlin between 1952 and 1956 (Figure 24.10). After World War II, Germany and its previous capital city were each divided into four sectors; the United States, Britain, France, and the Soviet Union each retained control of one sector of the country and one sector of Berlin. The Western allies eventually created the Federal Republic of Germany out of their three sectors, while retaining nominal authority over their individual parts of Berlin, which was an island in the Soviet

Figure 24.10. Hermann Henselmann, Stalinallee (Karl Marx Allee), Berlin, Germany, 1952–56.

sector. The historic center of the city became part of the German Democratic Republic, a Soviet satellite. The division of Berlin, even more than that of Germany, came to stand for the division of Europe itself between east and west, democratic and authoritarian, capitalist and communist. Both blocs used architecture to project an idealized identity. On both sides of the initially informal barrier that eventually became the Berlin Wall, government subsidies created model urban districts developed entirely independent of market forces. The communists led the way. The Stalinallee ran from the historic center of the city east through its old working-class districts toward Poland and Moscow. Apartment buildings atop shops and restaurants communicated the same promise of palaces for the people as they had in Moscow. Although the choice of style was mandated by the Soviets, East Germans cloaked Soviet socialist realism in references to local architectural traditions, in this case the neoclassicism of the late eighteenth and early nineteenth centuries.

Despite the provision of some of the communist world's best-stocked shops and ample green spaces, the propaganda effort patently failed. In 1953, work on the boulevard came temporarily to a standstill when the construction workers, the supposed elite of as ostensible workers' state, went on strike. Encouraged by American-sponsored radio broadcasts beamed from the other side of town, they attempted to overthrow the East German government. Without the support of the Western tanks stationed nearby, this first revolt against communist rule quickly collapsed, but not before many were killed. Also dead was the hope of continuing to associate Haussmannian architecture and urbanism with democracy, as Auguste Perret, for instance, had done in the postwar reconstruction of the French cities of Amiens and Le Havre. Instead the torch passed to the modern movement, which was presented, especially by the United States, as the face of capitalist democracy. The question of how representative governments could control urban growth remained.

FOR FURTHER READING

Peter Hall, *Cities of Tomorrow: An Intellectual History of Urban Planning and Design in the Twentieth Century* (Oxford: Blackwell, 2002), offers an overview of the subject of this chapter. Ebenezer Howard, *To-Morrow: A Peaceful Path to Real Reform* (1898; repr., London: Routledge, 2003), is better known by the title of the second edition, *Garden Cities of To-Morrow*. On Letchworth, see Mervyn Miller, *Letchworth: The First Garden City* (Chichester: Phillimore, 2002). On New Delhi, see Robert Grant Irving, *Indian Summer: Lutyens, Baker, and Imperial New Delhi* (New Haven, Conn.: Yale University Press, 1981); and Wolfgang Sonne, *Representing the State: Capital City Planning in the Early Twentieth Century* (Munich: Prestel, 2004). French colonial urbanism is addressed in Gwendolyn Wright, *The Politics of Design in French Colonial Urbanism* (Chicago: University of Chicago Press, 1991); and Jean-Louis Cohen, *Casablanca: Colonial Myths and Architectural Ventures* (New York: Monacelli, 2002). For discussion of Le Corbusier's City for Three Million, see Francesco Passanti, "The Skyscrapers of the Ville Contemporaine," *Assemblage* 4 (1987): 53–65; on its application to Algiers, Zeynep Çelik, *Urban Forms and Colonial Confrontations: Algiers under French Rule* (Berkeley: University of California Press, 1997). Paul Jaskot, *The Architecture of*

Oppression: The SS, Forced Labor, and the Nazi Building Economy (London: Routledge, 2000), details the oppressive character of that regime's monumental architecture. On Russian constructivism and its aftermath, see Hugh Hudson, *Blueprints and Blood: The Stalinization of Soviet Architecture, 1917–1937* (Princeton, N.J.: Princeton University Press, 1994); on Gorky Street and Stalinist architecture in the Soviet Union, Greg Castillo, "Gorki Street and the Design of the Stalin Revolution," in *Streets: Critical Perspectives on Urban Space,* ed. Zeynep Çelik, Diane Favro, and Richard Ingersoll (Berkeley: University of California Press, 1994). For an examination of socialist realist architecture in the rest of Eastern Europe, see Anders Aman, *Architecture and Ideology in Eastern Europe during the Stalin Era: An Aspect of Cold War History* (New York: Architectural History Foundation, 1992); and on its Cold War context, David Crowley and Jean Pavitt, eds., *Cold War Modern: Design 1945–1970* (London: Victoria and Albert Museum, 2008).

25 The Modern Movement in the Americas

Nowhere in the world did modernism dominate the alternatives to it in the 1920s. In the 1930s its popularity faded in Germany, the Netherlands, Czechoslovakia, and the Soviet Union but grew in Britain, Scandinavia, the Balkans, and the eastern Mediterranean. Throughout the interwar period the new aesthetic was almost invisible in such obviously modern environments as factories and skyscrapers. The latter in particular remained decorously clad in sometimes understated, sometimes exuberant ornament. The concrete-framed Kavanagh Building in Buenos Aires, commissioned by Corina Kavanagh and designed by the firm of Sánchez, Lagos, and de la Torre, was typical of the art deco towers erected across the length and breadth of the Americas. Upon its completion in 1936, it was, at 394 feet, Latin America's tallest building (Figure 25.1). For most North and South Americans, modern architecture in the 1920s and 1930s meant buildings crested in the faintly cubist ornament popularized at the Exhibition of Decorative Arts held in Paris in 1925, not the industrial abstraction championed by Gropius, Le Corbusier, and Mendelsohn. Art deco imparted a fashionable sense of European luxury to buildings constructed on an entirely American scale. In comparison, the Schocken store and the Universum Cinema were small and austere. The Kavanagh Building contained both offices and apartments, but art deco was also popular for environments more obviously devoted to pleasure, such as beachfront hotels and the public areas of large ocean liners.

This international modernism was gradually replaced across the course of the 1930s through the 1950s by more abstract but not necessarily less glamorous alternatives. This second modern movement, often referred to as the International Style, was strongly influenced by the work of Le Corbusier and Ludwig Mies van der Rohe and become the favored architecture of the urban upper-middle class and governments throughout the Americas. This process is usually described as the betrayal

Figure 25.1. Sánchez, Lagos, and de la Torre, Kavanagh Building, Buenos Aires, Argentina, 1934–36.

of the International Style's socialist roots in favor of a new alliance with capitalism. This is simplistic, however, considering modern architecture's engagement since its inception with the marketplace and the lack of an obvious relationship in many cases already in the 1920s between avant-garde form and social progress. More probable is that, like art deco before it, the International Style fulfilled widely shared desires. At a time when many American societies were seeking to become more equitable, it coupled newness with an understanding of sophistication as something other than just lavish living. No longer necessarily reserved for the rich, who in many cases preferred more conventional means of display, an inexpensive and ostensibly efficient imported architectural vocabulary represented the hope the middle classes of many American nations had of a prosperous future on the world stage.

Many adherents of modern architecture, foremost among them Le Corbusier, claimed that the International Style was universally applicable. This hope had enormous appeal in the Americas, which during and after World War II were in an unprecedented position to set international fashion. Already in the first years of the war, many North Americans, cut off from Europe, turned their attention southward toward Brazil. The United States emerged from the war as an international trendsetter as well as a global superpower. Moreover, by 1950, the association of classicism with both fascist and communist authoritarianism vastly increased the palatability of an alternative that had previously seemed too extreme.

What was the constellation of factors that encouraged architects and those who hired them to embrace forms that had been developed in very different conditions from the ones in which they were now being used? The easy answer was firsthand exposure to Europe's leading modernists. Le Corbusier first traveled to Brazil and Argentina in 1929; he ventured to the United States in 1935. After a brief sojourn in Britain, Gropius immigrated to the United States in 1937. Mies van der Rohe and Mendelsohn quickly followed. Like the Renaissance before it, however, the International Style was adopted only when it accorded with the needs of those who chose to use it. Being new and supposedly better was not enough.

Designed by a team of local architects, the Ministry of Education and Health in Rio de Janeiro was upon its completion in 1943 the most prominent International Style building in the Americas (Figure 25.2). Lucio Costa headed a team that also included Oscar Niemeyer. Le Corbusier's role as consultant ensured that the building attracted enormous attention. The vertical slab resting on a horizontal slab lifted high above the ground on *pilotis* became a popular composition around the world in the first fifteen years after World War II. Instead of lining the street, it was sited to create two small plazas. Pedestrian circulation between them flowed between the *pilotis* supporting the office slab. A glass curtain wall covered one principal facade of that slab; an enormous concrete sunscreen shaded the other. Attention to climate marked the most sensitive attempts to transfer an architectural vocabulary that originated in northern Europe to new conditions, although more often these details, widely imitated in situations where they were not needed, proved merely decorative.

Figure 25.2. Lucio Costa, Oscar Niemeyer, and others, Ministry of Education and Health, Rio de Janeiro, Brazil, 1937–43.

The sunshade also provided a depth and sturdiness that suggested a maturity lacking in the ephemeral elegance of many stucco-clad modernist buildings, whose originally pristine white surfaces often deteriorated quite quickly.

The Ministry of Education and Health was the point of departure for a team of talented people who helped to shape Brazilian architecture for decades to come. Cándido Portinari, one of the country's leading painters, contributed a tile mural and frescoes in which he characteristically combined cubist forms and specifically Brazilian subject matter. Roberto Burle Marx laid out the landscape gardens in front of the building and on the roof garden of one of the lower blocks. He, too, used foreign ideas to invent a new image of what it was to be Brazilian. In his case, the fusion of sinuous surrealist curves with indigenous tropical plant material created a compelling alternative to the continuing popularity throughout Latin America of formal French gardens.

The Ministry of Education and Health was an avant-garde building because a small group of ambitious architects and their political backer, Gustavo Capanema, were not only aware of recent European fashion but also anxious to demonstrate their own modernity in terms of that awareness. Key supporters of Getúlio Vargas, president of Brazil from 1930 to 1945 and again from 1950 to 1954, saw the International Style as uniquely appropriate to a country engaged in rapid industrialization. It also offered, as Le Corbusier had promised, an attractive alternative to more radical social change, which would have challenged the authority of Vargas's military dictatorship. To contemporaries, the ministry building seemed innately Brazilian and yet entirely modern.

This new Brazilian architecture flowered in the 1940s, when no ambitious new civilian buildings were being realized in war-ravaged Europe. Brazil's new buildings, especially those designed by Niemeyer in Pampulha, a suburb of Belo Horizonte, which also featured landscapes by Burle Marx, became not only the image of a modern tropical and apparently sensual nation but also the most stylish new architecture around. Erected largely out of concrete, a material that was labor- rather than capital-intensive, they defined what the architecture of a warm, not very wealthy country should look like. This image of a forward-looking nation led Juscelino Kubitschek, elected Brazil's president in 1956, to believe that architecture was integral to realizing his campaign slogan, "Fifty years of progress in five." Spurred as well by his experience as mayor of Belo Horizonte, founded only in the 1890s, he proposed moving the national capital to a new city in the interior. The shift was intended to spur the development of a sparsely inhabited part of the county and to demonstrate that Brazil was one of the world's most modern countries.

The first stage in the new city's realization was a competition for its design, won by Costa. He proposed a city organized around the intersection of a monumental axis and a residential axis (Figure 25.3). What was modern about this scheme? First, Costa celebrated the automobile. Limited-access dual-lane highways of the kind that had first begun to be built in the United States and Germany in the 1930s

Figure 25.3. Lucio Costa, city plan, Brasília, Brazil, 1956.

provided the spine of the new city. Although cars had recently begun to be manu-
factured in Brazil, very few Brazilians could yet afford them. Public buses, however,
were arguably less costly than fixed-rail alternatives, such as streetcars. Above- and
below-grade pedestrian passageways limited the intrusiveness of Brasília's highways.

An obvious example of the influence of Le Corbusier's City for Three Million on
the design of Brasília was Costa's strict separation of functions. This had been codi-
fied in the Charter of Athens, a document that grew out of the fourth meeting, held
in 1933, of the Congrès International d'Architecture Moderne (CIAM). The plan
for Brasília established specific areas for specific activities, grouping together hotels
and banks, for instance. This degree of regulation was possible only because a gov-
ernment, operating largely independent of market forces, built the city. Also frankly

modernist was the rhetoric about what built form could accomplish. Costa and Niemeyer, who built some of the earliest housing in the city as well as all the major public buildings, hoped that by providing only one type of housing, they could achieve social equality. In the end, the poor, who could not afford apartments with maids' quarters, built squatters' colonies on the outskirts. The rich, too, moved to the suburbs, where there was room for gated compounds with swimming pools. Urban planning alone could not bridge one of the world's largest gaps between classes, although income distribution in the federal district remains, by Brazilian standards, unusually equitable.

Brasília's superblocks serve the middle class (Figure 25.4). Raised on *pilotis,* these apartment slabs are just tall enough to require the elevators that form the core of their small, glazed lobbies. These buildings form the perimeter of blocks typically bounded on one long side by multilane highways and on a short one by neighborhood shopping strips. Within each block are generous shared communal green spaces, where children play and their elders stroll. The privacy associated with the single-family house is sacrificed, but the short walk to the car or bus becomes a social event. The ease of access to neighborhood shopping, just minutes away by foot, compensates for the lack of an engaging urban center. Brasília's planners successfully defeated the density and dirt that was still seen at midcentury as the scourge of existing cities, but they were unable to capture the dynamism of cities like Rio,

Figure 25.4. Superblock with shops at far right, Brasília, Brazil, after 1957.

with its lively beach culture, its intimate relationship between shantytowns and lux-
ury apartment towers, and its multiple commercial centers.

The center of Brasília was not, in any case, a commercial downtown, but the mon-
umental axis along which major government buildings are aligned. Here Niemeyer
created a powerful set of national symbols that transcended region or class. The
Esplanade of Ministries leads to the National Assembly and beyond to the Plaza
of the Three Powers, where the supreme court and presidential palace face each
other behind the assembly. Few pedestrians traverse spaces designed to be seen from
the air; the ministries are entered from the rear, except on ceremonial occasions.
Designed and built between 1956 and 1964, they were originally the only steel-
framed buildings in a largely concrete city and look lighter in weight in comparison
to the rest of the city as a result. In Brasília Niemeyer imitated the appearance of
new curtain-wall office buildings in the United States, but glass skins worked well
only where cheap energy enabled new central air-conditioning systems, such as that
installed in the Kavanagh Building, to cool interiors down. Niemeyer's focus on an
elegant image rather than practicalities eventually led to the disfiguration of many
ministry facades, as sunshades and individual air-conditioning units were gradually
added. The Ministries of Justice and Foreign Affairs fared better. Here the architect
encased glass boxes within larger concrete frames. Pools of water landscaped by
Burle Marx introduced a tropical note into the savanna landscape.

Niemeyer's National Assembly, located between the Esplanade of Ministries and
the Plaza of the Three Powers, provided the focal point for the entire city. The up-
turned and inverted bowls of the two legislative chambers above which soar coupled
towers presented Brazil as a technologically advanced democracy. More sensitively
detailed is the Supreme Federal Court, like the presidential palace another box
inside a box (Figure 25.5). Set atop the vacant expanse of the Plaza of the Three
Powers, its elegance and lightness do much to relieve the aridity of that space. The
proportions of the building volume and the rhythm of the exterior supports echo
those of a classical temple, while the sinuous curves and almost ethereal lightness are
distinctively and proudly modern. At a time when surrealism's mixture of organic
abstraction and psychologically charged representation had long replaced cubism
as the art with the greatest influence on contemporary architecture, this balance of
historical recall and fashionable sensuality became a paradigm for civic architecture
around the world.

Kubitschek's government saw the construction of Brasília as a shortcut toward
modernization. The reality was that the cost of the project contributed to an eco-
nomic crisis that triggered a military coup; the Brazilian economy stagnated for
decades afterward. Brasília, along with the new state capital of Chandigarh in India,
remains, like most planned capitals, slightly provincial, a showpiece isolated from
the crassness of market forces as well as from responsiveness to consumer taste.

The aspirations surrounding the importation of modern architecture into the
United States during the middle decades of the twentieth century were often the same

Figure 25.5. Oscar Niemeyer, Supreme Federal Court, Brasília, Brazil, 1960.

as in Brazil. Here, too, European precedents contributed to a sense of sophistication at a modest cost. There were also important differences. Americans were sure of their industrial and technological prowess and did not depend on architecture to express it. They were thus more likely to retain familiar, even historicist, imagery, especially for middle-class housing. At the same time, a vibrant consumer culture remained—as with much vernacular architecture in Brazil—largely outside the control of architects. Throughout the Americas the architectural profession had far less authority than in Europe, with modest domestic and commercial construction remaining the province of builders.

In 1932, the architectural historian Henry-Russell Hitchcock, who had already written a pioneering survey of early twentieth-century architecture, teamed with his friend Philip Johnson to curate the International Style section of the first architectural exhibition at New York's Museum of Modern Art. Other sections, organized by Lewis Mumford and Catherine Bauer, focused on housing reform and on the work of Frank Lloyd Wright. The International Style exhibit and the subsequent catalog, which popularized a term coined by the Austrian architect Frederick Kiesler, have been credited with introducing Americans to Le Corbusier, Gropius, and Mies, although the work of the European avant-garde was already familiar to readers of the country's major architectural journals. For the next fifteen years, the examples selected by Hitchcock and Johnson were largely ignored by American architects interested in modern expression.

The transformation of American architecture during those years is better illustrated by one admittedly extraordinary building, Fallingwater, the retreat Wright designed for Edgar Kaufmann, the owner of a Pittsburgh department store, and his family. Wright cantilevered the building over Bear Run, a stream in rural Pennsylvania. Although it was designed in 1935 as a private house on a secluded site, the widespread publication of Wright's perspective drawing and photographs taken soon after its completion quickly made it one of the most famous new buildings in the United States (Figure 25.6). These views, which draw attention to the engineering of the house, highlight Wright's promotional talents. Taken from a position beyond and below the house, they tell relatively little about the experience of approaching or inhabiting it. Instead they offer an optimistic vision of the way that one architect's genius could integrate modern architecture and engineering into what appeared to be an untrammeled American landscape.

Fallingwater was the key to Wright's reemergence from relative obscurity to become America's most widely celebrated architect. Although Wright benefited enormously from the admiration of the European avant-garde, he refused to adopt their industrial imagery. Instead he championed a quasi-spiritual relationship with nature coupled with conventional domesticity. Thrust out over the streambed in a way that pushed reinforced concrete to its limits, Fallingwater's porch trays convincingly displayed Wright as a master of both abstraction and engineering. He anchored this modernity in the same geological metaphors Richardson had employed in the Ames Gate Lodge, using exposed local stone for even the interior floors and wall surfaces. In tandem with low ceilings, this imparts a protective, cave-like sense of shelter. At Fallingwater, Wright still clearly separated the open plan of the main living spaces from the spaces occupied mainly by servants. Elsewhere, in more modest houses, he connected the kitchen with the living room, so that the person preparing meals could supervise children and participate in the general conversation.

Wright remained until his death in 1959 a highly individualistic force within American architecture, widely appreciated even as his inimitable work increasingly diverged from the modernist mainstream. During the 1930s and 1940s, William Wurster and his circle occupied the middle ground between Wright and the historicist conventions popular during the century's first three decades. A Californian, Wurster was associated with an understated regionalism that was, in fact, popular across the country and had parallels to the direction being taken in Europe by Le Corbusier and Alvar Aalto. With his encouragement, the hills surrounding the San Francisco Bay became a laboratory for ways to integrate the house and the landscape informally, using the clean lines and steel cantilevers pioneered in Europe in the 1920s. Architects working in the Bay Area assimilated European modernism by replacing its white stucco surfaces with indigenous redwood siding and by retaining the deep overhanging eaves favored by their local Arts and Crafts predecessors as well as by Wright. A major example is Harwell Hamilton Harris's Weston Havens House, completed in Berkeley in 1941 (Figure 25.7). Harris coupled two levels of

Figure 25.6. Frank Lloyd Wright, Fallingwater, Bear Run, Pennsylvania, 1935–38.

Figure 25.7. Harwell Hamilton Harris, Weston Havens House, Berkeley, California, 1941.

floor-to-ceiling glazing offering stunning views out over the bay with a more private patio where Havens and his largely gay network of friends could socialize without being seen by potentially prying neighbors.

The resulting dwellings and, more rarely, public or commercial buildings served the members of a middle class who, faced with the economic and political crises of the Great Depression and World War II, stood less on ceremony than had their counterparts during the prosperous 1920s. During the Depression almost no one except the federal government, which spent lavishly on public works through New Deal programs, could afford more than a modicum of ornament, and during the war all nonessential construction was forbidden. After his marriage in 1940 to Catherine Bauer, one of the country's foremost proponents of federally financed housing, Wurster addressed social issues, especially the problems of housing the working class. Even before the Japanese attack on Pearl Harbor drew the United States into World War II at the end of 1941, the federal government began to construct housing for workers in defense-related industries and—more rarely—to house other low-income renters. This program gave architects on both U.S. coasts a chance to rival the vast workers' settlements erected in Europe during the 1920s.

The differences were instructive. Although several architects participating in the program had recently emigrated from Europe, all shied away from an industrial

aesthetic. Efficient construction was paired with familiar materials, such as brick and wood. At Carquinez Strait in Vallejo, California, Wurster built housing for workers in the nearby shipyards in 1941, retaining such characteristics of his single-family houses as crisply geometric forms constructed with wooden siding and framing and an orientation toward dramatic natural settings (Figure 25.8). These units were particularly inexpensive, with curtains in place of some interior walls (many of the others were plywood or fiberboard, intended to be recycled in new construction at war's end), but the resemblance to middle-class housing helped dull criticism of federal intervention in the housing market.

Figure 25.8.
William Wurster,
Carquinez
Heights housing,
Vallejo,
California, 1941.

By the late 1940s, however, immigrants from Europe successfully challenged the primacy of this indigenous modernism. During the late 1930s and early 1940s a number of prominent modern architects had immigrated to the United States from Germany. Several received prestigious academic appointments from schools interested in keeping abreast of new alternatives to the Beaux-Arts curriculum, whose applicability to the scale and range of American construction was increasingly unclear. One of them, Mies van der Rohe, was appointed head of the architecture program at what became the Illinois Institute of Technology.

Mies's success in the United States had a great deal to do with his fascination with skyscrapers. In Germany he had in the early 1920s designed two curtain-walled towers, one with a faceted plan that owed a great deal to expressionism's crystalline forms and a second with rounded edges. These unbuildable schemes influenced the pair of apartment towers he completed on Chicago's Lake Shore Drive in 1951 (Figure 25.9). The towers were an enormous economic, aesthetic, and symbolic success. Cheaper to build than masonry-clad structures, especially since masons were much better paid than they had been during the Depression, the towers held their value well in a marketplace in which many bankers feared modern architecture was just a passing fad. Mies's meticulous attention to the proportions and details of his gridded frame satisfied sophisticated students of modern art more than a decade before the advent of minimalism tied his design to new developments in painting and sculpture. Steel-framed high-rises had been constructed in Chicago since the 1880s, and entirely glazed towers were beginning to be built on both coasts of the United States, but Mies's brilliantly original contribution was to represent this frame by applying I-beams vertically to the skin of the building. To many observers, this ornament appeared to be structural, although the actual frame was required by law to be wrapped in fireproof sheathing.

Mies's conversion of the pragmatic facts of construction into abstract modern art suited the situation in which he found himself. First, it confirmed the international importance of Chicago's late nineteenth-century office buildings, which were now celebrated as crucial precedents for interwar architectural experimentation in Europe. Second, the United States came to be seen as the place where those experiments bore substantial fruit when a commercial establishment adopted what had been the language of the avant-garde, as the Lake Shore Drive development became the template for new office towers across the country and abroad. This accorded with the country's new status as an international superpower, which ideally should be supported by cultural as well as economic and military achievements. Mies focused on construction and proportion. His architecture nonetheless came to represent what many Americans wanted to believe: that the rising international prominence of the United States had been accompanied by an increase in refinement and improvement in taste among Americans. Forged in the crucible of German political and economic instability, the curtain-wall skyscraper ironically became the preeminent architectural symbol of the capitalist democracy of Mies's adopted homeland.

Figure 25.9. Ludwig Mies van der Rohe, 860–880 Lake Shore Drive Apartments, Chicago, Illinois, 1948–51.

The limits of modern architecture's ability to meet consumer demand were none-theless obvious. In 1947, the year before Mies began work on Lake Shore Drive, the first houses went on sale in a newly created suburb of New York City, Levittown, on Long Island; a second Levittown quickly followed in Pennsylvania. The spectac-ular postwar growth of the American suburb, which now for the first time housed the lower-middle and even working classes as well as those who had been able for a century to afford alternatives to congested urban life, depended very little on con-tributions from architects. It was developers who kept one eye on public policy and the other on the consumer while creating environments increasingly reached by automobile rather than by streetcars and suburban rail networks. The Americans who lived, shopped, and, increasingly, worked in these new environments had little contact with International Style architecture.

By the 1940s the country's housing shortage seemed unworthy of the enormous service rendered by returning veterans, who had or hoped to start families, the emblem of social stability. In one of the greatest subsidies ever bestowed on the American middle class, federal mortgage programs made single-family houses in the suburbs available to most white families. Economies of scale contributed as large developers, who relied on standardization to cut costs, now built two-thirds of new suburban houses. The Levittowns were emblematic of new developments in which freestanding houses were small and more affordable than ever before (Figure 25.10). Levitt & Sons applied mass-production techniques borrowed from wartime indus-tries to keep costs low. Unlike Mies and Gropius, however, the developer employed reassuringly familiar images of domesticity in models that drew heavily on the cot-tages widely published in architecture magazines during the 1930s, when many American architects were forced by economic constraints to address the small house. One-and-a-half-story Cape Cod colonials gathered together under their high gabled roofs a welcome mix of modern conveniences and traditional styling.

Two things, aside from the small scale of the dwellings, distinguished new sub-urban developments from their predecessors. One was the relative youth of the new inhabitants, the other the distance that separated them from shops, which often could be reached conveniently only by car. A result was the increased isolation of young housewives. Betty Friedan's book *The Feminine Mystique,* published in 1963, chronicled the problems, especially depression, faced by college-educated women, in particular, in these child-centered environments. Earlier suburbs had featured vil-lage centers clustered around train stations or linear shopping districts laid out along streetcar routes. During the interwar years, suburban women still made their larger purchases in downtown department stores. The increased popularity of the automo-bile resulted in a gradual shift from buildings lining streets to traffic arteries fronted by substantial parking lots in which new freestanding shopping complexes floated.

A crucial figure in this development was another immigrant. Victor Gruen, an Austrian, focused on the pragmatic aspects of retailing. His Southdale in Edina, Minnesota, was the first entirely enclosed shopping mall in the country when it

No. 1

No. 2

REAR VIEW

The Rancher

A NEW HOUSE IN LEVITTOWN

•

PRICE—$8990

$57 A MONTH!

No cash required from veterans!

No. 3

No. 4

Figure 25.10. Advertisement for houses in Levittown, New York, begun 1947.

opened in 1956 (Figure 25.11). Protecting shoppers from the region's intense climate, at least once they crossed a vast parking lot, this complex structure also accommodated underground deliveries of goods by truck and the mechanical services needed to heat and cool the vast interior. Gruen gathered small shops together with large branches of downtown department stores. For the department store atrium he substituted an even larger space in which little selling originally occurred, but where shoppers could circulate and view shop fronts from multiple directions. Two levels high, with ample seating, escalators, and even trees, Southdale provided a generously scaled environment for a community life that, unlike the Main Street for which it was a conscious substitute, was subject to regulation by the mall owner.

Within less than a decade, downtowns throughout the United States were reeling from the impact of the new malls. In tandem with the social unrest of the late 1960s and the spiraling urban crime that followed the precipitous decline in well-paying jobs for unskilled labor and the rise of the drug trade, the convenience of regionally scaled facilities close to the new interstate highways kept shoppers in the suburbs.

Figure 25.11. Victor Gruen, Southdale, Edina, Minnesota, 1954–56.

The middle class was now physically separated not only from the poor, who over-whelmingly remained either in decaying urban neighborhoods or in pockets of rural poverty, such as Appalachia and the Mississippi delta, but also from high culture. Schools and houses of worship moved to the suburbs, but museums, concert halls, and universities did not.

Among those who remained in the city with the poor and many intellectuals and artists were architects, especially the most celebrated and ambitious ones, and many of their wealthy clients. Their increasing antipathy for suburbia, which they criticized as soulless and conformist, alienated the profession from the general public. Architects focused on form, dismissively ignoring the commercial and consumerist forces that were remaking the built environment. The international identity of the architectural profession intersected only occasionally with the more localized lifestyle developing in American suburbs. Architect-designed urban apartment towers housed the relatively rich and the desperately poor, while the middle classes dwelled in developer-built tract houses. The opacity of much modern institutional architecture of the 1960s, which neither reliably created community nor conveyed concern for its users, challenged a new generation of architects to confront the remoteness of modernism from the environments inhabited by most Americans.

From the 1920s through the 1960s, proponents of modern architecture, wherever in the world they practiced, advocated a firm break with history. Architecture now was to represent only itself, abstract form or structure, or at the most modernity communicated through an industrial aesthetic. In fact, the modern movement always carried other messages as well, although abstraction made them easy to forget. From the 1930s to the 1960s, the modern movement communicated the purported modernity and cultural sophistication of the societies that sponsored it. As had been the case with the meanings inscribed in buildings from the prince-bishop's palace at Würzburg to the viceroy's palace in New Delhi, these bold claims often had little substance. Brazil's ability to realize a paradigmatic example of modernist urbanism possibly delayed rather than prompted the country's actual economic modernization. The belief that American architectural culture had been transformed by the importation of European avant-garde forms was belied by the continued popularity of the colonial revival, the pseudo-Tudor, and the Spanish hacienda, and by the emergence of commercial strips along the country's new suburban highways. Although built of bricks and mortar, concrete and steel, architecture, even an architecture based on the frank depiction of its own construction, rarely succeeded in representing reality. Paradoxically, the modern movement became widely accepted at precisely the same time that it ceased in many cases to appeal to a mass audience. The way in which its more austere iterations were imposed by the architectural profession and its institutional clients eventually ensured a backlash from a public alienated by the movement's lack of accountability to popular taste.

FOR FURTHER READING

This chapter's discussion of Brazilian architecture follows Zilah Quezado Deckker, *Brazil Built: The Architecture of the Modern Movement in Brazil* (London: Spon Press, 2001); Fernando Luiz Lara, *The Rise of Populist Modern Architecture in Brazil* (Gainesville: University Press of Florida, 2008); and Richard J. Williams, *Brazil: Modern Architectures in History* (London: Reaktion, 2009). For an interpretation of postwar American architecture that seems equally valid for Brazil, see Alice T. Friedman, *American Glamour and the Evolution of Modern Architecture* (New Haven, Conn.: Yale University Press, 2010); and for the history of CIAM, Eric Mumford, *The CIAM Discourse on Urbanism* (Cambridge: MIT Press, 2000). Frederick Kiesler, *Contemporary Art Applied to the Store and Its Display* (New York: Brentano's, 1930), used the term *International Style*. On Fallingwater, see Franklin Toker, *Fallingwater Rising: Frank Lloyd Wright, E. J. Kaufmann, and America's Most Extraordinary House* (New York: Knopf, 2003). Wurster's significance was first detailed in Marc Trieb, *An Everyday Modernism: The Houses of William Wurster* (Berkeley: University of California Press, 1995). See also Annmarie Adams, "Sex and the Single Building: The Weston Havens House, 1941–2001," *Buildings and Landscapes* 17, no. 1 (2010): 82–97; H. Peter Oberlander, *Houser: The Life and Work of Catherine Bauer* (Vancouver: University of British Columbia Press, 1999); and Pierluigi Serraino, *NorCalMod: Icons of Northern California Modernism* (San Francisco: Chronicle Books, 2006). The classic source on Lake Shore Drive remains the chapter in William H. Jordy, *American Buildings and Their Architects*, vol. 5, *The Impact of European Modernism in the Mid-Twentieth Century* (Garden City, N.Y.: Doubleday, 1972). Dianne Harris, ed., *Second Suburb: Levittown, Pennsylvania* (Pittsburgh: University of Pittsburgh Press, 2010), supplements the sources on suburbs cited earlier. On suburban commercial architecture, see Richard Longstreth, *City Center to Regional Mall: Architecture, the Automobile, and Retailing in Los Angeles, 1920–1950* (Cambridge: MIT Press, 1997); and M. Jeffrey Hardwick, *Mall Maker: Victor Gruen, Architect of an American Dream* (Philadelphia: University of Pennsylvania Press, 2004).

26 Africa: Villages and Cities

Because extensive European acquaintance with the African interior dates only to the nineteenth century, it is often assumed that this is territory without a history. Indeed, earlier written documents are far rarer here than in many other parts of the world. Nonetheless, we know that even when Portuguese sailors first arrived on the African coasts in the fifteenth century, the borders of the territories occupied by various peoples were fluid and often disputed. Only when Africa was colonized by Europeans, a process that began in the fifteenth century and culminated in the Italian conquest of Ethiopia in the 1930s, were firm cartographic boundaries drawn. The borders of today's African countries were imposed by colonial powers; they seldom reflect spatial divisions between ethnic and linguistic groups, many of which span more than one country. Large nations such as Sudan and Nigeria include many different groups with diverse religious and architectural traditions.

The latter range from the portable dwellings of nomadic peoples to village huts and their urban counterparts, from the shanties of the slums to the mansions at the centers of expansive walled compounds. The most basic domestic structures are tents like those that house the nomads of the Saharan desert (Figure 26.1). Here the land is too dry to support year-round settlement. Small numbers of people travel across great expanses of land in search of water for themselves and their domesticated animals. The tents of the Mahria peoples might at first seem unassuming. The simplest and smallest physical structures, however, often support complex social structures and reflect equally developed religious beliefs that are often embedded in dwellings. The ritual erection of buildings and understanding their planning and inhabitation as an extension of religious beliefs survives in many rural areas in Africa. Supposedly traditional architecture seldom remains exactly the same across time; instead it changes constantly in small ways, adapting to such variables as the availability of materials.

Figure 26.1. Women constructing Mahria marriage tent, Mali, late twentieth century.

Throughout Africa, many women take an active role in the construction and decoration of their houses. New tents are constructed for Mahria brides, who as wives will be responsible for the tents' maintenance, erecting and demounting them as they move from place to place across the year. The initial erection of a tent is a communal activity, shared by a group of women as part of the rituals surrounding the celebration of a wedding. The bride's mother provides the materials and the initial furnishings. The materials are simple, beginning with the wooden frame, which can often be made from wood gathered from close to the site, although the framing members can also be bought at the market. This frame was once clad exclusively with mats woven by Mahria women; today canvas has largely replaced the mats, especially for a tent that will be moved from place to place. Canvas is lighter and packs up smaller, but woven mats provide better ventilation and circulation. Because everything within the tent must be capable of being easily packed up and carried on a camel, there are few furnishings. They include leatherwork bags and basketry, made usually by the woman who dwells within the individual tent with her husband and children. The tent frame doubles in part as the saddle upon which the woman sits when the family travels; in this form, some of the tent coverings shade, even hide, the woman who rides underneath them.

Throughout precolonial sub-Saharan Africa, most people lived settled, rural lives. Although some were hunter-gatherers, most farmed and herded. Typically they lived

in circular compounds, which continue to be built today (Figure 26.2). Like other vernacular architecture, these dwellings were mostly built out of locally available materials without the assistance of specialized labor. Most were carefully adapted to local climatic conditions. There was little need for monumentality. Hierarchy in many of these societies was more a product of age and gender than of imposing architecture. The distribution of wealth was far more equitable in most of precolonial Africa than in Europe or Asia, where the rulers lived very differently from the vast majority of their subjects. Early European explorers often felt that Africans lived much better than ordinary peasants in their own societies. In many cases what might first appear to be individual dwellings should more properly be thought of as rooms. The mild climate made it possible to arrange individual huts within a larger compound rather than to gather all together under a single roof. This orientation toward a shared open space is not so different from that of the Chinese courtyard house. This method of spatial organization particularly suited Africa's many polygamous households; in these situations every wife had her own hut.

The architecture of individual houses also reinforced gender roles and expressed religious beliefs. This can be seen in the houses of the Batammaliba, who live in Togo and Benin. The Batammaliba are monogamous, a social structure that promotes single-family houses accommodating all members of the nuclear family, sometimes along with the parents of one spouse (Figure 26.3). Batammaliba houses, constructed

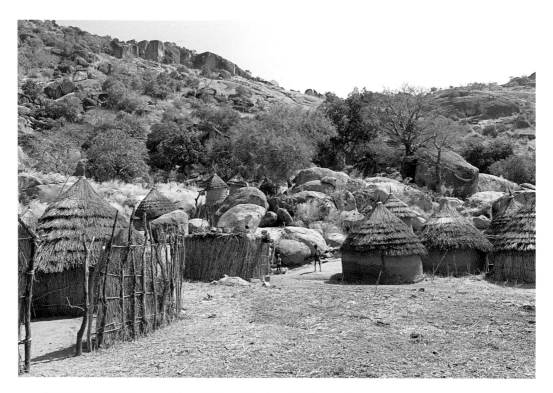

Figure 26.2. Nionsomoridou, Guinea, late twentieth century.

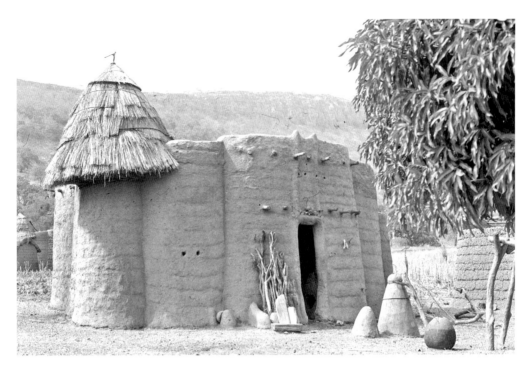

Figure 26.3. Batammaliba house, Benin or Togo, late twentieth century.

from local earth and thatch, embody many of the social practices and belief systems of the culture. Therefore, most houses are similar in appearance, regardless of who built them and who lives in them. They have a fortresslike appearance; grouped together in unwalled villages they provide a degree of protection from invaders, especially as each house has only a single entrance.

The Batammaliba understand the spatial interior organization of these houses in symbolic terms (Figure 26.4). The space of the house is divided horizontally and vertically along gender lines; the left half of the house is seen as female, the right half as male. The lower story is largely a masculine preserve; women's tasks are more likely to be conducted in the greater privacy of the upstairs terrace and the chambers opening from it. At the center is a two-story cylinder, each level of which serves as a bedchamber. The husband and wife sleep upstairs; their parents or older unmarried sons, downstairs. Around this cylinder unfold the cattle room downstairs and the terrace upstairs. Inserted into the walls defining this space and acting as buttresses to them are the additional chambers of the house. The most important of these are the kitchen and the male and female granaries, so called because they house the crops tended and harvested by men and women, respectively. Storage areas are crucial for households that produce most of their own food and, having no electricity, have no access to refrigeration.

The rituals surrounding the construction and inhabitation of the house make clear that the Batammaliba understand their dwellings to be semihuman and that

Figure 26.4. Plan, Batammaliba house, Benin or Togo, late twentieth century.

architectural references to human anatomy connect the inhabitants with the spirit world of the divine. Like many Africans, the Batammaliba explicitly equate their houses with the human body. This helps them to organize space into a comprehensible system, something particularly reassuring in an age before maps. The cylindrical room at the center of the house inhabited by the married couple is the place where children are conceived and born; not surprisingly, it is equated with the female sexual and reproductive system. In front of it a small hole connects the two stories of the house; this is understood as the solar plexus. The doorway, as might be expected, is understood as the mouth. The horns above it are representations of both testicles and the husband and wife. If one of them dies, a horn is ritually destroyed as part of the funeral ritual. Ordinary social rituals also enhance this understanding of the house as animate; when one goes to visit its inhabitants one greets the house first, even if the people one has come to see are actually outside. Houses are also ritually nourished, through offerings of food. For the Batammaliba, construction itself is a quasi-religious act, marked by many ceremonies. The Batammaliba have no separate religious buildings; instead, shrines to particular deities may

be located within individual houses, most often in the male or female granaries. These people thus dwell in a far more explicit relationship to their religious practices than do those in societies where the separation between sacred and secular buildings is explicit. Furthermore, shrines to the previous inhabitants of the house or to the ancestors of the current inhabitants are located within or just outside its walls.

Most studies of sub-Saharan African architecture focus on villages, for it is here that the details of African buildings are most distinct from contemporary practices elsewhere. The degree to which this architecture continues to be integrated with the particulars of the landscape, climate, social practice, and religious beliefs offers a counter to much contemporary building in Africa as well. Cities have long dotted the coasts, serving traders who before the fifteenth century were largely Arab rather than European. Located farther inland were the cities of the great trade routes that brought gold and slaves to Arab North Africa and beyond to Europe. Also inland are many of the continent's modern capitals, such as Nairobi in Kenya and Pretoria in South Africa.

Many of the older coastal cities were trading outposts established by first Arab and then European sailors. Dakar on the Atlantic coast in Senegal and Kilwa on the Pacific coast in Tanzania, for example, are places whose building and urbanism were always informed by both indigenous and imported traditions. The great city of Benin, on the other hand, was ruled over entirely by Africans until its destruction by the British at the end of the nineteenth century (Figure 26.5). From the time that the first Portuguese arrived, European visitors to Benin were amazed by the high quality of its ordinary dwellings and by the palace in which its ruler lived.

Figure 26.5. City view, Benin, Nigeria, 1897.

Today only the bronzes produced in Benin, some of the oldest and most prized examples of African art, offer testimony of the technologically advanced culture that flourished there.

Benin was a coastal city; other important cities lay upriver, where the Niger intersected with important trade routes going north and east. Here Arabs from North Africa arrived in caravans to trade for gold, slaves, and other goods that had often been carried to the edge of the desert from sites far to the south. Tombouctou (Timbuktu) and Djenné are among the most notable cities on these routes. Djenné sits on a peninsula that juts out into the Niger River; in spring when the river floods, it becomes an island. The site is easily defensible, and Djenné has flourished in the protective arc of the river since at least the fifteenth century. Three different strata of architectural thinking inform the architecture of Djenné. First are the local indigenous traditions of building in mud brick. These are integral to the geology and climate of the place. The architectural forms imported from the north by Muslim traders make up the second strand, which today is interwoven with the first. The inward-facing character of the streets and the separation of commercial from residential areas tie Djenné to the urban patterns of North Africa. Today the city's population is mostly Muslim, and the locals refer to the houses of one neighborhood as being Moroccan in design. These houses are nonetheless impregnated with the same kinds of animist content as Batammaliba dwellings. At the same time, many adobe elements imitate the construction in wood characteristic of Morocco, from which many of the traders historically came. Buildings like this fuse Western and North African architectural materials and spaces. The architecture of Djenné reflects its importance as a place where people from different cultures have for centuries met to do business.

The French, who ruled over the city from the 1880s until Mali gained its independence in 1960, made the third major contribution to the architecture of Djenné when the colonial administration rebuilt the Great Mosque in 1906–7 (Figure 26.6). Although monumental adobe buildings had been built in the region for centuries, several important aspects of this building reflect French rather than African ideas about architecture. Like all mosques, this building is oriented toward Mecca. In the case of Djenné, however, the *qibla* wall into which the mihrab niche is placed is on the side of the building that faces the market square. French engineers understood the urban situation of the mosque as requiring a monumental facade facing the square, even if the building must actually be entered from another side. The central stair leads to the back of the mihrab niche, but not to any door. Furthermore, the French favored the symmetry of their own neoclassical architectural traditions, which they imposed on local construction techniques. The result was an unusually imposing building, one that quickly became a model for both mosques and civic buildings throughout the region.

Why were the French interested in local architectural traditions? Why did they not choose to build a Roman Catholic cathedral, perhaps even in the Gothic style,

Figure 26.6. Great Mosque, Djenné, Mali, 1906–7.

or an imposing classical office building as the town's central architectural showpiece, as they had elsewhere? First, the town was too far away to attract many French settlers; most of the foreigners here were instead colonial administrators and soldiers. Even more than tourists, the major French audience for colonial architecture consisted of those who might look at pictures of it in the French illustrated press. They were more interested in exotic images of faraway places than in repeating their own familiar surroundings. Indeed, the Great Mosque served as the template for pavilions that represented the African colonies at numerous colonial expositions. The purpose of these exhibitions was to build support at home for the colonies, which many in France dismissed as costly and undemocratic. At the same time, within Djenné the construction of this monumental mosque was both a practical and a political decision. Before the popularization of the automobile or the invention of the airplane, Djenné was, for the French if not for the surrounding Africans, a remote site. It would have been difficult to ship the necessary stone or wood in to build European architecture there. Finally, by giving Djenné's inhabitants an enormous new mosque, the French hoped to suggest that only under European government could the city's inhabitants hope to resurrect the prosperity the city had enjoyed in the sixteenth and seventeenth centuries.

The mosque continues to be cherished by the community. Local craftsmen maintain it, regularly replastering its surfaces. Indeed, just as the French had hoped,

it has become the focal point of city life. This has happened because only the details of the space and nothing about its construction differ from its precolonial predecessors; everyone in Djenné understands how to use and maintain a building like this one. The interior of the mosque is very different from mosque interiors in Asia. Mud-brick columns cannot support as much weight as the baked brick and stone of Ottoman, Safavid, and Mughal mosques. In Djenné these columns dominate the interior, which lacks a single vast open space. Islam demands an orientation toward Mecca and a mihrab niche inserted into that wall, but not any particular style. Instead Muslim builders have always successfully adapted to the particular materials and climates of the specific regions in which they have worked. Interesting features of this mosque include the small vents on the otherwise flat roof. These allow heated air within the mosque to rise out, helping to keep the interior of this thick-walled structure cool despite the scorching sun outside. Built of pottery, the vents are produced by women, typically the wives of blacksmiths.

Benin has been destroyed; Djenné and Tombouctou are no longer among the world's most important trading centers. Today it is Dakar, Lagos, Johannesburg, and Nairobi that mirror the wealth and social problems of contemporary Africa. These include, most notably, the unequal division of the wealth created by the continent's rich natural resources. Tensions over these resources provoked numerous wars during European colonization and have not ceased with the establishment of independent nation-states. The most notorious example of the effect of such tensions on spatial practices comes from the richest country on the continent, South Africa.

The Dutch East India Company settled Cape Town, South Africa's oldest colonial city, in 1652 as a place where sailors journeying from the Netherlands to the Dutch East Indies (present-day Indonesia) and back could take on provisions. The Dutch were displaced at the end of the eighteenth century by the British, whose own East India Company had succeeded the Dutch company as the wealthiest colonial enterprise in Asia. The Cape Colony's importance grew exponentially following the discovery of first diamonds and then gold in the interior of what is now the Republic of South Africa and were then areas controlled by descendants of the Dutch settlers, called Afrikaaners. From their arrival, both groups of Europeans exploited the region's native populations. The situation reached a new extreme when the Afrikaaners gained control of the South African government in an election held in 1947 in which only whites were allowed to vote. One of the first acts of the new government was to impose apartheid, a legislated system of racial separation and discrimination that endured until the 1990s. Although its impact was most devastating in Johannesburg, South Africa's largest city and the metropolis closest to the diamond and gold fields, it was also debilitating in Cape Town, widely regarded as the most open and tolerant of the country's major cities.

When the Dutch arrived in South Africa, they, like their counterparts settling the Atlantic coast of North America during the same years, found indigenous peoples whose apparently casual dwellings encouraged the newcomers to decide that the

natives were not worthy to own the land they occupied. Three centuries later, however, the Dutch settlers' descendants justified their policies of racial segregation as "protecting" the native peoples and their traditions from modernity. In fact, many indigenous inhabitants had been displaced in the interim from the land that supported them into less hospitable environments that condemned them to malnutrition and poverty. Meanwhile, the country's mineral wealth, principally diamonds and gold, although gathered by poorly paid black labor, made most white South Africans very wealthy.

Apartheid had at least three specific spatial dimensions. First, blacks evicted from modern environments they had helped to produce were forced to move into "homelands." These were the South African equivalents of North American reservations, land that no one else wanted. Densities here were far greater than they had been, and the definition of modern infrastructure, including health care and education, not to mention electricity and indoor plumbing, as "unsuitable" for such people contributed to ensuring that living conditions were far worse than those that many of the people forced out of urban neighborhoods had earlier enjoyed.

The second spatial dimension of apartheid was within cities. Apartheid limited the ability of blacks to live with their families close to their jobs. Those who did not have the appropriate passes could not stay overnight in the city; such passes were given only to workers, not necessarily to their family members. Blacks, mixed-race populations, Indians, and whites were given their own separate residential neighborhoods. Existing mixed neighborhoods were either demolished or allotted to more privileged groups. Blacks were relocated to the least desirable land on the city outskirts, which had the least infrastructure. The rich metaphors that imparted meaning to their traditional counterparts were absent in shantytowns, which were not given the modern infrastructure that buffered cultural change (Figure 26.7). A white-authored government report on housing noted that pail latrines "are the most commonly encountered systems [of sewage disposal] in low-cost housing [for blacks]. There is no limitation to the size of a township that can be served in this way. . . . This factor gives rise to inconvenience in bad weather . . . however this is a non-European custom and the most practical."

The third spatial dimension of apartheid was that of individual buildings. Public and private buildings were reconfigured in ways that made explicit the second-class status of nonwhite citizens (Figure 26.8). Blacks were forced to use separate entrances to public facilities, such as post offices and banks, where they received services inferior to those accorded to whites. Most whites lived in walled compounds, with separate entrances for whites and blacks. Black servants lived in separate outbuildings, usually in a single room that was smaller, less well ventilated, and more dimly lit than the rooms in the neighboring house.

Apartheid was not without precedent. For instance, in the 1890s whites had imposed segregation in the American South, where it endured until the 1960s. African Americans in many southern states had to sit at the backs of buses, could not be

Figure 26.7. Khayelitsha township, Cape Town, South Africa. Photograph from 1996.

served food in most restaurants, could not stay in hotels, and suffered many other indignities. Although they paid the same taxes as whites, the facilities provided them were clearly unequal. Nonetheless, apartheid's extent went far beyond the multiple spatialized forms of discrimination found elsewhere in the world.

Architecture has provided vibrant symbols for South Africa's new democracy. European colonization and the decline in the living standards of ordinary villagers it often generated transformed the social patterns and religious practices of rural life throughout the subcontinent. New materials, such as corrugated tin roofs, have transformed the appearance and experience of buildings there, bringing more permanence to their construction but resulting in less flexible responses to the climate and higher costs for materials. Vernacular architecture has often proved able to accommodate such social, religious, and technological change. Moreover, it has served as a template for those who wish to reweave a social fabric that the travails of colonialism unraveled. The compounds of the Ndebele, one of South Africa's major ethnic groups, have become a focus of ethnic and racial pride, not only within the territory traditionally inhabited by the Ndebele but also across South Africa (Figure 26.9). Defined by high walls, within which there may be multiple small buildings, they are rectangular rather than circular. The Ndebele is another one of the many African cultures in which women are charged with building, maintaining,

Figure 26.8. Post office with separate entrances for whites and nonwhites, Senderwood, Johannesburg, South Africa, 1974.

Figure 26.9. Ndebele house, South Africa, early twenty-first century.

and decorating houses. Bright patterns are characteristic of Ndebele clothing and beadwork, and such patterns are reapplied annually to houses after the rainy season.

African architecture reintroduces us to ways of thinking about buildings that were long common to many rural societies as well as to oppressive ways of organizing space that are uniquely modern. Concentrating on small and simply built structures alone risks freezing African architecture in time and thus reduces its richness, but it is also easy to understand what was once typical throughout the world as exceptional and exotic. Even the smallest African dwellings would have appeared generous to most residents of the European and Asian countryside through at least the eighteenth century. In the United States, many farmhouses lacked flush toilets or electricity as recently as the 1930s; in Europe many urban apartments gained such amenities only in the 1960s. It is easy today to romanticize the strong connection between architecture and nature found in rural Africa, but not what was once a fairly equitable distribution of wealth and political authority. It was this that colonialism destroyed, leaving the continent vulnerable to the disease and civil war that engulf too much of it now. Today widening gaps between rich and poor, as well as racial and ethnic discrimination, shape the built environment in many parts of the world. Although it is less extreme than apartheid, this redistribution of resources toward those who already have them and away from those in need encourages homelessness, hampers the growth of small business, and directs industry toward places where pollution is tolerated and workers earn less and are more likely to be injured on the job. These decisions, as in apartheid-era South Africa, are not made specifically by architects, but they are embedded in the economic, political, and social contexts in which architects practice. The regulation of economic activities often does more to shape the environments we inhabit than do the design decisions of architects and builders.

FOR FURTHER READING

On nomadic architecture, see Labelle Prussin, *African Nomadic Architecture: Space, Place, and Gender* (Washington, D.C.: Smithsonian Institution Press, 1995); on its village counterpart, Jean-Paul Boudier and Trinh T. Minh-ha, *Drawn from African Dwelling* (Bloomington: Indiana University Press, 1996). For discussion of the Batammaliba, see Suzanne Preston Blier, *The Anatomy of Architecture: Ontology and Metaphor in Batammaliba Architectural Expression* (Chicago: University of Chicago Press, 1994). On the architecture of apartheid, see Keith Beavon, *Johannesburg: The Making and Shaping of the City* (Pretoria: University of South Africa Press, 2004); Hilton Judin and Ivan Vladislavić, *Blank: Architecture, Apartheid and After* (Cape Town: David Philip, 1998); and Rebecca Ginsburg, *At Home with Apartheid: The Hidden Landscapes of Domestic Service in Johannesburg* (Charlottesville: University of Virginia Press, 2011).

27 Postcolonial Modernism and Beyond

ew issues were more prominent in international architectural culture during the last decades of the twentieth century than that of cultural identity, or, to put it very differently, place making. How can one represent one's own cultural heritage or that of one's clients in order to create buildings specific to the places in which they are built while simultaneously making those buildings appealing enough to an international audience to achieve fame? What combination of climate, geology, and culture constitutes place? Some of the more sophisticated answers to these complex questions emerged in the Middle East and South Asia. Although modern architecture is often denounced as a built diagram of homogeneous global capital, there remains considerable variation in where and how it is deployed.

One of the questions often asked about modern architecture in the developing world is why it made headway there when it represented the antithesis of the integration of spatial practices and belief systems that characterize the preindustrial heritage of many of these societies. In parts of the Middle East and South Asia, people using buildings designed by architects are often far closer chronologically to these practices than are many of their counterparts in Europe and North America. And yet many of the architectural showpieces of the modern movement were erected there rather than in New York, Paris, or London, which for more than half of the twentieth century were relatively impervious to avant-garde architecture. Why has this been the case? Clues to the answer emerge from a project celebrated for its attempt to preserve cultural environments.

Since the 1980s, the Aga Khan Award for Architecture, presented by the Aga Khan Trust for Culture, has done a great deal to publicize creative solutions to the problem of using architecture to establish identity. A dialogue across national boundaries has encouraged Muslim and Indian architects in particular to participate in

international discussions, while Americans and Europeans focused in the 1980s on reviving specifically Western precedents. In 1980, the first year in which the awards were given, the Chairman's Award went to the Egyptian architect Hassan Fathy. Beginning in the 1940s, Fathy advocated developing new communities and neighborhoods based on the principles of some of Egypt's most remote villages rather than on ideas imported from Europe. Fathy combined a modern social position with resistance to modernist form. He advocated the revival of architecture built and inhabited by peasants, rather than the monumental architecture favored by his historically minded counterparts a century earlier. His loyalty to tradition made him one of the world's most influential architects in the 1980s.

Fathy's reputation was predicated in part on his work from 1945 to 1948 on the village of New Gourna (Figure 27.1). During World War II, the shortage of timber and other building materials sparked Fathy's interest in the vernacular architecture of Nubia in the far south of Egypt, which he revived in a new town built near Luxor by the Egyptian government to control looting of the nearby archaeological sites. New Gourna is important as an early effort by a professionally trained architect to recapture the spirit of non-Western vernacular social space, rather than focusing just on image as the French did at Djenné. Fathy also considered economic development; he proposed that the villagers support themselves by making crafts.

Not only did Fathy propose reviving mud-brick construction, but he also lovingly re-created the irregularity of vernacular spaces such as the market square and residential lanes. The center of each lane opened into a quasi-public area shared by the households that fronted it; he provided room for domestic animals as well as for the people who owned them. Fathy's willingness as an urban intellectual to reproduce spatial patterns intended in part to reinforce privacy for women was unusual. Most of his contemporaries were instead challenging patterns of gender segregation.

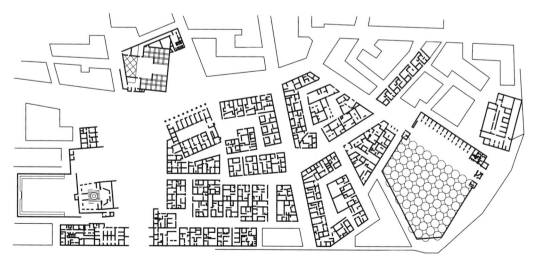

Figure 27.1. Hassan Fathy, town plan, New Gourna, Egypt, 1945–48.

The mosque was, of course, the community's most monumental building. Its mud-brick dome, a form not previously found in this part of the country, was a triumph of the revival of traditional southern Egyptian construction techniques using locally available materials. Fathy left it almost unornamented because, like most twentieth-century antimodernists, he was insecure about his ability to match previous standards of craft production and preferred simplicity to the more garish taste of the village's proposed inhabitants, which he would have dismissed as kitsch.

At the time, Fathy's insistence on low-tech construction and traditional spatial patterns seemed nostalgic and reactionary to many. As the villages Fathy admired became transformed by the availability of new materials, however, the views of the elite in particular began to change. When New Gourna was built, economic and political equality with Europe seemed just around the corner. When instead urbanization and economic development programs brought little improvement to the lives of average Egyptians, Fathy became a celebrated architect in part because he offered an alternative to a nagging sense of cultural inferiority. Advocates of sustainable design also admired his adherence to low-tech means of heating, cooling, and illuminating his buildings.

Ironically, Fathy's romantic view appealed little to actual villagers, who resisted moving into an environment they had done little to shape for themselves. They preferred the convenience of concrete and sheet metal, which did not have to be as carefully maintained as mud brick. The widening gap between what architectural culture values and rewards and what users appreciate was a hallmark of postwar architectural culture everywhere. What would appear to be populist was experienced as intrusive, even alienating by the public for which it was built. Only when construction of the Aswan Dam flooded many neighboring villages was New Gourna actually inhabited; the people for whom it was originally intended successfully resisted being removed from the archaeological remains that provided a far more lucrative income than selling crafts to tourists.

More in keeping with the spirit of the immediate postwar period was the housing erected in Morocco and Algeria, then still French colonies, in the early 1950s by ATBAT-Afrique (Figure 27.2). Georges Candilis and Shadrach Woods, the designers, had previously worked with Le Corbusier on Europe's most influential new housing prototype, the Unité d'Habitation, erected in Marseille, France, between 1947 and 1952. Their goal in North Africa was to fuse the efficiency of modern reinforced concrete construction with spaces that served what they understood to be the cultural norms of the Arab inhabitants. Large screened balconies replaced the courtyards around which individual dwellings had earlier been organized. An imported architectural vocabulary, itself inspired in part by the whitewashed vernacular housing of much of the Mediterranean basin, accommodated new densities in order to house rural migrants crowding into cities in order to work in factories.

This approach was closely tied to Candilis and Woods's eventual membership in Team X, a group of European architects who met regularly between 1953 and 1981.

Figure 27.2. ATBAT-Afrique, Carrières Centrales, Casablanca, Morocco, 1951–55.

Originally members of CIAM, Team X architects became critics of the strict separation of urban functions and of an industrial aesthetic. Instead they drew on anthropology and sociology for help in identifying social patterns that could be correlated with spatial and structural systems. Without relinquishing modernist abstraction, Candilis and Woods sought to learn from the self-built housing of the slums they worked to replace; Team X architects admired the vernacular housing of a wide array of exotic preindustrial societies. While Team X was in the European vanguard, the respect for premodern urbanism shown by its members was increasingly adopted even by architects who did not use Team X's diagrammatic design methods.

In North Africa, this enlightened attention to habitat was compromised by the colonial context in which it was realized. Colonial authorities served as clients for complexes whose locations and infrastructure were bounded by rapidly unraveling attempts to forestall independence. ATBAT-Afrique's projects were located on the urban periphery, where they could be more easily policed. Their minimal character reflected the prejudices of officials who believed the amenities of the Unité were not suitable for non-Europeans. Residents, who failed to recognize either their heritage or their present in the original forms, eventually completely transformed their homes, filling in the balconies to provide much-needed additional space.

The housing sponsored by the Grameen Bank in Bangladesh has been far more effective at balancing local construction traditions and economic development (Figure 27.3). In 2006 the bank and its founder, Muhammad Yunus, split the Nobel Peace Prize; the housing program had already received an Aga Khan Award in 1989. The architecture associated with this project, which began in 1976, was even more modest than that of New Gourna in its scale and complexity, if not in its effort to change the lives of those who inhabit it. The bank financed a system of concrete floor slabs and framing elements, topped by corrugated metal roofs, that stiffened the thatch houses in which many Bangladeshis live, making them less vulnerable to floods and winds. For $250 to $600 apiece, this improvement on local construction techniques cost less than entire buildings and did not require teaching residents how to maintain more permanent houses in more expensive and unfamiliar materials. At the same time, the bank's low-interest loans to groups of poor women helped buy the sewing machines and install the new wells that offered hope of grassroots economic development and improved health. This program is popular with actual villagers, not least because it offers real economic opportunity coupled to architectural and spatial flexibility.

While France had imposed modernism in North African cities, the leaders of many newly independent countries also freely chose it for civic infrastructure as well as for housing. Across Africa and Asia, the postwar period brought political

Figure 27.3. Grameen Bank housing, Bangladesh, begun 1984.

independence from the West, which was accompanied by the desire to erect buildings that expressed both national pride and international modernity. Although local architects designed most of these, some of the most ambitious were entrusted to foreign experts, in part because colonization had effectively disrupted the indigenous ability to craft monumental buildings. The colonizers had wrested responsibility for such construction away from local builders and given it to architects and engineers, while training almost no natives in the former profession in particular. Instruction in architectural draftsmanship became available in colonial India, for instance, only in 1885; the first program to train architects began there in 1913. Half a century later, the numbers of professional architects practicing in South Asia remained minuscule; none was well-known abroad. Foreign architects did not always understand what they were being asked to do, but the work of European-born architects in South Asia included some of the most important and influential buildings of the second half of the century.

In 1947 India and Pakistan won independence from Britain. India became a secular republic with a Hindu majority, and bifurcated Pakistan became a specifically Islamic state. Partition—the splitting of what had been British India into India and Pakistan—was traumatic; millions of refugees fled ancestral homes to live on the other side of the new border. Hundreds of thousands more died in this enormous exchange of populations. One of the provinces divided by the new border was Punjab, whose capital city, Lahore, lay in Pakistan. India's first prime minister, Jawaharlal Nehru, decided to build a new capital for the Indian half of the province, to be named Chandigarh. The task was originally entrusted to a young Polish-born American, Matthew Nowicki, who, however, died shortly afterward in a plane crash. In his stead, Nehru charged Le Corbusier with developing the city plan and designing the capital complex. Two British architects, Maxwell Fry and Jane Drew, shared responsibility for the city's housing with Le Corbusier's cousin and former partner Pierre Jeanneret. The ambitious scope of the project reflected the desire of an independent India to match the scale and artistry of New Delhi, a city inherited from the British. In part because of the use the British had made of indigenous precedents there, Nehru and his architectural team shied away from obvious quotations. Although they continued to wear their own clothes, play their own music, and make their own movies, many members of India's urban middle classes rejected their rich architectural heritage as contaminated by colonialism.

Although he was scarcely free of Western biases toward what he saw as an exotic, unchanging East, Le Corbusier offered his Indian clients an optimistic view of what they could achieve by adopting modern architecture. He regarded India's relative lack of industrialization and what he viewed as its unchanging culture as the nation's greatest strengths. They offered a clean slate on which the potential benefits of mechanization could be written with an orderly hand. Not recognizing the degree to which colonialism's devaluation of local production was responsible for much of India's contemporary poverty, Le Corbusier believed that "the continuity of India's

cogent philosophy" would inoculate it against the disorder, ugliness, and chaos that industrialization had unleashed on Europe.

Le Corbusier's plan stressed the integration of green and built space. He placed the civic core to the north, against the backdrop of the mountain foothills. Colonial planning practices remained in force, however, even as the architectural style changed. The various housing types were numbered according to an ascending scale, with the lowest numbers representing the best housing. Housing was allocated according to rank rather than ability to pay, with ministers and high court judges receiving far more generous quarters than midlevel civil servants, much less clerks. Regardless of the rank, all the dwellings reflected the standard thinking, against which Team X was rebelling, that the defining characteristic of place should be climate rather than local architectural traditions or social practices. Precast concrete screens, for instance, allowed the architects to shade interiors without quoting historical ornament. Concrete was the preferred modern material throughout those parts of the world where labor costs were low, as it used a minimum of expensive steel; Miesian models were seldom exported to newly independent countries.

A vast empty plaza that greatly disappointed many early visitors dominates Chandigarh's monumental core. Today it is cordoned off for security reasons, and visitors approach the buildings framing it from the rear. The scalelessness for which much modernist planning has been rightly condemned is less evident in Le Corbusier's High Court, Legislative Assembly, and even the far larger Secretariat (Figure 27.4). One of the greatest dilemmas facing the modern movement after its near total postwar victory over all alternatives was that of creating buildings whose permanence and grandeur were—without quoting historical ornament—appropriate to their civic and institutional functions. In India Le Corbusier was able to execute far more ambitious designs than anything Western clients would ever commission.

Figure 27.4. Le Corbusier, Legislative Assembly, Chandigarh, India, 1951–63.

This was clearly a carryover from colonialism as well, but that did not mean that the completed buildings were not specifically Indian. Modernism is often assumed to be specifically European and American, but midcentury modernism, although promoted as a universal style, was often designed in specific response to places in other parts of the world.

Already in postwar France, Le Corbusier had been experimenting with *beton brut,* or raw concrete. Instead of trying to achieve a smooth, uniform finish, he had encouraged the many contractors working on the Unité to leave the marks of the pour visible, in order to heighten the sense of concrete's materiality. In India, this treatment emphasized what Le Corbusier viewed as the primitivism of the country, while locals read his bold use of the material as emphatically modern. Also up-to-date was the way in which the volume of the Legislative Assembly's chamber, which resembled the cooling tower of a power plant, projected through the roof. The low rectangular volume of the building itself, with an open front wall screened by pillars, rightfully reminded observant viewers of the pavilions of Shah Jahan's palaces, which, unlike Greek temples, were oriented to the long axis. Less stylishly theatrical than Brazilian modernism, the earnestness of Chandigarh proved to have enormous appeal both at home and abroad. Many of the architects around the world who over the course of the next two decades quoted the entry facades of Chandigarh's Legislative Assembly and High Court paid no attention to the historical sources. Although designed specifically for India, they became hallmarks of French-inflected sophistication.

The international attention lavished on Chandigarh and Brasília helped encourage other developing countries to undertake their own ambitious architectural projects. India's neighbor, Pakistan, was one of them. The government sponsored the creation of the new capital city of Islamabad in what was then West Pakistan. This was balanced by the creation of a new governmental center in the existing city of Dhaka in East Pakistan, since 1971 the independent country of Bangladesh. After considering two European architects for this project, the Pakistani government awarded it in 1962 to an American, Louis Kahn. Kahn was one of the postwar architects who benefited most from the degree to which the U.S. government exported modern art and architecture as symbols of American cultural sophistication and openness. He built in Israel, India, and Nepal; projects for Morocco, Italy, and Iran remained on the drawing boards. Kahn's clients required him to adapt to local conditions. An official wrote to him: "In suggesting an Islamic touch to the architecture, it is not the intention that the internal construction and arrangement should be anything but the most modern and sophisticated. Our own climate and social conditions should, however, be borne in mind." Initially interested only in climate, Kahn was eventually inspired by his experiences of building throughout South Asia to integrate modern construction and indigenous spatial practices. For Team X's close study of indigenous vernaculars, he substituted a more abstract recall of a wide array of patently monumental sources.

The centerpiece of Kahn's capital complex was the National Assembly building (Figure 27.5). Construction began in 1963 and was completed only twenty years later, nine years after the architect's death. It was an enormous and expensive building in an extremely poor country. Bangladeshis often describe it, however, as having provided an inspirational vision of democracy. Roughly square in plan, it is surrounded by water except where opposite corners abut paved plazas that open onto parks. The sharply defined volumes are closed, almost fortified, where they touch land but eroded by rectangular, circular, and triangular cutouts where they face water. The horizontal white bands in the gray concrete walls, which mark the end of each day's pour, further break down the scale.

The request for "an Islamic touch" forced Kahn to move away from the kind of architecture found in Brasília and Chandigarh. The government fired him from the job of designing the Presidential Estate in Islamabad when he proved unwilling to quote historical motifs. The government's insistence led Kahn to look more closely at South Asia's architectural heritage, which he, like Le Corbusier, engaged at the typological level. It also paradoxically encouraged him to appreciate the Western classicism in which he had been trained as a young man. In Dhaka he fused the two, creating a structure that both South Asians and Europeans recognized as their

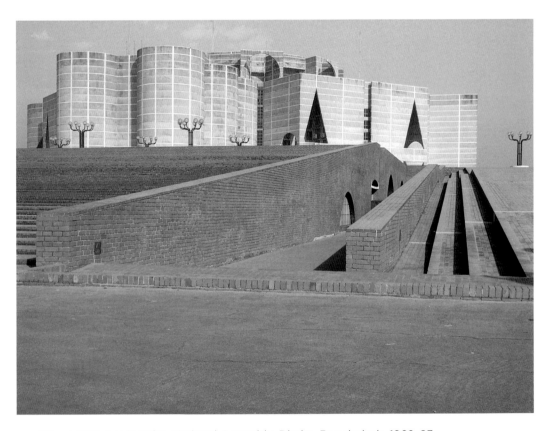

Figure 27.5. Louis Kahn, National Assembly, Dhaka, Bangladesh, 1962–83.

own. He achieved this multivalence in part by refusing to engage the ornamental traditions that remained specific to individual cultures, but also by echoing the layered spaces with flexible uses found from ancient Rome to modern South Asia, if unusual in colder climes.

Kahn belonged to the last generation of architects trained in Beaux-Arts principles; he studied at the University of Pennsylvania with Paul Philippe Cret, a Frenchman who was the leading American architectural pedagogue of his day. A classical sense of symmetry and order infuses the National Assembly; a book on Scottish castles also inspired Kahn, who admired the rugged enclosures illustrated in it. Equally important, however, were his experiences in South Asia, to which he traveled frequently in the last dozen years of his life. He began by addressing Dhaka's climate, which is, during the monsoon, wet as well as hot. Arresting cutouts in "ruins wrapped around walls," as Kahn called them, while inspired by Mughal *iwans,* do less to protect the interior from water and sun than their architect hoped. They introduce ordered, layered spaces: outer ring of offices, interior circulation street, and assembly chamber (Figure 27.6). In a reversal of modernist orthodoxy, geometry rather than function structures a plan that Kahn intended to provide informal spaces for assembly. This echoes the way in which the use of much similarly

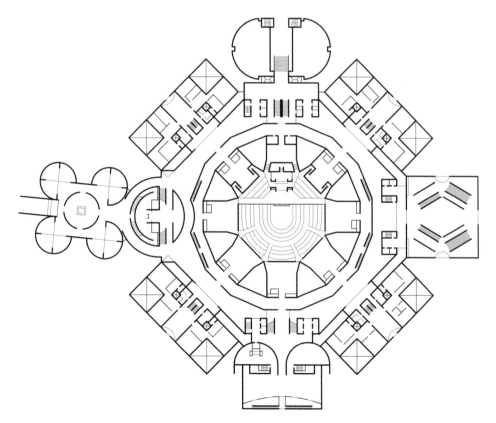

Figure 27.6. Plan, National Assembly, Dhaka.

structured early modern and vernacular space in South Asia changes according to the time of day and of the year.

For all his appreciation of history, Kahn remained a modernist, committed to abstraction. The closest he got in Dhaka to ornament were the inset marble strips. These faintly echo the polychromatic inlays of Mughal architecture. They also draw what was for Kahn characteristic attention to how a building is made. At a time when the custom in Dhaka was to cover roughly laid bricks or poured concrete with stucco, Kahn insisted on exposing well-finished raw materials. Training on this site provided a generation of local laborers with the construction skills that made them one of the country's most valuable exports. Kahn's engagement with identity reached its apex in the National Assembly's mosque, which he expanded to ten times the size the client had required. Here a Zionist Jew who shuttled back and forth between Pakistan and India during two wars between the two used light to invoke the sacred in a way that transcended any specific religious heritage.

During the 1960s and 1970s, as more locals received professional architectural training, there was a shift in developing countries away from imported expertise and toward hiring indigenous talent for even the most prestigious commissions. One of the landmarks of modern Indian architecture is Charles Correa's Gandhi Memorial Museum in Ahmedabad of 1958–63 (Figure 27.7). The museum provides

Figure 27.7. Charles Correa, Gandhi Memorial Museum, Ahmedabad, India, 1958–63.

the space through which visitors reach the ashram where Mahatma Gandhi lived during the last three decades of his life. As befits this champion of ordinary Indian peasants, the ashram is a place of great architectural simplicity, indebted to the local rural vernacular. And yet it is also a place of great sophistication, to which famous people from throughout the world once flocked to meet with one of the century's greatest political figures.

Correa achieved a delicate balance between respect for the scale and materials of the ashram and the well-educated elite's demand for buildings that participated in international architectural culture. Designed four years before Kahn was invited to build a business school in Ahmedabad, it was one of the first buildings anywhere in the world to quote Kahn's modest Bath Houses for Trenton, New Jersey's Jewish Community Center, finished in 1955. That structure consisted of four pyramidal roofed pavilions arranged around a square courtyard. Correa's expansion of this modular system rendered it less formal, while his use of local brick and tile, in addition to concrete, integrated it into indigenous building traditions. The result was a building that immediately attracted praise as one of modern India's best. One critic noted, "The plan by which a number of cubist structures were put together, isolating one from the other, succeeds in evoking, in permanent low cost material, the atmosphere which the prophet of Indian liberation, who was against machinery and technology, wanted for India."

Many of the same dilemmas that had confronted Indians since independence were faced by architects working in the Persian Gulf, a region transformed by the oil boom of the 1970s. With an even greater dearth of professional architects and without a well-established engineering profession, the Saudis and their neighbors in the United Arab Emirates and the other Gulf states turned to foreign experts in far greater numbers than had their South Asia counterparts. Architecture was becoming increasingly globalized as architects born in one country emigrated to a second and worked in a third. Candilis and Kahn, for instance, were born in what was then Russia, Woods in the United States. The talent imported into the Gulf now included fellow Muslims. Hassan Fathy, for instance, built many of his finest villas for Saudi patrons. Other Muslim architects took widely divergent positions across the 1980s, related in part to the functions of the buildings they designed, on the appropriate balance between tradition and innovation.

Few building types are as obviously modern as the airport terminal. Although much larger than the train stations and city gates they replaced as points of entry, airport terminals are seldom experienced as equally imposing. Islands in seas of asphalt located far from city centers, most were designed for convenience rather than aesthetic effect until the very end of the twentieth century. One of the rare exceptions was the Hajj Terminal of King Abdulaziz International Airport in the Saudi city of Jeddah (Figure 27.8). Built by the American firm of Skidmore, Owings & Merrill in 1978–81, with Gordon Bunschaft as the responsible architect, it is more an example of globalized architectural practice, however, than of the imposition

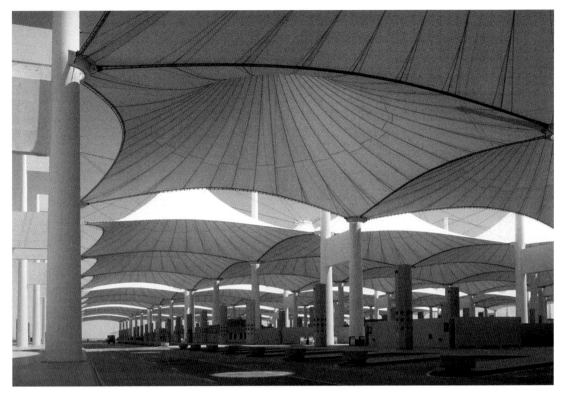

Figure 27.8. Skidmore, Owings & Merrill, Hajj Terminal, King Abdulaziz International Airport, Jeddah, Saudi Arabia, 1978–81.

of the West on others with their own distinctive heritage. The structural engineer responsible for many aspects of the design, Fazlur Khan, was a native of Dhaka who studied there and in Calcutta before immigrating to the United States. Other buildings on which Khan worked included the Sears Tower in Chicago, upon its completion in 1974 the tallest building in the world and still the tallest in the United States.

Every observant Muslim is required to make the hajj, the annual pilgrimage to the holy city of Mecca, once in a lifetime if he or she can afford it. The result is the largest peacetime movement of people on the planet. The logistics involved are enormous. The Hajj Terminal accommodates hundreds of thousands of pilgrims who arrive by plane and depart by bus. Only part of the structure is air-conditioned. Throughout, a tensile roof structure supported on an open grid of pylons offers protection from the scorching sun, while the semiconical form of the individual modules helps draw off hot air. A high-tech solution employing Teflon-coated fiberglass fabric, the terminal drew upon the latest structural solutions and materials while it evoked the tents used earlier by both hajj pilgrims and local nomads. The elegance of the solution led to its being imitated in very different circumstances. Denver International Airport, which opened in 1995, features a similar roof, described there as being appropriate to its setting next to the Rocky Mountains.

Not all the imported experts who worked in Saudi Arabia in the 1980s were as committed to modernism as were the architects of Skidmore, Owings & Merrill. The Island Mosque on Jeddah's corniche, designed by Abdel-Wahed El-Wakil, an Egyptian national practicing in London, was completed in 1986 (Figure 27.9). A fine example of postmodern historicism, the mosque was designed for worshippers traveling by automobile along the new seafront boulevard. As an urban marker seen in relative isolation in a way that had been unusual in Arab cities, it nonetheless faithfully repeated aspects of traditions cherished throughout the Arab world. Like Fathy, El-Wakil eschewed lavish ornament, preferring high standards of materials and understated decoration to the complex task of keeping handcraftsmanship alive at a time when most ornament was no longer the product of a well-paid and much-appreciated artisan elite.

The Island Mosque attracted high praise in the West, where it fulfilled aspirations for "Arabian Nights" exoticism on the part of those who rejected modernism if not modernity. The situation was quite different in Saudi Arabia, however. Here it seemed modern, as it bore little resemblance to the country's historic mosques. This highlights the way in which globalization can effect change within what appears to be historicist architecture. While Ottoman, Safavid, and Mughal mosques integrated references to the earlier architecture of the sites in which they were located, recent mosques around the world, many of them donated by Arab philanthropists,

Figure 27.9. Abdel-Wahed El-Wakil, Island Mosque, Jeddah, Saudi Arabia, 1986.

more often draw on imported precedents. These buildings are thus new within their individual settings even as they quote far-flung Islamic precedents, which they often combine in new ways.

How to preserve local identity and allow for the development of the expression of indigenous modernization at a time of rapidly increasing trade and instant communication poses enormous challenges. No one should be trapped in environments that preclude the possibility of change, nor should the preservation of craft maintain poor living conditions for those who still create alternatives to industrial products. Nor should the West's craving for exoticism or the desire of local elites to maintain social and political dominance define anyone's architectural identity. At its best, international architectural culture promotes dialogue, the dialogue that allowed Hassan Fathy to become a cult figure among Western environmentalists or Louis Kahn to inspire architects from Morocco to Tokyo. Like colonial urbanism, postcolonial modern architecture was the product of an unequal relationship with the rest of the world, but it was not specifically Western; the desires to which it responded effectively were local. Postcolonial architecture had to engage American and European architectural culture, with which it continued to have an unequal relationship, in order to have more than a local audience, but it also was capable of redefining that culture on its own terms.

FOR FURTHER READING

On the early Aga Khan Awards, see Renata Holod, ed., *Architecture and Community: Building in the Islamic World Today, the Aga Khan Award for Architecture* (Millerton, N.Y.: Aperture, 1983). On Fathy and ATBAT-Afrique, respectively, see Timothy Mitchell, *Rule of Experts: Egypt, Techno-politics, Modernity* (Berkeley: University of California Press, 2002); and Tom Avermaete, *Another Modern: The Post-war Architecture and Urbanism of Candilis-Josic-Woods* (Rotterdam: NAi, 2006). Eric Mumford, *Defining Urban Design: CIAM Architects and the Formation of a Discipline, 1937–69* (New Haven, Conn.: Yale University Press, 2009), chronicles the emergence from within of alternatives to modernist orthodoxy. On Chandigarh, see Vikramaditya Prakash, *Chandigarh's Le Corbusier: The Struggle for Modernity in Postcolonial India* (Seattle: University of Washington Press, 2002). For more on modern colonial and postcolonial architecture, see Tom Avermaete, ed., *Colonial Modern: Aesthetics of the Past Rebellions for the Future* (London: Black Dog, 2010); and Mark Crinson, *Modern Architecture and the End of Empire* (Aldershot, England: Ashgate, 2003). On Kahn, see in particular David D. Brownlee and David G. De Long, *Louis I. Kahn: In the Realm of Architecture* (New York: Rizzoli, 1991); Sarah Williams Goldhagen, *Louis Kahn's Situated Modernism* (New Haven, Conn.: Yale University Press, 2001); and Robert McCarter, *Louis I. Kahn* (London: Phaidon, 2005). On Correa and Khan, see Charles Correa, *Charles Correa* (London: Thames & Hudson, 1996); and Ali Mir, *The Art of the Skyscraper: The Genius of Fazlur Khan* (New York: Rizzoli, 2001).

28 Postwar Japan

For more than half a century, Japanese architects have maintained a balance between the architectural vocabulary of the modern movement and opaque, but nonetheless widely commented upon, references to premodern Japanese architecture. The architecture of postwar Japan demonstrates the ways in which ideas of tradition and innovation have intersected in the first non-Western country whose architects have played starring roles on the international scene. Regardless of national background, architects often have more in common with each other than they do with their own compatriots. Since at least the middle of the twentieth century, and often decades earlier, students in architecture schools around the world have read many of the same textbooks and looked at pictures in many of the same magazines. Throughout the world, American and European cultures, architectures, and languages have often swept aside local traditions that are more responsive to everything from social conditions to ecological construction and land use. Yet for more than sixty years, Japan's most celebrated architects, along with their Western advocates, have repeatedly understood their buildings as anchored in an ever-changing array of indigenous sources, whether preindustrial construction techniques, a distinctive sense of space, or Buddhist religious sensibilities.

For much of this period, moreover, Japanese architects have been unusually committed to technological expression. While modernism's original industrial aesthetic often faded in the postwar period, postwar Japanese architects have been particularly apt to embrace bold new engineering. Borrowing from the design of bridges, highways, and even vehicles for the exploration of outer space, the metabolists and their successors paid unprecedented attention to the expression of mechanical services and other infrastructure, which they paired with flexible or plug-in components. The standardization of interchangeable wooden members had long been a part of Japanese frame construction; now many of the same principles were transposed into

construction in reinforced concrete and skeletal steel systems, while wooden brackets provided precedents for daring cantilevers.

As a result of this compelling mix of obvious innovation and apparent tradition, Japan has in the postwar years played a leading role in international architectural culture. The Japanese have integrated international architectural trends with their own circumstances and traditions without being accused of betraying modernist ideals, not least because these ideals were often anchored in specifically Japanese precedent. At the same time, they have successfully balanced the need to be recognizably Japanese for an international audience and to be internationally up-to-date from both foreign and domestic points of view.

The cult of Japanese design that has resulted encourages the assumption that Japan is a country of beautifully designed places in which the market forces that contribute to chaotic environments in the rest of the world play only a minor role. A glimpse of almost any commercial street in postwar Tokyo at any point in the last half century reveals that this is not the case (Figure 28.1). Practices such as those discussed below remain as exceptional in Japan as they are elsewhere, although certainly standards of construction are currently unusually high there. How have issues of identity played out in the work of Japanese architects who, like their most

Figure 28.1. Ginza, Tokyo, Japan, circa 2010.

ambitious counterparts abroad, see their work as a method of intellectual inquiry that contributes to the shaping of form?

Almost any discussion of modern architecture in postwar Japan begins with the Peace Center, which Kenzo Tange designed and built in Hiroshima from 1949 to 1956 (Figure 28.2). Modern architecture was not new to Japan. As early as the 1920s, Japanese architects and Western architects practicing in Japan—notably Frank Lloyd Wright and Antonin Raymond—had erected buildings that demonstrated their familiarity with the work of the American and European avant-garde. Several Japanese architects worked in Le Corbusier's office in the 1930s. Nonetheless, it was only after 1945 that Japanese modernism achieved international renown and that modernism was widely used for civic architecture in Japan. With Japan's defeat in World War II, the nationalist practice of dressing modern construction techniques and functions in traditional Japanese or academic Western stylistic dress collapsed.

The Peace Center had an international impact unlike that of any previous example of modern architecture in Japan. One reason for this was its function. Regardless of nationality or politics, most people around the world regarded the dropping of the atomic bomb on Hiroshima as one of the most significant and terrifying events in human history. Any building that served as an architectural marker of the instantaneous destruction of an entire city using this revolutionary technology was sure to achieve prominence, almost without regard to its appearance. Tange, who had not previously designed any building that attracted much attention even in Japan, managed to synthesize two of the leading stylistic trends in international architectural culture, pairing the elegantly proportioned frame of Mies's pavilions with the rugged articulation in concrete and *pilotis* popularized by Le Corbusier. Furthermore, he managed to infuse this synthesis with something that was recognized

Figure 28.2. Kenzo Tange, Peace Center, Hiroshima, Japan, 1949–56.

as characteristically Japanese without undercutting the modernity of the result. The design of part of the surrounding garden was also obviously Japanese, while the framing system echoed historic Japanese as well as modern Miesian architecture. Even the emptiness of the plaza, one of the conspicuous failings of many urban schemes of this period, succeeds in this case. It poignantly evokes what is no longer there. The success of Tange's design for the Peace Center was aided by the admiration that the American and European pioneers of the modern movement had for premodern Japanese architecture. Wright, Gropius, and Taut all traveled to Japan and wrote admiringly of the Katsura Imperial Villa in particular.

The Olympic Games were crucial to the reintegration of the countries defeated in World War II into the international community. In 1960, the games were held in Rome, in 1964 in Tokyo, and in 1972 in Munich. In each case (as well as in 1968, when they were held in Mexico City), celebrated local architects designed the new athletic facilities required. In Rome, Tokyo, and Munich, these impressive buildings also marked the host countries' turn away from architectural historicism and thus nationalism. The architects of all these Olympics fused architecture and engineering. Tange's National Olympic Gymnasium and Annex for the 1964 games remained specifically Japanese, however (Figure 28.3). A number of commentators compared the profiles of the buildings' roofs to premodern Japanese structures such as the *minka* house.

Figure 28.3. Kenzo Tange, National Olympic Gymnasium and Annex, Tokyo, Japan, 1964.

Tange's designs masterfully replaced the industrial metaphors crucial to the first generation of the modern movement with the engineering that had only recently come to represent modernity. Crucial here, as in the Centennial Hall built in Wrocław a half century earlier, was the creation of uninterrupted space—no one wanted to sit behind a column! Tange achieved clear spans by hanging the roof from ridgepoles, using the same technology as that employed in suspension bridges. The excitement of the building lay in the boldly sculptured profiles he thus achieved, rather than in the quality of the detailing, which was seldom high in this period anywhere in the world. Tange, like many of his most celebrated contemporaries, focused on space and structure.

In Hiroshima and in his buildings for the Olympics, Tange worked within an idiom that was Western in origin, into which he injected specifically Japanese elements in order to achieve a modernism that was understood at home and abroad as uniquely Japanese. Many Western commentators denied the possibility of indigenous modernization emerging within a non-Western context, but Tange disproved their assumptions. His plan for Tokyo Bay, a project of 1960, was the first systematic alternative to Le Corbusier's tower-in-the-park planning to emerge from within the modern movement (Figure 28.4). This plan called for expanding Tokyo, then the world's most populous city, by building out over the water. Tange envisioned monumental masts and platforms onto which more individualized and potentially disposable elements, including entire buildings, could be placed. He contributed the highways that connected them but did not attempt to design the buildings themselves, which would be more flexible than this infrastructure. Like the roof of his National Gymnasium, the profiles of these platforms evoked premodern Japanese roof forms.

Tange's scheme responded to the impermanence of modern consumerism as well as the destruction of vast swaths of Tokyo, first in the fires that followed an earthquake in 1923 and then again by American bombers at the end of World War II. Tange recognized that modernism's emphasis on function was antithetical to the desire for architectural permanence characteristic of much postwar modern architecture, particularly the monumentality espoused by Le Corbusier and those who embraced his energetic use of concrete. Envisioning buildings as part of an integrative system, Tange created a technologically innovative frame for flexible and varied activities. He balanced the ephemeral against the permanent here in a way that proved to have enormous appeal. This project, developed as the result of a studio he taught at the Massachusetts Institute of Technology in the United States, was the single most important urban planning proposal of its day. It inaugurated the megastructural or—as it was usually called in Japan itself—metabolist movement, which dominated architectural culture in many parts of the world during the 1960s. The Japanese remained in the forefront, realizing actual buildings as well as designing unbuildable projects intended to stimulate intellectual inquiry and establish the reputations of young architects.

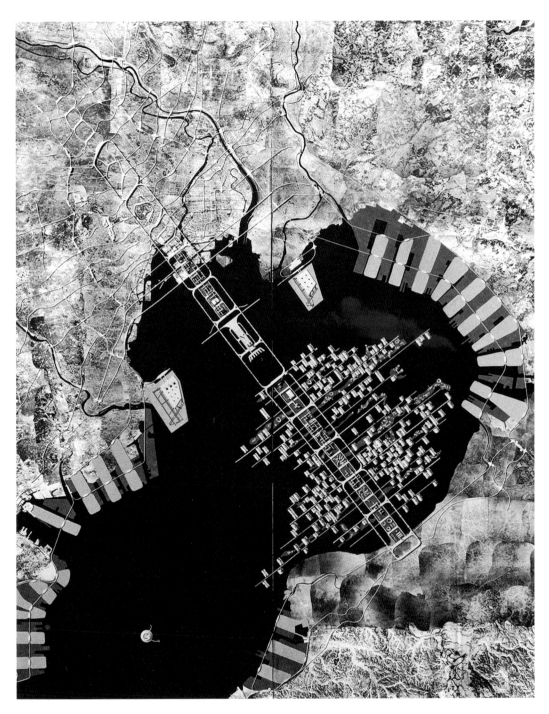

Figure 28.4. Kenzo Tange, plan for Tokyo Bay, 1960.

One of these was the Nakagin Capsule Building, which Kisho Kurokawa erected in Tokyo in 1972 (Figure 28.5). Japanese architects who adopted a megastructural approach were responding to an urban context that featured multiple modes of transportation. The immediate environs of the Nakagin Capsule Building included a multilane highway, elevated train tracks, and utility poles and wires. The building itself consisted of a mast into which individual modules could be plugged. (The metabolist emphasis on systems of masts connecting pod-like nodes hosting activities rather than infrastructure was inspired in part by the giant model of an iron atom erected in Brussels for the World's Fair of 1958.) Ideally, the mast would be permanent and the modules updated according to the latest technology, although this never happened. Because the megastructuralists were enamored of prefabricated construction, the studio apartments, designed for businessmen who would return to their suburban houses only on weekends, were constructed off-site. Many of those who experimented with these techniques found, to their chagrin, that it was cheaper to assemble buildings on-site than to have them manufactured elsewhere. A half century after it was developed, the rhetoric of the modern movement still sometimes failed to accord with the reality of one of the world's most advanced construction industries.

Kurokawa's idea was that instead of large amounts of space, at a premium in any city the size of Tokyo, tenants would be provided with high-tech amenities. These were certainly state of the art at the time. They included a typewriter, a calculator, a telephone, a television, a tape deck, and a clock. Furthermore, the entire building was air-conditioned. The window shutters worked like camera apertures. More than forty years later, the rooms look dated because these technologies have all changed so much.

The Capsule Building was actually a relatively late example of megastructural architecture. During the 1970s in Japan, as elsewhere around the world, avant-garde architects rejected the primacy of technology as the determinant of architectural form. Why did this happen? A new awareness of the environmental damage caused by industry, coupled with the oil crisis of 1973, left many people around the world less convinced of modernism's equation of technology with progress. Three Japanese architects proposed radical alternatives to the megastructural movement.

A new asceticism could verge on inhabitability, as in the house Kazuo Shinohara built in 1974 for the poet Shuntaro Tanikawa in Nagano (Figure 28.6). Shinohara completely rejected the consumer culture whose constant flux had fascinated the metabolists. From technology he turned toward abstraction rooted in Zen Buddhism. Nothing about the exterior of the simple wooden house appears unusual, although the planks were laid with great care in a fishbone pattern. This offers the first clue about the importance of site and materials to an architect who repeatedly pushed these aspects of his design to the fore.

In plan the house has two distinct areas. A vast open area supported on two posts is the summer space. Next to it are the much smaller conventionally habitable spaces

Figure 28.5. Kisho Kurokawa, Nakagin Capsule Building, Tokyo, Japan, 1972.

Figure 28.6. Kazuo Shinohara, interior, Shuntaro Tanikawa House, Nagano, Japan, 1974.

for bathing, cooking, eating, and sleeping. The first thing to note about the summer space is that Shinohara placed the house directly on the earth. Instead of covering the ground with a floor, he celebrated the steep grade of the site and the difficult orientation it provided. In this way he recalled an aspect of the *minka,* without, however, evoking its forms literally. He paid equal attention to support. The glazed side walls are partially screened by exposed and exaggerated bracing; the two posts supporting the ceiling received similar monumental treatment. There is a palpable sense here of how things are made of materials that are natural rather than industrial. This was an attempt to return, in a philosophical as much as a physical sense, to a closer relationship with nature, to purify architecture of the engagement with technology that had been strong among the metabolists and to focus instead on the primacy of the senses. The point was neither beauty nor comfort, but instead the creation of a place whose sternness resisted compromise with the circumstances of ordinary daily life.

Shinohara's work remained obscure. In comparison, that of Tadao Ando came during the 1980s to embody the balance between contemporary international fashion and Japan's particular heritage that Tange had represented a quarter century earlier. The Koshino House in Kyoto, built in 1981, cemented Ando's international reputation (Figure 28.7). Like Shinohara, Ando favored an extreme simplicity of

Figure 28.7. Tadao Ando, Koshino House, Kyoto, Japan, 1981.

means. The house consists of two concrete blocks connected by a stair. On one side are the bedrooms and two tatami rooms, on the other the kitchen, dining, and living rooms. The understatement of this architecture and the unsentimental concrete out of which it is built combine to create a place almost entirely disengaged from conventional domesticity. A Japanese house of this size and solidity set so expansively into the landscape is by definition extremely expensive, but nothing here conveys that luxury directly. Note, too, the way in which Ando built the house into the site. Much less extreme than Shinohara's, this is still an architecture that refuses to celebrate the itinerant aspects of modernity crucial to Kurokawa.

Until the 1990s, Ando built nothing outside Japan, yet he was numbered among the most respected architects in many different parts of the world. The Koshino House and the work that followed were typically lauded as being rooted in the same Zen Buddhism that had inspired Shinohara. Kenneth Frampton, a British-born professor of architecture at Columbia University in New York, identified Ando as an example of what he termed "critical regionalism." Frampton advocated critical regionalism as an alternative to the emphasis the postmodern architects discussed in the following chapter were placing on symbolic and historicist form. He wanted to reinstate the distance between architecture and mass culture characteristic of the work of architects such as Mies and Kahn, a gap that postmodernism had narrowed, especially in the United States. For Frampton, the elemental geometry of the Koshino House and its sense of rootedness imbued it with a late twentieth-century version of the timelessness that earlier critics had admired in Richardson's Ames Gate Lodge.

The degree to which Ando's architecture was specifically Japanese remains an open question. Certainly his use of light as ornament oriented the house's occupants to the times of the day and the path of the sun in a particular place. Nothing about the house refers directly, however, to its suburban Japanese context, to which Ando created a compelling alternative. At a time when even large Japanese buildings were being constructed by design-build firms without the participation of independent architects, Ando focused on the art of architecture and of its construction in ways that seem to have been at least as indebted to Kahn as to local premodern precedents.

Another famous Japanese architect took a very different approach to the collapse of the metabolist movement with which he—unlike Shinohara and Ando—had once been associated. When during the second half of the 1960s postmodernism's often originally ironic recall of history began to offer an alternative to metabolism's intertwined emphasis on infrastructure, especially mechanical systems, and its oscillation between permanence and flexibility, Arata Isozaki partook of the opportunities it offered to experiment with form and materials. Unlike most non-Western architects attracted by this new stance, he did not seek to review the traditions of his native country. Instead he made frank use of Western historical precedent in designs such the City Center in Tsukuba, completed in 1983 (Figure 28.8). The most notable of Isozaki's quotations here is the paving of the plaza, which refers to the Campidoglio, a plaza in Rome designed by Michelangelo. Others include the

Figure 28.8. Arata Isozaki, City Center, Tsukuba, Japan, 1979–83.

repetition of the stone panels with aluminum bolts of Otto Wagner's Post Office Savings Bank in Vienna of 1906. Isozaki justified his decision in terms of creating a space representative of the nation-state, even one with a relatively short history of neoclassical civic buildings. He wrote, "From the beginning, there was an issue at hand that I felt compelled to address: what architectural style should I impart to the Tsukuba Centre Building?" He continued:

> Neo-classicism adds calculated mass and volume to the classical system. To the last details, it adheres to over-all proportions and is always lucid and transparent. It might be called the visualization of order extending to the interior as well as the exterior. Nothing could be better suited to the needs of governments, which need to enforce their will to the last details too, than this virtually perfect architectural style. It is not only because of the ease with which it gives a monumental appearance that, for over a century, governments have used it in their institutions. A still more important reason is the way a style in which order pervades everything is useful in stimulating a clear awareness of the presence of the state structure throughout a domain.

Despite this talk of order, the plaza is frankly sensual and decorative, exactly what Shinohara's and Ando's houses were not. It was this absence of austerity that endeared postmodernism to those who found modernism, and even critical regionalism, to be at best banal and at worst inhuman. Of all the Japanese architects of the past half century who have achieved international stature, Isozaki is the one, not surprisingly, who has been most comfortable building abroad. Although, like Tange, he wrote a book on Katsura, which he also saw as quintessentially Japanese, he believed himself and his countrymen to be equally entitled to the architectural heritage of the rest of the world. Entirely modern and also prosperous, these Japanese refused to see themselves as constricted to a single tradition. Moreover, by the 1980s, they could convince others of the appropriateness of their choices.

Ando and Isozaki continue to be important architects, entrusted with prestigious commissions around the world. The postmodernist and critical regionalist positions with which they are associated no longer fill the pages of architecture magazines, however. Since the early 1990s, new positions have emerged in Japan, as elsewhere. In particular many of Japan's leading architects have returned to the favorite issues of their metabolist predecessors: technology and consumer culture. Both are present in the Kinbasha Pachinko Parlor II designed in Naka by Kazuyo Sejima, which opened in 1993 (Figure 28.9). In this relatively inexpensive and provincial commercial building, where a pinball-like game is played in a setting that resembles a games arcade, Sejima celebrates with almost Miesian elegance the material properties of glass.

From the beginning, postmodernism entailed not only the revival of historical forms but also the acknowledgment that forms have meanings. In the United States, Robert Venturi and Denise Scott Brown famously advocated decorated sheds, in which meaning was applied like wallpaper to multipurpose boxes. They preferred

Figure 28.9. Kazuyo Sejima, Kinbasha Pachinko Parlor II, Naka, Japan, 1993.

these sheds to buildings they called ducks, whose forms were explicitly tailored to their function—buildings that Aldo Rossi warned could quickly become obsolete, thereby depriving a culture of its memory. Although it is difficult to believe that the Kinbasha Pachinko Parlor is likely to become a historical monument, Sejima certainly applied meaning in the way in which Venturi and Scott Brown advocated. In order to maximize the street front, the front of the building is longer than the warehouse-like space containing the gaming machines. Enormous lettering, large enough to attract the eye of anyone in a car speeding by on the broad boulevard beyond, doubles as advertising and decoration. However, more than two decades after the publication of Venturi and Scott Brown's classic book *Learning from Las Vegas,* Sejima did not show her predecessors' ambivalence about modernist forms and materials, which here coexist comfortably with popular culture.

By the mid-1970s, the appeal of the megastructure had collapsed. High-tech architecture seemed to most observers to have reached a dead end. No longer would architects, their clients, and their publics construct their identities in terms of the human relationship with the machine. Many people around the world instead

believed in the importance of history, as cultivated by Isozaki, for instance, or of the sensuality that appeared to reside outside time, as courted by Ando and Shinohara. Only a few European architects kept the flame alive, most notably Richard Rogers and Renzo Piano in the Centre Pompidou in Paris, which opened in 1978. Today, however, architectural culture in many countries around the world, but nowhere more than Japan, has returned to an engagement with technology as a way of representing the new. Calling this development neomodernism emphasizes its historicist character.

Dana Buntrock has described the Mediatheque in Sendai by Toyo Ito (Figure 28.10), completed in 2001, as the most innovative building from an engineering perspective since Norman Foster's Hong Kong and Shanghai Bank, completed in 1986. Sejima, who worked for Ito before establishing her own independent practice, collaborated with him on the interior design of the Mediatheque's ground floor; the two have in common an interest in transparency. The building has an unusually innovative structural system. Instead of the rigid steel or concrete columns of conventional skeletal construction, Ito used lattices of hollow tubes, whose sculptural forms clearly break with the rectilinear rigidity of the system they replace. In late nineteenth-century Chicago, structural steel had to be wrapped in terra-cotta, brick, stone, or concrete in order to protect it from collapsing in a fire. Ito, however, had access to new kinds of glass that enabled him to expose his structural system.

Figure 28.10. Toyo Ito, Mediatheque, Sendai, Japan, 1995–2001.

Structure alone did not dictate the appearance of this building, designed to symbolize the new communications technologies that are housed inside it, including access to the Internet. While these communications systems, like Ito's pioneering structural system, are entirely new, the glass box, as developed by Mies van der Rohe eighty years before Ito's building was completed, still conveys modernity. We seem unable in the early twenty-first century to invent a novel image of the new. In that sense, the Mediatheque is more frankly historicist and thus more emphatically postmodernist than the Tsukuba City Center.

At least three other aspects of the building elaborate upon modernist precedents. The way in which Ito designed it to be viewed across the course of the day, with interior lighting schemes that contribute to its appearance from the street, has justly attracted attention. This echoes the theatrical abstraction developed by Taut and Mendelsohn in Germany during the 1910s and 1920s, which went out of fashion following the emotionally effective use to which Speer put searchlights. The flexible space provided by Ito's relatively open plan, interrupted by columns rather than walls, recalls the floor plates of postwar office buildings and the space frames popular a decade or two later. Finally, although Le Corbusier advocated a double glass skin to moderate climate conditions on the interior of the Swiss Pavilion he built in Paris in 1932, only recently have engineers created new kinds of glass that achieve this. This glass has the additional advantage of enormous strength, allowing Ito, like Sejima, to use large plates held in place with minimal, and in this case beautifully detailed, fasteners.

Today Japanese architecture is celebrated above all for its exquisite detailing, which is seen as a historical continuum with buildings such as Katsura. Certainly contemporary Japanese construction is at its best unmatched in the world today, but these standards are no more intrinsically Japanese than Katsura was typical of preindustrial Japanese architecture. Foreign visitors to Tange's early work often commented on the crudity of its concrete. Indeed, an ever-changing variety of architectural features have been identified as intrinsically Japanese over the course of the past fifty years. Tange's skeletal construction in concrete was seen as miming wooden forms; his sculptured roof profiles recalled those of premodern vernacular architecture. Shinohara and Ando instead emphasized the ways in which their buildings were sited and constructed, evoking experiential qualities that their champions often associated with Zen Buddhism. Sejima and Ito are premier examples of the country's contemporary association with high-tech craftsmanship. Japan's architects have succeeded on the world stage consistently on their own terms, without respect for the past impeding their reimagining of the present.

FOR FURTHER READING

The original Japanese engagement with modern architecture is detailed in Jordan Sand, *House and Home in Modern Japan: Architecture, Domestic Space, and Bourgeois Culture, 1880–1930* (Cambridge, Mass.: Harvard University Press, 2003); and Ken Oshima, *International*

Architecture in Interwar Japan: Constructing Kokusai Kenchiku (Seattle: University of Washington Press, 2010). On the connection between interwar European modernism and postwar modern architecture in Japan, see Jonathan Reynolds, *Maekawa Kunio and the Emergence of Japanese Modernist Architecture* (Berkeley: University of California Press, 2001). For a general overview, see David B. Stewart, *The Making of a Modern Japanese Architecture: 1968 to the Present* (Tokyo: Kodansha International, 1987). Zhongjie Lin, *Kenzo Tange and the Metabolist Movement: Urban Utopias of Modern Japan* (London: Routledge, 2009), offers a useful introduction to this aspect of postwar Japanese architecture. For essays on critical regionalism and on Ando, see Kenneth Frampton, *Labor, Work and Architecture: Collected Essays on Architecture and Design* (London: Phaidon, 2002). Arata Isozaki and Ken Oshima, *Arata Isozaki* (London: Phaidon, 2009), includes Isozaki's quote on the City Center in Tsukuba. Useful introductions to contemporary Japanese architecture are available in Dana Buntrock, *Japanese Architecture as a Collaborative Process: Opportunities in a Flexible Construction Culture* (New York: Spon Press, 2001); and Ron Witte and Hiroto Kobayashi, eds., *Toyo Ito: Sendai Mediatheque* (Munich: Prestel, 2002).

29 From Postmodern to Neomodern

The United States and Europe

etween 1965 and 1985, much of the European and American public turned away from modern architecture. Gradually, the architectural profession returned to the temporarily discredited paradigms, and the public has slowly followed. The reasons that modernism's original emphasis on technology, as revived in the megastructural movement of the 1960s, fell out of favor included its association of industry and engineering with progress. That idea faded as people became more concerned about what is now known as sustainability and was then termed the environment. Both industrial and engineering imagery had come to stand for economic and civic institutions that were increasingly seen in the late 1960s as unresponsive and arrogant. At the same time, the notion that architectural plans should be diagrams of function came to seem inhumane. In particular, low-income housing projects, when badly kept and policed, were deemed to have contributed to the alienation of the poor from the larger society. In fact, inadequate maintenance of this housing and society's failure to provide the projects' tenants with jobs and other meaningful occupation were more to blame than any type of building.

By the mid-1960s, few trusted architects to provide a future that would be better than the past that they seemed so determined to erase. For the American intelligentsia, this became clear when New York's Pennsylvania Station was torn down in 1963. Opened in 1910, Charles McKim's design endured for barely half a century. Vincent Scully, the preeminent American architectural critic of the time, wrote in 1969 describing its loss:

> Old Pennsylvania Station was all public grandeur, embodying a quality too rare in America. A later generation was to deride its formal dependence on the Baths of Caracalla. One is less sure than one used to be that such was a very relevant criticism at all. Much more memorable now that it is gone is the rhythmic clarity of the generous big

spaces of the station and the majestic firmness with which the great piers and columns and the coffered vault defined them. It was an academic building at its best, rational and ordered according to a pattern of use and a blessed sense of civic excess. It seems odd that we could ever have been persuaded that it was no good and, finally, permitted its destruction. Through it one entered the city like a god. Perhaps it was really too much. One scuttles in now like a rat.

In place of the International Style, Scully championed a sophisticated Arts and Crafts–era reworking of American vernacular architecture for domestic uses, eventually joined by classicism for civic purposes. Robert Venturi heeded Scully's call when he built a house for his mother in the Philadelphia suburb of Chestnut Hill in 1962 (Figure 29.1). Venturi rejected both the tract houses being built in American suburbs from coast to coast and the abstract alternatives offered by fellow architects. In their place he cited the Low House of 1887 by McKim, Mead, and White, demolished in 1962, the most prominent feature of which had been an enormous gable. He repeated its profile but split the composition open to reveal the thinness of the Vanna Venturi House's unusual green walls, which neither conveyed the solidity of the original's shingled surfaces nor repeated the transparency of most modernist dwellings. Instead, their billboard-like quality recalls the material properties of the original cardboard model.

Figure 29.1. Robert Venturi, Vanna Venturi House, Philadelphia, Pennsylvania, 1962.

It is almost impossible to reconstruct what a radical act even this far-from-forthright use of historical precedent and ornament was at the time. Criticisms of tower-in-the-park urbanism and an industrial aesthetic had emerged from within the modernist movement in the 1950s, but the alternatives remained abstract. Venturi's willingness to ornament his facades with motifs that were clearly entirely unrelated to the building's structure was new. Equally startling was the willful eccentricity of the almost gawky design. The house unleashed a controversy that continued for nearly two decades before the building's iconic status was widely accepted, at least within the United States. Many architects were almost as angry that Venturi had purposely not built a beautiful building as that he had rejected many aspects of modernism. For instance, in addition to the historic quotations, he had carefully distinguished between the front and rear facades rather than treating the house as a piece of abstract sculpture in the round. The facades, meanwhile, hinted at the degree to which ambitious American architects would for the rest of the century replace open plans with layered spaces.

Venturi was inspired above all by his love of the baroque, which could not be accommodated within the modern movement. He reintroduced history to contemporary American architectural practice, but he seldom quoted from it literally. Nor did any other American or European architectural firm of note until the 1980s. Only in 1977 did Charles Jencks attach the label *postmodern* to the work of those architects who had already for a decade and a half been challenging what was understood to be modernist orthodoxy. Another of these architects was Venturi's wife, Denise Scott Brown. She brought to the partnership a fascination with pop art and an unusual respect for the everyday. As an emigrant from South Africa by way of London, she insisted on analyzing the ordinary American environments that most architects of her generation simply deplored. Scott Brown argued instead that one had to understand how tract houses, suburban strips, and even Las Vegas hotels communicated messages that the general public could grasp.

The question was whether the consumer was actually driving design or whether, as Marxists argued, the market was being manipulated by profit-driven capitalists who used advertising to create demands for products and places—such as Las Vegas—that people had not previously known existed and that satisfied no real need. Those who believed the first tended to define themselves against popular taste every bit as much as those, such as the German cultural social theorist Theodor Adorno, who blamed capital for deceiving the masses. For years Venturi and Scott Brown had very few supporters, even though their work accorded in part with the shift from abstract expressionism to pop art and addressed the increasing hostility that even well-educated members of the general public often had toward modern architecture.

Far more obviously pleasurable was the work of Charles Moore. Moore was less interested in how architecture conveyed meaning than he was in creating spaces that were interesting to inhabit. The breakthrough project for his young collaborative

practice, Moore, Lyndon, Turnbull and Whitaker (MLTW), was an early condominium project at Sea Ranch on the Northern California coast, begun in 1964 and completed in the following year (Figure 29.2). Developing this former grazing land was controversial, and to allay concerns that it would soon resemble suburbia, Moore and his partners originally clustered the dwelling units in order to leave as much open land as possible. They completely rejected the flat-roofed glass boxes associated with advanced modern residences in favor of vertically laid wooden siding and angular profiles that referred to the architecture of local barns as well as the Bay Area's long tradition of woodsy modernism. This was in many ways the local equivalent of the understated approach Moore's friend Correa had taken in Ahmedabad. MLTW grouped the ten duplexes around a courtyard that recalled in miniature the medieval Italian plazas that fascinated their generation of American architects, offering an intimate alternative to the vast open spaces associated with Corbusian urbanism.

Despite their deep roots in two earlier generations of Bay Area architecture, the results were heralded nationally and internationally as a significant revision of modernism, one that was ecologically sound and culturally sensitive. What was new was the sense of fun, which paired the region's abiding commitment to informality

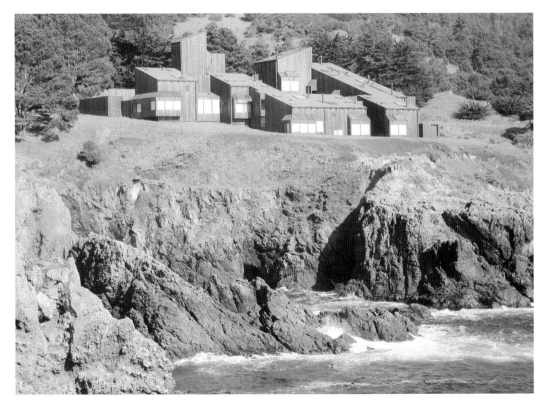

Figure 29.2. Moore, Lyndon, Turnbull and Whitaker, Condominiums, Sea Ranch, California, 1964–65.

with the emerging counterculture, which soon led to the so-called Summer of Love in San Francisco in 1967. This could be seen in the original decor of Moore's own unit, including the tented bed that could almost have been in one of the communes into which many hippies soon moved. Throughout his career, Moore experimented with participatory design, in which he would brainstorm with large client groups, such as church congregations, on the preliminary phases of design development.

Meanwhile, in Europe another criticism of modernist architecture and urbanism was emerging. Similar in its broad outlines to its American counterpart, whose references were often too insistently local for outsiders to grasp, it was led by the Italian architect Aldo Rossi. Where American postmodern architects began with buildings and moved only slowly to the scale of the city, the Europeans were much more critical of modern urbanism than of modern architecture. Rossi specifically proposed that the city is the locus of collective memory. His criticism of functionalism appealed to Europeans who wanted buildings that would respond so sensitively to their urban contexts that they would be cherished even when their original uses were rendered obsolete. Adaptive reuse had a far longer history in Europe than in the United States, although for much of the twentieth century, nineteenth-century commercial buildings remained vulnerable to demolition.

Although Rossi focused on the city, his breakthrough project, the Cemetery of San Cataldo in Modena, was located in the suburbs. He began work in 1971 on this expansion of a walled nineteenth-century cemetery that provided a well-defined foil for his original conception of a firmly enclosed counterpart (Figure 29.3). Because he focused on almost banal blank form rather than the details of construction and finish, the completed buildings were not as compelling as his haunting drawings.

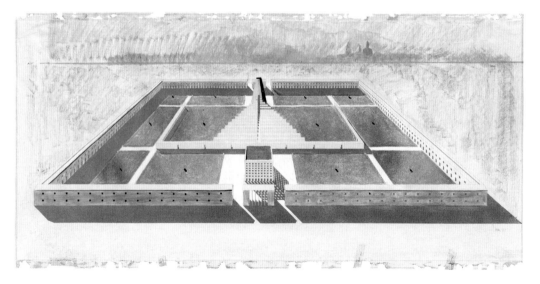

Figure 29.3. Aldo Rossi and Gianni Braghieri, aerial perspective, Cemetery of San Cataldo, Modena, Italy, 1971–84.

Rossi's evocation of classical order was as controversial as Venturi and Scott Brown's flirtation with advertising. Many in Italy and elsewhere believed that classicism remained contaminated because fascists had used it. For Rossi, who like many Italian intellectuals of his generation supported the Communist Party, classicism was too important to be easily sacrificed, yet at the same time he always avoided the direct imitation of its decorative details. Two sorts of remains are accommodated in the cemetery. Bodies are set into vaults along the sides of long passage-like buildings, supported on piers and capped with peaked blue roofs. Cremated remains are tucked inside the metal skeletal supports of a red stucco cube with a grid of window-like openings. In both settings Rossi, in an effort to achieve a timelessness in keeping with the complex's function as well as his theories, balanced abstraction with an invocation of the universal.

Rossi's challenge to Corbusian urbanism had a profound if not an immediate impact. Following his example, many architects began to pay increasing attention to typology, the study of the organization of a building type, rather than to style. This enabled them to match the scale and proportions of older buildings without imitating their details or forsaking modern materials. The most brilliant convert to the cause was the English architect James Stirling. His design for the Neue Staatsgalerie (New State Gallery) in Stuttgart, Germany, begun in 1977 and opened in 1984, harmonized with an existing museum as well as linked the residential neighborhood behind the museum with the center of the city (Figure 29.4).

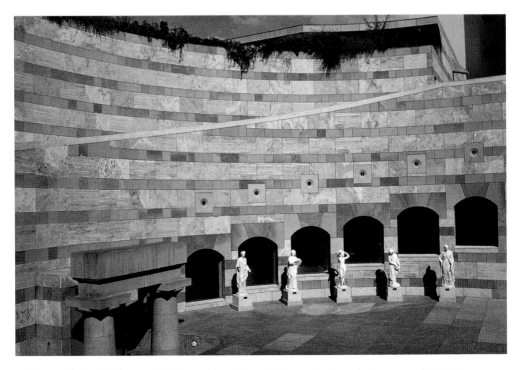

Figure 29.4. Stirling and Wilford, New State Gallery, Stuttgart, Germany, 1977–84.

Postmodernism posed a dilemma for those West Germans who had embraced modernism because of the distance it was (not always accurately) perceived as putting between themselves and the Third Reich. They turned repeatedly to foreign architects for prestigious commissions, not least for impressive cultural buildings that signaled their espousal of democratic values. Only a foreigner from one of the countries that had defeated Germany could revive the plan of Schinkel's Altes Museum, as Stirling did here. Even then, it was possible only because Stirling left his rotunda open to the sky, with plants growing out of the top of it as if it were a ruin.

Stirling, who devoted relatively little attention to the monotonous and poorly lit galleries, was not particularly interested in classicism, however. Instead, the two architectural problems that most engaged him were circulation and locating his building in relation not only to its immediate neighbor, of which it was technically an extension, but also to a larger history of architecture, especially museum architecture. In addition to the Altes Museum, Stirling invoked the Centre Pompidou, and probably also Stuttgart architect Paul Bonatz's Kunstmuseum in Basel of 1936, not to mention the dozens of other sources he gladly acknowledged. Creating a dialogue between alternating bands of sandstone and travertine, perhaps borrowed from Bonatz's alternation of limestone with granite, and the acid green, lipstick pink, and electric blue of the steel detailing inspired by the Pompidou, Stirling subverted modernist expectations. Most of the steel is clearly ornamental, while the lack of mortar between the stones makes it obvious that they are plates clipped onto a hidden frame. While he quoted the Centre Pompidou's exposed mechanical systems in two oversized ventilation funnels at the back, Stirling's building is far less monumental in relation to its setting.

To counter the formality of Bonatz (whose museum also featured an unroofed courtyard) and Schinkel without wholeheartedly adopting the mechanical imagery favored by Rogers and Piano, Stirling emphasized the degree to which the center of his building belonged not to art but to the public. There are two separate paths through it. Both are reached by ramps that reprise Le Corbusier's favored alternative to monumental staircases and bring visitors to the platform on which the museum sits atop underground parking. One path is open at all hours. It runs around the side of the rotunda and does not intersect with spaces devoted to the display of art. The other brings people directly into the rotunda and its adjacent terraces from the galleries. Perched high above the street, it frames views of the city center and, in good weather, of the tourists lolling on the ramps. At a time when the commercialization of the public sphere was about to become a major issue, Stirling created a multilevel stage set on which visitors, their activities, and their conversations were showcased with more bravura than was the actual art.

Rossi and Stirling were serious, but the best American postmodernists continued to cultivate a lighter touch, one that was comprehensible, moreover, to those with less acquaintance with architectural history. By the end of the 1970s, certain challenges to modernism were themselves becoming orthodoxy. These included an

attention to context, especially in the choice of materials, and the claim that buildings should meet the street rather than be set back in arid plazas. No one had more fun with these ideas, or used them more effectively to further the development of his own career, than Frank Gehry.

In 1978, when Gehry converted an ordinary Santa Monica bungalow, erected half a century earlier, into a wry comment on the state of contemporary architecture, Los Angeles was more synonymous with suburban sprawl than with serious architecture (Figure 29.5). Gehry, an experienced architect with fifteen years of practice behind him, had built nothing that had attracted much attention. Now, soon after designing the installation of a pioneering exhibition of Russian constructivist art, he

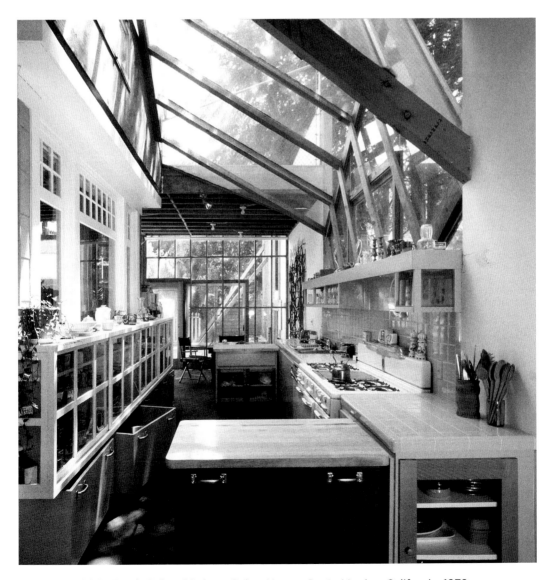

Figure 29.5. Frank Gehry, kitchen, Gehry House, Santa Monica, California, 1978.

made a mockery of the new fascination with historicism, with nineteenth-century urbanity, and with context. Being careful to meet the street line—in this case by adding a very low boundary wall that he painted the aqua blue used for the interiors of swimming pools—he created new space by exploding the house outward, including over the driveway. The odd angles at which he set the new walls and combined materials seemed to destabilize familiar domesticity.

By applying strategies intended to reconnect contemporary architecture with classical tradition to a relatively recent vernacular house, Gehry breathed new life into modernism. The contexts for which he professed an earnest reverence included the asphalt floor of his kitchen and the timber frame of the house, which he exposed by pulling off as much drywall cladding as possible, as well as chain-link fencing. At the same time his dizzying collages demonstrated great compositional skill, even as they literally exploded the boundaries of convention. Later, this strategy would become associated with postmodern literary theory, specifically with deconstruction, whose name seemed to describe Gehry's technique. Deconstruction is a means of analysis, espoused in particular by Jacques Derrida, that emphasizes the contradictions within texts. Although it is unlikely that Gehry was aware of these ideas when he designed his house, the pairing was enormously useful to a new generation of American architects who, unlike Gehry, were more at home in the academy than on construction sites.

By the early 1980s, postmodernism had choked out modernism across Europe and the United States, except in isolated corners, such as Los Angeles, that could claim modernism as their only real heritage. But was modernism's belief in the universal subject, who responded emotionally to a space and materials rather than superficial symbolism, to be abandoned altogether? The results of two competitions staged in the 1980s suggested paradoxically that commemoration was most effective when it was detached from historicism. The greatest American public debate over architecture of the era was ignited in 1981 when a twenty-one-year-old woman won the competition to design a memorial to what was then the single most controversial aspect of recent American history: the Vietnam War (Figure 29.6). Maya Lin's design was a resounding criticism of Scully's championship of academic classicism as the best way to build a civic architecture that was comprehensible and humane. Much of the criticism of Lin's design was frankly racist and misogynist. Many military veterans and their allies were uncomfortable with an Asian American woman designing a memorial to a war in which the North Vietnamese government and the Vietcong had defeated the United States. But the discomfort with the design went beyond the ethnicity, gender, and age of the architect. Lin proposed a new kind of monument, one that was not tall, white, and classical but instead cut into the earth, faced with black marble slabs, and profoundly abstract.

In the end Lin's design won approval, but only after the inclusion of a figurative statue by Frederick Hart. The opposition collapsed completely, however, following the memorial's dedication. Lin's design proved to have an amazingly cathartic effect

Figure 29.6. Maya Lin, Vietnam Veterans Memorial, Washington, DC., 1981–82.

on the hundreds of thousands who came to mourn and the millions who followed to see what she had achieved. Carved into the memorial's marble were the names of all the soldiers and other military personnel who had died in the war, listed in the order of their deaths. Although reading similar lists aloud had been a prominent feature of antiwar protests, those who had supported the war proved equally appreciative of this specificity. The abstraction of the setting into which the names were carved provided an effective foil for both individual grief and communal contemplation. The reflection of the faces of the living in the names of the dead humanized what many had assumed in advance would be a cold environment. The Smithsonian Institution eventually filled a warehouse with the outpouring of objects left in the embrace of the altar-like memorial, which helped reunite a country that had been divided by the war.

Lin transformed expectations about what brilliant architectural ideas could achieve. A spate of prominent memorials, none nearly as effective, have been built since. Indeed, for the subsequent quarter century, arguing about the appearance of memorials has become an important part of the process of commemoration that might earlier not have assumed physical form. Among the most significant progeny of the Vietnam War Memorial was Daniel Libeskind's Jewish Museum in Berlin, designed just months before the Berlin Wall fell in 1989 (Figure 29.7). The competition brief called for an annex to West Berlin's city museum. It would house

Figure 29.7. Daniel Libeskind, Jewish Museum, Berlin, Germany, 1989–99.

artifacts relating to the once-vibrant local Jewish community forced into exile or exterminated by the Nazis. The reunification of Germany and the decision to return the national capital to Berlin heightened the prominence of the commission and transformed its program. Construction of the extremely complicated and expensive project became one means of measuring German repentance for Nazi crimes against humanity, while the reintegration of the two East and West Berlin museums on the original eastern site allowed for the creation of a separate Jewish Museum housed in Libeskind's building, for which the existing building now served as little more than an entrance pavilion.

Like Lin, Libeskind preferred abstraction to historicism. He nonetheless used two different strategies in drawing on the past. The first was a mapping exercise, in which he claimed that an attenuated Star of David connected sites of importance to him and to Berlin's Jewish community. He used this to derive an angular geometry that had much in common with his own long-standing aesthetic preferences and also recalled a nearby union headquarters designed by Mendelsohn, Berlin's most important Jewish architect, which appeared on his site diagrams. In theory, mapping

exercises, like Rossi's emphasis on typology, offered architects a way of referring to the history of particular places; in fact, buildings generated in this way, such as Peter Eisenman's nearby apartment building at Checkpoint Charlie of 1981–85, tended to have a familial resemblance, wherever in the world they were built. Libeskind's second strategy was more daring. Deconstruction became a powerful tool for marking the absence of the city's Jewish community, re-creating the dislocation of exile, and even the claustrophobia that preceded annihilation in the gas chambers. The zigzag plan and windows became more than modernist ornament, disrupting the exhibitions. Prompted in part by labels, the voids between the galleries, the skewed ground of the "Garden of Exile," and the heavy door slamming on the "Tower of Remembrance" re-created the strong narrative that deconstruction as a literary theory challenged. Literary deconstruction denies a single privileged reading of a text and with it the importance of the author's intentions. Libeskind, some who wrote about the building, and those who led tours through it insisted, however, on the importance of intentions. The results revealed the thinness of contemporary architectural culture's intellectual pretensions, but they also, like Lin's memorial, demonstrated what built form could accomplish. Ironically, Libeskind revived modernism by fragmenting it.

The process of building the Jewish Museum transformed Libeskind from one of the most abstruse members of the architectural avant-garde into an articulate and comprehensible public intellectual. His biography figured prominently in accounts of the Jewish Museum. Born in Poland to survivors of the Holocaust, he grew up in Israel and the United States. During the 1990s, he divided his time between Los Angeles and Berlin, where he became the leading critic of the "critical reconstruction" of the center of the formerly divided city, a strategy that privileged the re-creation of the eighteenth- and nineteenth-century urban grid and limited the height and glazing of new buildings. Even before its completion and long before the exhibitions were installed, the Jewish Museum became one of the city's most popular new attractions, as Berliners expressed resistance to the Rossi-inspired reconstruction of the city center, which many found unnecessarily banal. Although Libeskind presented it as the acme of contemporary architecture, his design had deep roots in modern German architecture that were in many ways more profound than the mapping exercise with which he ostensibly began. Modernism was itself now a historical style, and one that was proudly cherished by many, especially in Berlin, one of the first places it had flourished. German politicians gave great credence to the ability of glass in new government buildings to represent democratic transparency; both they and Libeskind placed more faith in universalism than did those who wanted to revive neoclassicism, whose original emergence in Germany was associated with a rising educated middle class rather than the populace as a whole.

The Vietnam War Memorial was superbly understated; the Jewish Museum was more complex, and its zinc skin obviously referred to modern architecture's relationship with industry. By the 1990s, high tech's complex detailing was reemerging

from hibernation. It provided a richly detailed and beautifully crafted alternative to Lin's minimalism. Equally important, it offered a way back to the center of international architectural discussions for those who had been marginalized by the emphasis on classical heritage. Although postmodernism emerged as part of a general revolt against the status quo, by the 1980s its increasingly literal historicism was widely associated by its foes not only with the revival of untrammeled market forces but also with an attempt to turn back the social reforms of the 1960s and to reassert the primacy of (often specifically male) European cultural authorities in the face of challenges from a wide variety of outsiders.

The Arab World Institute, designed by Jean Nouvel in Paris, 1981–87, was prophetic of modernism's resurgence (Figure 29.8). The institute was one of the Grand Projects launched by François Mitterrand, the first socialist president of France, in preparation for the bicentennial of the French Revolution. The scale and purpose of these new institutions seemed at times more presidential than socialist, but their locations around the edges of Paris placed them in what were often still working-class districts at a slight remove from the traditional centers of power. The Arab World Institute, however, enjoyed a prominent position just to the east of the medieval heart of the city.

Figure 29.8. Jean Nouvel, Arab World Institute, Paris, France, 1981–87.

The institute was the most successful of the Grand Projects, in part because the sensitive location within sight of Notre Dame forced its architect to pay unusual attention to scale and massing. At the same time, the need to work cross-culturally encouraged innovation. The institute's function was to link France more tightly with Arab countries, among them the former French colonies of Morocco, Algeria, Tunisia, Syria, and Lebanon, in part by providing a venue in which their cultures could be exhibited and celebrated. The political context for its establishment included the economic clout of those Arab countries that exported petroleum as well as the increasing numbers of Arabs living in France. Although built by the French government, the project's purpose of strengthening alliances with these constituencies meant that it needed to engage their faith in the possibility of an indigenous Arab modernity. The form it took here contributed to the emergence of an architecture that married a modernist commitment to technological abstraction with a postmodern attention to ornament and detail.

The building is composed to two volumes: a long, thin slab facing a midblock plaza and a lower piece that bends in keeping with the street running alongside it. Both are glazed in a way that often displays the steel structure within. Nouvel folded exoticism into what remained a frank expression of the new. To regulate the amount of light entering the building through the curtain wall facing the plaza, he added a layer of apertures that expanded and contracted in response to light meters. High-tech architecture was married here with sustainability, as it often would be in Europe in the following years. Regulating the entrance of natural light also limited the need for air-conditioning. At the same time, the system doubled as ornament, ornament that in this case clearly referred to the lacy pierced window screens, executed in wood or, less commonly, marble, that were a prominent feature of preindustrial architecture across much of the Islamic and particularly the Arab world. The fact that the system was not operational for long did little to hinder the appreciation of its aesthetics, demonstrating the importance of image over reality in contemporary architectural culture. What endured was the fascination with transparency that characterized many of the finest buildings of the next two decades.

Another European project from the 1990s took a very different approach to modernism's roots in an industrial aesthetic. By the late twentieth century, European heavy industry had declined precipitously as much of the world's manufacturing shifted to places with lower wages, less expensive social safety nets, and less rigorous environmental regulations. Left behind were outmoded industrial installations, often on severely polluted sites. Peter Latz's conversion of one such place, an abandoned steel mill in Duisburg, in the heart of Germany's Ruhr district, previously one of Europe's leading centers of coal mining and steel production, into a public park confronted this decline head-on (Figure 29.9). Instead of redeveloping the land commercially or converting it into scenic landscape that erased the traces of its recent past, Latz, working in conjunction with local government authorities, sought to preserve the site's industrial history, reduce the ecological degradation produced

Figure 29.9. Peter Latz, Landschaftspark, Duisburg, Germany, 1994.

by that history, and convert a locus of work into one centered on leisure and enter-
tainment. He retained many of the industrial facilities, which he transformed from
technologically obsolete machinery into works of enduring modern art. At the same
time, new plantings and other interventions reduced the toxic traces of steel pro-
duction, facilitating the creation of a new ameliorative landscape, the outlying areas
of which, in comparison to the carefully manicured picturesque parks of an earlier
era, often verge on wilderness.

The Landschaftspark (landscape park), which opened in 1994, served some, but
not all, of the same social purposes as older municipal parks. One deficiency was
its location, far removed from the center of the city and in a neighborhood where
population had declined following the closure of the mill. Unlike its nineteenth-
century predecessors, it is not well integrated into the daily lives of a large number
of the city's or even the neighborhood's inhabitants. Many visitors drive to the site
specifically to tour it or to participate in events, such as rock concerts, that are
staged there.

Here modernism's fetish for factories reached its final apotheosis. Even more than
most urban public parks, the Landschaftspark offers an oasis from commercialized
urban life. In contrast to the shopping malls and multiplex cinemas that have been
erected on other brownfield sites in the region, the Landschaftspark provides few
opportunities to consume anything more than relatively fresh air, untrammeled (if
recently reintroduced) nature, and poignant views of capitalism's limits.

Within two decades of its supposed demise, modernism was back, inflected by
postmodern practices as well as a self-awareness of its own history, which is in-
creasingly detached from the reality if not the image of mass production. Indeed,
computer-assisted fabrication makes it easier to manufacture complex, individual-
ized details. Projects such as the Vietnam War Memorial and the Jewish Museum
demonstrated that historical quotations do not have a monopoly on memory or on

meaning. They helped lead the way to the revival of modernism as yet one more historical style in the Arab World Institute and the Landschaftspark. Here context matters, ornament and thus scale matter, and even the health of the land matters. Moreover, these projects demonstrate that there is still a civic realm and that it can be made popular without the use of strategies borrowed from retailing. The audience for architecture that, as Pennsylvania Station once did, communicates without opacity or condescension remains refreshingly substantial.

FOR FURTHER READING

Diane Ghirardo, *Architecture after Modernism* (New York: Thames & Hudson, 1996), offers a useful introduction to postmodernism and its aftermath. Vincent Scully's remarks on Pennsylvania Station appear in his *American Architecture and Urbanism* (New York: Praeger, 1969). The classic texts of postmodernism are Robert Venturi, *Complexity and Contradiction in Architecture* (New York: Museum of Modern Art, 1966); Robert Venturi, Denise Scott Brown, and Steven Izenour, *Learning from Las Vegas* (Cambridge: MIT Press, 1972); and Aldo Rossi, *The Architecture of the City* (1966; repr., Cambridge: MIT Press, 1982). For more on specific buildings and movements described above, see Donlyn Lyndon and Jim Alinder, *The Sea Ranch* (New York: Princeton Architectural Press, 2004); Frank Gehry, *The Architecture of Frank Gehry* (New York: Rizzoli, 1986); James Young, *At Memory's Edge: Afterimages of the Holocaust in Contemporary Art and Architecture* (New Haven, Conn.: Yale University Press, 2000); and Udo Weilacher, *Syntax of Landscape: The Landscape Architecture of Peter Latz and Partners* (Basel, Switzerland: Birkhäuser, 2007). A trio of Museum of Modern Art catalogs provides further context for much of this work. See Philip Johnson and Mark Wigley, *Deconstructivist Architecture* (New York: Museum of Modern Art, 1988); Terence Riley, *Light Construction* (New York: Museum of Modern Art, 1995); and Peter Reed, *Groundswell: Constructing the Contemporary Landscape* (New York: Museum of Modern Art, 2005).

30 Chinese Global Cities

I n 1991, the American sociologist Saskia Sassen published a prophetic book in which she coined the term *global cities*. In her study of the three centers of global finance—New York, London, and Tokyo—Sassen identified the salient characteristics of these cities' economies during the 1980s. First, she pointed to the transition from industrial to service economies. Second, she focused on the global nature of many of these services, especially those characteristic of finance; she paid less attention to tourism, which would prove almost equally crucial to the appearance of late twentieth- and early twenty-first-century cities. Sassen also noted the widening gap between rich and poor in global cities and observed that the poor were disproportionately from minority and immigrant backgrounds. Finally, she described these cities as producers as well as consumers of innovation.

Although some of the processes Sassen described had been under way for centuries, many were exacerbated by the loosening of state involvement in both capitalist and communist economies around the world beginning around 1980, combined with the development of new communications technologies. The effects of these processes would be particularly dramatic in the cities of East and Southeast Asia, where an influx of many rural migrants in tandem with the emergence of the Internet transformed manufacturing and service industries. Although few of the region's non-Japanese architects established significant international profiles, its new buildings include icons that serve as backdrops to television broadcasts and tourist photographs, whether or not they also fill the pages of architecture magazines.

The international prominence and economic importance of cities across this region have increased enormously, in some cases exponentially, during the past three decades. Bombay (now Mumbai) and Tokyo have been economic linchpins of the region since the second half of the nineteenth century, Shanghai since the early twentieth, although its vibrancy was eclipsed during the early decades of Chinese

communism. Today the most dynamic and rapidly changing cities in the world include Seoul, Beijing, Guangzhou, Hong Kong, Taipei, Singapore, Bangkok, Kuala Lumpur, and Bangalore. Most of these cities follow the New York rather than the Los Angeles model, with high densities expressed architecturally through many towers, some filled with offices and others with apartments. Although a great deal of scholarly attention has recently been paid to them, these cities tend to attract the attention of the international architectural community only when they become showcases of aesthetically ambitious design, something that has happened only irregularly over the course of their recent history.

Global cities are often condemned for their homogeneity. The lights of the Ginza district of Tokyo differ little from those of New York's Times Square; indeed, they advertise many of the same brands of soft drinks and consumer electronics. An examination of Shanghai, Hong Kong, and Beijing over the course of the past century reveals, however, that the dialogue between the local and the international there has been very different from that in nearby Japan during the same decades. In China the assimilation of international models of commercial and civic architecture, often designed by foreigners and always intended to communicate modernity to an international audience, has been accompanied by the development of residential environments unique to China.

Two of China's global cities, Shanghai and Hong Kong, owe their emergence on the world stage to the Treaty of Nanjing, signed in 1842 following Britain's humiliating defeat of China in the Opium War. China had long been one of the world's leading empires, and Britain's ability to force it to open its markets to South Asian opium was embarrassing proof of its temporary decline. From the mid-eighteenth through the mid-nineteenth century, China conducted its lucrative trade with the West through a single port, the city of Guangzhou (formerly Canton). Then Britain seized the nearby island of Hong Kong for itself and forced the Chinese to establish other port cities for international trade, which would be controlled in part by Western powers. Shanghai, where the shared International Settlement, controlled by the British and French, coexisted with areas of the city governed by the French and others controlled by the Chinese, emerged as the most important of these.

In the 1920s and 1930s, Shanghai was in many ways a prototype for today's global cities. Although manufacturing flourished, the city owed its prosperity above all to its role as a trading center. The origins of almost all indigenous Chinese modernisms, whether the birth of indigenous cinema or avant-garde literature, can be traced to Shanghai in this fertile period. At the same time, the gap between rich and poor was enormous, whether between Europeans and ordinary Chinese or between those Chinese who made phenomenal fortunes here and the vast majority who lived in squalor. This occurred despite the rise of an indigenous middle class that included many intellectuals. The exploitative economic and political system and the striking social inequalities differed little from conditions in previous colonial outposts. In China, however, foreign powers never governed much of the interior, even

as the imperial system was replaced in 1912 by a republic that seldom had firm control over the entire country, and was in turn overthrown in 1949 by communists led by Mao Zedong. This political instability turned Shanghai and Hong Kong into oases of Chinese economic growth and cultural experimentation.

One of the markers of this innovation was the waterfront street called the Bund (Figure 30.1). The buildings that lined it by the time the Japanese conquered the city in 1937 constituted what was at the time one of the world's most impressive assemblages of high-rises, matched by only a handful of cities in the Americas. At a time when there were few professionally trained Chinese architects, foreigners (in the case of the Bund, the British-led firm of Palmer and Turner) supervised the design and construction of most buildings employing advanced technology. The international character of the city was also reflected in the variety of people who paid for and used the buildings lining the Bund.

Palmer and Turner's Sassoon House, also known as the Cathay Hotel, completed in 1929, was named for its owner, a member of a family of Iraqi Jews who had immigrated less than a century earlier to Bombay, where they made their fortune before becoming part of the British social and literary elite. Luxurious hotels like this were by the late nineteenth century crucial to international contacts—places

Figure 30.1. The Bund, Shanghai, China, with Palmer and Turner, Sassoon House (Cathay Hotel), 1926–29; and Palmer and Turner with Lu Qianshou, Bank of China on right.

where businesspeople as well as tourists stayed in comfortable surroundings, and that also supported major social events in their elegant ballrooms and restaurants. Much of the lavish interior decoration was imported from France. Almost nothing about the building marks it as being located specifically in China.

Completed a decade later, its immediate neighbor, the Bank of China, was different in two important ways. A historicist Chinese roof capped the otherwise smooth walls of this skeletally framed building. For the rest of the twentieth century and into the twenty-first, the addition of such roof forms (the "big-roof style") has been the favored way of identifying buildings as distinctively Chinese. Just as with European historicism of the nineteenth century and the Indo-Saracenic in India in the early twentieth, this is a symbolic gesture divorced from the original structural system. In the case of the Bank of China, the roof was designed not by Palmer and Turner but by the firm's Chinese collaborator, the architect Lu Qianshou. Lu was one of the first generation of Chinese to receive professional architectural training abroad, in his case at the Architectural Association in London. Other members of this group included Liang Sicheng and his wife, Lin Huiyin, Maya Lin's aunt, who both studied at the University of Pennsylvania.

New architectural forms were not reserved for foreigners and the local elite. All levels of society occupied spaces transformed by new materials and forms of transportation, as well as by the real estate pressures that followed from the city's enormous growth. Other examples of hybrid architecture in the city included its extensive stock of *lilong* housing inhabited by the indigenous middle class (Figure 30.2). Here the traditional Chinese courtyard house was adapted to new urban densities and, at times, decorated with ornamental motifs imported from the West. The oldest examples featured two-story U-shaped units in which main rooms grouped around courtyards opened at the back onto a corridor off which opened a row of smaller rooms. Over time this model evolved to feature new materials, such as reinforced concrete, as well as tighter plans in which rooms were bigger but courtyards smaller, and lanes were wide enough to accommodate automobiles. *Lilong* housing displays the robust imagination of builders and developers rather than that of architects.

Shanghai's prosperity was shaken to its foundations by the Japanese invasion and the Communist Revolution. The Communist government fostered the development of a new urban form: the work unit. Bounded by walls that evoked the strongly spatially demarcated and easily policed districts of premodern Beijing, work unit compounds combined manufacturing or institutions like hospitals and universities with housing and other facilities for a wide range of employees (Figure 30.3). These could include communal kitchens and day-care facilities. High-rise buildings for both workplaces and dwellings often freed considerable space within compounds that, unlike *lilongs,* were organized with little reference to traditional streets.

Increasingly tall construction also predominated in late twentieth-century Hong Kong, which remained a capitalist outpost under British rule until 1997. After the

Figure 30.2. *Lilong* housing, Shanghai, China, 1920s.

Communist Revolution, Hong Kong replaced Shanghai as the most important man-
ufacturing, financial, and trading center on the Chinese coast. By the 1980s, how-
ever, its growth appeared threatened by the uncertainties that surrounded its eventual
return to China. In that context, the Hong Kong and Shanghai Bank, which had
abandoned Shanghai after the revolution, commissioned the British architect Nor-
man Foster to build its new headquarters (Figure 30.4). Designed in 1979 and com-
pleted in 1986, this was at the time the most expensive building in the world. The
excessive expenditure demonstrated the bank's confidence in the city's economic
future and was thus an extremely important political gesture.

These specific economic and political circumstances encouraged the bank to
splurge on a lavish design that propelled Foster into the first rank of star architects
and kept high tech alive through the height of postmodern historicism. Hong Kong's
bankers, unlike many Londoners, had no interest in Georgian classicism, favoring
in its stead not the Chinese equivalent but an optimistic investment in the future.
In Britain, high tech was itself a kind of historicism, drawing on the country's
industrial heritage just when the last coal mines and much of the manufacturing
base were shutting down for good. But British nostalgia for a time when factories
mattered was not sentimental in Hong Kong, a center in the postwar period of light
manufacturing, and one where the average income grew one hundredfold between

Figure 30.3. Site plan, Jishuitan Hospital, Beijing, China, 1956.

1950 and 2000. Here futuristic architecture was welcomed as a sign that growth might continue in the face of considerable political and economic uncertainty.

Foster's bank building looked like a large machine, one that could almost be set into motion. In addition to the optimism symbolized by its high-tech forms, Foster's design was governed by a systematic rethinking of the plan, structure, and energy usage that had characterized earlier skyscrapers. Foster's goal was to provide comfortable conditions for office workers while lowering energy consumption in a novel way that would draw international attention to his client. One of the building's most remarkable features was the open ground story. This served two distinct purposes. First, it allowed an older banking hall to continue to be used during the construction

Figure 30.4. Norman Foster, Hong Kong and Shanghai Bank, Hong Kong, China, 1979–86.

of its successor. Second, and equally important, it responded to the recommendations of a feng shui master whom Foster had consulted concerning Chinese tradition. Foster also completely rejected the deep floor plate characteristic of postwar office towers, which was heavily reliant on artificial illumination and ventilation. He replaced it with a series of stacked atria, around which he grouped offices. Escalators provided access to the atria, the first of which, located one level above the ground, was the main banking hall (Figure 30.5). This arrangement, in which the services were pushed from the core to the edges of the floor plate, meant that all office workers had access to daylight.

It also pushed the structure out to the perimeter of the building. Like many megastructures, the bank was intended to be a mast capable of supporting extensions, although none has been added. Foster rejected the emphasis on cladding that had dominated the design of skyscrapers since their inception by moving the building's vigorously articulated bracing forward of the glazing, where the complex detailing doubled, as in the Arab World Institute, as ornament. Executed mostly in aluminum, it established scale and created variety. Some of it, such as the system of sunshades, also lowered energy consumption, while machinery served such practical uses as assisting window cleaning. While most energy-efficient architecture in the United States has since the 1970s entailed a low-tech rejection of mechanization, Foster's office building integrated unusual attentiveness to ecological principles within forms that appeared to be paeans to industrialization but in fact often required complex individualized fabrication.

Hong Kong in the 1980s was in transition. The Hong Kong and Shanghai Bank was merely the most prominent of the city's many new high-rises. As wages rose in Hong Kong and political relations with the People's Republic of China improved, manufacturing began to shift to the lower-wage mainland. Hong Kong increasingly became a center of finance and tourism. At a time when fantasies of the past or of exotic locales dominated tourist attractions such as Disneyland and Las Vegas, Hong Kong focused on providing its target audiences—shoppers from throughout Southeast Asia and financiers from around the world—with the reality of modernity, which was spectacle enough for most. An explosive market for apartments in new high-rise towers during the 1990s fueled amazing densities. These were supported by a complex transportation system, which included subways, ferries, streets, elevated sidewalks, and highways, as well as an escalator and a funicular railroad climbing up steep hillsides.

High-tech rather than postmodern historicism represented the future, above all, in East Asia. The single most extraordinary scheme designed for Hong Kong remained unbuilt, however. In 1983 the young Iraqi-born, English-trained architect Zaha Hadid won a competition for a leisure and apartment complex called The Peak, to be located near the city's highest point (Figure 30.6). Hadid, who was fascinated by Soviet constructivism, proposed excavating the mountainside to provide platforms of polished stone above which she wanted to set a series of bar-like

Figure 30.5. Atrium, Hong Kong and Shanghai Bank.

Figure 30.6. Zaha Hadid, The Peak Leisure Club, project for Hong Kong, China, 1983.

apartment buildings, which would thrust horizontally out of the steeply sloping site. Spaces for various activities were to be located on these buildings' terraces and atop the apartments. Hadid declared of her design: "The whole project is this purely synthetic, invented landscape that becomes as critical as the real landscape. The artificial landscape replaces the natural rock formation that is carved away to prepare a field for the incision of the project." She pushed the understated integration of architecture and site represented by Ando's Koshino House a decade earlier in a boisterous new direction.

The Peak was remarkable as well for the innovative quality of the graphic presentation and the way in which Hadid harnessed the originally utopian vocabulary of avant-garde Soviet architecture to contemporary consumerism. Hadid, who would soon become a leading proponent of the use of computer graphics, exaggerated the skew of both site and building in her forceful paintings of her design. Her focus on splintered geometry rather than on the structural issues that dominated metabolist and high-tech architects set the stage for much of the deconstructivist architecture that was to follow across the course of the next decade. Her interest in historic forms for their own sake is characteristic of her generation of neomodernists, few of whom still believe in architecture as a path to reform society. The willingness of this group, which includes Hadid's former teacher Rem Koolhaas, the founder of the Rotterdam-based Office for Metropolitan Architecture, to work with developers, as well as their capacity to design projects simultaneously in many different countries, has resulted in what is known as "starchitecture," in which outsiders "parachute in" for particularly prestigious commissions. This is especially common when commissions are intended to indicate forward-looking vision or to attract tourists. Many of this cohort have created their largest and most expensive buildings in China, where more conventional architectural firms have also built some of their most daring work.

The dazzling tower of the Bank of China by the American firm of I. M. Pei Partners, completed in 1990 and organized around a daring atrium, is an early example of this phenomenon (Figure 30.7). It heralded the increasing height and innovation of a remarkably ambitious generation of Asian skyscrapers. At the time it was finished, it was the tallest building outside the United States. Throughout Asia, height often substitutes for aesthetic ambition in the competition to produce local landmarks sure to garner international attention. As of 2013, eight of the world's twelve tallest buildings were located in East or Southeast Asia. The torqued geometries of the Bank of China were clearly novel departures from the skeletal grids of earlier high-rises. The building's unusual form braced an unprecedentedly tall atrium, which was built in defiance of strictly economic considerations in order to demonstrate the ability of the building's owners to compete on the international architectural stage as well as the financial one.

Designed to upstage Foster's earlier building, over which it easily towered, the Bank of China was the work of the office established by the first internationally renowned

Figure 30.7. I. M. Pei, Bank of China, Hong Kong, China, 1982–90.

architect of Chinese origin. A native of Shanghai whose father had been a director of the Hong Kong and Shanghai Bank, Pei studied architecture with Gropius at Harvard. He remains best known for his museum buildings. These include trend-setting extensions for the National Gallery in Washington, D.C., the Museum of Fine Arts in Boston, the Louvre in Paris, and, more recently, the German Historical Museum in Berlin and the Museum of Islamic Art in Doha. With Stirling, Pei was one of the first to realize the limitations of a merely functional approach to this building type. Although difficult to engineer, the Bank of China's atrium was an extension of the generous public spaces Pei had already inserted into otherwise modernist museums.

In the 1980s, no city in Asia outside Japan rivaled Hong Kong as a showcase of the new, a title for which, at postmodernism's height, very few cities in Europe or North America were interested in competing. By the 1990s, however, Shanghai, which began a period of explosive growth following Chinese economic reforms that returned it to the first tier of global cities, had emerged as a strong local rival. Shanghai's new growth, unlike Hong Kong's, was accompanied by the protection and preservation of at least some of the evidence of its history of modernity. *Lilong* housing was demolished almost by the square mile, but the Bund and Nanjing Road offered cherished relics of the city's metropolitan status in the 1920s and 1930s. The city's expansion also included the creation of a subway, the erection of new bridges and highways, the construction of a new airport linked to downtown by one of the world's fastest trains, and the construction of new civic buildings, including a major art museum. Two of the most visible developments were a promenade along the Bund and, located right across the river from it, the new district of Pudong (Figure 30.8). The city's present and its once equally modern past established a dialogue between the many-peaked wall of its original street-oriented skyline and the tower-in-the-park urbanism first proposed in the 1920s, now updated by new forms of spectacle and ornament, including elaborate night lighting and polychrome mirror glass.

For Sassen, two new developments, Battery Park City in New York and Canary Wharf in London, epitomized the new form of the global city. Both developed along the New Urbanist lines that followed from the synthesis of Aldo Rossi's city planning ideals and the postmodern historicism popular in both the United States and Britain. Each consisted of a mix of residential and commercial development in a place that had previously been a working waterfront, as waterborne freight was now displaced to container ports farther from downtown. As in the nineteenth century, continuities in style, in this case with the art deco office towers of the 1920s, minimized controversy over an intrusive new scale. International capital and architectural talent played key roles in these developments. Canary Wharf was financed by the Canadian real estate partnership of Olympia & York and largely designed by the Chicago-based architectural firm of Skidmore, Owings & Merrill. Cesar Pelli, a native of Argentina, was the architect of both Battery Park City's World Financial Center and two towers in Canary Wharf.

Figure 30.8. Pudong district, Shanghai, China, with Shanghai Modern Architectural Design Company, Pearl Television Tower, 1994; Skidmore, Owings & Merrill and East China Architectural Design and Research Institute, Jin Mao Tower, 1994–99; and Kohn Pedersen Fox, Shanghai World Financial Center, 1997–2008.

Pudong is the Chinese counterpart to these developments. Its towers house primarily offices; low-rise enclosed shopping malls increasingly indistinguishable from their Hong Kong counterparts cluster in several of the towers' bases. Reinhold Martin could have been describing Pudong's ubiquitous mirror glass when he wrote, "The tricks with mirrors and other real materials performed by corporate globalization produce the illusion that there is an illusion; the illusion that their materiality is illusory, unreal, derealized." Many of the towers have been designed in part by foreign firms, but their tall, thin profiles, capped in several cases by references to pagodas, would—like their atria—not always be economically viable in Europe or North America. Although the original master plan by the British architect Richard Rogers has not been consistently implemented, state control of the economy has allowed a degree of comprehensive planning that remains unusual in the West, where developments of this scale are almost unknown.

Although the majority of new Chinese landmarks are frankly commercial structures, a new civic infrastructure is also taking shape. The staging of the Olympic Games in Beijing in 2008 showcased efforts to create buildings that would hold their own in comparison to the museums and opera houses that defined the prestige

of nineteenth-century European capitals. Perhaps the most widely recognized of these belonged, however, to a more modern building type, the sports stadium, closely associated with the commercialization of the public sphere and the rise in new forms of mass entertainment. Beijing National Stadium, also known as the Bird's Nest, was designed for the Olympics by the Swiss firm of Herzog and de Meuron (Figure 30.9). The Chinese artist Ai Weiwei was the artistic consultant; the engineering firm Ove Arup and the China Architectural Design and Research Group also made important contributions. The roof and the seating bowl are structurally separate, in part to safeguard against potential damage in an earthquake. The outer structure, which was originally intended to support a retractable roof, is a web of exposed steel beams that was inspired in part by Chinese ceramics. Especially dramatic at night, when the red seating area appears to glow from within, the stadium displays complex engineering, an example of the possibilities created by sophisticated computer rendering. Buildings such as this one, designed as much to be seen on television or online as to be experienced directly by spectators and athletes, lack the fine-grained detail that characterizes many of Herzog and de Meuron's smaller projects.

Architectural ideas have always moved across space and time. The process often seems faster today. A series of transformations in transportation and communication have made it possible for architectural offices that offer unusual technical expertise or distinctive designs to operate simultaneously on several different continents.

Figure 30.9. Herzog and de Meuron with Ai Weiwei, Beijing National Stadium, Beijing, China, 2003–8.

These firms are crowding out locally prominent practitioners on many different fronts. Leading designers jet in for occasional site visits and communicate the rest of the time with their local clients, associates, and contractors by mobile telephone, fax, and e-mail. Not surprisingly, twenty-first-century Hong Kong, Shanghai, and Beijing respond to far wider influences from abroad than did fifteenth- or even eighteenth-century Beijing. Images of the new are now more often imported than entirely homegrown, but the ways in which they are deployed often remain stubbornly local, as the Chinese preference for skyscrapers with pagoda roofs and atria demonstrates. In the end, such syntheses of old and new, foreign and local, as *lilong* housing and the Hong Kong and Shanghai Bank are more interesting than the historicism of the big-roof style, which masks rather than expresses the complexity of the changes housed beneath its ample eaves.

For more than a generation, architectural patrons in China's largest cities and their publics at home and abroad have striven to produce environments that celebrate their modernity. To do this they have pushed at the limits of contemporary engineering. At the same time, they have encouraged the revival of supposedly innovative forms whose long and distinguished pedigree is in fact an important component of their continued appeal. The need to employ these forms in obviously new ways, even as they refer to the past, diminishes the pleasure connoisseurs take in the vaguely familiar result. Consequently, despite determined efforts, none of these cities is at present as much a showcase of innovative architectural forms as it is a showcase of modernity itself. Nearly six hundred years after Brunelleschi, architects, often to their chagrin, continue to share the shaping of the built environment with a wide range of other participants. Nowhere in China have they seized control of the process to the degree illustrated in the idealized vision of the Renaissance city. As in fifteenth- and sixteenth-century Florence, the failure to conform to aesthetic ideals should not be condemned out of hand, however. More than aesthetics contributes to the liveliness and flair of these new cityscapes, with their evolving transportation systems and civic amenities and improved, if increasingly antiseptic, housing conditions. Their largest problems are a lack of public participation in the planning process and the environmental degradation associated with density, rather than the choice of architectural style.

In the first years of the new millennium at least three different architectural cultures coexist. The first comprises the places in which the disadvantaged and dispossessed live with inadequate access to the infrastructure that the middle class around the world takes for granted. Although those in this group often bring great imagination to the environments they inhabit, no amount of charm can compensate for the inequality of these conditions. These places are not confined to the developing world; they include the apartment blocks and tenements in which the poor, often immigrants, are warehoused in Europe and the United States, where their labor helps sustain comforts they themselves find unattainable. The second architectural culture consists of the places created by those who, as clients and consumers, exert a real

degree of economic as well as political and social control over the spaces in which they live, work, shop, and play. At their best, these can be dynamic and often democratic environments in which competing desires are allowed expression in chaotic if sometimes colorful ways. At their worst, they entail the selfish consumption of scarce resources, but any successful attempts to reform them, whether or not introducing aesthetic harmony is the goal, must acknowledge how and why they empower the imaginations of those who refuse to conform to the conventions of the architectural and planning profession. Decrying them as mere diagrams of capital designed to make money denies the degree to which they succeed only when they embody the desires of those who commission and use them. Finally, there is the relatively narrow sliver reserved for negotiation between the elite tier of the design professions and the clients and publics for whom they work. Although this volume has largely focused on the precedents venerated by these architects and clients, it should not be taken as a validation of either their aesthetic or their intellectual concerns. The dialogue between the public and architects, rather than simply the genius of the latter, creates the interest and appeal that animate the zestiest and most popular new buildings, parks, and plazas, environments to which entire societies deserve to gain equal access.

FOR FURTHER READING

Saskia Sassen, *The Global City: New York, London, Tokyo* (Princeton, N.J.: Princeton University Press, 1991), provides the context for the opening of this chapter. For general works on twentieth-century Chinese architecture and urbanism, see Lu Junhua, Peter G. Rowe, and Zhang Je, *Modern Urban Housing in China: 1840–2000* (Munich: Prestel, 2001); Duanfang Lu, *Remaking Chinese Urban Form: Modernity, Scarcity and Space, 1949–2005* (London: Routledge, 2006); and Peter Rowe and Seng Kuan, *Architectural Encounters with Essence and Form in Modern China* (Cambridge: MIT Press, 2002). For a useful survey of the range of early twenty-first-century building in China, see Christian Dubreau, *Sinotecture: New Architecture in China* (Berlin: Dom, 2008). Wilma Fairbank, *Liang and Lin: Partners in Exploring China's Architectural Past* (Philadelphia: University of Pennsylvania Press, 1994), provides an account of the careers of two of China's first professionally trained architects. For more on Shanghai, see Edward Denison and Guang Yu Ren, *Building Shanghai: The Story of China's Gateway* (Chichester: John Wiley, 2006); on Hong Kong, see Gary McDonough and Cindy Wong, *Global Hong Kong* (London: Routledge, 2005). On the Hong Kong and Shanghai Bank, see David Jenkins, ed., *Norman Foster Works 2* (London: Foster and Partners, 2005); on The Peak, see *Zaha Hadid* (New York: Guggenheim Museum, 2006). For a discussion of tourism, see Medina Lasansky, *Renaissance Perfected: Architecture, Spectacle, and Tourism in Fascist Italy* (State College: Pennsylvania State University Press, 2005); and for an examination of the latest generation of skyscrapers, see Reinhold Martin, *Utopia's Ghost: Architecture and Postmodernism, Again* (Minneapolis: University of Minnesota Press, 2010).

ILLUSTRATION CREDITS

Unless otherwise credited, all architectural plans were drawn by Neil Christianson.

INTRODUCTION

Figure I.1: Photograph by Wiggum, Creative Commons, Share Alike 3.0 License.

Figures I.2 and I.4: Photographs by Peter Scheier. Copyright Instituto Lina Bo e P. M. Bardi, São Paulo, Brazil.

Figure I.3: Photograph by Manuel Trujillo Berges, Creative Commons, Share Alike 2.0 License.

1. MING AND QING CHINA

Figure 1.1: Photograph by QuickBird Satellite, February 11, 2002, Satellite Imaging Corporation, http://www.globalsecurity.org.

Figure 1.2: Photograph by Rabs003, Creative Commons, Share Alike 3.0 License.

Figure 1.3: Photograph by Gisling, Creative Commons, Share Alike 3.0 License.

Figure 1.4: Photograph by Nabilah Mohd Nasirudin.

Figure 1.5: *Beijing gu jianzhu* (Beijing: Wenwu chuban she, 1959), plate 139.

Figure 1.6: Photograph by Jakub Hałun, GNU Free Documentation License.

Figure 1.7: Photograph by Kallgan, Wikimedia Commons.

Figure 1.8: Photograph by Meier and Poehlmann, GNU Free Documentation License.

Figure 1.9: Photograph by Gisling, GNU Free Documentation License.

2. TENOCHTITLÁN AND CUZCO

Figure 2.1: Photograph by Stephen Tobriner. Courtesy of College of Environmental Design Visual Resources Center, University of California, Berkeley.

Figure 2.2: Rare Books Division, The New York Public Library, Astor, Lenox, and Tilden Foundations.

Figure 2.3: Ignacio Marquina, *Arquitectura prehispánica* (Mexico City: Instituto Nacional de Antropología e Historia, Secretaria de Educación, Mexico, 1951), 196–97.

Figures 2.5, 2.7, 2.8, and 2.9: Courtesy of J. P. Protzen.

3. BRUNELLESCHI

Figure 3.1: Photograph by Amada44, GNU Free Documentation License.

Figure 3.5: Photograph by Warburg, Creative Commons, Share Alike 3.0 License.

Figure 3.8: Photograph by Stefan Bauer, Creative Commons, Share Alike 2.5 Generic License.

Figure 3.9: Photograph by Gryffindor, GNU Free Documentation License.

4. MEDICI FLORENCE

Figure 4.1: The Walters Art Museum, Baltimore, 37.677; acquired by Henry Walters with the Massarenti Collection, 1902. http://www.art.thewalters.org.

Figures 4.2, 4.5, and 4.6: Courtesy of Oliver Radford.

Figure 4.3: Photograph by Roland Geider, GNU Free Documentation License.

Figure 4.4: Photograph by Scala/Ministero per i Beni e le Attività culturali/Art Resource, NY.

Figure 4.8: Photograph by Scala/Art Resource, NY.

Figure 4.9: Photograph by Steven Zucker.

Figure 4.10: Painting by Giusto Utens, 1599. Photograph from Wikimedia Commons.

Figure 4.11: Photograph by Giacomo Brogi, circa 1865–81. Andrew Dickson White Collection of Architectural Photographs, Division of Rare Book and Manuscript Collection, Cornell University Library (15/5/3090.00348).

5. THE RENAISSANCE IN ROME AND THE VENETO

Figure 5.1: Photograph by Torvindus, GNU Free Documentation License.

Figure 5.3: Photograph copyright Dr. Ronald V. Wiedenhoeft. Courtesy of Saskia, Ltd., Cultural Documentation.

Figure 5.4: Engraving by Etienne Dupérac, 1573. Photograph from Wikimedia Commons.

Figure 5.5: Photograph by Adrian Pingstone, 2007.

Figure 5.6: Andrea Palladio, *The Four Books of Architecture* (New York: Dover Publications, 1965).

Figure 5.7: Photograph from Wikimedia Commons.

Figure 5.8: Photograph by Hans A. Rosbach, GNU Free Documentation License.

6. RESISTING THE RENAISSANCE

Figure 6.1: Photograph by Lieven Smits, GNU Free Documentation License.

Figure 6.2: Photograph by Helac, Creative Commons, Attribution 1.0 Generic License.

Figure 6.3: Photograph by Chachu207, GNU Free Documentation License.

Figure 6.6: Photograph by Diego Delso, Creative Commons, Share Alike 3.0 License.

Figure 6.7: Photograph by Cancre, GNU Free Documentation License.

Figure 6.8: Photograph by Pko, GNU Free Documentation License.

Figure 6.9: Photograph by Janericloebe, GNU Free Documentation License.

Figure 6.10: The Montreal Museum of Fine Arts, Purchase, John W. Tempest Fund. Photograph by Denis Farley, The Montreal Museum of Fine Arts.

Figure 6.11: Photograph by Yair Haklai, GNU Free Documentation License.

7. THE OTTOMANS AND THE SAFAVIDS

Figure 7.2: Painting by Konstantin Kapidagli (1789–1807?). Photograph from Wikimedia Commons.

Figure 7.3: Photograph copyright fulili; reprinted under license from Shutterstock.com.

Figure 7.4: Walter Denny, 1984. Courtesy of the MIT Libraries, Aga Khan Visual Archive.

Figure 7.5: Photograph by Ggia, GNU Free Documentation License.

Figure 7.7: Photograph by Arad Mojtahedi, GNU Free Documentation License.

Figure 7.8: Pascal Coste, *Monuments modernes de la Perse* (Paris: A. Morel, 1867).

Figure 7.9: Photograph by Zenith210, GNU Free Documentation License.

8. EARLY MODERN SOUTH ASIA

Figure 8.1: Photograph copyright Jorge Royan (http://www.royan.com.ar), Creative Commons, Share Alike 3.0 License.

Figures 8.2 and 8.3: Photographs by Hans A. Rosbach, Creative Commons, Share Alike 3.0 License.

Figure 8.4: Photograph by Lian Chang, Creative Commons, 2.0 Generic License.

Figure 8.5: Photograph by Vssun, Creative Commons, Share Alike 3.0 License.

Figure 8.6: Courtesy of Gretta Tritch Roman.

Figures 8.7 and 8.10: Courtesy of Cathy Asher.

Figure 8.11: Photograph by Knowledge Seeker, Wikimedia Commons.

9. BAROQUE ROME

Figures 9.2 and 9.9: Courtesy of Oliver Radford.

Figure 9.4: Photograph by Peter Jurik, Creative Commons, Share Alike 2.0 License.

Figure 9.5: Photograph from Wikimedia Commons.

Figure 9.6: Photograph by Welleschik, Creative Commons, Share Alike 3.0 License.

Figure 9.8: Photograph by David Iliff. License: CC-BY-SA 3.0.

Figure 9.10: Photograph by Sergey Smirnov, GNU Free Documentation License.

10. SPAIN AND PORTUGAL IN THE AMERICAS

Figure 10.1: Photograph by Alejandro Linares García, GNU Free Documentation License.

Figure 10.2: Courtesy of George and Eve DeLange.

Figure 10.3: Photograph by Hpschaefer, Creative Commons, Share Alike 3.0 License.

Figure 10.4: Photograph copyright Manuel González Olaechea y Franco, GNU Free Documentation License.

Figure 10.6: Library of Congress, Prints and Photographs Division, Historic American Buildings Survey [HABS CAL,49-SONO,2-11].

Figure 10.7: Photograph by Luidger, GNU Free Documentation License.

Figure 10.8: Photograph by Claudio Giovenzana (www.longwalk.it), GNU Free Documentation License.

Figure 10.9: Photograph by Sarah and Iain, Creative Commons, 2.0 Generic License.

Figure 10.10: Denver Public Library, Western History Collection, Jesse L. Nusbaum, N-51.

Figure 10.11: Photograph by Geremia, Wikimedia Commons.

11. NORTHERN BAROQUE

Figures 11.1 and 11.2: Courtesy of Oliver Radford.

Figure 11.3: Photograph by David Monniaux, GNU Free Documentation License.

Figure 11.4: Photograph by Myrabella, Wikimedia Commons/Creative Commons, Share Alike 3.0 License.

Figure 11.5: Photograph by VıP3R, Wikimedia Commons.

Figure 11.7: Photograph by Oleksandr Samoylyk, GNU Free Documentation License.

Figure 11.8: Photograph by Siyad Ma, Creative Commons, 2.0 Generic License.

Figure 11.9: Photograph by Sailko, GNU Free Documentation License.

12. CITY AND COUNTRY IN BRITAIN AND IRELAND

Figure 12.2: Photograph by Jim Linwood, Creative Commons, 2.0 Generic License.

Figures 12.3, 12.4, 12.6, 12.8, and 12.11: Courtesy of Oliver Radford.

Figure 12.5: Illustration by Augustus Charles Pugin, from W. H. Pyne and William Combe, *The Microcosm of London: or, London in Miniature* (London: R. Ackerman, 1808–11; reprint, London: Methuen and Company, 1904).

Figure 12.7: Courtesy of the Trustees of Sir John Soane's Museum.

Figure 12.9: Photograph by Chivalrickı, GNU Free Documentation License.

Figure 12.10: Photograph from Wikimedia Commons/Creative Commons, 2.0 Generic License.

13. LIVING ON THE NORTH AMERICAN LAND

Figure 13.1: Library of Congress, Prints and Photographs Division, Edward S. Curtis Collection [LC-USZ62-48373].

Figure 13.2: Richard Maynard, house called "House Chiefs Peep at from a Distance," Skidegate, British Columbia, 1884. Canadian Museum of Civilization, 67236.

Figure 13.3: Richard Maynard, interior of Chief Wiah's house, Masset, British Columbia, 1878. Canadian Museum of Civilization, S71-3730.

Figure 13.4: Library of Congress, Prints and Photographs Division, Historic American Buildings Survey [NM,31-ACOMP,1-9].

Figure 13.5: Library of Congress, Prints and Photographs Division, Detroit Publishing Company Photograph Collection [LC-USZ62-56511].

Figure 13.6: James Ford Bell Library, University of Minnesota, Minneapolis, Minnesota.

Figure 13.7: Library of Congress, Prints and Photographs Division, Carnegie Survey of the Architecture of the South [LC-DIG-csas-04845].

Figure 13.8: Library of Congress, Prints and Photographs Division, Carnegie Survey of the Architecture of the South [LC-DIG-csas-04874].

Figure 13.9: Library of Congress, Prints and Photographs Division, Frances Benjamin Johnston Collection [LC-USZ62-126816].

Figure 13.10: Courtesy of Jeffery Howe.

Figure 13.11: From a map by Thomas Holme held by the New York Public Library.

Figure 13.12: Library of Congress, Prints and Photographs Division, Carol M. Highsmith Archive [LC-DIG-highsm-12311].

14. COURT AND DWELLING IN EAST AND SOUTHEAST ASIA

Figure 14.2: Photograph by Daderot, GNU Free Documentation License.

Figure 14.3: Photograph by bifyu, Creative Commons, Share Alike 2.0 Generic License.

Figure 14.4: Photograph by Ondřej Žváček, GNU Free Documentation License.

Figure 14.5: Photograph copyright antloft; reprinted under license from Shutterstock.com.

Figure 14.6: Photograph by D. Alyoshin, GNU Free Documentation License.
Figure 14.7: Photograph by Peter Maas, Creative Commons, Share Alike 3.0 License.
Figure 14.8: Photograph by Michael J. Lowe, Creative Commons, Share Alike 2.5 Generic License.

15. EDO JAPAN

Figures 15.1, 15.5, 15.7, 15.9, 15.10, and 15.11: Courtesy of Don Choi.
Figure 15.2: Photograph by Hu Totya, Creative Commons, Share Alike 3.0 License.
Figure 15.4: Photograph by Bernard Gagnon, GNU Free Documentation License.
Figure 15.6: Library of Congress, Prints and Photographs Division [LC-DIG-jpd-02398].
Figure 15.8: Courtesy of the City of Kyoto, Japan.

16. NEOCLASSICISM, THE GOTHIC REVIVAL, AND THE CIVIC REALM

Figure 16.1: Marc-Antoine Laugier, *Essai sur l'architecture*, 2nd ed. (Paris, 1755), frontispiece.
Figure 16.2: Photograph, circa 1865–90. Andrew Dickson White Collection of Architectural Photographs, Division of Rare Book and Manuscript Collection, Cornell University Library.
Figure 16.3: Photograph by Jean-Christophe Benoist, Creative Commons, Share Alike 3.0 License.
Figures 16.4 and 16.7: Courtesy of Oliver Radford.
Figure 16.5: Bibliothèque Nationale de France.
Figure 16.6: Virginia Visual History Collection, Special Collections, University of Virginia Library.
Figure 16.9: Courtesy of John Archer.
Figure 16.10: Photograph by Mgimelfarb, Wikimedia Commons.
Figure 16.11: Photograph by Barry & Pugin, circa 1870–85. Andrew Dickson White Collection of Architectural Photographs, Division of Rare Book and Manuscript Collection, Cornell University Library.

17. THE INDUSTRIAL REVOLUTION

Figure 17.1: Photograph by Roger Cave, Creative Commons, 2.0 Generic License.
Figure 17.2: Steve Dunwell, *The Run of the Mill: A Pictorial Narrative of the Expansion, Dominion, Decline, and Enduring Impact of the New England Textile Industry* (Boston: David R. Godine, 1978), 39.
Figure 17.3: Library of Congress, Prints and Photographs Division, Historic American Engineering Record [HAER MASS,9-LOW,7-63 (CT)].
Figure 17.4: Courtesy of Oliver Radford.
Figure 17.5: Joseph Nash, Louis Haghe, and David Roberts, *Dickinson's Comprehensive Pictures of the Great Exhibition of 1851* (London: Dickinson Brothers, 1852).
Figure 17.7: "Slip on the Great Northern Railway," *Illustrated London News,* October 23, 1852, 340.
Figure 17.8: Photograph by dkl, Creative Commons, Share Alike 2.0 Generic License.
Figure 17.9: Photograph by Maxiiie, GNU Free Documentation License.
Figure 17.10: Photograph by Benh Lieu Song, Creative Commons, Share Alike 3.0 License.
Figure 17.11: Photograph by Postdlf, GNU Free Documentation License.

18. PARIS IN THE NINETEENTH CENTURY

Figure 18.1: Photograph by D. D. Egbert and Chevojon Frères, Paris, from Arthur Drexler, ed., *The Architecture of the École des Beaux-Arts* (New York: Museum of Modern Art, 1977), 125.

Figure 18.2: Julia Morgan Collection, Environmental Design Archives, University of California, Berkeley.

Figure 18.3: Courtesy of Oliver Radford.

Figure 18.4: Photograph by Marie-Lan Nguyen, Creative Commons, 2.0 France License.

Figure 18.6: Minneapolis Institute of Arts, The William Hood Dunwoody Fund.

Figure 18.7: Photograph by Jotel, GNU Free Documentation License.

Figure 18.8: Photograph by Albert Chevojon, circa 1875, Wikimedia Commons.

Figure 18.9: Library of Congress, Prints and Photographs Division, Photochrom Prints Collection [LC-USZC4-10679].

Figure 18.11: Courtesy of Christopher Mead.

19. THE DOMESTIC IDEAL

Figure 19.1: John B. Ellis, *Free Love and Its Votaries* (New York: United States Publishing Company, 1870).

Figure 19.2: Catharine E. Beecher and Harriet Beecher Stowe, *The American Woman's Home: or, Principles of Domestic Science* (New York: J. B. Ford and Company, 1872; reprint, New Brunswick, N.J.: Rutgers University Press, 2002).

Figure 19.3: Photograph by Tony Hisgett, Creative Commons, 2.0 Generic License.

Figure 19.4: Photograph by David Edwards.

Figures 19.5 and 19.7: Courtesy of Oliver Radford.

Figure 19.6: "Some Work of the Associated Artists," by Mrs. Harrison Burton, *Harper's Monthly Magazine,* August 1884.

Figures 19.8 and 19.10: Photographs by Daderot, GNU Free Documentation License.

Figure 19.9: Library of Congress, Prints and Photographs Division, Historic American Buildings Survey [HABS RI,3-NEWP,61-12].

20. EMPIRE BUILDING

Figures 20.1, 20.2, and 20.3: Courtesy of John Archer.

Figure 20.4: Photograph by Frederick Fiebig, circa 1851. Copyright the British Library Board.

Figure 20.5: Photograph by Felice Beato, 1858, Wikimedia Commons.

Figure 20.6: Photograph by Samuel Bourne, 1865, Flickr.com.

Figures 20.7, 20.8, and 20.9: Photographs courtesy of Phillips Images, www.phillips image.in.

Figure 20.10: Library of Congress, Prints and Photographs Division, George Grantham Bain Collection [LC-B2- 5655-12].

Figure 20.11: Courtesy of Cathy Asher.

21. CHICAGO FROM THE GREAT FIRE TO THE GREAT WAR

Figure 21.1: Library of Congress, Prints and Photographs Division, Historic American Buildings Survey [HABS ILL,16-CHIG,31-10].

Figure 21.2: Photograph by Chicago Architectural Photography Company, David R. Philips Collection.

Figure 21.3: Library of Congress, Prints and Photographs Division, Historic American Buildings Survey [HABS ILL,16-CHIG,65-5].

Figure 21.4: Rand, McNally, and Company, 1893. Photograph from http://www.vanished americana.com.

Figure 21.5: Hubert Howe Bancroft, *The Book of the Fair* (Chicago: The Bancroft Company, 1893), 269. Copyright Paul V. Galvin Library Digital History Collection.

Figure 21.6: *Report of Massachusetts Board of World's Fair Managers, World's Columbian Exposition, Chicago, 1893* (Boston: State Printers, 1894), 40. Photograph from MIT Institute Archives and Special Collections [T500.F3.M31 1894].

Figure 21.7: John Patrick Barrett, *Electricity at the Columbian Exposition* (Chicago: R. R. Donnelley, 1894), 403.

Figure 21.8: Jane Addams Memorial Collection, Special Collections and University Archives, University of Illinois at Chicago Library.

Figure 21.9: Photograph copyright Jeremy Atherton, 2003, Creative Commons, Share Alike 2.5 Generic License.

Figure 21.11: Library of Congress, Prints and Photographs Division, Historic American Buildings Survey [HABS ILL,16-OAKPA,3-1].

Figure 21.12: Library of Congress, Prints and Photographs Division, Historic American Buildings Survey [HABS ILL,16-OAKPA,3-4].

22. INVENTING THE AVANT-GARDE

Figure 22.1: Copyright DeA Picture Library/Art Resource, NY.

Figure 22.2: Photograph by Steve Cadman.

Figure 22.3: Photograph by Gryffindor, GNU Free Documentation License.

Figure 22.4: Photograph from Department of Fine Art, University of Glasgow, from Filippo Alison, *Charles Rennie Mackintosh as a Designer of Chairs* (Woodbury, N.Y.: Barron's, 1977), 101.

Figure 22.5: Photograph by Gustav Pichelmann and Michael Stoger, from Edward R. Ford, *The Details of Modern Architecture* (Cambridge, Mass.: The MIT Press, 1990), 228.

Figures 22.6 and 22.8: Courtesy of Oliver Radford.

Figure 22.10: Photograph by Etta Berkland.

Figure 22.12: Photograph by Martin van Dalen, GNU Free Documentation License.

23. ARCHITECTURE FOR A MASS AUDIENCE

Figure 23.1: Walter Müller-Wülckow, *Deutsche Baukunst der Gegenwart: Bauten der Arbeit und des Verkehrs* (Königstein im Taunus: Langewiesche, 1929).

Figure 23.2: Courtesy of Frederic J. Schwartz.

Figure 23.3: Gustav-Adolf Platz, *Die Baukunst der neuesten Zeit* (Berlin: Propylae, 1927), 209.

Figure 23.4: Gustav-Adolf Platz, *Die Baukunst der neuesten Zeit* (Berlin: Propylae, 1927), 305.

Figure 23.5: Staatliche Museen zu Berlin, Kunstbibliothek.

Figure 23.6: Staatliche Museen zu Berlin, Kunstbibliothek.

Figures 23.7 and 23.9: Courtesy of Oliver Radford.

Figure 23.8: Photograph copyright Raimond Spekking/CC-BY-SA-3.0, Wikimedia Commons.

Figure 23.10: Copyright 2012 Artists Rights Society (ARS), New York/VG Bild-Kunst, Bonn. Photograph from Bauhaus-Archiv, Berlin.

24. IMPOSING URBAN ORDER

Figure 24.1: Ebenezer Howard, *Garden Cities of To-Morrow* (London, 1902).

Figures 24.2, 24.3, 24.9, and 24.10: Courtesy of Greg Castillo.

Figures 24.5 and 24.6: Fondation Le Corbusier.

Figure 24.7: Bundesarchiv, Bild 146III-373. Photograph from o.Ang.

Figure 24.8: Erich Mendelsohn, *Russland, Europa, Amerika: Ein Architektonischer Querschnitt* (Berlin: Rudolf Mosse Buchverlag, 1929), 137.

25. THE MODERN MOVEMENT IN THE AMERICAS

Figure 25.1: Photograph by Phillip Capper, Creative Commons, 2.0 Generic License.

Figure 25.2: Photograph by Geir Haraldseth.

Figure 25.4: Photograph by Augusto Areal.

Figure 25.5: Photograph by Rob Sinclair, Creative Commons, 2.0 Generic License.

Figure 25.6: Photograph by Sturmvogel 66, GNU Free Documentation License.

Figure 25.7: Photograph by Maynard L. Parker. Courtesy of the Huntington Library, San Marino, California.

Figure 25.8: Courtesy of College of Environmental Design Visual Resources Center, University of California, Berkeley.

Figure 25.9: Courtesy of Oliver Radford.

Figure 25.10: Courtesy of Richard Longstreth.

Figure 25.11: *Architectural Forum* (March 1953): 130. Reproduced courtesy of Gruen Associates.

26. AFRICA

Figure 26.1: Photograph by Uta Holter, from Labelle Prussin, *African Nomadic Architecture: Space, Place, and Gender* (Washington, D.C.: Smithsonian Institution Press and the National Museum of African Art, 1995), plate 9.

Figure 26.2: Photograph by Rita Willaert, Creative Commons, 2.0 Generic License.

Figure 26.3: Photograph by Suzanne Preston Blier.

Figure 26.5: H. Ling Roth, *Great Benin: Its Customs, Art, and Horrors* (F. King and Sons Ltd., 1903; reprint, London: Routledge & Kegan Paul Ltd., 1968).

Figure 26.6: Photograph copyright Trevor Kittelty; reprinted under license from Shutterstock.com.

Figure 26.7: Courtesy of Rebecca Ginsburg.

Figure 26.8: Photograph by David Goldblatt.

Figure 26.9: Photograph by Andrew Hall, Creative Commons, Share Alike Generic License.

27. POSTCOLONIAL MODERNISM AND BEYOND

Figure 27.2: Photograph by Michel Ecochard. Courtesy of Tom Avermaete. Reproduced with permission of Jean Ecochard.

Figures 27.3, 27.8, and 27.9: Copyright Aga Khan Award for Architecture.

Figure 27.4: Photograph by duncid, Creative Commons, Share Alike 2.0 Generic License.

Figure 27.5: Photograph by Gretta Tritch Roman.

Figure 27.7: Photograph by Nichalp, Creative Commons, Share Alike 2.5 Generic License.

28. POSTWAR JAPAN

Figure 28.1: Photograph by David Jones, Creative Commons, 2.0 Generic License.
Figure 28.2: Photograph by Wiiii, GNU Free Documentation License.
Figure 28.3: Photograph by Kanegan, Creative Commons, 2.0 Generic License.
Figure 28.4: Photograph by Akio Kawasumi. Courtesy of Tange Associates.
Figures 28.5 and 28.8: Courtesy of Marc Treib.
Figure 28.6: Photograph by Koji Taki.
Figure 28.7: Courtesy of the Office of Tadeo Ando.
Figure 28.9: Photograph by Nacasa & Partners Inc.
Figure 28.10: Courtesy of Dana Buntrock.

29. FROM POSTMODERN TO NEOMODERN

Figure 29.1: Wikimedia Commons.
Figure 29.2: Courtesy of Jim Alinder.
Figure 29.3: Digital image copyright The Museum of Modern Art. Licensed by SCALA/Art Resource, NY.
Figures 29.4 and 29.6: Courtesy of Oliver Radford.
Figure 29.5: Photograph by Tim Street-Porter.
Figure 29.7: Photograph copyright Bitter Bredt. Courtesy Studio Daniel Libeskind.
Figure 29.8: Photograph copyright Georges Fessy. Courtesy Ateliers Jean Nouvel.
Figure 29.9: Photograph copyright Raimond Spekking/CC-BY-SA-3.0.

30. CHINESE GLOBAL CITIES

Figure 30.1: Courtesy of Don Choi.
Figure 30.2: Photograph copyright Edward Denison, 2012.
Figure 30.4: Photograph by Wing1990hk, Creative Commons, Share Alike 3.0 License.
Figure 30.5: Photograph by Javier Ocaña.
Figure 30.6: *Zaha Hadid: Complete Works* (New York: Rizzoli International Publications, Inc.), 22. Copyright 1998, 2009 Zaha Hadid.
Figure 30.7: Photograph by WiNG, Creative Commons, Share Alike 3.0 License.
Figure 30.8: Photograph by J. Patrick Fischer, Creative Commons, Share Alike 3.0 License.
Figure 30.9: Photograph by Jmex, GNU Free Documentation License.

INDEX

KATHLEEN JAMES-CHAKRABORTY is professor of art history at University College Dublin and chair of the Board of Directors of the Irish Architecture Foundation. She is author of *Erich Mendelsohn and the Architecture of German Modernism* and *German Architecture for a Mass Audience,* and editor of *Bauhaus Culture: From Weimar to the Cold War* (Minnesota, 2006).